Italian Paintings before 1600 in The Art Institute of Chicago

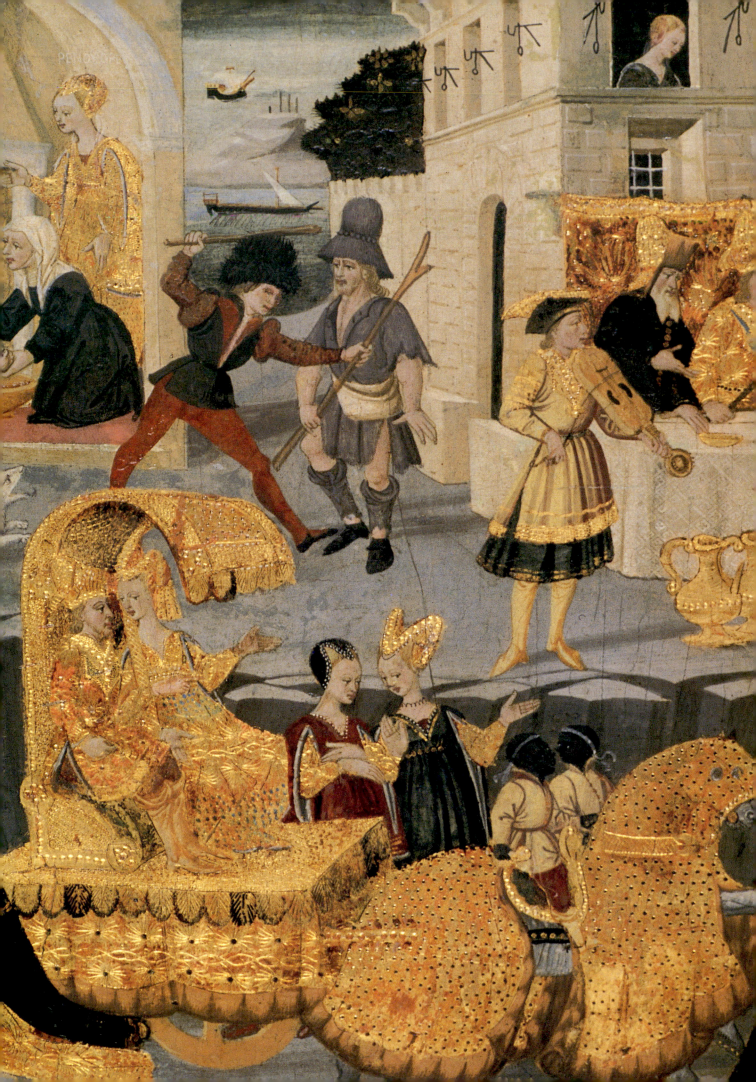

Italian Paintings before 1600 in The Art Institute of Chicago

A CATALOGUE OF THE COLLECTION

By Christopher Lloyd

With contributions by Margherita Andreotti, Larry J. Feinberg, and Martha Wolff

Martha Wolff, *General Editor*

The Art Institute of Chicago
in association with Princeton University Press

This book was made possible by grants from the National Endowment for the Arts, the Andrew W. Mellon Foundation, and the Old Masters Society of The Art Institute of Chicago.

Executive Director of Publications: Susan F. Rossen
Editor: Margherita Andreotti, assisted by Elisabeth Dunn
Production Manager: Katherine Houck Fredrickson, assisted by Manine Golden

Photography credits: Unless otherwise indicated in the captions, all illustrations were produced by the Department of Imaging and Technical Services, Alan Newman, Executive Director.

LIBRARY OF CONGRESS CATALOGING-IN-PUBLICATION DATA

Lloyd, Christopher, 1945–
Italian paintings before 1600 in the Art Institute of Chicago: a catalogue
of the collection / by Christopher Lloyd; with contributions by Margherita Andreotti,
Larry J. Feinberg, and Martha Wolff; Martha Wolff, general editor.
p. cm.
Includes bibliographical references and index.
ISBN 0-86559-110-5: $90.00. — ISBN 0-691-03351-X (Princeton): $90.00

1. Painting, Italian — Catalogs. 2. Painting, Medieval — Italy — Catalogs. 3. Painting,
Renaissance — Italy — Catalogs. 4. Painting — 16th century — Italy — Catalogs.
5. Painting — Illinois — Chicago — Catalogs. 6. Art Institute of Chicago — Catalogs.
I. Andreotti, Margherita. II. Feinberg, Larry J. III. Wolff, Martha.
IV. Art Institute of Chicago. V. Title.
ND614.L66 1993
759.5′ 074′ 77311 — dc20 93-12237
 CIP

Cover: Detail of Giovanni di Paolo, *Ecce Agnus Dei*, 1933.1011
Frontispiece: Detail of Apollonio di Giovanni, *The Adventures of Ulysses*, 1933.1006

Contents

Preface

One hundred years ago, the fledgling Art Institute of Chicago moved to its present location, an imposing Beaux-Arts building on Michigan Avenue in the center of the city. The building proved to be a powerful stimulus to the collecting instincts of the museum's trustees and friends. It is appropriate then that the first volume of a projected series of catalogues on the Art Institute's collection of European paintings should be published in this anniversary year. This volume provides a new and detailed examination of the early Italian paintings in the Art Institute's collection, in terms of their creation, their function, and their later history. It, and the other volumes that we hope will follow it in steady succession, will make the pictures fully accessible to scholars and museum visitors for the first time and suggest fresh ways of using and building the collection in the future.

We are deeply grateful to Christopher Lloyd for his work on this project—for the breadth of his knowledge and his meticulous standards of scholarship, for the enthusiasm with which he approached what was in many ways an under-studied collection, and for his commitment of time and energy to bring the work to fruition. As his duties as Surveyor of the Queen's Pictures increased, he encouraged the staff at the Art Institute to add information necessary to complete the catalogue. This was done by Margherita Andreotti, Larry Feinberg, and Martha Wolff, particularly in relation to the condition of pictures and their acquisition by Chicago collectors. Research and production of the catalogue have been generously supported by the National Endowment for the Arts, the Andrew W. Mellon Foundation, and the Old Masters Society of The Art Institute of Chicago.

James N. Wood
Director and President

Acknowledgments

The invitation to write a catalogue of the Italian paintings before 1600 in The Art Institute of Chicago was extended by Director James N. Wood in 1980 at the instigation of Richard R. Brettell, former Searle Curator of European Painting. I was duly appointed Research Curator of Early Italian Painting at the Art Institute for the year 1980–81. I am most grateful to Jim Wood and Richard Brettell for the opportunity to undertake this catalogue and to work for a year in one of the finest museums in the world. Mr. Wood and Katharine C. Lee, Deputy Director from 1982 to 1991, were vigilant in their support of this ambitious project and in their determination to see it realized. The warm welcome given to my family and myself by all members of the museum staff and by the Old Masters Society, during 1980–81, made our time in the United States a memorable and exciting experience.

The collection of early Italian paintings in Chicago is significant, a fact that has not yet received proper recognition. It includes remarkable groups of thirteenth-century panels and of fifteenth-century Florentine and Sienese paintings. The *Crucifix* by the Bigallo Master and the series of panels depicting scenes from the life of Saint John the Baptist by Giovanni di Paolo are works of the greatest distinction. Although I tried to take every opportunity to inspect other relevant collections in the United States during my stay, the preparatory work for this catalogue was done in the Art Institute, mainly in two areas: the conservation studio and the library. For their patience and expertise in examining numerous paintings on my behalf I must thank various members of the Conservation Department, some of whom did not begin their work in Chicago until after my time there. They include the late William R. Leisher, former Executive Director of Conservation, Frank Zuccari, Timothy J. Lennon, Faye T. Wrubel, Inge Fiedler, Karin Knight, Cynthia Kuniej, Barbara Pellizzari, and Jill Whitten. Martha Wolff coordinated the drafting of the final condition reports. I am very grateful to Daphne Roloff and to Jack Perry Brown, her successor as Executive Director of the Ryerson and Burnham Libraries, and to their staff for giving me every assistance. Katherine Haskins, Maureen A. Lasko, Susan E. Perry, Woodman Taylor, and Susan Walsh helped in substantial ways, particularly with interlibrary-loan requests. The establishment of the Archives Department at the Art Institute, headed by Catherine Stover, followed by Jane A. Kenamore and then John Smith, occurred after my time in Chicago, making much information about collecting in Chicago readily available for the first time. This was incorporated into the entries by Margherita Andreotti and Martha Wolff, and is reflected in Ms. Wolff's historical introduction to the catalogue. In addition, I must thank members of the Department of European Painting, where I was given an office, particularly the late Ilse Hecht, who is remembered with great affection, Susan Wise, and Ian B. Wardropper. Douglas W. Druick, who followed Richard Brettell as Searle Curator of European Painting, strongly supported the completion of the catalogue. My research assistant Carolyn Conover was especially helpful and relished following up references and preparing bibliographies. The diligence of other research assistants during 1980–81 and thereafter was equally important. They included Michael Heinlen, Caroline Hull, Mary Kuzniar, Anna Leider, and Susanna Meade. The departmental secretary Lorraine Schaefer, and her successors Theresa Brown, Lisabeth Burger, and Geri Banik helped to coordinate our activities.

The writing of the catalogue continued after my return to the Ashmolean Museum in Oxford, and the typescript was submitted in the mid-1980s. This was read by Everett Fahy and Cecil Gould, whose comments and opinions were pertinent and much appreciated. Both readers saved me from error. The generous contributions of numerous other scholars whose opinions were sought are acknowledged in the entries. In addition, the assistance of the staffs of the Witt Library, London, the Bodleian Library, Oxford,

the Frick Art Reference Library, New York, the Thomas J. Watson Library at The Metropolitan Museum of Art, New York, and the Resource Collection of the Getty Center for the History of Art and the Humanities, Santa Monica, is gratefully acknowledged.

The impetus for the present publication has come from Martha Wolff, who, in 1986, was appointed Curator of European Painting before 1750. Having been the joint author (with John Oliver Hand) of the catalogue of early Netherlandish paintings in the National Gallery of Art, Washington, D.C., Ms. Wolff brought to the Art Institute extensive experience in the art of catalogue writing, and I am grateful to her for the determination with which she has taken the initiative and supported the project in order to bring it to fruition. The catalogue has greatly benefited from the dedication and high standards with which she has overseen the manuscript's revision and completion. To this end, she has been ably supported by Associate Curator Larry J. Feinberg, who also wrote entries on several pictures added to the collection since the completion of the original manuscript (see 1986.1366, 1987.252, and 1988.266). On the editorial side, Susan F. Rossen, Executive Director of Publications, warmly supported the project from the outset and was instrumental in mobilizing the resources needed to bring this book to completion. Margherita Andreotti edited the manuscript with intelligence and sensitivity, demonstrating an exceptional dedication to the project and contributing in ways that far exceeded a purely editorial role. During the last phase of the project, she was admirably assisted by Elisabeth Dunn in the tasks of fact checking, editing, and coordinating the myriad details that a catalogue of this kind entails. Cris Ligenza, Bryan D. Miller, and Susan A. Snodgrass patiently typed and corrected the text and obtained comparative illustrations. Adam Jolles was also very helpful. Alan Newman and the staff of the Department of Imaging and Technical Services gave the photography of the paintings their most careful and sympathetic attention. This included the development of a system for making infrared reflectograms to which Carl L. Basner, Chester Brummel, William R. Leisher, Martina A. Lopez, Alan Newman, and Frank Zuccari all contributed, with Molly Faries of Indiana University providing valuable advice. Katherine Houck Fredrickson coordinated the production of the catalogue, insuring that its physical aspects met the highest standards. Bruce Campbell contributed a beautiful and practical design.

I am conscious, therefore, that *Italian Paintings before 1600 in The Art Institute of Chicago* has been a team effort and that it would have been difficult for me to have brought the book to a conclusion on my own. For the perseverance and consideration of all those involved, I am deeply grateful.

Christopher Lloyd

Introduction

This catalogue includes all the Italian Paintings executed before 1600 in the collection of The Art Institute of Chicago, a group of close to one hundred paintings. Among them are some of the first old master paintings acquired by Chicago collectors with their city's museum in mind. They cover a broad chronological range, from the Florentine *Crucifix* by the Master of the Bigallo Crucifix (1936.120) and the portable diptych painted by a cosmopolitan artist working in the Crusader kingdom (1933.1035), both works of the thirteenth century, to paintings by Palma il Giovane and Jacopo da Empoli executed on the eve of the seventeenth century and anticipating its realist tendencies. The collection does not claim to reflect the full range of painting types and regional styles that flourished in Italy before 1600. It remains essentially the gift of a single donor of refined taste, Martin A. Ryerson, supplemented and balanced by later gifts and purchases. Ryerson's preference for intimate and exquisitely wrought pictures accounts for some of the finest works in the collection. Because this catalogue is the first of a series devoted to the permanent collection and because Ryerson's extraordinary achievement as a collector has not received the attention it deserves, it seems appropriate to outline briefly the formation of the collection of early Italian paintings.

When The Art Institute of Chicago moved into its new Beaux-Arts building in 1893, it possessed few paintings, mostly nineteenth-century academic works. Only a small number represented the history of earlier European painting. Chief among these were fourteen seventeenth-century Dutch and Flemish pictures purchased in 1890 from the Demidoff collection by Charles Hutchinson, President of the Art Institute, and his close friend Martin A. Ryerson with the backing of two other trustees. Acting as an agent for the transaction was the Paris dealer Durand-Ruel, from whom both Hutchinson and Ryerson were also buying pictures for their own collections. In the next few years, individual trustees made donations that supported the acquisition of particular Demidoff pictures, donations that are remembered in each painting's credit line. However, Ryerson seems to have provided the bulk of the financial support for the initial, rather speculative, purchase of the pictures in 1890.[1] Ryerson, who was born in 1856, inherited a fortune founded on the lumber industry when his father died in 1887. He was a key supporter of numerous Chicago cultural institutions, serving as Vice-President of the Board of the University of Chicago from 1890 to 1892 and as its President from 1893 to 1922. He had become a trustee of the Art Institute in 1890 and his collecting activity seems to have begun about that time, both on behalf of the museum and privately with the institution in mind.

Almost half of the pictures in the present catalogue, a total of forty-one paintings, were bought by Ryerson and bequeathed at his death in 1932 or at the death of his widow, Carrie Ryerson, five years later. In his 1932 bequest, the "Italian primitives," consisting of thirty-seven objects, formed the largest group after the "modern Europeans," numbering seventy-eight, and their value was estimated as only slightly below that of the much more numerous modern Europeans. These works were already on long-term loan to the Art Institute where they were displayed in four galleries devoted to his collection. Italian paintings were also prominent in the group still in the Ryerson house (fig. 1), which would be bequeathed by Ryerson's widow in 1937.

Ryerson's papers, which are preserved in the Archives of the Art Institute, permit some generalizations about his collecting. They include letters from dealers and scholars, receipts for purchases, lists, and pages from a notebook of purchases and works offered to him in the 1910s. Unfortunately, copies of his letters are for the most part lacking, as are more personal travel notes and memoranda. He apparently bought largely on his own, without advisors. While he bought from various dealers, mostly during his extensive travels in Europe, he did maintain a long

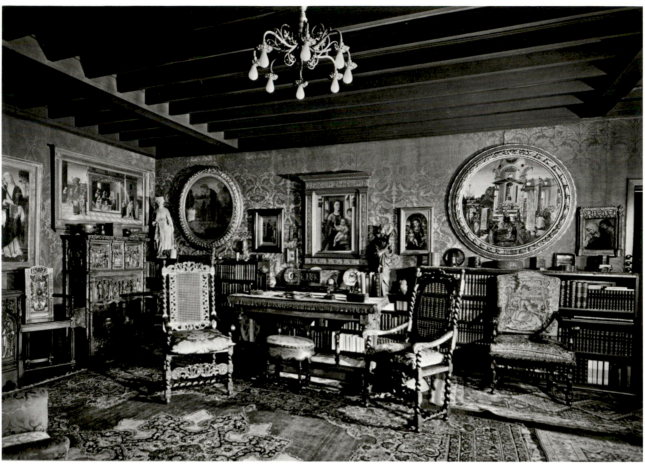

Fig. 1 Photograph of the Ryerson home, probably between 1924 and 1937 (Archives, The Art Institute of Chicago)

and fruitful relationship with the firm of Durand-Ruel, buying old masters, nineteenth-century academic paintings, and major Impressionist and Post-Impressionist works from them, as well as entrusting them with auction bids over a span of years. Thus, toward the beginning of his activity as a collector, Georges Durand-Ruel bid on his behalf in the 1892 sale of the Earl of Dudley's collection at Christie's, obtaining the four Perugino predella panels (1933.1023–26) and the portrait now recognized as that of Alessandro de' Medici by Pontormo (1933.1002), but then considered to represent an unknown man and ascribed to Bronzino. Correspondence with the firm indicates that they were still bidding at auction for him in 1920 and 1924. Interestingly, for the Dudley sale Ryerson gave Durand-Ruel quite ambitious instructions to bid on ten pictures, including the four Perugino panels. His highest bid of £1,500 was for Lorenzo di Credi's

Leonardesque *Virgin and Child with the Infant Saint John* (fig. 2), which was purchased in 1939 by the Nelson-Atkins Museum of Art in Kansas City and is now one of the treasures of its collection. He also bid on the *Mass of Saint Giles* by the Master of Saint Giles now in The National Gallery, London, one of the most important French panel paintings of the early Renaissance. Since Durand-Ruel had to exceed his instructions even to obtain the Pontormo and Perugino panels, it is fair to assume that Ryerson was ambitious and discriminating, but cautious in his spending (fig. 3).[2]

Apart from these purchases at the Dudley sale in 1892, Ryerson bought few Italian paintings in the 1890s. Those works he did buy, including the Botticini tondo (1937.997), *The Virgin Adoring the Child with the Young Saint John* by a follower of Domenico Ghirlandaio (1937.1005), and probably also the *Virgin and Child Enthroned with Saints Peter, Paul, John the*

Baptist, Dominic, and a Donor attributed to Ugolino di Nerio (1937.1007), were private in mood. Indeed, the last three paintings were among the objects that Ryerson still kept in his house at the time of his death and were bequeathed by his widow (fig. 1). In the first decade of the twentieth century, Ryerson apparently purchased very few paintings of any school, but his collecting activity accelerated markedly after 1910. In that year, he began a practice of buying Italian pictures in groups, acquiring at one time from James Kerr-Lawson the Gerini *Virgin and Child* (1937.1003), the Lorenzo di Bicci *Madonna of Humility with Two Angels* (1937.1004), and the Girolamo da Santacroce *Virgin and Child Enthroned* (1933.1008), as well as works attributed to Sano di Pietro and Andrea di Bartolo which were later deaccessioned. These paintings were all in the same rather modest taste as those acquired in the 1890s, and, with the exception of the Girolamo da Santacroce, were still in Ryerson's house at the time of his death. However, in the next few years, with increasing sureness, Ryerson

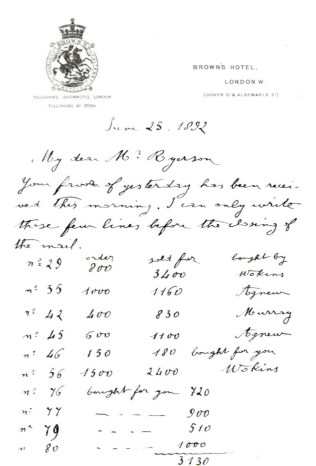

Fig. 3 Letter from Georges Durand-Ruel to Martin A. Ryerson, June 25, 1892 (Archives, The Art Institute of Chicago)

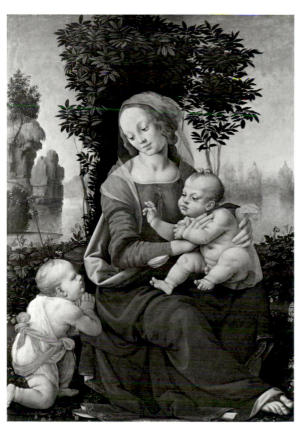

Fig. 2 Lorenzo di Credi, *Virgin and Child with the Infant Saint John*, The Nelson-Atkins Museum of Art, Kansas City, Missouri (Nelson Fund 39-3)

began acquiring paintings as bold and important as those that had earlier eluded him at the Dudley sale: the Apollonio di Giovanni cassone panel of Ulysses (1933.1006) in 1911, the Ridolfo Ghirlandaio *Portrait of a Gentleman* (1933.1009) in 1912, and the splendid group of six scenes from the life of Saint John the Baptist by Giovanni di Paolo (1933.1010–15) in 1914. This achievement cannot be separated from his equally bold purchases of early French and Netherlandish pictures in the same years, notably Rogier van der Weyden's *Portrait of Jean Gros* (1933.1051) in 1913 and *The Annunciation* by the Master of Moulins (1933.1062) bought in 1914, among others. His last purchases of Italian paintings in the 1920s show a still greater consistency and focus. They include works by Sano di Pietro (1933.1027), Lo Spagna (1937.1008), Starnina (1933.1017), Bartolommeo di Giovanni (1937.996), and Taddeo di Bartolo (1933.1033), as well as the Latin Kingdom diptych (1933.1035) and the

Florentine *Crucifixion* close in style to Lorenzo Monaco (1933.1032).

With his usual keen perception, Ellis Waterhouse pointed out that Ryerson probably turned to ambitious personal collecting after 1910 out of frustration with the cumbersome process of scouting pictures, purchasing them, and then finding support for them among his fellow trustees. This had been the way the Demidoff pictures and a few other works were acquired in the 1890s, and it was the way the great El Greco *Assumption of the Virgin* entered the Art Institute in 1906, again through Durand-Ruel.[3] However, in 1905 the museum was still trying to attract subscribers to support the purchase of the Demidoff pictures fifteen years earlier.[4] Beginning in the 1910s, when Ryerson's personal buying resumed and intensified, most of his purchases went directly into galleries set aside for his collection in the Art Institute. Thus only three of the sixteen early Italian pictures still in his house on Drexel Boulevard on the South Side at the time of his death in 1932 had been bought in the previous fifteen years.[5]

Despite Ryerson's goal of building the museum's collection, his choices always reflected his own taste, as did his often brilliant purchases of Impressionist and Post-Impressionist paintings. He was attracted to paintings that were complex, finely wrought, and personal — often intimate — in their communication. This sensibility also embraced works of an intense but refined devotional character. He was evidently less comfortable with the expressive, sensual qualities of Venetian painting. Writing from Venice after driving from Florence by way of Ravenna, Ferrara, and Padua in 1924, he noted that "we are seeing the city after an interval of many years," and offered a rare personal opinion, "We must confess, however, that the Venetian School as a whole does not appeal to us as do the Tuscan and the Umbrian."[6]

The example of Ryerson and collectors in other cities was powerful, and in the years from 1920 to 1950 old master paintings were actively collected in Chicago. Collections formed by Charles H. and Mary F. S. Worcester, Max Epstein, Chester D. Tripp, and George F. Harding, Jr., in these years ultimately enriched the Art Institute's holdings of Italian paintings.

The largest and most important contribution after Ryerson's was made by the Worcesters, husband and wife, whose collection was formed with the help of the Art Institute's staff as a conscious balance to that of Ryerson. Charles Worcester, who was born in 1864, also possessed a fortune made in the lumber and paper industry. He was an amateur painter and had been quietly collecting nineteenth-century works when he was made a trustee of the Art Institute in 1925 and began to acquire actively for the museum. The Worcesters approached then Director Robert Harshe, asking how they could help build the collection, and with his assistance concluded that "German primitives (save some few examples) and Renaissance masters of Venice were completely lacking."[7] They responded eagerly to this suggestion and were soon making buying trips to Germany and Italy. What was easily their most important early Italian acquisition, Moroni's grand portrait of *Gian Lodovico Madruzzo* (1929.912) painted in emulation of Titian, was bought shortly thereafter at the Stillwell sale in New York. It must be admitted that the Worcesters' efforts to provide Chicago with major works by the canon of Venetian painters, Giovanni Bellini, Titian, Veronese, and Domenico Tintoretto, were not wholly successful. Their Titian *Allegory of Venus and Cupid* (1943.90), bought with much fanfare from Wildenstein in 1936, has proved to be the work of an imitator. Of the three Veroneses they acquired, only one, *The Creation of Eve* (1930.286), is autograph, though in damaged condition. They did better with their purchases of early German paintings and with their farsighted buying of Baroque and eighteenth-century pictures. They were also ahead of their time in their interest in sketches and pictures that showed the artist's working process. The acquisitions fund they established has been an important support for subsequent purchases of paintings, including, appropriately, Vasari's unfinished *The Temptation of Saint Jerome* (1964.64).

By 1930, Robert Harshe had created a lively interest in the collecting of old master paintings among Art Institute supporters. The growth of his museum's professional staff and the emergence of a market in old master pictures in New York, as well as the example of other collectors, must have contributed to this trend. At Harshe's recommendation, the Worcesters and Catherine Barker Hickox were each willing to acquire one of a pair of panels from the workshop of Paolo Veneziano, eventually giving them to the Art

Institute (1947.116 and 1958.304). Though Venetian, these elegant fourteenth-century panels were also very much in Ryerson's taste, and it is clear that he too would have been happy to acquire the pair.[8]

It was also under Harshe's aegis that Chester Tripp bought the *Portrait of a Gentleman* then attributed to Raphael (1988.266, now given to an anonymous Veneto-Lombard painter) and deposited it on loan to the museum in 1930. Evidently there was a certain amount of competition for this picture, since early reports of its arrival in Chicago mentioned Mrs. Hickox as the buyer, even showing her photographed in front of the portrait.[9] Although the Veneziano was the only old master painting given by Mrs. Hickox to the Art Institute, through the Barker Welfare Foundation, she placed a number of pictures, including a version of Titian's *Danaë*, on long-term loan to the museum and lent others to the Yale University Art Gallery.

The bequest of the financier Max Epstein in 1954 brought a number of Italian paintings to the Art Institute, including several very fine late fifteenth-century Tuscan pictures, the two Madonnas by Botticelli (1954.282–83) and Frediani's *The Adoration of the Christ Child* (1954.289). These had been acquired by 1928 and were included in a luxurious catalogue of Epstein's collection privately printed in that year. The last group of early Italian paintings to come to the Art Institute from one of the collections formed in the early part of the twentieth century had belonged to George F. Harding, Jr. This flamboyant real estate magnate and political power broker had organized his collection as a museum in 1930 and housed it in a castle built for the purpose on Chicago's South Side. Harding, and his father before him, had accumulated a highly eclectic mass of material, chiefly an exceptionally fine and extensive array of arms and armor, but also European decorative arts and sculpture, nineteenth-century academic painting, and old master paintings. When the castle was condemned to make way for an urban renewal project in 1962, the collection of the Harding Museum became essentially inaccessible, resulting in a succession of legal problems until it was transferred to the Art Institute beginning in 1982.

These gifts were supplemented by a relatively small number of purchases intended to balance

and support the works already in the collection. Thus the *Crucifix* by the Master of the Bigallo Crucifix (1936.120) and the Veneto-Riminese tripych (1968.321) gave additional strength to the core of Byzantine-influenced paintings bequeathed by Ryerson. Most of the other purchases of Italian paintings addressed the collection's weakness in sixteenth-century works. Daniel Catton Rich, director from 1939 to 1958, had a particular affinity for Baroque paintings, a period not then much sought after. He also bought two important sixteenth-century paintings, Cambiaso's *Venus and Cupid* (1942.290) and Tintoretto's *Tarquin and Lucretia* (1949.203), that anticipate the Baroque in their dramatic lighting effects and dynamic combinations of figures. Of the several Italian paintings added by John Maxon, who came to the Art Institute as Director of Fine Arts in 1958, the most important was undoubtedly Correggio's *Virgin and Child with the Young Saint John the Baptist* (1965.688), whose rich synthesis of the traditions of Emilia and Northern Italy with the developments of the High Renaissance addresses several areas that remain gaps in the Art Institute's collection.

Several efforts during the early part of this century to catalogue and research the collection in depth did not bear fruit, making the present volume all the more important. A manuscript catalogue of Ryerson's collection completed by members of the museum staff in 1926 served as the basis a few years later for William R. Valentiner's unpublished catalogue of the Ryerson collection. The exchange of letters between Ryerson and Valentiner, then Director of the Detroit Institute of Arts, concerning this catalogue reveals Ryerson's penchant for scholarly detail. He evidently wanted complete bibliographical references to his pictures, something Valentiner would have been happy to avoid. Valentiner's exasperation shows when he writes, " . . . if you would like to have [complete references] included perhaps Mr. Rich could fill it in. If I had gone so much into detail in regard to references in the way Mr. Rich or whoever corrected the catalogue recommends, I would not have accomplished much in my life, as it would have taken all my time. After all, references are for art students and not for pedantic libraries."[10] Ryerson clearly wanted completeness and practicality rather than the lavish

catalogue volumes favored by some of his contemporaries. The project was suspended shortly before Ryerson's death, however, due to "uncertainty as to the form it should take."[11]

A commitment to produce a catalogue of all the paintings in the permanent collection was made with the hiring of the German emigré art historian Hans Huth as research curator in 1944. Huth continued work on this project until the mid-1950s assisted by Waltraut van der Rohe, the daughter of Mies van der Rohe. By 1955, their manuscript was entangled in a discussion regarding the degree of popular or scholarly emphasis appropriate to such a catalogue. In the end, his text, much condensed, was the basis for the 1961 catalogue of the Art Institute's paintings. Updated and reprinted in 1968, it has remained the only complete publication of the Art Institute's paintings. It is hoped that, by presenting the first full discussion of the paintings in the collection, the present catalogue and the other volumes that will begin to follow it in steady succession will make the collection more accessible both to the public and to the world of scholars, providing a basis for further acquisitions, study, and interpretation.

Martha Wolff

NOTES
I am grateful to Christopher Lloyd, who always felt that the catalogue of the Art Institute's Italian pictures should be preceded by a brief history of this part of the collection, to Rick Brettell for his exemplary understanding of Chicago collectors, and to David Van Zanten for sharing his knowledge of the city. I am also grateful to Jack Perry Brown, John Smith, and Elisabeth Dunn for their help.

1 See the balance sheet, recording receipts and expenditures for pictures from 1890 to 1894, preserved in the Hutchinson papers, The Newberry Library, Chicago.
2 His other bids were for nos. 35, 42, and 45, attributed to Murillo, Marco Basaiti, and Giovanni Bellini, respectively.
3 Waterhouse 1983, p. 90.
4 The booklet *Important Facts Regarding The Art Institute of Chicago with Reproductions of the Demidoff Masterpieces*, Chicago, 1905, is essentially a prospectus to attract donations in support of Demidoff pictures not yet paid for.
5 These were the Bartolommeo di Giovanni (1937.996), the Ghissi (1937.1006), and the Lo Spagna (1937.1008).
6 Draft of letter of May 3, 1924, to Arthur Acton, who was acting as his agent for the purchase of a sculpture (Ryerson papers, Archives, The Art Institute of Chicago). It should be remembered that Ryerson was also active as a collector of sculpture, textiles, decorative arts, oriental art, and American paintings and watercolors, and that he made highly important bequests to the Art Institute in these areas as well.
7 As reported by Daniel Catton Rich, the compiler of the 1938 catalogue of Worcester's collection and later director of the Art Institute, in *Worcester Collection* 1938, p. v.
8 Letter of April 1, 1930, from Harshe to Ryerson, and Ryerson's response of April 5, 1930 (Ryerson papers, Archives, The Art Institute of Chicago). Ryerson did buy an *Ecce Homo* (1933.1049) by a fifteenth-century Dutch painter, no. 64 in this sale.
9 *Chicago Post*, May 17, 1930; copy in scrapbook in the Ryerson Library, The Art Institute of Chicago.
10 Letter of October 23, 1930 to Ryerson (Valentiner papers, Archives, The Art Institute of Chicago).
11 Letter of January 19, 1932, from Ryerson to Valentiner (Valentiner papers, Archives, The Art Institute of Chicago).

Notes to the Reader

Entries are organized alphabetically by artist, except for paintings of recent origin which are listed at the end of the catalogue section. Entries on works by unknown artists are integrated alphabetically throughout the catalogue under the chosen designation (Florentine, Master of the Bigallo Crucifix, Venetian, etc.). When there are several works by a given artist, entries are arranged in order of acquisition. Basic biographical information on the artist is incorporated into the discussion section of each entry. When there are several works by a given artist, this information is provided in the entry that appears first in the catalogue.

The following attribution terms are used to describe the work's relationship to a given artist:

Attributed to: Believed to be by the named artist, but final confirmation is needed before the attribution can be fully accepted.

Workshop of: Produced by students or assistants under the supervision of the named artist and in his style.

Follower of: An unknown artist working in the style of the named artist, but not necessarily under the immediate influence or in the lifetime of the named artist.

After: A copy after a specific work or works by the named artist.

Imitator of: Someone working in the style of the named artist with intention to deceive.

The following conventions for dating a work are used:

1525	if executed in 1525
c. 1525	if executed sometime around 1525
1525–30	if begun in 1525 and completed in 1530
1525/30	if executed sometime within or around the years 1525 to 1530

Descriptions of painting medium are based on visual observation, since the medium has not been analyzed. The picture's dimensions are given in centimeters, height preceding width, followed by dimensions in inches in parentheses. Inscriptions on the front of the painting are given at the beginning of each entry, after dimensions, and relevant inscriptions on the back are given in the notes. Left and right refer to the viewer's left and right unless the context implies otherwise. Whenever possible condition reports include a list in parentheses of available technical documentation.

In the provenance section, abbreviations have been used for the following dealers:

Agnew	Thomas Agnew & Sons Ltd., London
Colnaghi	P. & D. Colnaghi & Co., London
Duveen	Duveen Brothers, New York/London/Paris
Kleinberger	F. Kleinberger Galleries, New York/Paris
Knoedler	M. Knoedler & Co., New York/London/Paris
Wildenstein	Wildenstein & Co., London/New York

The provenance section includes the owner's death date when the owner is known to have died in possession of the picture. Variant attributions and titles are recorded for sales and exhibition catalogues, but not for other types of references. Sales and exhibition catalogues cited in the provenance and exhibition sections are generally not repeated in the list of references. Biblical citations refer to the King James Version. A list of abbreviations of frequently cited works follows.

Bibliographical Abbreviations

Art Bull.	*The Art Bulletin*	AIC 1925	The Art Institute of Chicago, *A Guide to the Paintings in the Permanent Collection*, 1925
AIC 1890	The Art Institute of Chicago, *Catalogue of Works of Old Dutch Masters and Other Pictures*, November 1890		
		AIC 1932	The Art Institute of Chicago, *A Guide to the Paintings in the Permanent Collection*, 1932
AIC 1893	The Art Institute of Chicago, *Catalogue of Paintings, Sculpture, and Other Objects Exhibited at the Opening of the New Museum, December 8, 1893* (reprinted January 1, 1894)	AIC 1935	The Art Institute of Chicago, *A Brief Illustrated Guide to the Collections*, 1935
		AIC 1946	The Art Institute of Chicago, *A Picture Book: Masterpieces of Painting, XV and XVI Centuries in the Collections of The Art Institute of Chicago*, 1946
AIC 1894	The Art Institute of Chicago, *Catalogue of Paintings, Sculpture, and Other Objects in the Museum*, March 15, 1894		
		AIC 1948	The Art Institute of Chicago, *An Illustrated Guide to the Collections of The Art Institute of Chicago*, 1948
AIC 1895	The Art Institute of Chicago, *Catalogue of Objects in the Museum, Part I, Sculpture and Painting*, 1895		
		AIC 1952	The Art Institute of Chicago, *Masterpieces in The Art Institute of Chicago*, 1952
AIC 1896	The Art Institute of Chicago, *Catalogue of Objects in the Museum, Part I, Sculpture and Painting*, 2d ed., 1896		
		AIC 1961	The Art Institute of Chicago, *Paintings in The Art Institute of Chicago: A Catalogue of the Picture Collection*, 1961
AIC 1898	The Art Institute of Chicago, *Catalogue of Objects in the Museum, Part I, Sculpture and Painting*, 3d ed., 1898		
		AIC Bulletin	*Bulletin of The Art Institute of Chicago*
AIC 1904	The Art Institute of Chicago, *General Catalogue of Objects in the Museum*, January 1904	AIC Museum Studies	*The Art Institute of Chicago Museum Studies*
		AIC Quarterly	*The Art Institute of Chicago Quarterly*
AIC 1907	The Art Institute of Chicago, *General Catalogue of Sculpture, Paintings, and Other Objects*, February 1907	Bénézit	Emmanuel Bénézit, *Dictionnaire critique et documentaire des peintres, sculpteurs, dessinateurs, et graveurs de tous les temps et de tous les pays*, 2d ed., 8 vols., Paris, 1948–55; 3d ed., 10 vols., 1976
AIC 1910	The Art Institute of Chicago, *General Catalogue of Sculpture, Paintings, and Other Objects*, June 1910		
AIC 1913	The Art Institute of Chicago, *General Catalogue of Paintings, Sculpture, and Other Objects in the Museum*, 1913		
		Berenson 1909a	Bernard Berenson, *The Central Italian Painters of the Renaissance*, 2d ed., New York and London, 1909
AIC 1914	The Art Institute of Chicago, *General Catalogue of Paintings, Sculpture, and Other Objects in the Museum*, 1914	Berenson 1909b	Bernard Berenson, *The Florentine Painters of the Renaissance*, 3d ed., New York and London, 1909
AIC 1917	The Art Institute of Chicago, *Catalogue of Paintings, Drawings, Sculpture, and Architecture*, August 1917	Berenson 1932	Bernard Berenson, *Italian Pictures of the Renaissance*, Oxford, 1932
		Berenson 1936	Bernard Berenson, *Pitture italiane del Rinascimento*, Milan, 1936
AIC 1920	The Art Institute of Chicago, *Handbook of Sculpture, Architecture, Paintings, and Drawings*, August 1920	Berenson 1957	Bernard Berenson, *Italian Pictures of the Renaissance: Venetian School*, 2 vols., London, 1957
AIC 1922	The Art Institute of Chicago, *Handbook of Sculpture, Architecture, and Paintings*, May 1922	Berenson 1963	Bernard Berenson, *Italian Pictures of the Renaissance: Florentine School*, 2 vols., London, 1963
AIC 1923	The Art Institute of Chicago, *Handbook of Sculpture, Architecture, and Paintings*, 1923	Berenson 1968	Bernard Berenson, *Italian Pictures of the Renaissance: Central Italian*

	and North Italian Schools, 3 vols., London, 1968
Burl. Mag.	*The Burlington Magazine*
Davies 1951	Martin Davies, *National Gallery Catalogues: The Earlier Italian Schools*, London, 1951
Davies 1961	Martin Davies, *National Gallery Catalogues: The Earlier Italian Schools*, 2d ed., London, 1961
Dizionario	*Dizionario enciclopedico Bolaffi dei pittori e degli incisori italiani, dall' XI al XX secolo*, 11 vols., Turin, 1972–76
Fredericksen/Zeri 1972	Burton B. Fredericksen and Federico Zeri, *Census of Pre-Nineteenth-Century Italian Paintings in North American Public Collections*, Cambridge, Mass., 1972
Garrison 1949	Edward B. Garrison, *Italian Romanesque Panel Painting: An Illustrated Index*, Florence, 1949
The Golden Legend	Jacobus de Voragine, *The Golden Legend*, 2 vols., tr. and ed. by G. Ryan and H. Ripperger, London, New York, and Toronto, 1941
Huth 1961	Hans Huth, "Italienische Kunstwerke im *Art Institute* von Chicago, USA," in *Miscellanea Bibliothecae Hertzianae*, Munich, 1961
Lugt	Frits Lugt, *Répertoire des Catalogues de ventes*, 4 vols., The Hague and Paris, 1938–87
Van Marle	Raimond van Marle, *The Development of the Italian Schools of Painting*, 19 vols., The Hague, 1923–38
Maxon 1970	John Maxon, *The Art Institute of Chicago*, London, 1970
Maxon 1977	John Maxon, *The Art Institute of Chicago*, rev. ed., London, 1977
Ryerson Collection 1926	Rose Mary Fischkin, *Martin A. Ryerson Collection of Paintings and Sculpture, XIII to XVIII Century, Loaned to The Art Institute of Chicago*, unpub. MS, 1926, Ryerson Library, The Art Institute of Chicago
Shapley 1966	Fern Rusk Shapley, *Paintings of the Samuel H. Kress Collection: Italian Schools, XIII–XV Century*, London, 1966
Shapley 1979	Fern Rusk Shapley, *National Gallery of Art: Catalogue of the Italian Paintings*, 2 vols., Washington, D.C., 1979
Thieme/Becker	Ulrich Thieme and Felix Becker, *Allgemeines Lexikon der bildenden Künstler von der Antike bis zur Gegenwart*, 37 vols., Leipzig, 1907–50
Valentiner [1932]	William R. Valentiner, *Paintings in the Collection of Martin A. Ryerson*, unpub. MS [1932], Archives, The Art Institute of Chicago
Vasari, *Vite*, Milanesi ed.	Giorgio Vasari, *Le vite de' più eccellenti pittori, scultori e architettori scritte da Giorgio Vasari*, ed. by Gaetano Milanesi, 9 vols., Florence, 1878–85
A. Venturi	Adolfo Venturi, *Storia dell'arte italiana*, 11 vols., Milan, 1901–39
L. Venturi 1931	Lionello Venturi, *Pitture italiane in America*, Milan, 1931
Waterhouse 1983	Ellis Waterhouse, "Earlier Paintings in the Earlier Years of the Art Institute: The Role of the Private Collectors," *The Art Institute of Chicago Museum Studies* 10 (1983), pp. 79–91
Worcester Collection 1938	Daniel Catton Rich, *Catalogue of the Charles H. and Mary F. S. Worcester Collection of Paintings, Sculpture, and Drawings*, Chicago, 1938
Zeri/Gardner 1971	Federico Zeri and Elizabeth E. Gardner, *Italian Paintings, a Catalogue of the Collection of The Metropolitan Museum of Art: Florentine School*, New York, 1971
Zeri/Gardner 1973	Federico Zeri and Elizabeth E. Gardner, *Italian Paintings, a Catalogue of the Collection of The Metropolitan Museum of Art: Venetian School*, New York, 1973
Zeri/Gardner 1980	Federico Zeri and Elizabeth E. Gardner, *Italian Paintings, a Catalogue of the Collection of The Metropolitan Museum of Art: Sienese and Central Italian Schools*, New York, 1980

CATALOGUE

Attributed to Alessandro Allori

1535 Florence 1607

Francesco de' Medici, c. 1560

Gift of Edgar Kaufmann, Jr., 1965.1179

Oil on panel (poplar), 97.9 x 76.4 cm (38½ x 30⅛ in.)

CONDITION: The painting is in fair to good condition. It was cleaned in 1965–66 by Alfred Jakstas. The panel appears to be composed of two boards with vertical grain, joined approximately 19 cm from the left edge. It has been thinned, as indicated by exposed worm tunneling, and then cradled. Some paint loss along the join has been filled and inpainted. Substantial paint and ground losses to the left of the head, above the right and left shoulders, and on the left arm above the elbow have also been filled and inpainted. There is a small paint and ground loss on the forehead and slight abrasion in the face, but in general the figure is well preserved. The background curtain, however, is disfigured by a combination of abrasion, cupping paint, blanching, and repaint so that it is difficult to read its form. The side of the table is also extensively repainted, as are the tassels on the back of the chair (infrared, mid-treatment, ultraviolet, x-radiograph).

PROVENANCE: Apparently Prince Anatole Demidoff, Florence.[1] Sulley and Co., London.[2] Sold by Sulley and Co. to Edward R. Bacon (d. 1915), New York and Netherdale House, Turriff (Aberdeenshire).[3] At his death to his sister-in-law, Virginia Purdy Bacon; sold Christie's, London, December 12, 1919, no. 69, as Bronzino, *Portrait of a Youth*, for £620.[4] Duveen, New York, by 1925.[5] Edgar Kaufmann, Jr., Pittsburgh, by 1932;[6] given to the Art Institute, 1965.

REFERENCES: J. B. Townsend and W. S. Howard, *Memorial Catalogue of Paintings by Old and Modern Masters Collected by Edward R. Bacon*, privately printed, New York, 1919, p. 224, no. 282. A. McComb, *Agnolo Bronzino: His Life and Works*, Cambridge, 1928, p. 73. Berenson 1932, p. 116; 1936, p. 100; 1963, vol. 1, p. 43. A. Emiliani, *Il Bronzino*, Milan, 1960, pp. 70, 336. J. Maxon, "Some Recent Acquisitions," *Apollo* 84 (1966), p. 221, fig. 2. L. Berti, *Il Principe dello Studiolo: Francesco I dei Medici e la fine del Rinascimento fiorentino*, Florence, 1967, p. 33, fig. 20. Maxon 1970, p. 254 (ill.). Fredericksen/Zeri 1972, pp. 36, 515, 571. E. Baccheschi, *L'opera completa del Bronzino*, Classici dell'arte 70, Milan, 1973, p. 106, no. 130 (ill.). K. Langedijk, *The Portraits of the Medici, 15th to 18th Centuries*, vol. 2, Florence, 1983, p. 858, no. 42.13b. G. Langdon, "A Reattribution: Alessandro Allori's Lady with a Cameo," *Zeitschrift für Kunstgeschichte* 52 (1989), p. 31 n. 25.

This portrait of Francesco I de' Medici (1541–1587), eldest son of Cosimo I and Eleonora of Toledo, is closely related in type to two others of comparable size: one formerly in the van Gelder collection, Brussels (fig. 1), the other in the collection at Wawel Castle, Cracow (fig. 2).[7] In all three portraits the sitter is dressed in a crimson doublet with gold embroidery, but the portrait formerly in Brussels differs from the others in the red used for the upholstery of the chair and the blue used for the cloth covering the table, as opposed to the green favored for these furnishings in the portraits in Chicago and Cracow. Another distinction between the portraits lies in the image on the medallion held by the sitter. In the ex-van Gelder and Cracow portraits, the image is, according to Langedijk,[8] definitely Lucrezia, Francesco's younger sister, but in the Chicago portrait Francesco displays what appears to be a cameo with a bust-length likeness of an unidentified female figure. The significance of this substitution has yet to be explained; the image on the cameo may well be intended not as a portrait but rather as a classical allusion.

The naturally reclusive and introverted Francesco de' Medici did not share his father's interest in statecraft and only grudgingly entered public life. In accordance with his father's political ambitions, Francesco married Giovanna of Austria, daughter of Emperor Ferdinand I, sister of Emperor Maximilian II, and cousin of Philip II of Spain, in 1565. He later wed Bianca Cappello in 1579, having had a liaison with her for several years previously. Francesco de' Medici succeeded his father as Grand Duke of Tuscany in 1574, gaining official recognition of the title from the Emperor in 1576 and being awarded the Order of the Golden Fleece in 1585. As regards the arts, Francesco undertook extensive building projects and patronized numerous artists. He also conducted scientific experiments himself. His interests are best

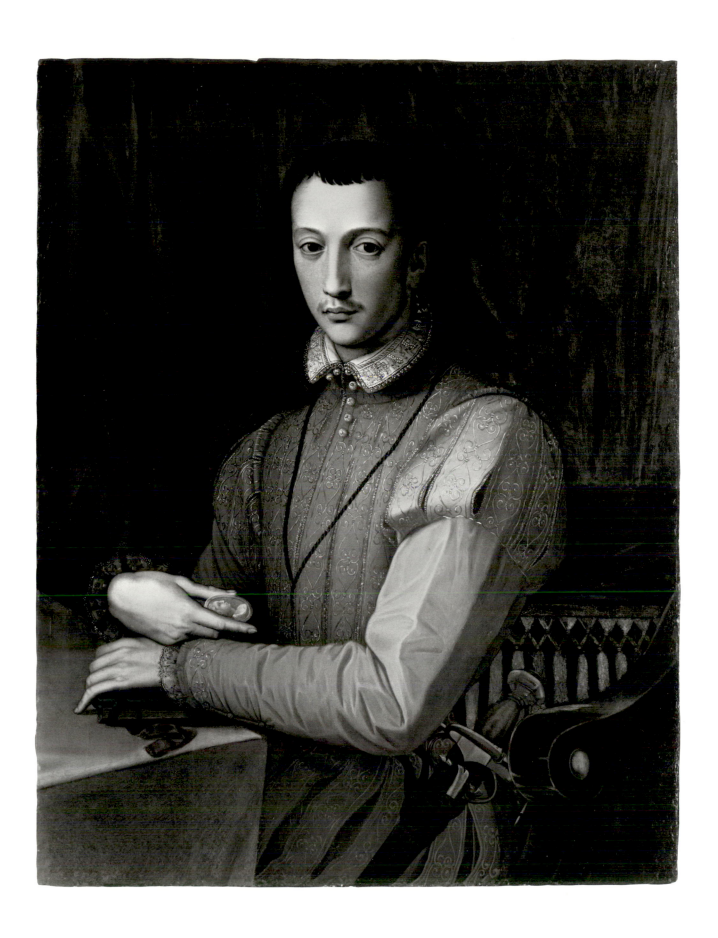

ATTRIBUTED TO ALESSANDRO ALLORI 3

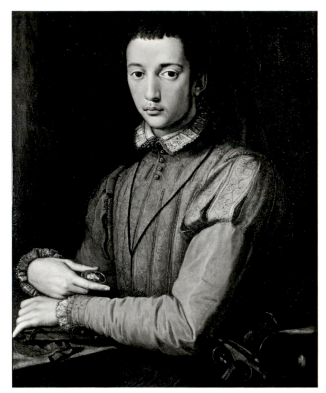

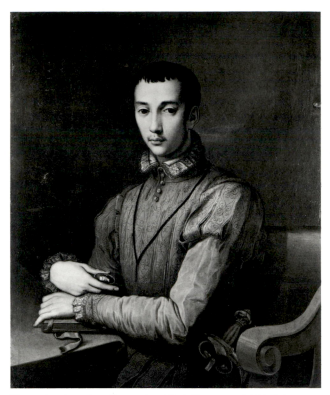

Fig. 1 Attributed to Alessandro Allori, *Francesco de' Medici*, private collection (formerly van Gelder collection, Brussels) [file photo]

Fig. 2 Attributed to Alessandro Allori, *Francesco de' Medici*, Państwowe Zbiory Sztuki na Wawelu, Cracow

represented in the decorative scheme for the Studiolo in the Palazzo Vecchio.[9]

The Chicago, ex-van Gelder, and Cracow portraits have all at one time or another been attributed to Bronzino. McComb (1928), Berenson (1932, 1936, 1963), Maxon (1970), and Fredericksen and Zeri (1972) all attributed the present picture to Bronzino. Baccheschi (1973), however, only attributed it tentatively to the master, while Berti (1967) preferred an attribution to an unknown painter of the Florentine school, although he admitted the possibility that the portrait might be derived from a lost prototype by Bronzino. Langedijk pointed out that during the 1560s Francesco's official portrait painter seems to have been Alessandro Allori and not Bronzino.[10] This means that after Bronzino had painted the outstanding portrait of Francesco as a boy in 1551 (Florence, Uffizi),[11] he ceded further informal or official portraits of this particular sitter to Allori, whose early style is indeed based on Bronzino's.[12] Langedijk, therefore, tentatively attributed the portrait formerly in the van Gelder collection to Allori himself and described the others in Chicago and Cracow as copies.[13]

A pupil of Bronzino, with whom he developed a familial bond, Alessandro Allori practiced an opulent, Florentine Mannerist style well into the first decade of the seventeenth century. His elegant and polished artistic manner depended primarily on his master's, but also on that of Michelangelo, whose works he studied and copied during an extended period in Rome (1554–60). After returning to Florence, he apparently reentered Bronzino's shop and assisted in the creation and replication of court portraits of the Medici.[14] In addition to major church commissions, such as altarpieces for the churches of Santa Croce and Santa Maria Novella, Allori executed numerous jewel-like cabinet pictures, including two paintings representing *The Banquet of Cleopatra* and *The Gathering of Pearls* (1570/71), for the Studiolo of Francesco I de' Medici.[15] Distinguishing Allori's portrait style from Bronzino's is a slightly more naturalistic treatment of flesh and, often, a more plausible and painterly rendering of the background. Allori's portraits, including the portrait of Francesco in question here, also lack the extreme refinement of detail, particularly in the costumes, of Bronzino's works.

Langedijk's designation of the Chicago picture as a copy after an Allori portrait of Francesco I is probably correct insofar as the treatment of the facial features, the hands, and the folds of the doublet in the present portrait are in places mechanically handled. The use of the word "copy," however, is perhaps misleading, as it suggests a certain distance from the original, whereas, in fact, the portrait in Chicago could well be a studio replica of the type produced, for example, in great numbers in Bronzino's own workshop and therefore conceivably also in Allori's growing practice. In this context the outline around the shoulders of the sitter (particularly on the left) cannot be described strictly as a *pentimento* so much perhaps as a false start.

The date of the painting is largely determined by the age of the sitter. Bronzino, in the portrait of 1551 mentioned above, showed the sitter as a boy aged ten. The present group of portraits is the first of Francesco as a young man, according to McComb's estimate, "aged between eighteen and twenty-one years old," which gives a date of 1559/62. Because Francesco seems to be holding medallions with images of his sister Lucrezia in the ex-van Gelder and Cracow versions of the painting, Langedijk has argued that this type of portrait was executed in connection with the marriage of Lucrezia to Alfonso II d'Este.[16] The marriage actually took place in 1558, although Lucrezia officially left Florence for Ferrara in 1560 accompanied by Francesco. If Allori was responsible for the present work, then it must have been executed in or after 1560, when he returned from Rome, or during an earlier, unrecorded visit to Florence.[17]

Notes

1 McComb (1928) stated that the picture was once in the collection of Prince Anatole Demidoff, which is probably correct, but difficult to verify. Langedijk (1983) has erroneously written that the portrait was at one time in the collection of the Earl of Northbrook.

2 According to Townsend and Howard 1919.
3 Ibid.
4 According to annotated sale catalogue in the Resource Collection of the Getty Center for the History of Art and the Humanities, Santa Monica.
5 According to McComb 1928 and information on the mount of a photograph of this picture in the Witt Library, London.
6 According to Berenson 1932.
7 Both are listed by Langedijk (vol. 2, 1983, pp. 855–56, no. 42.13, p. 858, no. 42.13c), who also published several other pictures that appear to derive from the same prototype (see pp. 854–55, no. 42.12, p. 861, no. 42.23). The van Gelder portrait was sold at Christie's, New York, January 12, 1978, no. 86 (ill.). It should also be noted that the drawing in the Museum Boymans-van Beuningen, Rotterdam, which Langedijk cautiously regarded as a study for the ex-van Gelder portrait, seems to be accepted by George Knox as by Giovanni Battista Tiepolo (G. Knox, *Giambattista and Domenico Tiepolo: A Study and Catalogue Raisonné of the Chalk Drawings*, Oxford, 1980, vol. 1, p. 212, no. M.26) rather than Annibale Carracci, to whom it had been attributed. In any case, the drawing is certainly not by Alessandro Allori. Furthermore, the resemblance between the head in the drawing and Francesco de' Medici is by no means as obvious as Langedijk asserted.
8 Langedijk, vol. 2, 1983, pp. 1198–207, no. 76.
9 See Berti 1967, a biography of Francesco, for further details.
10 Langedijk, vol. 1, 1981, pp. 121–22.
11 Ibid., vol. 2, 1983, pp. 861–62, no. 42.24 (ill.).
12 This is evidenced by Allori's *Portrait of an Unknown Man* in the Ashmolean Museum, Oxford (no. 1982.38, formerly Mentmore, sold Sotheby's, London, May 25–26, 1977, no. 2408 [ill.]), which after cleaning has been found to be dated 1561.
13 Langedijk, vol. 2, 1983, pp. 855–58.
14 Ibid., vol. 1, 1981, p. 122, and P. Costamagna, "Osservazioni sull'attività giovanile di Alessandro Allori. Seconda parte — Les Portraits," *Antichità viva* 27, 1 (1988), pp. 28–29.
15 A. Venturi, vol. 9, pt. 6, 1933, fig. 54; and W. Vitzthum, *Lo Studiolo di Francesco I a Firenze*, Milan, 1968, p. 24 (ill.).
16 Langedijk, vol. 1, 1981, p. 121.
17 For speculation on possible trips to Florence during Allori's Roman period, see S. Lecchini Giovannoni, *Mostra di disegni di Alessandro Allori*, exh. cat., Florence, Gabinetto Disegni e Stampe degli Uffizi, 1970, p. 11, and Costamagna (note 14 above), p. 26. In view of the sitter's youthful appearance, particularly his wispy adolescent mustache, in the Chicago portrait and in the related pictures, Francesco may have been in his early to mid-teens when the painting, or more likely a prototype that it replicates, was conceived. Thus the picture could date as early as 1556/58.

Apollonio di Giovanni

1415 or 1417–Florence 1465

The Adventures of Ulysses, 1435/45

Mr. and Mrs. Martin A. Ryerson Collection, 1933.1006

Tempera on panel, visible surface: 42 x 131.7 cm
(16 9/16 x 51 7/8 in.)

INSCRIBED: in white pigment, PVLIFEMO (three times
on left), VLISSE (seven times in all, but on two occasions,
above the scenes of Ulysses found by Nausicaa and Ulysses
meeting Irus, very rubbed), [ER]ME, INACO, and
PENOLOPE (twice)

CONDITION: The overall condition of the painting is good.
In 1940 Leo Marzolo consolidated lifting paint; in 1962
Alfred Jakstas cleaned the picture, and treated it more exten-
sively in 1967, when old repaint, including added fig leaves,
was removed. The panel is bowed. The frame, which sur-
rounds the painting and covers the back, is comparatively
modern.[1] The junction of panel and frame has been filled and
repainted to look like an engaged frame. There are small,
widely scattered paint losses throughout, as well as some
pitting, which is especially pronounced in the upper half
toward the center. There is a larger area of local damage in
the group of standing women at the extreme right, which
has been inpainted. In general, the faces of the figures are
well preserved, with the exception of those of the suitors to
the left of Penelope's chamber. The gold is also well pre-
served and exhibits clear patterns of punching and scribing.
The outlines of the architecture and the gold elements of the
design are incised. Other design elements are outlined in
brown paint (infrared, ultraviolet).

PROVENANCE: William Graham (d. 1885), Grosvenor
Place, London, by 1875;[2] sold Christie's, London, April 8,
1886, no. 172, as "The labours of Ulysses: from a Cassone,"
to Martin Colnaghi, acting on behalf of Francis George
Baring, for 29 gns. Francis George Baring, second Earl of
Northbrook, from 1886 to at least 1894.[3] Robert Langton
Douglas, London.[4] Sold by Langton Douglas to Julius Böhler,
Munich. Sold by Böhler to Martin A. Ryerson (d. 1932),
Chicago, 1911;[5] on loan to the Art Institute from 1911;
bequeathed to the Art Institute, 1933.

REFERENCES: AIC 1913, p. 197, no. 2088; 1914, p. 208,
no. 2088. P. Schubring, Cassoni: Truhen und Truhenbilder
der italienischen Frührenaissance, Leipzig, 1915, vol. 1, pp.
113, 276, no. 253 (ill.). AIC 1917, p. 164; 1920, p. 62; 1922,
p. 71; 1923, p. 71. G. E. Kaltenbach, "Cassoni," American
Magazine of Art 14 (1923), p. 599 (ill.). F. J. Mather, A
History of Italian Painting, New York, 1923, pp. 182–83.
AIC 1925, p. 159, no. 2018. Ryerson Collection 1926, pp.
16–17. Van Marle, vol. 10, 1928, p. 554. AIC 1932, p. 180,
no. 282.11. Berenson 1932, p. 346; 1936, p. 283; 1963,
vol. 1, p. 18, vol. 2, figs. 736a–b. Valentiner [1932], n. pag.
W. Stechow, "Marco del Buono and Apollonio di Giovanni,
Cassone Painters," Bulletin of the Allen Memorial Art
Museum 1 (1944), p. 17. Thieme/Becker, vol. 37, 1950,
"Meister der Dido-Truhe," p. 79. AIC 1961, p. 299. Huth
1961, p. 516. B. Wriston, "Joiners' Tools in The Art Insti-
tute of Chicago," AIC Museum Studies 2 (1967), p. 77
(detail ill.). E. Callmann, Apollonio di Giovanni, Oxford,
1974, pp. 16–19, 53, no. 3, pl. 29. Fredericksen/Zeri 1972,
pp. 12, 478, 571. E. Callmann, "Apollonio di Giovanni and
Painting for the Early Renaissance Room," Antichità viva 27,
3–4 (1988), p. 11, fig. 20.

EXHIBITIONS: London, Royal Academy of Arts, Works
by the Old Masters, 1875, no. 169, as "A Landscape, with
Architecture and Figures. Painter Unknown. 23 1/2 x 52 1/2
in." Brooklyn, Institute of Arts and Sciences Museum,
European Art, 1450–1500, 1936, no. 15, as Dido Master.

*T*he Adventures of Ulysses is the earliest in date and
the finest in quality of the distinguished group of
cassone panels in the collection of The Art Institute
of Chicago. Such panels originally formed part of gilt
wooden chests (*cassoni*), often made in pairs and usu-
ally in the context of a marriage. The larger panels,
horizontal in format, decorated the front of the
cassone, while the smaller rectangular panels were
inserted at either end. The backs of the chests were
adorned with simple decorative motifs and the insides
of the lids with either reclining figures or stenciled
patterns. The subject matter of the narrative scenes
was invariably taken from ancient history or from
vernacular Italian literature. It is apparent that the
demand for decorated *cassone* chests was considerable
and that Apollonio di Giovanni, in partnership with
Marco del Buono Giamberti, was a leading supplier.
A list of orders from their workshop dating from
1446 to 1463 survives in a seventeenth-century copy.[6]

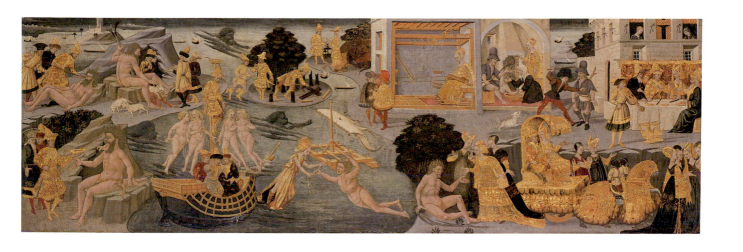

The individual style of Marco del Buono Giamberti is unknown, but Apollonio di Giovanni was renowned as a narrative painter and so his personal style is easier to evaluate. It is likely that, although a younger man, Apollonio di Giovanni was in artistic terms the senior partner. The fact that the entries in the workshop order book begin in 1446 would seem to imply that the partnership was formed in that year, and that both artists worked independently prior to that date, but this is not a settled matter.[7]

The following events from Homer's *Odyssey*, as identified by Callmann, have been portrayed on the present panel beginning in the lower left corner: Ulysses and his companions observe Polyphemus eating his victims as Ulysses offers him a bowl of wine (9.343–61); Ulysses and his companions blind Polyphemus (9.381–95); Ulysses and his companions escape from Polyphemus's cave beneath the sheep (9.426–45); Hermes warns Ulysses against Circe (10.277–306); Ulysses builds a raft (5.243–45); Ulysses meets Circe, who turns his companions into beasts (10.312–13); Ulysses, tied to the mast of his ship, listens to the Sirens' song (12.180–96); Leucothea (Inaco on the panel) helps the shipwrecked Ulysses (5.313–53); Nausicaa finds Ulysses (6.135–48); Nausicaa takes Ulysses to her father's palace (contradictory to 6.251–315); Alcinous's feast (8.62–586); Ulysses encounters his dog Argus (17.290–320) and the beggar Irus (18.1–109); the old nurse Eurycleia recognizes Ulysses (19.386–472); Penelope weaves, while her suitors wait outside (19.138–386). As Callmann observed, the events are depicted, with a few minor exceptions, in the order that Ulysses experienced them rather than in the order of the text. It seems that Apollonio specialized in depicting scenes from ancient history and mythology, since beyond the confines of his workshop and the sphere of its immediate influence there are few representations of either the *Odyssey* or of the *Aeneid* in early Florentine painting.

Apollonio's two *cassone* panels in the Yale University Art Gallery with scenes taken from Virgil are thematically related to his manuscript of the *Aeneid* in the Biblioteca Riccardiana in Florence.[8] The incidents on the panel in Chicago, on comparison with the panels based on the *Aeneid*, are assembled in a way that suggests a similar dependence upon the episodic treatment found in manuscripts, although we know of no manuscript of the *Odyssey* illustrated by Apollonio. Manuscripts of the *Odyssey* in Greek were, nevertheless, available in Italy during the fifteenth century,[9] and it is likely that Apollonio could have had access to an illustrated manuscript and have found someone to translate the Greek for him, since his work was much admired in humanist circles.[10]

The present panel was acquired by Martin A. Ryerson as a work by Pesellino, but was subsequently attributed by Schubring (1915), Van Marle (1928), and Valentiner (1932) to the Master of the Dido Panels, and by Berenson (1932, 1936) to the Master of the Jarves *Cassoni*.[11] The first writer to connect the panel with Apollonio di Giovanni was Stechow in his pioneering article of 1944 reconstructing that painter's work, and that association is now universally accepted.

On stylistic grounds, Callmann suggested a date for this panel in the late 1430s or early 1440s, that is, from the period before Apollonio is first recorded as working in partnership with Marco del Buono Giamberti. As she pointed out, the styles of Pesellino, Filippo Lippi, Paolo Uccello, and Domenico Veneziano are reflected in the treatment of the figures, in the light palette, and in the handling of the landscape. Similarly, the attempt to create a unified composition out of the numerous incidents in the narrative reveals an alignment with the latest tendencies in Florentine painting, even though the relationship of the figures to the setting is rather arbitrary.[12] Callmann observed, for instance, that Apollonio borrowed a motif from Lorenzo Ghiberti's Baptistery doors in Florence, namely, Adam's pose in the Genesis panel on the East Door (Gates of Paradise), which Apollonio used for the figure of the seated Ulysses right of center.[13] This pose also occurs in Uccello's fresco *The Creation of Adam* in the Chiostro Verde of Santa Maria Novella in Florence and is ultimately derived from an antique sarcophagus of Adonis.[14] There is, too, an undeniable Ghibertian flavor to the figure of Ulysses rescued by Leucothea, in the center foreground, whose pose recalls in reverse that of Eve, also on the Genesis relief of the Baptistery doors and similarly derived from the antique.[15] Finally, the musician in the scene of Alcinous's feast echoes, perhaps unconsciously, his counterpart in Giotto's fresco *The Feast of Herod* in the Peruzzi Chapel in Santa Croce,

Florence.[16] For his final wanderings, Ulysses is dressed in the traditional clothes of a pilgrim usually reserved for Saint James the Greater or Saint Roch.

Callmann recorded one other autograph panel devoted to the *Odyssey* of approximately the same date, but this is much damaged and has, in fact, been cut into two uneven parts now divided between The Fogg Art Museum in Cambridge, Massachusetts, and The Frick Art Museum in Pittsburgh.[17] In the selection of scenes, the panel in Chicago is more closely related to the pair of *cassone* panels of the *Odyssey* painted by Apollonio's workshop, formerly in the Lanckoronski collection in Vienna.[18] Many more incidents from the narrative are included on this pair than on the Chicago panel, suggesting that the latter may once have been accompanied by a paired panel now lost. On the other hand, the present panel could be described with equal justification as an abridgment of the pair formerly in the Lanckoronski collection.

The Adventures of Ulysses is a work of distinction against which the workshop products catalogued below should be measured. Possibly, as Callmann has argued, it is a rare example of Apollonio di Giovanni's own style of painting. The drawing and modeling of the figures are particularly eloquent (for once, the Sirens live up to their literary reputation), the colors are soft and luminous, the relationship of one scene to another is adroitly handled, and the glimpses of distant landscape are skillfully offset by the more precise treatment of the architecture.

NOTES

1 On the back of the frame are three identical blue-bordered labels bearing the following handwritten ink inscriptions: upper left, *W Graham / 169*; upper right, *F. Baring / OB430 / May 21.94*; also upper right, *The [Hall?] / Francis Baring / May 21/94*. Likewise on the back, center right, is an oval label with the printed inscription *J. Chenue / French Packer / 10 Great St. Andrew Street, / Shaftesbury Avenue / London, W.C.*, to which have been added by hand in ink the words *Douglas.Bohler*. The number *169* on the label at the upper left confirms the identification of this painting with the one in the 1875 exhibition.

2 According to 1875 Royal Academy exhibition catalogue. This work is listed in an inventory of Graham's pictures made for insurance purposes in 1882 as "No. 533. Cassone — Labour of Ulysses. Florentine," valued at £25 (according to Oliver Garnett in a letter to the author of January 5, 1988, in curatorial files). Graham was an important collector of early Italian paintings and patron of Dante Gabriel Rossetti and Edward Burne-Jones (see O. Garnett,

"William Graham e altri committenti di Burne-Jones," in *Burne-Jones dal preraffaellismo al simbolismo*, ed. by M. T. Benedetti and G. Piantoni, Milan, 1986, pp. 86–92; idem, "A Dosso Discovery in Nottingham," *Burl. Mag.* 126 [1984], pp. 429–30; and his forthcoming entry on Graham in *The Dictionary of Art*).

3 The date of 1894 is given on two labels on the back of the panel's frame (see note 1 above). The Baring family accumulated one of the most prestigious collections of European painting formed in England during the nineteenth century (see F. Haskell, *Rediscoveries in Art*, London, 1976, pp. 72–73). Donald Garstang of Colnaghi (letter of December 17, 1987, in curatorial files) kindly verified that the firm acted as agent for Baring in this purchase.

4 According to Chenue label cited in note 1 above, and a letter of April 27, 1987, from Julius Böhler to Margherita Andreotti (in curatorial files) stating that the *cassone* "came from Langton Douglas."

5 According to letter from Julius Böhler (note 4) and bill of sale (Ryerson papers, Archives, The Art Institute of Chicago).

6 Transcribed in Callmann 1974, Appendix I, pp. 76–81.

7 Additional documents of payments to Apollonio di Giovanni alone dated 1457–60 indicate that he produced a wide range of works for domestic use; see Callmann (1988, pp. 5–18, esp. pp. 6–7), who suggested that Marco del Buono Giamberti may in fact not have been Apollonio's partner.

8 For illustrations of the *Aeneid* panels and manuscript, see Callmann 1974, pp. 54–56, nos. 6–7.

9 R. Bolgar, *The Classical Heritage and Its Beneficiaries*, Cambridge, 1973, pp. 498–500.

10 E. H. Gombrich, "Apollonio di Giovanni: A Florentine Cassone Workshop Seen through the Eyes of a Humanist Poet," *Journal of the Warburg and Courtauld Institutes* 18 (1955), pp. 16–34, reprinted in his *Norm and Form*, London, 1966, pp. 11–28.

11 Bernard Berenson began by attributing the panel to "a close follower of Pesellino" in a letter to Martin A. Ryerson of August 31, 1917 (Ryerson papers, Archives, The Art Institute of Chicago), but later (1932, 1936) listed it as a "studio copy" from the workshop of the Master of the Jarves *Cassoni*.

12 Callmann (1974, pp. 17–18, pl. 28) aptly made a comparison with the compositional arrangement of the *Thebaid (Scenes from the Lives of the Hermits)* in the Uffizi, Florence.

13 R. Krautheimer, *Lorenzo Ghiberti*, Princeton, 1950, pls. 82, 83a.

14 J. Pope-Hennessy, *Paolo Uccello*, 2d ed., London and New York, 1969, pl. 6; Krautheimer (note 13), pl. 343, fig. 122.

15 Krautheimer (note 13), pls. 82, 83b, p. 344, fig. 124. Given the aquatic context, this same figure of Ulysses anticipates the drawing of two swimmers with waterwings and paddles on f. 49v of the manuscript by Francesco di Giorgio in the British Museum (A. E. Popham and P. Pouncey, *Italian Drawings in the Department of Prints and Drawings in the British Museum: The Fourteenth and Fifteenth Centuries*, London, 1950, vol. 1, no. 55, pp. 32–38; vol. 2, pl. L).

16 L. Tintori and E. Borsook, *Giotto: The Peruzzi Chapel*, New York, 1965, pl. 51.

17 Callmann 1974, pp. 53–54, nos. 4–5, fig. 29.

18 Location unknown; Callmann 1974, p. 67, no. 34, fig. 30.

Workshop of Apollonio di Giovanni and Marco del Buono Giamberti

1415 or 1417–Florence 1465
1403–1489

The Continence of Scipio, c. 1455
Mr. and Mrs. Martin A. Ryerson Collection, 1933.1036

Tempera on panel, 41.8 x 137.7 cm (16½ x 54⅛ in.)

CONDITION: The painting is in poor condition. The panel, which is composed of two boards with a horizontal grain, has been thinned and cradled. The cradle members are now fixed, causing stress within the support and consequent rupture. An unpainted edge and a barbe are visible on all sides, though the edges of the paint and ground are chipped. The ground layer is unusually thick, and traces of a finely woven fabric interleaf are visible at the edges. Incised lines mark the original edge of the painted surface, the architectural elements, and the gold ornamentation, which is also punched. The paint and ground layers have suffered a great deal from surface abrasion, blows, and scratches, and from unsympathetic restoration. A previous, highly falsifying restoration was removed in 1963 by Lawrence Majewski; inpainting was begun by Majewski and continued by Alfred Jakstas. These retouches have now discolored and, together with the damage, contribute to the picture's overall lack of legibility (infrared, mid-treatment, ultraviolet).

PROVENANCE: Probably Emile Gavet, Paris.[1] Martin A. Ryerson (d. 1932), Chicago, by 1912;[2] on loan to the Art Institute from 1924; bequeathed to the Art Institute, 1933.

REFERENCES: AIC 1925, p. 160, no. 2069. *Ryerson Collection* 1926, pp. 18–19. AIC 1932, p. 183, no. 2884.24. Berenson 1932, p. 346; 1936, p. 283; 1963, vol. 1, p. 18. Valentiner [1932], n. pag. AIC 1961, p. 225. Huth 1961, p. 516. B. Anderson, "A Cassone Puzzle Reconstructed," *AIC Museum Studies* 5 (1970), pp. 23–30, figs. 1, 1a, 1b. Fredericksen/Zeri 1972, pp. 12, 571. E. Callmann, *Apollonio di Giovanni*, Oxford, 1974, pp. 42, 73, no. 50, pls. 201, 203. E. Callmann, "The Growing Threat to Marital Bliss as Seen in Fifteenth-Century Florentine Paintings," *Studies in Iconography* 5 (1979), pp. 84, 90 n. 22.

In the 1926 catalogue of the Ryerson Collection, this panel was attributed to the School of Pesellino, probably on the basis of Frank Jewett Mather's opinion.[3] Valentiner (1932) gave the panel to a follower of Paolo Uccello. Berenson (1932, 1936) assigned it to the Master of the Jarves *Cassoni*, one of the appellations for the author of works now associated with Apollonio di Giovanni and Marco del Buono Giamberti. Callmann correctly regarded the panel as a product of this workshop and implied a date of around 1455 on the basis of the divided composition and the darker colors.[4]

Several scholars have speculated on the subject of this panel (formerly known as *The Betrothal* or *The Betrothal and Wedding Dance*). Anderson (1970) suggested that it might be the Reconciliation of the Romans and Sabines, symbolized by the marriage of Romulus, King of Rome, to Herselia, daughter of Tatius, leader of the Sabines, as recorded in Plutarch's *Lives* (*Life of Romulus*, 9–13). This identification was made on the assumption that the panel formed a pair with one of the Rape of the Sabines, as in the case of a pair of *cassone* panels in the collection of the Earl of Harewood.[5] Callmann (1974), however, pointed out that the actual subject complementing the Rape of the Sabines is not the marriage of Romulus to Herselia, but the Continence of Scipio, the principal accounts of which are given by Polybius (*The Histories*, 10.19), Livy (*History*, 26.50), and Valerius Maximus (*Factorum et dictorum memorabilium*, 4.3.1).[6] According to these authors, Scipio, having captured Carthage, showed clemency to a young woman called Lucretia by allowing her to marry her betrothed, Allucius, and by returning the ransom offered by the girl's family for her freedom. This incident is depicted on the left of the present panel, while on the right the bridal couple is shown seated, watching the wedding celebrations. Thus, the pairing of the Rape of the Sabines with the Continence of Scipio was based not so much on narrative elements as on complementary themes,

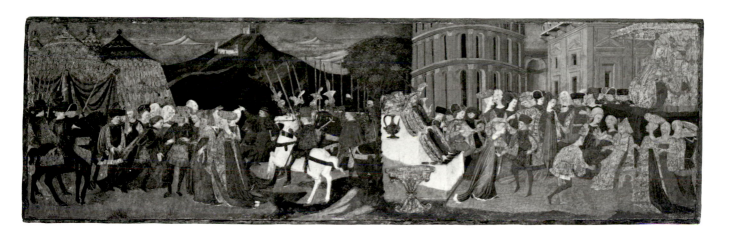

namely the contrast between the treacherous duplicity of Romulus and the generosity of Scipio.

Anderson further claimed that two smaller panels now in Edinburgh (National Gallery of Scotland) and Oxford (Ashmolean Museum) were endpieces (testate) from the cassone to which the panel in Chicago belonged. It is now apparent, however, that these two panels are fragments from two separate cassoni, both of which most probably depicted the Rape of the Sabines.[7]

The panel's composition should be compared with that of another of the same subject also from Apollonio's workshop and now in the Victoria and Albert Museum in London.[8] The main difference between the two lies in the architectural setting, which in the London version extends across both halves of the panel. The London panel also includes a depiction of the ransom, which is laid out on the ground before the group of figures on the left.[9]

Anderson pointed out several notable features in the architectural background of the Chicago panel. She correctly identified the round building with Corinthian columns right of center as the Colosseum. This depiction of the Colosseum offers an interesting comparison with the drawing of the same subject in Francesco di Giorgio's treatise in Turin.[10] In both cases, the artists experienced similar difficulty in rendering the building's elliptical shape. Anderson also compared the "bizarre un-Florentine window cornices" of the palace on the extreme right with the upper story of the Temple of Jerusalem in an engraving of Solomon and the Queen of Sheba, possibly by Francesco Rosselli after Botticelli.[11] This connection does not seem valid, however, since the fenestration, although admittedly unusual, bears little resemblance to that shown in the engraving.

The workshop practice of repeating stock figures in different contexts is well illustrated by a comparison of this panel with others in the Art Institute's collection. For instance, the pose of the bridegroom Allucius on the left of the panel resembles that of two foot soldiers in The Battle of Pharsalus and the Death of Pompey catalogued below (1974.394), and in reverse, that of Artemidorus in The Assassination and Funeral of Julius Caesar, also catalogued below (1974.393). The male figure on the right of the present panel, paying his respects to the ladies, is likewise a recurring type on panels from this workshop.

NOTES

1 Registrar's records state that the painting was previously in the collection of Emile Gavet, Paris, but this cannot be verified.
2 According to a letter from Frank Jewett Mather, Jr., to Martin A. Ryerson of November 22, 1912 (Ryerson papers, Archives, The Art Institute of Chicago).
3 Letter to Ryerson of January 24, 1920 (Ryerson papers, Archives, The Art Institute of Chicago).
4 For general comments on the workshop of Apollonio di Giovanni and Marco del Buono Giamberti, see The Adventures of Ulysses catalogued above (1933.1006).
5 Callmann 1974, pp. 72–73, no. 48, pls. 194, 198.
6 Ibid., pp. 41–42. On the availability of these classical sources in the fifteenth century, see R. Bolgar, The Classical Heritage and Its Beneficiaries, Cambridge, 1973, pp. 478, 531. Valerius Maximus was almost as popular a source as Plutarch or Livy in providing exemplars of classical life and deeds.
7 See C. Lloyd, A Catalogue of the Earlier Italian Paintings in the Ashmolean Museum, Oxford, 1977, pp. 10–11; and H. Brigstocke, Italian and Spanish Paintings in the National Gallery of Scotland, Edinburgh, 1978, pp. 5–6.
8 C. M. Kauffmann, Victoria and Albert Museum: Catalogue of Foreign Paintings, vol. 1, Before 1800, London, 1973, pp. 12–13, no. 9; and Callmann 1974, p. 73, no. 49, pl. 200.
9 For other panels depicting the Continence of Scipio, a relatively rare subject in fifteenth-century Italian art, and for a list of pairings with panels of the Rape of the Sabines, see Callmann 1979, pp. 90–91 n. 22.
10 C. Maltese, Francesco di Giorgio Martini: Trattati di architettura, ingegneria e arte militare, Milan, 1967, vol. 1, f. 71, pl. 129.
11 A. M. Hind, Early Italian Engraving, pt. 1, vol. 1, London, 1938, B III.4, pp. 137–38 (ill.).

The Assassination and Funeral
of Julius Caesar, 1455/60

Bequest of C. Ruby Sears in honor of Richard Warren
Sears II, 1974.393

Tempera on panel, now transferred to canvas mounted
on pressed hardboard and cradled, 39.5 x 126.7 cm
(15½ x 49⅞ in.)

CONDITION: The painting is in poor condition. It was
treated in 1974–75 by Alfred Jakstas, who cleaned it and
removed overpaint. Originally the panel probably had
an unpainted edge, which has been filled and inpainted.
The surface is pitted, and there are numerous small losses
throughout. Splits across the center of the panel, evidently
caused by warping along the grain of the wood, have caused
numerous losses in the heads of the figures; these have been
filled and inpainted. The sky and the architecture of the
assassination scene also contain substantial repairs. Losses to
the gilding have been renewed in some areas and toned with
paint in others. Incised lines mark the placement of archi-
tecture and areas of gilding, as well as the edges of the orig-
inal painted surface on all sides. In addition, the gilded areas
have elaborate punched designs (infrared, mid-treatment,
ultraviolet).

PROVENANCE: Richard Warren Sears II (d. 1949), Chicago,
by 1923;[1] on loan to the Museum of Fine Arts, Boston,
1923–25.[2] At Sears's death to his widow, C. Ruby Sears
(d. 1974); bequeathed to the Art Institute, 1974.

REFERENCES: Van Marle, vol. 10, 1928, pp. 554–56 (ill.).
E. Callmann, *Apollonio di Giovanni*, Oxford, 1974, pp. 47,
75, no. 57, fig. 214.

The panel (formerly known as *Scenes from the
Life of a Martyr* or *The Death of Julius Caesar*) was
ascribed by Van Marle (1928) to the Dido Master, one
of many names under which works now recognized as
belonging to the workshop of Apollonio di Giovanni
and Marco del Buono Giamberti were once grouped.[3]
Although the architecture is clumsily handled, the
figures are of good quality, suggesting that the panel
may have a slightly higher status than a mechanical
workshop production. The type of composition
divided into several parts and the darker colors sug-
gest a date of 1455/60. *The Battle of Pharsalus and
the Death of Pompey* catalogued below (1974.394)
forms a pair with the present panel.

The literary source for the subject is in all probabil-
ity Plutarch's *Lives* (*Life of Julius Caesar*, 62–68). On

the extreme left, Caesar (100–44 B.C.) is shown on
the Ides of March making a sacrifice to Apollo. Caesar
then makes his way to the Forum in Rome and is
intercepted by Artemidorus, a teacher of philosophy,
who hands him a message of warning. The murder of
Caesar in the Senate is represented on the right, and
his funeral pyre is depicted on the extreme right.
The panel, however, omits an important feature in
Plutarch's account, the statue of Pompey before
which Caesar was murdered (Plutarch, *Life of
Caesar*, 66.12–13). In Plutarch's words:

> And it is said by some writers that although Caesar
> defended himself against the rest and darted this way
> and that and cried aloud, when he saw that Brutus
> had drawn his dagger, he pulled his toga down over
> his head and sank, either by chance or because pushed
> there by his murderers, against the pedestal on which
> the statue of Pompey stood. And the pedestal was
> drenched with his blood, so that one might have
> thought that Pompey himself was presiding over this
> vengeance upon his enemy, who now lay prostrate at
> his feet, quivering from a multitude of wounds.[4]

The only direct reference in the panel to the topogra-
phy of Rome seems to be the column left of center,
which, judging from its base, is intended for that
erected by Marcus Aurelius.[5] The same column is
similarly illustrated in the scene of the Death of
Panthus in Apollonio's manuscript of the *Aeneid* in
the Biblioteca Riccardiana in Florence.[6] In the manu-
script, the figures in low relief on the column are
incorrectly shown as Lapiths and Centaurs and, as far
as can be made out, the same mistake was repeated on
the present occasion.[7] The centrally planned building
representing the Senate is presumably inspired by
the interior of the Pantheon, although it is far from
being an accurate depiction.[8]

Only one other panel of this composition from
the workshop of Apollonio and Marco del Buono is
known.[9] This is in the Ashmolean Museum in Oxford
(fig. 1) and is regarded by Callmann as being partly

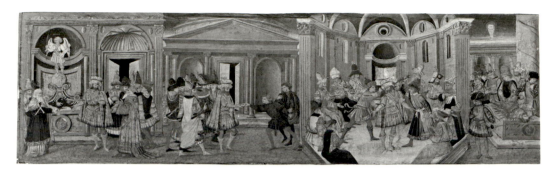

Fig. 1 Workshop of
Apollonio di Giovanni
and Marco del Buono
Giamberti, *The
Assassination and
Funeral of Julius
Caesar*, Ashmolean
Museum, Oxford

autograph.[10] In accordance with the practice of a busy
and popular Florentine workshop, there are several
differences between the panels in Chicago and
Oxford in the disposition of the figures and the archi-
tectural elements.[11] For example, on the panel in
Oxford the scene of Caesar meeting Artemidorus
takes place in front of the Pantheon instead of the
Column of Marcus Aurelius, which, accordingly, is
moved to the far right of the composition. There are
likewise differences between the two panels in the
fenestration of the Senate's interior. Another work-
shop practice, that of repeating stock figures in dif-
ferent contexts, is also illustrated by the present
panel. For instance, the figure of Artemidorus, just to
the left of center, occurs several times in different
guises and sometimes reversed, even within the
group of panels from this workshop in the Art Insti-
tute's collection. The composition of *The Assassina-
tion and Funeral of Julius Caesar* obviously achieved
some popularity, since it was still being used by
painters toward the close of the fifteenth century.[12]

The subject of the present panel, as Gombrich
argued, was a salutary one in the context of fifteenth-
century Florentine politics, where the failure to heed
a timely warning might lead to political downfall.[13]
Callmann suggested that the main implication of the
subject was that pride could easily result in political
eclipse. Clearly, as Callmann also pointed out, the
artist's intention was cautionary, since we know that
by the fifteenth century Caesar was no longer re-
garded as a symbol of *virtù* but as a tyrant.[14] A similar
significance can be ascribed to the subject of the com-
panion panel — Pompey's downfall at the Battle of
Pharsalus (1974.394), even though Pompey's name
did not have the same potency as Caesar's in the his-
tory of Florence as written by the humanists.

NOTES

1 See note 2 below, and a letter from Minerva S. Buerk,
 C. Ruby Sears's sister, to Valerie R. Tvrdik of October 31,
 1975, in curatorial files, which states that "Warren Sears II
 purchased the panels in [the] early 1920's.... probably...
 in Florence."
2 According to a label on the back of the panel (*Museum of
 Fine Arts / T. L. 1303 / Mr. R. W. Sears II*) and a note from
 Linda Thomas, Registrar, Museum of Fine Arts, Boston, to
 Valerie R. Tvrdik of September 4, 1975, in curatorial files.
3 On the Dido Master, see P. Schubring, *Cassoni: Truhen und
 Truhenbilder der italienischen Frührenaissance*, Leipzig,
 1915, vol. 1, pp. 113–14. The panel was apparently bought
 by Richard Warren Sears II as a work by Paolo Uccello,
 according to the letter from Minerva S. Buerk cited in note
 1 above. For general comments on the workshop of Apollo-
 nio di Giovanni and Marco del Buono Giamberti, see *The
 Adventures of Ulysses* catalogued above (1933.1006).
4 B. Perrin, tr., *Plutarch's Lives*, Loeb Classical Library, vol.
 7, Cambridge, Mass., and London, 1971, p. 599.
5 See E. Nash, *Pictorial Dictionary of Ancient Rome*, London,
 1961, vol. 1, pp. 276–79, especially fig. 237, showing the
 original base.
6 P. Schubring (note 3), vol. 2, pl. LI, no. 232 (ill.).
7 C. Hülsen, "On Some Florentine *Cassoni* Illustrating
 Ancient Roman Legends," *Journal of the British and Ameri-
 can Archaeological Society of Rome* 4 (1911), p. 475 n. 2.
8 See Nash (note 5), vol. 2, pp. 170–75, especially fig. 898;
 and T. Buddensieg, "Criticism and Praise of the Pantheon in
 the Middle Ages and the Renaissance," in *Classical Influ-
 ences on European Culture, A.D. 500–1500*, ed. by R.
 Bolgar, Cambridge, 1971, pp. 259–67.
9 Callmann 1974, p. 47 n. 44.
10 Ibid., see also C. Lloyd, *A Catalogue of the Earlier Italian
 Paintings in the Ashmolean Museum*, Oxford, 1977,
 pp. 8–10, pls. 9–11.
11 Callmann 1974, pp. 30–34.
12 See Shapley 1966, pp. 128–29, K1929, Master of the
 Apollini Sacrum.
13 E. H. Gombrich, "Apollonio di Giovanni: A Florentine
 Cassone Workshop Seen through the Eyes of a Humanist
 Poet," *Journal of the Warburg and Courtauld Institutes* 18
 (1955), p. 29 n. 2, reprinted in his *Norm and Form*, London,
 1966, p. 143 n. 42.
14 See H. Baron, *The Crisis of the Early Italian Renaissance*,
 Princeton, 1955, vol. 1, pp. 50, 52ff.

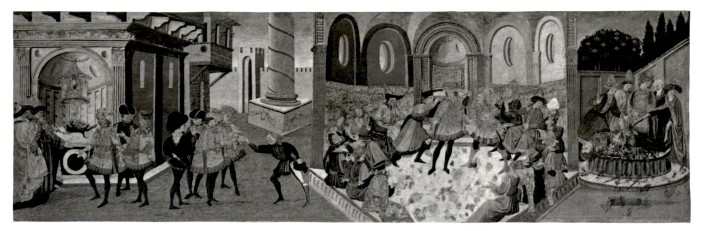

Workshop of Apollonio di Giovanni and Marco del Buono Giamberti, *The Assassination and Funeral of Julius Caesar*, 1974.393

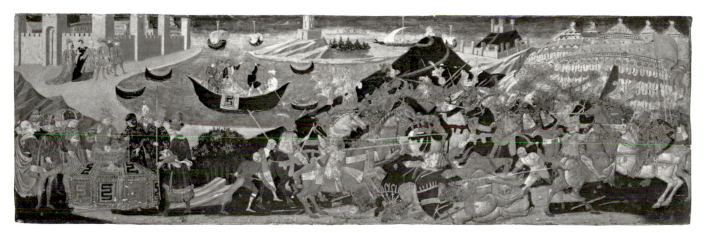

Workshop of Apollonio di Giovanni and Marco del Buono Giamberti, *The Battle of Pharsalus and the Death of Pompey*, 1974.394

The Battle of Pharsalus and the Death of Pompey, 1455/60

Bequest of C. Ruby Sears in honor of Richard Warren Sears II, 1974.394

Tempera on panel, 40.5 x 127.5 cm (16 x 50¼ in.)

CONDITION: The painting is in fair condition. The panel has been thinned and cradled. In 1974–75 Alfred Jakstas cleaned it, removed old overpaint, and repaired some gilding. The surface is pitted and there are numerous small retouches throughout, especially in the upper half. The figures in the boat have sustained the most damage and much of the architecture has been strengthened. The gilding is abraded down to the red bole through the center of the battle scene, in the armed figures on the boat, and to the right of the table. Yet the impression of the panel's original quality is by no means lost, and the colors are still fresh. Incised lines mark the placement of figures, tents, and architecture (infrared, mid-treatment, ultraviolet).

PROVENANCE: Richard Warren Sears II (d. 1949), Chicago, by 1923;[1] on loan to the Museum of Fine Arts, Boston, 1923–25.[2] At Sears's death to his widow, C. Ruby Sears (d. 1974); bequeathed to the Art Institute, 1974.

REFERENCES: Van Marle, vol. 10, 1928, pp. 554–55. E. Callmann, *Apollonio di Giovanni*, Oxford, 1974, p. 75, under no. 57.

The panel (formerly known as *The Battle of Metaurus*) was, like the preceding one, ascribed by Van Marle (1928) to the Dido Master and is now recognized as belonging to the workshop of Apollonio di Giovanni and Marco del Buono Giamberti.[3] It forms a pair with *The Assassination and Funeral of Julius Caesar* catalogued above (1974.393), with which it shares an identical provenance. As with *The Assassination and Funeral of Julius Caesar*, the quality is above that of a routine workshop production.

The literary source for the panel is found in Plutarch's *Lives*, where the events surrounding the Battle of Pharsalus are described in both the *Life of Pompey* (68–80) and the *Life of Julius Caesar* (42–48). Pompey (106–48 B.C.) was an outstanding military commander who served as consul three times. Although he married Caesar's daughter Julia as his first wife (she died in 54 B.C.), political machinations during the closing decades of the Republic forced Pompey to become the inveterate enemy of Caesar.

The composition of the present panel provides a clear exposition of the battle at which Caesar defeated Pompey. The engagement itself is depicted on the right. The city in the upper left corner is Alexandria, where Pompey sought refuge after the battle. The murder of Pompey, which was plotted by the Ptolomeians, takes place, left of center, in a boat on the river Nile, as Pompey's second wife, Cornelia, witnesses the event from the shore. The head of Pompey is presented to Caesar in the lower left corner of the composition. This last is a famous incident in classical history, eloquently described by Plutarch, who wrote of Caesar: "From the man who brought him Pompey's head he turned away with loathing, as from an assassin; and on receiving Pompey's seal-ring, he burst into tears" (*Life of Pompey*, 80.5).[4] Callmann included one other representation of the Battle of Pharsalus in the oeuvre of Apollonio di Giovanni and Marco del Buono Giamberti, namely, the panel in the Museum of Fine Arts in Boston, and referred to others not painted in this workshop.[5]

The rearing and fallen horses that characterize the battle scene on the right of the panel are stock motifs employed by Apollonio's workshop, most probably on the basis of drawings recorded in model books.[6] The two stooping foot soldiers with spears in the foreground of the battle scene are further examples of standard types used by this workshop, and can be compared to the bridegroom on the left of *The Continence of Scipio* catalogued above (1933.1036), or in reverse, to the figure of Artemidorus in this painting's companion panel, *The Assassination and Funeral of Julius Caesar*, also catalogued above (1974.393).

NOTES
1 See note 2 below, and letter from Minerva S. Buerk, C. Ruby Sears's sister, to Valerie R. Tvrdik of October 31, 1975, in curatorial files, which states that "Warren Sears II purchased the panels in [the] early 1920's.... probably... in Florence."

2 According to a label on the back of the panel (*Museum of Fine Arts / T. L. 1303 / Mr. R. W. Sears II*) and a note from Linda Thomas, Registrar, Museum of Fine Arts, Boston, to Valerie R. Tvrdik of September 4, 1975, in curatorial files.

3 On the Dido Master, see P. Schubring, *Cassoni: Truhen und Truhenbilder der italienischen Frührenaissance*, Leipzig, 1915, vol. 1, pp. 113–14. The panel was apparently bought by Richard Warren Sears II as a work by Paolo Uccello, according to the letter from Minerva S. Buerk cited in note 1 above. For general comments on the workshop of Apollonio di Giovanni and Marco del Buono Giamberti, see *The Adventures of Ulysses* catalogued above (1933.1006).

4 B. Perrin, tr., *Plutarch's Lives*, Loeb Classical Library, vol. 5, Cambridge, Mass., and London, 1968, p. 385. Plutarch's *Lives* exerted a considerable fascination on Italian Renaissance society, with its emphasis on individual achievement (for further bibliography, see R. Pfeiffer, *History of Classical Scholarship from 1300 to 1850*, Oxford, 1976, p. 29). For general observations on the significance of this choice of subject, see the entry for the pendant, *The Assassination and Funeral of Julius Caesar* (1974.393).

5 Callmann 1974, pp. 46 n. 36, 74, no. 54.

6 Ibid., pp. 30, 33, pls. 132–33, 136, 237–47.

Bartolommeo di Giovanni

Active Florence, c. 1465–1501

Scenes from the Life of Saint John the Baptist, 1490/95
Mr. and Mrs. Martin A. Ryerson Collection, 1937.996

Tempera on panel (poplar), 74 x 150.4 cm (29 3/16 x 59 3/16 in.)

CONDITION: The painting is in very good condition. Alfred Jakstas cleaned it lightly in 1962 and undertook a more extensive treatment in 1964–65. The poplar panel is approximately 3 cm thick and is composed of two boards joined horizontally approximately 44 cm from the bottom edge. Splits in each board at heights of 25 cm and 58 cm, respectively, measuring from the bottom on the left side, are due to movement of the panel. The back of the panel has been strengthened by butterfly cleats along these splits and along the join. There is retouching along the join in the center and along the splits, but otherwise, apart from minor retouches in the foreground pavement and in the landscape on the right, the paint surface is well preserved. The figures are largely free of retouches with the exception of the legs of the kneeling female attendant holding the towel and the left edge of Zacharias's cloak in the scene of the Naming of the Baptist. These retouches have now discolored, but in general the colors are resplendent and there is remarkably little abrasion. In the 1964 cleaning, the gold forming radiating lines within the halos was largely removed.[1]

The architecture is incised. Infrared reflectography reveals that the figures and portions of the landscape at the left are underdrawn in what appears to be brush. In the figures, a rather free contour drawing is used, with some hatching and other notations indicating drapery folds. There are slight changes in the placement of contours between the drawn and painted designs. In addition, the Virgin in the episode of the Meeting of the Christ Child and the Young Baptist was first drawn in a more upright and frontal posture and then redrawn in the present pose (infrared, mid-treatment, ultraviolet, x-radiograph).

PROVENANCE: Possibly Francesco di Bonacorso Pitti, Florence, from 1494.[2] Luigi Grassi, Florence.[3] Sold by Grassi to Martin A. Ryerson (d. 1932), Chicago, 1924; on loan to the Art Institute, 1924.[4] At Ryerson's death to his widow, Mrs. Martin A. Ryerson (d. 1937); bequeathed to the Art Institute, 1937.

REFERENCES: AIC 1925, p. 159, no. 2027. Van Marle, 1931, vol. 12, p. 441 n. 2, vol. 13, p. 122, fig. 76. Berenson 1932, p. 6; 1936, p. 5; 1963, vol. 1, p. 25. Valentiner [1932], n. pag. M. Aronberg Lavin, "Giovannino Battista: A Study in Renaissance Religious Symbolism," *Art Bull.* 37 (1955), pp. 88 n. 23, 98 n. 81. AIC 1961, p. 18. *Art Institute of Chicago*, Grands Musées 2, Paris [1968], pp. 24 (ill.), 67. Fredericksen/Zeri 1972, pp. 16, 416, 571. E. Fahy, *Some Followers of Domenico Ghirlandajo*, New York and London, 1976, pp. 132–33, no. 18, p. 156.

EXHIBITIONS: The University of Chicago, The Renaissance Society, *Old and New Masters of Religious Art*, 1931, no. 78. The University of Chicago, The Renaissance Society, *Commemorative Exhibition from the Martin A. Ryerson Collection*, 1932, no. 8.

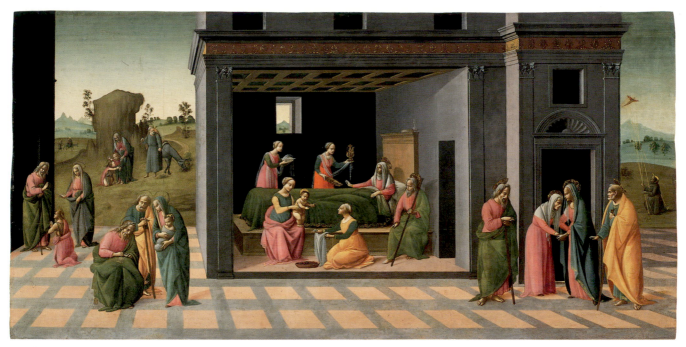

Bartolommeo di Giovanni, *Scenes from the Life of Saint John the Baptist*, 1937.996

Acquired in 1924 as School of Ghirlandaio, the panel was correctly attributed to Bartolommeo di Giovanni in the 1931 exhibition catalogue,[5] an attribution apparently first proposed by Sirén and accepted by Berenson (1932, 1936, 1963) and Valentiner (1932).[6] A follower principally of Domenico Ghirlandaio, Bartolommeo's work also shows the lingering influence of Filippo Lippi, in addition to that of contemporaries such as Botticelli and Filippino Lippi.[7] Bartolommeo appears to have specialized in relatively small-scale works, such as predella panels, tondi, and *cassone* panels. His individual style is apparent here in the barrel-shaped figures, the meticulously observed and brightly colored (pink, light green, red, blue, and yellow) swaths of drapery, the chiaroscural lighting of the faces, and the rounded features. The scene is lit from the left, the contrast between light and dark being most marked in the architecture, so that many of the figures are silhouetted against areas of deep shadow (for example, the two women attend-

ing the Virgin in the center, or the scene of the Visitation on the right).

The composition comprises several incidents relating to the early life of Saint John the Baptist arranged chronologically from right to left. The Visitation, the Birth of Saint John the Baptist, the Naming of Saint John the Baptist by Zacharias, and Saint John the Baptist Taking Leave of His Parents all occur in the foreground. In the background on the left can be made out the Return of the Holy Family from Egypt and the Meeting of the Holy Family with the Young Saint John the Baptist in the Desert, which is balanced in the right background by Saint Francis Receiving the Stigmata. The principal literary source for these events in the life of Saint John the Baptist as portrayed on this particular panel is the anonymous *Vita di San Giovanni Battista* written at the very beginning of the fourteenth century and frequently used by artists throughout the Renaissance.[8] The inclusion of Saint Francis receiving the stigmata on the right

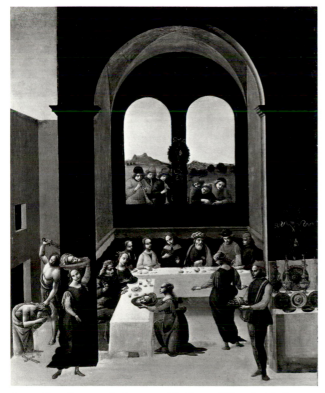

Fig. 1 Bartolommeo di Giovanni, *The Feast of Herod with the Beheading of Saint John the Baptist*, on loan to the National Gallery of Ireland, Dublin, from the Dominican Fathers, St. Mary's, Tallaght, County Dublin

Fig. 2 Detail of *The Feast of Herod with the Beheading of Saint John the Baptist* (see fig. 1)

may possibly be explained by the fact that it parallels the moment when the young Saint John the Baptist meets Christ in the desert, or it may reflect the personal devotion of the patron.

The dimensions of the panel suggest that it formed part of an elaborate decorative scheme for a room, possibly as a *spalliera* panel to be set into the wainscoting. A famous example of such a system of decoration is the bedroom of Pierfrancesco Borgherini,[9] but other schemes for Florentine families are mentioned by Vasari in his life of Piero di Cosimo.[10] The narrative treatment characterizing the panel in Chicago clearly implies that the artist would have continued the life of Saint John the Baptist on other panels. Fahy (1976), in fact, suggested that a panel belonging to the Dominican Fathers of Saint Mary's at Tallaght, County Dublin, on loan to the National Gallery of Ireland, may be related to the same decorative scheme (fig. 1).[11] This shows *The Feast of Herod with the Beheading of Saint John the Baptist*, but it measures 70 x 56.2 cm and may therefore only be a fragment.[12] Of great significance, however, is the fact that a coat of arms is depicted twice on the panel in Ireland: once on the column separating the round-headed openings of the window and secondly above the table at the right edge of the composition (fig. 2). Ellen Callmann kindly investigated this coat of arms and discovered that it represents the Pitti family crossed with the Ridolfi, and that Pellegrina di Lorenzo di Bernardino di Lorenzo Ridolfi married Francesco di Bonacorso Pitti in 1494.[13] Pellegrina died shortly after her marriage, and Francesco di Bonacorso Pitti then married her sister Papera in 1497. If the panels in Chicago and Dublin do therefore belong to the same series, it is possible that they were painted in connection with the first of these two alliances between the Pitti and Ridolfi families. Such a date accords with the style of the panel, which is not far removed from that of Bartolommeo's documented predella panels of 1488 for Ghirlandaio's Innocenti altarpiece.[14]

The compositions of the panels in Chicago and Dublin were undoubtedly inspired by Domenico Ghirlandaio's frescoes of the life of Saint John the Baptist on the right wall of the choir in the church of Santa Maria Novella in Florence.[15] There are, however, no exact correspondences between these works. A series of panels depicting the life of Saint John the Baptist was undertaken between 1500 and 1510 by another considerably younger pupil of Ghirlandaio, Francesco Granacci. Only three of these panels (two in New York, The Metropolitan Museum of Art, and one in Liverpool, Walker Art Gallery), together with a fragment in Cleveland, have survived.[16]

NOTES

1 These were felt to be later additions or reinforcements of fragmentary original gold; see treatment report of Alfred Jakstas in conservation file. It is noteworthy that the Baptist in the Dublin picture (see discussion section) has a halo identical to those in the Chicago panel before the 1964 cleaning.
2 See discussion section.
3 According to bill of sale dated March 18, 1924, in curatorial files.
4 Bill of sale (see note 3). According to registrar's records, the panel was on loan to the Art Institute from June to November 1924. This may explain why the panel is listed among works on loan from Martin A. Ryerson in AIC 1925, even though there is no evidence that the panel was on loan to the museum after 1924.
5 That same year, however, Van Marle (1931) attributed the panel to two different artists in the course of the same publication: once to Raffaellino del Garbo and then to Benedetto Ghirlandaio.
6 Valentiner (1932) credited Osvald Sirén with the attribution to Bartolommeo di Giovanni. Berenson, however, preferred to retain the designation Alunno di Domenico under which he had first grouped the works of this artist (B. Berenson, "Alunno di Domenico," *Burl. Mag.* 1 [1903], pp. 6–20). Berenson did not abandon this designation until the 1963 edition of his lists, although he had already identified the artist with Bartolommeo di Giovanni in a postscript to his 1903 article.
7 E. Fahy, "Bartolommeo di Giovanni Reconsidered," *Apollo* 97 (1973), pp. 462–69. See also N. Pons, "Precisazioni su tre Bartolomeo di Giovanni: Il cartolaio, il sargiaio e il dipintore," *Paragone* 479–81 (1991), pp. 117–28, with documentary information indicating that the painter was not identical with the miniaturist of the same name.
8 See Aronberg Lavin 1955, with corrections in idem, "Giovannino Battista: A Supplement," *Art Bull.* 43 (1961), pp. 319–26; P. A. Dunford, "The Iconography of the Frescoes in the Oratorio di S. Giovanni at Urbino," *Journal of the Warburg and Courtauld Institutes* 36 (1973), pp. 367–73; and idem, "A Suggestion for the Dating of the Baptistery Mosaics at Florence," *Burl. Mag.* 116 (1974), pp. 96–98.
9 A. Braham, "The Bed of Pierfrancesco Borgherini," *Burl. Mag.* 121 (1979), pp. 754–65. See also E. Callmann, "Apollonio di Giovanni and Painting for the Early Renaissance Room," *Antichità viva* 27, 3-4 (1988), pp. 6–13.

10 Vasari, *Vite*, Milanesi ed., vol. 4, pp. 139, 141–42.

11 Fahy 1976, p. 156, no. 71.

12 Details kindly supplied by Michael Wynne of the National Gallery of Ireland, Dublin.

13 Verbal communications and letter to the author of July 15, 1985, in curatorial files. For this marriage between the Pitti and Ridolfi families, see G. Carocci, *La famiglia dei Ridolfi di Piazza*, Florence, 1889, pl. VII. For the coat of arms on a pair of *cassoni* made for another Ridolfi marriage, see E.

Callmann, "The Triumphal Entry into Naples of Alfonso I," *Apollo* 109 (1979), pp. 24–31.

14 For these predella panels, see Fahy 1973 (note 7 above), p. 462, fig. 1.

15 J. Lauts, *Domenico Ghirlandaio*, Vienna, 1943, fig. 57, and esp. fig. 83.

16 C. von Holst, *Francesco Granacci*, Munich, 1974, pp. 24–25, 132–35, nos. 7–8, p. 194, no. 162, pp. 199–200, no. 182, figs. 15–18.

Jacopo da Ponte, called Bassano

c. 1510 Bassano 1592

Diana and Actaeon, 1585/92

Charles H. and Mary F. S. Worcester Collection, 1939.2239

Oil on canvas, 63.6 x 68.7 cm (25 x 27 in.)

CONDITION: The painting is in poor condition. It was cleaned by Alfred Jakstas in 1969. The canvas has an old glue lining.[1] It has clearly been trimmed at the right and left, where there are ragged edges of canvas and paint. The top and bottom edges are covered by strips of tape which predate the lining, making it hard to determine whether these edges have been cut.[2] The x-radiograph shows weave distortion on all four sides.

The painting has a blackish ground. The paint layer has been flattened in lining. It has suffered extensive minute paint and ground loss in addition to abrasion of the remaining surface. These losses have been retouched in some areas, such as the nymphs, but remain elsewhere, for example, in the sky. Apart from the upper right corner, which has been filled and inpainted, there are no areas of larger local loss (x-radiograph).

PROVENANCE: Possibly no. 130 of inventory dated April 27, 1592, drawn up shortly after the artist's death.[3] Dupille, Paris, by 1763.[4] E. and A. Silberman Galleries, New York, by 1939.[5] Sold by Silberman to Charles H. Worcester, Chicago, 1939; given to the Art Institute, 1939.

REFERENCES: P. Crozat, *Recueil d'estampes d'après les plus beaux tableaux et d'après les plus beaux dessins qui sont en France...*, vol. 2, Paris, 1763, *L'Ecole venitienne*, no. XII (ill.). L. Fröhlich-Bum, "Some Original Compositions by Francesco and Leandro Bassano," *Burl. Mag.* 61 (1932), p. 114. F. A. Sweet, "Actaeon and the Nymphs," *AIC Bulletin* 34 (1940), pp. 94–96 (ill.). R. Longhi, "Calepino veneziano. XIV. Suggerimenti per Jacopo Bassano," *Arte veneta* 2

(1948), p. 55, fig. 65; reprinted in *Opere complete di Roberto Longhi*, vol. 10, Florence, 1978, p. 98, fig. 197. F. A. Sweet, "La pittura italiana all'*Art Institute* di Chicago," *Le vie del mondo: Rivista mensile del Touring Club Italiano* 15 (1953), p. 698. Berenson 1957, vol. 1, p. 17. R. Pallucchini, "Commento alla mostra di Jacopo Bassano," *Arte veneta* 11 (1957), p. 115. P. Zampetti, *Jacopo Bassano*, tr. by J. Guthrie, Rome, 1958, p. 57, pls. LXXV–LXXVI. E. Arslan, *I Bassano*, vol. 1, Milan, 1960, p. 259. AIC 1961, p. 18. A. Ballarin, "Chirurgia bassanesca (I)," *Arte veneta* 20 (1966), p. 116. A. Ballarin, "La vecchiaia di Jacopo Bassano: Le fonti e la critica," *Atti dell'istituto veneto di scienze, lettere ed arti* 125 (1967), pp. 159, 161. Fredericksen/Zeri 1972, pp. 18, 469, 571. L. Magagnato in *The Genius of Venice, 1500–1600*, exh. cat., London, Royal Academy of Arts, 1983–84, p. 151, under no. 11.

EXHIBITIONS: Venice, Palazzo Ducale, *Jacopo Bassano*, 1957, no. 60. Peoria, Illinois, Lakeside Center for the Arts and Sciences, *The Grand Tour*, 1970 (no cat.).

This picture has traditionally been attributed to Jacopo Bassano, who was first trained by his father, Francesco, in his native Bassano. He then resided for a brief period (before 1534) in nearby Venice, where he became a member of the shop of Bonifazio de' Pitati and studied the paintings of Titian. In the later 1530s to early 1540s, his art was strongly influenced by the works of Salviati and Parmigianino, and he became, despite his provincial location, one of the most influential practitioners of a Mannerist style in the

Veneto. Among the artists who imitated Jacopo's manner, with its tendencies toward serpentine forms and brilliant color, were his sons Francesco il Giovane, Giambattista, Leandro, and Gerolamo.

The story of Diana and Actaeon is recounted at length by Ovid (*Metamorphoses* 3.138–252). Actaeon, while out hunting, comes across Diana and her nymphs bathing in a secret grotto. On being discovered by Actaeon, Diana sprinkles him with water and changes him into a stag. As the stag, Actaeon is then pursued by his own pack of hounds and eventually killed by them. In this picture the artist has conflated different parts of Ovid's story into a single composition.

The attribution to Jacopo Bassano has been upheld by Sweet (1940), Longhi (1948), Berenson (1957), Zampetti (1958),[6] Ballarin (1966, 1967), Fredericksen and Zeri (1972), and Magagnato (1983). Other writers have preferred attributions to Bassano's sons: Fröhlich-Bum (1932) and Arslan (1960) postulated Leandro, the artist's third son, while Pallucchini (1957) maintained an attribution to the eldest son, Francesco il Giovane. It can be demonstrated now, however, that *Diana and Actaeon* forms part of a fairly small group of paintings dating from the final decade of Bassano's life. Of crucial significance in the evaluation of the artist's late style is the painting of

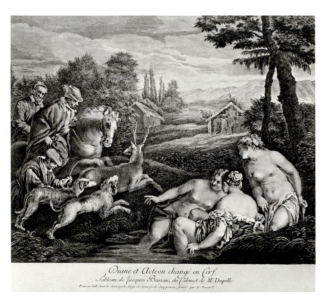

Fig. 1 Etienne Fessard, *Diane et Acteon changé en cerf*, engraving published in P. Crozat, *Recueil d'estampes . . .*, vol. 2, *L'Ecole venitienne*, Paris, 1763

Susanna and the Elders in the Musée des Beaux-Arts in Nîmes, which in 1965–66, at the time of the Paris exhibition *Le Seizième Siècle européen*, was found after cleaning to be signed and dated 1585.[7] Previously, it had been argued that Jacopo was doing little, if any, painting of his own at this stage of his career, relying instead upon the family workshop. This belief was based on a letter by Francesco Bassano of May 25, 1581, to the Florentine collector Niccolò Gaddi, stating that his father was unable to work very much because he was afflicted by old age and was losing his eyesight.[8] The painting at Nîmes proves that Bassano was still active during the 1580s. Other paintings that can also now be dated to the same decade include *The Purification of the Temple* in The National Gallery in London and *The Baptism of Christ* once on loan to The Metropolitan Museum of Art in New York.[9] All these pictures have in common loose, almost dabbed brush strokes and a vivid chiaroscuro.

In size and treatment, the painting in Chicago is closest to *Susanna and the Elders*, although it is less vibrant in coloring. Indeed, one of the principal features of *Diana and Actaeon* is the overall silvery tonality of the picture evoking a moonlit atmosphere. The eye progresses from the milk-white flesh tones of Diana and the nymphs in the left foreground, contrasted with the warmer colors used for the figures and animals on the right, across the middle ground to the streaked sky above the distant hills. As with *Susanna and the Elders*, the composition depends upon the interaction of diagonals, and it is wholly characteristic of Bassano to position reclining figures across one of the lower corners of the picture. The special significance of the present painting is mainly derived from the intensely personal quality of the brushwork, most apparent in the handling of the folds of the garments. In this respect, Bassano's late style was certainly influenced by, and is on occasion even comparable to, Titian's own late style. Longhi (1948), in a perspicacious passage inspired by the painting in Chicago, likened Bassano's brushwork to that of the aged Renoir:

Una favola di "Atteone," tematicamente svisata come da un Watteau di campagna veneta, vi si macera, quasi a tastoni, in una pressura di rosolacci stinti. Da far pensare che anche Jacopo, da vecchio, come il

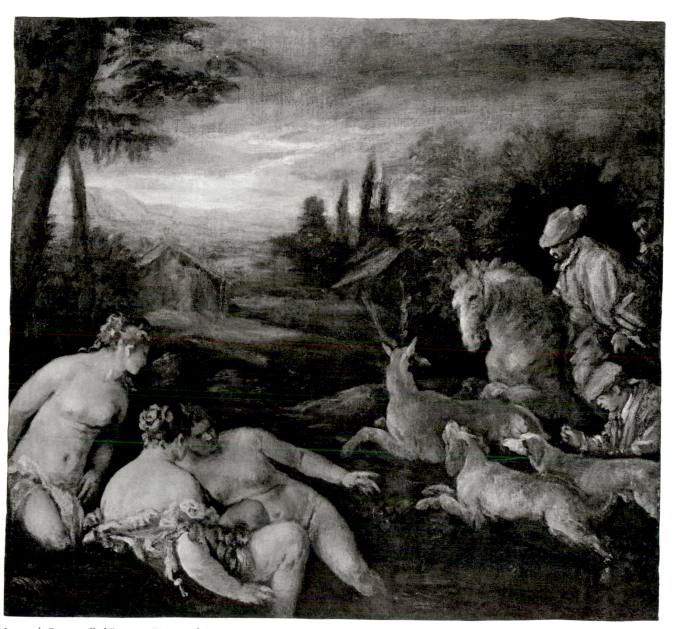

Jacopo da Ponte, called Bassano, *Diana and Actaeon*, 1939.2239

vecchio Renoir, dipingesse ormai col pennello legato alle dita e intriso in succhi di fiori e d'erba: colandone un ricordo smagato di paesi, di donne, di cacciatori, in una favola quasi irreperibile, senza più nome.[10]

Sweet (1940), in an otherwise perceptive analysis of the present painting, mistakenly referred to it as "a sketch... not to be considered as a finished composition," but in making this judgment he must have been misled by the character of Bassano's late style.[11] Sweet also made compositional links with other works by the artist, but these are of a general nature only.[12]

A variant of the present composition, probably painted by Leandro Bassano, was formerly in a private collection in Vienna.[13] First published by Fröhlich-Bum (1932), this picture is characterized by a vertical composition divided by a tree in the foreground on either side of which are arranged the same two groups of figures, but in reverse order: the pursuit of Actaeon on the left, Diana and her nymphs on the right.[14]

An engraving (fig. 1) by Etienne Fessard, included in the *Recueil d'estampes...* published by Pierre Crozat in 1763, shows the composition in reverse and reveals the extent to which the canvas has been cut down.[15]

NOTES

1 The stretcher bears the old inscription *No 55* in white paint.

2 See note 4 below.

3 As Erica Tietze-Conrat first observed (letter to Silberman of September 11, 1939, in curatorial files), a painting that might be identifiable with the present *Diana and Actaeon* is mentioned in the inventory of pictures dated April 27, 1592, drawn up shortly after the artist's death: "No. 130. L'Istoria d'Ateo, d'un braccio d'ogni banda" (The Story of Actaeon, one *braccio* in every direction); see G. B. Verci, *Notizie intorno alla vita e alle opere de' pittori, scultori e intagliatori della città di Bassano,* Venice, 1775, p. 75.

4 See Crozat 1763; the inscription under the engraving (see fig. 1) reads *Diane et Acteon changé en Cerf / Tableau de Jacques Bassan, du Cabinet de Mr. Dupille / Peint sur toille, haut de deux pieds, large de deux pieds cinq pouces, gravé par E. Fessard.* The Dupille collection was sold in Paris in November 1780 (Lugt 3199), but this picture was not included. The measurements given in the engraving, which translate to 64.8 x 78.3 cm, indicate that almost 10 cm were trimmed from the width of the painting after 1763.

5 See letter from Tietze-Conrat to Silberman mentioned above (note 3) and letter from Charles H. Worcester's secretary to Silberman of October 5, 1939, in curatorial files.

6 Before the publication of his monograph on Bassano, Zampetti had included the painting in his selection for the important exhibition devoted to Bassano in 1957 (see Exhibitions).

7 *Genius of Venice* 1983–84, p. 150, no. 11 (ill.).

8 The full text of the letter is given in M. G. Bottari and S. Ticozzi, *Raccolta di lettere sulla pittura, scultura ed architettura,* vol. 3, Rome, 1759, pp. 179–80.

9 See C. Gould, *National Gallery Catalogues: The Sixteenth-Century Italian Schools,* London, 1975, pp. 19–20; and W. R. Rearick, "Jacopo Bassano's Last Painting: *The Baptism of Christ,*" *Arte veneta* 21 (1967), pp. 102–07, fig. 118.

10 This evocative passage may be roughly translated as follows: "The story of Actaeon, thematically altered as if by a Watteau of the Venetian countryside, seems steeped here in a solution of faded poppies and rendered in a groping manner. It makes one wonder if Jacopo, in his old age, like the old Renoir, painted with a brush tied to his fingers soaked in the juices of flowers and grass: draining from them a faint memory of places, women, hunters, in an almost irretrievable, by now nameless, story."

11 Arslan (1960) also described the painting as a *bozzetto.*

12 For example, Sweet referred to *Adam and Eve in Paradise* (Rome, Galleria Doria) and *Saint Martin with the Beggar* (Bassano, Museo Civico), in Zampetti 1958, pl. LXXVII, and Arslan 1960, vol. 2, figs. 139, 182.

13 Arslan 1960, vol. 1, p. 275, vol. 2, fig. 311. A copy of the Chicago painting, attributed to Leandro, appeared at auction in 1990 (Sotheby's, London, December 12, 1990, no. 168).

14 Wilhelm Suida ("Studien zu Bassano," *Belvedere* 12 [1934–37], pp. 195–96, fig. 227) published what he described as a sketch, then in the collection of W. Goetz, Paris, relating to the group of Diana and the nymphs on the right of Leandro Bassano's composition. Suida attributed the sketch to Jacopo Bassano and the finished picture once in Vienna to Francesco Bassano. Arslan (1960) included the sketch in a large category of Bassanesque works, but supported Fröhlich-Bum's attribution of the completed variant once in Vienna to Leandro.

15 See note 4 above.

Virgin and Child with the Young Saint John the Baptist, 1560/65

Wilson L. Mead Fund Income, 1968.320

Oil on canvas, size of canvas: 79.5 x 90.5 cm (31¼ x 35⅝ in.); size of stretcher: 73.7 x 84.5 cm (29 x 33¼ in.)

INSCRIBED: IAC͡SA PŌTE / BASS.P (top left, on wall behind the Virgin)

CONDITION: The painting is in fair to good condition. It was cleaned and wax lined in 1968 by Alfred Jakstas and cleaned again in 1988 by Frank Zuccari. The edges of the canvas have been folded over the stretcher by approximately 6 cm on all sides. There is a tear in the lower left corner through the Virgin's right forearm to the bottom edge of the canvas. Damage along the tear has been retouched. The paint surface is abraded throughout, but particularly in the flesh tones, in the Christ Child's left hand, and in the Baptist's face, left hand, and arm. The background drapery is also abraded. The Christ Child's head and the Virgin's face and veil, however, are particularly well preserved (infrared, mid-treatment, ultraviolet, x-radiograph).

PROVENANCE: George James Howard (d. 1911), ninth Earl of Carlisle, Castle Howard, Yorkshire, by 1894.[1] By descent to his son the Hon. Geoffrey William Algernon Howard (d. 1935), Castle Howard, Yorkshire. His heirs, sold Christie's, London, February 18, 1944, no. 3, to Agnew.[2] Sold by Agnew to Archibald Werner, Newlands, Kent, 1944;[3] sold Sotheby's, London, March 27, 1968, no. 27, to Agnew.[4] Sold by Agnew to the Art Institute, 1968.

REFERENCES: W. Arslan, "Un nuovo dipinto di Jacopo Bassano," *Bollettino d'arte*, n.s., 8, 7 (1929), pp. 407–13, fig. 1. W. Arslan, *I Bassano*, Bologna, 1931, pp. 116–17, 188, fig. 27. S. Bettini, *L'arte di Jacopo Bassano*, Bologna, 1933, pp. 66, 169. F. M. Godfrey, "Jacopo Bassano in English and Scottish Collections," *The Connoisseur Year Book*, London, 1955, p. 89 (ill.). Berenson 1957, vol. 1, p. 17. Edinburgh, National Gallery of Scotland, *Catalogue of Paintings and Sculpture*, 51st ed., Edinburgh, 1957, vol. 1, p. 19. M. Muraro, "The Jacopo Bassano Exhibition," *Burl. Mag.* 99 (1957), p. 292. R. Pallucchini, "Commento alla mostra di Jacopo Bassano," *Arte veneta* 11 (1957), p. 108. E. Arslan, *I Bassano*, Milan, 1960, vol. 1, pp. 108–09, 167, 282; vol. 2, figs. 136–37. A. Ballarin, "Aggiunte al catalogo di Paolo Veronese e di Jacopo Bassano," *Arte veneta* 22 (1968), pp. 43–46. *AIC Calendar* 63, 1 (1969), ill., n. pag. Maxon 1970, pp. 39–40 (color ill.). A. Ballarin, "Introduzione a un catalogo dei disegni di Jacopo Bassano — III," *Arte veneta* 27 (1973), pp. 95, 108, 110. K. J. Garlick, "A Catalogue of Pictures at Althorp," in *The Forty-Fifth Volume of the Walpole Society, 1974–1976*, London, 1976, p. 4, under no. 28. H. Brigstocke, *Italian and Spanish Paintings in the National Gallery of Scotland*, Edinburgh, 1978, pp. 16–17, under no.

1635. A. M. S. Logan, *The "Cabinet" of the Brothers Gerard and Jan Reynst*, Amsterdam, 1979, p. 114, under no. 6.

EXHIBITIONS: London, The New Gallery, *Venetian Art*, 1894–95, no. 115. London, Thomas Agnew and Sons, *Spring Exhibition*, 1944 (no cat.). London, Thomas Agnew and Sons, *Thirty-Nine Masterpieces of Venetian Painting*, 1953, no. 2. Venice, Palazzo Ducale, *Jacopo Bassano*, 1957, no. 52. The Art Institute of Chicago, *Christmas Exhibition*, 1968–69 (no cat.).

An extremely resourceful artist, Bassano was adept at reworking his compositions to create interesting variations on a theme. He and his workshop produced numerous versions of his more successful compositions.[5] Two other versions of the present composition are known: one in the Contini-Bonacossi Collection in Florence (fig. 1), measuring 75 x 78 cm; the other in a private collection in Milan, measuring 81 x 86 cm.[6] The painting in Florence is signed on the architectural element behind the Virgin: JAC͡SA POTE / BASSANE͡S / PINXIT. The painting in Milan lacks a signature. Arslan (1929, 1931, 1960) read the last letter of the signature on the present picture as F (for *fecit*), but it is in fact a P (for *pinxit*).

While the essential elements of the composition are the same in each painting, there are minor differences. For instance, the modeling of the drapery over the Virgin's knee is different in the version in Florence, whereas in the painting in Milan the toes of the Christ Child's right foot do not appear between the fingers of the Virgin's hand, and Saint John the Baptist's cross is held at a flatter angle. These variations, to which can be added those of facture and color, make it clear that the same cartoon was not used on each occasion. The high level of quality of each picture implies, furthermore, that the three versions are autograph works by Jacopo Bassano rather than workshop products. An example of the latter is in the National Gallery of Scotland in Edinburgh, where the same composition is repeated with the addition of a donor.[7] A similar composition by Bassano involving the same figures as in the three principal versions has often been included in the discussion.[8]

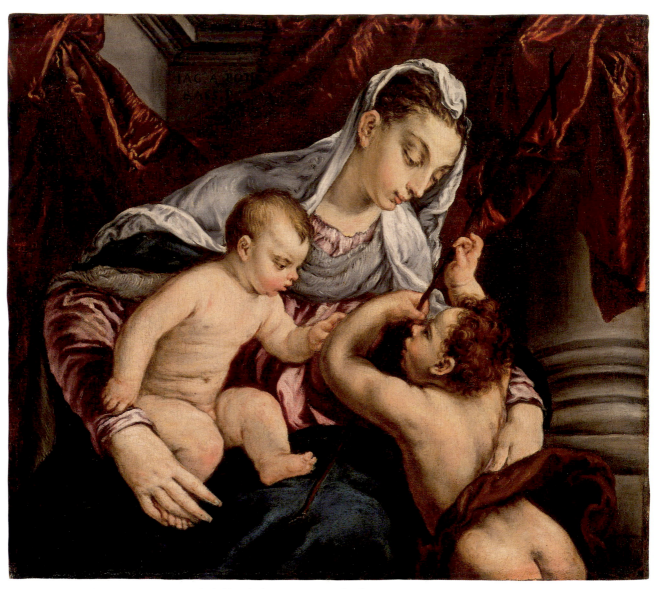

Jacopo da Ponte, called Bassano, *Virgin and Child with the Young Saint John the Baptist*, 1968.320

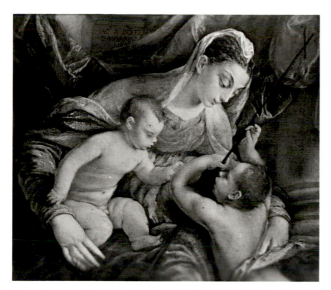

Fig. 1 Jacopo da Ponte, called Bassano, *Virgin and Child with the Young Saint John the Baptist*, Galleria degli Uffizi, Florence, Contini-Bonacossi Collection [photo: Alinari/Art Resource, New York]

The dating of the composition, or rather, of the three different versions of the composition, is unsettled. The consensus of opinion has favored a date during the 1560s. Arslan (1960), Zampetti (1957 exh. cat.), and Pallucchini (1957) suggested a date between the altarpiece of the *Crucifixion* of 1562–63 from the church of San Teonisto in Treviso (now Treviso, Museo Civico) and the altarpiece of the *Adoration of the Shepherds* of 1568 from the church of San Giuseppe in Bassano (now Bassano, Museo Civico).[9] More recently, Ballarin (1968) argued that many of the paintings dated by scholars to the second half of the 1560s should, in fact, be placed in the previous decade on comparison with the painting of *Saint John the Baptist* of 1558 in the Museo Civico in Bassano,[10] mainly, it would seem, on account of the residual Mannerist tendencies derived from Emilian artists that characterize the compositions. The same author in a later article of 1973 proposed a definite chronology for the three versions of the composition, dating the paintings in Florence and Milan around 1559 and the present picture around 1561.

Compositionally, there is an affinity with an even earlier treatment of the *Virgin and Child with the Young Saint John the Baptist* (c. 1545–47) also in the Contini-Bonacossi Collection in Florence (fig. 2), so that the present picture, together with the two related

versions, could perhaps be termed a remaking of the earlier work. The handling of the architectural elements introduced into the later composition provides a useful indication of the Mannerist principles at work in Bassano's style. Any sense of stability in the grouping of the figures that might be derived from the architecture is negated by the fact that the most prominent architectural elements on the right and left do not seem to be related. The low viewpoint, the agitated drapery, and the exaggerated movement are also common features of Mannerist art. Ballarin (1968) noted the similarity of the pose of the young Saint John in the present composition to that of the small child in the foreground of *Jacob's Journey* by Bassano in the Royal Collection, which is a painting of comparable date.[11] There may also be a connection with Paolo Veronese in the treatment of the playful poses of the Christ Child and Saint John the Baptist, since the body of the latter cut by the lower edge is reminiscent of that in Veronese's *Holy Family with*

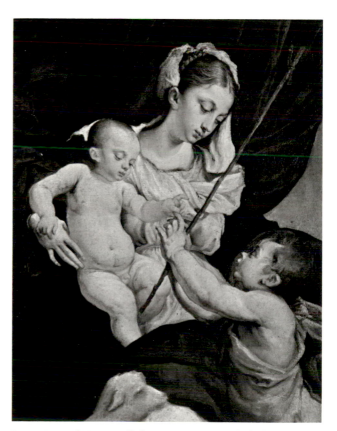

Fig. 2 Jacopo da Ponte, called Bassano, *Virgin and Child with the Young Saint John the Baptist*, Galleria degli Uffizi, Florence, Contini-Bonacossi Collection [photo: Scala/Art Resource, New York]

the Young Saint John and Saint George.[12] A connection with Veronese would suit Ballarin's analysis of Bassano's stylistic development around 1560, as the artist turned away from Mannerism and began to reexamine his Venetian heritage, which inspired the cool, yet vibrant colors of the present picture and its abundant use of highlights.

NOTES

1 According to the 1894–95 London exhibition catalogue.
2 According to correspondence from Agnew to the Art Institute of October 9, 1968, in curatorial files.
3 According to a letter from Agnew to Michael Heinlen of April 26, 1989, in curatorial files.
4 Ibid.
5 For general comments on Bassano, see *Diana and Actaeon* catalogued above (1939.2239).

6 Ballarin 1968, fig. 55.
7 Brigstocke 1978, pp. 16–17, no. 1635.
8 Recently rediscovered in the collection of the Earl Spencer at Althorp; Garlick 1976, p. 4, no. 28. The painting was sold at auction in 1991 (Sotheby's, New York, May 30, 1991, no. 9). Before its rediscovery by Ballarin (1973, pp. 94, 122–23 n. 10, 124 *postscriptum*), this painting was only known through a print by the seventeenth-century Dutch engraver Theodor Matham made when the picture was in the collection of Gerard Reynst (see Logan 1979, p. 114, no. 6, pl. P6).
9 Arslan 1960, vol. 2, figs. 113, 150; *The Genius of Venice, 1500–1600*, exh. cat., London, Royal Academy of Arts, 1983–84, no. 9 (ill.).
10 Arslan 1960, vol. 2, fig. 104.
11 J. Shearman, *The Early Italian Pictures in the Collection of Her Majesty the Queen*, Cambridge, 1983, p. 25, no. 19, pl. 12; *Genius of Venice* (note 9), no. 8 (color ill.).
12 C. Lloyd, *A Catalogue of the Earlier Italian Paintings in the Ashmolean Museum*, Oxford, 1977, pp. 187–88, no. A863, pl. 135; *Genius of Venice* (note 9), no. 140 (ill.).

Domenico Beccafumi, called Il Mecarino

1486? Montaperti–Siena 1551

Saint Ignatius of Antioch Disemboweled by Trajan's Torturers, 1525/27

Gift of Richard L. Feigen, 1986.1366

Oil on panel, diameter 61 cm (24 in.)

INSCRIBED: [...] QVALE IN QVESTA CHONPAGNIA LA SVA·MAN SIGNATIO·EPISCHOPO·ANTIOCHIA D[G?]B (on band surrounding the image)

CONDITION: The painting is in poor condition. It was evidently cleaned between 1981 and 1983.[1] The panel is composed of two vertical boards joined and reinforced approximately 30 cm from the left edge with three double dove-tailed keys. The panel is worm tunneled, with some exit holes pitting the painted surface. There is also considerable abrasion over the entire painted surface with extensive retouching throughout, filling minute losses.

Before the picture was treated between 1981 and 1983, overpaint masked the saint's entrails. The entrails at left appear to be well integrated into the surrounding areas of paint and thus part of the original composition. The configuration of the entrails at right has been altered to some extent by a later hand. Examination with infrared reflectography reveals that the entrails emerging from the saint's left side were originally rendered as extending over the spindle, passing through the hand of the torturer, and returning to the spindle (x-radiograph).

PROVENANCE: Probably Compagnia di San Michele Arcangelo, Siena, by 1525/27.[2] Probably Chigi-Saracini collection, Palazzo Chigi-Saracini, Siena, by 1819.[3] Richard L. Feigen, New York, 1981–86;[4] given to the Art Institute, 1986.

REFERENCES: F. Bisogni, "Le opere di Domenico Beccafumi nella Collezione di Galgano Saracini," *Prospettiva* 26 (1981), pp. 32, 34–35, figs. 6–8. A. Angelini in *Domenico Beccafumi e il suo tempo*, exh. cat., Siena, Chiesa di Sant'Agostino, Pinacoteca Nazionale di Siena, Duomo, Palazzo Pubblico, Oratorio di San Bernardino, Ospedale di Santa Maria della Scala, Palazzo Bindi-Sergardi, 1990, p. 120, under no. 11.

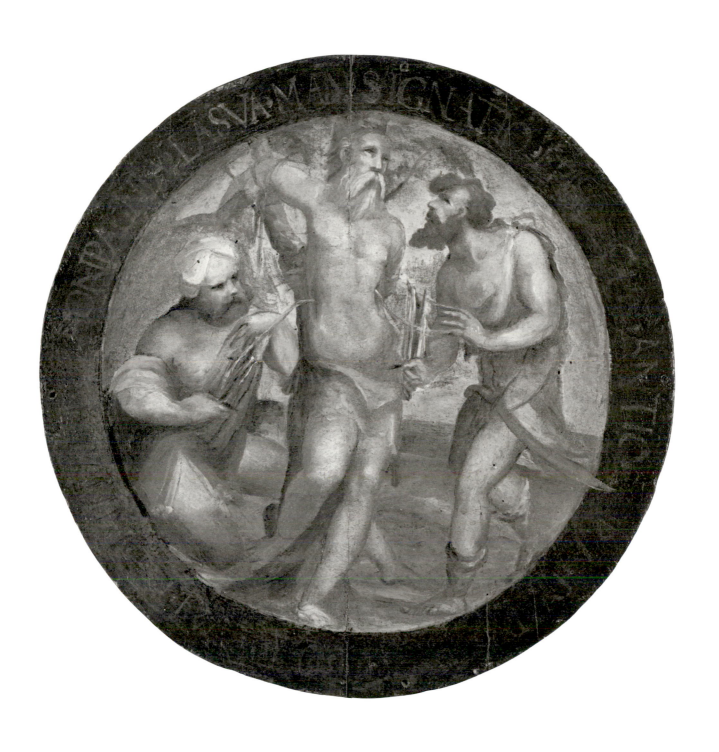

Although seriously damaged and much restored, this picture (formerly known as *The Martyrdom of Saint Ignatius of Antioch*) appears to be an autograph work by the Sienese painter and sculptor Domenico Beccafumi. Drawing upon the eccentricities of his native Sienese artistic tradition and the innovations of Rosso in Florence, Beccafumi created the first and most influential Mannerist style in Siena in the first half of the sixteenth century. Beccafumi's Mannerism was tempered, at least intermittently, by elements he assimilated from the High Renaissance works he viewed in Florence and Rome (c. 1511), from the paintings of his Sienese compatriot Sodoma, and those of Fra Bartolommeo and Andrea del Sarto. After a second trip to Rome in 1519, his art took on a decidedly Roman cast as he imitated the monumental figure types and decorative schemes of Raphael and Peruzzi. Beccafumi's frescoes depicting scenes of ancient history in the Palazzo Bindi-Sergardi (1524/25) and in the Sala del Concistoro of the Palazzo Pubblico in Siena (1529–35) are prominent examples of his mature, Romanizing manner.[5]

Although the dating of the Chicago painting is somewhat problematic, largely due to its condition, the work should probably be assigned to the period of 1525/27, that is, to the years at the end of Beccafumi's involvement with the Bindi-Sergardi decorations and before he executed his *Mystic Marriage of Saint Catherine* (1528) in the collection of the Monte dei Paschi di Siena (formerly Chigi-Saracini collection)[6] and his Sala del Concistoro frescoes. Similar figure types and a comparable broad, summarizing manner can be seen in his Bindi-Sergardi tondi depicting *The Creation of Man by Prometheus* and the *Birth of Minerva*.[7] The construction of the shoulder and neck of the torturer at right is very close to that of the figure of *Speusippus Tegaeatum* on the Sala del Concistoro ceiling.[8] However, the figures in the Chicago picture have neither the hard-edged sculptural quality nor the gravity of their counterparts in the Palazzo Pubblico frescoes and in the slightly earlier Monte dei Paschi *Mystic Marriage of Saint Catherine*.[9]

Fabio Bisogni (1981), who first published the present picture, plausibly suggested that it was painted for the members of the Sienese Confraternity of Saint Michael the Archangel.[10] The confraternity claimed to possess the hand of Saint Ignatius, the relic to which the inscription on the Chicago painting refers.[11] A tabernacle for the relic was commissioned in 1518, and inventories of 1579 and 1584 mention works depicting Saint Ignatius in the confraternity's possession.[12]

Were it not for the inscription on the Chicago panel, the subject would probably be mistaken for the martyrdom of Erasmus, a third-century saint whose executioners extracted his entrails with a windlass. This portrayal of Ignatius (35/50–c. 107), bishop of Antioch, is unusual if not unique, as there is apparently no pictorial precedent or textual basis for Beccafumi's representation. Ignatius is usually depicted in one of two ways: grasping a heart that bears a golden IHS monogram (because of Vincent de Beauvais's statement that when Ignatius's heart was cut up, "the name Lord Jesus Christ was found inscribed in golden letters on every single piece")[13] or accompanied by a lion, an allusion to his martyrdom (he was devoured by lions in a Roman amphitheater).[14]

As Martha Richardson has suggested, Beccafumi in the present work seems to have elaborated on an apocryphal event in the saint's life described by Jacobus de Voragine in *The Golden Legend*.[15] According to Voragine, the Emperor Trajan, having failed to persuade Ignatius to reject his Christian faith, had the bishop subjected to various indignities. The emperor commanded his torturers to "beat [Ignatius] about the shoulders with lead-weighted whips, rip open his sides with iron blades, and grate his wounds with sharp stones."[16] Presumably, to make Ignatius's side wounds more obvious and dramatic in this picture, Beccafumi decided to show the saint's entrails being wound on two spindles.[17] Such an embellishment would not be completely out of character for Beccafumi, whose iconographic inventiveness is displayed also in his *Saint Michael Expelling the Rebel Angels* (c. 1528) in the Chiesa del Carmine and in his *Birth of the Virgin* (c. 1530) in the Pinacoteca, Siena.[18]

NOTES

1 Compare the photograph of the picture before cleaning published by Bisogni 1981, fig. 6. The painting was presumably cleaned while in the possession of Richard Feigen, who acquired it in 1981, and no later than 1983 (see Martha Richardson, "Domenico Beccafumi: *The Martyrdom of*

St. Ignatius of Antioch," unpublished paper, 1983 [copy in curatorial files]).

2 See discussion section.

3 Bisogni (1981, p. 34) has connected the panel with a work described in the 1819 inventory of the Galleria Saracini as "Il Martirio d'un Santo in un tondo, di Mecarino"; see *Relazione in compendio delle cose più notabili nel Palazzo e Galleria Saracini di Siena*, Siena, 1819, p. 66.

4 According to a document in curatorial files.

5 D. Sanminiatelli, *Domenico Beccafumi*, Milan, 1967, pls. 31, 31a–s, 47, 47a–u.

6 *Beccafumi* 1990, p. 165 (ill.).

7 See Sanminiatelli (note 5), pls. 31l, 31r. The latter painting is sometimes identified as an *Allegory of the Sciences and Letters* (ibid., and G. Briganti and E. Baccheschi, *L'opera completa del Beccafumi*, Classici dell'arte n.s. [4], Milan, 1977, p. 95, no. 63).

8 Briganti and Baccheschi (note 7), pl. XLIII.

9 Bisogni (1981, pp. 34–35) has dated the Chicago picture to c. 1525.

10 Ibid., pp. 34, 46 n. 43.

11 Ibid., pp. 32, 34. The inscription roughly translates as: "... which in this confraternity [is] the hand of Saint Ignatius bishop of Antioch D[G?]B." The initials at the end of the inscription presumably stand for Domenico di Giacomo Beccafumi.

12 Ibid., pp. 32, 34, 46 n. 44. According to Bisogni, the standing bishop saint in a painting in the collection of the Monte dei Paschi di Siena (formerly Chigi-Saracini collection), traditionally identified as Saint Augustine, is actually a representation of Saint Ignatius of Antioch. Bisogni has also speculated that the Monte dei Paschi picture, like the Chicago work, was once in the possession of the Confraternity of Saint Michael the Archangel. This new identification of the subject is not entirely convincing, since the heart the saint holds as an attribute does not have a golden IHS monogram, a detail almost always included in portrayals of

Saint Ignatius, and the book he grasps with his left hand is an occasional attribute of Augustine, a Father of the Church and prolific writer, but not of Ignatius.

13 Ignatius is portrayed in this manner in Fra Angelico's *Christ Glorified in the Court of Heaven* (c. 1435), London, The National Gallery; illustrated in *National Gallery Illustrations: Italian Schools*, London, 1937, p. 9. It is more likely that Beccafumi would have known the story of Ignatius's heart from Jacobus de Voragine's *The Golden Legend* than from the earlier account given in Vincent de Beauvais's *Speculum Historiale* (bk. 10, sec. 57), the third part of his encyclopedic *Speculum Majus* (1247–59); see Vincent de Beauvais, *Speculum Historiale*, Venice, 1494, bk. 10, sec. 57, p. 122; and *The Golden Legend*, vol. 1, p. 148.

14 See, for example, Sigismondo Caula's *Saint Ignatius of Antioch* (1700/10) in the Santuario della Beata Vergine di San Clemente, Bastiglia (Modena); illustrated in A. Garuti, "Il Martirio di S. Ignazio di Antiochia: Un dipinto di Sigismondo Caula ritrovato," in *Musei Ferraresi 1983/1984: Bollettino annuale 13/14*, Florence, 1985, p. 142, fig. 1. See also *The Golden Legend*, vol. 1, pp. 147–48.

15 Richardson (note 1), pp. 4–5.

16 *The Golden Legend*, vol. 1, p. 147.

17 Beccafumi's treatment of the subject may reflect a passage in Eusebius's account of the life of Polycarp, which is presented in the book immediately following the one with the story of Ignatius's martyrdom in Eusebius's *Ecclesiastical History* (fourth century). In his book on Polycarp (4.15.4), Eusebius described how Christian martyrs "were torn by scourges down to deep-seated veins and arteries, so that the hidden contents of the recesses of their bodies, their entrails and organs, were exposed to sight" (Eusebius, *The Ecclesiastical History*, vol. 1, tr. by K. Lake, Cambridge, Mass., and London, 1980, p. 341). Because of masking overpaint (see Condition above), Bisogni (1981, p. 34) read the spindles as "strumenti taglienti" (sharp instruments).

18 Reproduced in *Beccafumi* 1990, pp. 169, 179.

After Giovanni Bellini

Active Venice by c. 1460, d. Venice 1516

Virgin and Child, sixteenth century or later

Charles H. and Mary F. S. Worcester Collection, 1933.550

Tempera or oil on panel, 71.5 x 55.4 cm (28⅛ x 21¾ in.)

CONDITION: The painting is in fair condition. It was restored in 1930 or shortly before, when rather extensive glazes were applied and the Child's right forefinger was adjusted to tickle the Virgin's chin.[1] The picture was cleaned in 1934–35 by Leo Marzolo, at which point the glazes

and the tickling gesture were removed. The inscription IOANNES BELLINVS was also removed at this time. During this treatment the panel was thinned and attached to a plywood board. It was surface cleaned by Alfred Jakstas in 1964. The panel has a vertical grain, and several vertical splits are evident, particularly in the right half. Most disfiguring is a split extending the whole height of the panel through the Virgin's white veil and the Child's left hand. Losses along these splits have been filled and inpainted. There are small areas of local loss on either side of the

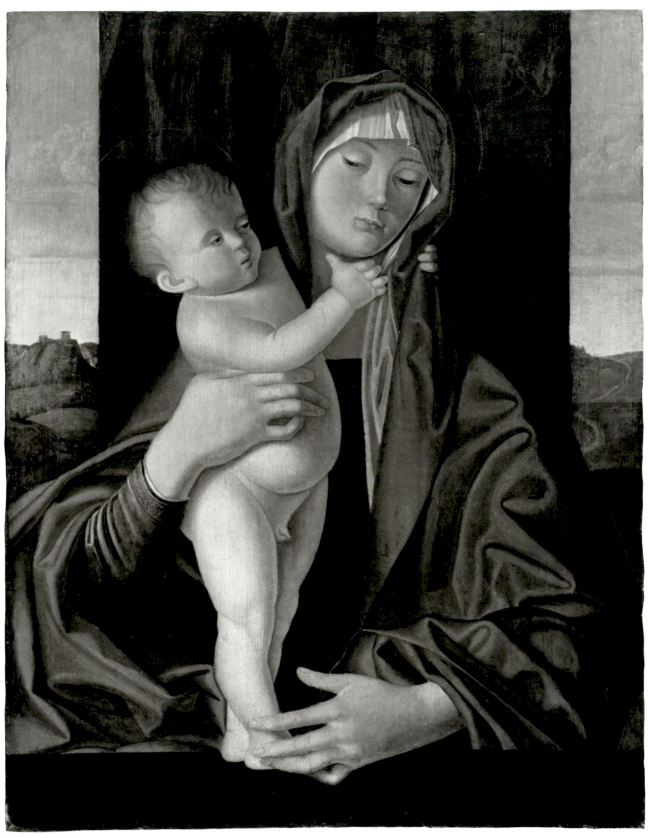

After Giovanni Bellini, *Virgin and Child,* 1933.550

Virgin's head, on the Child's right ankle, and between the thumb and forefinger of the Virgin's left hand. Although there is no single area of major damage, the paint surface has sustained minor abrasions and minute flake losses throughout. A contour drawing used to position the figures is evident in the infrared photograph. This photograph and microscopic examination suggest that a *pentimento* may have been the basis for the Child's tickling gesture (infrared, mid-treatment, x-radiograph).

PROVENANCE: Possibly Carlo Ferrari, Turin.[2] Possibly Count Papadopoli, Padua.[3] Paolo Paolini, Rome, to 1924; sold American Art Association, New York, December 10–11, 1924, no. 115 (ill.), for $5000.[4] Carlo Foresti, Milan, to 1930.[5] Sold by Foresti to Charles H. Worcester, Chicago, 1930;[6] given to the Art Institute, 1933.

REFERENCES: "Paolini Collection of Italian Art of the Xth Century to the XVIth to Be Placed on Sale in New York City," *Art News* 23, 9 (1924), p. 5. "Titian Brings $600, Lippi $300 at Sale," *Art News* 23, 11 (1924), p. 1. "The Century of Progress Exhibition of the Fine Arts," *AIC Bulletin* 27 (1933), p. 60. "The Century of Progress Exhibition of Art for 1934," *AIC Bulletin* 28 (1934), p. 47. Van Marle, vol. 15, 1934, p. 560 n. 1; vol. 17, 1935, pp. 274–75, 294, fig. 162. AIC 1935, p. 21. *Worcester Collection* 1938, pp. 8–9, no. 5, fig. 5. L. Dussler, *Giovanni Bellini*, Vienna, 1949, pp. 63–64. R. Pallucchini, *Giovanni Bellini: Catalogo illustrato della mostra*, exh. cat., Venice, Palazzo Ducale, 1949, under no. 90. Berenson 1957, vol. 1, p. 36. AIC 1961, pp. 21–22. S. Bottari, *Tutta la pittura di Giovanni Bellini*, Milan, 1962, vol. 2, p. 21, under no. 22. F. Heinemann, *Giovanni Bellini e i belliniani*, Venice, 1962, vol. 1, p. 16, under no. 50 (d), vol. 2, fig. 217. L. Sciascia and G. Mandel, *L'opera completa di Antonello da Messina*, Classici dell'arte 10, Milan, 1967, p. 105. Fredericksen/Zeri 1972, pp. 22, 333, 570. E. Camesasca, ed., *Da Raffaello a Goya…da Van Gogh a Picasso: 50 dipinti dal Museu de Arte di San Paolo del Brasile*, exh. cat., Milan, Palazzo Reale, 1987, pp. 68 (ill.), 72.

EXHIBITIONS: The Art Institute of Chicago, *A Century of Progress*, 1933, no. 105, as Giovanni Bellini. The Art Institute of Chicago, *A Century of Progress*, 1934, no. 44, as Giovanni Bellini.

Van Marle (1934, 1935) seems to have been the first to attribute the painting in print to Giovanni Bellini, one of the most innovative and influential painters in late fifteenth-century Venice. Rich (*Worcester Collection* 1938), however, recorded the opinions of a number of other scholars who had seen the picture at an earlier date, either in the original or in a photo-

graph. Thus, Bode and Fiocco attributed the painting to Giovanni Bellini,[7] while Berenson (1957) considered it a copy after the Willys Madonna (fig. 1) now in the Museu de Arte in São Paulo.[8] Van Marle evidently placed great emphasis on the signature which once appeared on the parapet of the picture in Chicago, but was later found to be false and removed. Although aware of the many versions and derivations of this composition, he regarded the Worcester painting as the prototype executed around 1480 and the Willys Madonna as a later autograph version dating from 1485/90. Pallucchini, at the time of the Giovanni Bellini exhibition held in Venice in 1949, which included the Willys Madonna, also appeared to regard the present picture as autograph. In the more recent literature, however, Berenson's opinion that the Willys Madonna is the autograph work from which all the other versions followed has found general acceptance.

The wooden drawing and workmanlike handling of the Worcester picture became fully apparent when it was treated in 1964 and substantiate its status as a

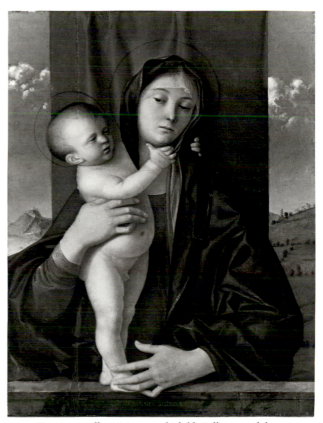

Fig. 1 Giovanni Bellini, *Virgin and Child*, Collection of the Museu de Arte de São Paulo, Brazil [photo: Luiz Hossaka]

copy. Berenson characterized the painting in 1957 as by a close follower of Giovanni Bellini. The style is somewhat reminiscent of Marco Basaiti, and it is conceivable that this copy was made by a weak painter working in Basaiti's studio. However, the picture's warm tonality may indicate that it is a replica made from a version that was itself obscured by dirt and discolored varnish (cleaning tests indicate that the varnish has not discolored significantly since the 1964 cleaning). A full list of other versions and derivations is given by Heinemann (1962).[9]

NOTES

1 A photograph bearing an expertise by Bode dated December 18, 1922, in curatorial files, shows the picture before restoration, with the Child's forefinger parallel to the Virgin's chin. An expertise by Fiocco dated May 20, 1930, also in curatorial files, refers to a recent restoration and shows the picture softened by repaint and glazes, with the Child tickling the Virgin's chin. This is the state reproduced by Van Marle 1935, fig. 162.

2 According to registrar's records and early publications, such as the 1938 catalogue of the Worcester collection.

3 Ibid. See also Van Marle 1935. Some of these early sources give Papadopoli before Ferrari (registrar's records) or omit Papadopoli entirely (1933 and 1934 exhibiton catalogues).

4 According to *Art News* 23, 11 (1924), p. 1, and an annotated copy of the sale catalogue in the Ryerson Library, The Art Institute of Chicago.

5 According to a letter from Charles H. Worcester to Marion Borwell of June 3, 1930, in curatorial files.

6 Ibid.

7 Bode's and Fiocco's opinions (note 1 above), as well as an undated opinion by Van Marle, are in curatorial files.

8 *Museu de Arte de São Paulo: Catálogo des pinturas, esculturas e tapeçarias*, São Paulo, 1963.

9 Of these, the signed version by Antonello da Saliba formerly in Berlin is of particular interest, as his familial connections with Antonello da Messina suggest that the composition may not have been originally devised by Giovanni Bellini. For an illustration of this painting, see Berenson 1957, vol. 1, fig. 298.

Bolognese

Madonna of Humility, 1375/1400
Charles H. and Mary F. S. Worcester Collection, 1947.56

Tempera on panel, 98.9 x 59.4 cm (39 x 23⅜ in.); painted surface: 97.7 x 57 cm (38½ x 22½ in.)

INSCRIBED: *ave maria gr[at]ia* (around outer edge of panel, each letter separated by gilt decoration), ·*salve*·*regina*·*vergene*·*maria*·*[gratia]*·*plena*· (around the mandorla), ·VERGENE·MATRE·[...]GLO (on the Virgin's halo), DEV·HOMO·R (on Child's halo), *salve·regina* (on scrolls supporting repeated pelican motif on Virgin's robe)[1]

CONDITION: The painting is in poor condition despite early statements to the contrary.[2] It seems not to have been treated since its acquisition by the Worcesters. The panel, which has a vertical grain, has been planed down to a thickness of approximately 4 mm and then cradled. There is evidence of extensive worm tunneling on the back and at least 2 cm of the paint and ground have been lost along the lower edge. There is a clear barbe around the scallops of the arched top, but on the sides the ground extends beyond the painted design to the edge of the panel. The picture has suffered severely from abrasion and past cleaning action.

The Virgin's face is particularly abraded and also disfigured by a pronounced craquelure, which appears to have been set down in the past. There are retouches on her forehead and her neck through the jaw into the cheekbone. Further, but less significant, retouching is evident in the Virgin's crown and along the top of her veil. Her blue drapery is thinly painted and some of the shadows have been reinforced. The pelican motif repeated on her robe in gold is original, though abraded. The ground on which she sits has also been retouched. The green used for the Child's drapery and for the lining of the Virgin's mantle has darkened to brown. The seraphim filling the Virgin's mandorla are executed in red pigment over the gold with wavy sgraffito lines used to animate them. The gold background is basically in good condition. The face and hands of the Child are also comparatively well preserved and give some indication of the original quality and delicacy of the picture. The contours of the design are incised. The ground plane is also incised with a scroll-like design, perhaps related to a brocade pattern which is now lost (infrared, ultraviolet, x-radiograph).

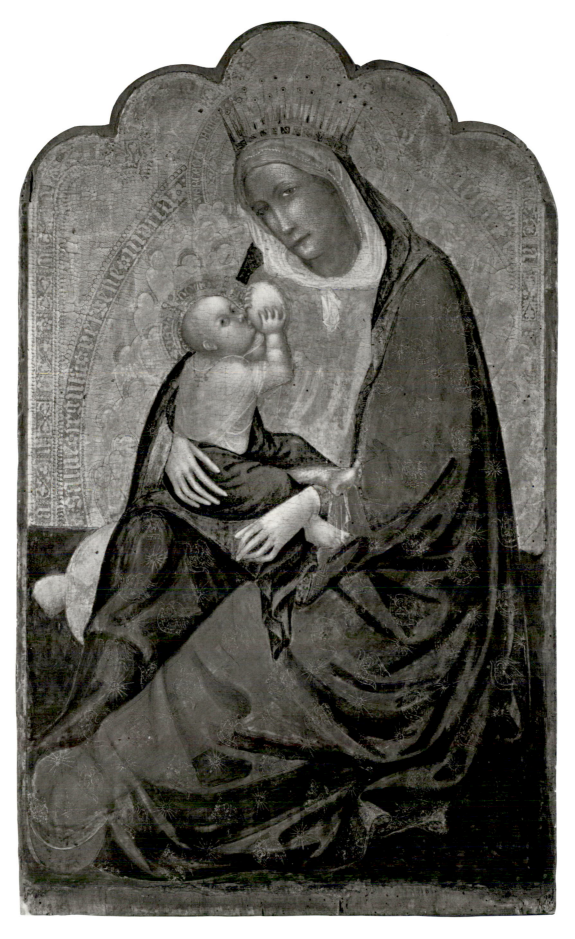

PROVENANCE: Count Ambroz-Migazzy, Sarvar, Hungary.[3] E. and A. Silberman Galleries, New York.[4] Sold by Silberman to Charles H. Worcester, Chicago, 1928;[5] given to the Art Institute, 1947.

REFERENCES: *Art News* 27, 10 (1928), p. 1 (ill.). "Famous Art Works Exhibited in Clubhouse," *Art in the Union League Club of Chicago: Union League Club Bulletin*, January 1929, p. 7 (ill.). *Pantheon* 3 (1929), pp. 102 (ill.), 104. D. C. Rich, "Two Trecento Venetian Panels," *AIC Bulletin* 24 (1930), pp. 88–89, cover ill. The University of Chicago, The Renaissance Society, *Anniversary Bulletin*, Autumn–Winter 1930, cover ill. W. Suida, review of *Pitture italiane in America* by L. Venturi, in *Belvedere* 10 (1931), p. 191, pl. 104. L. Venturi 1931, pl. CIV. M. Meiss, "The Madonna of Humility," *Art Bull.* 18 (1936), p. 67 n. 23; reprinted in M. Meiss, *Painting in Florence and Siena after the Black Death*, Princeton, 1951, p. 137 n. 20. "The Christmas Story in Art," *AIC Bulletin* 32 (1938), p. 105. *Worcester Collection* 1938, pp. viii, 6, no. 2, pl. II. L. Coletti, *I primitivi*, vol. 3, *I padani*, Novara, 1947, pp. XXXIV–XXXVI, LXXIII, pl. 66. L. Coletti, "Sulla mostra della pittura bolognese del Trecento: Con una coda polemica," *Emporium* 112 (1950), pp. 252–54. W. Suida, "Some Bolognese Trecento Paintings in America," *Critica d'arte* 9, 1 (1950), p. 58, fig. 62. P. Toesca, *Il trecento*, Turin, 1951, p. 751 n. 276. D. C. Shorr, *The Christ Child in Devotional Images in Italy during the XIV Century*, New York, 1954, pp. 61, 65, fig. 9. AIC 1961, p. 225. Huth 1961, p. 516, fig. 380. Fredericksen/Zeri 1972, pp. 216, 346, 571. I. Hecht, "Madonna of Humility," *AIC Bulletin* 70 (1976), pp. 10–13, fig. 2.

EXHIBITIONS: Chicago, The Union League Club, 1928 (no cat.). The University of Chicago, The Renaissance Society, *Religious Art from the Fourth Century to the Present Time*, 1930, no. 33, as Jacobello di Bonomo. The Art Institute of Chicago, *A Century of Progress*, 1933, no. 86, as Jacobello di Bonomo(?). The Art Institute of Chicago, *The Christmas Story in Art*, 1938–39 (no cat.).

This painting represents the *Madonna dell'Umiltà* (Madonna of Humility), a type of devotional image in which the Virgin is depicted seated on the ground nursing the Christ Child. Images of this devotional type, which came to prominence in Italian painting in the second half of the fourteenth century, often share a number of features in common in addition to the Virgin's humble position. The Virgin gazes directly at the viewer, and the Child turns in her arms so that he too looks directly out at the viewer. The Virgin is frequently shown with the attributes of the Woman of the Apocalypse as described in Revelation (12.1):

"And there appeared a great wonder in heaven; a woman clothed with the sun, and the moon under her feet, and upon her head a crown of twelve stars." Thus, in the Chicago panel, the crown worn by the Virgin, the sun emblazoned on her breast, and the small crescent moon at her feet are all references to the Woman of the Apocalypse.

The origins of this popular theme were traced by Meiss to Simone Martini. According to Meiss, its iconographic sources were to be found in depictions of both the Nativity and the Apocalypse.[6] Van Os also regarded Simone Martini as the originator of the type, but argued that it was more closely related to the humility of the Virgin at the moment of the Annunciation than to the Nativity.[7] The power of the Madonna of Humility as a devotional type derived not only from its reference to the Virgin's role in the scheme of salvation, but also from the intimacy of the relationship between mother and child and their accessibility to the worshiper. This intimacy is still evident in the Chicago picture, despite its damaged state.

Numerous attributions have been suggested for this painting. At first, scholars favored various artists of the Venetian school, such as Jacobello di Bonomo (Rich 1930) and Jacobello del Fiore (L. Venturi 1931).[8] More recently, the panel has been ascribed to artists working in the Marches (Meiss 1936) or to the Emilian school (Suida 1950, Toesca 1951, Coletti 1947 and 1950, Fredericksen/Zeri 1972). Between 1936 and 1951, Meiss narrowed his opinion from a general attribution to the Marchigian school to Carlo da Camerino, on comparison with panels by that artist in Baltimore and Cleveland.[9] Within the Emilian school, Suida and Toesca referred to Jacopo da Bologna, now known as Jacopino di Francesco, while Coletti posited Barnaba da Modena. Fredericksen and Zeri maintained an ascription to an anonymous artist of the Emilian school.

When due allowance has been made for the condition of the panel, its close relation to the work of the Bolognese painter Jacopino di Francesco suggests Bologna as a possible solution to the problem of attribution. An important follower of Vitale da Bologna, Jacopino was active in Bologna from 1360 and had died by 1386.[10] Comparison with Jacopino's polyptych of *The Presentation in the Temple* (fig. 1) reveals many similarities in the treatment of the face and the

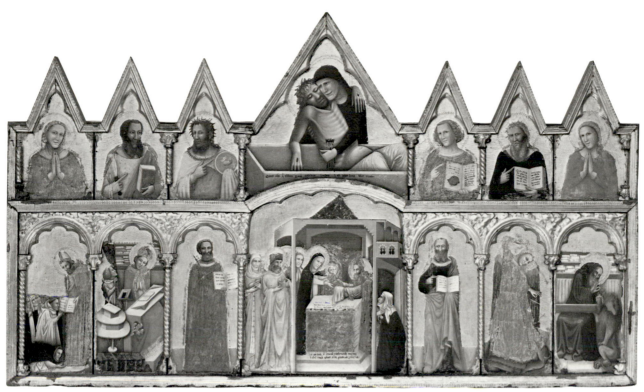

Fig. 1 Jacopino di Francesco, *The Presentation in the Temple*, Pinacoteca Nazionale, Bologna

drawing of the hands, particularly with respect to the figures in the upper tier of the altarpiece.[11] The pronounced jaw, the wide mouth, the narrow eyes, and the skeletal fingers are not dissimilar to comparable features in the types depicted by Jacopino di Francesco. Nevertheless, the forms seem softer, more sinuous, and in general closer to the aesthetic of the International Style than those of Jacopino di Francesco. Therefore a more general attribution to a Bolognese artist of the late fourteenth century should be retained.

The arched frame suggests that the panel might have formed part of a larger complex, but the size and the subject perhaps make this unlikely.

NOTES

1 The inscriptions on these scrolls are more readily visible under ultraviolet light. The *salve* is then clearly legible and *regina* appears in several abbreviated forms. Regarding the meaning of the inscriptions, see note 7 below.

2 See Georg Gronau's expertise of May 7, 1928, in curatorial files, and Rich 1930, p. 88.

3 According to *Worcester Collection* 1938.

4 According to receipt dated November 21, 1928, in curatorial files.

5 See receipt cited in the above note, as well as *Art News* 1928 and *Pantheon* 1929.

6 Meiss 1936 (1951), pp. 132–45.

7 H. W. van Os, *Marias Demut und Verherrlichung in der sienesischen Malerei, 1300–1450*, Kunsthistorische Studiën van het Nederlands Historisch Instituut te Rome 1, The Hague, 1969, pp. 77–127, esp. pp. 107–08. The inscription on the mandorla surrounding the Virgin in the Chicago picture indicates a connection with Gabriel's salutation to the Virgin Mary at the Annunciation (Luke 1.28) and thus may support Van Os's argument. The scrolls inscribed *salve·regina* repeated with the pelican motif on the robe of the Virgin may be an echo of this inscription or may refer to the famous antiphon *Salve, regina* (see J. Julian, *A Dictionary of Hymnology*, rev. ed., London, 1907, pp. 991–92). The pelican pricking its breast is a symbol of Christ's sacrifice (see *Lexikon der christlichen Ikonographie*, vol. 3, Rome, Freiburg, Basel, and Vienna, 1971, pp. 190–91). Together with the inscription *salve· regina*, it presumably refers to the Virgin's role as mediatrix.

8 Rich based his attribution on Gronau's expertise (see note 2 above).

9 F. Zeri, *Italian Paintings in the Walters Art Gallery*, vol. 1, Baltimore, 1976, pp. 68–71, no. 41, pl. 35; and The Cleveland Museum of Art, *European Paintings before 1500: Catalogue of Paintings, Part One*, Cleveland, 1974, pp. 59–61, no. 22, fig. 22.

10 For Jacopino di Francesco, see F. Arcangeli, *Natura ed espressione nell'arte bolognese-emiliana*, exh. cat., Bologna, Palazzo dell'Archiginnasio, 1970, pp. 125–38, nos. 28–32 (ills.).

11 A. Emiliani, *La Pinacoteca Nazionale di Bologna*, Bologna, 1967, p. 142, no. 41 (ill.).

Sandro Botticelli

1444/45 Florence 1510

Virgin and Child with Two Angels, 1485/95
Max and Leola Epstein Collection, 1954.282

Tempera on panel (thinned and mounted on pressed board), diameter 34.4 cm (13½ in.); painted surface: diameter 32.5 cm (12¹³⁄₁₆ in.)

CONDITION: The painting is in poor condition. It was planed down and mounted on pressed board while it was in the Epstein collection, according to an undated treatment record signed with Leo Marzolo's initials in the Art Institute's conservation file. In 1962 Alfred Jakstas cleaned the painting and in 1974 he undertook another more extensive cleaning, including the mechanical removal of overpaint in the Virgin's robe. At this time the sprays of foliage framing the arches of the arbor were also removed.

The paint surface is severely abraded, particularly in the flesh tones. There are also some areas of paint and ground loss in the foliage and in the robes of the angels and of the Virgin to the right of her forearm. The flesh tones, the angels' robes, the throne, and the foliage of the arbor have been very extensively retouched. Despite the poor condition of the paint surface, the quality of the design is by no means lost.

The x-radiograph clearly shows incised guidelines for the orthogonals of the throne and for the placement of the composition (infrared, mid-treatment, ultraviolet, x-radiograph).[1]

PROVENANCE: Possibly Monastery of Santa Maria degli Angeli, Florence, sixteenth century.[2] Julius Böhler, Munich.[3] Sold by Böhler to Max Epstein (d. 1954), Chicago, by 1928;[4] bequeathed to the Art Institute, 1954; on loan to Leola Epstein, Chicago, 1955–68.

REFERENCES: *Old Masters in the Collection of Max Epstein*, Chicago, 1928, ill., n. pag. Van Marle, vol. 12, 1931, p. 171. AIC 1961, p. 29. E. Fahy, "A Tondo by Sandro Botticelli," *AIC Museum Studies* 4 (1969), pp. 14–25 (ill.). Maxon 1970, pp. 31–32 (ill.). Fredericksen/Zeri 1972, pp. 33, 321, 571. *The Art Institute of Chicago: 100 Masterpieces*, Chicago, 1978, pp. 42–43, no. 6 (color ill.). R. Lightbown, *Sandro Botticelli*, London, 1978, vol. 2, p. 83, no. B74 (ill.). J. D. Morse, *Old Master Paintings in North America*, New York, 1979, p. 28. R. Lightbown, *Sandro Botticelli: Life and Work*, New York, 1989, color pl. 89.

EXHIBITIONS: The Art Institute of Chicago, *Old Masters from the Collections of Cyrus H. McCormick and Max Epstein*, 1928 (no cat.). The Art Institute of Chicago, *Summer Exhibition: Old Masters Lent by Max Epstein*, 1930 (no cat.). The Art Institute of Chicago, *A Century of Progress*, 1933, no. 107, as *Adoration with Angels*.

The lyrical paintings of Sandro Botticelli represent the culmination of a mystical Christian tradition in Florentine Renaissance art, advanced earlier by Fra Angelico and by Botticelli's teacher, Fra Filippo Lippi. Botticelli's mature style lent itself equally well to mythological subject matter, as seen in the paintings he created for the Medici, such as the famous *Primavera*, which reflect the Neoplatonic preoccupations of the scholars who gathered at Lorenzo the Magnificent's villa at Careggi. In the mid-1490s the artist came under the influence of the archconservative Dominican friar Savonarola, and Botticelli's style became somewhat naive and less graceful in character, presumably to suggest an unsophisticated, sincere piety.

Before Fahy's important 1969 article, only Van Marle (1931) had published this panel. Van Marle advanced the attribution to Botticelli with a date in the early 1490s.[5] Fahy suggested a date either during the late 1480s or during the early 1490s on the basis of style and Botticelli's use of the motif of angels drawing back curtains, which the artist began to use fairly frequently from the late 1480s onwards, notably in the *San Barnaba Altarpiece* now in the Uffizi in Florence.[6] In addition, Fahy argued that the tondo can be identified with one mentioned by Vasari in his *Life of Botticelli*: "È molto bello ancora un picciol tondo di sua mano, che si vede nella camera del priore degli Angeli di Firenze, di figure piccole, ma graziose molto, e fatte con bella considerazione."[7] Previously, a tondo of the *Virgin and Child with Three Angels* (*Madonna del Padiglione*), now in the Pinacoteca Ambrosiana in Milan, measuring 65 cm in diameter, had been associated with this passage in Vasari, but Fahy posited that the size of the tondo in Chicago (given incorrectly in Lightbown 1978) is more appropriate to Vasari's description, since the dimensions are approximately half those of the tondo in Milan.

The painting in Chicago is less well preserved than that in Milan, but it was clearly a work of consider-

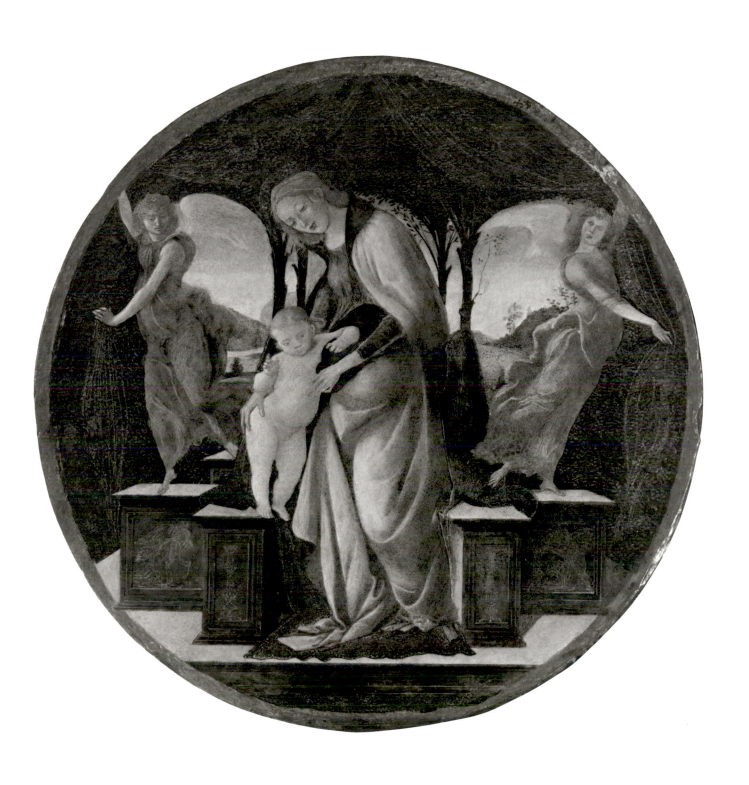

able refinement in the attention paid to the decorative details and in the use of gold. Both tondi, however, date from the same period and in both cases the early provenance is unknown. Fahy's suggestion, therefore, although persuasive, is still in need of documentary support.

Fahy pointed out that the pose of the Child recurs in another, much larger tondo, known as the *Madonna dei Candelabri*, now in Berlin,[8] which is often regarded as a workshop product after a design by Botticelli possibly dating from the late 1480s.

As an explanation for the four trees behind the Virgin in the Chicago tondo, Fahy suggested that Botticelli has here adapted the iconography of the *Madonna degli Alberetti*, which was otherwise very rarely depicted by Florentine artists. Lightbown rejected this suggestion, remarking that the paintings of the *Madonna degli Alberetti* normally have only two trees.[9] Perhaps Botticelli intended the trees to represent the seclusion usually associated with the *hortus conclusus*, symbolizing Mary's virginity based on a passage in the *Song of Solomon* (4.12).[10] This association is possibly given greater credence by the fact that the Annunciation itself is depicted on the face of the two pedestals supporting the angels in the present composition.

The motif of the angels parting the curtains is one that recalls Piero della Francesca's *Madonna del Parto* at Monterchi, as well as the lunette above the altarpiece painted by Antonio and Piero del Pollaiuolo in the Chapel of the Cardinal of Portugal in San Miniato al Monte, Florence.[11] Although both instances cited are connected with mortuary chapels and although the motif itself does indeed have its origins in tomb sculpture of the thirteenth century,[12] it is unlikely that there is such a connection in the present instance. Botticelli may simply have relished the motif as a decorative or compositional device. Interestingly, one of the instances of Botticelli's use of angels to draw back curtains referred to by Fahy occurs on the embroidered vestment the artist almost certainly designed for the Chapel of the Cardinal of Portugal.[13] The embroidery shows *The Coronation of the Virgin* and can be dated 1485/90.[14]

NOTES

1 The x-radiograph is illustrated in Fahy 1969, p. 24, fig. 14.
2 Vasari, *Vite*, Milanesi ed., vol. 3, pp. 323–24: "Very beautiful, too, is a little round picture by his hand that is seen in the apartment of the Prior of the Angeli in Florence, in which the figures are small but very graceful and wrought with beautiful consideration" (G. Vasari, *Lives of the Most Eminent Painters, Sculptors, and Architects*, tr. by G. Du C. de Vere, New York, 1979, p. 675). Lightbown (1978, vol. 2, pp. 82–83, no. B73) established that the Prior of Santa Maria degli Angeli in Florence, from 1486 until 1498, the period when the tondo under discussion was painted by Botticelli, was Don Guido di Lorenzo di Antonio, while in Vasari's time, during the sixteenth century, the same post was held by Don Antonio di Lionardo di Lorenzo Corsi, a connoisseur of art with works by Giotto and Raphael, as well as the tondo by Botticelli, hanging in his rooms (Vasari, *Vite*, Milanesi ed., vol. 1, p. 396).
3 See letter from Böhler to Everett Fahy of January 20, 1969, in curatorial files.
4 See letter cited in note 3 above, as well as *Old Masters* 1928 and the 1928 exhibition.
5 Before Van Marle, Wilhelm von Bode had attributed the work to Botticelli and dated it to 1492/95 in an expertise of July 3, 1927, in curatorial files. Lionello Venturi likewise attributed the work to Botticelli on February 6, 1929 (Archives, The Art Institute of Chicago). On November 19, 1936, Kenneth Clark, however, described the picture as "a nineteenth-century work, probably not intended as a fake but as a picture in the manner of Botticelli" (Archives, The Art Institute of Chicago).
6 Lightbown 1978, vol. 1, pl. 31, vol. 2, pp. 66–67, no. B49.
7 See note 2.
8 Lightbown 1978, vol. 2, pp. 131–32, no. C29.
9 See L. Molmenti and G. Ludwig, "La Madonna degli Alberetti," *Emporium* 20 (1904), pp. 109–20.
10 M. Levi d'Ancona, *The Garden of the Renaissance: Botanical Symbolism in Italian Painting*, Florence, 1977, pp. 176–78, no. 75.
11 K. Clark, *Piero della Francesca*, 2d ed., London and New York, 1969, pl. 97; F. Hartt, G. Corti, and C. Kennedy, *The Chapel of the Cardinal of Portugal, 1434–1459*, Philadelphia, 1964, pl. 139.
12 For example, the tomb of Cardinal de Braye by Arnolfo di Cambio in San Domenico, Orvieto (J. Pope-Hennessy, *Italian Gothic Sculpture*, 2d ed., London and New York, 1972, p. 182, fig. 25, pls. 26–27).
13 Fahy 1969, pp. 18–19, figs. 5–6. The same motif of angels drawing back curtains, as well as the framing trees, can also be found in Lombardy, as exemplified by the painting of the *Virgin and Child with Two Angels* signed in monogram B. B. and dated 1500 in Berlin (Staatliche Museen Preussischer Kulturbesitz, Gemäldegalerie, no. III.90). This was brought to the author's attention by Everett Fahy (letter of November 15, 1984, in curatorial files).
14 M. C. Mendes Atanasio, "Il cappuccio di piviale al Museo Poldi-Pezzoli e altri paramenti della cappella del Cardinale di Portogallo," *Commentari* 14 (1963), pp. 227–45.

Virgin and Child with Angel, 1475/85
Max and Leola Epstein Collection, 1954.283

Tempera on panel, 85.7 x 59.1 cm (33¾ x 23¼ in.)

CONDITION: The painting is in fair condition. In 1955 Leo Marzolo consolidated flaking paint and surface cleaned the painting. In 1969 Alfred Jakstas undertook a more extensive cleaning, including the mechanical removal of overpaint in the Virgin's blue robe. A star on the Virgin's shoulder was removed at this time. The panel is composed of two boards with vertical grain and a join 15.5 cm from the left edge. At an early date, wooden battens were added along the upper and lower edges, the back of the panel having been cut out here.[1] There are several vertical cracks at the upper edge of the panel.

The paint surface has tended to blister in the past, affecting particularly the lower edge, the Virgin's blue robe, the angel's sleeve, and the sky. An area of damage in the Virgin's cheek has been filled and inpainted. In addition, the picture has suffered from abrasion, particularly along the Virgin's brow and nose, in the face of the Child, in the Virgin's hand and blue robe, and in the Child's left leg. These areas have been fairly extensively inpainted.

Infrared reflectography revealed underdrawn contours for the head and hands of the Virgin and the Christ Child (fig. 1), and for the legs of the Child. These contours were adjusted at the paint stage, most notably in the face of the Virgin, which has been made slightly broader and less angular. The lines of the architecture have been incised into the ground (infrared, infrared reflectogram, ultraviolet, x-radiograph).

PROVENANCE: Possibly Dr. Paoletti, Florence.[2] Jules Féral, Paris, 1907–19.[3] Sold by Féral to a Scandinavian collector, 1919.[4] Arnold van Buuren, Naarden, Holland; sold A. Mak, Amsterdam, May 26–27, 1925, no. 10, to De la Faille for 25,500 gulden.[5] Max Epstein (d. 1954), Chicago, from 1925 or 1928 to 1954;[6] bequeathed to the Art Institute, 1954; on loan to Leola Epstein, Chicago, 1955–68.

REFERENCES: A. Venturi, "Une Oeuvre inconnue de Botticelli," *Gazette des beaux-arts* 3d ser., 38 (1907), pp. 5–11 (ill.). J. A. Crowe and G. B. Cavalcaselle, *A History of Painting in Italy*, 2d ed., vol. 4, ed. by R. Langton Douglas, New York, 1911, p. 271. A. Venturi, vol. 7, pt. 1, 1911, pp. 601–04, fig. 339. A. Venturi, *Botticelli*, Rome, 1925, p. 116, pl. CLXXXV. Y. Yashiro, *Sandro Botticelli*, vol. 1, London, 1925, pp. 227, 234; rev. ed., London and Boston, 1929, p. 239. W. von Bode, *Botticelli*, Klassiker der Kunst 30, Berlin and Leipzig, 1926, p. 4 (ill.). *AIC Bulletin* 22 (1928), pp. 76, 82, cover ill. *Old Masters in the Collection of Max Epstein*, Chicago, 1928, ill., n. pag. R. Valland, "Une Madone de Botticelli," *La Renaissance* 11 (1928), p. 354 (ill.). E. Singleton, *Old World Masters in New World Collections*, New York, 1929, pp. 64–66 (ill.). Van Marle, vol. 12, 1931, p. 46, fig. 12. C. J. Bulliet, *Art Masterpieces of the 1933 World's Fair, Exhibited at The Art Institute of Chicago*, vol. 1, Chicago, 1933, no. 28 (ill.), n. pag. A. M. Frankfurter, "Art in the Century of Progress," *Fine Arts* 20 (June 1933), pp. 11 (ill.), 60. C. Gamba, *Botticelli*, Milan, 1936, p. 94. J. Mesnil, *Botticelli*, Paris, 1938, p. 225. *AIC Quarterly* 48 (1954), p. 77. R. Salvini, *Tutta la pittura del Botticelli*, vol. 1, 1445–1484, Milan, 1958, pp. 67–68, 74, pl. 128. AIC 1961, p. 29. F. A. Sweet, "Great Chicago Collectors," *Apollo* 84 (1966), p. 203, fig. 37. M. Levey and G. Mandel, *The Complete Paintings of Botticelli*, Eng. ed., New York, 1967, p. 86, no. 9, fig. 9. Maxon 1970, pp. 30–31 (ill.). Fredericksen/Zeri 1972, pp. 33, 328, 571. R. Lightbown, *Sandro Botticelli*, vol. 2, London, 1978, p. 17, no. A13 (ill.).

EXHIBITIONS: The Art Institute of Chicago, *Old Masters from the Collections of Cyrus H. McCormick and Max Epstein*, 1928 (no cat.). The Art Institute of Chicago, *Summer Exhibition: Old Masters Lent by Max Epstein*, 1930 (no cat.). The Art Institute of Chicago, *A Century of Progress*, 1933, no. 108. The Art Institute of Chicago, *A Century of Progress*, 1934, no. 45. The Art Institute of Chicago, *The Christmas Story in Art*, 1938–39 (no cat.). The University of Chicago, The Renaissance Society, *Max Epstein Memorial Exhibition*, 1955, no. 3.

The present panel was first published by Adolfo Venturi (1907) as an early work by Botticelli.[7] This attribution was maintained by Venturi on two later occasions (1911, 1925) and upheld by Langton Douglas in the second edition of Crowe and Cavalcaselle (1911), as well as by Yashiro (1925, 1929), Bode (1926), Van Marle (1931), Mandel (1967), Fredericksen and Zeri (1972), and Lightbown (1978). Of these writers, Yashiro suggested a date of 1472, Bode c. 1468–69, Van Marle c. 1470, and Lightbown 1467–70. Gamba (1936) and Salvini (1958) dissented from this view, the former regarding the painting in Chicago as a copy after the *Virgin and Child with Angel* now in the collection of the Norton Simon Art Foundation (fig. 2), while the latter described the panel as a workshop replica of a later date.[8]

The close similarity between the present panel and that belonging to the Norton Simon Art Foundation

Fig. 1 Infrared reflectogram assembly of detail of *Virgin and Child with Angel*, 1954.283 [infrared reflectography: Carl A. Basner and Martina A. Lopez]

has frequently been observed. The panel in Chicago has been trimmed along the left edge, while the Norton Simon panel appears only to have been slightly trimmed on the right. Compositionally, the paintings differ only in minor respects. In the Norton Simon painting, the profile of the angel is seen mainly against the landscape, and the cord of the same figure's drapery lies on the parapet forming a still life with the bowl of flowers. The angel's clasped hands are also differently posed. The Child is virtually identical, apart from the omission of the cross in the halo and some slight differences in the treatment of the hair. The Virgin wears her veil off the top of the head, and the folds in the lower part of the sleeve of her mantle are more elaborate, although this part of the panel in Chicago has been heavily abraded and retouched. In neither composition has the awkward pose of the angel leaning out over the parapet to obtain a better view of the Virgin and Child been resolved with total success, although it is more convincingly rendered on the Norton Simon panel. The landscape also differs, notably in the far distance. The Norton Simon picture is much abraded, but it remains a work of high quality. It is clearly an early work by Botticelli dating in all probability before 1470, since the influence of Verrocchio is apparent in the facial type of the Virgin, the sculptural effect of

the poses of the Virgin and Child, and the upward twisting movement of the angel.

The differences between the two panels, however, have not been sufficiently emphasized. It is important that they should be, because such considerations affect the status of the panel in Chicago. The essential differences are twofold: first, in the physiognomy of the Virgin and, secondly, in the technique. In the Norton Simon picture, the Virgin's facial features, particularly the shape of the mouth and the chin, are markedly derived from Verrocchio, while the drawing is crisper and the brush strokes are shorter. The present panel, on the other hand, is more characteristic of Botticelli's mature works, notably in the more sinuous drawing of the eyes, mouth, and jaw, in the more even modeling of the flesh tones, and in the less animated rhythms of the draperies. Venturi (1907) hinted at these differences in his initial publication of the picture and Salvini (1958) also drew attention to them. Without knowledge of the Norton Simon panel, therefore, the *Virgin and Child with Angel* in Chicago might be dated to the second half of the

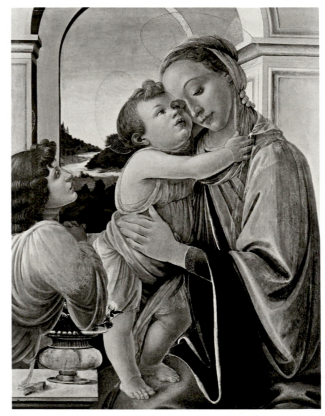

Fig. 2 Sandro Botticelli, *Virgin and Child with Angel*, Norton Simon Art Foundation, M.1987.2.P, Pasadena, California

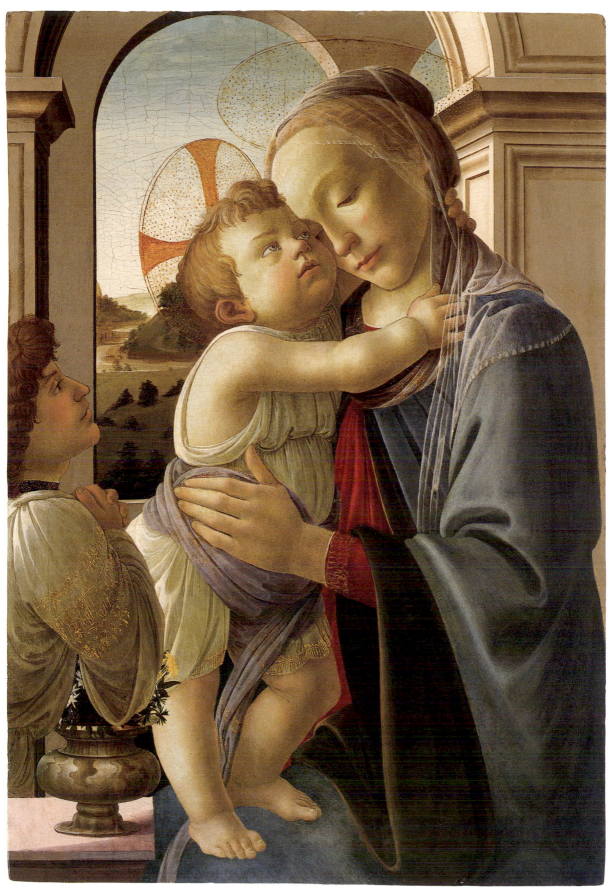

Sandro Botticelli, *Virgin and Child with Angel*, 1954.283

1470s, or during the early 1480s, that is, contemporary with the *Madonna del Magnificat* in the Uffizi, the *Raczynski Tondo* in Berlin, and the mythologies (*Primavera, Pallas and the Centaur, Mars and Venus,* and *The Birth of Venus*).[9] On this basis a strong case could be made, as Salvini was tempted to do, for dismissing the present picture as a workshop replica executed by an assistant after an early composition by the master. The apparent difference in date between the two panels would also provide an explanation for the participation of an assistant, since some writers have noted that it was unlikely that the youthful Botticelli would have employed workshop assistants of his own before 1470. Yet, it does not immediately follow that the panel in Chicago is a routine workshop production undertaken at a later date.

Admittedly, it is most unusual, as far as the author is aware, for Botticelli to repeat one of his own compositions himself. However, the quality of the painting in Chicago is such that the possibility of it being autograph cannot be too hastily dismissed. Allowing for abrasion, the modeling of the Virgin's face is of some distinction, while the attitude of the angel, although less animated and less intense than his counterpart in the earlier painting, can still be truthfully described as one of religious rapture, even if it is more restrained. Only the handling of the Child seems weaker than the other figures, although the treatment of the drapery is not as wooden as the face. One very small characteristic of Botticelli's personal style during the late 1470s and early 1480s that occurs on this panel is the suggestion of the left ala of the Virgin's nose, which at first sight might be mistaken for a *pentimento*. Recognition of the panel's rightful date and of its undoubted quality suggests that Botticelli himself has here painted in part, if not throughout, a close variant of one of his own earlier compositions. The underdrawing revealed by infrared reflectography would seem to support this view (fig. 1; see Condition above). At the paint stage, the artist altered the Virgin's face, changing a narrow, Verrocchio-like chin, similar to that of the Norton Simon *Virgin and Child with Angel*, into a fuller form characteristic of the mature Botticelli.

The flowers in the vase on the parapet closely resemble jasmine, traditionally regarded as a symbol of the Virgin Mary.[10]

NOTES
1 The back of the panel is inscribed in ink: *AlEs:Botti:*; there is an indecipherable gray wax seal in the bottom right corner of the back.
2 According to a note in curatorial files, a Dr. Richter, presumably Jean Paul, stated during a visit to the Epstein home in June 1935 that the picture had formerly been in the collection of a Dr. Paoletti in Florence.
3 Lightbown 1978.
4 Ibid.
5 See annotated copy of sale catalogue in the Resource Collection of the Getty Center for the History of Art and the Humanities, Santa Monica.
6 Levey and Mandel (1967) maintained that Epstein bought the work in 1925, while other sources, such as Lightbown (1978), gave a date of 1928 for Epstein's purchase of the picture. According to Singleton (1929, p. 64), the picture did not arrive in the United States until May 1928, which seems to be confirmed by registrar's records dated May 15, 1928. From 1926 to 1928, the picture was apparently exhibited at the "Utrecht Museum of Historical Art," according to a note in curatorial files.
7 For general comments on Botticelli, see *Virgin and Child with Two Angels* catalogued above (1954.282).
8 In addition, in a letter to Martin A. Ryerson of February 14, 1929, Wilhelm R. Valentiner asserted that this was "surely a school picture" (Archives, The Art Institute of Chicago). Kenneth Clark considered it "possibly a good workshop picture in fine condition with some work on it by Botticelli" (visit of November 19, 1936; Archives, The Art Institute of Chicago).
9 Lightbown 1978, vol. 2, nos. B29, B40, B39, B43, B41, and B46, respectively, all of which are accompanied by illustrations.
10 M. Levi d'Ancona, *The Garden of the Renaissance: Botanical Symbolism in Italian Painting,* Florence, 1977, pp. 193–94, no. 81. The identification of the flowers in the vase as jasmine was confirmed by J. K. Burras, Superintendent of the Botanic Garden in Oxford, in a letter to the author of January 6, 1984, in curatorial files. Burras added that "the flowers with the divided petals (if that is what they are), bottom right, could be cornflowers *Centaurea cyanus.*"

Attributed to Francesco Botticini

Active Florence by 1459, d. Florence 1497

Virgin and Child with Two Angels, 1465/75
Mr. and Mrs. Martin A. Ryerson Collection, 1937.1009

Tempera on panel, 78.2 x 55.5 cm (30¾ x 21⅞ in.)

CONDITION: The painting is in fair condition. The panel, which has a vertical grain and no clearly discernible join, has been thinned and cradled. It has been trimmed on the sides, as is indicated by exposed worm tunneling. There is exposed worm tunneling on the back as well.

The paint surface has been extensively repainted, probably on more than one occasion in the past. In 1962, Alfred Jakstas cleaned and inpainted the picture, but left substantial areas of old repaint, notably in the shadows of the Virgin's drapery and in her hands. The mid-treatment photograph (fig. 1) gives some indication of the extent of damage and of old repaint. The Virgin's neck, the face of the angel on the right, and the still life on the left are relatively intact and should be used as a touchstone of the picture's tonal quality (mid-treatment, x-radiograph).

PROVENANCE: Alexander Barker (d. 1874), London; sold Christie's, London, June 6, 8–11, 1874, no. 66, as Antonio Pollaiuolo, "The Madonna, seated with the infant Saviour upon her lap in the act of blessing, two saints in the background," to G. P. Boyce for £84.[1] G. P. Boyce, London, 1874–97; sold Christie's, London, July 1, 1897, no. 344, as Antonio Pollaiuolo, to Agnew for £446 5s.[2] Sold by Charles Sedelmeyer, Paris, to Consul Eduard F. Weber, Hamburg, 1897; sold Lepke, Berlin, February 20–22, 1912, no. 23, pl. 8, as Florentine School, c. 1475, for 40,000 marks.[3] Sold by Arthur Tooth and Sons, London, to Kleinberger, New York, 1916.[4] Sold by Kleinberger to Martin A. Ryerson (d. 1932), Chicago, 1917;[5] at his death to his widow, Mrs. Martin A. Ryerson (d. 1937); bequeathed to the Art Institute, 1937.

REFERENCES: "The Royal Academy Winter Exhibition: Old Masters and Deceased British Painters (First Notice)," *Athenaeum* 1 (1877), p. 23. "The Royal Academy Winter Exhibition: Old Masters and Deceased British Painters (Fourth and Concluding Notice)," *Athenaeum* 1 (1877), p. 123. *Gemälde alter Meister der Sammlung Weber, Hamburg*, Lübeck [1897], ill., n. pag. Charles Sedelmeyer Gallery, *Illustrated Catalogue of the Fourth Series of 100 Paintings by Old Masters..., being a portion of the Sedelmeyer Gallery*, Paris, 1897, p. 67, no. 57, fig. 57. K. Woermann, *Wissenschaftl. Verzeichnis der älteren Gemälde der Galerie Weber in Hamburg*, Dresden, 1907, pp. 22–23,

no. 23. E. Schaeffer, "La vendita della collezione Weber a Berlin," *Rassegna d'arte* 12 (1912), p. 74. P. Schubring, "La collezione Weber di Amburgo," *L'arte* 15 (1912), p. 141. "Der Versteigerung der Sammlung Weber," *Der Kunstmarkt* 9 (1912), p. 196. O. Sirén, *The Madonna and Child by Piero Pollaiuolo...from the Collection of the late Consul E. F. Weber in Hamburg*, New York, 1916, n. pag. Berenson 1932, p. 101; 1936, p. 87; 1963, vol. 1, p. 33. Valentiner [1932], n. pag. A. M. Frankfurter, "Art in the Century of Progress," *Fine Arts* 20 (June 1933), pp. 11 (ill.), 60. AIC 1961, p. 225. E. Fahy, "Some Early Italian Pictures in the Gambier-Parry Collection," *Burl. Mag.* 109 (1967), p. 137. M. Levey and G. Mandel, *The Complete Paintings of Botticelli*, Eng. ed., New York, 1967, p. 88, no. 33, fig. 33. Fredericksen/Zeri 1972, pp. 33, 331, 571.

EXHIBITIONS: London, Royal Academy of Arts, *The Winter Exhibition of Works by the Old Masters...*, 1877, no. 142, as Antonio Pollaiuolo. Berlin, Verein Berliner Künstler, *Ausstellung aus Berliner Privatbesitz*, 1901 (no cat.?). New York, F. Kleinberger Galleries, *Italian Primitives*, 1917, no. 27, as Piero Pollaiuolo. The University of Chicago, The Renaissance Society, *Commemorative Exhibition from the Martin A. Ryerson Collection*, 1932, no. 5, as Piero Pollaiuolo — school of Botticelli (?). The Art Institute of Chicago, *A Century of Progress*, 1933, no. 111, as School of Botticelli. Chicago, Tribune Building, 1952–53 (no cat.). Highland Park, Illinois, Immaculate Conception School, 1955 (no cat.).

During the nineteenth century, the panel was attributed to Antonio Pollaiuolo, and it was not until the painting was in the Weber collection that this attribution was reconsidered by Woermann (1907), who favored an anonymous Florentine painter and a date of about 1475. Sirén (1916) later revived the attribution to one of the Pollaiuolo brothers, only this time positing Piero as the artist. Schaeffer (1912) first proposed the name of Francesco Botticini, a student

of Neri di Bicci, whose art depended heavily on the works of his contemporaries, including the Pollaiuoli, Castagno, Verrocchio, and especially Botticelli. Berenson (1932, 1936, 1963) persisted in the belief that the panel was a copy after an early work by Sandro Botticelli, a line of thought continued by Valentiner (1932), Levey and Mandel (1967), and Fredericksen and Zeri (1972), who assigned the painting to a follower of Botticelli. Fahy (1967) preferred the name of Botticini, which, on comparison with the altarpiece of 1471 in the Musée Jacquemart-André in Paris, seems fully justified (fig. 2). The facial types of Saints Pancras and Sebastian on the altarpiece are closely related to those of the two angels on the panel in Chicago; the drawing of the Christ Child and of the hands and neck of the Virgin, as well as the somewhat sculptural system of highlighting and the voluminous folds of drapery, is also similar in these two works. As far as can be judged from the condition of the present panel, both the composition and the handling suggest a date shortly before the altarpiece in Paris. The Paris painting has been tentatively attributed by Boskovits to Francesco Botticini's father,

Giovanni di Domenico Botticini.[6] If this suggestion is correct, it would imply that the Chicago panel is by a painter of an earlier generation keeping pace with new developments, rather than by the youthful Francesco.

The composition of the Virgin and Child placed within an architectural framework is one that was first employed by Donatello for the Pazzi Madonna (Berlin, Staatliche Museen Preussischer Kulturbesitz, Gemäldegalerie) at the beginning of the 1420s and was then developed in painting by Filippo Lippi during the 1430s and 1440s.[7] The relationship of the angels to the architectural elements in the *Virgin and Child Enthroned with Two Angels* by Lippi in The Metropolitan Museum of Art in New York foreshadows that of the panel in Chicago.[8] The composition was further evolved during the second half of the fifteenth century in the workshop of Verrocchio, which included such artists as Perugino, Botticelli, Ghirlandaio, and Leonardo da Vinci.[9]

Whatever conclusions are reached about the altarpiece in the Musée Jacquemart-André, the present panel reveals the amalgam of styles to which any Florentine painter reaching maturity in the 1460s

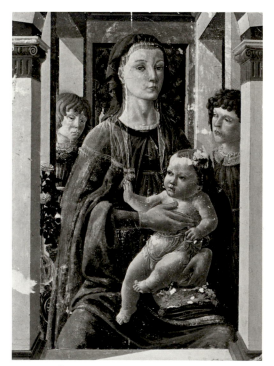

Fig. 1 Mid-treatment photograph of *Virgin and Child with Two Angels*, 1937.1009

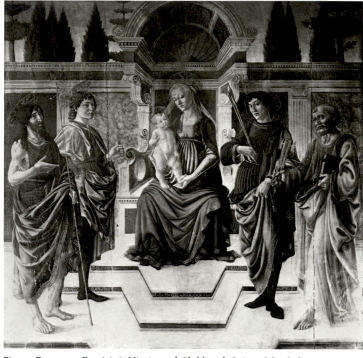

Fig. 2 Francesco Botticini, *Virgin and Child with Saints*, Musée Jacquemart-André, Paris [photo: Bulloz, Paris]

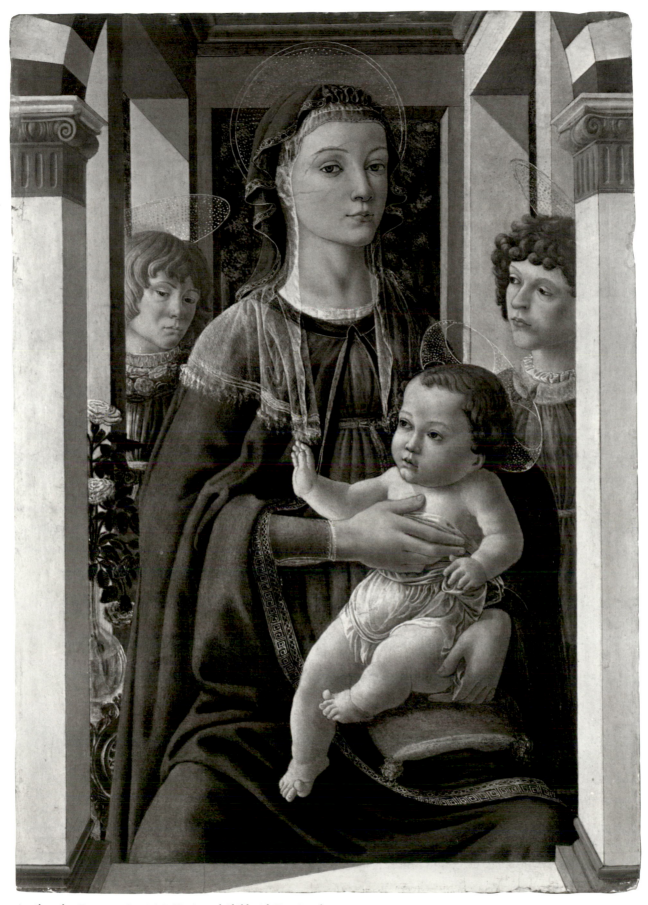

Attributed to Francesco Botticini, *Virgin and Child with Two Angels*, 1937.1009

would have been subject. Both the composition and the palette (red, blue, lavender, gray) display knowledge of Filippo Lippi, while the facial type of the angels and the treatment of the hair are reminiscent of Andrea del Castagno.[10] These painters may have served as formative influences, but there are also significant similarities with works by contemporaries of Francesco Botticini. The stiff, almost ungainly pose of the elongated figure of the Virgin, who appears to be leaning slightly backward, recalls the six *Virtues* (Florence, Uffizi) painted by Antonio and Piero Pollaiuolo in 1469/70 for the Arte della Mercanzia in Florence.[11] The pose of the Child blessing also occurs in the *Chigi Madonna* by Botticelli of c. 1469 (Boston, Isabella Stewart Gardner Museum) and was later adapted by Leonardo da Vinci for the *Benois Madonna* of c. 1480 (St. Petersburg, Hermitage).[12]

Furthermore, the panel in Chicago is close to works executed in Verrocchio's workshop, where this particular composition was being brought up to date by a new generation of artists. This is most evident in the way the architectural framework is used to establish the position of the figures, but at the same time is counteracted by the gesture of the Child breaking through the barrier imposed by the archway. Numerous solutions were sought, usually varying the angle of the Virgin's body with respect to the picture plane and the pose of the Child either on the Virgin's lap or supported on the parapet; among these works may be included the *Virgin and Child with Angel* by Botticelli catalogued above (1954.283). Botticini's solution is not as advanced as most of those produced in Verrocchio's workshop, but the painter does show his concern with a problem that an artist of the previous generation, such as his father, might have chosen to ignore. Even if the condition of the present panel disappoints, the composition affords further consideration.

The red and white roses in the glass decanter on the left are symbols of martyrdom and of purity, respectively. The Virgin's head is silhouetted against a forested background, somewhat resembling that in the small tondo by Botticelli in the present collection (1954.282). This background may be a reference to the *hortus conclusus*.[13]

The author of the exhibition review in *Athenaeum* of 1877 described the panel as "much injured," adding that "more than enough remains to supply a most valuable and charming example." This is not a wholly inaccurate assessment and it is clear that the panel was once a work of some quality, thereby justifying its reputation in the second half of the nineteenth century.

NOTES

1 Price and buyer given in G. Redford, *Art Sales: A History of Sales of Pictures and Other Works of Art*, vol. 2, London, 1888, p. 245. It should be noted that two paintings of the Virgin and Child ascribed to Antonio Pollaiuolo were sold in the Alexander Barker sale of 1874. The present painting can be firmly identified as no. 66, even though the angels are inaccurately described as saints. A label attached to the painting's cradle states: printed *Antonio Pollaiuolo / 66 THE MADONNA, seated, with the Infant Saviour upon her lap in / the act of blessing, two saints in the background. /* handwritten *Sale of Christie & Manson's June 6–7 & 3 following days 1874 of the collection / of the late Alexander Barker, Esq. of 103 Piccadilly, London.* The composition of no. 65, which is also described in detail in the sale catalogue, is totally different. Nonetheless, there was some confusion in the earlier literature as to the identity of each painting.

 Other labels on the back of the panel, all on cradle members, are: (1) *11026 / Pollaiuolo*; (2) handwritten *Aº· Pollaiuolo / 1429–1498 / Madonna mit Kind u. 2 Engeln / 79 x 56 103 x 81 / 1897 967* with stamp *Hamburg Gallerie Weber*; (3) handwritten *From catalogue of R. A. Winter Exhib. of Old Masters /* printed *142 VIRGIN AND CHILD / G. P. Boyce, Esq.* handwritten *Gallery No. 3* printed *Antonio Pollaiuolo / The Virgin, seated in an archway, holding the Infant Jesus on her lap; a / saint on either side; foliage background. Panel 30½ x 21½ in. /* handwritten *at Burlington House in 8th year, Jany 1877.*; and (4) red wax impression of seal of Sedelmeyer collection, Paris.

2 Price and buyer given in A. Graves, *Art Sales from Early in the Eighteenth Century to Early in the Twentieth Century*, London, 1921, vol. 2, p. 336.

3 In the sale catalogue of the 1912 Lepke sale of the Weber collection, the picture is described as having been purchased in 1897 from Sedelmeyer; see also Sedelmeyer 1897, p. 67, no. 57, fig. 57. Price given in an annotated copy of the Lepke sale catalogue in the Resource Collection of the Getty Center for the History of Art and the Humanities, Santa Monica.

4 According to the Kleinberger records, Department of European Paintings, The Metropolitan Museum of Art, New York.

5 According to the bill of sale (Archives, The Art Institute of Chicago).

6 M. Boskovits, "Una scheda e qualche suggerimento per un catalogo dei dipinti ai Tatti," *Antichità viva* 14, 2 (1975), pp. 17–19.

7 For the Pazzi Madonna, see H. W. Janson, *The Sculpture of Donatello*, Princeton, 1963, pl. 19b.

8 Zeri/Gardner 1971, p. 84 (ill.).

9 K. Oberhuber, "Le Problème des premières oeuvres de

Verrocchio," *Revue de l'art* 42 (1978), pp. 63–76.

10 Compare the handling of the children in the frescoed *Madonna di Casa Pizzi* painted shortly after 1445 (M. Horster, *Andrea del Castagno*, Oxford, 1980, pls. 24–27).

11 L. Ettlinger, *Antonio and Piero Pollaiuolo*, Oxford, 1978, pls. 31–32, 34–36.

12 R. Lightbown, *Sandro Botticelli*, London, 1978, vol. 2,

pp. 23–24, no. B9, vol. 1, pl. II; and H. Bodmer, *Leonardo*, Klassiker der Kunst 37, Stuttgart, 1931, p. 8 (ill.), respectively.

13 For the symbolism of the rose in general, see M. Levi d'Ancona, *The Garden of the Renaissance: Botanical Symbolism in Italian Painting*, Florence, 1977, pp. 330–55, no. 14.

Attributed to Raffaello Botticini

b. 1477 Florence, last documented 1520

The Adoration of the Magi, c. 1495

Mr. and Mrs. Martin A. Ryerson Collection, 1937.997

Tempera on panel (poplar), diameter 104.2 cm (41 in.)

INSCRIBED: $\bar{c}\,\bar{P}\,\bar{o}$ (on column, center left)

CONDITION: The painting is in fair condition. The poplar panel, which is composed of four horizontal boards aligned at a slight angle to the design, has been thinned and cradled. The x-radiograph shows extensive worm tunneling, particularly in the lower half. The painting was treated by H. A. Hammond Smith in 1920/21, by Leo Marzolo in 1940, and by Alfred Jakstas in 1970, when discolored varnish and repaint were removed. There are small scattered losses in the sky, as well as abrasion throughout this area, particularly at the left near the boat. The effect of damage in the sky is accentuated by discolored inpainting. The figures and the architecture have suffered from scattered abrasion, which particularly affects the figures at the extreme right and the dwarf and dog in the foreground. The gold insets on the columns have been inpainted with ochre paint, which disturbs the design, especially on the left column supporting the pitched roof. The outlines of the architecture are incised. Changes by the artist in relation to the incised contours include the two oculi within the ruined dome, which were incised below the painted design, and the left arch of the dome, which stops short of the incised contour (infrared, ultraviolet, x-radiograph).

PROVENANCE: Probably Emile Gavet, Paris.[1] Sold by Gavet to Martin A. Ryerson (d. 1932), Chicago, 1894;[2] at his death to his widow, Mrs. Martin A. Ryerson (d. 1937); bequeathed to the Art Institute, 1937.

REFERENCES: E. Kühnel, *Francesco Botticini*, Strasbourg, 1906, pp. 16–17, 37, pl. XI (3). Berenson 1909b, p. 119; 1932, p. 107; 1936, p. 96; 1963, vol. 1, p. 39. J. A. Crowe and G. B. Cavalcaselle, *A History of Painting in Italy*, 2d ed., vol. 4, ed. by R. Langton Douglas, New York, 1911, p. 297 n. 1. Van Marle, vol. 13, 1931, p. 398 (ill.). Valentiner [1932], n. pag. "Exhibition of the Ryerson Gift," *AIC Bulletin* 32 (1938), p. 3; reprinted as J. L. Allen, "Entire Ryerson Collection Goes to The Chicago Art Institute," *Art News* 36, 21 (1938), p. 10 (ill.). *AIC Bulletin* 32 (1938), cover ill. K. L. Brewster, "The Ryerson Gift to The Art Institute of Chicago," *Magazine of Art* 31 (1938), p. 97 (ill.). AIC 1946, pp. 12–13 (ill.); 1948, p. 26. Davies 1951, p. 78, under no. 1033; 1961, p. 102, under no. 1033. AIC 1952, n. pag. (ill. only); 1961, p. 226. B. Berenson, *I disegni dei pittori fiorentini*, Milan, 1961, vol. 1, p. 111. Huth 1961, p. 516. A. Chastel, *The Studios and Styles of Renaissance Italy, 1460–1500*, London, 1966, p. 18 (ill.). *Art Institute of Chicago*, Grands Musées 2, Paris [1968], pp. 25 (ill.), 68. Fredericksen/Zeri 1972, pp. 35, 272, 571. R. Lightbown, *Sandro Botticelli*, London, 1978, vol. 2, pp. 25–26, no. B11. J. Devisse and M. Mollat, *The Image of the Black in Western Art*, Lausanne, 1979, vol. 2, pp. 164–66 (ill.). Waterhouse 1983, pp. 86, 91 n. 10, fig. 6. H. P. Horne, *Alessandro Filipepi, Commonly Called Sandro Botticelli, Painter of Florence*, ed. by C. Caneva, Florence, 1987, vol. 3, p. 224.

EXHIBITIONS: The University of Chicago, The Renaissance Society, *Commemorative Exhibition from the Martin A. Ryerson Collection*, 1932, no. 4, as Francesco Botticini. The Art Institute of Chicago, *A Century of Progress*, 1933, no. 112, as Francesco Botticini. The Art Institute of Chicago, *A Century of Progress*, 1934, no. 46A, as Francesco Botticini. The Art Institute of Chicago, *The Christmas Story in Art*, 1938–39, as Francesco Botticini (no cat.). The Art Institute of Chicago, *Masterpiece of the Month*, November

1940, as Francesco Botticini (no cat.). Burlington, Vermont, Robert Hull Fleming Museum, 1947 (no cat.). Chicago Federal Savings and Loan Association, *Christmas Exhibition,* 1954–55 (no cat.).

Since its initial publication by Kühnel in 1906, the tondo has been universally attributed in print to Francesco Botticini,[3] except by Waterhouse (1983), who thought that the artist might possibly be Francesco Botticini's son Raffaello.[4] The kinship with Francesco Botticini is apparent in the facial types and the handling of the drapery, but close examination reveals that the artist was less skillful than Francesco. Weaknesses are evident in the unsteady postures, the abundant, almost overwhelming, swaths of drapery, the fixed expressions on many of the faces, and the arbitrary way in which the heads are joined to the bodies. The suggestion, first made in print by Waterhouse and supported by Everett Fahy in subsequent correspondence,[5] that the tondo is by Raffaello Botticini is borne out by comparison with the scenes in the predella of the *Tabernacle of the Holy Sacrament,* originally painted for the Compagnia di Sant'Andrea in Empoli and now in the Museo della Collegiata.[6] The tabernacle was commissioned from Francesco Botticini in 1484 and assessed in 1491, at which date it was still not completely finished even though it was set up on the altar. It seems that the predella, showing *The Crucifixion of Saint Andrew, The Passion of Christ,* and *The Death of Saint John the Baptist,* was added in 1504 by the artist's son. In addition to the stylistic features already cited concerning the figures, the treatment of the landscape in *The Crucifixion of Saint Andrew* matches that depicted on the tondo of *The Adoration of the Magi.*

Two other works have been discussed in connection with the Ryerson tondo. Everett Fahy observed that a painting of *The Adoration of the Magi* in the Kress Collection (Memphis, Brooks Memorial Art Gallery) might be by the same hand,[7] and Waterhouse claimed that a panel of *The Adoration of the Child* at the Williams College Museum of Art in Williamstown, Massachusetts (no. 55.20, 65.2 x 44.5 cm), should also be ascribed to this artist.[8]

The panel in Chicago may be dated to c. 1495 insofar as the figure types reflect the influences of

Domenico Ghirlandaio and Sandro Botticelli prevalent in Francesco Botticini's later work, which formed the basis of Raffaello's as yet undefined style.

The tondo has also attracted considerable attention owing to its format and subject. The panel's stylistic and iconographic points of reference seem, in fact, to outweigh its intrinsic artistic merits. The circular composition partakes of a tradition established in Florence by Domenico Veneziano and Filippo Lippi,[9] which was continued during the second half of the fifteenth century by Botticelli and Ghirlandaio in paintings devoted to the Adoration of the Magi. Kühnel (1906) first pointed out the connection between the tondo in Chicago and Botticelli's composition of the same subject in The National Gallery in London, an observation that all writers have reiterated, including most recently Davies (1951, 1961) and Lightbown (1978). The tondo by Botticelli was probably painted in Florence around 1471/75 for Antonio Pucci and may be regarded as an adaptation of Lorenzo Ghiberti's rectangular relief of *Solomon and Sheba* on the east door of the Baptistery in Florence.[10] The chief similarity between the Botticelli tondo and the one in Chicago lies in the general distribution of the figures in relation to the architecture, the focal point being the Virgin and Child, to whom the three kings have come to pay homage. There do not, however, appear to be any exact quotations from Botticelli's painting. Because of the multitude of figures that take part in scenes of the Adoration of the Magi, the subject lent itself to the circular form. Recently, scholars have emphasized how both the frequently performed *sacre rappresentazioni* of the Adoration of the Magi and the incorporation of the scene as part of the procession for one of the leading *compagnie* in Florence ensured that the subject remained a visual and even a political spectacle in fifteenth-century Florence.[11]

Several aspects of the iconography of the tondo in Chicago are worth discussing in greater detail. Prominent in the setting is a ruined building housing an altar dedicated to a pagan deity. Symbolically, this ruin, like the remnants of the piers and the capital and block of masonry strewn in the foreground, represents the Old Law, which Christ, as the representative of the New Law, will replace, just as the roof of the simple shed in which Christ was born is shown as an

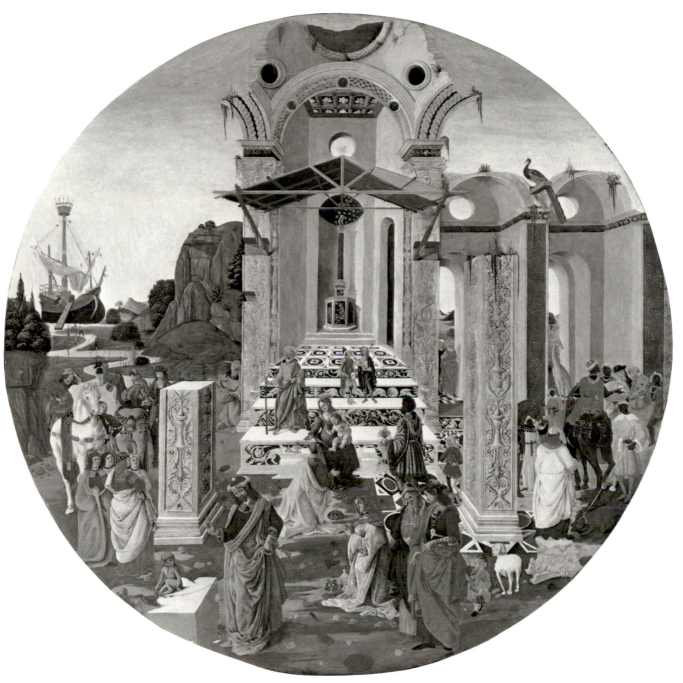

Attributed to Raffaello Botticini, *The Adoration of the Magi,* 1937.997

extension to the ruins. In the fifteenth century this ruined structure was associated with the Templum Pacis in Rome, which, according to Jacobus de Voragine, contained a statue of Romulus and collapsed on the night of Christ's birth.[12] Archaeologically, the Templum Pacis was equated with the Basilica of Maxentius (or Basilica Constantinus), as comparison between the structure depicted in the painting and a drawing in the treatise of Francesco di Giorgio reveals.[13] Also of archaeological interest are the decorative motifs, known as grotesques, used on the piers. This system of decoration became popular with artists during the last quarter of the fifteenth century following the excavation of Nero's Domus Aurea on the Palatine Hill in Rome.[14]

The animals have varying connotations, from the symbolic to the exotic. While the peacock, for example, represents eternal life, the ape and the giraffe are perhaps not intended to be symbols. The ape, like the horses and the dogs, was often included in scenes requiring exotic figures, such as the Adoration of the Magi or its prototype, the Meeting of Solomon and Sheba.[15] The giraffe was an animal of local significance to Florentines, one having been sent to Lorenzo de' Medici in 1487 as a gift from the Sultan of Egypt.[16]

Two other details of the composition are of interest: the dwarf, right of center, and the ship in the background on the left. Dwarfs were often employed at Renaissance courts and took part in processions.[17] Insofar as contemporary processions in Florence or elsewhere were associated with the Adoration of the Magi, as in the work of Benozzo Gozzoli and Botticelli,[18] their appearance in the present tondo can be expected. It is also conceivable that these images of dwarfs were actual portraits, as Tietze-Conrat suggested in discussing the earlier of Botticelli's two paintings of the Adoration of the Magi in The National Gallery in London.[19] The ship refers to the return of the three kings to the East by a route that avoided Jerusalem and thus ignored Herod.[20] Such a depiction is an amplification of the scriptural text found in Matthew (2.12): "And being warned of God in a dream that they should not return to Herod, they departed into their own country another way." The nautical context is directly implied by the account in *The Golden Legend*, which states that "Herod, as he

passed by Tarsus, learned that the three kings had embarked on a vessel in that port and in his anger he fired all the ships in the harbour."[21] A more vivid depiction of the departure of the kings by sea is found on a fifteenth-century panel of the Florentine School in the Sterling and Francine Clark Art Institute in Williamstown, Massachusetts.[22]

NOTES

1 According to registrar's records. The panel is not listed, however, in any of the following sources: E. Molinier, *Collection Emile Gavet: Catalogue raisonné*, Paris, 1889; E. Molinier, *Collection Emile Gavet: Catalogue raisonné*, Paris, 1894; Paris, Galerie Georges Petit, *Catalogue des objets d'art composant la collection de M. Emile Gavet*, sale cat., May 31–June 9, 1897.

2 According to registrar's records.

3 Berenson had already attributed the tondo to Botticini on viewing the Ryerson collection in late 1903 or early 1904. In a letter to Ryerson of January 18, 1904, Robert Herrick reported on Berenson's visit, stating that "the picture he [Berenson] spent most time over was the tondo, which he judged to be probably by Botticini. He thought it very 'charming,' in excellent condition, and untarnished" (Ryerson papers, Archives, The Art Institute of Chicago). A subsequent letter from Mary Logan Berenson to Ryerson of November 22, 1905, confirms this. "We were especially struck," she wrote, "with your tondo representing the 'Adoration of the Magi,' a very fine work, as it seemed to us, of the Florentine painter Francesco Botticini, whose works are frequently mixed up with the works of Botticelli, Fra Filippo Lippi, Verrocchio and other Florentines" (Ryerson papers, Archives, The Art Institute of Chicago).

4 Both the traditional attribution to Filippino Lippi and the alternative one to Signorelli, privately posited by Van Marle, are untenable. Both these attributions are cited in the catalogue of the 1933 *Century of Progress* exhibition. In a letter to Ryerson of January 13, 1930, Daniel Catton Rich reported that Van Marle, on viewing the tondo, attributed it "to the early period of Signorelli or to an artist greatly influenced by him" (Ryerson papers, Archives, The Art Institute of Chicago). It should be noted, however, that in 1931 Van Marle (see References above) published the tondo as a work by Francesco Botticini.

5 Letters of March 31, September 3, and October 19, 1987, to Martha Wolff, in curatorial files.

6 For an account of the painting of the *Tabernacle of the Holy Sacrament*, see U. Baldini, *Itinerario del Museo della Collegiata*, Florence, 1956, pp. 13–14. The relevant documents are published in full by G. Poggi, "Della tavola di Francesco di Giovanni Botticini per la Compagnia di S. Andrea d'Empoli," *Rivista d'arte* 3 (1905), pp. 258–64. The panels from the tabernacle are reproduced in Kühnel 1906, pls. I (1, 2), II (1–3).

7 Verbal communication to the author in 1981. Shapley 1966, p. 134, K316, fig. 361, as Jacopo del Sellaio.

8 Everett Fahy independently made the same attribution for the panel in Williamstown (letter of March 31, 1987, to Martha Wolff, in curatorial files).

9 H. Wohl, *Domenico Veneziano*, Oxford, 1980, pp. 120–23, no. 4 (ill.); Shapley 1966, pp. 95–96, K1425, figs. 259–61; and J. Ruda, "The National Gallery Tondo of the *Adoration of the Magi* and the Early Style of Filippo Lippi," *Studies in the History of Art* 7 (1975), pp. 7–39.

10 R. Krautheimer, *Lorenzo Ghiberti*, Princeton, 1956, pl. 116.

11 See R. Hatfield, "The Compagnia de' Magi," *The Journal of the Warburg and Courtauld Institutes* 33 (1970), pp. 107–61; and D. Davisson, "The Iconology of the S. Trinita Sacristy, 1418–1435: A Study of the Private and Public Functions of Religious Art in the Early Quattrocento," *Art Bull.* 57 (1975), pp. 313–34.

12 *The Golden Legend*, vol. 1, p. 48.

13 C. Maltese, *Francesco di Giorgio Martini: Trattati di architettura, ingegneria e arte militare*, Milan, 1967, vol. 1, pp. 278–79, f. 76, pl. 139. For a general discussion of these iconographic aspects and the theme of renewal in the context of the Adoration of the Magi, see R. Hatfield,

Botticelli's Uffizi "Adoration," Princeton, 1976, pp. 56–57.

14 N. Dacos, *La Découverte de la Domus Aurea et la formation des grotesques à la renaissance*, London and Leiden, 1969.

15 H. W. Janson, *Apes and Ape Lore in the Middle Ages and the Renaissance*, London, 1952, pp. 51, 67 n. 105.

16 J. Barclay Lloyd, *African Animals in Renaissance Literature and Art*, Oxford, 1971, pp. 49–52.

17 See E. Tietze-Conrat, *Dwarfs and Jesters in Art*, London, 1957, pp. 64–71.

18 Hatfield (note 13), pp. 72–83.

19 Tietze-Conrat (note 17), p. 108, no. 69; Davies 1961, pp. 97–98.

20 G. Schiller, *Iconography of Christian Art*, tr. by J. Seligman, Greenwich, 1971, vol. 1, p. 100.

21 *The Golden Legend*, vol. 1, p. 65.

22 *List of Paintings in the Sterling and Francine Clark Art Institute*, Williamstown, 1972, p. 40 (ill.), no. 940, as Florentine School, c. 1440. The panel is also reproduced by Berenson 1963, pl. 633, as Domenico di Michelino, with the title *John Palaeologus Setting Out for Venice*.

Bernardino Butinone

Documented Milan and Treviglio, 1484–1507

The Flight into Egypt, c. 1485

Mr. and Mrs. Martin A. Ryerson Collection, 1933.1003

Tempera on panel (poplar), 25.6 x 22 cm (10⅛ x 8¹¹⁄₁₆ in.); painted surface: 25.2 x 21.8 cm (9¹⁵⁄₁₆ x 8½ in.)

CONDITION: The painting is in good condition. It was cleaned by Alfred Jakstas in 1967. The poplar panel is composed of a single board with horizontal grain. It has been thinned, as is evident from exposed worm tunneling, and then cradled. Edging strips have been added on all four sides. Nevertheless, at the lower edge there is a barbe, and remnants of a narrow red border overlap the painted design. There have been some minor paint losses, together with scattered flaking, throughout the panel. These damages have been repaired and, in addition, there is some inpainting along the fairly pronounced crackle pattern. On the whole, the picture is better preserved than *The Descent from the Cross* and is considerably fresher in appearance. A contour underdrawing is visible with infrared reflectography in the figures and with the naked eye in Saint Joseph's purple robe (infrared, mid-treatment, ultraviolet, x-radiograph).

PROVENANCE: See below.

REFERENCES: See below.

EXHIBITIONS: See below.

The Descent from the Cross, c. 1485

Mr. and Mrs. Martin A. Ryerson Collection, 1933.1004

Tempera on panel (poplar), 26 x 20.4 cm (10³⁄₁₆ x 8¹⁄₁₆ in.); painted surface: 25.6 x 20 cm (10 x 7⅞ in.)

CONDITION: The painting is in fair condition. It was cleaned by Alfred Jakstas in 1968. The poplar panel is composed of a single board with vertical grain. It has been thinned, as is evident from the exposed worm tunneling, and then cradled. Edging strips have been attached to the left and right sides, but the barbe and unpainted edge of the panel are visible at the top and bottom. The paint surface is somewhat abraded, particularly in the sky, at the top of the

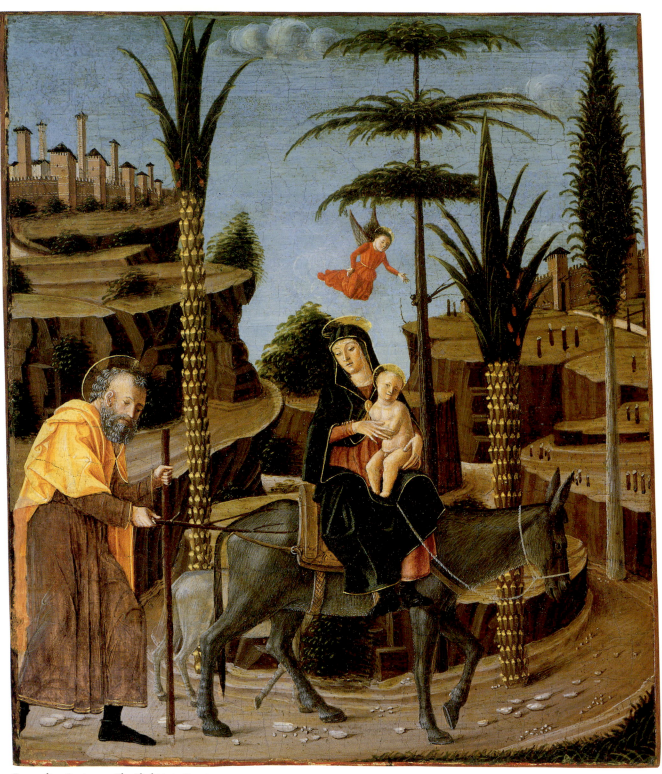

Bernardino Butinone, *The Flight into Egypt*, 1933.1003

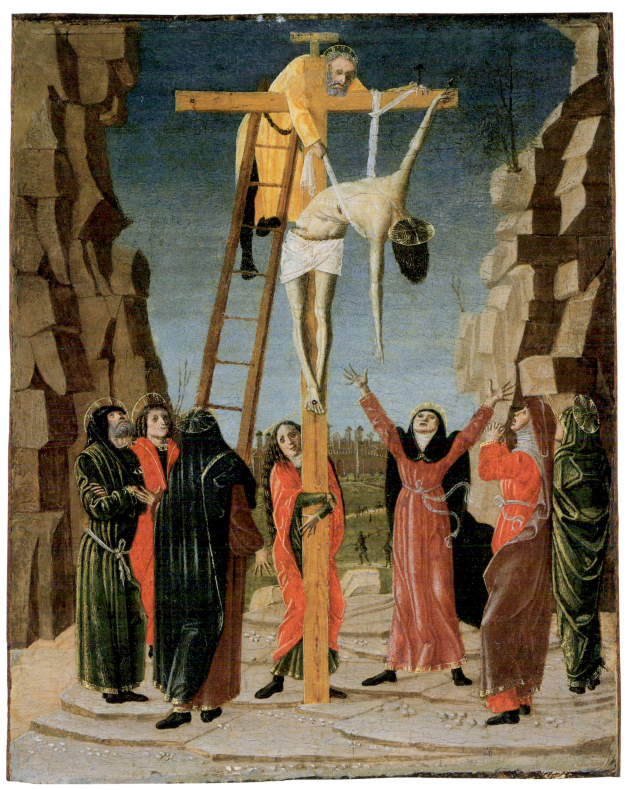

Bernardino Butinone, *The Descent from the Cross*, 1933.1004

cliff by the foliage on the right, and toward the bottom of the cliff on the left, as well as in the faces of the figures. Areas of local damage include the right shoulder and forehead of Nicodemus, who supports the body of Christ, as well as the lower portion of the cloak of the woman seen in profile with hands clasped. Infrared reflectography reveals that the figures are underdrawn with delicate contour lines (infrared, ultraviolet).

PROVENANCE: Count de Malherbe, Paris.[1] Kleinberger, Paris, 1921–23; Kleinberger, New York, 1923–27.[2] Sold by Kleinberger to Martin A. Ryerson (d. 1932), Chicago, 1927;[3] on loan to the Art Institute from 1927; bequeathed to the Art Institute, 1933.

REFERENCES: D. C. Rich, "Three Paintings of the Quattrocento," *AIC Bulletin* 21 (1927), pp. 86–88 (ill.). E. S. Siple, "Art in America: The Art Institute of Chicago — The Ryerson Collection," *Burl. Mag.* 51 (1927), pp. 240–41, pl. I. M. Salmi, "Bernardino Butinone — I," *Dedalo* 10 (1929), pp. 347 (1933.1003 ill.), 351. L. Venturi 1931, pls. CCCXXV–XXVI. AIC 1932, p. 179, nos. 803.27, 804.27. Berenson 1932, p. 121; 1936, p. 105; 1968, vol. 1, p. 69, vol. 3, pl. 1345 (1933.1004). "Ryerson Makes Princely Bequest to the Art Institute of Chicago," *Art Digest* 6, 20 (1932), p. 3 (1933.1004 ill.). Valentiner [1932], n. pag. R. Longhi, "Le arti," in J. De Blasi, ed., *Romanità e Germanesimo*, Florence, 1941, ill. opp. p. 305; reprinted in *Opere complete di Roberto Longhi*, vol. 9, Florence, 1979, pl. 39b. AIC 1948, p. 25. Davies 1951, p. 102, under no. 3336; 1961, p. 132, under no. 3336. C. Baroni and S. Samek Ludovici, *La pittura lombarda del quattrocento*, Messina and Florence, 1952, pp. 235, 238–39. F. Zeri, "Two Contributions to Lombard Quattrocento Painting," *Burl. Mag.* 97 (1955), p. 77 n. 4. AIC 1961, pp. 63–64. Huth 1961, p. 517. Fredericksen/Zeri 1972, pp. 38, 275, 295, 571. Maxon 1977, p. 30 (1933.1003 ill.). H. Brigstocke, *Italian and Spanish Paintings in the National Gallery of Scotland*, Edinburgh, 1978, pp. 25–26. M. Natale in M. Gregori, ed., *Pittura tra Adda e Serio: Lodi, Treviglio, Caravaggio, Crema*, Milan, 1987, p. 165. A[ngelo] O[ttolini], "Butinone, Bernardino" in F. Zeri, ed., *La pittura in Italia: Il quattrocento*, Milan, 1987, p. 594.

EXHIBITIONS: New York, Lotos Club, 1927 (no cat.). The Art Institute of Chicago, *A Century of Progress*, 1933, nos. 82–83. The Art Institute of Chicago, *A Century of Progress*, 1934, nos. 25–26.

These two panels form part of an extensive series illustrating scenes from the life of Christ. The related panels, all of comparable dimensions, may be listed as follows: 1. *The Nativity* (London, The National Gallery);[4] 2. *The Adoration of the Magi* (New York, The Brooklyn Museum);[5] 3. *The Circumcision* (Bergamo,

Accademia Carrara);[6] 4. *The Massacre of the Innocents* (The Detroit Institute of Arts);[7] 5. *Christ Disputing with the Doctors* (Edinburgh, National Gallery of Scotland);[8] 6. *The Baptism of Christ* (formerly Keir, Stirling-Maxwell collection);[9] 7. *The Marriage at Cana* (Isola Bella, Borromeo collection);[10] 8. *Christ in the House of Martha and Mary* (New York, Suida collection);[11] 9. *Christ before Caiaphas* (Vaduz, Liechtenstein collection);[12] 10. *The Lamentation* (Milan, Aldo Crespi collection);[13] 11. *The Resurrection* (Milan, Aldo Crespi collection);[14] 12. *The Incredulity of Saint Thomas* (Pavia, Galleria Malaspina);[15] 13. *The Last Judgment* (New York, private collection).[16] *The Last Judgment* is slightly longer than the other panels, but this may be owing to the exigencies of the complex to which all these compositions once belonged.

Bernard Berenson attributed the Art Institute's panels to Butinone,[17] who is first documented in Milan in 1484 and frequently collaborated with his compatriot, Bernardino Zenale of Treviglio. Rich (1927) and Siple (1927) suggested that the two panels in Chicago probably formed part of a complex similar to the triptych by Butinone in the Castello Sforzesco in Milan, comprised of thirteen scenes from the life of Christ.[18] Indeed, the compositions of the two Chicago panels correspond closely to those of the same scenes in the Castello Sforzesco triptych. Scholars have generally concurred with this suggestion, even though the triptych in the Castello Sforzesco is on a fairly small scale.[19] Mario Salmi (1929) first indicated the range of surviving related panels and reproduced many of them. It has, however, been doubted whether the fifteen known panels did once form part of the same complex. Baroni and Samek Ludovici (1952) diagnosed at least three different stylistic categories within the group, while in the catalogue of the 1958 exhibition of Lombard art it has been suggested that, apart from the possibility of workshop intervention, which might account for differences in quality, the panels may have belonged to different related series.[20]

There are, indeed, minor variations in style among the fifteen panels. In the case of the two panels in Chicago, *The Flight into Egypt*, though better preserved than *The Descent from the Cross*, is less fluent in the gestures and spatial arrangement of its figures. These minor variations in style can be attributed to

workshop collaboration and, in the present state of knowledge, there is no overriding reason for asserting that some of the panels came from separate complexes, particularly since they form a narrative sequence. A close comparison of the physical characteristics of the panels might provide additional information on their arrangement. Thus, *The Flight into Egypt* is painted on a panel with horizontal grain, while *The Descent from the Cross* has a vertical grain. Presumably, too, other panels from the series have yet to be rediscovered and it is possible that such compositions are recorded in drawings: *The Flagellation* in a drawing in the Louvre,[21] and *The Ascension of Christ* in a drawing at Christ Church, Oxford.[22] It is conceivable that the *Crucifixion* in the Galleria Nazionale in Rome could have been the center of the altarpiece to which the panels belonged.[23] Finally, it is possible that the panels decorated a sacristy cupboard or the cover of a tabernacle.

The principal features of Butinone's style found in this series include: the broad characterization of the figures, the short, crisp highlights representing individual strands of hair, the long thin fingers, and the flattening of the draperies between the folds that is so typical of contemporary Lombard sculptors such as Cristoforo and Antonio Mantegazza. Stylistically, all these panels of scenes from the life of Christ are compatible with the triptych in the Castello Sforzesco and, most importantly, with the scenes in the predella of the altarpiece in San Martino at Treviglio, a documented work dating from 1485 painted jointly by Butinone and Bernardino Zenale.[24] A similar date may be tentatively proposed for these fifteen panels. Salmi (1929) favored a date around 1480.

The Flight into Egypt and *The Descent from the Cross* are both scenes included on the triptych in the Castello Sforzesco, although with some minor differences. Some of the motifs, as well as the setting of *The Descent from the Cross* in Chicago, are reminiscent of Mantegna, as Siple (1927) observed. Thus, the female figure seen in profile with hands clasped on the right is comparable with the figure of Saint John the Evangelist in Mantegna's print of *The Entombment*,[25] while the dramatic pose of the slumped body of Christ recalls a print of the same subject after Mantegna.[26] These motifs, however, are translated into Butinone's own quixotic style derived

mainly from the Paduan and Ferrarese schools. There are few passages of such dramatic import as the figure of Christ with hair hanging loose and hand extending downward so that the fingertips almost reach the outstretched arm of the Virgin. This impassioned gesture prompted Longhi (1941) to compare *The Descent from the Cross* to German sculpture and in particular to the work of Hans Leinberger (*Deposition*, Berlin, Staatliche Museen Preussischer Kulturbesitz, Gemäldegalerie).[27] Such passages are typical of Butinone at his best.[28]

NOTES

1 Kleinberger records, Department of European Paintings, The Metropolitan Museum of Art, New York. These two pictures were not included in the Malherbe sale held at Valenciennes, October 17–18, 1883.

2 See letter from Berenson to Kleinberger of October 10, 1921, in the Ryerson papers, Archives, The Art Institute of Chicago, as well as information in the Kleinberger records (see note 1).

3 According to the Kleinberger records (see note 1).

4 Davies 1961, pp. 132–33; and Salmi 1929, p. 345 (ill.).

5 Salmi 1929, p. 344 (ill.).

6 Ibid., p. 346 (ill.).

7 *Bulletin of the Detroit Institute of Arts* 44, 2 (1965), p. 39 (ill.).

8 Brigstocke 1978, pp. 25–26; illustrated in *National Gallery of Scotland: Illustrations*, Edinburgh, 1965, p. 12, fig. b.

9 Sold Sotheby's, London, July 3, 1963, no. 36; last recorded in *From Butinone to Chagall*, exh. cat., London, Hallsborough Gallery, 1965, no. 10 (color ill.). See also *Arte lombarda dai Visconti agli Sforza*, exh. cat., Milan, Palazzo Reale, 1958, no. 465, pl. CLXXXVIII.

10 Salmi 1929, p. 349 (ill.).

11 Ibid., p. 348 (ill.).

12 W. Suida, *Österreichische Kunstschätze*, vol. 1, 1911, pl. LX.

13 Salmi 1929, p. 342 (ill.).

14 Ibid.

15 Ibid., p. 350 (ill.).

16 Zeri 1955, p. 79, fig. 20; nos. 3, 6, 7, and 13 are illustrated in color in A. Ottino della Chiesa, *Pittura lombarda del quattrocento*, Bergamo, 1959, pp. 90–93.

17 Letter from Berenson to Kleinberger of October 10, 1921 (note 2).

18 Zeri 1955, fig. 15.

19 Zeri (1955) has also proposed very tentatively an alternative prototype, namely, the retardataire altarpiece published by Longhi as a work by Antonio Vivarini. See Zeri 1955, p. 77 n. 7; illustrated in R. Longhi, *Viatico per cinque secoli di pittura veneziana*, Florence, 1946, pl. 45; illustrated only in part in idem, *Opere complete di Roberto Longhi*, vol. 10, Florence, 1978, pl. 38b.

20 *Arte lombarda dai Visconti agli Sforza* 1958 (note 9), p. 149, nos. 463–71. On the occasion of this exhibition, nine of the panels were reunited.

21 W. Boeck, "Bernardo Butinone," *Old Master Drawings* 9 (1935), p. 58, pl. 61.
22 J. Byam Shaw, *Drawings by Old Masters at Christ Church, Oxford*, Oxford, 1976, vol. 1, p. 188, no. 699, vol. 2, pl. 396.
23 *Arte lombarda dai Visconti agli Sforza* 1958 (note 9), p. 147, no. 463, pl. CLXXXVI, measuring 179 x 78 cm.
24 G. Carlevaro, "Materiale per lo studio di Bernardo Zenale," *Arte lombarda*, n.s., 63 (1982–83), pp. 26–30, 41, figs. 1–6.
25 A. M. Hind, *Early Italian Engraving*, London, 1948, pt. 2, vol. 5, pp. 10–12, no. 2, vol. 6, pl. 487.
26 Ibid., vol. 5, pp. 19–20, no. 10.1, vol. 6, pl. 502.

27 Longhi 1941, ill. opp. p. 304, reprinted in Longhi 1979, pls. 39a–b. The comparison is implied by the juxtaposition of illustrations, although it is not specifically discussed in Longhi's text.
28 See, for example, Butinone's *Christ Disputing with the Doctors* in the National Gallery of Scotland, Edinburgh, for a unique treatment of another subject. For the significance of the ladder in scenes of the Crucifixion, or related themes, and its connection with contemporary methods of public execution, see S. Y. Edgerton, Jr., *Pictures and Punishment: Art and Criminal Prosecution during the Florentine Renaissance*, Ithaca and London, 1985, esp. pp. 185–91.

Luca Cambiaso

1527 Genoa–Madrid 1585

Venus and Cupid, c. 1570

A. A. Munger Collection, 1942.290

Oil on canvas, 107.5 x 95.7 cm (42⅜ x 37⅝ in.)

CONDITION: The painting is in good condition. It was surface cleaned and revarnished by Alfred Jakstas in 1962. In 1970 a vandal, possibly using a roulette, caused a line of tiny losses extending vertically from Cupid's head through his ear and left knee to a point below Venus's arm; these losses were inpainted that same year. The painting has an aqueous lining and the tacking margins have been trimmed. Small tears in the upper left and lower right have been repaired. The paint layers are slightly abraded throughout and the brown threads of the canvas are visible as dark pinholes, giving the picture an overall grayish tonality. Nevertheless, the paint layers are generally well preserved. There are *pentimenti* at Cupid's head, his right thigh, and along Venus's forearm, including the hand.

PROVENANCE: William Patoun (d. 1782), Richmond (London).[1] Sold by Patoun to Sir Abraham Hume, Bt. (d. 1838), Wormley Bury, Hertfordshire, by 1782.[2] By descent to his grandson Viscount Alford (d. 1851), Ashridge Park, Berkhamsted, 1838–51.[3] By descent to Adelbert Salusbury Cockayne Cust, fifth Baron Brownlow, 1851–1923; sold Christie's, London, May 4, 1923, no. 109, to Collings for 12 gns.[4] Private collection, Italy.[5] William E. Suida, Baden (Vienna) and New York, by 1927 to 1941.[6] Sold by A. F. Mondschein, New York, to the Art Institute, 1942.

REFERENCES: Sir A. Hume, *A Descriptive Catalogue of a Collection of Pictures, comprehending Specimens of all the various Schools of Painting: belonging to (Sir A. H.)*, London, 1824, p. 28, no. 88. P. Torriano, "Luca Cambiaso nel quarto centenario della nascita," *L'illustrazione italiana* 54 (1927), pp. 522–23 (ill.). A. Venturi, vol. 9, pt. 7, 1934, p. 854 n. F. A. Sweet, "Venus and Cupid by Luca Cambiaso," *AIC Bulletin* 37 (1943), pp. 2–3, cover ill. B. Suida Manning, "Una Obra Maestra de Luca Cambiaso en la Coleccion del Duque de Alba en Madrid," *Archivio Español de Arte* 25 (1952), p. 161. F. A. Sweet, "La pittura italiana all'*Art Institute* di Chicago," *Le vie del mondo: Rivista mensile del Touring Club Italiano* 15 (1953), pp. 698–700 (ill.). A. Podestà, "Luca Cambiaso e la sua fortuna," *Emporium* 124 (1956), pp. 245 (ill.), 248. B. Suida Manning and W. Suida, *Luca Cambiaso: La vita e le opere*, Milan, 1958, pp. 25, 159–60, fig. 338. L. Fröhlich-Bum, "Luca Cambiaso," *Apollo* 70 (1959), p. 94, fig. I. AIC 1961, pp. 64–65. Maxon 1970, pp. 255 (ill.), 278. F. C. Poleggi, *La pittura a Genova e in Liguria dagli inizi al cinquecento*, Genoa, 1970, p. 239. S. J. Freedberg, *Painting in Italy 1500–1600*, Harmondsworth, 1971, p. 416, pl. 269. Fredericksen/Zeri 1972, pp. 40, 476, 571.

EXHIBITIONS: London, British Institution, *Pictures by Italian, Spanish, Flemish, Dutch and English Masters...*, 1831, no. 2, as "Cupid stung by a Bee in his finger, complains to Venus." London, British Institution, *Pictures by Italian, Spanish, Flemish, Dutch, and French Masters...*,

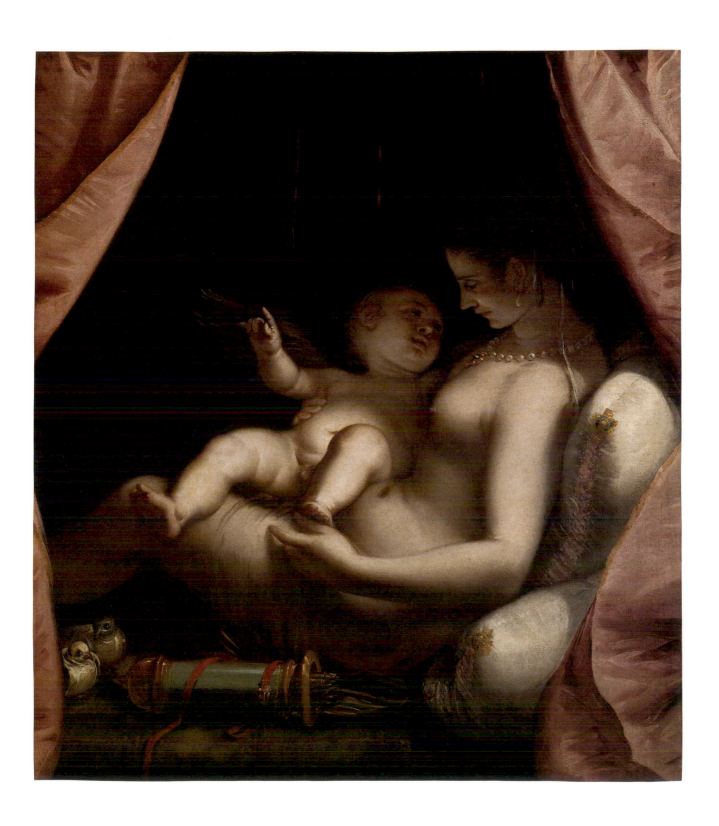

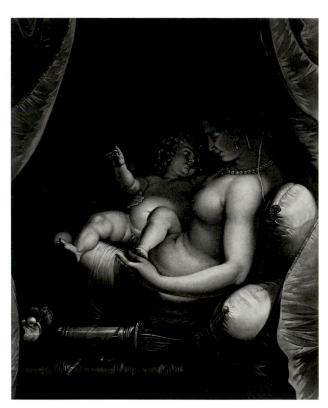

Fig. 1 Valentine Green, mezzotint after *Venus and Cupid*,
1942.290 [photo: courtesy of the Trustees of the British Museum]

1836, no. 97. Genoa, Teatro Carlo Felice, *Mostra centenaria
di Luca Cambiaso organizzata dalla Compagna*, 1927, no. 8.
Indianapolis, The John Herron Art Museum, *Pontormo to
Greco: The Age of Mannerism*, 1954, no. 49. Genoa,
Palazzo dell'Accademia, *Luca Cambiaso e la sua fortuna*,
1956, no. 37.

Luca Cambiaso is the most important Genoese
painter of the sixteenth century. His varied oeuvre
includes frescoes, altarpieces, and numerous highly
individual drawings. His Mannerist style had its ori-
gins not so much in the art indigenous to Genoa as
exemplified by his father, but in the work of painters
who visited the city, and was developed by frequent
travel in northern and central Italy. Cambiaso con-
ceived his figures on a grand scale and showed con-
siderable facility in a wide range of subject matter,
from religious works influenced by the Counter-
Reformation to historical and mythological themes.
The artist died in Spain where he had traveled in
1583 at the behest of Philip II.

During the eighteenth century, the present paint-
ing was apparently ascribed to Agostino Carracci, as
shown by the attribution given to Valentine Green's
mezzotint after this composition (fig. 1), published
in 1785.[7] Sir Abraham Hume was the first to recog-
nize the style of Cambiaso while the picture was in
his collection.

There is general agreement about the date of the
painting, although in the literature this matter seems
more complicated than it actually is because of the
terminology used. Thus Sweet (1943) placed the
painting in Cambiaso's "middle period," while Suida
Manning and Suida (1958) referred to the artist's late
period, and Poleggi (1970) implied a date coinciding
with the transition between the second and third
phases of the artist's career. More specifically, Suida
Manning and Suida cited a date of about 1570 and
Poleggi one of 1570/75.

The style of the present picture appears to be
particularly close to Cambiaso's *Death of Adonis* in
the Galleria Nazionale in Rome, his *Allegory* in the
collection of the Duke of Alba, and his *Diana and
Callisto* in the Galleria Sabauda in Turin.[8] *Venus and
Cupid* certainly ranks in quality with the finest of
Cambiaso's mythological paintings, which all seem to
have been painted during a period of about twenty-
five years, from c. 1550 to c. 1575.

The chief elements in Cambiaso's style, displayed
in the painting in Chicago, were ultimately derived
from Emilian and Venetian sources. The rich tex-
ture of the paint, the range of color (violet curtains
trimmed with yellow, turquoise quiver with red
straps, offset by an abundance of flesh tones), and the
variety of elegant accessories (silk-embroidered cush-
ions, pearl necklace with pendant, drop-pearl earrings,
and ribbons in the hair) recall works by Correggio,
Titian, and Veronese. Characteristic of Cambiaso,
however, are the complementary poses of the figures
and the treatment of light. The reclining pose of
Venus, nearly parallel to the picture plane, is counter-
balanced by the foreshortened figure of Cupid, whose
body leads the eye into the background. The juxtapo-
sition of the poses in this way, together with the high
viewpoint, is less radical than in some other paintings
by Cambiaso; it is, nonetheless, wholly typical of
the Mannerist principles he could have derived from
seeing works by artists such as Perino del Vaga,
Beccafumi, and Pordenone, who had all worked in
Genoa during the 1530s. The painting in Chicago

is not strictly speaking tenebrist in style, since it depends upon an external source of light, but the chiaroscural effect of the flesh tones seen against the darkened interior of the bed heralds the vivid contrasts in light that typify the artist's late religious paintings. The same model, or female type, used for Venus and the looped curtains which function as a *repoussoir*, emphasizing the feeling of recession, recur in other works.[9]

A weak drawing of Venus and Cupid in the Cincinnati Art Museum was described by Sweet (1943) as closely related to the painting in Chicago, but this comparison is unconvincing, since the figures are reversed and set in a landscape.[10] In fact, Cambiaso made a large number of drawings on the theme of Venus and Cupid, but no surviving example relates directly to the present painting.

The iconography of the painting seems fairly straightforward. The two doves are an attribute of Venus, while the bow and the quiver are those of Cupid. Since the attributes of Cupid have been laid aside, the picture should perhaps be more properly entitled *Venus Disarming Cupid*. The strap of the quiver appears to be broken or unbuckled, implying that Cupid will not be using his weapons again. Here, Venus is shown overcoming Cupid by dalliance rather than by the more playful games or tricks represented by Cambiaso on at least two other occasions.[11] In this respect, the picture is much less complicated than other contemporary allegorical treatments of this and related themes, like the *Venus and Cupid* by Bronzino in The National Gallery in London.[12]

It should be noted, however, that a former owner of the picture, Sir Abraham Hume, had a different interpretation. This is recorded in both the manuscript catalogue of Hume's collection compiled around 1820 and in the printed version dating from 1824.[13] The entry from the printed catalogue, which is extremely rare, is worth quoting in full, since it has only been partially transcribed on a label attached to the back of the picture:

> The subject is taken from an Ode of Anacreon, in which Cupid being stung by a bee complains to his Mother. The composition, which is in the style of Correggio, is quite beautiful, but the colour partakes too much of a general silvery tint, like the effect of moonlight. Both the heads are probably portraits;

that of Venus appears to have a sort of sourire in her countenance at Cupid's complaint. It is a picture of very pleasing effect and may be reckoned superior to most of those he painted. A mezzotinto of it was done by Valentine Green above forty years ago, with the name of Augustin Caracci, so little was Cangiagi's [i.e., Cambiaso's] peculiar manner then known in this Country. Purchased of Mr. Patoun.

The literary reference is to a poem associated with the sixth-century B.C. Greek poet Anacreon,[14] which was widely known and frequently translated into English. A very similar poem entitled *The Honey Stealer* is ascribed to Theocritus.[15] No bee appears in the painting, but it must be acknowledged that Cupid's gesture might be more explicable in that particular context.[16]

It is often argued that Cambiaso's emphasis on chiaroscuro and dynamic poses foreshadows the work of seventeenth-century artists like Georges de la Tour, Caravaggio, and Rembrandt. In discussing the *Venus and Cupid* in Chicago, Fröhlich-Bum compared it to the painting of the same subject by Simon Vouet now in Lyon.[17] To a limited extent, the composition also anticipates Rembrandt in such paintings as *Danaë* (St. Petersburg, Hermitage) or *Hendrickje Stoffels in Bed* (Edinburgh, National Gallery of Scotland).[18]

NOTES

1 Sweet (1943) tentatively postulated that the painting in Chicago might have been commissioned by Rudolf II, the Holy Roman Emperor, and then entered the collection of Queen Christina of Sweden. Although there can be no doubt that the subject would have appealed to Rudolf II and we know that Cambiaso painted such pictures for him, there appears to be no reference to this particular painting in the published archives of the collection of either Rudolf II or Queen Christina of Sweden (Suida Manning and Suida 1958, pp. 163, 165, conveniently printed the relevant entries from the inventories so far published).

2 Hume himself acquired the painting from William Patoun, probably privately and not on the occasion of Patoun's sale held at Christie's on March 14–15, 1783, since none of the lots acquired by Hume at that sale can be identified with the picture now in Chicago. Furthermore, Hume recorded that the painting was "Purchased of Mr. Patoun," implying a private transaction and not a purchase at a public sale. Several of the paintings in Hume's printed catalogue of 1824 are recorded as gifts from William Patoun. For information on Hume as a collector, besides the *Dictionary of National Biography*, see J. Byam Shaw, *The Italian Drawings of the Frits Lugt Collection*, vol. 2, *Polidoro Album*, Paris, 1983, p. 7 n. 2; and F. Russell in Christie's, Belton House, Lincolnshire, April 30–May 2, 1984, pp. 162–65.

3 *List of the Paintings and Pictures settled by Sir Abraham Hume, Bart. as Heirlooms contained in a Deed of Settlement dated the 27th February, 1834*, no. 36, typescript copy, London, National Gallery Library.

4 According to an annotated copy of the 1923 sale catalogue (Christie's, London).

5 According to Sweet 1943, p. 2 n. 1.

6 See the 1927 Genoa exhibition catalogue, and Suida Manning and Suida 1958, p. 159.

7 Inscribed: "Painted by Agostino Caracci [sic] /From the Original Picture in the Possession of Sir Abraham Hume Bar.ᵗ." A. Whitman, *British Mezzotinters: Valentine Green*, London, 1902, p. 157, no. 243. This attribution to Agostino Carracci is understandable on the basis of such a well-known picture as Annibale Carracci's *Venus, a Satyr, and Two Cupids*, which was hung in the Tribuna Gallery of the Uffizi in Florence; see D. Posner, *Annibale Carracci*, London, 1971, vol. 2, pp. 21–22, pl. 47.

8 Suida Manning and Suida 1958, figs. 340, 346–47. *Diana and Callisto* is also illustrated in N. Gabrielli, *Galleria Sabauda: Maestri italiani*, Turin, 1971, p. 90, fig. 199.

9 See, for instance, Cambiaso's *Holy Family with the Young Saint John*, c. 1570, in the National Gallery of Scotland (Suida Manning and Suida 1958, fig. 369; H. Brigstocke, *Italian and Spanish Paintings in the National Gallery of Scotland*, Edinburgh, 1978, p. 27).

10 Gift of Emily Poole in Memory of Allyn C. Poole, no. 1953.105; Sweet 1943, p. 3 (ill.). Suida Manning and Suida

(1958) referred to another drawing related to the Poole sheet (New York, The Metropolitan Museum of Art, no. 87.12.10). This is now considered to be by an imitator of Cambiaso (letter from Jacob Bean to the author of June 21, 1983, in curatorial files).

11 Suida Manning and Suida 1958, figs. 268, 337.

12 C. Hope, "Bronzino's *Allegory* in the National Gallery," *Journal of the Warburg and Courtauld Institutes* 45 (1982), pp. 239–43, pl. 38a, which includes earlier bibliography.

13 For the manuscript version, see London, Victoria and Albert Museum Library, Reserve V 19 (f. 16).

14 T. Bergk, ed., *Poetae Lyrici Graeci*, vol. 3, Leipzig, 1867, *Anacreontea*, frag. 33.

15 A. S. F. Gow, ed. and tr., *Theocritus*, 2d ed., Cambridge, 1973, Idyll XIX, pp. 146–47, commentary on pp. 362–63.

16 The bees are usually more prominent in the theme of *Cupid Complaining to Venus*, as in the painting by Lucas Cranach the Elder in the National Gallery, London (no. 6344, illustrated in *The National Gallery Illustrated General Catalogue*, London, 1973, p. 157), kindly pointed out by Cecil Gould (letter to the author of December 28, 1986). See also M. J. Friedländer and J. Rosenberg, *The Paintings of Lucas Cranach*, Ithaca, N.Y., pls. 244–45, 247–48.

17 W. Crelly, *The Paintings of Simon Vouet*, New Haven and London, 1962, p. 176, no. 60, fig. 26.

18 A. Bredius, *Rembrandt: The Complete Edition of the Paintings*, ed. by H. Gerson, London, 1969, pls. 382, 98, respectively.

Vincenzo Catena

Active Venice by 1506, d. Venice 1531

Virgin and Child with a Female Saint in a Landscape, 1500/10

Gift of Chester D. Tripp, 1964.1169

Tempera and oil on panel (poplar), 65.7 x 85 cm (25⅞ x 33½ in.)

INSCRIBED: *Viz[e]nzius [ch?]aena pinxit* (on the ledge below the book)

CONDITION: The painting is in very poor condition. It was cleaned and inpainted in 1965 by Alfred Jakstas. The condition report prepared at that time refers to "a general overpainting by Cabenaghi in the early 1900's."[1] The poplar panel has a horizontal grain with no perceptible join. There are, however, a number of horizontal splits in the center and lower half of the panel, including one that extends the full width of the panel about 32.5 cm from the bottom edge. The panel has been thinned and cradled.

The paint surface is severely damaged from losses along the splits, from flaking, particularly in the green robe of the saint, and from past cleaning action. While the photographs taken in 1965, including an ultraviolet photograph, indicate that the picture had been overpainted in the past, it is by no means clear that all the paint removed in the 1965 cleaning was overpaint. The flesh areas are now severely abraded and substantially reconstructed, and very few traces of earlier restoration remain on the picture. The inpainting applied in the 1965 treatment has now discolored, contributing to the picture's disturbed appearance. Nevertheless, some isolated areas of the picture remain intact, in particular, the magenta underrobe of the Virgin and the blue drapery covering her right knee. The face of the saint and the Child's left eye are

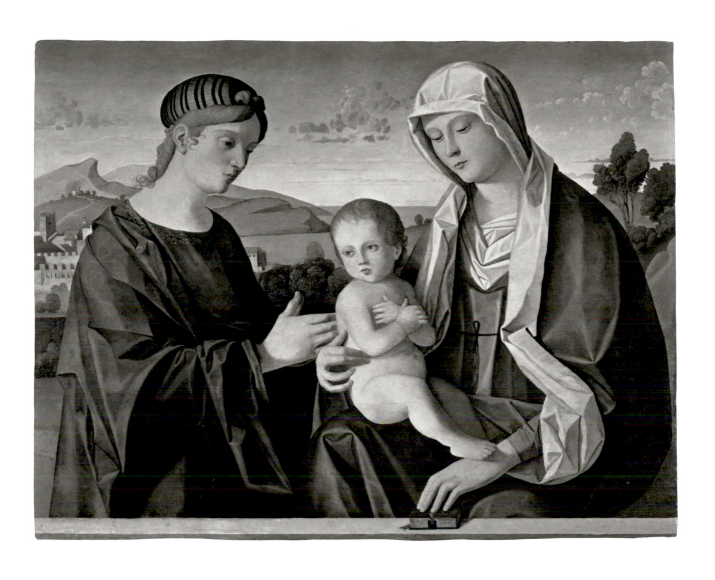

better preserved than the rest of the flesh areas. Microscopic examination suggests that the inscription is not a later addition.

Infrared reflectography and infrared photography reveal that the painting is underdrawn with rather loose, angular contour lines, which are most readily visible in the figure of the Virgin (infrared, mid-treatment, ultraviolet, x-radiograph).

PROVENANCE: Private collection, England.[2] John Levy Galleries, New York, 1927.[3] Chester D. Tripp, Chicago, 1929–64;[4] given to the Art Institute, 1964.

REFERENCES: *Art News* 26, 5 (1927), p. 7 (ill.). Maxon 1970, p. 251 (ill.). Fredericksen/Zeri 1972, pp. 49, 327, 571. *Chicago Tribune Magazine*, December 22, 1974, cover ill.

The present work reveals how completely Vincenzo Catena, a colleague of Giorgione and a well-to-do member of humanist circles in Venice, based his earliest manner on that of Giovanni Bellini. Although he gradually assimilated the innovations of Giorgione and Titian into his art, his works remained fundamentally linked to Bellini's, both in composition and figure types. The somewhat stiff geometry of Bellini characterizes even Catena's mature pictures, such as his ambitious *Saint Catherine Adoring the Resurrected Christ* (1520; Venice, Santa Maria Mater Domini), in which he aspired to Giorgione's lyrical mood.[5]

Acquired as a work by Catena, the present painting may be dated fairly early, during the first decade of the sixteenth century, based on the angular folds of the crumpled, silk-textured draperies and the narrow parapet in the foreground.[6] Compositionally, comparison may be made with the *Virgin and Child with the Baptist and Saint Jerome* in the Accademia in Venice and the *Holy Family with a Female Saint* in the Svépmüvészeti Múzeum in Budapest,[7] both fully discussed and dated shortly after 1500 and c. 1505–06 respectively in Robertson's 1954 monograph.[8] On the other hand, the modeling, as far as may be judged in the picture's present damaged condition, is somewhat softer than in either of those pictures and closer to the *Virgin and Child with Saints and a Donor* dated to 1507, in the Walker Art Gallery in Liverpool.[9]

The *sacra conversazione* type of composition in a rectangular format used here is ultimately derived from Giovanni Bellini, in whose oeuvre it can first be found around 1490, although not immediately with a landscape background.[10] Though Bellini is normally credited as the originator of this type of composition, Mantegna also used it. Highly characteristic of Catena, however, is the relationship of the figures to the landscape. The towering forms of the two female figures in the present painting dominate the picture space and prevent the eye from penetrating the landscape too quickly. The portrayal of the figures with a hint of a double chin and the elaborate coiffure and exotic headgear of the female saint are also typical.

NOTES

1 Treatment report in conservation file. The basis for this statement is unclear, especially in view of the picture's uncertain provenance.
2 In a letter to John Maxon of August 13, 1964, Chester D. Tripp stated that the picture "had been the property of a lady friend of King Edward VII" (see copy of letter in curatorial files).
3 According to *Art News* 1927.
4 See letter cited in note 2 above.
5 A. Venturi, vol. 7, pt. 4b, Milan, 1915, p. 570, fig. 352.
6 In an expertise dated July 27, 1925, on the back of an old photograph in curatorial files, Adolfo Venturi described the painting as "opera tra le più belle del Catena" (among the most beautiful works by Catena).
7 S. M. Marconi, *Gallerie dell'Accademia di Venezia: Opere d'arte dei secoli XIV e XV*, Rome, 1955, pp. 109–10, no. 108, fig. 108; A. Pigler, *Katalog der Galerie Alter Meister*, Budapest, 1968, vol. 1, pp. 132–33, no. 78, vol. 2, pl. 69.
8 G. Robertson, *Vincenzo Catena*, Edinburgh, 1954, pp. 41–43, nos. 2, 6, pls. 2, 5. The Chicago picture also relates closely, particularly in the rendering of the Virgin, to the painting by Catena of the *Virgin and Child with the Baptist, a Female Martyr, and Donors* (c. 1505) in the Pospisil Collection, Venice (ibid., p. 42, no. 3, pl. 4). The poses and physiognomies of the Virgin and female saint can be compared as well to those of saints in two paintings by Catena that were on the art market in 1970 and 1987 (Christie's, London, April 10, 1970, no. 35 [ill.]; and Bruno Scardeoni, *Burl. Mag.* 12 [March 1987], p. xiii [ill.]).
9 Robertson (note 8 above), p. 45, no. 10, pl. 9; and *Walker Art Gallery, Liverpool: Foreign Catalogue*, Liverpool, 1977, vol. 1, p. 40, vol. 2, p. 44 (ill.).
10 G. Robertson, *Giovanni Bellini*, Oxford, 1968, p. 94, pl. LXXVI.

Central Italian

Virgin and Child, c. 1450
George F. Harding Collection, 1984.16

Tempera and oil on panel, 81.6 x 49 cm (32⅛ x 19½ in.)

CONDITION: The painting is in fair condition. It was treated by Cynthia Kuniej in 1988–89. The panel is composed of a single board with vertical grain. Triangular segments have been added in the upper corners, though the original support extends approximately 3.5 cm beyond the painted design into the corners. A gesso ground covers both original panel and added segments in this area. The sides of the panel have been trimmed slightly, as is evident from exposed worm tunneling. The gilding appears to have been renewed. There is considerable abrasion throughout the flesh areas, which is particularly pronounced on the left side of the Virgin's face and in her neck; the top of the Christ Child's head is also substantially abraded. While the green robe of the Child is fairly well preserved, the Virgin's garments have suffered from abrasion and small local losses, and the blue of her cloak has darkened. The incised lines used to place the figures and drapery are clearly visible in the x-radiograph (ultraviolet, x-radiograph).

PROVENANCE: Achillito Chiesa, Milan; sold American Art Association, New York, April 16, 1926, pt. 2, no. 58 (ill.), as Jacopo del Sellaio. The George F. Harding Museum, Chicago, by 1939;[1] Sotheby's, New York, December 2, 1976, no. 93 (ill.), as Girolamo di Giovanni da Camerino, withdrawn; transferred to the Art Institute, 1984.

REFERENCES: Fredericksen/Zeri 1972, pp. 221, 323, 572.

EXHIBITIONS: The Saint Paul Art Center, Minnesota, *Age of Belief: An Exhibition of Religious Art from the Harding Museum Collections*, beginning 1966, no. 10, as Jacopo del Seliaio [sic].[2]

When exhibited in 1966, the painting was attributed to Jacopo del Sellaio and dated to c. 1460. In 1972, it was ascribed to a Florentine artist of the fifteenth century by Fredericksen and Zeri,[3] but when transferred to the Art Institute in 1984, it was registered as Gerolamo di Giovanni da Camerino.[4] This division of opinion reflects the hybrid nature of the panel. The composition of the standing Virgin shown in three-quarter length holding the Child is derived from Filippo Lippi or his circle. The Virgin may be compared to a panel ascribed to Filippo Lippi in The National Gallery in London,[5] and the pose of the Child is related to that in a painting formerly in the collection of Carl Hamilton in New York.[6] Stylistically, the association with a Marchigian painter such as Gerolamo di Giovanni da Camerino is not unreasonable, since mid-fifteenth-century painters in the Marches were receptive to a wide range of influences emanating from Florence, Urbino, Padua, and Bologna. In 1984, Everett Fahy identified a number of panels that he tentatively attributed to this same hand and grouped around the *Virgin and Child with an Angel* (formerly Cambó collection) in the Museo de Artes Decorativas in Barcelona,[7] suggesting the appellation "Master of the Cambó Madonna."[8] Fahy's list also includes a *Virgin and Child* at San Simeon, California,[9] a tondo with the prophet Jeremiah sold at the Galerie Fischer, Lucerne, in 1959,[10] and a *Virgin and Three Angels Adoring the Christ Child* in the National Gallery of Art in Washington, D.C.[11] No doubt this list will form the basis of further discussion on this essentially provincial artist.

NOTES

1 The collections of George F. Harding, Jr. (d. 1939), were incorporated as a nonprofit institution in 1930.
2 The only date given in the exhibition catalogue is "beginning 17 November 1966."
3 In a letter of March 8, 1967, to the Harding Museum, Fredericksen questioned the attribution of the painting to Sellaio, stating that he felt it was "a bit too good for Sellaio" (Archives, The Art Institute of Chicago).
4 Registrar's records.
5 Davies 1961, pp. 296–97, no. 3424. The painting is reproduced in *National Gallery Illustrated General Catalogue*, 2d rev. ed., London, 1986, p. 326, no. 3424.
6 Berenson 1963, vol. 2, pl. 853.
7 No. 64.971; see, most recently, G. Romano in *Colección Cambó*, exh. cat., Fundación Caja de Barcelona, 1991, no. 15, p. 192 (ill.), as Francesco del Cossa (?).

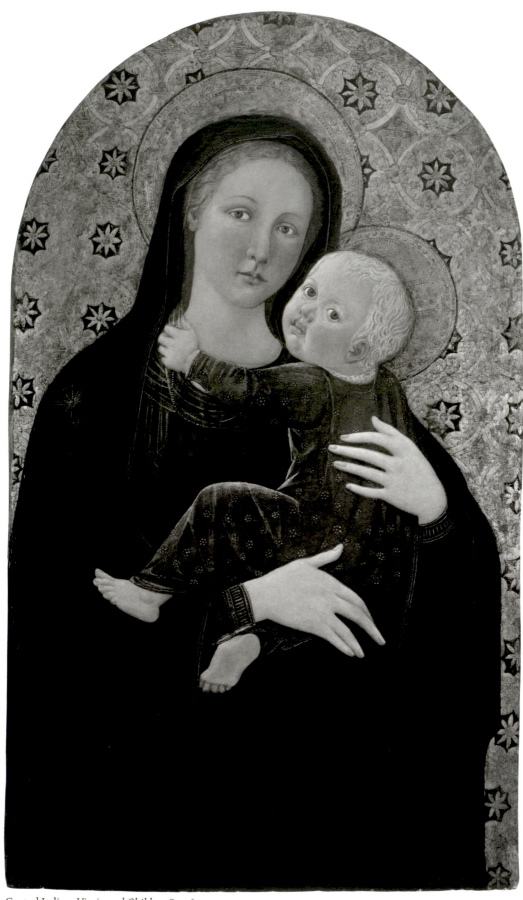

Central Italian, *Virgin and Child*, 1984.16

8 Letter to Anna Leider of April 14, 1984, in curatorial files.
9 No. 6568; see B. B. Fredericksen, *Handbook of the Paintings in the Hearst San Simeon State Historical Monument*, [Sacramento], 1977, n. pag., no. 25, cover ill., as anonymous Umbrian artist.
10 Sold Lucerne, Galerie Fischer, June 16–22, 1959, no. 1845, pl. 16, as circle of Benozzo Gozzoli.
11 Shapley 1979, vol. 1, pp. 143–44, no. 226; vol. 2, pl. 101, as attributed to Francesco del Cossa. Other paintings Fahy grouped around the Cambó Madonna include a *Virgin and Child* in the Louvre (ill. in A. Brejon de Lavergnée and

D. Thiébaut, *Catalogue sommaire illustré des peintures du musée du Louvre*, vol. 2, *Italie, Espagne, Allemagne, Grande-Bretagne et divers*, Paris, 1981, p. 255, no. M.N.R. 910, as Florentine, end of fifteenth century [?]); a *Virgin and Child* from the Pringsheim collection, Munich (sold Lucerne, Galerie Fischer, June 16–22, 1959, no. 1838, pl. 15); and a *Virgin Holding the Sleeping Christ Child with Two Angels* in the Museo Stibbert, Florence (G. Cantelli, *Il Museo Stibbert a Firenze*, Milan, 1974, vol. 2, p. 66, pl. 118, as Florentine School).

Antonio Allegri, called Correggio

c. 1494 Correggio 1534

Virgin and Child with the Young Saint John the Baptist, c. 1515
Clyde M. Carr Fund, 1965.688

Oil on panel (poplar), transferred to processed wood support and cradled, 64.2 x 50.2 cm (25¼ x 19¾ in.)

CONDITION: Despite its recent history, which is detailed below, the picture is in excellent condition. The painting was surface cleaned in 1965 by Alfred Jakstas. At that time there were two horizontal battens on the back of the panel at the top and bottom extending the full width and dovetailed into the wood. These must have been attached during an earlier restoration when the panel was presumably also planed down, since the batten along the lower edge interrupted exposed worm tunnels. Examination of the panel preliminary to this light surface cleaning revealed slight retouching in the darks of the Virgin's drapery and in the darker strands of hair. The only area of disfigurement was to the right of the Virgin's mouth caused by worm tunneling on a line extending fractionally upwards from the corner of the mouth. There was also minor abrasion on the Virgin's lips, as well as minor paint losses on her right hand and in the folds of the drapery covering her raised leg. Small paint losses were also apparent on the right leg of the Christ Child and on the face, neck, and body of the young Saint John the Baptist. The landscape was well preserved. In general then the overall condition of the painting was extremely good.

On October 30, 1966, the painting was stolen from the Art Institute; although it was recovered the same day, it was thrown in its frame from a second-floor window onto a roof below, evidently landing with the image face downward when the thief was attempting to escape. A split occurred in the center of the panel extending upward from the lower edge for at least three quarters of the panel's height; two further splits, visible at the upper and lower edges, were sustained on either side of the central one, while both the vertical edges were weakened. The effect of the jolt was to expose the worm tunneling in the panel's lower half, particularly from the Christ Child's right foot down to the bottom edge. The impact also caused indentation and a local paint loss about 1.2 cm wide just to the right of the Virgin's neck fractionally above the shoulder, as well as several smaller scattered paint losses on the figures, trellis, and distant landscape. In addition, there were surface scratches passing diagonally, first, across the Virgin's right arm and, secondly, through the figures of the young Saint John the Baptist and the Christ Child into the landscape on the right. These damages can be made out in a photograph taken on October 31, 1966, after the painting had been recovered (fig. 1).

The vicissitudes suffered by the painting in October 1966 led not so much to irreversible damage to the surface of the painting as to damage to the support, which was already much weakened by worm tunneling. It was therefore decided to renew the support by transferring the paint and the very thin ground layer to a new wood support. This process was carried out by Jean Marchig in Geneva between March and October of 1967, after which the painting was fully restored by Alfred Jakstas. It should be emphasized that, despite its dramatic history, the painting has suffered

no major loss and that the delicacy of the modeling of the flesh tones, the quality of light in the landscape, and the purity of the colors are still readily apparent.[1] Pigment analysis was carried out in 1968 by McCrone Associates of Chicago: the findings are summarized in Brown's 1972 article.[2]

The x-radiograph taken in 1965 reveals a number of minor *pentimenti* in the design, including an extension of the Virgin's mantle to the right over the lower portion of the landscape, fabric folds under the Virgin's right hand, and indications of changes in the form in the area of her right shoulder. Foliage is also visible under the mantle to the right of the Virgin's head (infrared, ultraviolet, x-radiograph).[3]

PROVENANCE: Baron Nicolas Massias, Paris, by 1815;[4] sold Laneuville and Lacoste, Paris, December 13 or following, 1825 (originally scheduled for December 14, 1824), no. 27, as Bernardino Luini, for Fr 4,000.[5] Private collection, Germany.[6] Minari collection, Milan.[7] Wildenstein, New York. Purchased from Wildenstein by the Art Institute through the Clyde M. Carr Fund, 1965.

REFERENCES: C. P. Landon, *Galerie de M. Massias, ancien résident de France à Carlsruhe...*, Paris, 1815, p. 17, pl. 6. "Accessions of Canadian and American Museums, October–December 1965," *Art Quarterly* 29 (1966), p. 71, cover ill. M. Laskin, "A New Correggio for Chicago," *Burl. Mag.* 107 (1966), pp. 190–93, fig. I. J. Maxon, "Correggio's Virgin and Child with the Infant St. John," *Art News* 66, 2 (1966), pp. 31–32, 64–65 (color ill.). J. Maxon, "Some Recent Acquisitions," *Apollo* 84 (1966), p. 221, fig. 3. "The Sensual Innocent," *Time* 87, 14 (1966), pp. 78–79 (color ill.). "La Chronique des arts," *Gazette des beaux arts* 6th ser., 69 (1967), suppl. no. 1177, p. 69, no. 253 (ill.). Berenson 1968, vol. 1, p. 92. Maxon 1970, p. 93, no. 30 (ill.). D. A. Brown, "Correggio's Virgin and Child with the Infant St. John," *AIC Museum Studies* 7 (1972), pp. 7–33, fig. 1. Fredericksen/Zeri 1972, pp. 56, 336, 571. C. Gould, *The Paintings of Correggio*, Ithaca, N.Y., 1976, pp. 43, 46, 47, 58, 169, 199, pl. 16A. H. Zerner and A. C. Quintavalle, *Tout l'oeuvre peint de Corrège*, Paris, 1977, pp. 86, 93, under no. 29, no. 30. *The Art Institute of Chicago: 100 Masterpieces*, Chicago, 1978, p. 47, no. 10 (color ill.). D. A. Brown, *The Young Correggio and His Leonardesque Sources*, New York and London, 1981, pp. 68–69, 74–80, 98, 194–96, no. 11, fig. 18. *Important Old Master Paintings and Discoveries of the Past Year*, exh. cat., New York, Piero Corsini, Inc., 1986, pp. 18, 21 n. 4, under no. 4. C. Gould in *The Age of Correggio and the Carracci: Emilian Painting of the Sixteenth and Seventeenth Centuries*, exh. cat., Washington, D.C., National Gallery of Art, 1986, under no. 28. C. Gould, "A Major New Attribution to the Young Correggio," *Artibus et historiae* 18 (1988), p. 9. *Master Paintings in The Art Institute of Chicago*, Chicago, 1988, p. 20 (color ill.). P. Piva, *Correggio giovane e l'affresco ritrovato di San Benedetto in Polirone*, Turin, 1988, pp. 155, 166, 168, 173, pl. XIV.

The acquisition of this painting was one of the most notable purchases made by a museum in the United States during the 1960s. The Art Institute of Chicago not only acquired an important work in well-nigh pristine condition by one of the outstanding masters of the Italian High Renaissance, but also a painting whose rediscovery added considerably to existing knowledge of Correggio's development as an artist.

Since its reappearance in 1965, the picture has been universally accepted as an early work by Correggio.[8] Although the reconstruction of Correggio's early oeuvre is notoriously difficult, there is general consensus about the date of the present picture because of its close relationship with his altarpiece *Virgin and Child with Saints Francis, Anthony of Padua, Catherine of Alexandria, and John the Baptist* (fig. 2), a signed work with a documented date of 1514–15, now in Dresden's Gemäldegalerie. Opinion differs, however, as to whether the picture in Chicago preceded or followed this altarpiece: Maxon (*Art News* 1966, 1970) argued for a date just after the altarpiece, Laskin (1966) proposed a date before it

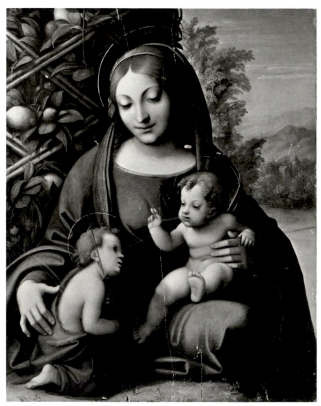

Fig. 1 *Virgin and Child with the Young Saint John the Baptist*, 1965.688 (photograph taken October 31, 1966)

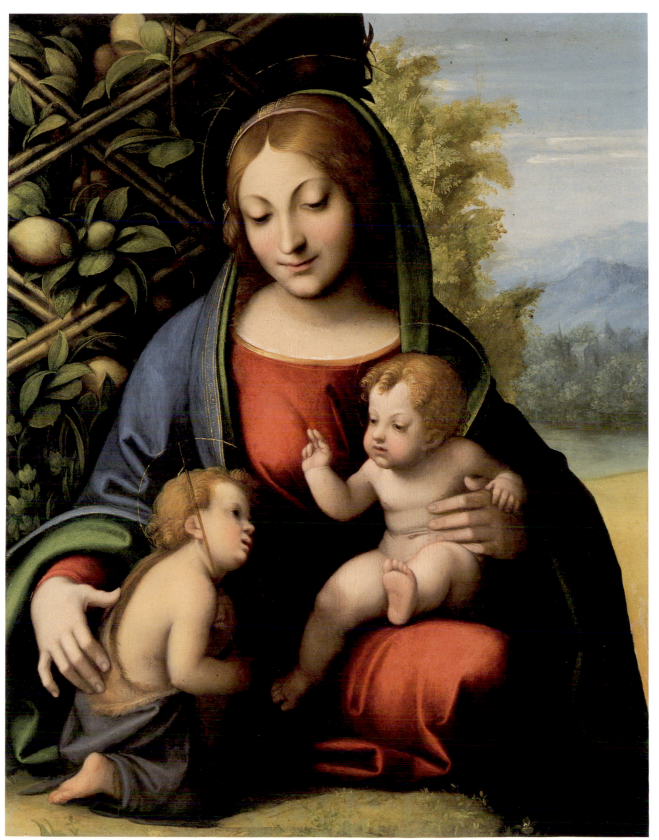

Antonio Allegri, called Correggio, *Virgin and Child with the Young Saint John the Baptist*, 1965.688

(1513 or 1514), Bevilacqua and Quintavalle (1970) suggested an even later date (c. 1517), while Brown (1972, 1981) decided upon c. 1516, and Piva (1988) proposed a date of 1515/16.[9] Gould (1976) did not address this specific problem, though he acknowledged that the painting is one of a number that can be grouped around the altarpiece in Dresden. The parallels between the panel in Chicago and the Dresden altarpiece lie principally in the Virgin and Child, in the expression on the Virgin's face, in the careful treatment of the drapery, and in the pose of the Christ Child.

Virgin and Child with the Young Saint John the Baptist was executed at a critical phase in Correggio's development, when the painter had begun to outgrow the provincial influences reflected in his earliest work and was broadening his appreciation of the work of other artists to include the mainstream of Italian art. Thus, scholars have detected an awareness on Correggio's part of works by several different artists. For the poses of the Virgin and Child, reference has been made to Mantegna. Maxon (*Art News* 1966, 1970), followed by Brown (1972, 1981), compared these figures with their counterparts in the central panel (*The Adoration of the Magi*) of Mantegna's triptych of c. 1464 in the Uffizi in Florence.[10] Laskin (1966) and Gould (1976) pointed out that the Child is almost a mirror image of the one in Mantegna's altarpiece of 1497, once in the church of Santa Maria dell'Organo in Verona and now in the Castello Sforzesco in Milan.[11] Other references to Mantegna have involved connections between the fruit-laden trellis in the present composition and similar motifs in Mantegna's work. These include the bower that forms the setting for the *Madonna della Vittoria* in the Louvre and the decorative vegetation on the cupola of Mantegna's funerary chapel in Sant'Andrea in Mantua.[12] Both Laskin and Brown offered these comparisons, but they are, in fact, perhaps no more than associations, albeit legitimate ones. Swags of fruit can easily be found elsewhere in Mantegna's work; perhaps more to the point is that, as a compositional device, the trellis in the present painting replaces the usual drapery or curtain favored by artists such as Giovanni Bellini. The lemon is probably included here as a symbol of the Virgin. Lombard (Bernardino Luini) and Veronese (Girolamo dai Libri) artists also often incorporated a fruit-laden trellis or tree into their paintings for symbolic purposes.[13]

The landscape on the right of the present composition seems to reflect Correggio's awareness of Dürer's prints: Maxon (*Art News* 1966, 1970) cited two engravings, namely, the *Virgin and Child with the Monkey* of c. 1498 and the *Virgin and Child with the Pear* of 1511, while Brown (1972, 1981) referred to Dürer's woodcut of *Christ Taking Leave from His Mother* from *The Life of the Virgin* of 1511, which was used by Correggio for his painting of that subject in The National Gallery in London.[14] As Brown emphasized, the landscape is not a direct quotation from Dürer's prints, but rather reveals Correggio's thorough grasp of "Dürer's spatial sequence of landscape forms."

It is, however, in the artist's amalgamation of sources, as well as in his ability to penetrate to their essence, that Correggio's composition of the *Virgin and Child with the Young Saint John the Baptist* assumes greater significance, as all writers on the painting have agreed. The subject is one that Correggio explored intensely during this early period, sometimes concentrating on the Virgin, Christ Child, and young Saint John alone, at others including additional members of the Holy Family. Directly comparable to the present picture are the paintings of this subject in the Philadelphia Museum of Art (John G. Johnson Collection), in the Castello Sforzesco in Milan, in the Borghese Gallery in Rome (copy after a lost original), and in the Prado in Madrid.[15] What these paintings reveal is a preoccupation with the interlocking of the figures, particularly in the interplay between the two children, and a concern with the relationship of the figures to the background. The compositions in Philadelphia, Milan, and Chicago all show the Virgin in the front plane of the picture space, offset by an architectural or decorative feature, which is balanced by a distant landscape view on the other side. Two other Correggio compositions devoted to this subject — one in the Museo Comunale in Pavia, the other in the Los Angeles County Museum of Art — deserve to be mentioned because of their exploration of the relationship between the Christ Child and the young Saint John, even though in these the group is placed behind a parapet.[16] The exact order in which all these

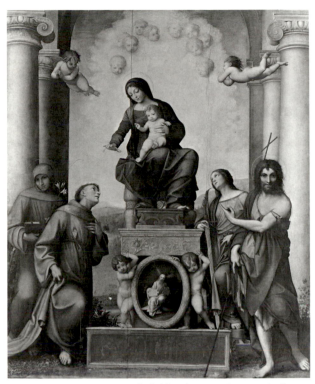

Fig. 2 Correggio, *Virgin and Child with Saints Francis, Anthony of Padua, Catherine of Alexandria, and John the Baptist*, Gemäldegalerie Alte Meister, Staatliche Kunstsammlungen Dresden

paintings were carried out is still much discussed, but it is not necessarily based on an increasing complexity and it is apparent that the picture in Madrid should stand at the end of the sequence.

Correggio's eagerness to develop an increasingly sophisticated treatment of this subject attests to his growing awareness of the work of contemporaries such as Leonardo da Vinci. This awareness would eventually lead him to transcend the formulaic compositions, the use of hard, enamel-like colors (acid greens, blue, and red), and the lush, verdant landscapes inherited from Francesco Francia, Lorenzo Costa, and other Emilian, specifically Ferrarese, artists.[17] Maxon (*Art News* 1966, 1970), very tentatively, and Laskin (1966), with greater precision, noted Correggio's debt to Leonardo, but it is Brown (1972, 1981) who has given this topic closest study. Laskin observed that the Virgin's posture on the grassy ledge distantly recalls Leonardo's *Madonna of the Yarnwinder*, while the protective gesture of the Virgin's right hand around the young Saint John the Baptist evokes comparison with the *Virgin of the Rocks*.[18] Brown added further relevant examples by Leonardo's

followers, such as the *Virgin and Child with the Infant Saint John* by Cesare da Sesto in the Museu Nacional de Arte Antiga in Lisbon.[19]

The debt to Leonardo is, of course, by no means limited to composition. Aspects such as gesture, expression, direction of glance, and *contrapposto* rhythms serve to heighten the sense of religious mystery, whereas suffused outlines, tonal modeling, and subtle shifts of light passing across the surface help to soften forms. Brown remarked, for instance, that the positioning of the young Saint John and the Christ Child on a diagonal parallel to the trellis is counteracted by an opposing diagonal formed by the lower part of the Virgin's body. Since the direction of the Virgin's glance is countered by the position of the rest of her body, the only stable point in the figural grouping, as in Leonardo's *Virgin of the Rocks*, is the Virgin's torso, which is itself, in fact, only partially on the frontal plane.

Yet, as Gould (1976) rightly observed, there is also a debt to Raphael that should not be overlooked. This debt is most apparent in the pyramidal grouping of the figures, which recalls Raphael's Florentine Madonnas dating from 1504/08 and especially the *Aldobrandini Madonna* in The National Gallery in London, painted shortly after Raphael's arrival in Rome (c. 1509–10).[20] Clearly, the availability of the cited works by Leonardo and Raphael has to be taken into consideration. To explain Correggio's awareness of Leonardo's paintings, Brown posited a trip to Milan sometime before September 1513. Scholars have also long debated the possibility of a visit to Rome to account for Correggio's knowledge of Raphael's works in central Italy. Although important questions remain about Correggio's movements beyond the confines of Emilia, these do not invalidate the visual evidence offered by the painting in Chicago. Brown (1972, p. 23) admirably summed up the work's significance for Correggio's development by describing it as "the product of his realization of the need for radical change in his art and of his bold, imaginative effort to overcome the limitations inherent in the tradition in which he was working."

Notes

1 See also summaries of condition given by Laskin (1966, p. 190 n. 2) before the theft, and by Brown (1972, p. 27 n. 2, reprinted in Brown 1981, p. 194) after the theft.

2 Brown 1972, p. 32 n. 35: "It is especially worth noting that Correggio obtained all his tones in the essentially opaque pigment layer. They do not depend on the gesso."

3 The x-radiograph is reproduced in Gould 1976, pl. 16B.

4 See Landon 1815. The remnants of several red wax seals were still attached to the back of the original panel, but none could be deciphered. It is possible that such seals are indications not of ownership but of import and export.

5 See annotated sale catalogue in the Resource Collection of the Getty Center for the History of Art and the Humanities, Santa Monica.

6 According to an undated statement in curatorial files submitted by Wildenstein at the time the painting was purchased, and a letter from John Maxon to Edward Barry, art editor of the *Chicago Tribune*, of February 8, 1966, in the Maxon papers, Archives, The Art Institute of Chicago. In this letter, Maxon wrote that the painting's "history before it belonged to the German collector is unknown, except that it is said to have come to the collector from a German princely house."

7 The Milanese collector whose name is given in the undated statement from Wildenstein mentioned above (note 6) is presumably the same one referred to in letters from Maxon to Myron Laskin, Jr., of January 19, 1966, to Edward Barry of February 8, 1966 (note 6), and to James W. Alsdorf of March 10, 1966, in the Maxon papers, Archives, The Art Institute of Chicago. According to these letters, the picture was bought by the Milanese collector sometime around the beginning or end of World War II at an unidentified public auction in Germany, where the painting was cata-

logued as "Italian, first quarter of the sixteenth century."

8 In 1815, while in the Massias Collection, it was attributed to Bernardino Luini, an attribution retained at the time of the 1825 sale.

9 In a letter to Maxon of May 4, 1965, Sydney Freedberg dated the picture "almost certainly" to 1515; and, in a letter to Maxon of August 5, 1965, Federico Zeri placed it in 1513 (Maxon papers, Archives, The Art Institute of Chicago).

10 R. Lightbown, *Mantegna*, Oxford, 1986, pl. 50.

11 Ibid., pl. 127.

12 Ibid., pl. XIV, fig. 17, respectively.

13 M. Levi d'Ancona, *The Garden of the Renaissance: Botanical Symbolism in Italian Painting*, Florence, 1977, pp. 205–09, no. 88.

14 F. W. H. Hollstein, *German Engravings, Etchings, and Woodcuts, ca. 1400–1700*, vol. 7, Amsterdam, 1962, nos. 30, 33, 204 (ills.); and Gould 1976, pl. 7A, respectively.

15 Gould 1976, pls. 6A, 6B, 19A, 27A, respectively.

16 Both are disputed attributions, and the painting in Pavia was reported stolen in 1971; see Gould 1976, pls. 5C, 18A, respectively.

17 See, for example, Francia's *Virgin and Child with the Infant Saint John* (Budapest, Szépmüvészeti Múzeum) illustrated in Brown 1972, fig. 18.

18 L. Goldscheider, *Leonardo da Vinci: Life and Work*, London, 1959, p. 36 (ill.), pls. 64–65, respectively.

19 Brown 1972, fig. 14, but catalogued in *Museu Nacional de Arte Antiga: Roteiro da pintura estrangeira*, Lisbon, 1966, p. 89, no. 337, inv. 1607, as Boltraffio (?).

20 Gould 1976, fig. 10.

Carlo Crivelli

1430/35 Venice–Ascoli Piceno 1495

The Crucifixion, 1480/90
Wirt D. Walker Fund, 1929.862

Tempera on panel, 75 x 55.2 cm (29½ x 21¾ in.);[1] image (arched): 74 x 55.2 cm (29⅛ x 21¾ in.)

INSCRIBED: ·I·N·R·I· (at top of cross)

CONDITION: The painting is in relatively good condition. It was surface cleaned by Alfred Jakstas in 1965. The panel has a vertical grain. It has been thinned to a thickness of approximately 8 mm, edging strips have been added on all sides, and panel and strips have been attached to a secondary wood support which was then cradled. The strip at the right edge was removed in 1991 to facilitate examination. The rectangular panel seems to have been prepared with a ground layer only in the arched shape of the painted design. The x-radiograph shows worm tunneling in the spandrels, which are now painted black, in a strip along the left side of the picture, and in the cross above Christ's head. There is a knothole or disturbance to the wood to the right of Christ's head. A split runs the height of the panel through the head of Christ and down his right leg, and another split runs from the top of the panel through Christ's right wrist. The x-radiograph reveals what appear to be fabric patches or reinforcements at the knothole, at the right edge at the level of Saint John's head, and in a vertical strip corresponding to the split at the top of the panel described above. Other fabric patches or reinforcements appear in the lower half of the panel in four thin vertical strips to the left of the Virgin, through the base of the cross, to the left of Saint John, and at the lower right edge, respectively. Examination of the

right edge confirms that these are indeed made of fabric underlying the ground. They are presumably part of the preparation of the panel, though the possibility that they are reinforcements as part of a transfer process cannot be entirely excluded.

The paint surface is generally in very good condition. However, an irregular strip approximately 4 cm wide along the left edge has been filled and repainted. There is another fill at the junction of the two beams of the cross. Repaint in this area extends further than the loss and includes the crossbeam between Christ's hands, the right half of his halo, and portions of the sky above the cross. There are score marks in the gesso 2 cm from the bottom edge and around the arched top. Infrared reflectography (fig. 1) revealed that the figures and skull are underdrawn in what appears to be brush. This underdrawing is also visible with the naked eye in some areas, including the torso of Christ and the skull. Diagonal hatching strokes are used to model broad areas of folds, and short hooked lines indicate the edges of folds in Saint John's robe (infrared reflectogram, x-radiograph).

PROVENANCE: Alexander Barker (d. 1874) and his executors, London; sold Christie's, London, June 21, 1879, no. 472, to Lesser for £100 16s.[2] Baron E. de Beurnonville, Paris; offered for sale but bought in, Charles Pillet, Paris, May 9–16, 1881, no. 632;[3] sold Hôtel Drouot, Paris, May 21–22, 1883, no. 126, for Fr 2,800.[4] Joseph Spiridon, Rome, probably by 1883;[5] sold Cassirer and Helbing, Berlin, May 31, 1929, no. 15, pl. XXIII, to Knoedler for 250,000 marks.[6] Sold by Knoedler, London, to the Art Institute, 1929.

REFERENCES: F. Drey, Carlo Crivelli und seine Schule, Munich, 1927, pp. 89–90, 147, pl. LXXIV. W. R. Deusch, "Die Sammlung Spiridon — Paris," Kunst und Künstler 27 (1929), p. 331 (ill.). R. van Marle, "Die Sammlung Joseph Spiridon," Der Cicerone 21 (1929), p. 187, fig. 11. L. Dussler, "Die italienischen Bilder der Sammlung Spiridon," Pantheon 3 (1929), p. 166. D. C. Rich, "A Crucifixion by Carlo Crivelli," AIC Bulletin 23 (1929), pp. 145–47, cover ill.; reprinted as "Crivelli from the Spiridon Sale in Chicago," Art News 28 (1929), pp. 3 (ill.), 6. F. Schottmüller, "Bilder der Sammlung Spiridon," Zeitschrift für bildende Kunst 63 (1929), p. 27 (ill.). AIC 1932, p. 3 (ill.). Berenson 1932, p. 161; 1936, p. 139; 1957, vol. 1, p. 69, pl. 153. A. M. Frankfurter, "Art in the Century of Progress," Fine Arts 20, 2 (1933), pp. 12 (ill.), 60. AIC 1935, p. 20. Van Marle, vol. 18, 1936, pp. 59–60 (ill.). AIC 1946, pp. 10–11 (ill.). R. P[allucchini], "Dipinti veneziani a Chicago, Detroit, Toledo e Hartford," Arte veneta 1 (1947), p. 147. AIC 1948, p. 75. U. Galetti and E. Camesasca, Enciclopedia della pittura italiana, vol. 1, Milan, 1950, p. 760. P. Zampetti, Carlo Crivelli nelle Marche, Urbino, 1952, p. 67. F. A. Sweet, "La pittura italiana all'Art Institute di Chicago," Le vie del mondo: Rivista mensile del Touring Club Italiano 15 (1953), pp. 695 (ill.), 697. AIC 1961, p. 111. A. Bovero, Tutta la pittura del Crivelli, Milan, 1961, p. 77, pl. 113. Huth 1961, p. 517. P. Zampetti, Carlo Crivelli, Milan, 1961, pp. 89–90, fig. 101. P. Zampetti, La pittura marchigiana da Gentile a Raffaello, Milan, 1969, p. 181; Eng. ed., Paintings from the Marches: Gentile to Raphael, London, 1971, p. 179. Fredericksen/Zeri 1972, pp. 60, 292, 570. Dizionario, vol. 4, 1973, p. 78. P. Zampetti, Carlo Crivelli, Florence, 1986, p. 284, pl. 73.

EXHIBITIONS: The Art Institute of Chicago, A Century of Progress, 1933, no. 115. The Art Institute of Chicago, A Century of Progress, 1934, no. 27. The Art Institute of Chicago, Masterpiece of the Month, February 1942 (no cat.).

The picture has a distinguished provenance and rightly received a great deal of praise at the time of the Spiridon sale in Berlin in 1929 as a fine example of Crivelli's impassioned and expressive late style. Though Crivelli probably received his earliest training in his native Venice, where he was active as early as 1457, his work shows the influence of Paduan painters, particularly Squarcione and his students Schiavone and Mantegna. By 1468 he had settled in the Marches. Crivelli spent the rest of his career there, producing elaborate polyptychs that combine an intense realism with rich decorative effects.

Drey (1927) suggested a date of c. 1490 for the present panel, which has been accepted by most writers. Only Zampetti (1961, 1986) has favored a slightly earlier date sometime during the 1480s.[7] Many features of the Chicago painting are typical of Crivelli's works of the 1480s: the intensely linear manner of the drawing, the vigorously dramatic characterization of the figures, the crystalline quality of the light, the ochreous tonality of the flesh tones, and the subdued coloring of the draperies. Comparison may be made, for example, with the Pietà of 1485 in the Museum of Fine Arts in Boston or with the Pietà in the Pinacoteca Vaticana in Rome.[8]

The Crucifixion was not a subject that Crivelli painted frequently. An early instance occurs in the predella of the polyptych in the church of San Silvestro at Massa Fermana dating from 1468,[9] and a much later example, closer in date to the panel in Chicago, is in the Pinacoteca di Brera in Milan.[10] In both these late Crucifixions, the figure of Christ almost writhes upon the cross. The distorted anatomy, particularly the tautly stretched tendons in the arms, the large hands, the massing of the muscles

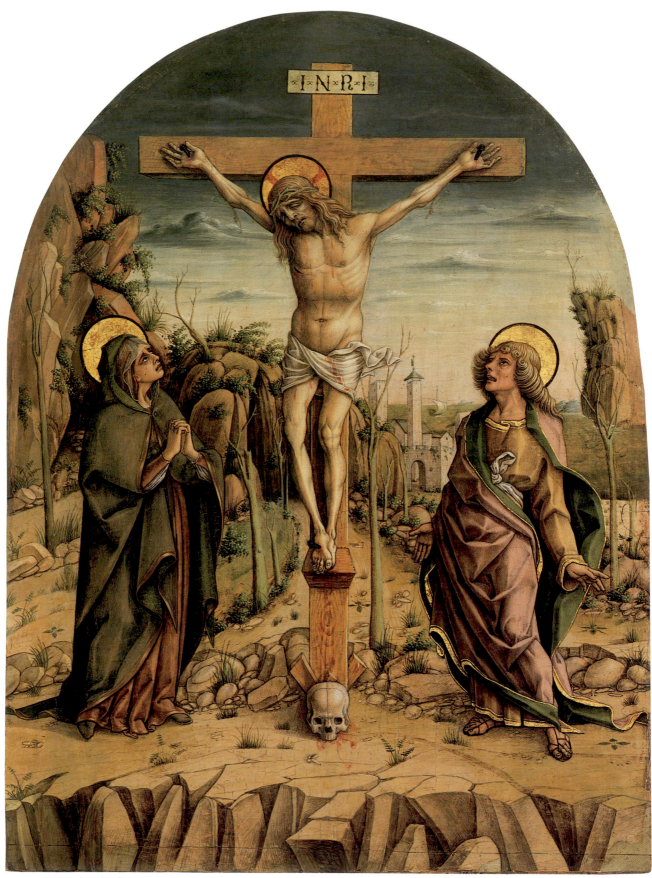

Carlo Crivelli, *The Crucifixion*, 1929.862

around the knees and the concavity of the stomach, all areas revealing maximum physical tension, contribute to this impression. The principal difference between the compositions in Milan and Chicago is in the landscape. Here it is rocky and arid, even though by no means totally devoid of vegetation. The barren trees in this context can be interpreted symbolically as representing the dead Tree of Life from which new life will one day spring as a result of Christ's sacrifice on behalf of mankind.[11] The gateway in the middle distance is the entrance to the city of Jerusalem. An unusual feature, first observed by Drey (1927), is the view of the ship at sea in the background, which must surely have been inspired by the fact that the artist spent nearly all his life working in the Marches on the eastern seaboard of Italy.[12]

Judging by the size, it is possible that the panel was originally placed in the upper tier of an altarpiece,

most probably on a central axis, as may have been true, according to Zampetti, for the very tall *Crucifixion*, already referred to, in the Pinacoteca di Brera in Milan.[13] It should be noted, however, that Crivelli usually reserved the subject of the *Pietà* for panels in that prominent position, as in the altarpiece of 1473 in the cathedral of Sant'Emidio in Ascoli Piceno.[14] Crivelli often devised large and elaborate altarpieces, many of which were subsequently dismembered but can be reconstructed from the *membra disjecta*. This panel, however, has not yet been included in any such reconstruction.

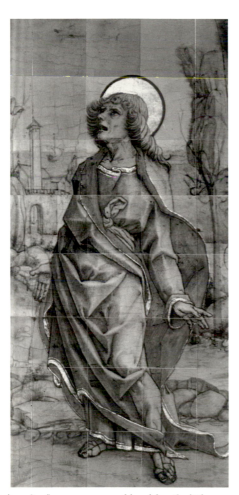

Fig. 1 Infrared reflectogram assembly of detail of *The Crucifixion*, 1929.862 [infrared reflectography: Carl A. Basner and Martina A. Lopez]

NOTES

1 Measurements do not include the edging strips.
2 For price and buyer, see annotated sale catalogue in the Frick Art Reference Library, New York; G. Redford, *Art Sales: A History of Sales of Pictures and Other Works*, vol. 2, London, 1888, p. 227; and A. Graves, *Art Sales from Early in the Eighteenth Century to Early in the Twentieth Century*, vol. 1, London, 1918, p. 184.
3 The annotated sale catalogue in the Resource Collection of the Getty Center for the History of Art and the Humanities, Santa Monica, gives a sale price of Fr 2,600, which is presumably the price at which the work was bought in, since it reappeared in the 1883 Beurnonville sale.
4 Price given in H. Mireur, *Dictionnaire des ventes d'art faites en France et à l'étranger pendant les XVIIIme et XIXme siècles*, vol. 2, Paris, 1911, p. 321.
5 According to the 1929 sale catalogue of the Spiridon collection, the picture was acquired directly from Baron de Beurnonville in 1876, but this must be a misprint, since the painting was definitely included in the two sales of Baron de Beurnonville's collection in 1881 and 1883.
6 Price and buyer given in annotated sale catalogue in the Resource Collection of the Getty Center for the History of Art and the Humanities, Santa Monica.
7 Zampetti dated the Art Institute panel around 1480 in his most recent (1986) monograph on Crivelli, which is essentially a revised version of his 1961 book on the artist.
8 For the Boston *Pietà*, see Zampetti 1961, pl. XIX, fig. 102, and Zampetti 1986, pl. 75; for the Rome *Pietà*, see Zampetti 1961, fig. 114, and Zampetti 1986, pl. 79.
9 Zampetti 1961, fig. 5, and Zampetti 1986, pl. 4.
10 Zampetti 1961, fig. 128, and Zampetti 1986, pl. 89.
11 M. Levi d'Ancona, *The Garden of the Renaissance: Botanical Symbolism in Italian Painting*, Florence, 1977, p. 382.
12 Interestingly, Antonello da Messina had also set his first depiction of the *Crucifixion* (Bucharest, Muzuel de Arta), painted c. 1455–60, against a background that included a view of the Straits of Messina (illustrated in *Antonello da Messina*, exh. cat., Messina, Museo Regionale, 1981–82, no. 6).
13 See note 10 above.
14 Zampetti 1961, fig. 42, and Zampetti 1986, pl. 29.

Jacopo Chimenti, called Jacopo da Empoli

1551 Florence 1640

Portrait of a Noblewoman Dressed in Mourning, c. 1593

Frank H. and Louise B. Woods Fund, 1960.1

Oil on canvas, 221 x 122.5 cm (87 x 48¼ in.)

INSCRIBED: A L. ℍ.B. (on the pedestal of the crucifix)

CONDITION: The painting is in very good condition. It has not been treated since its acquisition in 1960, but was probably cleaned shortly before that. The canvas has been glue lined. The paint surface is in general very well preserved. There are no major areas of damage or restoration, apart from a few small losses in the lower part of the sitter's robe, some rubbing and inpainting along the edges, and some inpainting in the shadow of the crucifix and in a vertical strip to the left of this shadow. There is slight cupping in the dark blue draperies of the curtain and table cover.

PROVENANCE: Probably Giovanni Battista Matteo, Cavaliere di Candia (1810–1883), Villa Salviati, Florence.[1] Nicholas Vansittart (d. 1851), first Baron Bexley, Foots Cray Place, near Sidcup (Kent);[2] sold Christie's, Foots Cray Place, May 2, 1876, no. 237, as Sustermans, *Portrait of an Abbess — full length*, to Eyles for £52 10s.[3] Probably by descent to Nancy Oswald Smith of Shottesbrooke Park, Maidenhead (Berkshire); sold Christie's, February 13, 1948, no. 62, as Sustermans, to Berendt for £26 5s.[4] Galerie Heim, Paris, by 1958.[5] Purchased from Heim by the Art Institute through the Frank H. and Louise B. Woods Fund, 1960.

REFERENCES: "Il collezionista," *Sele arte* 39 (1959), p. 80 (ill.). "Accessions of American and Canadian Museums," *Art Quarterly* 23 (1960), p. 305 (ill.). AIC 1961, pp. 48 (ill.), 78. Maxon 1970, p. 255 (ill.). Fredericksen/Zeri 1972, pp. 52, 515, 571. M. A. Bianchini, "Jacopo da Empoli," *Paradigma* 3 (1980), p. 129, fig. 32. G. Cantelli, *Repertorio della pittura fiorentina del seicento*, Florence, 1983, p. 42. A. Marabottini, *Jacopo di Chimenti da Empoli*, Rome, 1988, pp. 97, 226, no. 67 (ill.).

EXHIBITIONS: Paris, Galerie Heim, *Tableaux de maîtres anciens: Nouvelles acquisitions*, 1958, no. 19. The Art Institute of Chicago, *European Portraits, 1600–1900, in The Art Institute of Chicago*, 1978, no. 1.

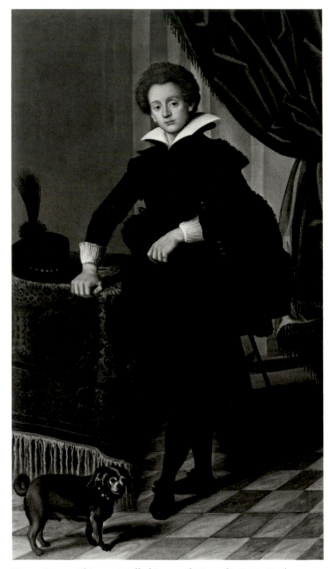

Fig. 1 Jacopo Chimenti, called Jacopo da Empoli, *Portrait of a Young Nobleman*, private collection [photo: Wildenstein & Co., Inc., New York]

This imposing portrait appears traditionally to have been attributed to the Medici court painter Justus Sustermans under whose name it appeared for sale at Christie's in 1876 and 1948. When acquired by the Art Institute in 1960, several scholars (Voss, Longhi, and Zeri) had apparently already expressed the opinion that the portrait was by the Florentine artist Jacopo da Empoli.[6] Maxon (1970) and Fredericksen and Zeri (1972) accepted this attribution and, more recently, Marabottini (1988), in his catalogue of Empoli's works, assigned the painting to him without reservation. A *Portrait of a Young Nobleman* (fig. 1),

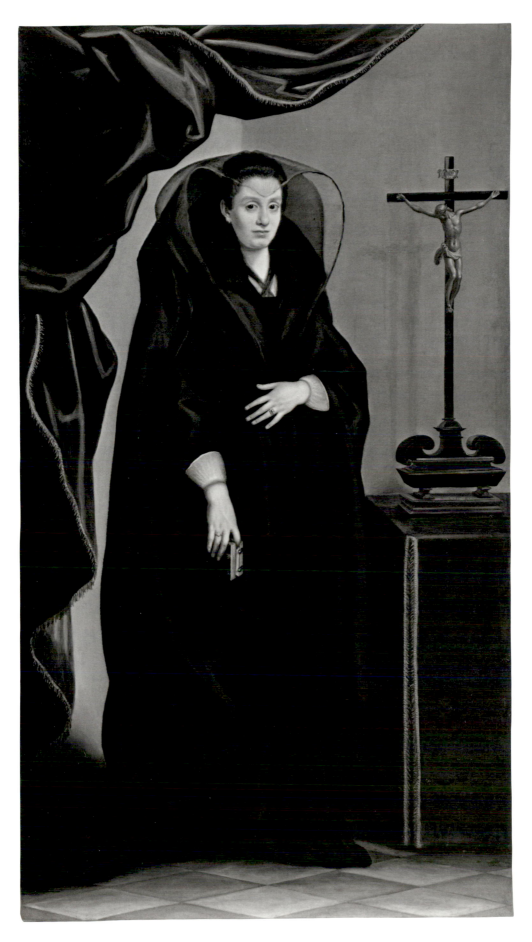

now in a private collection, but in the nineteenth century, together with the Chicago picture, in the possession of the Vansittart family,[7] is almost certainly a pendant to the present work. This other portrait measures 210.8 x 118.7 cm and is inscribed on the fourth row of squares of the tiling with the following initials and date: . A . M . B . F . / 15[9?]3. The date is not distinct. The picture also includes a very similar curtain and tiled flooring. Dressed in black mourning like the woman in the Chicago portrait, the young nobleman would appear to be her son.

A pupil of Maso da San Friano, Empoli followed the reformist tendencies of Santi di Tito and created a similarly naturalistic style, reminiscent of High Renaissance works produced some sixty years earlier. His very legible, prosaic artistic manner was well suited for propagandist decorations for the pageants of the Medici court. He was thus an important contributor to the decorations for the festivals celebrating the weddings of Ferdinando I de' Medici to Christina of Lorraine (1589), Marie de' Medici to Henry IV (1600), and Cosimo de' Medici to Maria Maddalena of Austria (1608), and for the funerals of Filippo II de' Medici (1598) and Henry IV (1610). The formal clarity, the carefully harmonized tones, and the precision of naturalistic details brought to the Chicago painting are typical of Empoli's style. Comparison may be made with the *Portrait of Concino Concini* that is widely attributed to Empoli and apparently dates from 1610.[8] The present painting is also similar in handling, particularly in its cool, pellucid illumination, to Empoli's *Susannah* (1600) in the Kunsthistorisches Museum, Vienna, and to his bust-length *Saint Barbara* (c. 1600), which was on the art market in 1984.[9]

Compositionally, the portrait in Chicago is highly successful, with the central vertical of the figure continued upward by the angle of the room, which is glimpsed briefly in the background before being concealed again by the curtain. There are other insistent verticals, like the corner of the table on the right and the crucifix placed upon it, which casts a shadow on the wall behind. Only the draped curtain, the sitter's headdress, and some of the folds in the drapery create subdued rhythms that counterbalance these verticals.

The iconography of the portrait is suitably pietistic so as to emphasize the theme of bereavement. Apart from the official dress of mourning, both the cross on the table and the missal in the sitter's right hand imply sources of comfort for the widow, while the position of her left hand, with the ring prominently displayed on the fourth finger, underlines the significance of her recent loss. Indeed, this gesture is distinctly reminiscent of that of Giovanna Cenami in the painting of *The Marriage of Giovanni Arnolfini and Giovanna Cenami* by Jan van Eyck in The National Gallery in London.[10] Although the sitter in the Chicago portrait does not hold up her dress as in the painting by van Eyck, the position of the hand across the stomach, which has been interpreted as symbolizing marriage, is not dissimilar.[11] A further comparison may be made with the *Portrait of Smeralda Bandinelli* by Botticelli in the Victoria and Albert Museum in London.[12] Ultimately, the pose can be traced back to the fourteenth century, as in the *Virgin Crowned by Two Angels* by the Master of San Martino alla Palma in the Uffizi.[13]

Marabottini (1988) has noted that the crucifix in the painting recalls very closely a bronze sculpture by Giambologna, of which the finest versions can be found in the convent of Santa Maria degli Angiolini (c. 1588) and in the Salviati Chapel of San Marco (before 1588).[14] Marabottini has speculated that a *modello* for, or a smaller version of, the Salviati crucifix may have been in the possession of the *casa Salviati* and may indicate that the subject of the Chicago picture was a member of that illustrious family.[15] The provenance of the painting (see above) would seem to lend credibility to his suggestion.

Unfortunately, the initials on the pedestal of the cross do not corroborate this hypothesis concerning the patrons and have so far defied interpretation. Theoretically, they could refer either to the painter or to the sitter: if the former, then the attribution to Empoli must be examined afresh, and if the latter, then the identification of the sitter as a Salviati would seem less likely. Traditionally, it was assumed that the subject was a member of the Medici family, but the sitter's features do not correspond with any of those catalogued by Karla Langedijk, who omitted the portrait from her three-volume study, *The Portraits of the Medici, 15th to 18th Centuries* (Florence 1981, 1983, 1987).[16] Internal evidence also suggests the possibility that the sitter belonged to the Strozzi family,

as the cluster of crescent moons decorating the band around the hat on the table in the presumed pendant *Portrait of a Young Nobleman* could be a reference to that family's emblem. Until further information on the early provenance of the two pictures and on the meaning of the inscriptions is available, efforts to link the sitters to prominent Florentine families must remain speculative.

NOTES

1 Giovanni di Candia, a famous tenor known as "Mario," is listed in the provenance of the work on an information sheet provided by the Heim gallery (in curatorial files). The picture's provenance from Villa Salviati is confirmed by a label attached to the stretcher. This reads: "A lady of the Medici Family from Foots Cray Place brought there from Villa Salviati, Florence."

2 Foots Cray Place was the home of the Vansittart family, one of whose members, Nicholas, served as Chancellor of the Exchequer and was created first Baron Bexley in 1823. He died without heirs and the peerage became extinct. Shottesbrooke Park (see following item of provenance) had been acquired earlier by the family in the late seventeenth or early eighteenth century. On the death of Coleraine Robert Vansittart in 1886 without heirs, the ownership of Foots Cray Place passed to his cousin Robert Arnold Vansittart and Shottesbrooke devolved on his sister Rose Sophia, who had married Oswald Augustus Smith in 1856 (see B. Burke, *A Genealogical and Heraldic History of the Landed Gentry of Great Britain*, 11th ed., London, 1906, pp. 1714–16, 1539–40).

3 According to annotated sale catalogue in the Resource Collection of the Getty Center for the History of Art and the Humanities, Santa Monica, and G. Redford, *Art Sales: A History of Sales of Pictures and Other Works*, vol. 2, London, 1888, p. 330, no. 1876. It seems probable that the Chicago picture and its presumed pendant (see note 7) were bought in by Eyles, as they reappeared in the same family in 1948 (see following item of provenance).

4 According to annotated sale catalogue in the Ryerson Library, The Art Institute of Chicago. Although several of the paintings in the 1948 sale are designated as having come from Foots Cray Place, strangely, this information is omitted for the present picture, even though it was included in the sale of the contents of the house in 1876.

5 According to 1958 Galerie Heim exhibition catalogue.

6 According to information sheet provided by the Heim gallery upon acquisition (note 1).

7 This picture was sold as *Portrait of an Italian Nobleman — full length, with a dog* at Christie's, London, on May 2, 1876 (no. 238, as Moroni, to Eyles), and was for sale again at Christie's, London, on February 13, 1948 (no. 35, as Moroni, to Wallraf), according to annotated copies of the sale catalogues (notes 3–4). The painting was at Wildenstein, New York, by 1970, and in 1991 passed to a private collection. It is not included in Marabottini's 1988 catalogue of Empoli's works.

8 Marabottini 1988, pp. 224–25, no. 66 (ill.).

9 Ibid., pp. 199–201, nos. 39–40 (ills.).

10 M. Davies, *National Gallery Catalogues: Early Netherlandish School*, 3d ed., London, 1968, pp. 49–52, no. 186.

11 It is possible, on comparison with a portrait of Giovanna of Austria in the Royal Collection related in style to the work of Anthonis Mor (see L. Campbell, *The Early Flemish Pictures in the Collection of Her Majesty the Queen*, Cambridge, 1985, pp. 103–04, no. 64, pl. 72), that the sitter is pregnant, as the hand appears not only to be placed across the stomach but also to be resting gently on its curvature. Attention was kindly drawn to the portrait in the Royal Collection by Joanna Woodall of the Courtauld Institute of Art, London (verbal communication with the author).

12 C. M. Kauffmann, *Victoria and Albert Museum: Catalogue of Foreign Paintings*, vol. 1, *Before 1800*, London, 1973, pp. 37–39, no. 37 (ill.).

13 L. Marcucci, *Gallerie Nazionali di Firenze: I dipinti toscani del secolo XIV*, Rome, 1965, pp. 67–68, no. 37, fig. 36. The entry for the present portrait in the 1978 exhibition catalogue claims that a drawing in the Gabinetto Disegni e Stampe degli Uffizi, Florence, could be a preparatory study (A. Forlani, *Mostra di disegni di Jacopo da Empoli*, Florence, 1962, pp. 26–27, no. 23, fig. 7), but this is not convincing, since the dress is totally different and the highly symbolic position of the subject's left hand is not the same.

14 Marabottini 1988, p. 226. For illustrations, see C. Avery and A. Radcliffe, eds., *Giambologna, 1529–1608: Sculptor to the Medici*, exh. cat., London, Arts Council of Great Britain, 1978, pp. 143–44, nos. 105, 107.

15 Marabottini 1988, p. 226.

16 It has been suggested that the sitter might be Maria Maddalena of Austria, the wife of Duke Cosimo II, who was widowed in 1621 and was often portrayed by Sustermans in mourning (see K. Langedijk, *The Portraits of the Medici, 15th to 18th Centuries*, vol. 2, Florence, 1983, pp. 1273–301, no. 90), but this identification was convincingly refuted by Marco Chiarini in a letter to Ilse Hecht of May 11, 1977, in curatorial files.

Attributed to Giovanni Antonio Fasolo

1530 Mandello del Lario–Vicenza 1572

Portrait of a Lady, 1565/70
Gift of Chester Dale, 1946.382

Oil on canvas, 179.5 x 115.7 cm (70⅛ x 45⁹⁄₁₆ in.)

CONDITION: The painting is in good condition. It was surface cleaned by Alfred Jakstas in 1962 and cleaned by Barry Bauman in 1976. There are three seams in the canvas. One, approximately 14 cm from the left edge, extends the whole height of the picture; the resulting narrow strip is pieced from two lengths of canvas joined by a horizontal seam approximately 79 cm from the bottom edge. Another horizontal seam just below the seat of the chair ends at this vertical strip. The canvas has been glue lined. Remnants of the tacking margin are visible at the left and right edges. The paint surface is relatively well preserved, apart from some damage along the edges and some abrasion in the lady's shoulders and in the sky. Old repaint, indicating shadows and highlights on the white skirt, was removed during the 1976 treatment (infrared, mid-treatment, ultraviolet).

PROVENANCE: Don Gaspar Méndez de Haro y Guzmán, Marqués del Carpio y Helice, viceroy of Naples (d. 1687), Naples.[1] Estate of Don Gaspar Méndez de Haro y Guzmán, 1687–1704, inv. 1692, no. 328.[2] Florentine creditors of Don Gaspar de Haro y Guzmán, by 1704, from whom presumably acquired by Martelli family, Florence, inv. 1712, 1771, and 1802–13.[3] By descent to the brothers Niccolò, Carlo, and Ugolino Martelli, Florence.[4] Sold by them to Albert Harnish, 1910.[5] Mrs. Henry Osborne Havemeyer (d. 1929); sold American Art Association, New York, April 10, 1930, no. 104 (ill.), for $800, to Metropolitan Gallery, New York.[6] Chester Dale, New York; given to the Art Institute, 1946.

REFERENCES: G. Ostoya, Les Anciens Maîtres et leurs oeuvres à Florence, Florence, 1884, p. 294. The H. O. Havemeyer Collection: Catalogue of Paintings, Prints, Sculpture and Objects of Art, privately printed, Portland, Maine, 1931, p. 495. F. A. Sweet, "A Portrait of a Lady by Veronese," AIC Bulletin 41 (1947), pp. 2–4, cover ill. AIC 1961, p. 246. G. Piovene and R. Marini, L'opera completa del Veronese, Classici dell'arte 20, Milan, 1968, p. 132, no. 321 (ill.). Fredericksen/Zeri 1972, pp. 69, 531, 571. T. Pignatti, Veronese, Venice, 1976, vol. 1, p. 175, no. A48; vol. 2, fig. 761. F. Weitzenhoffer, The Havemeyers: Impressionism Comes to America, New York, 1986, p. 256. A. Civai, Dipinti e sculture in Casa Martelli: Storia di una collezione fiorentina dal Quattrocento all'Ottocento, Florence, 1990, pp. 64, 71, 113, 118, fig. 28.

EXHIBITIONS: Chicago, Bonwit Teller, 1952 (no cat.).

This picture passed through several distinguished collections, for much of its history bearing an attribution to Veronese. However, by the time of the Havemeyer sale, it was only cautiously attributed to Veronese.[7] All writers since then, except for Sweet (1947), have omitted the portrait from Veronese's oeuvre. The suggestion that the painting might be by the Vicentine artist Giovanni Antonio Fasolo, an occasional collaborator with Veronese and Andrea Palladio on palace and villa decorations, first occurred in print in the 1961 catalogue of the Art Institute's paintings and this was accepted by Fredericksen and Zeri (1972). The portrait is clearly inspired in part by Veronese, although the particular formula used for the present portrait, with the figure positioned before a window, is one that had been more fully exploited by Jacopo and Domenico Tintoretto. The dress of the sitter displays the vibrant, shimmering illumination characteristic of Veronese, and her face, though a portrait, has been reshaped slightly to conform to Veronese's ideal types.

There are several examples of Fasolo's work, including portraits, in the Museo Civico in Vicenza.[8] Comparison may also be made with the three-quarter-length Portrait of a Lady in Dresden,[9] which has a traditional attribution to Fasolo, and particularly with the recently published portrait in the Zanella collection at Santorso.[10] In light of its affinity to these portraits, most of which are usually dated to the mid- to late 1560s,[11] the Chicago picture should tentatively be assigned to the years 1565/70. A comparable portrait with close similarities in pose and dress to the one in Chicago, although the composition is reversed and the view in the background changed, was formerly in the collection of Alfred S. Karlsen in Beverly Hills, California (photograph London, Witt Library).

An important stylistic feature of the portrait in Chicago is the vivid handling of the highlights on the

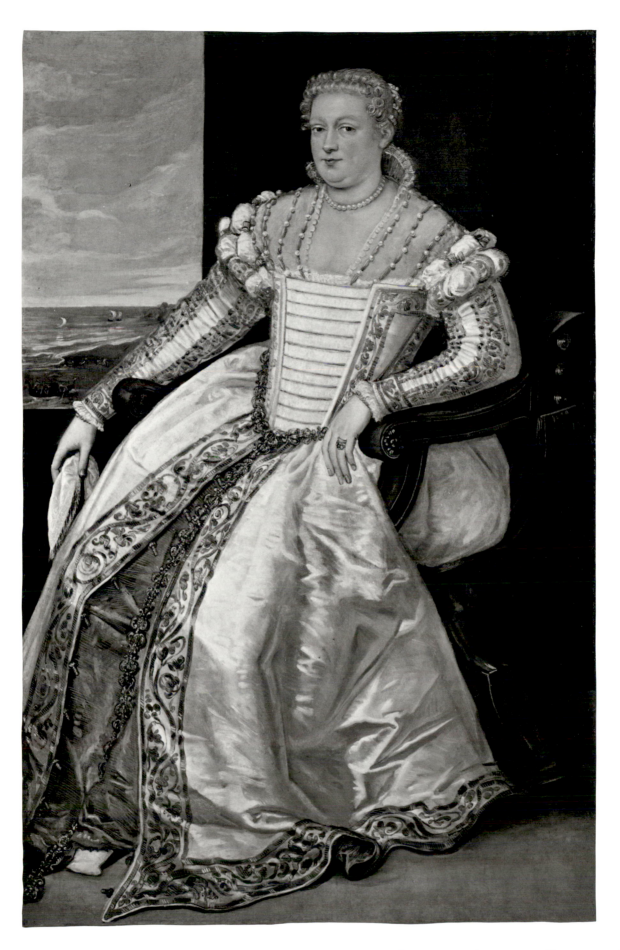

lower parts of the dress, which flicker over the surface like sheets of lightning and create a sheen that suggests the texture of the material itself. Curiously, this stylistic feature is less evident in Fasolo's other portraits, but there are similarities with the handling of the draperies of the figures in the altarpiece of the Madonna del Rosario in Vicenza,[12] and it is a quality not unexpected in a fresco painter.[13]

NOTES

1 The mark *DGH. / li67* surmounted by a crown (initials in ligature) is painted on the back, probably transposed from the back of the canvas when it was lined. The monogram is that of Don Gaspar Méndez de Haro y Guzmán, Marqués del Carpio y Helice, an avid collector who was Spanish ambassador to Rome as well as viceroy of Naples; see Civai 1990, pp. 62–64.

2 Civai (1990, pp. 62–64) noted that an inventory of Guzmán's collection was made in 1692 and that his pictures came into the possession of a group of his Florentine creditors in 1704. She proposed that 1946.382 is identical with no. 328 in this inventory, "ritratto di donna veneziana palmi 6 e 4 di Paol Veronese."

3 Civai (1990, pp. 64, 71) noted that the portrait was not among those that passed directly to Niccolò Martelli (d. 1711) as his share of the debt owed by Guzmán, but must have been acquired by him shortly thereafter from one of his associates, possibly Del Rosso.

4 Ibid., p. 113, fig. 28, who documents the picture in Martelli possession through an old photograph.

5 Ibid.

6 Price given in annotated sale catalogue in the Ryerson Library, The Art Institute of Chicago. Buyer given in annotated sale catalogue at Knoedler, New York, according to letter from Melissa De Medeiros to Mary Kuzniar of April 14, 1991, in curatorial files.

7 Some of the literature on this picture (AIC 1961 and Pignatti 1976) incorrectly listed G. Fiocco, *Paolo Veronese*, Bologna, 1928, p. 202, as containing a reference to the Art Institute portrait. Fiocco did refer to two portraits by Veronese in the Havemeyer collection, but both of these are now in The Metropolitan Museum of Art, New York (Zeri/ Gardner 1973, p. 44, no. 29.100.14, *Portrait of a Woman*, as Francesco Montemezzano, and p. 87, no. 29.100.105, *Boy with a Greyhound*, as Paolo Veronese).

8 F. Barbieri, *Il Museo Civico di Vicenza: Dipinti e sculture dal XVI al XVIII secolo*, Venice, 1962, pp. 68–77 (ills.). Two of these portraits, of members of the Gualdo family (pp. 73–77, nos. A867–68), are documented works by Fasolo and were dated by Barbieri to 1566–67 on the basis of style and the probable age of the sitters. G. Zorzi, "Gio. Antonio Fasolo, pittore lombardo-vicentino emulo di Paolo Veronese," *Arte lombarda* 6, 2 (1961), p. 213, preferred a date of c. 1566–68 for these paintings.

9 *Die Staatliche Gemäldegalerie zu Dresden*, pt. 1, *Die romanischen Länder*, Dresden and Berlin, 1929, p. 134, no. 249 (ill.).

10 V. Sgarbi, *Palladio e la maniera: I pittori vicentini del cinquecento e i collaboratori del Palladio, 1530–1630*, exh. cat., Vicenza, Tempio di Santa Corona, 1980, p. 76 (ill.). Sgarbi dated the Zanella portrait to c. 1566–67, to the time of the Gualdo portraits and the period just before Fasolo began to decorate the Villa Caldogno near Vicenza.

11 See notes 8 and 10 above.

12 Barbieri (note 8), pp. 68–70, no. A55 (ill.).

13 G. Zorzi (note 8), pp. 209–26.

Ferrarese or Northern Italian

Phaeton Driving the Chariot of Phoebus, 1475/1500
George F. Harding Collection, 1984.27

Tempera or distemper on canvas, 55.3 x 55.6 cm (21¾ x 21¹³⁄₁₆ in.)

CONDITION: The painting is in poor condition. The fine linen support has been relined with a fabric of coarser weave. Wooden edging strips have been attached on all four sides. Removal of the strip at the left edge showed that the picture retains its original unpainted tacking edge on this side. It seems likely that the other edges are also original. The paint surface is disturbed by abrasion and by minute flake losses following the crackle pattern. The faces are particularly abraded. In addition, there are old tears beneath the front wheel of the chariot and beneath the front hooves of the pair of horses at the right. There is a substantial area of repaint in the hill behind the cityscape, although the degree to which it covers original paint is unclear. The sky above the path of the chariot has darkened almost to black, although the original deep blue-green, presumably azurite, is visible in microscopic examination. The picture has been varnished, with a resulting darkening of the paint surface and loss of the delicate matte effect appropriate to the technique of tempera on linen. Nevertheless, the painting's

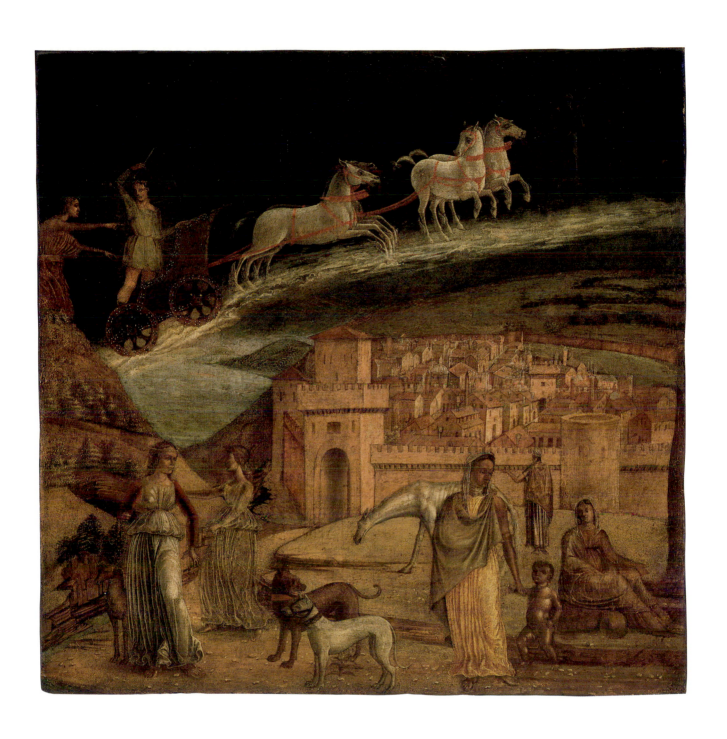

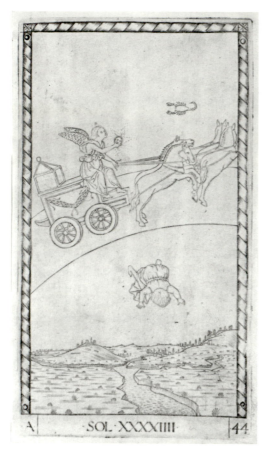

Fig. 1 Master of the E-series Tarocchi, *The Sun*, The Art Institute of Chicago, Gift of Mr. and Mrs. Potter Palmer, 1924.39/41

original poetry and luminosity can still be felt, particularly in the use of gold to accent the draperies, the landscape, and the chariot, and in the sensitive delineation of the horses and clouds against the sky (x-radiograph).

PROVENANCE: Paolo Paolini, Rome; sold American Art Galleries, New York, December 10–11, 1924, no. 94 (ill.), as Parentino, to George F. Harding, Jr.[1] George F. Harding, Jr. (d. 1939), Chicago, from 1924; The George F. Harding Museum, Chicago; Sotheby's, New York, December 2, 1976, no. 95 (ill.), withdrawn; transferred to the Art Institute, 1984.

REFERENCES: Fredericksen/Zeri 1972, pp. 249, 474, 572.

In the catalogue of the Paolini sale (1924), the picture was given to Bernardino Parentino, an attribution with which Van Marle apparently concurred.[2] In the Harding collection, it was regarded as a work from the circle of Michele da Verona, but this was rejected by Fredericksen and Zeri (1972), who attributed it to an anonymous Veronese painter of the fifteenth century. The picture shows a commingling of stylistic

elements from Ferrara and the Veneto which may have prompted the initial attribution to Parentino. Yet analogies to the Ferrarese school are particularly telling. Both the poetic treatment of the subject and the ungainly poses of the figures recall the engraved *tarocchi* series associated with Ferrara (fig. 1).[3] In general terms, the picture's classicizing manner is fairly typical of artists working in humanist circles in northern Italy toward the end of the fifteenth century. This and its damaged condition preclude a definite attribution.

The subject is taken from Ovid's *Metamorphoses* (2.1–400). Phaeton, the son of Phoebus, on being granted any wish by his father as evidence of his paternity, requested to drive the Sun God's chariot. Phoebus attempted to dissuade Phaeton from insisting upon this request, but finally acquiesced, although he knew the consequences would be fatal. Phaeton failed to keep control of the chariot and the four horses careered off course, causing fire and devastation when they came too close to earth. To prevent further destruction, Jupiter hurled a thunderbolt at the chariot and Phaeton fell to earth in flames, landing in the river Eridanus (sometimes identified as the river Po). Phaeton's mother, Clymene, mourned at her son's grave with her four daughters, the Heliades, who were eventually turned into poplar trees, their tears becoming drops of amber. This story contains some of Ovid's most glorious poetry, particularly in the account of Phaeton losing control of the chariot (*Metamorphoses* 2.201–07):

> When the horses feel . . . [the reins] lying on their backs, they break loose from their course, and, with none to check them, they roam through unknown regions of the air. Wherever their impulse leads them, there they rush aimlessly, knocking against the stars set deep in the sky and snatching the chariot along through uncharted ways. Now they climb up to the top of heaven, and now, plunging headlong down, they course along nearer the earth.[4]

The artist has tried, not unsuccessfully, to represent the principal aspects of the narrative. Phaeton is depicted in the upper half of the picture, fully illuminated by the light of Phoebus, the Sun God. The figure dimly perceived in the heavens just to the right of the leading pair of horses may be Luna. The figures

in the foreground may be Phaeton's four sisters, possibly with Clymene seated at the right.[5]

The visual tradition for the story of Phaeton is particularly rich. The subject was widely illustrated in antiquity, and such images were transmitted largely through the medium of manuscript illumination until their revival in the early Renaissance.[6] In Neoplatonic circles during the Renaissance, the plight of Phaeton was given a moralistic interpretation, as suggested by Philostratus's *Imagines* (1.11), and the subject was frequently included as an illustration to astrological texts.[7] The engraved *tarocchi* (fig. 1) illustrated the moment of Phaeton's fall as part of the series of the ten firmaments. The painter of the picture in Chicago was probably content to provide only a narrative account. There appears to be no direct visual quotation from any earlier treatment of the subject, and no hidden meanings seem to have been intended.

NOTES

1 According to The George F. Harding Museum papers (Archives, The Art Institute of Chicago).
2 See the Paolini sale catalogue (1924).
3 For these anonymous engravings, see J. Levenson in *Early Italian Engravings from the National Gallery of Art*, exh. cat., Washington, D.C., 1973, pp. 81–157, nos. 14–66.
4 Ovid, *Metamorphoses*, Loeb Classical Library, tr. by F. J. Miller, 3d ed., Cambridge, Mass., and London, 1984, pp. 74–75.
5 Another literary source for the fall of Phaeton is Philostratus, *Imagines* 1.11; but if the painter did refer to a text, it was probably to Ovid's.
6 P. P. Bober and R. O. Rubinstein, *Renaissance Artists and Antique Sculpture*, Oxford, 1986, pp. 69–70, no. 27. For more on this visual tradition, see J. J. G. Alexander, "A Manuscript of Petrarch's *Rime* and *Trionfi*," *Victoria and Albert Museum Handbook* 2 (1970), pp. 30–31; and L. Armstrong, *Renaissance Miniature Painters and Classical Imagery: The Master of the Putti and His Venetian Workshop*, London, 1981, pp. 65–66.
7 Armstrong (note 6), pp. 66, 96 n. 52.

Florentine

The Crucifixion, c. 1400
Mr. and Mrs. Martin A. Ryerson Collection, 1933.1032

Tempera on panel, including frame: 57.3 x 28 cm (22½ x 11¹⁄₁₆ in.); painted surface: 51 x 23.3 cm (20⅛ x 9³⁄₁₆ in.) at widest point, 13.2 cm (5³⁄₁₆ in.) at center

INSCRIBED: ·Ī·C̄·X̄·C̄· (in white pigment at the top of the cross), EREMID (on the scroll held by the figure at the foot of the cross)

CONDITION: The painting is in very good condition. It was treated in 1963 by Lawrence Majewski. Panel and frame are carved from a single piece of wood approximately 2.3 cm thick. During the 1963 treatment, an added foliate rim was removed from the frame, exposing portions of the original gilding. These are still visible on the inner rim of the frame to either side of the figure of Christ. The frame was then regessoed and regilt. At the same time, a foliate ornament was removed from the foot of the panel and a new wooden spike approximately 1 cm in diameter inserted into the hole in the wood. This hole is evidently old, since it had caused the surface of the panel to bulge slightly in the body of King David and also necessitated a fill approximately 4 cm upward on the back of the panel. A hole approximately 5 mm in diameter has been bored in the top of the panel. The back of the panel was prepared with a gesso ground applied with rather broad diagonal strokes and painted to imitate porphyry or marble (fig. 1).

The gold ground is intact, apart from small areas on either side of Christ and on his halo. The paint surface is in very good condition, having sustained only minor damage, mainly in the lower half. Tiny local losses in the figure of King David, the lower portions of the Magdalen's robe, and the head of the kneeling penitent have been filled and inpainted. The body of Christ and the roundel above the cross are particularly well preserved. Incised lines mark the outlines of the figures against the gilding, as well as the edges of the punched design, the latter drawn freehand (infrared, mid-treatment, ultraviolet, x-radiograph).

PROVENANCE: Achillito Chiesa, Milan; sold American Art Association, New York, pt. 4, November 22–23, 1927, no.

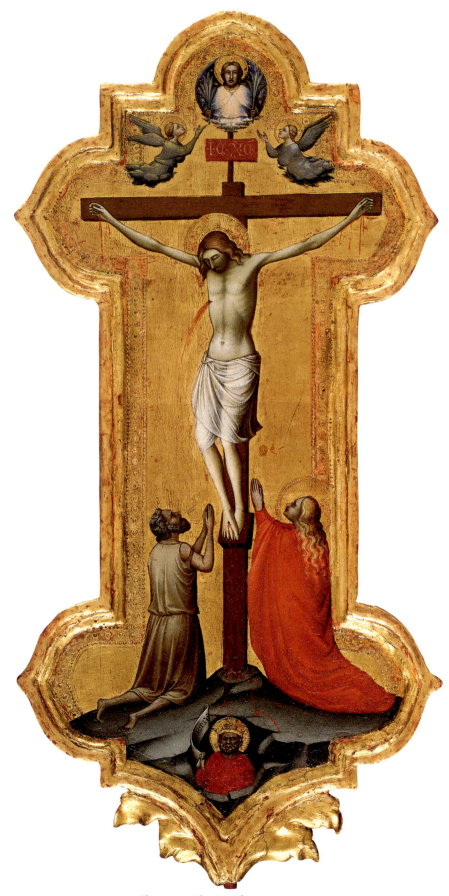

Florentine, *The Crucifixion*, 1933.1032

110, as Pietro Lorenzetti, for $1800.[1] Sold by Kleinberger, New York, to Martin A. Ryerson (d. 1932), Chicago, 1927;[2] on loan to the Art Institute from 1927; bequeathed to the Art Institute, 1933.

REFERENCES: D. C. Rich, "A Crucifixion by Bernardo Daddi," *AIC Bulletin* 22 (1928), pp. 74–75 (ill.). AIC 1932, p. 183. Berenson 1932, p. 165; 1936, p. 142; 1963, vol. 1, p. 53. Valentiner [1932], n. pag. AIC 1961, pp. 224–25. Huth 1961, p. 516. Maxon 1970, p. 24 (ill.). Fredericksen/Zeri 1972, pp. 111, 292, 571. M. Boskovits, *Pittura fiorentina alla vigilia del Rinascimento, 1370–1400*, Florence, 1975, p. 340, fig. 457. *The Art Institute of Chicago: 100 Masterpieces*, Chicago, 1978, p. 37, no. 1 (color ill.). M. Eisenberg, *Lorenzo Monaco*, Princeton, 1989, p. 182.

EXHIBITIONS: Muskegon, Michigan, Hackley Art Gallery, *Italian Paintings in the Loan Collection from Mr. Martin A. Ryerson*, M. Knoedler and Company, E. and A. Silberman, 1932, no. 1, as Gherardo Starnina. The Art Institute of Chicago, *A Century of Progress*, 1933, no. 97, as Gherardo Starnina. The Art Institute of Chicago, *The Art of the Edge: European Frames, 1300–1900*, 1986, no. 2.

The panel is of high quality, but its attribution, function, and penitential iconography remain problematic. Recent discussion of its authorship has focused on its relation to Lorenzo Monaco and his circle. At the time of the Chiesa sale in New York in 1927, an attribution to Pietro Lorenzetti was thought to

Fig. 1 Florentine, *The Crucifixion*, 1933.1032 (reverse)

be appropriate, although Rich (1928) and Berenson (1932, 1936, 1963) changed this to Bernardo Daddi, which is also too early in date. Van Marle proposed Starnina,[3] and the panel was ascribed to him when it was exhibited in 1932 and 1933. Lorenzo Monaco's name was first advanced in the 1960s, tentatively by Millard Meiss, who described the panel as "made in the shadow of the rather early Lorenzo Monaco," and more decidedly by Everett Fahy and Luciano Bellosi.[4] This suggestion was first published by Fredericksen and Zeri (1972), followed by Boskovits (1975), who proposed a date of 1395–1400. However, Eisenberg, though recognizing the panel's "superb quality," considered it the work of an anonymous Florentine contemporary of Lorenzo Monaco.[5]

The painter known as Lorenzo Monaco entered the Camaldolese monastery of Santa Maria degli Angeli in Florence in 1390 as a novice. The extent to which he was active as a painter before entering the monastery and the nature of his artistic training, possibly under Agnolo Gaddi, are matters of conjecture.[6] Santa Maria degli Angeli was the site of an important scriptorium. Illuminations as well as panel paintings are among the early works attributed to Lorenzo. The documented *Monte Oliveto Altarpiece* of 1407/10 in the Accademia, Florence, and the signed altarpiece of the *Coronation of the Virgin* dated 1413 (1414 according to the Gregorian calendar) in the Uffizi are the basis for attributions to him.[7] Lorenzo Monaco's exquisite color harmonies, subtle evocation of space, and rhythmic design exercised a powerful influence on Florentine painting about 1400.

Comparison of the Chicago *Crucifixion* with those works generally regarded as painted by the young Lorenzo Monaco is inconclusive, although there are stylistic similarities in the handling of the rock formation in the foreground and in the bronzed flesh tones. If the figure of Christ on the Cross is compared, for example, with that occurring in the *Crucifixion* from the predella from Santa Maria degli Angeli and now in the Louvre, dating from 1387/88 and attributed to Lorenzo,[8] it is evident that the painter of the Chicago panel had a better understanding of anatomy achieved primarily with a more vivid system of highlights. This argues for a comparison to slightly later works by Lorenzo Monaco such as the *Agony in the Garden* in the Accademia, Florence,[9]

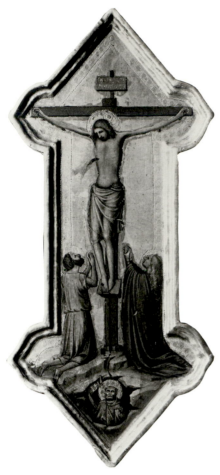

Fig. 2 *The Crucifixion*, La Quiete, Convento delle Montalve, Florence [photo: Gabinetto Fotografico della Soprintendenza ai Beni Artistici e Storici, Florence]

yet the drawing in the Chicago panel differs markedly from that in Lorenzo's works. The painter of the present panel favored attenuated arms and legs with thin wrists and ankles, dark outlines which silhouette the figures against the gold ground, and an emphatically linear treatment of the hair, which gives the impression that each figure is wearing a wig. Moreover, the figures' draperies are relatively contained, lacking the serpentine rhythms that already characterized the works of Lorenzo's early maturity.

In 1964 Millard Meiss called attention to the painter Matteo Torelli, who worked in the scriptorium of Santa Maria degli Angeli and is known to have collaborated with Lorenzo Monaco on manuscript illumination.[10] Torelli's hand has been isolated in several Florentine manuscripts, but these do not justify the attribution of the Chicago panel to him.

There can be little doubt, however, that a monastic scriptorium, possibly that at Santa Maria degli Angeli, is the most probable ambience for the origin of this panel.

The panel's iconography also seems to indicate the miniaturist tradition. At the foot of the cross to the left is an unidentified male figure whose garment is torn at the right shoulder and from whose head issue incised rays signifying that he is a *beatus* rather than a saint.[11] To the right of the cross is Mary Magdalen. On the central axis at the top is the figure of Christ in Glory holding a palm in each hand symbolizing his victory over death, while below is the crowned figure of King David, holding an inscribed scroll, shown somewhat in the manner of the *Lignum Vitae* (Tree of Life). These depictions of Christ in Glory and of King David are rare in panel painting, where normally the pelican is shown at the top of the cross and the skull of Adam at the foot. John Howett identified the inscription on the scroll carried by King David as being from Psalm 50, verse 3, of the Vulgate, "Miserere mei, Deus, secundum magnam misericordiam tuam; et secundum multitudinem miserationum tuarum, dele iniquitatem meam," which is Psalm 51, verse 1, of the Authorized Version, "Have mercy upon me, O God, according to thy loving kindness; according unto the multitude of thy tender mercies blot out my transgressions."[12]

The panel's shape and purpose are likewise difficult to explain. As noted above (see Condition), the frame is original, panel and frame being carved from a single piece of wood. A hole made at the lower edge for the insertion of a pole is apparently original, but whether this indicates that the panel was carried in processions or attached to a larger complex by this means cannot be positively determined. Another hole has been made at the top of the panel. The back is painted in imitation of porphyry (fig. 1), which suggests that it was probably not used in religious processions or as a reliquary cross. Neither does the panel seem to have served a particular liturgical function in the same way as a pax. It may simply have ornamented a cell of the monastic community in which it was almost certainly painted. A pietistic character is in any case expressed through the intensity of the two suppliant figures and the slight angle of the horizontal beam of the cross, which gives the

impression that the Crucified Christ turns toward the unidentified *beatus*.

Bellosi pointed out that a very similar composition (fig. 2), but one by a weaker hand close in style to Lorenzo di Niccolò, is preserved in the Convento delle Montalve in Florence (La Quiete).[13] This other panel lacks the two angels at the top, as well as the figure of Christ in Glory holding the palms. It is pointed at the top and bottom, but in all other respects is directly comparable.

NOTES

1 Price given in annotated copy of sale catalogue, Ryerson Library, The Art Institute of Chicago, as well as in *American Art Sales* 3, 1 (December 1927), p. 40.

2 According to registrar's records.

3 Opinion reported in a letter from Daniel Catton Rich to Martin A. Ryerson of January 13, 1930 (Archives, The Art Institute of Chicago). Evelyn Sandberg-Vavalà called it school of Agnolo Gaddi in an undated note in curatorial files.

4 Letters from Meiss to John Maxon of February 28, 1964, from Fahy to Maxon of June 25, 1968, and from Bellosi to Joseph Rishel of November 11, 1968. Fahy reaffirmed his opinion in a letter of March 31, 1987, to Martha Wolff. Laurence Kanter also accepted an attribution to Lorenzo Monaco, in a letter to Ian Wardropper of May 10, 1988. All of the above letters are in curatorial files.

5 Letter to Joseph Rishel of March 7, 1969, in curatorial files, a position restated in Eisenberg 1989, p. 182.

6 For recent discussions of Lorenzo Monaco's early career, see Eisenberg 1989 and M. Boskovits, *Gemäldegalerie Berlin: Frühe italienische Malerei*, ed. by E. Schleier, Berlin, 1988, pp. 93–99.

7 Eisenberg 1989, pp. 100–01, figs. 22–28, and pp. 120–24, figs. 44–62, pls. 7–9, respectively.

8 See F. Zeri, "Investigations into the Early Period of Lorenzo Monaco, I and II," *Burl. Mag.* 106 (1964), pp. 554–58, fig. 7. The Louvre predella panels are not universally accepted as early works by Lorenzo Monaco; see Eisenberg 1989, pp. 200–01, figs. 213, 216, and B. Cole, *Agnolo Gaddi*, Oxford, 1977, pp. 84–87, pls. 46–48.

9 Eisenberg 1989, pp. 98–99, figs. 7–14.

10 Letter from Meiss cited in note 4. See M. Levi d'Ancona, *Miniatura e miniatori a Firenze dal XIV al XVI secolo*, Florence, 1962, pp. 186–91, and idem, "Matteo Torelli," *Commentari* 9 (1958), pp. 244–58. A more restrictive notion of Torelli's collaboration with Lorenzo Monaco is expressed by M. Boskovits, "Su Don Silvestro, Don Simone e la 'Scuola degli Angeli,'" *Paragone* 23, 265 (1972), pp. 44–46.

11 Eisenberg's suggestion (1989, p. 182) that the radiant nimbus is a later addition is not supported by microscopic examination of the picture.

12 Letter from John Howett (Emory University, Atlanta) to the author of July 13, 1981, copy in curatorial files.

13 Letter from Bellosi cited in note 4; this panel was exhibited in Florence in 1933 (*Mostra del tesoro di Firenze sacra*, exh. cat., Florence, Convento di San Marco, 1933, p. 90).

Virgin and Child, 1270/80

Mr. and Mrs. Martin A. Ryerson Collection, 1933.1034

Tempera on panel, 81.7 x 47.8 cm (32⅛ x 18⅞ in.)

CONDITION: The painting is in fair condition. In 1957 Louis Pomerantz consolidated areas of delaminating paint and ground and adjusted the inpainting. In 1965 Alfred Jakstas cleaned the picture. The panel is composed of a single board of softwood with vertical grain. It is approximately 4 cm thick. The sides and bottom edge have been trimmed (see discussion below), though probably not in the recent past. The ground layer was prepared with a fabric interleaf, clearly visible in the x-radiograph and at the edges. The paint surface is generally pitted and uneven. The background has been completely abraded so that the red bole, and in some areas the ground, are exposed. Electron microprobe analysis demonstrated that remnants of a gray-black layer in the Virgin's halo are tarnished silver. Under the microscope tiny remnants of gold are also visible at the edge of the Virgin's head. The Child's halo has a gray-black layer that could not be identified as silver, together with more abundant traces of gold. Two circular areas of damage on either side of the Virgin's neck have been filled and inpainted. Two nail holes clearly visible on either side of the Child's head indicate that an ornament, probably a crown, was once attached to the panel. Very similar holes, now filled and inpainted, are clearly visible on either side of the Virgin's head in the x-radiograph; they may have served a similar purpose. The flesh tones are comparatively well preserved, apart from a paint loss extending from the left of the Virgin's mouth downward into her neck. This loss generally corresponds with a block inserted into the back of the panel, possibly as a repair at an early date. The draperies have suffered more damage than the flesh tones. The Child's robe, which now appears orange, seems to have had a red glaze, and his green mantle is painted over this red-orange tone. The x-radiograph shows incised lines marking the contours of the design and the centers of the two faces (x-radiograph).

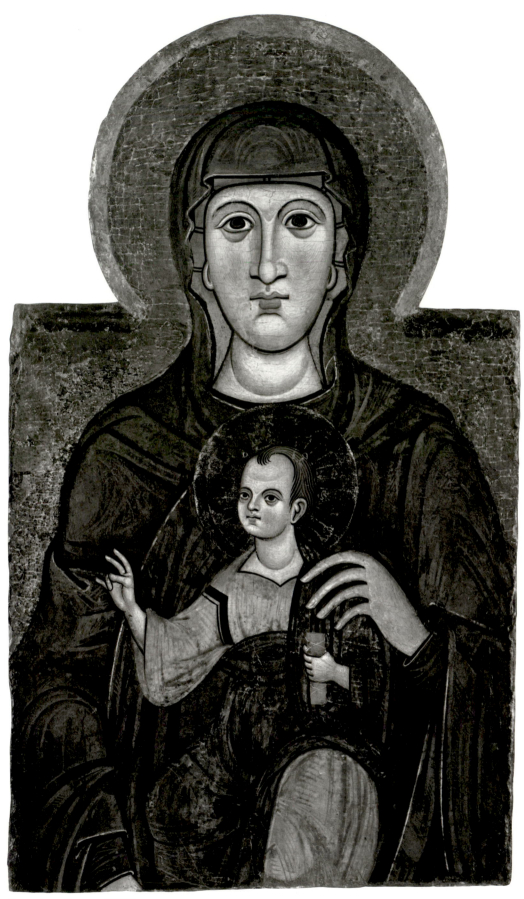

Florentine, *Virgin and Child*, 1933.1034

PROVENANCE: Bromhead, London.[1] Sold by Achille de Clemente, possibly through the agency of Paolo Monari Rocca, Florence, to Martin A. Ryerson (d. 1932), Chicago, 1924;[2] on loan to the Art Institute from 1924; bequeathed to the Art Institute, 1933.

REFERENCES: AIC 1925, p. 160, no. 2049. R. M. F[ischkin], "Two Thirteenth-Century Italian Paintings," *AIC Bulletin* 20 (1926), pp. 77–80 (ill.). *Ryerson Collection 1926*, pp. 5–6. C. H. Weigelt, "Über die 'Mütterliche' Madonna in der italienischen Malerei des 13. Jahrhunderts," *Art Studies* 6 (1928), p. 215. E. Sandberg-Vavalà, *La croce dipinta italiana e l'iconografia della passione*, Verona, 1929, p. 708 n. 39. L. Venturi 1931, pl. 111. AIC 1932, p. 183. R. van Marle, *Le scuole della pittura italiana*, rev. ed. of English text, vol. 1, The Hague and Milan, 1932, p. 213. Valentiner [1932], n. pag. C. J. Bulliet, *Art Masterpieces in a Century of Progress: Fine Arts Exhibition at The Art Institute of Chicago*, vol. 1, Chicago, 1933, no. 27 (ill.). A. M. Frankfurter, "Art in the Century of Progress," *Fine Arts* 20, 2 (1933), pp. 9 (ill.), 59–60. R. Offner, "The *Mostra del Tesoro di Firenze Sacra* — I," *Burl. Mag.* 63 (1933), p. 80. D. C. Rich, "The Paintings of Martin A. Ryerson," *AIC Bulletin* 27 (1933), p. 3 (ill.). AIC 1935, p. 20 (ill.). L. Coletti, *I primitivi*, Novara, 1941, vol. 1, p. XXXIII. G. Sinibaldi and G. Brunetti, *Pittura italiana del duecento e trecento: Catalogo della Mostra Giottesca di Firenze del 1937*, Florence, 1943, p. 61, under no. 18, p. 175, under no. 54, p. 213, under no. 64, pp. 217–18, under no. 65. E. B. Garrison, Jr., "Post-War Discoveries: Early Italian Paintings — I," *Burl. Mag.* 89 (1947), p. 152. AIC 1948, p. 25. R. Longhi, "Giudizio sul duecento," *Proporzioni* 2 (1948), p. 43, under M.64; reprinted in *Opere complete di Roberto Longhi*, vol. 7, Florence, 1974, p. 40, under M.64. Garrison 1949, pp. 23, 89, no. 213 (ill.). F. A. Sweet, "La pittura italiana all'*Art Institute* di Chicago," *Le vie del mondo: Rivista mensile del Touring Club Italiano* 15 (1953), pp. 689, 691 (ill.), 708. V. Lasareff, "Un nuovo capolavoro della pittura fiorentina duecentesca," *Rivista d'arte* 30 (1955), pp. 49 n. 104, 52, 53 n. 118. C. L. Ragghianti, *Pittura del dugento a Firenze*, Sele arte monografie, vol. 1, Florence, [1955], p. 99, fig. 141. AIC 1961, p. 34 (ill.). Huth 1961, p. 516. *Art Institute of Chicago*, Grands Musées 2, Paris [1968], pp. 19, 67. Maxon 1970, p. 22 (ill.). Fredericksen/Zeri 1972, pp. 140, 310, 571. A. Tartuferi, "Pittura fiorentina del duecento," in *La pittura in Italia: Il duecento e il trecento*, vol. 1, Milan, 1986, p. 275. A. Bencistà, *Arte nel contado: Itinerari nel Chianti fiorentino alla scoperta dei maestri minori*, Radda in Chianti, 1987, p. 90. L. C. Marques, *La Peinture du duecento en Italie centrale*, Paris, 1987, pp. 74, 85, 242 n. 130, 291. M. Ciatti in *La pieve di San Leolino a Panzano: Restauro e restituzione dei dipinti recuperati*, Il Chianti, storia, arte, cultura, territorio, vol. 8, Radda in Chianti, 1988, pp. 47–50. A. Tartuferi, *La pittura a Firenze nel duecento*, Florence, 1990, pp. 38, 52 n. 9, 85, 86, under Panzano, Pieve di San Leolino, fig. 109.

EXHIBITIONS: The Art Institute of Chicago, *A Century of Progress*, 1933, no. 99, as Tuscan School. The Art Institute of Chicago, *A Century of Progress*, 1934, no. 33, as Meliore Toscano. The Art Institute of Chicago, *Masterpiece of the Month*, December 1951, as Meliore Toscano (no cat.).

The Virgin is seen directly from the front with the Christ Child seated, apparently unsupported, in her lap. The Child is seen in three-quarters profile facing left, with his right hand raised in blessing. The Virgin's right hand, now cropped, presumably once held the Child's right foot. The painter seems to have

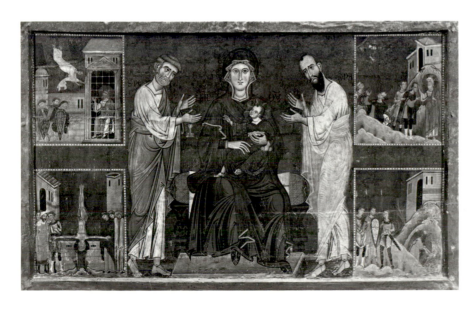

Fig. 1 Florentine, *Virgin and Child Enthroned between Saints Peter and Paul with Scenes from Their Lives*, San Leolino a Panzano [photo: Gabinetto Fotografico della Soprintendenza ai Beni Artistici e Storici, Florence]

combined aspects of two separate types of the early iconography of the Virgin and Child: the Virgin's frontal pose resembles that of the Virgin *Nikopeia*, while the Child's three-quarter pose is more suited to the Virgin *Hodegitria*, though the panel lacks the interaction between Mother and Child usually conveyed by this type.[3]

The shape of this painting, with the Virgin's head and halo protruding from the main portion of the panel, is known as an arcuated rectangle. This form of altarpiece achieved considerable popularity in Florence during the second half of the thirteenth century, a famous example being Coppo di Marcovaldo's panel in the church of Santa Maria Maggiore in Florence.[4] All the panels of this shape recorded by Garrison (1949) depict the Virgin and Child. The panel in Chicago has clearly been cut down, and is best described as a fragment. The panel was most drastically cut at the lower edge, but the sides were also trimmed, probably quite severely. Comparison with several related panels (see below) suggests that the Virgin may originally have been full-length and seated on a low throne. Two angels may also have been included in the upper corners of the main field, although no traces of these survive at the edges of the panel today.

Shortly after the first appearance of the panel, several scholars, notably Sirén, Weigelt (1928), and later Coletti (1941), favored an attribution to the Magdalen Master, an eclectic painter named after an altarpiece in the Accademia in Florence, or to his workshop.[5] Offner (1933) first suggested Meliore Toscano, whose only extant secure work is a low dossal signed and dated 1271 now in the Uffizi.[6] Also attributed to Meliore by Offner was the altarpiece of *The Virgin and Child Enthroned between Saints Peter and Paul with Scenes from Their Lives* in the church of San Leolino at Panzano (fig. 1).[7] The connection between the Panzano dossal and the Art Institute's *Virgin and Child* was underscored by Lasareff (1955). It is to this last altarpiece, in fact, that the panel in Chicago is most closely related in style. Comparison with the Virgin on this altarpiece reveals a similar formula for the drawing of the face with large staring eyes, round chin, cylindrical neck, pinched lower lip, and dew-drop ears. The fingers in both pictures are long and rather lifeless. The Christ Child

on the Chicago panel bears a comparable relationship to his counterpart on the Panzano altarpiece, although in the Art Institute's painting the hair at the back of the neck is shorter and his gaze is directed straight at the viewer. These similarities are sufficiently close to suggest that the painter of the present panel might at some stage have worked within the orbit of the author of the Panzano dossal, or even have been a member of his workshop.

The Chicago and Panzano panels have frequently been cited together as early works of Meliore, most recently by Tartuferi (1990). However, Longhi's (1948) and Lasareff's (1955) rejection of the direct association of these works with Meliore appears to be correct. Both paintings lack the decorative energy of the artist's signed altarpiece in the Uffizi. Furthermore, close comparison of the Chicago and Panzano panels suggests a difference in quality even between these two works, particularly in the drawing and the use of shadows. Where on the Panzano altarpiece the outline of the Virgin's jaw is suggested and is reinforced only by a short line at the chin, the painter of the panel in Chicago defined the entire face with one continuous outline. The present panel also lacks the shadow caused by the underside of the Virgin's veil, which gives greater subtlety to the lighting of her face on the altarpiece. As a result, where the painter of the Panzano altarpiece has created a lively characterization, the painter of the Chicago panel has only produced a stiff and somewhat wooden image. This distinction is emphasized by the treatment of the Child, whose animated pose on the altarpiece has become more stilted on the present panel.

It is clear that the painter was one of a number of popular artists active in Tuscany during the last quarter of the thirteenth century. He is close to the Rovezzano Master, the Bagnano Master, and the painter of the panel in the Museo Bandini in Fiesole.[8] All these painters are united stylistically by firm drawing, pale flesh tones relieved by rose-red highlights, and the use of deep colors for the drapery. The iconography of their work is also strictly traditional.

NOTES

1 According to Garrison 1949.
2 Achille de Clemente is listed as the seller of the painting in registrar's records. A note of April 12, 1924, signed by Paolo Monari Rocca of Florence, records information about the

transport of the panel from London to Ryerson in Chicago (Ryerson papers, Archives, The Art Institute of Chicago).

3 R. Jaques, "Die Ikonographie der *Madonna in trono* in der Malerei des Dugento," *Mitteilungen des Kunsthistorischen Institutes in Florenz* 5 (1937), pp. 2–31.

4 Garrison 1949, p. 91, no. 219 (ill.).

5 According to *Ryerson Collection* 1926, Sirén was the first to propose this attribution. For the altarpiece in Florence, see L. Marcucci, *Gallerie Nazionali di Firenze: I dipinti toscani del secolo XIII, scuole bizantine e russe dal secolo XII al secolo XVIII*, Rome, 1958, pp. 50–52, no. 16, fig. 17.

6 Marcucci (note 5), pp. 35–36, no. 9, fig. 8. Offner was followed in this suggestion by Garrison (1949), Ragghianti (1955), Tartuferi (1986, 1990), Bencistà (1987), Marques

(1987), and Ciatti (1988). The Chicago panel will be included in the *Corpus of Florentine Painting* among the works of Meliore (letter of March 23, 1992, from Ada Labriola for Miklós Boskovits, in curatorial files).

7 In this opinion he followed G. M. Richter, "Megliore di Jacopo and the Magdalen Master," *Burl. Mag.* 57 (1930), pp. 223–36. Garrison 1949, p. 143, no. 374 (ill.), and Ragghianti [1955], p. 98, fig. 145, also accepted Richter's attribution of the Panzano dossal to Meliore.

8 Garrison 1949, p. 94, no. 234 (ill.), p. 47, no. 35 (ill.), p. 90, no. 215 (ill.), respectively; for the painting in Fiesole, see also M. C. Bandera Viani, *Fiesole: Museo Bandini*, Bologna, 1981, p. 2, figs. 3, 5, 8.

Workshop of Francesco Francia

c. 1450 Bologna 1517/18

The Mystic Marriage of Saint Catherine of Alexandria, 1500/10
Mr. and Mrs. Martin A. Ryerson Collection, 1937.1002

Oil and tempera on panel, transferred to canvas, 60.2 x 48.4 cm (23¹¹⁄₁₆ x 19⅛ in.)

CONDITION: The painting is in fair to poor condition. It was transferred to canvas at an unknown date. Alfred Jakstas surface cleaned the picture in 1962 and undertook a more thorough treatment in 1963. There are two main areas of damage caused, in part, by splits along the vertical grain of the original panel. One extends roughly from the Virgin's left eye through the back of the Child's head down through his body, almost to his right foot. It involves a major area of paint and ground loss in the body and head of the Child, which has been repainted. The other extends in a jagged line from the right eye of Saint Catherine, between her raised hand and that of the Christ Child, and ends in a further area of paint and ground loss above the Child's left hand. Apart from these large areas of damage and numerous minute losses following the vertical crackle pattern of the original wood grain, the paint surface is in relatively good condition. The ends of Saint Catherine's fingers had been painted out in an earlier restoration. The x-radiograph and infrared photograph reveal that the artist changed the angle of her fingers and thumb, which perhaps added to the problematic appearance of this area. In the 1963 cleaning, existing repaint in the body and head of the Child was not removed. This area and other areas of more recent inpainting are now discolored. The halos were removed in 1963, leaving only traces of concentric gold lines around the heads of the Virgin, Saint Catherine, and the unidentified male saint.

Lightly incised lines mark the outer ring of these halos. A band of white paint approximately 2 cm wide was apparently painted over the original design at the bottom edge (infrared, mid-treatment, ultraviolet, x-radiograph).

PROVENANCE: Horace Morison, Boston, by 1910 to 1916.[1] Sold by Morison to Martin A. Ryerson (d. 1932), Chicago, 1916; at his death to his widow, Mrs. Martin A. Ryerson (d. 1937); bequeathed to the Art Institute, 1937; Parke-Bernet, New York, May 4, 1944, no. 62 (ill.), withdrawn.

REFERENCES: F. Mason Perkins, "Dipinti italiani nelle raccolte americane," *Rassegna d'arte* 10 (1910), p. 100, ill. opp. p. 99. A. Venturi, vol. 7, pt. 3, 1914, p. 960, fig. 715. G. H. Edgell, "The Loan Exhibition of Italian Paintings in the Fogg Museum, Cambridge," *Art and Archaeology* 2 (1915), p. 21, fig. 9. Valentiner [1932], n. pag. "Exhibition of the Ryerson Gift," *AIC Bulletin* 32 (1938), p. 3. AIC 1961, p. 226. Fredericksen/Zeri 1972, pp. 74, 385, 571.

EXHIBITIONS: Cambridge, Massachusetts, Fogg Art Museum, *Loan Exhibition of Italian Paintings*, 1915 (no cat.). Rockford Art Association, Illinois, 1951 (no cat.). Beloit College, Wisconsin, 1952–53 (no cat.). Fort Wayne Art School, Indiana, 1955 (no cat.).

Perkins was the first to publish the picture in 1910, praising it highly and confidently advancing an attribution to Francesco Francia. While Edgell (1915)

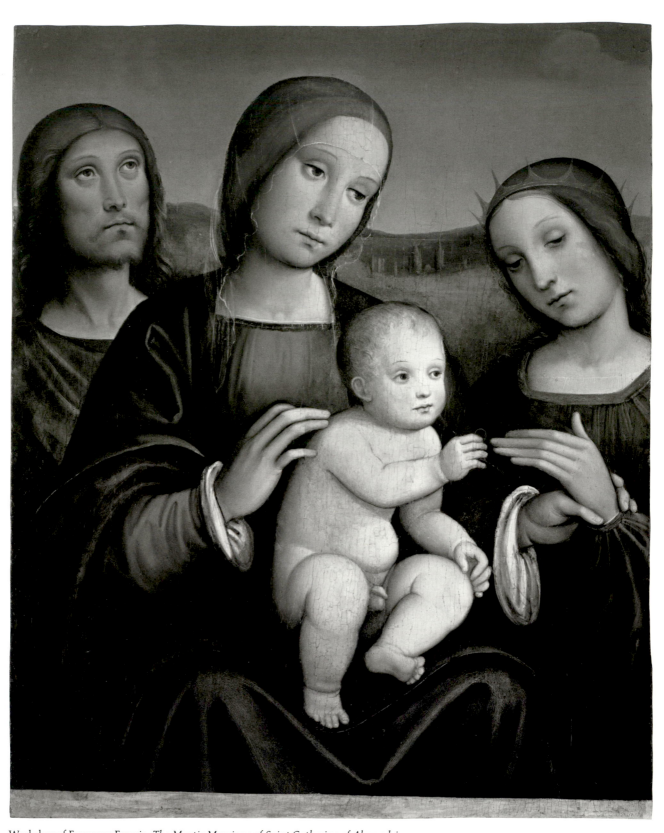

Workshop of Francesco Francia, *The Mystic Marriage of Saint Catherine of Alexandria*, 1937.1002

and Valentiner (1932) agreed with Perkins, Adolfo Venturi (1914) suggested the name of Jacopo de' Boateri, a follower of Francia, by whom there is a signed painting in the Palazzo Pitti in Florence and a not totally dissimilar composition of the *Virgin and Child with Saints Anthony Abbot and Catherine of Alexandria* in the Villa Borghese in Rome;[2] this suggestion has not been widely accepted. On the other hand, the Art Institute's 1961 catalogue of paintings settled for an unnecessarily cautious attribution to an anonymous Italian painter (c. 1510). Fredericksen and Zeri (1972) have more recently quite correctly restored the connection with Francia, describing the picture as a product of the workshop. Another version of this subject of approximately the same dimensions, ascribed to Francesco's son Giacomo, is in the National Collection of Fine Arts at the Smithsonian Institution in Washington, D.C. (1913.6.3).

The male saint on the left, balancing Saint Catherine of Alexandria, has not been identified.

Although this is not a picture of very high quality, it is relevant to recall that Francia exercised a considerable influence on Correggio, who painted this subject on no less than four separate occasions and by whom there is an important painting in the Art Institute (1965.688).

NOTES
1 See Perkins 1910, a letter from Morison to Ryerson of February 16, 1916 (curatorial files), and an entry in Ryerson's notebook dated February 1916 (Ryerson papers, Archives, The Art Institute of Chicago).
2 See Venturi 1914, fig. 713, and P. Della Pergola, *Galleria Borghese: I dipinti*, vol. 1, Rome, 1955, p. 17, no. 8, fig. 8. Antonio Morassi gave the painting to the school of Francesco Francia during a visit to the Art Institute on October 10, 1952 (see notes in curatorial files).

Vincenzo Frediani

Active Lucca by 1481, d. Lucca 1505

The Adoration of the Christ Child, c. 1490
Max and Leola Epstein Collection, 1954.289

Tempera on panel, 52 x 47.2 cm (20½ x 18⁹⁄₁₆ in.); painted surface: 50.5 x 45.7 cm (19⅞ x 18 in.)

CONDITION: The painting is in good condition. It was treated in 1961–62. The panel, which has a vertical grain, was presumably planed down, since it is now 0.5 cm thick and has been laminated to a secondary support. The unpainted edges and a barbe indicating that the picture had an engaged frame remain on all four sides. In general, the paint surface is in good condition, the landscape being especially well preserved. There are minor retouches in the flesh tones, but the only area of extensive retouching is in the Virgin's blue mantle, particularly at the lower left. Some minor repairs have been made to the architecture behind Joseph.

PROVENANCE: Counts Sardini, Lucca; sold to Charles Fairfax Murray, London.[1] Ralph Brocklebank, Haughton Hall, Tarporley, Cheshire, 1897–1922; sold Christie's, London, July 7, 1922, no. 93, as Filippo Lippi, *The Madonna Adoring the Infant Saviour*, to Visman for £39 18s.[2] Max Epstein (d. 1954), Chicago, by 1926;[3] on loan to the Art Institute, 1926; bequeathed to the Art Institute, 1954.

REFERENCES: R. R. Carter, *Pictures and Engravings at Haughton Hall, Tarporley, in the Possession of Ralph Brocklebank*, London, 1904, pp. viii, 12, no. 9 (ill.). *Old Masters in the Collection of Max Epstein*, Chicago, 1928, ill., n. pag. A. Scharf, *Filippino Lippi*, Vienna, 1935, p. 114, no. 93, fig. 210. AIC 1961, p. 261. Fredericksen/Zeri 1972, pp. 131, 352, 571. M. Ferretti, "Percorso lucchese," *Annali della Scuola Normale Superiore di Pisa: Classe di lettere e filosofia*, ser. 3, 5 (1975), pp. 1041 n. 15, 1042 n. 17. E. Fahy, *Some Followers of Domenico Ghirlandajo*, New York and London, 1976, p. 177. M. Natale, "Note sulla pittura lucchese alle fine del quattrocento," *The J. Paul Getty Museum Journal* 8 (1980), p. 55, fig. 37. C. Baracchini and M. T. Filieri, "Pittori a Lucca tra '400 e '500," *Annali della Scuola Normale Superiore di Pisa: Classe di lettere e filosofia*, ser. 3, 16 (1986), pp. 752, 755, pl. XXXIV, 1. M. Ferretti, "Vincenzo Frediani," in *Colección Cambó*, exh. cat., Barcelona, Fundación Caja de Barcelona, 1991, pp. 266 (ill.), 268–69.

The panel was formerly in a tabernacle frame of unknown date with a painted lunette of God the Father surrounded by cherubim above and a coat of arms below said to be that of the Counts Sardini of Lucca (fig. 1).[4]

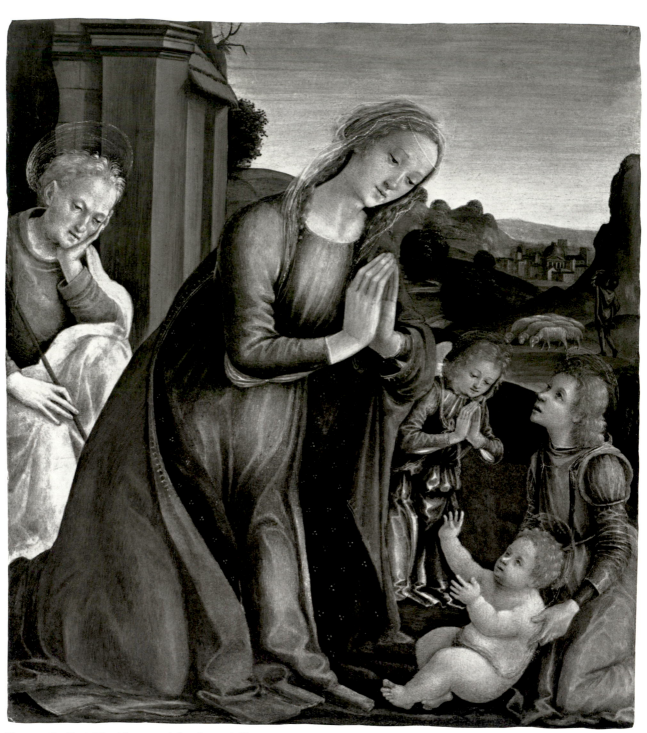

Vincenzo Frediani, *The Adoration of the Christ Child*, 1954.289

When in the Brocklebank and Epstein collections the painting was regarded as a work by Filippino Lippi.[5] Scharf (1935) described it as a product of the workshop, but the panel was again attributed to Filippino Lippi in the Art Institute's 1961 catalogue of paintings. An attribution to Filippino Lippi's anonymous Lucchese follower known as the Master of the Lucchese Immaculate Conception was first made by Fahy in 1968, followed by Fredericksen and Zeri (1972) and by Ferretti (1975). However, Natale (1980) tentatively attributed the panel to the Master of the Paolo Buonvisi Altarpiece, whose name is derived from an altarpiece of the *Virgin and Child with Saints John the Baptist, Matthew, Frediano, and Pellegrino* of 1487.[6] This artist's works were first separated from those attributed to the Master of the Lucchese Immaculate Conception by Ferretti (1975), who nevertheless did not assign the panel in Chicago to this new grouping.

The groupings of late fifteenth-century paintings from Lucca made on the basis of style have recently been confirmed and also qualified by archival research into the careers of documented Lucchese painters. Thus, the Master of the Lucchese Immaculate Conception (named after the altarpiece of the *Immaculate Conception with Saints Augustine and Anselm, the Prophets David and Solomon, and Saint Anthony of Padua* from the church of San Francesco in Lucca) can now be conclusively identified as Vincenzo Frediani, documented in Lucca from 1481 until his death in 1505.[7] Indeed, the discovery of the contract for the eponymous altarpiece of the Immaculate Conception, commissioned at the end of 1502 to be completed in the following year,[8] indicates that this is in fact a late work by Frediani. The attribution of a separate group of works to the Master of the Paolo Buonvisi Altarpiece no longer seems necessary and has been repudiated by Ferretti.[9] The distinct character of the Buonvisi altarpiece, dated 1487, seems now to be due not to the authorship of another painter but to its earlier date, to the conservative arrangement of standing saints against a gold ground, which must be a factor of its commission, and to its more overt debt to Filippino Lippi.[10] While the possibility of workshop participation in the oeuvre now assigned to Frediani should not be excluded, it seems likely, as Everett Fahy has suggested, that the works once given to the

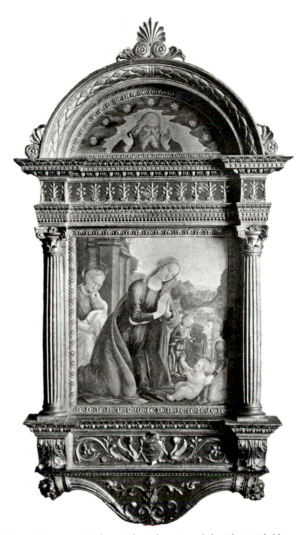

Fig. 1 Vincenzo Frediani, *The Adoration of the Christ Child*, 1954.289 [photo: R. R. Carter, *Pictures and Engravings at Haughton Hall, Tarporley, in the Possession of Ralph Brocklebank*, London, 1904, no. 9]

Master of the Paolo Buonvisi Altarpiece are in fact relatively early works by Frediani.[11]

Comparison of the Chicago panel to the altarpiece of the Immaculate Conception shows that the pose and draperies of the kneeling Virgin are closely related in the two works. Nevertheless, the more sinuous, even slightly unstable, treatment of the Virgin's figure is closer to earlier works by Frediani such as the altarpiece from San Bartolomeo in Ruota (near Lucca), completed by 1488.[12] The delicate features of the angels find their counterparts in the altarpiece formerly in the Alte Pinakothek in Munich,[13] which is itself directly related in type to the *Virgin and Child* from Montefegatesi dated 1491.[14] Hence a date of about 1490 or shortly thereafter seems appropriate for the Chicago panel.[15]

NOTES

1 Carter (1904, p. 12) stated that the picture "had been in an oratory in the Sardini Palace for some centuries — perhaps from the time it was painted" and that "it was brought to England by Mr. Fairfax Murray."

2 Ralph Brocklebank bought the picture in 1897, according to Carter (1904, p. 12). The price and buyer at the 1922 Christie's sale are given in *Art Prices Current, 1921–1922,* p. 435. The price is confirmed in an annotated copy of the sale catalogue in the Resource Collection of the Getty Center for the History of Art and the Humanities, Santa Monica.

3 According to registrar's records.

4 According to Carter (1904, p. 12), who reproduced the picture in this frame. A photograph bearing an expertise by Wilhelm von Bode and the date 1926 (in curatorial files) shows the picture framed only with the rosette-trimmed inner molding. This too has now disappeared.

5 In 1926, Bode supported the attribution to Filippino Lippi (see expertise cited in note 4 above); in 1929, Lionello Venturi rejected the attribution to Filippino, proposing Bartolommeo di Giovanni instead (opinion of February 6, 1929, quoted in registrar's records), and Wilhelm Valentiner rejected the attribution to Filippino, but offered no alternative attribution (letter to Martin A. Ryerson of February 14, 1929, Archives, The Art Institute of Chicago); in 1930, Raimond van Marle suggested that the picture might "possibly" be by Ghirlandaio (opinion of January 11, 1930, quoted in registrar's records).

6 *Museo di Villa Guinigi: La villa e le collezioni,* Lucca, 1968, p. 169, fig. 75.

7 For the altarpiece, see ibid., pp. 164–66, color pl. VI. For the career of Frediani, see M. Tazartes, "Anagrafe lucchese — I. Vincenzo di Antonio Frediani 'pictor de Luca': Il Maestro dell'Immacolata Concezione?" *Ricerche di storia dell'arte* 26 (1985), pp. 4–17; and G. Ghilarducci and C. Ferri, "Pittori a Lucca tra '400 e '500: Notizie biografiche," *Annali della Scuola Normale Superiore di Pisa: Classe di lettere e filosofia,* ser. 3, 16 (1986), pp. 777–89.

8 For the contract for the altarpiece, see Ghilarducci and Ferri (note 7 above), pp. 785–86; and M. Tazartes, "Nouvelles Perspectives sur la peinture lucquoise du quattrocento," *Revue de l'art* 75 (1987), pp. 32–34.

9 Ferretti 1991, pp. 262–70, esp. p. 264.

10 For Filippino's work in Lucca in 1482–83, see M. Meiss, "A New Monumental Painting by Filippino Lippi," *Art Bull.* 55 (1973), pp. 479–93; and idem, "Once Again Filippino's Panels from San Ponziano, Lucca," *Art Bull.* 56 (1974), pp. 10–11.

11 Letter of August 30, 1987, to Martha Wolff in curatorial files.

12 Baracchini and Filieri 1986, p. 752, pl. XXXIII, 1; and Ghilarducci and Ferri 1986 (note 7 above), p. 778.

13 Natale 1980, figs. 32, 36; exhibited Milan, Gallerie Salamon Agustoni Algranti, *Mostra di 36 dipinti di antichi maestri,* 1986, no. 4.

14 Now in the Museo Nazionale Villa Guinigi, Lucca; Natale 1980, p. 53, fig. 31; and Ferretti 1991, pp. 265 (ill.), 268.

15 Baracchini and Filieri (1986, p. 752) suggested a date in the first years of the 1490s, while Ferretti (1991, p. 269) dated it around 1492/93.

Niccolò di Pietro Gerini

Documented Florence 1368–1411

Virgin and Child, 1390/1400

Mr. and Mrs. Martin A. Ryerson Collection, 1937.1003

Tempera on panel transferred to canvas, 78.7 x 46.5 cm (31⅜ x 18⁵⁄₁₆ in.)

INSCRIBED: AVE·MARIA·GRACIA·PLENA·DOMINVS·TE (along base of frame)[1]

CONDITION: The painting is in very poor condition. It was transferred to a canvas support at an unknown date. In 1976–78 it was cleaned and retransferred in an extensive treatment supervised by Alfred Jakstas. The canvas to which it had been transferred was removed, and the paint and ground layers were reattached to a plywood support faced with linen. The report of the 1976–78 treatment and the x-radiograph indicate the presence, at the level of the ground, of an irregularly pieced fabric layer which is probably original. The picture's surface remains disfigured by pronounced craquelure and areas of irregularly lifting paint. Losses along the edges, particularly at the bottom and around the arch, have been filled and repainted. Damage, probably caused by disturbances in the original wood support, extends downward from the arched top of the picture into the Virgin's veil and down through her forehead, left eye, neck, and brocaded robe into the joined hands of the Virgin and Child. Her left eye and the Child's raised hand are largely reconstructed. The flesh tones are almost completely repainted. The punching, however, is fairly well preserved. The contours have been incised. The elements making up the base and the arch of the frame are old, but the entire frame construction has been made up and then thinned and attached to a new frame (infrared, midtreatment, ultraviolet, x-radiograph).

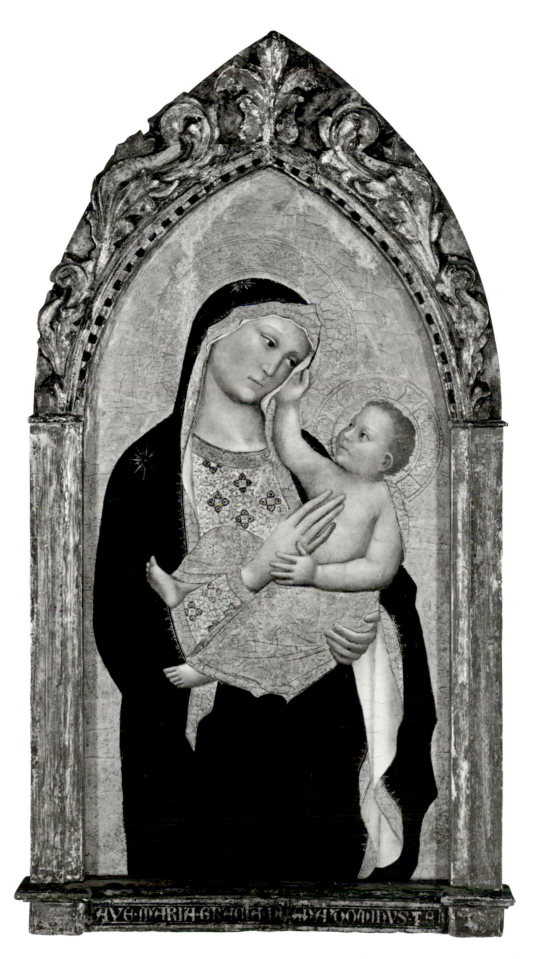

PROVENANCE: James Kerr-Lawson, Florence.[2] Sold by Kerr-Lawson to Martin A. Ryerson (d. 1932), Chicago, 1910; at his death to his widow, Mrs. Martin A. Ryerson (d. 1937); bequeathed to the Art Institute, 1937.

REFERENCES: R. Offner, "Niccolò di Pietro Gerini," *Art in America* 9 (1921), pp. 148, 153–55, fig. 1. Van Marle, vol. 3, 1924, p. 614. R. Offner, *Studies in Florentine Painting: The Fourteenth Century*, New York, 1927, pp. 83, 85–87, 92, fig. 5. Berenson 1932, p. 394; 1936, p. 339; 1963, vol. 1, p. 158. Valentiner [1932], n. pag. "Exhibition of the Ryerson Gift," *AIC Bulletin* 22 (1938), p. 3. AIC 1961, p. 174. Huth 1961, p. 516. Fredericksen/Zeri 1972, pp. 81, 312, 571. M. Boskovits, *Pittura fiorentina alla vigilia del Rinascimento, 1370–1400*, Florence, 1975, p. 404. R. Offner, *A Critical and Historical Corpus of Florentine Painting: A Legacy of Attributions*, ed. by H. B. J. Maginnis, *Supplement*, New York, 1981, p. 72.

EXHIBITIONS: The University of Chicago, The Renaissance Society, *Old and New Masters of Religious Art*, 1931, no. 76. The University of Chicago, The Renaissance Society, *Commemorative Exhibition from the Martin A. Ryerson Collection*, 1932, no. 2. The Art Institute of Chicago, *Exhibition of the Ryerson Gift*, 1938 (no cat.). Chicago, Englewood High School, 1946 (no cat.). Chicago, C. D. Peacock Co., 1952 (no cat.).

The attribution to Niccolò di Pietro Gerini, which is undisputed, was first made by Offner (1921). Gerini may be characterized as a late Giottesque painter much influenced by Orcagna with whom he may indeed have collaborated. In his penetrating stylistic analysis of the work of this artist, Offner (1921, 1927) dwelt on the panel in Chicago at some length, even though it has seemingly always been in a precarious state of preservation. Despite its poor condition, both the composition and the original outline of the forms of the figures are still evident. Indeed, the monumentality of the three-quarter-length figure of the Virgin in relation to the size of the panel is still remarkably striking, bearing out Offner's vivid description of "the constant conflict and reconciliation between the sense of growth and the sense of gravity" in Gerini's work.[3] Offner suggested a date around 1400, while Boskovits (1975) favored a slightly earlier date of 1390/95.

The Child reaching up to the Virgin's veil is a gesture found frequently in Florentine art from the late thirteenth century.[4] It can be interpreted as a premonition of the Passion in that the Virgin's veil foreshadows the shroud in which the dead Christ would later be wrapped.[5]

NOTES
1 Luke 1.28.
2 According to registrar's records and invoice from Kerr-Lawson to Ryerson of June 14, 1910, in curatorial files.
3 Offner 1921, p. 154, and Offner 1927, p. 85.
4 For the origin of this iconographic motif, see D. C. Shorr, *The Christ Child in Devotional Images in Italy during the XIV Century*, New York, 1954, pp. 116–23.
5 Ibid., p. 117.

Follower of Domenico Ghirlandaio

c. 1448 Florence 1494

The Virgin Adoring the Child with the Young Saint John, 1490/1510

Mr. and Mrs. Martin A. Ryerson Collection, 1937.1005

Tempera on panel, diameter 97.5 cm (38⅜ in.)

INSCRIBED: ·EC[CE]·AGN[US]·DEI·QUI [. . .] (on the scroll held by the young Saint John)[1]

CONDITION: The painting is in poor condition. It was cleaned by Alfred Jakstas in 1963–64. At an unknown date, the panel was thinned to approximately 6 mm and placed on a secondary wooden support, which was then cradled. The panel appears to be comprised of at least three boards aligned at an angle to the painted design. There are now so many splits in the wood that the exact number of the constituent boards cannot be determined even in the x-radiograph. Fills and heavy retouching along these splits and joins add to the general disfigurement of the panel. There are also several areas of paint and ground loss on the Virgin's mantle, in the sky, and below Saint Francis's left elbow. The whole painting has suffered from considerable abrasion and past cleaning. In particular, the flesh tones are abraded in many areas to

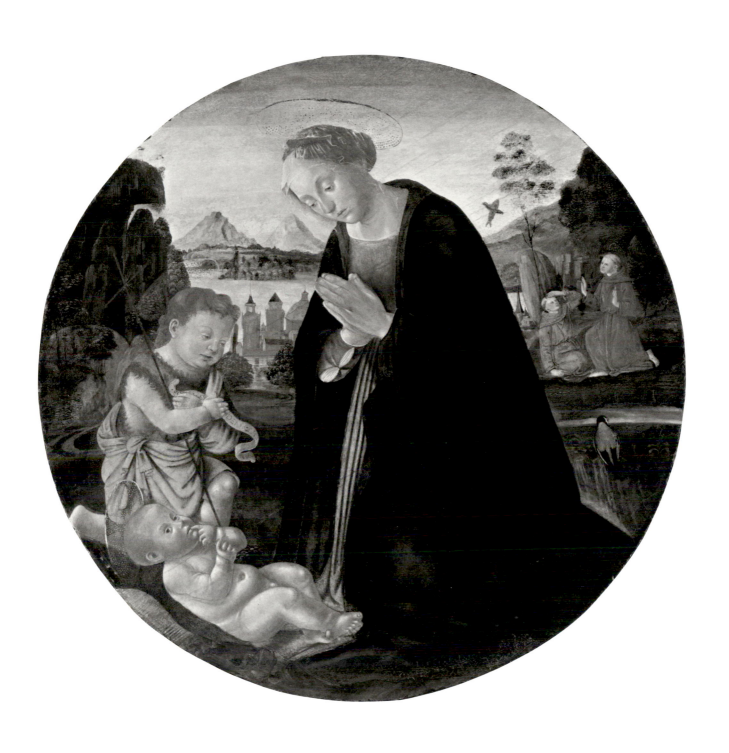

the level of the green underpainting. Although some of the highlights over the flesh tones remain, particularly in the face of the Virgin, the middle tones modeling the flesh are for the most part gone. Because of the abrasion, adjustments in the positioning of the Christ Child and the young Saint John are now clearly visible (infrared, mid-treatment, ultra-violet, x-radiograph).

PROVENANCE: Ehrich Galleries, New York.[2] Sold by Ehrich to Martin A. Ryerson (d. 1932), Chicago, 1898; on loan to the Art Institute, 1898;[3] at Ryerson's death to his widow, Mrs. Martin A. Ryerson (d. 1937); bequeathed to the Art Institute, 1937.

REFERENCES: AIC 1898, p. 124. Van Marle, vol. 13, 1931, p. 222 n. 1. Valentiner [1932], n. pag. "Exhibition of the Ryerson Gift," AIC Bulletin 32 (1938), p. 3. AIC 1961, p. 266. Huth 1961, p. 516. Fredericksen/Zeri 1972, pp. 117, 344, 571. E. Fahy, Some Followers of Domenico Ghirlandaio, New York and London, 1976, p. 214.

EXHIBITIONS: The University of Chicago, The Renaissance Society, Religious Art from the Fourth Century to the Present Time, 1930, no. 19, as Mainardi. The Art Institute of Chicago, Old and Modern Masters from Chicago Collections, 1935 (no cat.). The Art Institute of Chicago, Exhibition of the Ryerson Gift, 1938 (no cat.), as Mainardi. Fort Wayne Art Museum, Indiana, Christmas Story in Art, 1953 (no cat.), as Mainardi.

Van Marle (1931) ascribed the panel to Sebastiano Mainardi, an attribution that was upheld in the Art Institute's 1961 catalogue of paintings and subsequently by Fredericksen and Zeri (1972).[4] Fahy (1976), however, tentatively listed the painting as a work by Benedetto Ghirlandaio, the younger brother of the more famous Domenico, who was a leading master in Florence in the last quarter of the fifteenth century and the teacher of Michelangelo. Only one signed work by Benedetto is known, an altarpiece of The Nativity in the church of Notre Dame in Aigueperse (near Vichy).[5] Fahy asserted that the panel in Chicago is by the same hand as The Nativity in the John G. Johnson Collection in the Philadelphia

Museum of Art.[6] However, the similarities between these two panels are by no means overwhelming, and neither is similar enough to the signed altarpiece by Benedetto to warrant attribution to that artist. The facial type of the Virgin on the Philadelphia panel approximates that of her counterpart on the altarpiece in France, and the pleated folds and the swaths of drapery on the Chicago panel are also found on the altarpiece, but other similarities with Benedetto's signed work are not evident. The principal differences between the panels in Chicago and Philadelphia lie in the treatment of the Virgin's features (especially the eyes and mouth) and in the drawing of the Christ Child (notably the head and stomach). Although the poor condition of the present panel may preclude any final decision about the attribution of the painting, both the circular composition and the landscape are wholly typical of works painted by followers of Domenico Ghirlandaio around 1500.[7]

The scene of Saint Francis receiving the stigmata in the right background serves as a reference to Christ's death, insofar as the stigmata are associated with the wounds suffered by Christ on the cross.[8] The goldfinch perched to the right of the Virgin, below the scene of the stigmatization, symbolizes Christ's Passion.

NOTES
1 John 1.29.
2 See receipt from Ehrich to Ryerson of June 28, 1898 (Archives, The Art Institute of Chicago).
3 According to AIC 1898, p. 124.
4 The Chicago picture can be compared to Mainardi's Madonna and Saints in the Wallraf-Richartz Museum, Cologne (note the head of Saint Catherine), and to a Madonna, Saint John, and Angels, also by Mainardi, in the Liechtenstein Collection (compare the head of John the Baptist). For illustrations, see Van Marle, vol. 13, figs. 131, 136.
5 Berenson 1963, vol. 2, fig. 998.
6 B. Sweeny, John G. Johnson Collection: Catalogue of Italian Paintings, Philadelphia, 1966, p. 31, no. 68, p. 163 (ill.).
7 For examples, see Van Marle, vol. 13, figs. 81, 98, 101.
8 H. W. van Os, "St. Francis of Assisi as a Second Christ in Early Italian Painting," Simiolus 7 (1974), pp. 115–32.

Ridolfo Ghirlandaio

1483 Florence 1561

Portrait of a Gentleman, c. 1505
Mr. and Mrs. Martin A. Ryerson Collection, 1933.1009

Oil, probably with some tempera, on panel transferred to canvas, 68.2 x 49.2 cm (26¹¹⁄₁₆ x 19⅜ in.)

CONDITION: The painting is generally in fair condition. It received minor treatment in 1953 and 1981, and was cleaned and restored by Frank Zuccari in 1988–89. Previous major treatments took place before the picture entered the Ryerson collection in 1912. These included transfer from panel to canvas as well as extensive repainting. Despite the transfer, the picture retains the character of a panel painting. The repainting included the landscape at the top left, large areas of the *cappuccio* and cloak, and the parapet in the foreground. Cleaning in 1988 revealed the flesh areas to be relatively well preserved, though there is thinning and blanching in the shadow tones. The red-brown robe, the gray background wall, and the parapet are also fairly well preserved, as are parts of the black cloak and the *cappuccio*, although the areas on the shoulders and immediately surrounding the head are severely abraded. In the landscape, the mill, the figures, and the tree have suffered severe damage and have been extensively reconstructed. In addition, there are relatively large local losses in the paint and ground layers in the center of the parapet, in the sitter's sleeve above the parapet, and in the *cappuccio* above the sitter's left eye. These areas have been filled and inpainted.

X-radiography reveals that the parapet was added by the artist himself, thereby eliminating the lower part of the figure, which had already been brought to a high degree of finish. The left contour of the long side of the *cappuccio* was extended somewhat over the background, while its right contour was also moved to the left, leaving a slightly larger triangle of background visible between the chin and hat. The artist first painted a ledge underneath the window and then painted it over. This ledge was revealed through past cleaning action and was then reinforced when the background was restored sometime before 1901. Microscopic examination confirms that the traces of gray background color covering the ledge at the left of the sitter's hat are indeed original paint.[1]

There is underdrawing in the face, the shape of which is outlined by a precise contour. The nose has been painted very slightly smaller than the underdrawing (infrared, mid-treatment, ultraviolet, x-radiograph).

PROVENANCE: Prince Brancaccio, Rome.[2] William Beattie, Glasgow, by 1901.[3] Arthur T. Sulley, London, by 1910.[4]

Scott and Fowles, New York. Sold by Scott and Fowles to Martin A. Ryerson (d. 1932), Chicago, 1912;[5] on loan to the Art Institute from 1912; bequeathed to the Art Institute, 1933.

REFERENCES: W. Armstrong, "Early Italian Portraits," *Art Journal* 53 (1901), pp. 46 (ill.), 47. *Drawings by Old Masters in the Collection of the Duke of Devonshire at Chatsworth*, intro. by S. A. Strong, London, 1902, p. 5. Berenson 1909b, p. 139; 1932, p. 226; 1936, p. 194; 1963, vol. 1, p. 77. AIC 1914, p. 208, no. 2097; 1917, p. 164; 1920, p. 62; 1922, p. 71; 1923, p. 71; 1925, p. 159, no. 2026. *Ryerson Collection* 1926, pp. 23–24. C. Gamba, "Ridolfo e Michele di Ridolfo del Ghirlandaio," *Dedalo* 9 (1929), pp. 465–67 (ill.). L. Venturi 1931, pl. CCCXXXVIII. AIC 1932, p. 180, no. 203.12. Valentiner [1932], n. pag. D. C. Rich, "The Paintings of Martin A. Ryerson," *AIC Bulletin* 27 (1933), pp. 5 (ill.), 12. AIC 1935, p. 20 (ill.). H. Tietze, *Meisterwerke europäischer Malerei in Amerika*, Vienna, 1935, p. 331, no. 109 (ill.). R. Brimo, *Art et goût: L'Evolution du goût aux Etats-Unis d'après l'histoire des collections*, Paris, 1938, p. 92. AIC 1948, p. 26. F. A. Sweet, "La pittura italiana all'*Art Institute* di Chicago," *Le vie del mondo: Rivista mensile del Touring Club Italiano* 15 (1953), p. 697 (ill.). AIC 1961, pp. 41 (ill.), 177. S. J. Freedberg, *Painting of the High Renaissance in Rome and Florence*, Cambridge, Mass., 1961, vol. 1, p. 78; vol. 2, pl. 80. Huth 1961, pp. 516–17. Fredericksen/Zeri 1972, pp. 83, 571. A. Fabre and P. Costamagna, "A propos de *L'Orfèvre* du Pitti," *Antichità viva* 24 (1985), p. 33 n. 6.

EXHIBITIONS: London, Lawrie and Co., *Portraits and Pictures of the Early Italian School*, 1900, no. 12. The Art Institute of Chicago, *A Century of Progress*, 1933, no. 116. The Art Institute of Chicago, *A Century of Progress*, 1934, no. 47. New York, M. Knoedler and Co., *Italian Renaissance Portraits*, 1940, no. 18. The Art Institute of Chicago, *Masterpiece of the Month*, October 1943 (no cat.).

Ridolfo Ghirlandaio was the son of Domenico, a distinguished Florentine painter of the late fifteenth century who operated a large workshop. Ridolfo was clearly trained within this tradition even though his father died when he was eleven. His style was developed by contact with Fra Bartolommeo, Piero di

Cosimo, and Francesco Granacci. Like several other Florentine painters of lesser talent, Ridolfo was profoundly influenced by leading contemporaries such as Leonardo da Vinci and Raphael, and seems to have responded as well to Flemish paintings he viewed in Florence. He presided over a large shop, which came to be favored by the Medici for its special skills in creating festival decorations. The Ghirlandaio shop was also noted for its production of portraits and training of portrait painters such as Domenico Puligo and Michele Tosini.

The present painting has been almost unanimously attributed to Ridolfo, starting with its first recorded appearance at the London exhibition held in 1900 by the dealer Lawrie and Co.[6] It is generally regarded as an early work by the artist. Freedberg correctly suggested a date around 1505–06, that is, slightly after Ridolfo's *Virgin and Child with Saints Francis and Mary Magdalen* of 1503 (Florence, Accademia) and just before *The Procession to Calvary* (London, The National Gallery) of c. 1506.[7] Similarities between the figures on the altarpiece in Florence and the portrait in Chicago are apparent in the treatment of the flesh tones and in the handling of the swaths of drapery. Few of Ridolfo's portraits are dated; indeed, the first such example, *Portrait of a Woman* of 1509 (Florence, Palazzo Pitti), is in a more refined style than the present portrait.[8] Freedberg rightly related the portrait in Chicago to Netherlandish art, referring

Fig. 1 Portrait of Domenico di Giovanni, called il Burchiello, woodcut illustration from *Rime del Burchiello comentate dal Doni*, Venice, 1553, p. 16 [photo: Bodleian Library, Mortara 134, Oxford]

to it as "perhaps an adaptation of an older Flemish image." The device of showing a landscape through a window behind the sitter is Netherlandish in origin and is found in portraits by Hans Memling and Dieric Bouts. Memling's portraiture was certainly known in Florence by the last quarter of the fifteenth century, and his portrait conventions and specific landscape motifs were adapted by leading Florentine painters.[9]

The most important aspect of the portrait, however, is the sitter's pose, which marks the transition from the fifteenth to the sixteenth century. Like Raphael, Leonardo da Vinci, and Piero di Cosimo, Ridolfo was clearly concerned to develop quattrocento principles of portraiture. The diagonal created by the shoulders in relation to the background and the turning of the head toward the viewer were aspects of portraiture already exploited in the fifteenth century, especially in sculpture, but they are here enlivened by the gesture and the strong lighting of the face. The foreshortening of the hand emerging from the voluminous sleeve is a vibrant passage of painting and the forthright characterization is impressive.

Interestingly, technical examination of the picture (see above) has revealed that the artist decided to add the parapet only at a later stage, painting over the finished part of the figure at the bottom of the composition. This imprisons the sitter between two walls, but it also helps to define his position in space more accurately. At the same time, both the stare and the gesture serve to break down the very barrier behind which the painter has deliberately placed the sitter. The hand, for example, does not rest upon the parapet, as so often happens in fifteenth-century portraiture, but, instead, like the sitter's gaze, is directed out of the picture, casting a shadow on the sleeve covering the other arm. It is the gesture, working in conjunction with the gaze, that invests the portrait with an added sensibility. This dialogue between the sitter and the spectator is one that continued to be explored during the first half of the sixteenth century with greatest distinction in the work of Leonardo da Vinci and Raphael. With such names in mind, it is important to stress once more the early date of the portrait in Chicago, lest its compositional significance be overlooked.

The identity of the sitter is uncertain. Linda Klinger has pointed out that this likeness was used

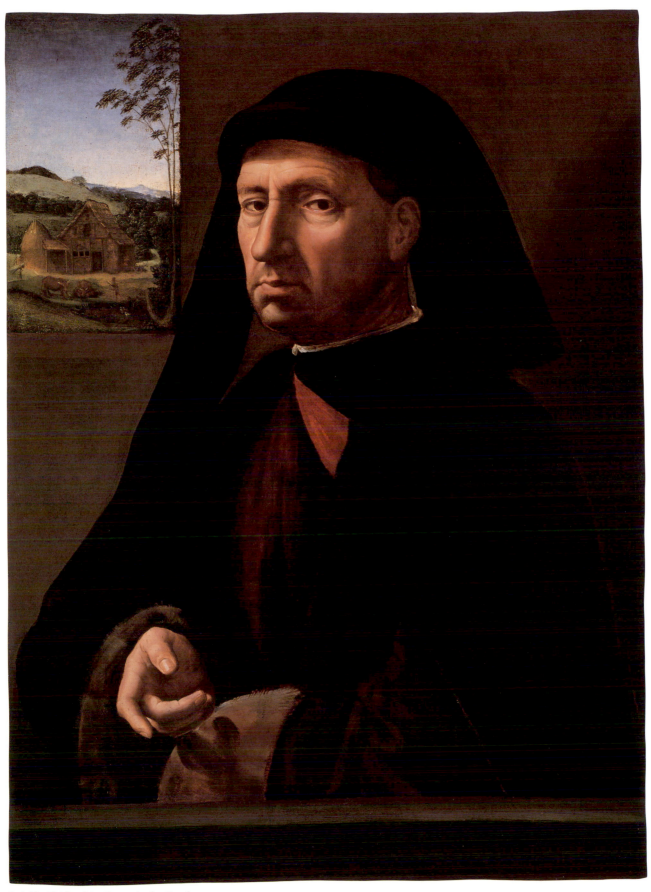

Ridolfo Ghirlandaio, *Portrait of a Gentleman*, 1933.1009

for the portrait (fig. 1) of the Florentine poet Domenico di Giovanni, called il Burchiello (1404–1449), in the critical edition of his poetry published in Venice in 1553 (*Rime del Burchiello comentate dal Doni*).[10] The book's publisher was Francesco Marcolini, and the implication in the preface is that the woodcut was based on a painting by Jacopo Tintoretto, which is manifestly not the case. It is difficult to know on what authority this portrait was accepted as an authentic likeness of the early fifteenth-century poet, particularly since, as Klinger also observed, the portrait of Burchiello owned by Paolo Giovio (1483–1552), who collected images of military figures and men of letters in connection with his historical and biographical writing, shows a different person.[11]

NOTES

1 The reinforced ledge is evident in Armstrong 1901, p. 46 (ill.) and Gamba 1929, p. 467 (ill.), among other early illustrations.

2 Letter from Wilhelm von Bode to Scott and Fowles of January 2, 1912. Scott and Fowles's bill of sale of April 13, 1912, however, states that the picture was "bought from the collection of Prince Piombino, Rome, about twenty years since." Both the letter and the bill of sale are in the Ryerson papers, Archives, The Art Institute of Chicago.

3 See Armstrong 1901, p. 46.

4 See letter from Bernard Berenson to Arthur T. Sulley of October 23, 1910, in the Ryerson papers, Archives, The Art Institute of Chicago.

5 See bill of sale (note 2).

6 Wilhelm von Bode was apparently the first to attribute the panel to Ridolfo. In the letter mentioned above (note 2), he

wrote, "The portrait of a bearded man in a Florentine costume of about 1510 to 1520 is well known to me as I discovered it once in the Gallery of Principe Brancacci [*sic*] in Rome. It was under the name of Raphael; I told the Principe that it had nothing to do with Raphael, but that it is a very characteristic and vigorous work by Ridolfo Ghirlandajo, full of character, of fine chiaroscuro and in very good state." Osvald Sirén apparently gave one of the few dissenting opinions, considering the portrait "an earlier work of the Piero di Cosimo type" (*Ryerson Collection* 1926, p. 23).

7 Freedberg 1961, vol. 2, pls. 74, 76; C. Gould, *National Gallery Catalogues: The Sixteenth-Century Italian Schools*, London, 1975, p. 100. A *terminus post quem* of 1504 can be established for *The Procession to Calvary*.

8 Freedberg 1961, vol. 2, pl. 277.

9 For an instance of specific borrowings from Memling, see L. Campbell, "Memlinc and the Followers of Verrocchio," *Burl. Mag.* 125 (1983), pp. 675–76; and idem, *Renaissance Portraits: European Portrait-Painting in the 14th, 15th, and 16th Centuries*, New Haven and London, 1990, pp. 232–33.

10 Letter from Linda Klinger to the author of April 3, 1984, in curatorial files. The woodcut portrait occurs twice (on p. 16 and after the index) in the copy of the book in the Bodleian Library, Oxford.

11 The portrait owned by Giovio is known through a copy by Cristofano dell'Altissimo in the Uffizi (see *Gli Uffizi: Catalogo generale*, Florence, 1979, p. 614, fig. Ic85). According to Tilman Falk (T. Falk, *Hans Burgkmair: Studien zu Leben und Werk des Augsburger Malers*, Munich, 1968, pp. 59–60), the portrait in Florence bears a certain resemblance to the drawing by Dürer of Hans Burgkmair in the Ashmolean Museum, Oxford (K. T. Parker, *Catalogue of the Collection of Drawings in the Ashmolean Museum*, vol. 1, *Netherlandish, German, French and Spanish Schools*, Oxford, 1938, no. 290, ill.), a resemblance which must surely be no more than coincidental. Interestingly, Giovio did not include the portrait in his *Elogia virorum litteris illustrium*, Basel, 1577.

Attributed to Francescuccio Ghissi

Active in the Marches, mainly Fabriano, c. 1359–1395

The Crucifixion, 1370/80

Mr. and Mrs. Martin A. Ryerson Collection, 1937.1006

Tempera on panel, 72.7 x 50.3 cm (28⅝ x 19¾ in.)

INSCRIBED: ·I·N·R·I· (at the top of the cross in white paint on red)

CONDITION: The painting is in fairly good condition. It was cleaned in 1953,[1] and again by Barry Bauman in 1978–79. The raised arch is carved and gessoed. The panel was probably cut on all sides, and the edges below the corbels of the arch have been filled, painted, and gilded. The panel,

which is cradled, has evidently undergone movement in the past, resulting in several vertical splits in the paint and ground layers, as well as a pronounced network crackle pattern. Splits extend through the body of Christ and down through Christ's left forearm, the angel, the figure of Saint John the Evangelist, and into the kneeling donor. In addition, there are circular local losses to the gold and ground to the left of the plaque on the cross and at the upper margin, to the left and right of the arch. Damage to these areas and scattered flake losses have been filled and inpainted. A painted crackle pattern has been added to the three larger

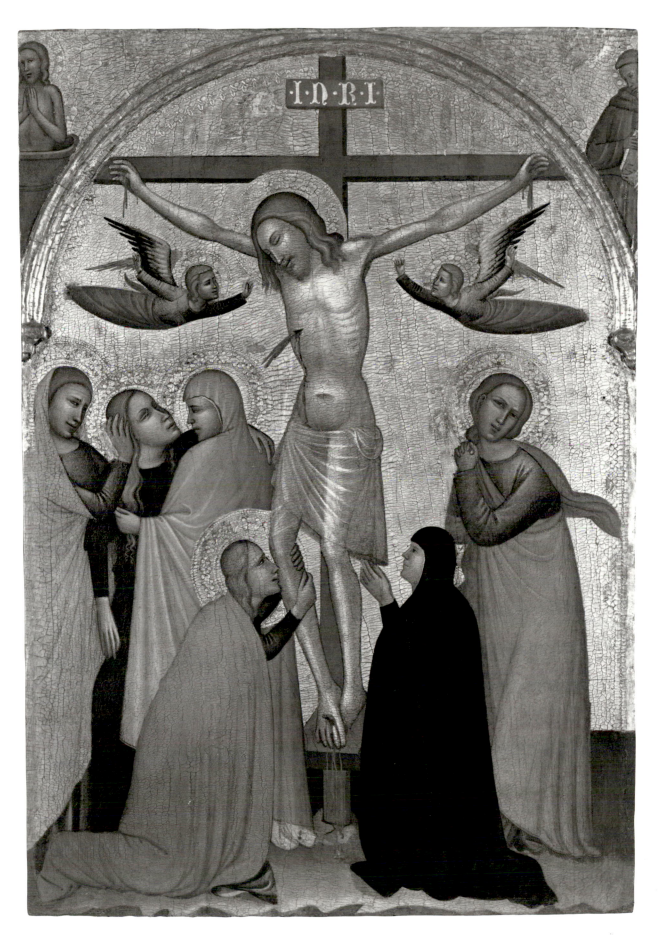

areas of local damage in the gold. The modeling of the dark robes of the donor and of the swooning Madonna is no longer legible, a condition which is accentuated by blanching in these areas. However, the original quality of the painting is by no means lost. The area to the left of the bunched hem of the donor's robe, which in reproduction resembles a *pentimento*, is, in fact, a restored shadow (infrared, ultraviolet).

PROVENANCE: Probably a member of the Altieri family, Rome.[2] Philip Lehman, New York. Sold by Lehman to Kleinberger, New York, 1916; sold American Art Association, New York, January 23, 1918, no. 41 (ill.), for $1750 to S. Bourgeois, Paris, who returned it to Kleinberger, March 11, 1918. Kleinberger, New York and Paris, 1918–24.[3] Sold by Kleinberger, Paris, to Martin A. Ryerson (d. 1932), Chicago, 1924;[4] on loan to the Art Institute, 1924; at Ryerson's death to his widow, Mrs. Martin A. Ryerson (d. 1937); bequeathed to the Art Institute, 1937.

REFERENCES: L. Venturi 1931, pl. XC. Berenson 1932, p. 399; 1936, p. 343; 1968, vol. 1, p. 302. Valentiner [1932], n. pag. F. Zeri, "Note su quadri italiani all'estero," *Bollettino d'arte* 34 (1949), pp. 21–30 (ill.). AIC 1961, p. 344. L. Vertova, "What Goes with What?," *Burl. Mag.* 109 (1967), p. 671. *Dizionario*, vol. 1, 1972, pp. 80, 82. Fredericksen/Zeri 1972, pp. 4, 290, 395, 419, 571. F. Zeri, "Un'ipotesi sui rapporti tra Allegretto Nuzi e Francescuccio Ghissi," *Antichità viva* 14, 5 (1975), p. 6. K. Christiansen, "Fourteenth-Century Altarpieces," *Metropolitan Museum of Art Bulletin* 40, 1 (1982), pp. 46–48, fig. 45. J. Pope-Hennessy with L. Kanter, *The Robert Lehman Collection*, vol. 1, *Italian Paintings*, New York, 1987, p. 60, under no. 28.

EXHIBITIONS: New York, F. Kleinberger Galleries, *Italian Primitives*, 1917, no. 71, lent anonymously, as Alegretto [*sic*] Nuzi. The University of Chicago, The Renaissance Society, *Commemorative Exhibition from the Martin A. Ryerson Collection*, 1932, no. 3, as Allegretto Nuzi. The Art Institute of Chicago, *A Century of Progress*, 1933, no. 92, as Allegretto Nuzi. The Art Institute of Chicago, *Masterpiece of the Month*, March–April 1956, as Allegretto Nuzi (no cat.).

The panel formed the center of an altarpiece from which seven other panels have survived, each portraying a scene from the life of Saint John the Evangelist based on the account given in *The Golden Legend*.[5] An eighth panel has yet to be found. The altarpiece dates in all probability from the 1370s. Zeri (1949) reconstructed the altarpiece and demonstrated that four panels arranged in two rows were disposed on either side of *The Crucifixion*. The related panels are as follows: *The Resurrection of Drusiana, Saint*

John the Evangelist Reproving the Philosopher Crato, Saint John Converting Acteus and Eugenius, and *Saint John and the Poisoned Cup*, all from the Kress Collection,[6] *Saint John the Evangelist Causing a Pagan Temple to Collapse, Saint John the Evangelist Raising Satheus to Life*, and *Saint John the Evangelist with Acteus and Eugenius* in The Metropolitan Museum of Art in New York.[7] The missing eighth scene probably showed, as Zeri suggested, either the Death of Saint John or the Baptism of the Roman high priest Aristodemus. Saint John on Patmos is another possible subject for this missing panel.[8] Christiansen (1982) followed the chronology of events given in *The Golden Legend* and thus made one small change to Zeri's sequence, interchanging the positions of *Saint John the Evangelist Raising Satheus to Life* and *Saint John and the Poisoned Cup*. The photomontage reproduced here (fig. 1) shows Christiansen's reconstruction. The four panels in the upper row are all arched, like *The Crucifixion*, and have figures in the spandrels, while the four below are rectangular. When the altarpiece was dismantled, the figures in the spandrels on each of the arched panels were cut. Those in the spandrels of *The Crucifixion* (Saint John the Evangelist in a cauldron of oil to the left and Saint Francis to the right) are continued on the panels of *Saint John the Evangelist Reproving the Philosopher Crato* and *Saint John the Evangelist with Acteus and Eugenius*, respectively.

The Crucifixion, like the altarpiece as a whole, was attributed from the first to Allegretto Nuzi (see 1937.1022), and regarded by both Berenson (1968) and Zeri as a late work, possibly with workshop participation.[9] This late date was assumed mainly because the influence of Florentine painters such as Bernardo Daddi and Maso di Banco, with whose work Nuzi came into contact early in his career, is here tempered by local Fabrianese characteristics. The tall figures bending at the waist, the wooden gestures, the long faces, and the stiffened draperies occur, for example, in works such as the frescoes by Nuzi in the church of San Biagio in Caprile at Campodonico, near Fabriano.[10] Zeri later (1975) proposed, on grounds of inferior quality, that the altarpiece had been executed by Francescuccio Ghissi, a close follower of Nuzi. This stylistic distinction between Ghissi and Nuzi can be confirmed, according to Frinta, on the basis of tech-

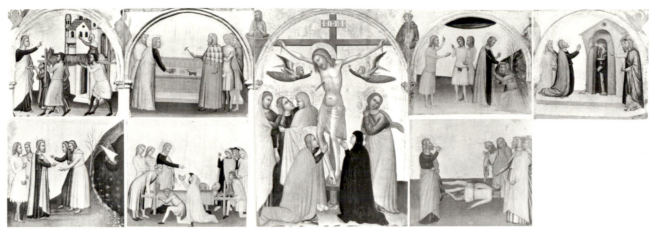

Fig. 1 Attributed to Francescuccio Ghissi, *Altarpiece with the Crucifixion and Scenes from the Life of Saint John the Evangelist* (reconstruction)

nical evidence provided by the punching.[11] Ghissi is only known, otherwise, by five panels of the *Madonna dell'Umiltà*.[12] The attribution of this altarpiece adds considerably, therefore, to his oeuvre.

The Crucifixion in particular, especially after its treatment in 1978, is a work that reveals Ghissi to be a slightly more accomplished painter than is usually credited. Although the grouping of the three Marys on the left may have been taken from Nuzi,[13] the soft coloring of the draperies (blue, green, pink, and orange), the way Mary Magdalen grasps Christ's leg, and the mannered elegance of Saint John the Evangelist to the right of the cross are impressive. Zeri (1975) contended that throughout the altarpiece Ghissi was merely following designs prepared by Nuzi. This may be so, but it does not necessarily detract from the overall effect of the finished work.

The original location of the altarpiece has yet to be discovered. Judging from the female donor kneeling at the foot of the cross, the altarpiece was most probably painted for a Dominican church or monastery, presumably a local one in the Marches.

The shape of the altarpiece, as reconstructed by Zeri, is that of a horizontal rectangular dossal, a type of altarpiece dating back to the thirteenth century.[14] Interestingly, Giovanni di Bartolomeo Cristiani used this same shape for his altarpiece of Saint John the Evangelist, showing eight scenes from the saint's life, in San Giovanni Fuorcivitas in Pistoia, dated 1370.[15] The most elaborate fresco cycle with scenes from the life of Saint John the Evangelist, and roughly contem-

porary with the altarpiece to which *The Crucifixion* belongs, is in the Castellani Chapel in Santa Croce, Florence, begun in 1383/84 by Agnolo Gaddi.[16] Likewise in Santa Croce, but dating from earlier in the century, is Giotto's cycle in the Peruzzi chapel, of which Ghissi, perhaps through Nuzi, shows knowledge in two of the narrative scenes (*The Resurrection of Drusiana* and *Saint John the Evangelist Raising Satheus to Life*).[17] Apart from the altarpiece reconstructed by Zeri, the incidents involving Acteus and Eugenius seem to be represented only in Tuscany.[18]

NOTES

1 According to a label formerly on the back of the panel and now in the conservation file.

2 This statement is based on the seal on the back of the panel. The identification of the seal with an ecclesiastic member of the Altieri family was confirmed by Michael Maclagan, former Richmond Herald (letter to the author of February 15, 1989). Maclagan suggested an identification with either Giovanni Battista Altieri, Bishop of Camerino, who was Cardinal Priest of Santa Maria Minerva and Bishop of Todi in 1643 (d. 1654), or with Emilio Altieri (1590–1676), also Bishop of Camerino, who was made a cardinal in 1669 before being elected Pope as Clement X the following year (for Pope Clement X as collector, see F. Haskell, *Patrons and Painters*, London, 1963, pp. 161–62). The pope's adopted nephew, Don Gasparo Altieri, was Gonfaloniere of the Church and an important patron of Claude Lorrain (see M. Kitson, "The 'Altieri Claudes' and Virgil," *Burl. Mag.* 102, 688 [1960], pp. 312–18).

3 According to an annotated photograph of this picture in the Witt Library and information in the Kleinberger records, Department of European Paintings, The Metropolitan Museum of Art, New York. The Kleinberger records also show that the painting was on deposit at Smith College,

Northampton, Massachusetts, from November 3, 1919, to November 24, 1920.

4 According to a letter from Kleinberger to Ryerson of June 3, 1924, Ryerson papers, Archives, The Art Institute of Chicago.

5 *The Golden Legend*, vol. 1, pp. 58–64.

6 Shapley 1966, pp. 75–76, K205A–D, figs. 207–10. *The Resurrection of Drusiana* is now in The Portland Art Museum, Oregon, and the other three panels are in the North Carolina Museum of Art.

7 Zeri/Gardner 1980, pp. 17–19, nos. 69.280.1–3, pls. 24–26.

8 For the reconstruction of the altarpiece, see Zeri 1949, p. 22, fig. 5, and Christiansen 1982, pp. 48–49, fig. 45.

9 Osvald Sirén first argued for an attribution to Nuzi in an expertise for Kleinberger dated June 1917 (Ryerson papers, Archives, The Art Institute of Chicago) and in the catalogue of the exhibition of *Italian Primitives* held later that same year, which he edited with Maurice W. Brockwell.

10 See A. Marabottini, "Allegretto Nuzi," *Rivista d'arte* 27 (1951–52), pp. 26–29; and F. Zeri, "Un *Unicum* su tavola del Maestro di Campodonico," *Bollettino d'arte* 48 (1963), pp. 325–31.

11 Letters to the author of March 20 and April 2, 1981, and to Margherita Andreotti of April 30, 1988, in curatorial files.

12 Van Marle, vol. 5, 1925, figs. 106–07, 109–11.

13 Compare *The Crucifixion* in the Lehman Collection, The Metropolitan Museum of Art, New York, illustrated in Pope-Hennessy 1987, no. 28.

14 Garrison 1949, p. 140, nos. 357–79.

15 Berenson 1963, vol. 1, fig. 325.

16 B. Cole, *Agnolo Gaddi*, Oxford, 1977, pp. 78–79, Appendix II, pp. 57–59.

17 L. Tintori, *Giotto: The Peruzzi Chapel*, New York, 1965.

18 See G. Kaftal, *Saints in Italian Art: Iconography of the Saints in Tuscan Painting*, Florence, 1952, cols. 559–70, no. 164; G. Kaftal with F. Bisogni, *Saints in Italian Art: Iconography of the Saints in the Painting of North East Italy*, Florence, 1978, cols. 525–43, no. 151.

Giovanni di Paolo

Active Siena by 1417, d. Siena 1482

Six Scenes from the Life of Saint John the Baptist

Saint John the Baptist Entering the Wilderness, 1455/60
Mr. and Mrs. Martin A. Ryerson Collection, 1933.1010

Tempera on panel, 68.5 x 36.2 cm (27 x 14¼ in.); painted surface: 66.3 x 34 cm (26¹⁄₁₆ x 13⁷⁄₁₆ in.)

CONDITION: The painting is in very good condition. It was treated in 1965 by Alfred Jakstas, who gave it a light surface cleaning and corrected old retouches. The cradled panel has been thinned, as is evident from exposed worm tunneling. An Arabic *1* is inscribed on the back over a partially erased Arabic *2*. There are additions to the panel on all four sides. The added strips at left and right are approximately 1 cm wide, and the top has been renewed with an addition lap-joined to the original panel so that the new wood covers approximately 3.5 cm of the back of the panel. Along the lower edge, a new section measuring approximately 4.4 cm has been added to the painted design, with repaint extending for a further 2 cm upward onto the original panel. This added strip has a horizontal grain, in contrast to the vertical grain of the rest of the panel, and the cradle has been extended here. Hence this repainted exten-

sion presumably postdates the first cradling and the added strips on the other sides. There is a black, painted border approximately 1 cm wide around all four sides. There are several short vertical splits at the top edge and two longer splits to the right of the upper figure of the Baptist and adjacent to the right river bank. Retouching along the splits is minimal and only really evident in the last of these. Two fairly large areas of old damage can be detected where the surface is pitted: a 2.5 cm square loss by the bush next to the figure of Saint John the Baptist retreating through the mountains and a 5.1 cm gouge by the buildings in the middle distance on the right. However, in general the paint surface is well preserved. The old retouches are now somewhat discolored. Electron microprobes showed that the area of water at the very top of the composition was originally silvered. This part is now much tarnished and abraded, exposing the underlying red-brown bole and making the artist's original intentions difficult to interpret. For instance,

an island (or celestial city) at the top to the left of center is hardly visible in reproduction. There are numerous incised lines in the architecture and in the patterning of the fields, as well as a repeated wave-like pattern in the sea (infrared, ultraviolet, x-radiograph).

PROVENANCE: See below.

REFERENCES: See below.

EXHIBITIONS: See below.

Ecce Agnus Dei, 1455/60
Mr. and Mrs. Martin A. Ryerson Collection, 1933.1011

Tempera on panel, 68.5 x 39.5 cm (27 x 15½ in.); painted surface: 66.3 x 37 cm (26¹/₁₆ x 14⅝ in.)

INSCRIBED: ADA D[?] GM (on bridge, upper right)

CONDITION: The painting is in good condition. It was treated in 1965 by Alfred Jakstas, who gave it a light surface cleaning and corrected old retouches. The cradled panel is prepared in the same way as 1933.1010, with three of the edges renewed and a larger section of approximately 4 cm added at the lower edge where repaint extends a further 2 cm into the picture. An Arabic 2 is inscribed on the back over another number that appears to be a 5. Horizontal rows of fills below the center of the panel are evident in the x-radiograph (fig. 1). The fills are clearly visible on the back of the panel. Some of these appear to result from long clinched nails which are also evident as disruptions in the paint surface. This hardware may relate to a hinge or batten or both used in the original construction of the ensemble (see also Condition report for 1933.1014 and 1933.1015). There are two prominent vertical splits in the panel, one extending from the top of the panel through the figure of the Baptist to the right of his ear and the other in the center of the panel to the left of Christ's outstretched hand. Retouching is evident at the right edge and along the splits. The feet of all the figures, except those of Saint John the Baptist, have also been retouched, but not totally repainted. There are scattered small paint and ground losses throughout, though in general the paint surface is fairly well preserved. The old retouches are now somewhat discolored. As in 1933.1010, the water at the upper edge of the painting was originally silvered and is now tarnished and abraded, exposing a red-brown bole. There are numerous incised lines in the landscape, in the patterning of the fields, and in the waves on the shoreline (infrared, ultraviolet, x-radiograph).

PROVENANCE: See below.

REFERENCES: See below.

EXHIBITIONS: See below.

Saint John the Baptist in Prison Visited by Two Disciples, 1455/60
Mr. and Mrs. Martin A. Ryerson Collection, 1933.1012

Tempera on panel, 68.3 x 40 cm (26⅞ x 15¾ in.); painted surface: 66.3 x 37.8 cm (26¹/₁₆ x 14⅞ in.)

CONDITION: The painting is in very good condition. It was treated in 1965 by Alfred Jakstas, who gave it a light surface cleaning and corrected old retouches. The cradled panel has been thinned, as is evident from exposed worm tunneling. An Arabic 3 is inscribed on the back of the panel. The edges on either side are made up of strips of new wood. The bottom and top edges are also new, though, as distinguished from 1933.1010 and 1933.1011, the wood has been lap-joined to the original so that the new wood covers approximately 3.5 cm of the back of the panel at top and bottom. The actual join is hidden by the horizontal cradle member here. All four edges have been painted black. There are two knots in the wood: one above the chain and ring holding the cheetah and the other by the figure seen in the doorway right of center. There are two diagonal scratches approximately 15 cm long running parallel to and below the chain, and another about 8 cm to the right of the disciples. The paint surface is otherwise in good condition, although there is repaint along all four edges of the original panel. The modeling of the drapery of the disciple on the far left is particularly well preserved. Infrared reflectography reveals several changes, such as underdrawn *beatus* rays for the disciple on the far left and adjustments in the placement of the disciples' feet. The architecture and many details of the composition, including the grill over the window, the cheetah's leash, and the distant figures in the landscape, were prepared with incised lines in the gesso (infrared, ultraviolet, x-radiograph).

PROVENANCE: See below.

REFERENCES: See below.

EXHIBITIONS: See below.

Salome Asking Herod for the Head of Saint John the Baptist, 1455/60
Mr. and Mrs. Martin A. Ryerson Collection, 1933.1013

Tempera on panel, 69.1 x 36 cm (27³/₁₆ x 14³/₁₆ in.); painted surface: 66.7 x 33.7 cm (26⁵/₁₆ x 13¼ in.)

CONDITION: The painting is in very good condition. In 1965 it was lightly cleaned and varnished by Alfred Jakstas. The cradled panel has been thinned, as is evident from exposed worm tunneling. An Arabic 4 is inscribed on the back over another 4. There are two vertical splits extending

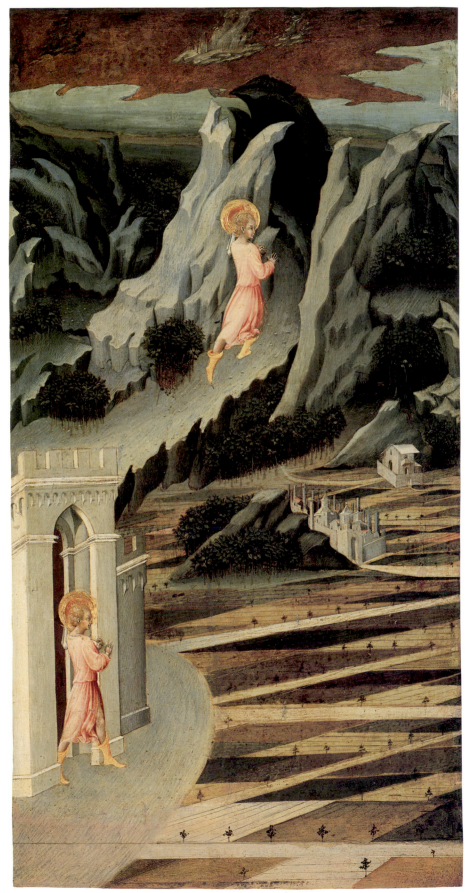

Giovanni di Paolo, *Saint John the Baptist Entering the Wilderness*, 1933.1010

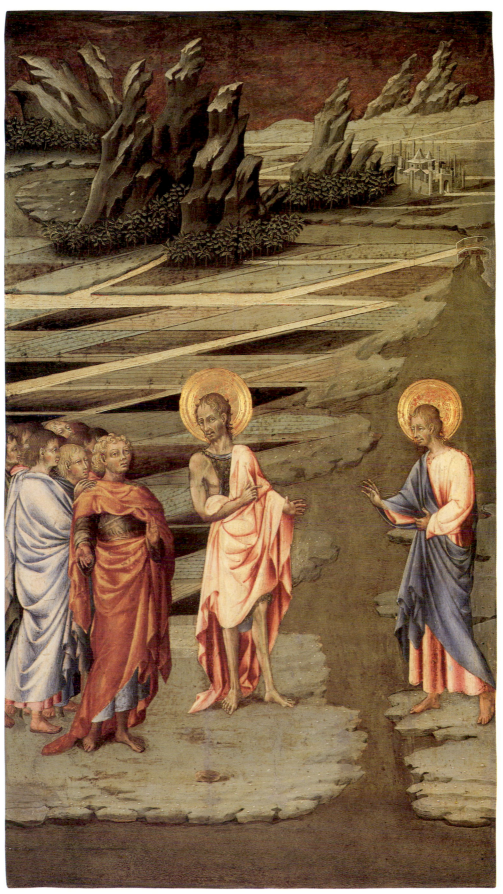

Giovanni di Paolo, *Ecce Agnus Dei*, 1933.1011

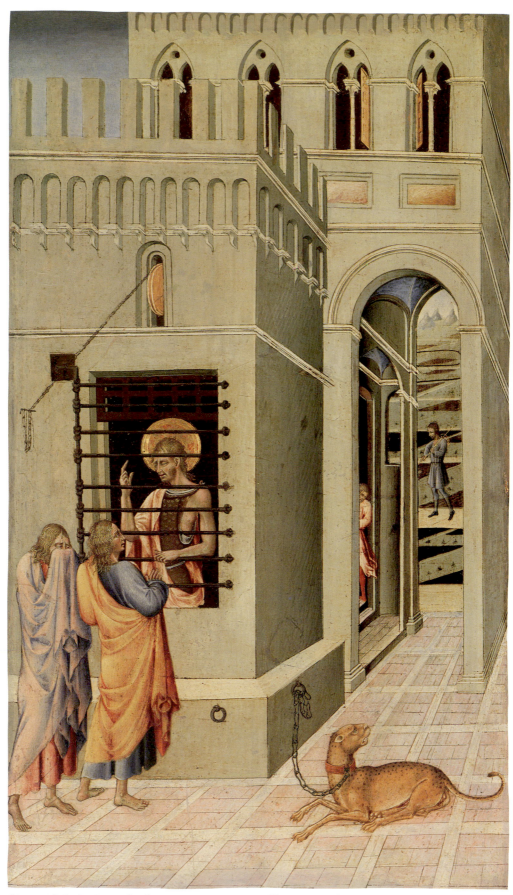

Giovanni di Paolo, *Saint John the Baptist in Prison Visited by Two Disciples*, 1933.1012

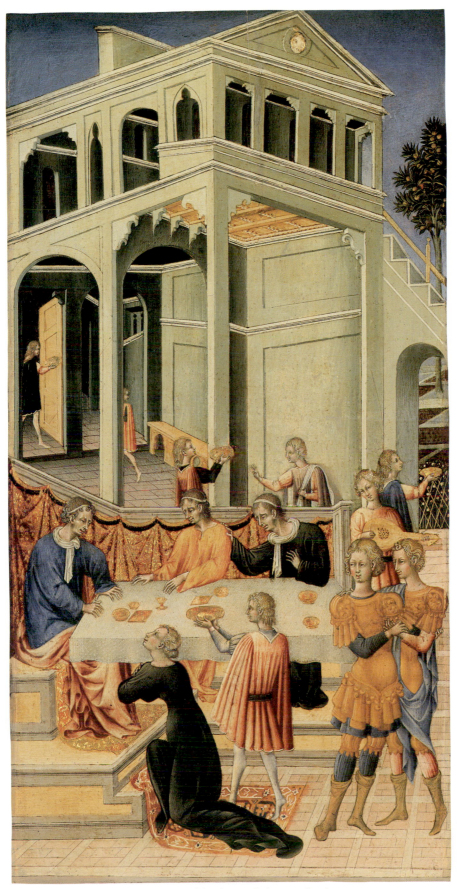

Giovanni di Paolo, *Salome Asking Herod for the Head of Saint John the Baptist*, 1933.1013

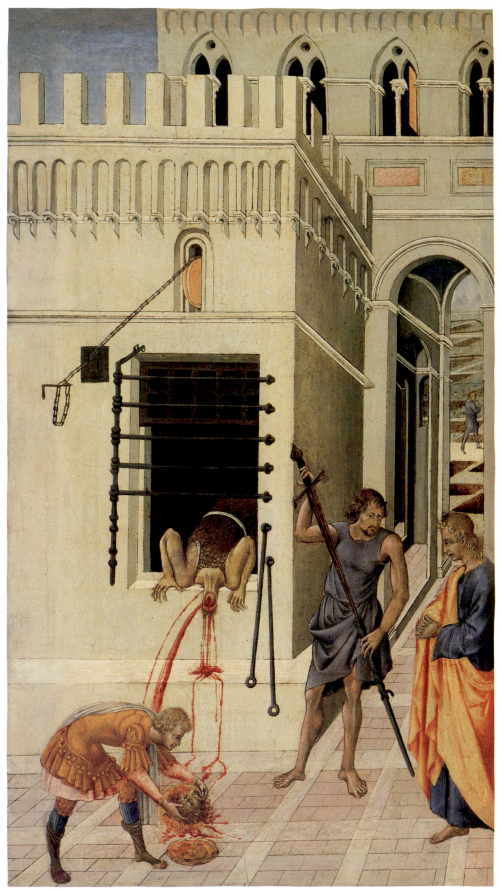

Giovanni di Paolo, *The Beheading of Saint John the Baptist*, 1933.1014

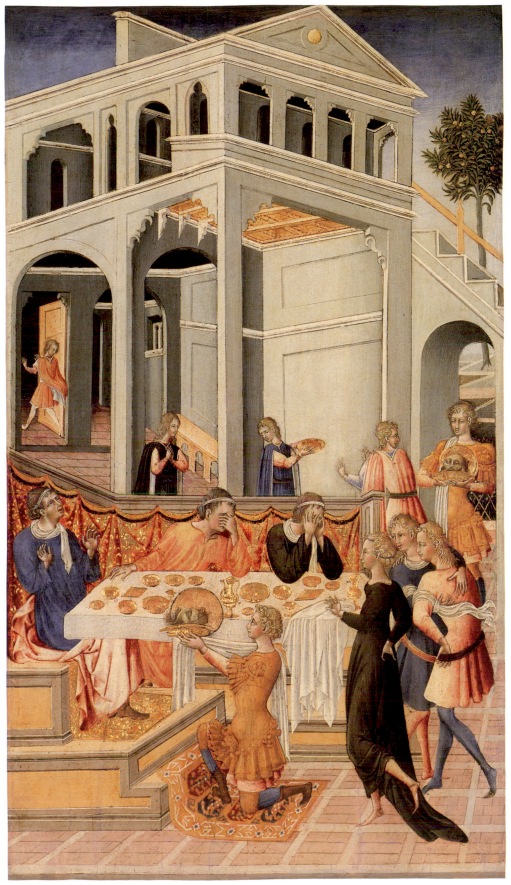

Giovanni di Paolo, *The Head of Saint John the Baptist Brought before Herod*, 1933.1015

from the upper edge just to the right of center approximately 17 cm into the panel. The edges have been renewed in the same manner as those of 1933.1012 and painted black. Repaint extends approximately 5 mm into the design all around. At the left and right sides, this repainted strip barely overlaps what seem to be remnants of a barbe indicating the original edge of the painted design. The sky has been substantially repainted except for the segment visible through the opening of the loggia at the far right. The figures are generally well preserved. There is a small area of local damage in the gold plate held by the servant behind the table, and there is discolored retouching in the shadow behind the servant to his right and in scattered small losses on the wall behind them. The oculus is raised in relief. The architecture is prepared with numerous incised lines, some of which differ slightly from the paint layer (infrared, ultraviolet, x-radiograph).

PROVENANCE: See below.

REFERENCES: See below.

EXHIBITIONS: See below.

The Beheading of Saint John the Baptist, 1455/60

Mr. and Mrs. Martin A. Ryerson Collection, 1933.1014

Tempera on panel, 68.6 x 39.1 cm (27 x 15⅜ in.); painted surface: 66.3 x 36.6 cm (26 1/16 x 14 7/16 in.)

CONDITION: The painting is in very good condition. In 1965 Alfred Jakstas gave it a surface cleaning. The cradled panel has been thinned, as is evident from exposed worm tunneling. An Arabic 5 is inscribed on the back over what appears to be a partially erased 3. Horizontal rows of fills like those in 1933.1011 extend across the panel below the center. Two fabric strips in the area of these fills are visible in the x-radiograph (fig. 2) and must have been incorporated in the preparation of the ground, thus indicating that this hardware was part of the ensemble's original structure. The panel's edges have been renewed, as in the previous two panels, and painted black. There is repaint along the edge of the painted surface on all sides, extending approximately 2 cm in from the black border at the top, 1 cm on the right side, and 2.5 cm in a shallow curve across the bottom. At the left, the band of repaint is 4 cm wide and covers what appears to be an old added strip of wood. The strip, which is more severely worm tunneled than the rest of the panel, lacks the incisions used to prepare the design elsewhere. There are several short vertical cracks in the panel engendered by the cradle. Knots in the wood have disturbed the paint surface in the Baptist's shoulder and the head of the executioner. The body of the executioner and the figure at

the right edge are comparatively well preserved. The executioner's sword was originally silvered and is now tarnished. As in 1933.1012, there are numerous incised lines in the architecture and details of the composition, but no alterations as on the earlier panel in the sequence (infrared, ultraviolet, x-radiograph).

PROVENANCE: See below.

REFERENCES: See below.

EXHIBITIONS: See below.

The Head of Saint John the Baptist Brought before Herod, 1455/60

Mr. and Mrs. Martin A. Ryerson Collection, 1933.1015

Tempera on panel, 68.5 x 40.2 cm (27 x 15 13/16 in.); painted surface: 66.1 x 38.1 cm (26 1/32 x 15 in.)

CONDITION: The painting is in very good condition. In 1965 it was lightly cleaned and varnished by Alfred Jakstas. The cradled panel has been thinned, as is evident from exposed worm tunneling. An Arabic 6 has been inscribed on the back of the panel. The panel's edges have been renewed, as in the previous three panels, and painted black. The x-radiograph (fig. 3) shows traces of hardware below the middle of the panel, as in 1933.1011 and 1933.1014, although there are fewer long clinched nails than in these panels. Repaint extends approximately 5 mm into the design at the sides and slightly further at the top and bottom. There are numerous short vertical splits in the panel at the top and bottom edges. The paint surface is generally well preserved. Small areas of damage in the face of the servant carrying a plate in the center of the middle distance, in the face of the guest next to Herod, in the architecture, and along the splits have been inpainted. There is a larger area of loss and repaint in the lower right corner. The architecture is prepared with incised lines. Infrared reflectography reveals underdrawing in the figures, with a number of small adjustments in the placement of hands and other details (infrared, ultraviolet, x-radiograph).

PROVENANCE: Edouard Aynard, Lyons, by 1907;[1] sold Galerie Georges Petit, Paris, December 1–4, 1913, no. 51, to Kleinberger, Paris.[2] Sold by Kleinberger to Martin A. Ryerson (d. 1932), Chicago, 1914;[3] on loan to the Art Institute from 1914; bequeathed to the Art Institute, 1933.

REFERENCES: F. M. Perkins, "Dipinti sconosciuti della scuola senese," *Rassegna d'arte senese* 3 (1907), pp. 82–83 (all ill.). E. Jacobsen, *Das Quattrocento in Siena: Studien in der Gemäldegalerie der Akademie*, Strasbourg, 1908, p. 50. Berenson 1909a, p. 177; 1932, p. 245; 1936, p. 211; 1968, vol. 1, p. 176, vol. 2, fig. 602 (1933.1014). P. Schubring,

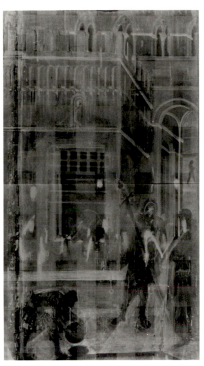

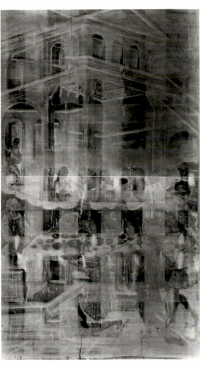

Fig. 1 X-radiograph of *Ecce Agnus Dei,* 1933.1011

Fig. 2 X-radiograph of *The Beheading of Saint John the Baptist,* 1933.1014

Fig. 3 X-radiograph of *The Head of Saint John the Baptist Brought before Herod,* 1933.1015

"Opere sconosciute di Giovanni di Paolo e del Vecchietta," *Rassegna d'arte* 12 (1912), pp. 163–64. J. A. Crowe and G. B. Cavalcaselle, *A History of Painting in Italy,* 2d ed., vol. 5, ed. by T. Borenius, New York, 1914, p. 178 n. F. M. Perkins, "Dipinti senesi sconosciuti o inediti," *Rassegna d'arte* 14 (1914), p. 163 n. 2. P. Schubring, *Cassoni: Truhen und Truhenbilder der italienischen Frührenaissance,* Leipzig, 1915, vol. 1, pp. 324–25, nos. 445–50, vol. 3, pls. CIV–CVI (all ill.). AIC 1917, p. 165. G. De Nicola, "The Masterpiece of Giovanni di Paolo," *Burl. Mag.* 33 (1918), pp. 45–54, pls. I–III (all ill.). *Fogg Art Museum, Harvard University: Collection of Mediaeval and Renaissance Paintings,* Cambridge, Mass., 1919, p. 121. AIC 1920, p. 62. C. H. Weigelt in Thieme/Becker, vol. 14, 1921, p. 135. AIC 1922, p. 71; 1923, p. 71. F. J. Mather, Jr., *A History of Italian Painting,* New York, 1923, p. 95. G. Soulier, *Les Influences orientales dans la peinture toscane,* Paris, 1924, p. 206. AIC 1925, p. 159, nos. 2028–33. *Ryerson Collection* 1926, pp. 30–34. R. Offner, *Italian Primitives at Yale University,* New Haven, 1927, p. 40. Van Marle, vol. 9, 1927, pp. 427–30, fig. 276 (1933.1010). R. Lehman, *The Philip Lehman Collection,* Paris, 1928, note to pl. XLVI. K. Erdmann, "Orientalische Tierteppiche auf Bildern des XIV. und XV. Jahrhunderts: Eine Studie zu den Anfängen des orientalischen Knüpfteppichs," *Jahrbuch der preussischen Kunstsammlungen* 50 (1929), p. 283. E. Cecchi, *Pietro Lorenzetti,* Milan, 1930, p. 27. C. H. Weigelt, *Sienese Painting of the Trecento,* New York, 1930, p. 86 n. 75. L. Venturi 1931, pls. CXXXVI–CXLI

(all ill.), n. pag. AIC 1932, p. 180. G. H. Edgell, *A History of Sienese Painting,* New York, 1932, pp. 218–20, figs. 307, 309–11 (all ill.). Valentiner [1932], n. pag. D. C. Rich, "The Paintings of Martin A. Ryerson," *AIC Bulletin* 27 (1933), pp. 6–8 (all ill.). A. M. Frankfurter, "Art in the Century of Progress," *Fine Arts* 20 (1933), p. 60. H. Tietze, *Meisterwerke europäischer Malerei in Amerika,* Vienna, 1935, p. 325, nos. 37–38 (1933.1010, 1933.1015 ill.). J. Pope-Hennessy, *Giovanni di Paolo,* London, 1937, pp. 80–90, pls. XX–XXII (1933.1010–11, 1933.1014–15). R. Brimo, *Art et goût: L'Évolution du goût aux États-Unis d'après l'histoire des collections,* Paris, 1938, p. 92. R. Langton Douglas, review of *Giovanni di Paolo* by J. Pope-Hennessy, in *Burl. Mag.* 72 (1938), pp. 43–47 (1933.1010 ill.). H. F. Mackenzie, "Panels by Giovanni di Paolo of Siena," *AIC Bulletin* 32 (1938), pp. 106–09 (all ill.). J. Pope-Hennessy, "Letters: Giovanni di Paolo," *Burl. Mag.* 72 (1938), p. 95. A. Weller, review of *Giovanni di Paolo* by J. Pope-Hennessy, *Art Bull.* 20 (1938), p. 126. H. Focillon, "The Fantastic in Medieval Art," *Magazine of Art* 33, 1 (1940), p. 25, fig. 7 (1933.1010). A. M. Frankfurter, "The Mediaeval Style in Painting," *Art News* 38, 20 (1940), p. 14 (1933.1010 ill.). C. Brandi, "Giovanni di Paolo, II," *Le arti* 30 (1941), pp. 325–28, 331–32, pl. CXXVII, figs. 42–43 (1933.1010, 1933.1015). R. Shoolman and C. E. Slatkin, *The Enjoyment of Art in America,* Philadelphia and New York, 1942, pp. 256 (1933.1010), 285. P. Bacci, *Documenti e commenti per la storia dell'arte,* Florence, 1944, pp. 89–90. H. G. Fell,

"The Connoisseur Divan," *Connoisseur* 116 (1945), p. 53. J. Lipman, "The Composite Scene in Primitive Painting," *Gazette des beaux-arts* 6th ser., 29 (1946), p. 124, fig. 5 (1933.1010). C. Brandi, *Giovanni di Paolo*, Florence, 1947, pp. 44–48, 51–52, 120, figs. 54–60 (all ill.). J. Pope-Hennessy, *Sienese Quattrocento Painting*, Oxford, 1947, pp. 9, 13, 27, fig. 13, pls. XXVIII–XXX (1933.1010–11). AIC 1948, p. 25 (1933.1010 ill.). C. Brandi, *Quattrocentisti senesi*, Milan, 1949, pp. 101, 261–62, pls. 149–55 (all ill.). U. Galetti and E. Camesasca, *Enciclopedia della pittura italiana*, vol. 1, Milan, 1950, pp. 1164–65, 1167 (1933.1011, 1933.1014). Davies 1951, p. 191, under no. 5454; 1961, p. 245, under no. 5454. *Art News* 51, 4 (1952), ill. on p. 5 and cover (1933.1012). G. Kaftal, *Saints in Italian Art: Iconography of the Saints in Tuscan Painting*, Florence, 1952, col. 552. M. Salmi, *L'arte italiana*, vol. 1, Rome, 1953, p. 431, fig. 656 (1933.1011). F. A. Sweet, "La pittura italiana all'*Art Institute* di Chicago," *Le vie del mondo: Rivista mensile del Touring Club Italiano* 15 (1953), pp. 694 (ill.), 696–97. E. Carli, *La pittura senese*, Milan, 1955, pp. 224, 226, pl. 147 (1933.1010, 1933.1014–15). M. Aronberg Lavin, "Giovannino Battista: A Study in Renaissance Religious Symbolism," *Art Bull.* 37 (1955), pp. 90–91 n. 33. E. Carli, *Sienese Painting*, Greenwich, Conn., 1956, pp. 63–64, pl. 116 (1933.1011). L. Réau, *Iconographie de l'art chrétien*, vol. 2, pt. 1, Paris, 1956, pp. 442, 450, 452, 455–56, 458. G. U., "Schede di restauro," *Bollettino dell'Istituto Centrale del Restauro* 27–28 (1956), p. 160. J. Pope-Hennessy, "Sassetta and Giovanni di Paolo," *Art News Annual* 27 (1958), pp. 133, 137, 142, 144–48, 151, 154, 180 (all ill. in color). AIC 1961, pp. 36–37 (1933.1010, 1933.1012 ill.), 179. E. Carli, "Problemi e restauri di Giovanni di Paolo," *Pantheon* 19 (1961), pp. 163–77. E. T. De Wald, *Italian Painting, 1200–1600*, New York, 1961, p. 339, fig. 18.3 (1933.1010). Huth 1961, p. 517. *Encyclopedia of World Art*, vol. 6, New York, 1962, col. 357 (1933.1010 ill. in color). "The Great Grey City," *Apollo* 84 (1966), p. 177. V. Lasareff, "Saggi sulla pittura veneziana dei sec. XIII–XIV: La maniera greca e il problema della scuola cretese (II)," *Arte veneta* 20 (1966), p. 48, fig. 50 (1933.1011). F. A. Sweet, "Great Chicago Collectors," *Apollo* 84 (1966), pp. 198, 202, fig. 22 (1933.1010). E. Ourusoff de Fernandez-Gimenez, "Giovanni di Paolo: The Life of St. Catherine of Siena," *Bulletin of The Cleveland Museum of Art* 54 (1967), pp. 105–07, fig. 3 (1933.1010). *Art Institute of Chicago*, Grands Musées 2, Paris [1968], pp. 11, 20–21 (all ill.), 67. B. Degenhart and A. Schmitt, *Corpus der italienischen Zeichnungen, 1300–1450*, pt. 1, vol. 2, Berlin, 1968, p. 320, under no. 240, fig. 423 (1933.1011). F. Hartt, *A History of Italian Renaissance Art: Painting, Sculpture, and Architecture*, Englewood Cliffs and New York, 1969, pp. 312–13 (1933.1010 ill.); 3d rev. ed., New York, 1987, pp. 351–52, fig. 368 (1933.1010). Maxon 1970, pp. 26–27 (1933.1012 ill.). Fredericksen/Zeri 1972, pp. 89, 416, 571. K. Kuh, "These Are a Few of My Favorite Things," *Chicago Tribune Sunday Magazine*, April 23, 1972, pp. 32 (1933.1010 ill.), 34. M. Meiss, *"Sts. Elijah and John the Baptist" by Pietro Lorenzetti; "The Baptism" by Giovanni di Paolo (Three Loans from the Norton Simon Foundation)*, exh. cat., Princeton University, The Art Museum, 1973, pp. 3–5, fig. 8 (1933.1011). *Dizionario*, vol. 6, 1974, p. 56. M. Meiss, "A New Panel by Giovanni di Paolo from His Altarpiece of the Baptist," *Burl. Mag.* 116 (1974), pp. 73–78 (all ill.). R. S. Slatkin, "François Boucher: St. John the Baptist. A Study in Religious Imagery," *The Minneapolis Institute of Arts Bulletin* 62 (1975), p. 8, fig. 6 (1933.1010). M. Eisenberg, "A Late Trecento *Custodia* with the Life of St. Eustace," in *Studies in Late Medieval and Renaissance Painting in Honor of Millard Meiss*, ed. by I. Lavin and J. Plummer, vol. 1, New York, 1977, p. 143 n. 1. *The Art Institute of Chicago: 100 Masterpieces*, Chicago, 1978, pp. 40–41, no. 4 (1933.1013 ill. in color). E. Carli and G. C. Dini in *Il gotico a Siena: Miniature, pitture, oreficerie, oggetti d'arte*, exh. cat., Siena, Palazzo Pubblico, 1982, pp. 352, 359. Waterhouse 1983, p. 90. S. Edgerton, *Pictures and Punishment: Art and Criminal Prosecution during the Florentine Renaissance*, Ithaca and London, 1985, pp. 150–52, fig. 36 (1933.1014). P. Pieper, ed., *Die deutschen, niederländischen und italienischen Tafelbilder bis um 1530*, Münster, 1986, pp. 529–35 (all ill.). J. Pope-Hennessy with L. Kanter, *The Robert Lehman Collection*, vol. 1, *Italian Paintings*, New York, 1987, pp. 121–23. *Master Paintings in The Art Institute of Chicago*, Chicago, 1988, pp. 14–15 (1933.1010, 1933.1014 ill.). J. Pope-Hennessy, "Giovanni di Paolo," *The Metropolitan Museum of Art Bulletin* 46, 2 (1988), p. 20, figs. 23–24 (1933.1010–11). C. B. Strehlke in K. Christiansen, L. B. Kanter, and C. B. Strehlke, *Painting in Renaissance Siena, 1420–1500*, exh. cat., New York, The Metropolitan Museum of Art, 1988, p. 216, fig. 1 (all ill.). M. Boskovits with S. Padovani, *The Thyssen-Bornemisza Collection: Early Italian Painting, 1290–1470*, London, 1990, p. 113. *Edouard Aynard*, Les Dossiers du Musée des Tissus 4, exh. cat., Lyon, Musée Historique des Tissus, 1990, pp. 38, 41. H. W. van Os, *Sienese Altarpieces, 1215–1460: Form, Content, Function*, vol. 2, *1344–1460*, Groningen, 1990, pp. 89, 218, fig. 81 (1933.1015). J. Dunkerton, S. Foister, D. Gordon, and N. Penny, *Giotto to Dürer: Early Renaissance Painting in The National Gallery*, New Haven and London, 1991, p. 278, figs. 25b–c (1933.1010, 1933.1015).

EXHIBITIONS: New York, F. Kleinberger Galleries, *Italian Primitives*, 1917, nos. 54–59. New York, The Metropolitan Museum of Art, *Loan Exhibition of the Arts of the Italian Renaissance*, 1923, nos. 12–17. London, Royal Academy of Arts, *Exhibition of Italian Art, 1200–1900*, 1930, nos. 927–32. The Art Institute of Chicago, *A Century of Progress*, 1933, no. 85. The Art Institute of Chicago, *A Century of Progress*, 1934, no. 29. The Cleveland Museum of Art,

Twentieth Anniversary Exhibition, 1936, nos. 137–39. The Art Institute of Chicago, The Children's Museum, *Explanatory Exhibition of the Panels Showing Scenes from the Life of St. John the Baptist by Giovanni di Paolo*, 1939 (no cat.). Boston, Museum of Fine Arts, *Arts of the Middle Ages, 1000–1400*, 1940, nos. 65–67.

These six scenes of the life of Saint John the Baptist are among Giovanni di Paolo's most outstanding works. Pope-Hennessy (1937) once described two of the scenes (1933.1010–11) as "the apex of Giovanni di Paolo's art, and perhaps the freest expression of visual individualism in the whole body of Italian painting." Together with the scenes of the life of Saint Francis painted by Sassetta between 1437 and 1444 as part of the altarpiece once in the church of San Francesco at Borgo Sansepolcro,[4] Giovanni di Paolo's panels devoted to the life of John the Baptist mark the climax of narrative painting on panel in fifteenth-century Siena.

Giovanni di Paolo was active in Siena as early as 1417, when he apparently received payment for illuminating a book of hours.[5] Throughout his long career, his style was dominated by the sinuous, attenuated forms and sumptuous textures of the International Gothic prevalent during the first quarter of the century. His production of datable altarpieces extends from the so-called Pecci altarpiece of 1426 painted for the church of San Domenico in Siena to the altarpiece of the *Assumption of the Virgin* of 1475 for Staggia (near Siena).[6] Apart from the *Saint Anthony Altarpiece* commissioned by Pius II for the cathedral at Pienza, his altarpieces eschew the comparatively new format of a unified *sacra conversazione* in favor of the complex hierarchy of panels making up the traditional Sienese polyptych.[7] Although he frequently made use of the compositions of older Sienese painters or Florentine contemporaries and repeated his own compositions, he invariably transformed these through his nervous, linear style and exquisite sense of color. His small-scale narrative panels are particularly vivid in their balance of decoration and emotion.

The six panels in the Art Institute were unknown until published in 1907 by Perkins with an attribution to Giovanni di Paolo that has rightly remained unquestioned. In addition to the six scenes in Chicago, there are five other related panels: *The Annunciation to Zacharias* (New York, The Metropolitan Museum of Art, Lehman Collection), *The Birth of Saint John the Baptist* (Münster, Westfälisches Landesmuseum), *Saint John the Baptist Preaching* (Paris, Louvre),[8] *The Baptism of Christ* (Pasadena, Norton Simon Museum), and *Saint John the Baptist Accusing Herod* (Münster, Westfälisches Landesmuseum). It is almost certain that one further panel from the series existed, but it has yet to be found. The subject of this missing panel is discussed below. Only Schubring (1912, 1915) and Van Marle (1927) denied that these panels all belonged to the same series and duly separated the two at Münster and that in the Lehman Collection from those in Chicago.

All the incidents depicted on the surviving panels of the series are based on scriptural sources. The artist need not necessarily have referred to *The Golden Legend* of Jacobus de Voragine or to the anonymous *Vita di San Giovanni Battista*, which were both then in circulation.

The early life of Saint John the Baptist is recounted in the gospel of Saint Luke. The series begins with Gabriel's appearance to the priest Zacharias as he burns incense in the Temple. The angel announces that Zacharias's wife Elizabeth will bear a son who will be named John, but Zacharias doubts Gabriel's message and is struck dumb. In the second scene, following the birth of a son to the once barren Elizabeth, Zacharias is asked what name the child should be given and writes on a tablet, "his name is John," whereupon his power of speech returns. The third scene (1933.1010) refers to the conclusion of Saint Luke's account of the childhood of the Baptist, "and the child grew, and waxed strong in spirit, and was in the deserts till the day of his showing unto Israel" (Luke 1.80). The Baptist, "borne along in his ecstasy" (Offner 1927), is depicted twice in this panel, as he leaves the walled city and as he climbs above patterned fields into the rugged mountain wilderness.

The next scenes represent the ministry of Saint John the Baptist. The fragmentary panel in the Louvre would appear to show the Baptist responding to the delegation sent out from Jerusalem by the Pharisees to ask whether he is the Messiah (John 1.19–28). In the second of the Art Institute's panels

(1933.1011), the Baptist gestures toward Jesus on the opposite bank of the River Jordan, in illustration of the passage that follows immediately in Saint John's gospel, "The next day John seeth Jesus coming unto him, and saith, Behold the Lamb of God, which taketh away the sin of the world" (John 1.29). This panel is followed by the *Baptism of Christ* in the Norton Simon Museum. The missing scene from the series probably illustrated another aspect of the Baptist's ministry and may have been the *Baptism of the Multitude*, as Meiss (1974) suggested by analogy to earlier narrative cycles. This identification was accepted by Pope-Hennessy (1987) and Strehlke (1988).[9]

The events leading to the Baptist's martyrdom begin with his denunciation of the Tetrarch Herod "for Herodias his brother Philip's wife, and for all the evils which Herod had done" (Luke 3.19; also Matthew 14.3–4). Herodias, who had entered into an irregular union with Herod, is seated on the dais beside the ruler in the panel in Münster. Furious at this denunciation and fearful of John's hold over the people, Herod imprisoned him. He is shown in captivity in the next panel in the Art Institute (1933.1012), which apparently illustrates the episode in which the imprisoned John sent two disciples to Jesus to inquire, "Art thou he that should come, or do we look for another?" (Matthew 11.2–3). In the remaining scenes, all in the Art Institute, the artist follows the gospel account (Matthew 14.5–11), but chooses not to stress the role played by Herodias. Thus at the celebration of Herod's birthday, Herodias's daughter Salome danced before Herod and pleased him so much that he promised to give her whatever she asked. "And she, being before instructed by her mother, said, Give me here John Baptist's head in a charger" (Matthew 14.8). The Art Institute's panel (1933.1013) shows the moment when Salome pleads for the Baptist's head, although Herodias is omitted. In the next scene (1933.1014), the Baptist has been executed and his head placed on a golden charger. In the last panel (1933.1015), Herod and his courtiers react in horror as the Baptist's head is presented to him. The presentation of the head, like the departure of the young Baptist for the wilderness, is treated as a sequential narrative. Salome appears to be dancing in this scene, as she is often portrayed in the earlier episode of Herod's birthday feast.[10]

Most of the discussion about these panels, the most extensive narrative cycle produced by Giovanni di Paolo, has centered on the reconstruction of the complex to which they originally belonged.[11] The fullest account of the earlier reconstructions is provided by Meiss (1973, 1974). Of these, the reconstruction by Schubring (1912, 1915), who argued that the panels decorated a ciborium, and the one by De Nicola (1918), who envisaged them as forming an altarpiece complete in itself, can be rejected, although De Nicola's comparison with the polyptych of Sant'Umiltà by Pietro Lorenzetti, now in the Uffizi, was perfectly creditable.[12] Venturi (1931), Pope-Hennessy (1937), and Meiss (1973, 1974) all substantially agreed on the basic structural arrangement of the panels, but differed slightly over the sequence of the panels and the type of complex in which the scenes were originally inserted.

In discussing the sequence of the panels, both Venturi (1931) and Pope-Hennessy (1937) were handicapped by the fact that some of the panels were still missing at the time of writing. The rediscovery of *The Baptism of Christ* now in the Norton Simon Museum in Pasadena, however, enabled Meiss (1973, 1974) to provide the most convincing reconstruction yet published (fig. 4), a reconstruction now fully accepted by Pope-Hennessy (1987, 1988) and Strehlke (1988). In this reconstruction the four panels with arched tops (*The Annunciation to Zacharias, The Birth of Saint John the Baptist, The Baptism of Christ,* and *Saint John the Baptist Accusing Herod*) were placed in the upper row. The other panels were arranged below them in pairs to form a narrative sequence. Thus, there were four vertical rows of panels, forming two separate sections of two rows each, divided horizontally into three registers. Consequently, the narrative sequence extends, as with Andrea Pisano's bronze doors for the south portal of the Baptistery in Florence, down the left half from upper left to lower right and then moves across to the upper row in the right half.

Scholars have speculated at length on the type of complex to which the panels originally belonged and its function. The most important indication of the series' probable function is the figure of an angel, presumably Gabriel (fig. 5), painted on the back of *The Annunciation to Zacharias* and the fact that this

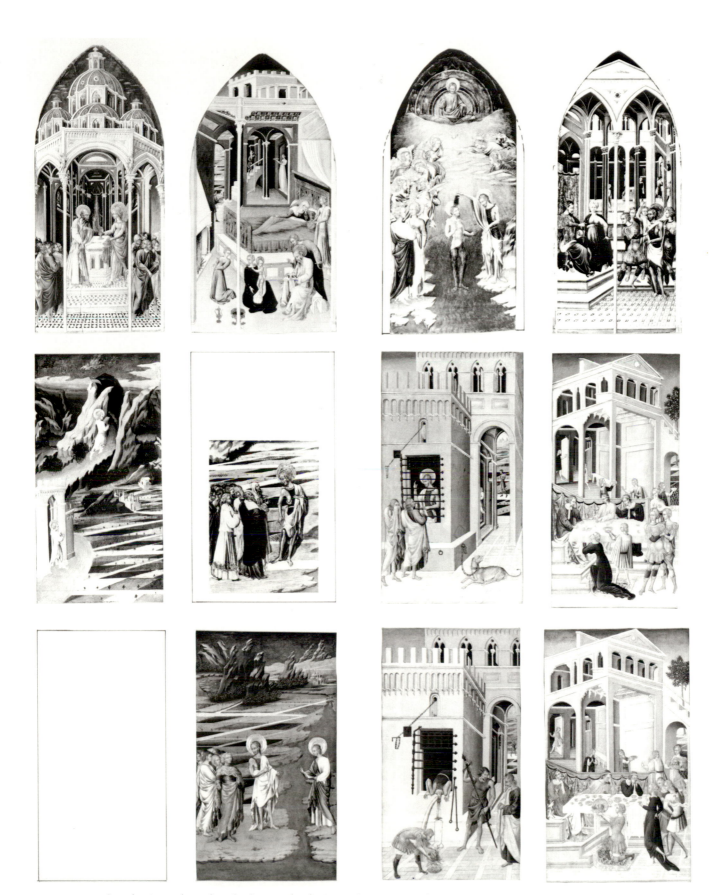

Fig. 4 Giovanni di Paolo, *Scenes from the Life of Saint John the Baptist* (reconstruction)

panel was hinged. Venturi (1931) first drew attention to this figure, suggesting on the basis of this evidence that the panels served as the wings covering a central image of *Saint John the Baptist in Glory*.

It is important to tabulate the overall measurements of the panels at this point. The approximate dimensions (without frame) are as follows: left wing, 212 x 75 cm; right wing, 212 x 75 cm. It will be noted that the width of the center (approx. 150 cm), to be concealed by the panels, if that was indeed their function, was fairly large in proportion to its height.[13]

Pope-Hennessy (1937) favored a sculptured figure of Saint John the Baptist in the center. Brandi (1941, 1947) tentatively drew a comparison with the doors of the reliquary cupboard (now dismembered) painted by Benedetto di Bindo in 1412–13 for the sacristy of the Duomo in Siena,[14] and also with that similarly painted by Vecchietta in 1445 for the church of Santa Maria Annunziata in the Ospedale di Santa Maria

Fig. 5 Giovanni di Paolo, *The Angel of the Annunciation*, The Metropolitan Museum of Art, New York, Robert Lehman Collection, 1975 (1975.1.37v)

della Scala in Siena.[15] Carli (1961) argued that a painted representation of the *Crucifixion*, possibly that of which fragments are preserved (formerly in the church of Santi Giovannino e Gennaro in Siena, now in the Opera del Duomo), would have been wider than a single image of the saint and therefore more likely to have been placed in the center. Meiss (1974), following Venturi's lead, examined the backs of all the panels afresh only to find that those in Chicago and Münster are cradled, but that *The Baptism of Christ* in Pasadena was originally prepared with gesso and covered in red paint or bole. From this he deduced reasonably that the panel of *Saint John the Baptist Accusing Herod* (Münster) must also have been painted on the reverse with the figure of the Virgin Annunciate to balance the Angel Gabriel on the back of *The Annunciation to Zacharias*. He tentatively raised the possibility that the panels formed part of an altarpiece that was visible from both sides, in the tradition of Duccio's *Maestà* for the Duomo in Siena, Masolino's altarpiece for Santa Maria Maggiore in Rome, or, more appropriately, Sassetta's Sansepolcro altarpiece for San Francesco.[16]

In the literature on the series, insufficient attention has been paid to the fact that the hinge on the back of the Lehman Collection's *Annunciation to Zacharias* is placed to allow movement between the first and second rows of panels. This makes Eisenberg's proposal (1977), that the panels may have formed the two doors and sides respectively of a *custodia* or reliquary cupboard containing a sacred relic or effigy of Saint John the Baptist, of great interest. Eisenberg's suggestion was taken up and significantly strengthened by Strehlke (1988), who drew attention to the acquisition by the Sienese of an important relic of the Baptist, his right arm, an acquisition negotiated in 1459 to 1461, according to Strehlke, but possibly anticipated in the years before that. The relic was given to the cathedral by Pius II in 1464. By analogy to existing *custodie*, such as that of Pacino di Bonaguida in the University of Arizona Museum of Art, Tucson (fig. 6), and that by an anonymous artist in the parish church of Fossa in the Abruzzi,[17] Eisenberg pointed out that the narrative sequence of the Saint John the Baptist panels would have been visible when the doors were open. When closed, the panels would form three sides of a box with the Annunciation facing the

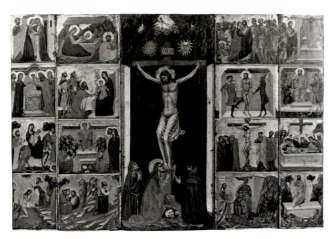

Fig. 6 Pacino di Bonaguida, *Custodia*, Collection of The University of Arizona Museum of Art, Tucson, Gift of the Samuel H. Kress Foundation

spectator. Pope-Hennessy (1987) suggested that the gilt *pastiglia* decoration, of which remnants are visible below the figure of Gabriel on the reverse of the Lehman panel, may have extended downward onto the backs of the other panels. The possibility that the backs also contained figural decoration cannot be entirely excluded.[18]

Strehlke's association of the Saint John the Baptist series with the reliquary containing the right arm of the Baptist is of particular interest, since there is, at this point, no specific documentary evidence for the original location of the panels.[19] He noted that the reliquary containing the arm was kept in a *cassone*, which must itself have been placed in a cabinet for safekeeping. In support of this hypothesis, he cited the record of Bossio's visit to the cathedral in 1575 indicating that the *cassone* containing this relic was kept outside the sacristy in a "special space, or small room (*stantiam*) seemingly not large enough for a man to enter, closed off by two doors reached by two stone steps."[20] Strehlke speculated further that Donatello's bronze statue of the Baptist, sent to Siena in 1457, and the Giovanni di Paolo panels may have been commissioned in anticipation of the arrival of this important relic.

Other physical evidence provided by the panels may support the hypothesis of reliquary cupboard doors. Although all the Chicago panels have been thinned and cradled, x-radiographs nevertheless show remnants of hardware (see Condition) just below the

center of the three panels presumed to come from the lower register, *Ecce Agnus Dei*, *The Beheading of Saint John the Baptist*, and *The Head of Saint John the Baptist Brought before Herod* (figs. 1–3). This appears comparable to the hardware fixing the hinge to the Lehman Collection *Annunciation to Zacharias*, as seen in x-radiography, and suggests that the three Chicago panels were indeed aligned in a row.[21] While the edges of all the panels in Chicago have been renewed, comparison of the dimensions of the individual panels suggests that the outer rows, topped by the *Annunciation to Zacharias* and *Saint John the Baptist Accusing Herod*, respectively, were slightly narrower.[22] This variation may be analogous to the differences in the width of the doors and sides of the *custodie* cited by Eisenberg (1977). These narrower rows would then have formed the doors rather than the sides of a reliquary cupboard.

There has been consensus on the general dating of the panels, although no agreement has yet been reached on a specific date. Schubring (1912) proposed c. 1450; De Nicola (1918), 1445–1447/49; Valentiner (1932), c. 1450–60; Pope-Hennessy (1937, 1938, 1987, 1988), c. 1455–60; Brandi (1941), 1445–49, (1947) c. 1450, and (1949) c. 1453, on comparison with the San Nicola polyptych of that year (Siena, Pinacoteca, no. 173); Carli (1961), 1445–49; Degenhart and Schmitt (1968), 1440–50; and Meiss (1974) recognized the panels' stylistic compatibility with the altarpiece of 1454 in The Metropolitan Museum of Art in New York.[23] Langton Douglas (1938) was alone in suggesting a date as early as 1436–38.

There can be little doubt that the panels are in Giovanni di Paolo's mature style. The figure types are distinguished by their curly hair, pert, sharply defined facial features, often shown in profile, thin fingers, and exaggerated postures. The characterizations range from the ascetic, almost disheveled appearance of the Baptist or of the executioner, through the intense concern displayed by the Baptist's followers, to the callous foppishness of the courtiers populating Herod's palace, culminating in the figure of Salome herself. The theme treated in these panels, perhaps more than any other in Giovanni di Paolo's oeuvre, suited an artistic temperament that combined spiritual ecstasy with acutely observed realism.

Kenneth Clark aptly described the saint as stepping out into "a wilderness which is the Sinai of Byzantine iconography carved into a Gothic sharpness."[24]

Giovanni di Paolo painted what De Nicola aptly termed an *editio minor* of these panels of scenes from the life of Saint John the Baptist in a group of horizontal predella panels now in The National Gallery in London.[25] Davies was uncertain about the chronological sequence of the two series, but Pope-Hennessy (1987, 1988) has recently placed the London panels earlier, since the additional height of the more extensive series is comprised of architectural or landscape elaboration. He connected the London panels to the altarpiece of the *Virgin and Child with Saints* dated 1454 in The Metropolitan Museum of Art.[26] A later date would also accord with Strehlke's hypothesis that the series relates to the acquisition of the relic of Saint John's arm.

The compositions of these panels are remarkable in their combination of personal imagination and dependency upon other works of art. This duality probably stems from the fact that cycles of the life of Saint John the Baptist were not as prevalent in Siena as they were in Florence until the erection of the font in the Baptistery with its bronze reliefs by Jacopo della Quercia, Ghiberti, Donatello, and the workshop of Turino di Sano and his son Giovanni. The famous thirteenth-century retable of *Saint John the Baptist Enthroned*, with six scenes from the saint's life on either side (once in the monastic church of Santa Petronilla in Siena and now in Siena's Pinacoteca),[27] might, for example, have been known to the artist, but it does not seem to have been an inspiration for any of the present compositions. It seems, in fact, that for Giovanni di Paolo the reliefs on the font in the Baptistery in Siena (completed by 1434) assumed the significance that the mosaics in the Baptistery in Florence did for artists of that school.

The composition of the second Chicago panel (1933.1011), as well as that of *Saint John the Baptist Preaching* in the Louvre, is based on Giovanni Turini's bronze relief for the font in Siena.[28] The placing of the river between Christ and Saint John, the group of followers on the left, the mountains, and the building are common to both compositions.[29] Donatello's bronze relief of *The Head of Saint John the Baptist Brought before Herod* for the font in Siena

served as the basis for the two scenes of feasting in Herod's palace (1933.1013 and 1933.1015) as regards the general distribution and activity of the figures, as well as the depiction of recession within an interior.[30] This is especially evident in Giovanni di Paolo's panel of this subject, where Herod's pose, the kneeling soldier holding the charger, and the group of three figures on the right, comprising Salome and her two foppish companions, all correspond to Donatello's relief. Giovanni di Paolo has also followed Donatello in placing two seated figures on the other side of the table, but gave them similar expressions of horror, whereas Donatello varied their gestures. Brandi (1941) argued that the architectural setting of both 1933.1013 and 1933.1015 might have been influenced by the work of Melchior Broederlam, although Franco-Flemish manuscript illumination would have been more accessible to Giovanni di Paolo.[31]

The setting of the prison scene is similarly repeated in 1933.1012 and 1933.1014. The type of architecture in these, and perhaps in all the panels in which architecture is dominant, is chiefly dependent upon Ambrogio Lorenzetti, although there seems to be no specific quotation.[32] Concerning the scene of execution, De Nicola (1918) first noted that the pose of the executioner replacing his two-handed sword in its scabbard is based upon the executioner in Masolino's fresco of *The Conversion and Martyrdom of the Empress* in the church of San Clemente in Rome.[33] Weigelt (1930) and Cecchi (1930) both suggested that a fresco of *The Beheading of Saint John* and *The Dance of Salome* by Pietro Lorenzetti (church of Santa Maria dei Servi, Siena) might have served as a source for the manner of execution.[34] Edgerton (1985) observed that the beheading has not been properly carried out, since the lower jaw is still attached to the trunk of the body; presumably the executioner botched his stroke.

The treatment of the patterned landscape, which occurs in two of the Chicago panels (1933.1010–11), as well as in *Saint John the Baptist Preaching* (Paris), and is glimpsed elsewhere in the series beyond the buildings, is a feature found in the works of Paolo Uccello and Sassetta, as Douglas (1938) and Pope-Hennessy (1938, 1947) pointed out.[35] Meiss (1974) regarded Sassetta's example as providing the most likely precedent. Pope-Hennessy (1937) asserted that

the artist's flat treatment of the landscape was derived from the style and technique of the bronze reliefs executed for the font in Siena, notably *The Baptism of Christ* by Lorenzo Ghiberti,[36] but later (1958) called attention to the compositional similarities with an illumination in a French manuscript of the *Dialogues of Pierre Salmon*.[37] In commenting on the landscape, Focillon (1940) referred to the "irrational perspective of cartography joined to the obsessive delight in rock forms." This characterization perhaps obscures the fact that in these panels Giovanni di Paolo appears to be attempting to emulate recent developments in the use of perspective, although without great success, since both the landscapes and the buildings have clearly been drawn without recourse to mathematics. The architecture is especially bizarre in its mixture of styles and wobbly structures, but the patterned fields stretched tautly across the landscape do reveal an awareness of the theoretical possibilities of one-point perspective.

Notes

1 The panels are listed as belonging to Aynard in Perkins 1907.

2 An entry in Ryerson's notebook (Archives, The Art Institute of Chicago) dated June 18, 1914, reads: "Bot [*sic*] of Kleinberger, Paris, 6 panels by Giovanni di Paolo (purchased by him at Aynard sale for 160 000 fr + 10%)."

3 Receipt from Kleinberger dated June 18, 1914, in curatorial files.

4 A. Braham, "Reconstructing Sassetta's Sansepolcro Altarpiece," *Burl. Mag.* 120 (1978), pp. 386–90 (ill.).

5 Strehlke 1988, p. 168.

6 For the Pecci altarpiece, now dismembered, see C. Brandi, "Ricostruzione di un'opera giovanile di Giovanni di Paolo," *L'arte* 37 (1934), pp. 462–81, figs. 1–8; and I. Bähr, "Die Altarretabel des Giovanni di Paolo aus S. Domenico," *Mitteilungen des Kunsthistorischen Institutes in Florenz* 31 (1987), pp. 357–66. For the Staggia altarpiece and its date, see P. Torriti, *La Pinacoteca Nazionale di Siena: I dipinti dal XII al XV secolo*, Genoa, 1977, pp. 338–40, nos. 324, 186/189 , figs. 411–12.

7 Van Os 1990, pp. 193–99, fig. 204.

8 A full technical report on *Saint John the Baptist Preaching*, which has been cut down, was published in the *Bollettino dell'Istituto Centrale del Restauro* in 1956 (see References above).

9 Pope-Hennessy had earlier (1937) followed Venturi (1931) in suggesting an otherwise unrepresented scene (except in opera) of the meeting between Saint John the Baptist and Salome.

10 Comparison should be made in this respect with Benozzo Gozzoli's predella panel from the important altarpiece painted in 1461–62 for the meeting place of the Confraternity of the Purification of the Virgin in the church of San Marco, Florence. Shapley 1966, p. 116, no. K1648, fig. 317.

11 Of archaeological interest only is that in the Aynard collection the six scenes now in Chicago were assembled side by side in sequence within a single unifying frame. As such, they are reproduced first in Perkins (1907) and again in the Georges Petit sale catalogue of 1913.

12 See De Nicola 1918, pl. 1, for the hypothetical reconstruction. Lorenzetti's polyptych is reproduced in L. Marcucci, *Gallerie Nazionali di Firenze: I dipinti toscani del secolo XIV*, Rome, 1965, pp. 153–57, no. 109.

13 Venturi (1931), Carli (1961), and Meiss (1974) pointed out that the center would have been larger than the width of the central panel of Sassetta's altarpiece for San Francesco at Borgo Sansepolcro.

14 Brandi 1949, pls. 11b–15.

15 For Vecchietta's reliquary doors, see H. W. van Os, *Vecchietta and the Sacristy of the Siena Hospital Church*, The Hague, 1974, fig. 1.

16 See note 4.

17 Eisenberg 1977, fig. 2.

18 Vecchietta's *custodia* doors (see note 15), with their figures of saints on the exterior and Passion narrative on the interior, provide an interesting precedent.

19 In view of their quality and the scale of the undertaking, this lack of early provenance is strange. Various other suggestions of a possible destination have been made. As already noted, Carli (1961) attempted, unsuccessfully according to Meiss (1974), to link the panels with the church of the Confraternita di San Giovanni Battista sotto il Duomo (also known as Santi Giovannino e Gennaro). A suggestion first made by Bacci (1974) that the panels formed part of the decoration of Giovanni di Paolo's name chapel in the church of San Egidio in Siena, where the artist expressed the wish to be buried in his will of 1477, is certainly worth further investigation, especially in the light of Van Os's recent studies on Vecchietta. H. W. van Os, "Vecchietta and the Persona of the Renaissance Artist," in *Studies in Late Medieval and Renaissance Painting in Honor of Millard Meiss*, ed. by I. Lavin and J. Plummer, vol. 1, New York, 1977, pp. 445–54, esp. pp. 452–53.

20 Strehlke 1988, p. 217.

21 The long clinched nails holding the hinge in place are comparable to the nails or fills visible in the x-radiographs of the Chicago panels. The x-radiograph of *The Baptism of Christ* in the Norton Simon Museum also shows a row of long clinched nails at the same level as in the Lehman panel. This panel from the upper row has not been thinned and cradled, though its hinge has been removed. Another row of what appear to be three metal studs, whose function is unclear, is evident in the x-radiographs of the Lehman panel, the Norton Simon panel, and all three of the Chicago panels from the lower register. Laurence Kanter of the Lehman Collection and Gloria Williams of the Norton Simon Museum very kindly examined the panels in their care and made x-radiographs available.

22 Thus the width of the panels in the upper row is: *Annunciation to Zacharias*, Lehman Collection, 34.2 cm (not 43.2 cm as given in Strehlke 1988); *The Birth of Saint John the*

Baptist, Münster, 38.5 cm; *The Baptism of Christ*, Norton Simon Museum, 34.1 cm (this panel has been trimmed on both sides); and *Saint John the Baptist Accusing Herod*, Münster, 33.4 cm. Géza Jászai kindly remeasured the two Münster panels, slightly correcting the dimensions given in Pieper (1986). The variation in the widths of the four panels was already noted by Pieper, who also correctly noted that the width of the last panel of the series, *The Head of Saint John the Baptist Brought before Herod* (1933.1015), is anomalous given its position in the narrative. Pieper nevertheless believed that the narrative panels formed wings that did not cover the center when closed.

23 Zeri/Gardner 1980, pp. 22–23.

24 K. Clark, *Landscape into Art*, London, [1949] 1976, p. 87.

25 Davies 1961, pp. 243–45, nos. 5451–54.

26 See note 23.

27 G. Sinibaldi and G. Brunetti, *Pittura italiana del duecento e trecento*, Florence, 1943, pp. 103–04, no. 32, figs. 32a–b.

28 R. Krautheimer, *Lorenzo Ghiberti*, Princeton, 1956, pl. 73; 2d ed., 1970, vol. 2, fig. 40.

29 Lasareff (1966) discussed the composition of 1933.1011 in the context of the lingering influence of Byzantine art in Siena. It has not been previously observed that the letters ADA D[?] GM are inscribed on the bridge at the right edge.

30 H. W. Janson, *The Sculpture of Donatello*, Princeton, 1957, vol. 2, pl. 93.

31 Brandi drew a comparison with the panels (*The Annunciation and Visitation* and *The Presentation and the Flight into Egypt*) that once formed the shutters of the sculptured altarpiece of 1393–99 from the Charterhouse at Champmol and are now in the Musée des Beaux-Arts in Dijon (see E. Panofsky, *Early Netherlandish Painting*, Cambridge, Mass., 1953, vol. 1, pp. 86–89, figs. 104–05).

32 Compare the architecture, for example, of the frescoes of *Good and Bad Government in the City*, reproduced in G. Rowley, *Ambrogio Lorenzetti*, vol. 2, Princeton, 1958, pls. 157–58, 206–08. Schubring (1915) suggested that the architecture might have been inspired by that used by Domenico di Bartolo, Vecchietta, and Priamo della Quercia for the frescoes in the Pellegrinaio of the Ospedale in Siena. For reproductions of two of the frescoes, see Berenson 1968, vol. 2, pls. 795, 797. Pope-Hennessy (1937, pp. 110–11 n. 74) reported Clark's opinion that the cheetah in the foreground might be a quotation from a Florentine woodcut, but did not specify which one. Comparison may also be made with a sheet in Jacopo Bellini's sketchbook in the Louvre; see C. Eisler, *The Genius of Jacopo Bellini*, New York, 1989, pl. 88, *Enthroned Ruler Presented with Severed Head* (also known as *The Head of Hannibal Presented to Prusias*). On the identification of this animal in fifteenth- and sixteenth-century Italy, see W. Tresidder, "The Cheetahs in Titian's *Bacchus and Ariadne*," *Burl. Mag.* 123 (1981), pp. 481–85.

33 Berenson 1963, vol. 1, pl. 570.

34 Cecchi 1930, pl. LXXVII.

35 See, for example, two of the panels of *The Rout of San Romano* and the less firmly attributed *Saint George and the Dragon* in Paris, reproduced in J. Pope-Hennessy, *Paolo Uccello*, 2d ed., London, 1969, pls. 51, 61, and 77, respectively; and Sassetta's *The Mystic Marriage of Saint Francis* from the Borgo Sansepolcro altarpiece, illustrated in Braham (note 4), p. 391, fig. 53.

36 Krautheimer (note 28), pl. 73.

37 Pope-Hennessy 1958, p. 142 (ill.); more recently, Pope-Hennessy (1987, p. 123) compared the compositions to those of the Boucicault Master.

Girolamo da Santacroce

Documented Venice by 1503, d. Venice 1556

Virgin and Child Enthroned, 1516
Mr. and Mrs. Martin A. Ryerson Collection, 1933.1008

Tempera or oil on panel, transferred to canvas, 86.9 x 44.7 cm (34¼ x 17⅝ in.)

INSCRIBED: ·M·D·XVI·ADI·XX / IIII·OTVBRIO· / ·IHERONIMO·DA·SĀTA· + (lower right, on the step of the throne)

CONDITION: The painting is in poor condition. It was transferred to canvas and restored in 1913, after it entered the collection of Martin A. Ryerson.[1] There are no other records of treatment before 1962, when Alfred Jakstas cleaned and restored the picture. It has suffered considerable abrasion and paint loss throughout. A vertical join or split about 10 cm from the left edge and extending the full height of the panel has been filled and inpainted. There are substantial areas of inpainting in the Virgin's rose cloak, the flesh areas, and the steps of the throne. The inpainting in these areas is now discolored. The modeling of the Child's body is further impaired by two circular blemishes, one on his left shoulder and the other on his right knee, possibly caused by knots in the original panel (x-radiograph).

PROVENANCE: James Kerr-Lawson, Florence. Sold by Kerr-Lawson to Martin A. Ryerson (d. 1932), Chicago, 1910;[2] on loan to the Art Institute from 1923;[3] bequeathed to the Art Institute, 1933.

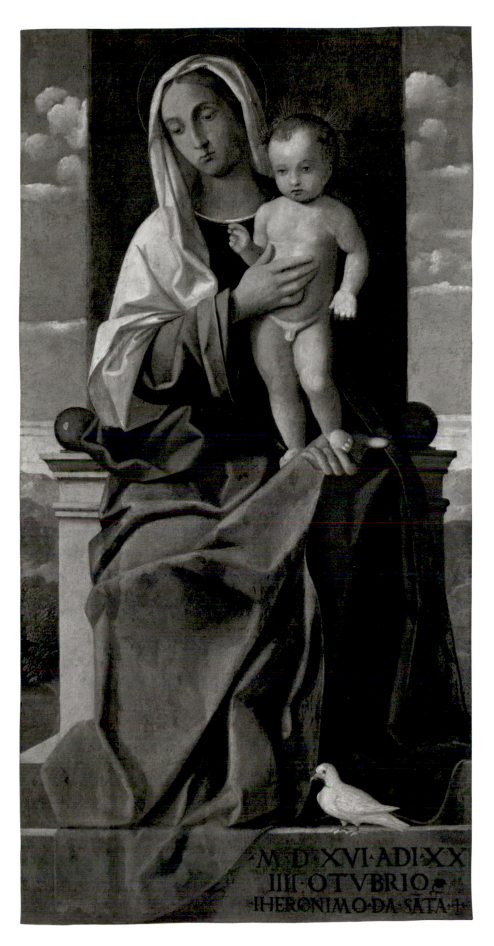

REFERENCES: AIC 1925, p. 159, no. 2025. *Ryerson Collection 1926*, pp. 53–55. W. H., "Some Recently Acquired Pictures of the Venetian School," *Bulletin of The Detroit Institute of Arts* 8, 5 (1927), p. 51. AIC 1932, p. 180. Berenson 1932, p. 507; 1936, p. 436; 1957, vol. 1, p. 154, pl. 574. Valentiner [1932], n. pag. Thieme/Becker, vol. 29, 1935, p. 423. AIC 1961, p. 410. Huth 1961, p. 517. F. Heinemann, *Giovanni Bellini e i belliniani*, Venice, 1962, vol. 1, pp. 39, 161, no. 136 (l), vol. 2, fig. 647. Fredericksen/Zeri 1972, pp. 93, 336, 571. B. Della Chiesa and E. Baccheschi, "I pittori da Santa Croce," in *I pittori bergamaschi dal XIII al XIX secolo: Il cinquecento*, vol. 2, Bergamo, 1976, p. 29, no. 10, p. 58, fig. 3. Waterhouse 1983, p. 89.

EXHIBITIONS: Chicago, South Side Community Art Center, *Exhibition of Religious Art*, 1942, no. 1.

This is the earliest surviving work by Girolamo da Santacroce to be signed and dated. As first noted in the Ryerson Collection catalogue of 1926, the poses of the Virgin and Child, as well as the arms of the throne, are closely derived from Giovanni Bellini's great altarpiece of the *Virgin and Child Enthroned with Saints Peter, Catherine of Alexandria, Lucy, and Jerome* of 1505 in the church of San Zaccaria in Venice.[4] This close connection is appropriate, since after the death of his first master, Gentile Bellini, in 1507, Girolamo da Santacroce most probably worked as an assistant of Giovanni Bellini. Though Bergamasque in origin, Girolamo was trained and worked in Venice. The works of this essentially eclectic and somewhat overproductive painter are not without a certain charm in the gentle characterizations of the figures and warm glow of the colors.

It is possible that the Art Institute panel is a fragment of an altarpiece such as that of the *Virgin and Child Enthroned with Saints Joseph and Nicholas of Bari* of 1527 (or 1537) in the church of Chiesa Madre, Isola d'Istria,[5] but it may in fact only have been slightly trimmed. There are no signs of additional figures at the edges and no cast shadows. Furthermore, the contemplative mood of the painting, with the landscape behind and the white dove on the step, is strongly reminiscent of the *Virgin and Child Enthroned* by Giovanni Bellini in the Musée Jacquemart-André in Paris. Robertson identified the latter as the work commissioned in 1515 by the Venetian Republic as a gift for the Duchesse d'Alençon, sister of Francis I, and described it as "an important document for the last phase of Giovanni's development."[6]

The dove is the symbol of the Holy Ghost, according to New Testament accounts of the baptism of Christ (Matthew 3.16–17 and John 1.32), but here it may simply be an allusion to the birth of Christ.

NOTES

1 The picture was transferred to canvas in 1913; see receipt from Durand-Ruel dated December 1, 1913, in the Ryerson papers, Archives, The Art Institute of Chicago.
2 See letter from Kerr-Lawson to Ryerson of May 10, 1910, and invoice of June 14, 1910, in curatorial files.
3 According to registrar's records, the picture was briefly on loan to the Art Institute in 1913 and was again in the museum at various times in 1921 and 1922, although there is no record of receipt prior to September 18, 1923.
4 G. Robertson, *Giovanni Bellini*, Oxford, 1968, frontispiece. Curiously, having agreed with this derivation in a written communication (letter from Heinemann to Hans Huth of July 20, 1956, in curatorial files), Heinemann (1962) listed the picture as a copy after the altarpiece of the *Virgin and Child with Saints John the Baptist, Francis, Jerome, Sebastian, and a Donor* of 1507 in the church of San Francesco della Vigna in Venice. This must be a mistake, as neither the poses nor the format are comparable, while the connections with the San Zaccaria altarpiece are indisputable.
5 Della Chiesa and Baccheschi 1976, p. 29, no. 13, p. 59 (ill.).
6 Robertson (note 4), p. 153, pl. CXIX-b.

Latin Kingdom of Jerusalem

Diptych: *Virgin and Child Enthroned with the Archangels Raphael and Gabriel* (left wing), *Christ on the Cross between the Virgin and Saint John the Evangelist* (right wing), 1275/85

Mr. and Mrs. Martin A. Ryerson Collection, 1933.1035

Tempera on panel, left wing: 38 x 29.5 cm (14$\frac{15}{16}$ x 11$\frac{5}{8}$ in.); painted image of left wing: 29.8 x 22.3 cm (11$\frac{3}{4}$ x 8$\frac{3}{4}$ in.); right wing: 38 x 29.5 cm (14$\frac{15}{16}$ x 11$\frac{5}{8}$ in.); painted image of right wing: 30 x 22.3 cm (11$\frac{7}{8}$ x 8$\frac{3}{4}$ in.)

INSCRIBED: left wing, S. RAPAEL [RAPHAEL] (upper left in red pigment), S. GABRIEL (upper right in red pigment), .FL[...] (vertically, below center left in red pigment); right wing, $\overline{\text{IC}}$ $\overline{\text{CR}}$ (on the cross in gold pigment),[1] $\overline{\text{MP}}$ $\overline{\text{OY}}$ (center left in red pigment),[2] s[...] (center right in red pigment)[3]

CONDITION: The diptych is generally in good condition. It was cleaned in 1953 and again by Alfred Jakstas in 1974, when discolored varnish and overpaint were removed. The two wings of the diptych are joined by old hinges placed 4.5 cm and 4.2 cm from the upper and lower edges respectively. The x-radiograph suggests that the frames are engaged rather than carved from single pieces of wood. It also shows numerous modern nails inserted from the sides, presumably to resecure the engaged frame. The sides of the frames and the backs around the edges have been regessoed, covering these nails. The flat front edges of the frames are white with traces of silver, though this surface may not be original, since earlier photographs show dark edges. The sides of the frames are now painted a mottled red. Those parts of the back that remain intact have a dark field speckled with red and cream to simulate stone. The scrollwork decoration of the halos and on the beveling of the frames is in *pastiglia*, a form of gesso decoration applied freehand and then gilded. This decoration is generally in excellent condition, though the bottom bevel of the left panel and the bottom and right bevels of the right panel have been reconstructed. The Christ Child's halo on the left wing differs from the others in that it is decorated with a diagonal diaper pattern. The paint surface of the left wing is slightly worn, particularly on the left side of the throne. There are some minor losses and abrasions in the wings and sleeves of the angels, as well as in the backcloth of the throne to the left. There are some filled flake losses in the Virgin's right sleeve, as well as larger paint and ground losses in her right knee. Apart from minor damages alongside her neck and right cheek, the faces are very well preserved. On the right wing, the ground plane below the cross has suffered considerable loss, especially on the left side. There are scattered paint and ground losses in the drapery of Saint John, the largest being below his left hand. In addition, the folds of the Virgin's drapery have sunk so that her robe appears flat. The figure of Christ is comparatively well preserved, except for some paint and ground losses to his left hip. The background on both wings was once gilded, although the gold is now substantially abraded, revealing a neutral ground of gesso (infrared, mid-treatment, ultraviolet, x-radiograph).

PROVENANCE: Albin Chalandon, Paris, by 1850. By descent to Henri Chalandon, La Grange Blanche, Parcieux (near Lyon).[4] Sold by Chalandon to Robert Langton Douglas, London, by 1924.[5] Sold by Langton Douglas to Martin A. Ryerson (d. 1932), Chicago, by 1924;[6] on loan to the Art Institute from 1924; bequeathed to the Art Institute, 1933.

REFERENCES: AIC 1925, p. 160, no. 2048. *Ryerson Collection* 1926, pp. 7–10. R. M. F[ischkin], "Two Thirteenth-Century Italian Paintings," *AIC Bulletin* 20 (1926), pp. 77–80 (ills.). E. Sandberg-Vavalà, *La croce dipinta italiana e l'iconografia della passione*, Verona, 1929, p. 394. E. Sandberg-Vavalà, "A Dugento Diptych in Chicago," *International Studio* 95 (April 1930), pp. 32–36, 88, fig. 9. AIC 1932, p. 183, no. 2922.24. Valentiner [1932], n. pag. AIC 1935, p. 20. E. B. Garrison, "Post-War Discoveries: Early Italian Paintings, II," *Burl. Mag.* 89 (1947), p. 210. AIC 1948, p. 25 (ill. of right wing). Garrison 1949, pp. 32, 97, no. 241 (ill.). F. A. Sweet, "La pittura italiana all'*Art Institute* di Chicago," *Le vie del mondo: Rivista mensile del Touring Club Italiano* 15 (1953), pp. 689–90. H. Buchthal, *Miniature Painting in the Latin Kingdom of Jerusalem*, Oxford, 1957, pp. 48–49, 51, pls. 57a, b. AIC 1961, p. 224. Huth 1961, p. 516. E. B. Garrison, "A Sacramentary for Roman Use with Sicilian Decoration," *Studies in the History of Medieval Italian Painting* 4, 3–4 (1962), p. 415 n. 4. K. Weitzmann, "Thirteenth-Century Crusader Icons on Mount Sinai," *Art Bull.* 45 (1963), pp. 181, 189, reprinted in his *Studies in the Arts at Sinai*, Princeton, 1982, pp. [293], [301]. Maxon 1970, pp. 23 (ill.), 288. G. Gamulin, *Madonna and Child in Old Art of Croatia*, Zagreb, 1971, pp. 11, 15, 51 n. 15, fig. 5. Fredericksen/Zeri 1972, pp. 244, 288, 311. D. Sutton, "Robert Langton Douglas: Dramatic Days," *Apollo* 109 (1979), p. 469, fig. 37. M. Frinta, "Raised Gilded Adornment of the Cypriot Icons, and the Occurrence of the Technique in the West," *Gesta* 20 (1981), pp. 335–36, 340, fig. 3.

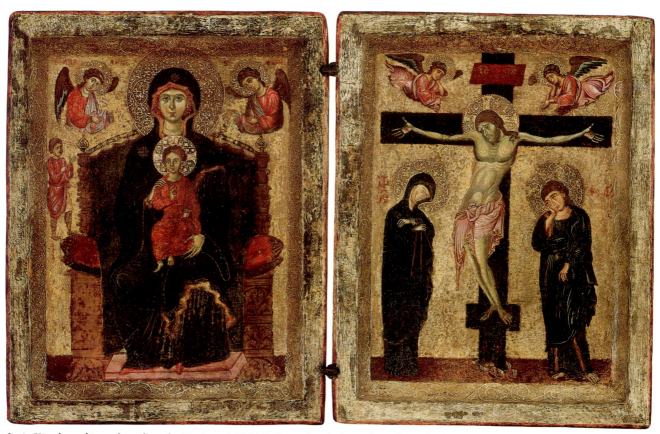

Latin Kingdom of Jerusalem, diptych: *Virgin and Child Enthroned with the Archangels Raphael and Gabriel* (left wing), *Christ on the Cross between the Virgin and Saint John the Evangelist* (right wing), 1933.1035

EXHIBITIONS: The Art Institute of Chicago, *A Century of Progress*, 1933, no. 100, as Tuscan School. The Art Institute of Chicago, *A Century of Progress*, 1934, no. 39, as Tuscan School.

The diptych has recently assumed some importance in the discussion of painting in the Latin Kingdom of Jerusalem during the thirteenth century when artists of Western and Eastern origin worked in close proximity. Its affiliation with this school of Crusader art can be established on the basis of style and technique. The diptych's small dimensions suggest that it was portable and probably used for private worship.

The diptych was acquired by Ryerson as a work of the Pisan school.[7] Sandberg-Vavalà (1930) advanced an attribution to the painter of the earlier (1255/65) of the two crosses in the church of San Francesco in Bologna, now recognized as having been directly influenced by the cross painted by Giunta Pisano in the church of San Domenico in the same city.[8] Garrison (1949) assigned the diptych to the Venetian school with a date of 1275/85. In his pioneering book on miniature painting in the Latin Kingdom, Buchthal (1957) drew attention to the similarities in style between this diptych and a Missal (Cod. 6) in the Biblioteca Capitolare in Perugia, which, on account of a direct liturgical reference, can be associated with the city of Acre, the capital and principal cultural center of the Latin Kingdom from 1244 to 1291, following the fall of Jerusalem.[9] Comparison of the Crucifixion scene on the diptych's right wing with the illumination of the same subject in the Missal in Perugia is particularly persuasive (fig. 1). It follows from Buchthal's observations that a number of other icon panels could have been painted in Acre. Indeed, Buchthal's findings have been developed further both by Weitzmann, with regard to icons, and by Folda, with regard to manuscripts.[10]

The iconography of the diptych is typical of the cross-fertilization that characterizes so much of the work done in the Latin Kingdom. The left wing is the iconic type known as the Virgin *Nikopeia*,[11] and even more Byzantine is the small figure, posed as a suppliant, to the left of the throne. The inscription below this figure is indecipherable, but it is almost certain that he represents the donor, since he wears lay costume. Weitzmann pointed out that such figures are

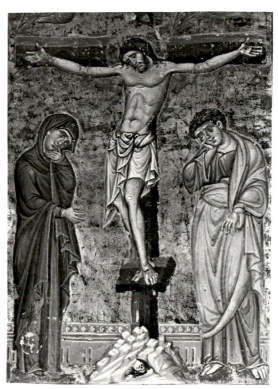

Fig. 1 Detail of *The Crucifixion*, Biblioteca Capitolare del Duomo di Perugia, codice 6, f. 182v

frequently found on icons, as, for example, on the early thirteenth-century icon of *Saint George* by a Byzantine painter in the collection at the monastery of Saint Catherine on Mount Sinai.[12] It should also be noted, however, that they are a particular feature of Cypriot art.[13] The knotted cords hanging from the Virgin's drapery on the left wing of the diptych can be found on other icons in the Mount Sinai group,[14] but they also occur as a motif in the West, for instance, hanging from the drapery of full-length figures of the Virgin in the terminals of crosses by Emilian followers of Giunta Pisano.[15] The curving figure of Christ on the cross on the right wing of the diptych reflects the type found in the work of Giunta Pisano himself, whose influence is also apparent in the Crucifixion in the Missal in Perugia.[16] All the inscriptions on the left wing are in Western script, but the inscriptions on the right wing, apart from that over Christ, are in Greek with standard abbreviations, although that by Saint John the Evangelist is so damaged as to be almost illegible. The inscription over Christ is a Latinized abbreviation of the Greek for Jesus Christ.

The style of the various ateliers established in the Latin Kingdom was heterogeneous, with a mixture of French, Italian, and Byzantine elements. A number of the icons published by Weitzmann in his articles evince general stylistic similarities with the diptych in Chicago, particularly the facial types with the frowning expressions, small mouths, exaggerated eyebrows, and pronounced jaws. Yet, there are some discrepancies due most probably to the personal idiosyncracies of the painter of the Chicago diptych: the eyes do not roll in the head, the fingers are long, thin, and closer together, and the arms of the Virgin below the cross are differently posed.[17] There can be little doubt in terms of style, however, that this diptych was painted somewhere in the Latin Kingdom, although it is hard to establish exactly where or in which atelier. Weitzmann began by ascribing such icons to an artist working in Acre, but in 1982, on republishing his earlier article of 1963, he advanced the hypothesis that the monastery of Saint Catherine on Mount Sinai might itself have been the center of production.[18] Frinta in turn has stressed the importance of the evidence provided by the *pastiglia* decoration, which can also be found on some of the icons in the monastery of Saint Catherine.[19] These include a triptych with *Scenes from the Life of the Virgin, Saint Sergius on Horseback*, and the double-sided icon of the *Crucifixion and Anastasis*, to which should be added a *Saint George and the Young Man of Mitylene* in the British Museum.[20] However, on the basis of Weitzmann's previous detailed stylistic analysis of these icons, only two may be by a single hand and none is by the same artist who painted the diptych in Chicago.[21] There have, in addition, been efforts to ascribe these same icons to an atelier on the island of Cyprus.[22] Although few icons painted on Cyprus dating from the thirteenth century seem to have survived, some, as Frinta observed, do have backgrounds with *pastiglia* decoration.[23] Cypriot icons, however, adhered far more strictly to Byzantine prototypes and, given the heterogeneity of styles and techniques of painters working in the Latin Kingdom, it is unlikely that *pastiglia* decoration was ever limited exclusively to one atelier or even to one locality.[24] As regards the diptych in Chicago, while a general association with the Latin Kingdom remains valid, a specific connection with Acre still seems likely, even though this city's position politically and militarily became more and more precarious as the thirteenth century advanced.[25]

In accordance with other works produced at Acre, the style of painting throughout the diptych has distinctly Western (ostensibly Italian) features. The handling of the faces and of the draperies, the treatment of the strands of hair, and the free use of white highlights, especially over the body of Christ, denote a painter trained within or experienced in the Italian tradition. It was, for example, suggested by Garrison (1949) that the artist responsible for the diptych came originally from Venice, but this cannot be proved. The evidence for thirteenth-century painting in Venice is scanty and what has survived is not overwhelmingly similar in style to the diptych in Chicago.[26] The fact that Giunta Pisano's influence is so apparent implies, as Sandberg-Vavalà first concluded and as Weitzmann (1963, p. 181) did not totally dismiss, that Emilia or Umbria should be considered as possible alternatives to Venice for this anonymous painter's stylistic starting point. It is also the affiliation with Giunta Pisano, particularly in the treatment of Christ on the cross, that indicates a date of 1275/85.

Notes

1 Latinized abbreviation of the Greek, \overline{IC} \overline{XP} = Ἰησοῦς χριστός (Jesus Christ).

2 Μητῆρ Θεοῦ (Mother of God).

3 Possibly, ὁ ἅγιος [Ἰωάννης ὁ Θεολόγος] (Saint John the Theologian, i.e., Saint John the Evangelist).

4 Information about the Chalandon family is based on registrar's accession records, which, in turn, were presumably based on information provided by Langton Douglas. Surviving letters from Langton Douglas to Ryerson (see notes 5 and 6 below) merely state that the diptych had been in the Chalandon collection "for nearly a century" (letter of November 11, 1924) and was bought by him at the Chalandons' "country-house, *La Grange Blanche*, near Parcieux, in the country north of Lyons" (letter of November 13, 1924).

5 Letter from Langton Douglas to Ryerson of November 11, 1924, Ryerson papers, Archives, The Art Institute of Chicago.

6 Letter from Langton Douglas to Ryerson of November 13, 1924, Ryerson papers, Archives, The Art Institute of Chicago.

7 According to receipt from Langton Douglas dated November 18, 1924, Ryerson papers, Archives, The Art Institute of Chicago.

8 Garrison 1949, p. 208, nos. 547, 546, respectively.

9 Buchthal 1957, pp. 48–51; A. Caleca, *Miniatura in Umbria*, vol. 1, *La Biblioteca Capitolare in Perugia*, Florence, 1969,

no. XII, pp. 79–82, 169–71 (ill.).

10 See Weitzmann 1963, as well as Weitzmann's "Icon Painting in the Crusader Kingdom," *Dumbarton Oaks Papers* 20 (1966), pp. 51–82, and "Four Icons on Mount Sinai: New Aspects in Crusader Art," *Jahrbuch des österreichischen Byzantinistik* 21 (1972), pp. 279–93, both reprinted in his *Studies in the Arts at Sinai*, Princeton, 1982, pp. [325–357], pp. [387–401]. Also, J. Folda, *Crusader Manuscript Illumination at Saint-Jean d'Acre, 1275–1291*, Princeton, 1976.

11 R. Jaques, "Die Ikonographie der *Madonna in trono* in der Malerei des Dugento," *Mitteilungen des Kunsthistorischen Institutes in Florenz* 5 (1937), pp. 2–14.

12 Written communication to the author of April 9, 1981 (in curatorial files); for the icon, see G. and M. Sotiriou, *Icones du Mont Sinai*, Athens, 1956, pl. 167.

13 D. Talbot Rice, *The Icons of Cyprus*, London, 1937, pp. 44–48; for further general observations on the context of such portraits in altarpieces of the late thirteenth century, see J. Wollesen, "Vasari, Cimabue, und Duccio, Aspekte zu Norm, Form, und Funktion in der Malerei des späten Dugento," *Kunstchronik* 36 (1983), pp. 28–30.

14 Weitzmann 1963, figs. 7, 22.

15 Garrison 1949, p. 208, no. 547, p. 211, no. 559.

16 Ibid., p. 179, no. 449, p. 208, nos. 543, 546, p. 215, no. 578.

17 Compare Weitzmann 1963, figs. 1, 3, 5.

18 Weitzmann 1982, p. [433].

19 *Pastiglia* decoration is often thought to have evolved in the West as a cheaper and easier alternative to the embossed, repoussé sheets of precious metal that were sometimes used to sheathe icons in Byzantine workshops.

20 For illustrations, see Weitzmann 1963, figs. 7, 9–12; Weitzmann 1966, fig. 49; Weitzmann 1963, figs. 5–6; R. Cormack and S. Mihalarias, "A Crusader Painting of St. George: *Maniera greca* as *lingua franca*," *Burl. Mag.* 126 (1984), pp. 132–41 (ill.).

21 Weitzmann 1982, p. [435], who argued that *Saint Sergius on Horseback* and the double-sided icon of the *Crucifixion and Anastasis* could be attributed to the so-called Master of the Knights Templars (rechristened in 1982 in the plural as "Apulian Painters" or "South Italian Painters").

22 Folda (note 10), pp. 118–19.

23 See Talbot Rice (note 13), pp. 43–61; idem, "Cypriot Icons with Plaster Relief Backgrounds," *Jahrbuch des österreichischen Byzantinistik* 21 (1972), pp. 269–78 (ills.); A. Papageorgiou, *Byzantine Icons from Cyprus*, exh. cat., Athens, Benaki Museum, 1976, nos. 13–17, 19.

24 Cormack and Mihalarias (note 20), p. 138.

25 Folda (note 10), pp. 8–20.

26 See, for comparison, P. Toesca, "Un capolavoro dell'oreficeria veneziana della fine del dugento," *Arte veneta* 5 (1951), pp. 15–20.

Lippi-Pesellino Imitator

Florence c. 1450–1500

Virgin and Child, 1460/70
Bequest of Joseph Winterbotham, 1954.318

Oil and tempera on panel (poplar), 93 x 60.5 cm (36⅝ x 23⅝ in.); image: 68.9 x 36.3 cm (27⅛ x 14⁵⁄₁₆ in.)

INSCRIBED: GLORIAINEXCELSISDOE IINERRAPAX HOMNIBVSBONEVOLVNATIS LA/DAVSEBENE (within molding across top beginning at the lower left), [AV]E MARIAGRATIAPLENA (within molding across the bottom)[1]

CONDITION: The painting is in poor condition. It was lightly cleaned by Alfred Jakstas in 1965. The poplar panel, which is approximately 3.7 cm thick, has a vertical grain. A segment with horizontal grain makes up the top 4.5 cm of the panel. Exposed worm tunneling on the back indicates that the panel must have been thinned. An iron ring for hanging the picture has been inserted at the back. A vertical split or join approximately 22 cm from the left edge extends through the whole panel, disrupting the paint surface, particularly in the body of the Child. The small size of the painted image in relation to the overall panel is puzzling, especially since the inscription, the outer raised molding, and the green marblized decoration on the rim of the panel appear to be modern. In the background, the gold ground and bole have been almost entirely removed, and there are also traces of a blue-green background color, also largely removed, but in some places covering the remnants of gold. The gilding in the halos appears to be modern. The paint surface is abraded throughout. The Virgin's mantle has suffered considerable damage and has been substantially repainted. The best-preserved parts are the Virgin's face and her red robe (x-radiograph).

PROVENANCE: French collection.[2] Joseph Winterbotham, Jr. (d. 1954), Chicago;[3] bequeathed to the Art Institute, 1954.

REFERENCES: AIC 1961, p. 354. Fredericksen/Zeri 1972, pp. 134, 328, 571.

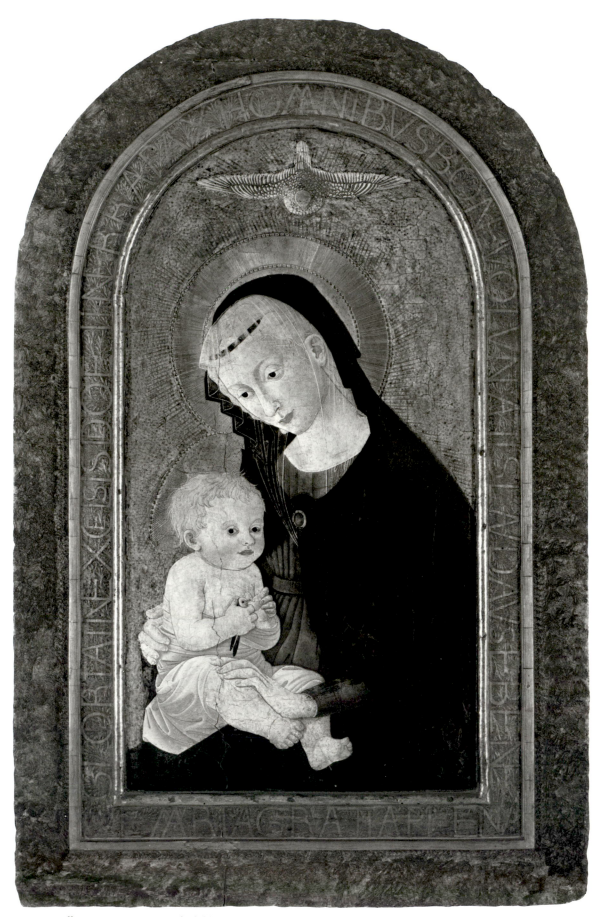

Lippi-Pesellino Imitator, *Virgin and Child*, 1954.318

This is one of a large number of panels of the Virgin and Child falling under the appellation Lippi-Pesellino Imitator.[4] These works, which sometimes include additional figures, were painted by artists belonging to one or more Florentine workshops, who exploited the designs of Filippo Lippi and Francesco Pesellino. Judging by the large number of these composite paintings, the workshop must have fulfilled a popular demand. The panels are not of high quality, although care is usually taken over the decorative features. In many instances the same cartoon seems to have been used for a whole series of works, even though the backgrounds may differ. This group of panels had previously been assigned to Pier Francesco Fiorentino, a priest whose documented works are more closely related to Benozzo Gozzoli and Neri di Bicci than to Lippi and Pesellino. Berenson showed that this attribution was unsatisfactory and coined the term the Pseudo-Pier Francesco Fiorentino to characterize the group.[5] The use of this name, however, proved misleading, and Zeri adopted the designation Lippi-Pesellino Imitator.[6]

The present painting is a typical product of this busy workshop. The poses of the Virgin and Child are derived from a painting by Pesellino known in two versions, both of which are probably autograph; one of these is in the Isabella Stewart Gardner Museum in Boston, the other is in the Christian Museum at Esztergom, Hungary.[7] The basic difference between the panel in Chicago and its prototype occurs in the background, where, instead of a marble niche, the painter has here preferred a plain gold ground to offset the figures. Minor details, such as the design of the Virgin's headband and the decorated edge of her mantle, have also been altered, but such changes occur in many of the other versions as well. Of these, the examples in the following collections provide a good cross section in terms of quality and variation in design: Baltimore, Walters Art Gallery;[8] London, The National Gallery;[9] and New York, The Metropol-

itan Museum of Art.[10] A date of 1460/70 seems appropriate for the Chicago panel. The thin, almost transluscent treatment of the flesh tones, the sharp, dark line prescribing the shape of the face, and the crowded halo pattern are typical features of this workshop, as can be seen on comparison with the tondo *Virgin and Child with Saint John the Baptist and an Angel* in The National Gallery in London.[11]

The goldfinch held in the Child's right hand is a symbolic allusion to the Passion and the dove painted over the gold ground above the Virgin's head symbolizes the Holy Ghost.

NOTES

1 The first part of the inscription is mainly from Luke 2.14 and the second is from Luke 1.28.
2 The panel has a French customs stamp on the back.
3 According to registrar's records, the panel was in Joseph Winterbotham's summer residence in Burlington, Vermont, at the time of his death.
4 The painting was accessioned as School of Pesellino and was listed under this name in the 1961 catalogue of the Art Institute's paintings.
5 B. Berenson, "Quadri senza casa — il quattrocento fiorentino, II," *Dedalo* 12 (1932), pp. 692–94.
6 See F. Zeri, *Italian Paintings in the Walters Art Gallery*, vol. 1, Baltimore, 1976, pp. 80–81.
7 See P. Hendy, *European and American Paintings in the Isabella Stewart Gardner Museum*, Boston, 1974, pp. 178–80 (ill.); A. Mucsi, *Catalogue of the Old Masters Gallery in the Christian Museum in Esztergom*, Budapest, 1975, p. 48, no. 217, pl. 47; and M. Boskovits, *Tuscan Paintings of the Early Renaissance*, Budapest, 1968, pl. 29.
8 Zeri (note 6), pp. 81–83, no. 50, pl. 43. The entries for this painting and for the one in the Isabella Stewart Gardner Museum in Boston (note 7) include lists of numerous other versions, to which might be added one that does not seem to occur in either of these publications, although it is often mentioned in the early literature, namely, the *Virgin and Child* formerly in the Bracht collection in Berlin, illustrated in M. Logan, "Compagno di Pesellino et quelques peintures de l'école," *Gazette des beaux-arts* 3d ser., 26 (1901), p. 32.
9 Davies 1961, pp. 194–95, no. 6266, as Florentine School; and T. Borenius, "Early Italian Pictures in the Collection of Lord Carmichael," *Apollo* 1 (1925), ill. opp. p. 65.
10 Zeri/Gardner 1971, pp. 108–09, no. 65.181.4 (ill.).
11 Davies 1961, p. 186, no. 1199, as Florentine School; and M. Davies, *National Gallery Catalogues: The Earlier Italian Schools, Plates*, London, 1953, vol. 1, p. 145 (ill.).

Lorenzo di Bicci

Active Florence c. 1370–1415

Madonna of Humility with Two Angels, 1375/1400

Mr. and Mrs. Martin A. Ryerson Collection, 1937.1004

Tempera on panel, 72.4 x 41 cm (28½ x 16⅛ in.); painted surface: 59.3 x 38.1 cm (23⅜ x 15 in.)

CONDITION: The painting is in poor condition. It was cleaned and restored in 1974–76 by Alfred Jakstas. The panel is composed of two pieces of wood with vertical grain, joined approximately 23 cm from the left edge, and is roughly dressed on the back. The framing elements have been applied to the front of the panel and are original, except for the moldings at the base of the socles, which were replaced at the time of the 1974–76 cleaning. A small piece of the panel is missing at the apex. Two metal loops attached to the socles appear to be old. The frame has lost its gilding and the columns are severely worm damaged. There is an open vertical split in the panel in the lower right corner, in addition to several horizontal cracks in the paint surface in the upper half.

Generally, there has been a great deal of abrasion and paint loss, especially in the figure of the Virgin, whose features are somewhat blurred as a result of flaking and abrasion and whose mantle is heavily retouched. The features of the Child, who is relatively well preserved, and those of the two angels are not so badly abraded. The forms of the two angels and the brocade textiles were originally thinly painted on the gold ground and are now very worn (infrared, ultraviolet).

PROVENANCE: James Kerr-Lawson, Florence, by 1910.[1] Sold by Kerr-Lawson to Martin A. Ryerson (d. 1932), Chicago, 1910; at his death to his widow, Mrs. Martin A. Ryerson (d. 1937); bequeathed to the Art Institute, 1937.

REFERENCES: Berenson 1936, p. 235; 1963, vol. 1, p. 103. AIC 1961, pp. 246–47. F. Zeri, "Early Italian Pictures in the Kress Collection," *Burl. Mag.* 109 (1967), p. 477. Fredericksen/Zeri 1972, pp. 110, 318, 571. M. Boskovits, *Pittura fiorentina alla vigilia del Rinascimento, 1370–1400*, Florence, 1975, pp. 108, 331, fig. 129. I. Hecht, "Madonna of Humility," *AIC Bulletin* 70, 6 (1976), p. 10, fig. 1. R. Offner, *A Critical and Historical Corpus of Florentine Painting: A Legacy of Attributions*, ed. by H. B. J. Maginnis, New York, 1981, p. 39.

EXHIBITIONS: The University of Chicago, The Renaissance Society, *Old and New Masters of Religious Art*, 1931, no. 75. Decatur, Illinois, Art Center, *Masterpieces of the Old and New World*, 1948, no. 11.

Berenson (1936, 1963) assigned this panel to Jacopo di Cione, a brother of Orcagna and of Nardo di Cione, and the picture was accessioned with an attribution to him. This attribution was still accepted in the 1961 catalogue of the Art Institute's paintings, but was changed to follower of Orcagna in 1976. The attribution to Jacopo di Cione was doubted by Sandberg-Vavalà who proposed Bicci di Lorenzo instead.[2] Offner apparently first suggested the name of Lorenzo di Bicci,[3] although Zeri (1967) was the first to make this attribution in print. Boskovits (1975) agreed with this attribution, dating the panel to 1375–80.[4] Lorenzo di Bicci, the father of Bicci di Lorenzo, worked in the conservative style of followers of Orcagna that dominated Florentine painting during the latter part of the fourteenth century.[5]

The Art Institute's painting can be readily connected to a group of private devotional pictures of the Madonna and Child given to Lorenzo di Bicci,[6] and shares with these works the stiff pose of the Virgin and the blandly rounded facial types. However, in view of its conservative character as well as its damaged state, it is difficult to date the picture more precisely than the last quarter of the fourteenth century.

The treatment of the Virgin follows the traditional iconography of the *Madonna dell'Umiltà*, although here the emphasis is placed solely on the Virgin nursing the child (*Madonna del Latte*) without the attributes of the Woman of the Apocalypse (compare Bolognese, 1947.56). The *Madonna del Latte* signifies the Virgin's role as intercessor and protector and is essentially an image of compassion for which there was no scriptural basis. It became popular during the course of the fourteenth century and is paralleled in literary works such as the *Meditationes vitae Christi* and in contemporary sermons.[7] Meiss has noted that early Florentine treatments of the Madonna of Humility are characterized by a more frontal, contained pose of the Madonna and a more monumental

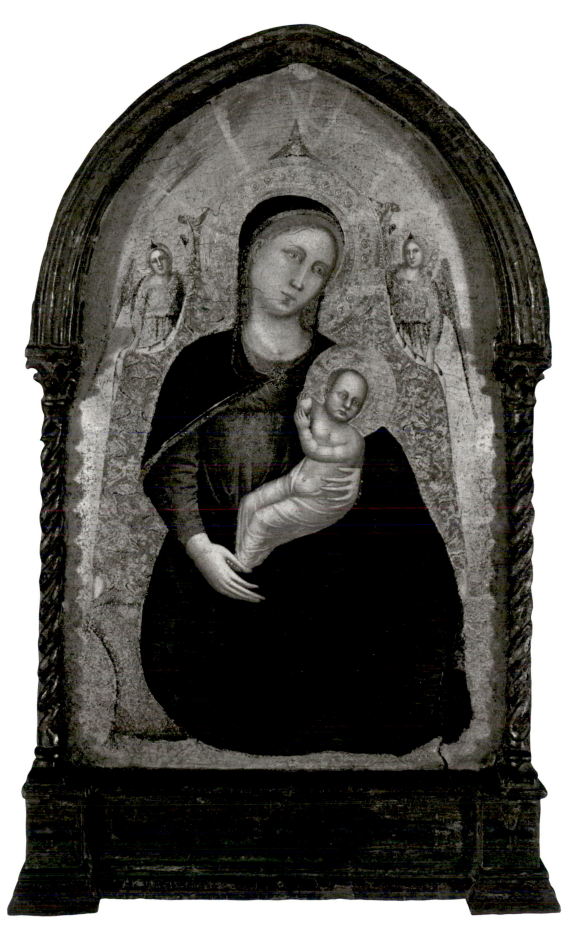

effect.[8] It is worth observing that the Art Institute's panel shares these Florentine characteristics and, though the Virgin is shown seated on the ground, that the cloth of honor held by the two angels recalls the more hierarchical theme of the Virgin enthroned.

Hecht (1976) drew attention to the fact that the pink necklace (now badly rubbed and barely visible in reproduction) worn by the Christ Child would originally have had a branch of coral suspended from it as an amulet. Iconographically, this is a tradition stemming from antiquity.[9] The necklace occurs frequently in fourteenth- and fifteenth-century representations of the Christ Child. An apposite example is the panel of the Virgin and Child in the M. H. de Young Memorial Museum in San Francisco, now generally attributed to Lorenzo di Bicci.[10]

NOTES

1 See invoice from Kerr-Lawson to Ryerson of June 14, 1910, in curatorial files.
2 Undated notes in curatorial files.
3 Undated opinion on mount of photo at Witt Library. See also Offner 1981.
4 Carlo Volpe also attributed this picture to Lorenzo di Bicci in a letter of November 14, 1971, in curatorial files.
5 For his career, as distinct from that of his son, see most recently C. Frosinini, "Il passaggio di gestione in una bottega pittorica fiorentina del primo rinascimento: Lorenzo di Bicci e Bicci di Lorenzo," *Antichità viva* 25, 1 (1986), pp. 5–15.
6 Compare Boskovits 1975, figs. 130–33.
7 M. Meiss, *Painting in Florence and Siena after the Black Death*, Princeton, 1951, pp. 151–52.
8 Ibid., pp. 137–38.
9 S. A. Callisen, "The Evil Eye in Italian Art," *Art Bull.* 19 (1937), pp. 450–62, esp. pp. 455–60.
10 *European Works of Art in the M. H. de Young Memorial Museum*, Berkeley, 1966, p. 21 (ill.); Boskovits 1975, p. 336.

Attributed to Pietro de Mariscalchi

c. 1520 Feltre 1589

Portrait of a Gentleman, 1540/50
Gift of Mrs. Lillian S. Timken, 1951.318

Oil on canvas, 115 x 95 cm (45¼ x 37⅜ in.)

CONDITION: The painting is generally in good condition with areas of localized damage. It was selectively cleaned by Alfred Jakstas in 1962 and treated again by Barbara Pellizzari in 1990. The relatively fine plain-weave canvas has been glue lined to a much coarser piece of fabric. There are several repairs to small holes and tears, the largest being a vertical tear approximately 22 cm long above and to the right of the sitter's left hand. In the area of the fur collar, the paint surface is quite abraded, probably from past cleaning action. Other areas, such as the face and parts of the red curtain, background, and costume, are well preserved. The x-radiograph and examination of the picture in raking light indicate that the placement of the curtains has been changed and that they first framed the sitter's head more closely. The artist also altered the position of the thumb and index finger of the right hand and the thumb of the left hand (mid-treatment, x-radiograph).

PROVENANCE: Private collection, Warsaw.[1] Van Diemen Galleries, New York, by 1929.[2] Mr. and Mrs. William R. Timken, New York; given to the Art Institute, 1951.

REFERENCES: AIC 1961, p. 294. Fredericksen/Zeri 1972, pp. 120, 526, 571.

EXHIBITIONS: New York, Van Diemen Galleries, *Masterpieces of the Venetian School*, 1929, no. 15.

According to the catalogue of the Art Institute's paintings published in 1961, this portrait was traditionally attributed to Paolo Veronese, an attribution that was rightly rejected and changed to Pietro de Mariscalchi.[3] It is not known who first made this suggestion, but it was accepted by Fredericksen and Zeri

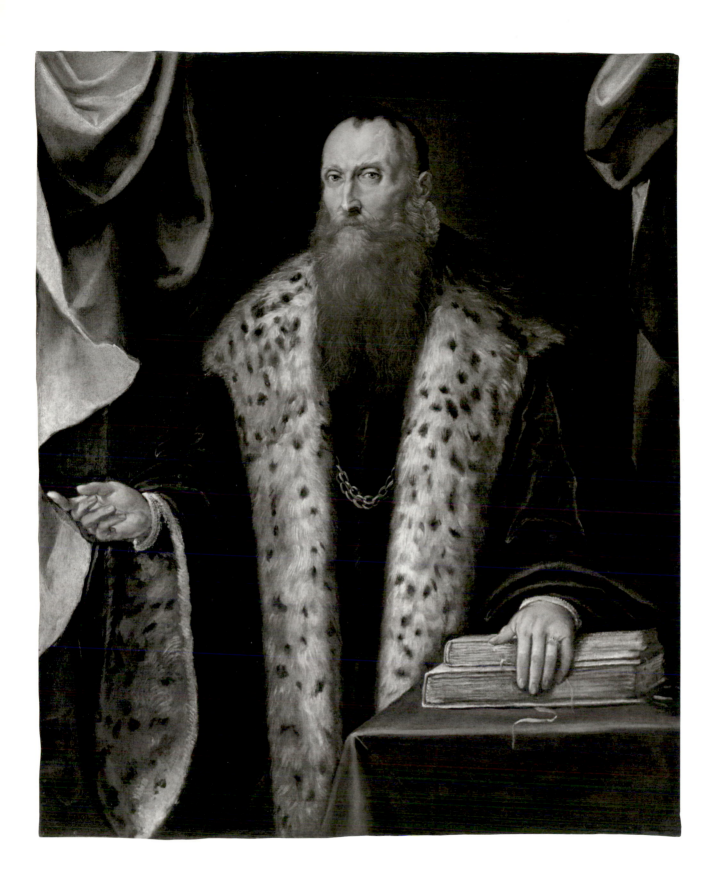

(1972). The thin paint surface, the monochrome tonality, the treatment of the domed forehead, the long fingers, and the sharp characterization are all typical of this painter. Mariscalchi's style reveals the influence of Schiavone, Jacopo Tintoretto, Giovanni de' Mio, and El Greco. The two portraits attributed to Mariscalchi in the Museo Civico in Feltre are not strikingly close to the present portrait,[4] but some of the male figures in the painter's altarpieces are similar: for example, Saint Anthony Abbot to the right of the Virgin in the *Farra Altarpiece* (Farra [Feltre], Parrocchiale) or Saint Joseph in the *Mystic Marriage of Saint Catherine* (Feltre, Museo Civico).[5] Both these works date from the mid-1540s, and it is unlikely that the present portrait was painted after 1550. There is little evidence here of the Mannerist principles that dominated the painter's work during the 1550s and 1560s.[6]

The pose of the sitter in the Chicago painting — facing to the right with right hand pointing while the left is at rest, on a book or otherwise — was common in sixteenth-century Venetian portraiture and can be found in works by Titian and Tintoretto.[7] This well-to-do gentleman wears the long coat, or *robone*, with *lupo cerviero* (lynx) collar and lining that was considered the height of fashion in sixteenth-century Venice.[8]

NOTES

1 According to information presumably supplied by the Van Diemen Galleries (copy in curatorial files). The Polish provenance of this picture is confirmed by the Warsaw customs seal on the stretcher.
2 According to 1929 Van Diemen exhibition catalogue.
3 The picture was attributed to Veronese in expertises by August L. Mayer and Wilhelm von Bode, dated respectively November 27, 1926, and October 10, 1927 (copies in curatorial files).
4 F. Valcanover, *Museo Civico di Feltre: Catalogo della Pinacoteca*, Venice, 1954, pp. 43–44, nos. 8–9, figs. 10–11.
5 For illustrations, see G. Fiocco, "Il pittore Pietro de Mariscalchi da Feltre," *Arte veneta* 1 (1947), figs. 40–41; and Valcanover (note 4), p. 40, no. 6, fig. 8.
6 For a recent assessment of Pietro de Mariscalchi with further bibliography, see *The Genius of Venice, 1500–1600*, exh. cat., London, Royal Academy of Arts, 1983–84, pp. 183–85, nos. 56–57.
7 For examples, see H. E. Wethey, *The Paintings of Titian: Complete Edition*, vol. 2, *The Portraits*, London, 1971, p. 139, no. 96, pl. 160; and C. Bernari and P. De Vecchi, *L'opera completa del Tintoretto*, Classici dell'arte 36, Milan, 1970, p. 96, no. 104 (ill.).
8 R. Levi Pisetzky, *Storia del costume in Italia*, vol. 3, Milan, 1966, pp. 145–48.

Master of Apollo and Daphne

Active Florence c. 1480–1510

Susanna and the Elders in the Garden, and the Trial of Susanna before the Elders, c. 1500

Mr. and Mrs. Martin A. Ryerson Collection, 1933.1029

Tempera on panel, 64 x 159 cm (25¼ x 62⅝ in.)

CONDITION: The painting is in good condition. It was treated for cleavage and cleaned by Alfred Jakstas in 1962–63. It was cleaned by Faye Wrubel in 1991–92. The panel is composed of two boards with horizontal grain, joined approximately 31.5 cm from the bottom edge. Two vertical battens have been set into the panel, which shows an advanced stage of worm tunneling. The panel is slightly warped and has added edging strips at top and bottom.

The paint surface in general is in fairly good condition, although losses along the join have been filled and inpainted, particularly in the left half of the picture. The flesh tones of some of the figures, especially Susanna and her three attendants at the left and the group of men on the extreme right, are abraded. However, there are no areas of major damage. Both panels have been freely and rather thinly painted, with numerous *pentimenti* visible with the naked eye. The figures and the architecture around the dais on the right are extensively underdrawn, as is visible with the naked eye as well as with infrared photography. The architecture and the pavement are also incised (infrared, ultraviolet, x-radiograph).

PROVENANCE: See below.

REFERENCES: See below.

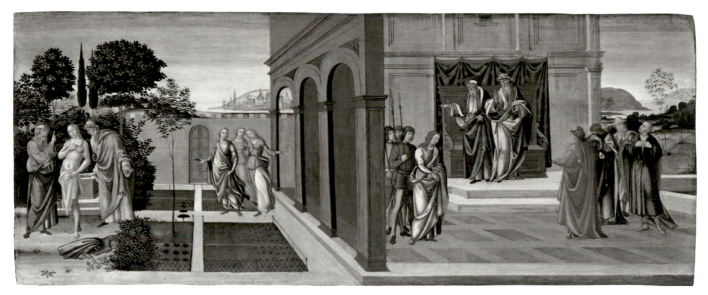

Master of Apollo and Daphne, *Susanna and the Elders in the Garden, and the Trial of Susanna before the Elders*, 1933.1029

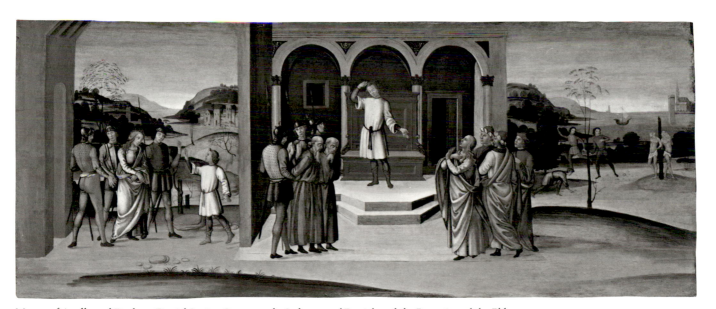

Master of Apollo and Daphne, *Daniel Saving Susanna, the Judgment of Daniel, and the Execution of the Elders*, 1933.1030

Daniel Saving Susanna, the Judgment of Daniel, and the Execution of the Elders, c. 1500

Mr. and Mrs. Martin A. Ryerson Collection, 1933.1030

Tempera on panel, 63.7 x 157.8 cm (25⅛ x 62⅛ in.)

CONDITION: The painting is in fair condition. It was treated for cleavage and cleaned by Alfred Jakstas in 1962–63. It was cleaned by Faye Wrubel in 1991–92. The panel is composed of two boards with horizontal grain, joined approximately 31.8 cm from the bottom edge. Each board is slightly warped. Two vertical battens, as well as several butterfly cleats, secure the two boards, which show worm tunneling throughout. There are added edging strips on all four sides.

Losses along the join have been filled and inpainted and are more prominent than in the companion panel. Damage from abrasion is also more extensive than in 1933.1029 and occurs not only in the flesh tones, but in the sky, in the landscape at the right, and in the feathery foliage of the trees in the middle ground. In addition, there is substantial flake loss in the orange robe of the bound elder at the left. As in 1933.1029, the figures and architecture are underdrawn and the architecture is incised (infrared, ultraviolet, x-radiograph).

PROVENANCE: Trotti and Co., Paris, by 1915.[1] Sold by the Ehrich Galleries, New York, to Martin A. Ryerson (d. 1932), Chicago, 1917;[2] on loan to the Art Institute from 1917; bequeathed to the Art Institute, 1933.

REFERENCES: P. Schubring, *Cassoni: Truhen und Truhenbilder der italienischen Frührenaissance*, Leipzig, 1915, vol. 1, pp. 301–02, 351–52, vol. 2, pl. 83. P. E. Küppers, *Die Tafelbilder des Domenico Ghirlandajo*, Strasbourg, 1916, p. 85. *American Art News* 15, 33 (1917), p. 7 (ills.). AIC 1917, p. 166; 1920, p. 64; 1922, p. 73; 1923, p. 73. G. E. Kaltenbach, "Cassoni," *American Magazine of Art* 14 (1923), pp. 598 (ills.), 599. AIC 1925, p. 160, nos. 2072–73. *Ryerson Collection* 1926, pp. 20–22. Van Marle, 1931, vol. 12, p. 409, vol. 13, p. 234. AIC 1932, p. 182. Berenson 1932, p. 525; 1936, p. 452; 1963, vol. 1, p. 197. Valentiner [1932], n. pag. R. Brimo, *Art et goût: L'Evolution du goût aux Etats-Unis d'après l'histoire des collections*, Paris, 1938, p. 92. AIC 1961, p. 414. E. Fahy, "The 'Master of Apollo and Daphne,'" *AIC Museum Studies* 3 (1968), pp. 21–34, 36, nos. 7–8, figs. 1, 4, 7. C. Seymour, *Early Italian Paintings in the Yale University Art Gallery*, New Haven and London, 1970, p. 17. Fredericksen/Zeri 1972, pp. 124, 266–67, 571. E. Fahy, *Some Followers of Domenico Ghirlandajo*, New York and London, 1976, pp. 11–20 bis, 105, nos. 7–8. F. Zeri, *Italian Paintings in the Walters Art Gallery*, Baltimore, 1976, vol. 1, p. 104. *Walker Art Gallery, Liverpool:*

Foreign Catalogue, Liverpool, 1977, p. 118. E. Callmann, "The Growing Threat to Marital Bliss as Seen in Fifteenth-Century Florentine Paintings," *Studies in Iconography* 5 (1979), pp. 86–87, figs. 16–17, p. 91 n. 30.

The panels illustrate the incidents recounted in the Story of Susanna, which is one of the books of the Apocrypha sometimes appended to the Book of Daniel (Daniel 13.19–62). Susanna is propositioned by two elders and is then falsely accused by them of adultery because of her refusal to comply with their desires. The elders condemn her to death, but at this juncture the young Daniel intervenes and examines the claims made by the elders. By questioning them separately, Daniel exposes their falsehood, whereupon they are put to death. These events in the early life of Daniel, as well as similar incidents in the life of Joseph, are paralleled in Christ's life by the Dispute with the Doctors (Luke 2.40–50), when divine wisdom again overcomes ill-intentioned guile and intellectual obduracy, the New Law prevailing over the Old Law. In this respect Daniel and Joseph were interpreted in the Renaissance as precursors of Christ.

While depictions of the story of Susanna are comparatively rare in fifteenth-century Italian painting, this particular artist treated the subject on one other occasion besides the present example, namely, on four panels divided between the Walker Art Gallery in Liverpool and the Walters Art Gallery in Baltimore.[3] For this second series, the painter devised more spacious compositions, treating two of the main incidents, *The Condemnation of Susanna* and *Susanna Led to the Place of Execution*, both in Baltimore, on separate panels. Fahy also demonstrated that a smaller panel at Yale,[4] showing Daniel alone, must have belonged to the same ensemble as the series divided between Baltimore and Liverpool, because Daniel's costume is identical. Since the narrative is complete within the two panels in Chicago, there can be no question that any part of the sequence is missing, but it is possible that two other panels, each showing one of the main protagonists alone, as in the panel at Yale, might have once existed.[5]

As Fahy (1968) first pointed out, it is unlikely that the panels in Chicago could have formed part of

a *cassone*. The subject is certainly applicable in a marital context, but the height of the pictures is too great, while the physical makeup of the panels, and to a certain extent their condition, also militate against such an identification. The panels in Chicago are in relatively good condition, whereas *cassone* panels frequently show evidence of hard use in daily life. Fahy tentatively suggested that the subject would lend itself to public display, as in a judicial or civic chamber. This suggestion is given considerable credence by the fact that elaborate decorative schemes were being devised by Florentine artists in both the domestic and public spheres at the turn of the fifteenth and sixteenth centuries. Such schemes, some of which are described by Vasari, often involved the architectural features of the room, as well as the furniture.[6] Furthermore, Fahy's suggestion accords well with Callmann's argument (1979) that the subject of the chaste Susanna, so favored by painters of *cassoni* during the first half of the fifteenth century, was given a new emphasis by artists working later in the century. By stressing the importance of the act of judgment in the story, as opposed to the earlier part of the narrative, these artists gave the events a political bias.

Scholars have held varying opinions about the attribution of the Chicago panels. Schubring (1915) and Küppers (1916) proposed the workshop of Domenico Ghirlandaio, Berenson (1932, 1936, 1963) and Valentiner (1932) favored Jacopo del Sellaio, and Van Marle (vol. 13, 1931) suggested Bartolommeo di Giovanni. Fahy included them in a group of twenty-six panels, which he assigned to a close follower of Ghirlandaio known as the Master of Apollo and Daphne after two panels in the Kress collection.[7] The style of this anonymous painter sometimes resembles that of Bartolommeo di Giovanni, but the drawing of the figures is less convincing and the compositions are not so tautly arranged. The two panels in Chicago reveal the painter's dependence upon the late frescoes of Ghirlandaio in the choir of Santa Maria Novella in Florence, particularly in the use of architecture to separate different parts of the narrative.[8] Fahy (1968, 1976) also referred to the influence of Botticelli in the handling of the draperies, but there is perhaps also an affinity with Piero di Cosimo in some of the figure types, particularly in the group to the right of the judgment scene on the second panel (1933.1030). The panels were probably painted around 1500, which accords well with the attempt to integrate the foreground with the landscape.

NOTES

1 Schubring 1915, p. 301.

2 According to an entry in Ryerson's notebook, the panels were purchased from the Ehrich Galleries on April 24, 1917 (Ryerson papers, Archives, The Art Institute of Chicago). A receipt of payment in curatorial files is dated May 8, 1917.

3 *Walker Art Gallery* 1977, vol. 1, pp. 117–18, no. 2808, vol. 2, p. 146, fig. 2808; and Zeri 1976, vol. 1, pp. 103–05, nos. 66–68, pls. 52–53. These, together with a smaller related panel in the Yale University Art Gallery, New Haven (Seymour 1970, pp. 156–57, no. 110, fig. 110), are all conveniently reproduced by Fahy 1968, figs. 3, 5–6, 8–9.

4 See note 3 above.

5 Neither the relevant panel in Chicago (1933.1029), nor that from the series divided between Liverpool and Baltimore, depicts the scene of the elders gathering in the house of Susanna's husband, Joachim, which was being used for the purposes of administering the law. This scene occurs on the panels by Domenico di Michelino now in Avignon and on a fragment now in Baltimore from a *cassone* panel by Apollonio di Giovanni and Marco del Buono Giamberti. M. Laclotte and E. Mognetti, *Avignon, Musée du Petit Palais: Peinture italienne*, Paris, 1976, nos. 65–66, figs. 65–66, n. pag.; and Zeri 1976, vol. 1, pp. 76–79, no. 47, pl. 39.

6 See A. Braham, "The Bed of Pierfrancesco Borgherini," *Burl. Mag.* 121 (1979), pp. 754–65; and E. Callmann, "Apollonio di Giovanni and Painting for the Early Renaissance Room," *Antichità viva* 27, 3–4 (1988), pp. 6–13.

7 Shapley 1966, pp. 129–30, nos. K1721A–B, figs. 347, 349, now in the University of Chicago, David and Alfred Smart Gallery (nos. 1973.44–45).

8 J. Lauts, *Domenico Ghirlandajo*, Vienna, 1943, figs. 56–57.

Master of the Bigallo Crucifix

Active c. 1225–1265

Crucifix, 1255/65
A. A. Munger Collection, 1936.120

Tempera on panel, 191 x 127.2 cm (75¼ x 50⅛ in.); more detailed measurements are provided on the accompanying outline drawing (fig. 1)

INSCRIBED: .ĪC. .X̄C. (above head of Christ in white pigment)

CONDITION: The painting is in good condition. Leo Marzolo cleaned it and coated it with multiple layers of beeswax in 1936. It was surface cleaned by Alfred Jakstas in 1965. A more extensive treatment was undertaken by Mellon fellow Helen White in 1983 when areas of blistering were consolidated, layers of wax and varnish were removed from the paint surface, and wax was removed from the support. The support has been heavily worm tunneled, damage being particularly severe at the lower terminal of the cross and at the edges. Exposed worm tunneling on the back indicates that the support has been planed down. An aluminum plate set into the back reinforces the weakened wood. The x-radiograph, made with the metal plate removed, suggests the probable disposition of joins (fig. 2). The nimbus and head of Christ are on a separate, raised piece of wood. A fine fabric layer extending over the entire panel, including the side of the nimbus, serves as a support for the gesso and paint layer. The pronounced craquelure relates to this fabric layer rather than to the underlying wood support. Several splits in the paint and ground correspond to joins in the panel, notably a vertical split through the figure of Saint John, a horizontal split corresponding to the lower edge of the crossbeam, and a curved split where the lower edge of the nimbus is attached to the crossbeam. Though the edges of the crucifix have been largely eaten away by worm tunneling, traces of an edge painted reddish-brown are visible, particularly on the undersides of the arms of the cross and the bottom of the apron.

The gold background is substantially abraded. No layer of bole between it and the gesso ground is visible, though a white bole may have been used. Subsidiary figures, such as

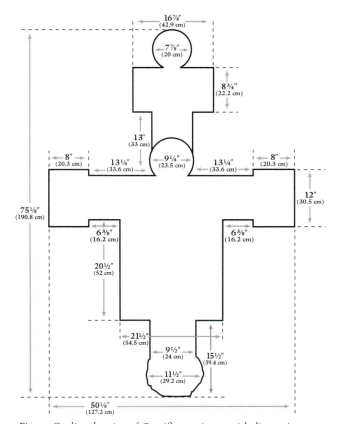

Fig. 1 Outline drawing of *Crucifix*, 1936.120, with dimensions indicated

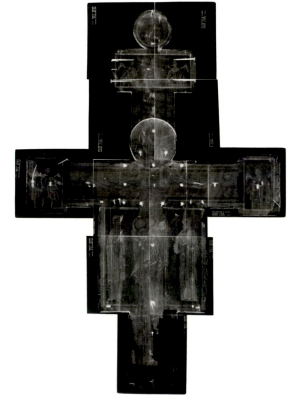

Fig. 2 X-radiograph of *Crucifix*, 1936.120

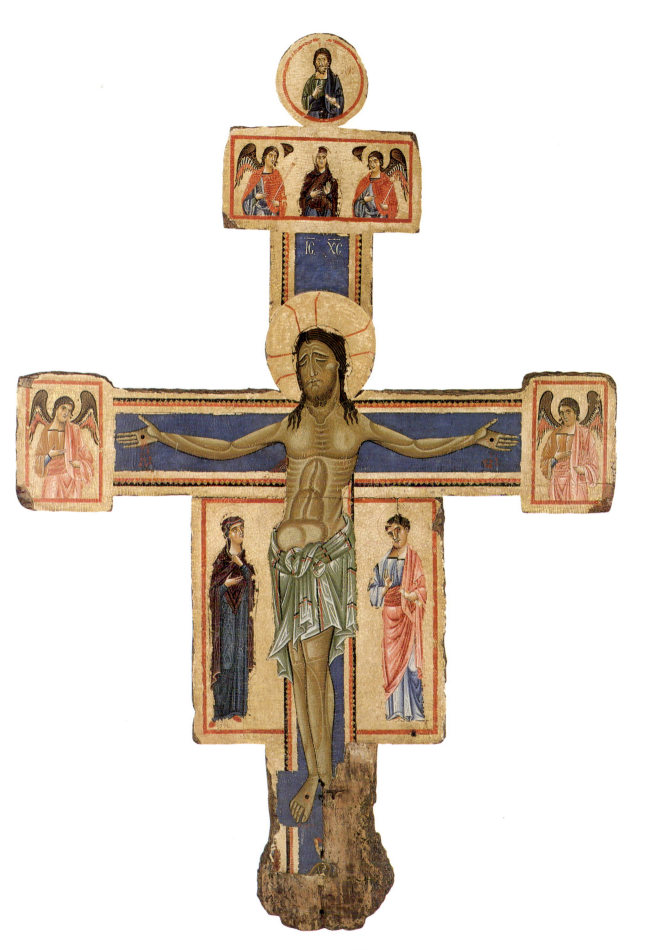

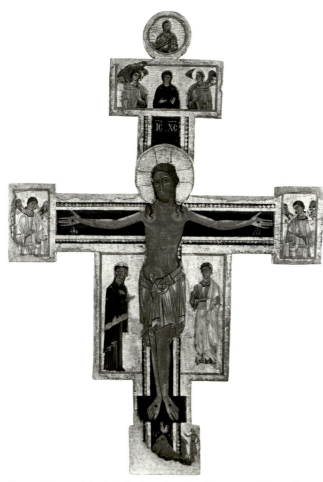

Fig. 3 Master of the Bigallo Crucifix, *Crucifix*, Museo del Bigallo, Florence

the Virgin and Saint John flanking the Christ, seem to have been painted over the gold ground. The paint layer is somewhat abraded in the figure of the Virgin beside the cross, in the hair of Christ, and in the half-length figures of the Virgin in the upper terminal of the cross. In general, though, the paint layer is well preserved and there are only small scattered areas of inpainting (raking light, mid-treatment, ultraviolet, x-radiograph).

PROVENANCE: Count Hans Wilczek, Kreuzenstein, Austria.[1] E. and A. Silberman Galleries, New York. Sold by Silberman to the Art Institute, 1936.

REFERENCES: "Fifteen New Acquisitions at Chicago," *Art News* 35, 13 (1936), pp. 8–9 (ill.), 25. "Thirteenth-Century Crucifix for Chicago," *Art Digest* 11, 7 (1937), p. 12 (ill.). E. Sandberg-Vavalà, "A Crucifix at Chicago," *AIC Bulletin* 33, (1939), pp. 34–40, figs. 1, 3, 5, detail on cover. R. Oertel, "Italienische Malerei des Mittelalters bis zum Trecento," *Zeitschrift für Kunstgeschichte* 9 (1940), p. 121. "The Face of Christ: A Portfolio of His Image through the Ages," *Fortune* 33 (1946), p. 135 (color ill.). AIC 1948, p. 25.

Garrison 1949, pp. 12, 181, 185, no. 467 (ill.). Thieme/Becker, vol. 37, 1950, p. 48. F. A. Sweet, "La pittura italiana all'*Art Institute* di Chicago," *Le vie del mondo: Rivista mensile del Touring Club Italiano* 15 (1953), pp. 689–90 (ill.). C. L. Ragghianti, *Pittura del dugento a Firenze*, Florence, 1955, p. 12, fig. 28. E. B. Garrison, *Studies in the History of Medieval Italian Painting*, vol. 2, no. 4, Florence, 1956, "Addenda ad Indicem IV," p. 210. Bénézit, 2d ed., vol. 5, 1960, p. 711; 3d ed., vol. 7, 1976, p. 88. AIC 1961, pp. 35 (ill.), 299. Huth 1961, p. 516. E. B. Garrison, *Studies in the History of Medieval Italian Painting*, vol. 2, nos. 3–4, Florence, 1962, "Addenda ad Indicem VI," p. 384. D. Campini, *Giunta Pisano Capitini e le croci dipinte romaniche*, Milan, 1966, pp. 44, 204. Maxon 1970, pp. 20–21 (ill.). Fredericksen/Zeri 1972, pp. 125, 287. A. Tartuferi, "Pittura fiorentina del duecento," *La pittura in Italia*, vol. 1, *Il duecento e il trecento*, Milan, 1986, p. 269. L. C. Marques, *La Peinture du duecento en Italie centrale*, Paris, 1987, pp. 74, 242 n. 128. A. Tartuferi, *La pittura a Firenze nel duecento*, Florence, 1990, pp. 14, 21 n. 38, 22 n. 44, 71, fig. 26.

EXHIBITIONS: The Art Institute of Chicago, *Recent Accessions*, 1936–37 (no cat.). The Art Institute of Chicago, *Masterpiece of the Month*, June 1946 (no cat.). The Art Institute of Chicago, *Masterpieces of Religious Art*, 1954, pp. 12–13.

The cross is one of the most important panels by an Italian painter of the thirteenth century in a public collection in the United States. It is rare to find a work of this early date and large scale outside of Italy. The impact of the panel is also considerably enhanced by its good condition.

Christ's body hangs almost straight, eyes closed (*Christus patiens*) and feet splayed. In the *cimasa* toward the top of the cross, a half-length figure of the Virgin is shown standing between two angels holding scepters. In the roundel above the *cimasa* is an image of Christ the Redeemer blessing. Three-quarter-length figures of angels are placed in the terminals and these also seem to be holding scepters. The Virgin and Saint John the Evangelist occupy the side fields, or apron, of the cross. At the base, below the *suppedaneum*, is a rooster on a hill, which, together with the fragment of a figure on the left, was revealed during the treatment of the panel undertaken in 1936. Comparison with the two related crosses (see below) suggests that the damaged base was probably rectangular in shape and contained the scene of the Denial of Christ by Saint Peter, which would have

included the figure of the saint on the left and that of the servant woman on the right. The mound below Christ's feet on which the rooster stands presumably symbolizes Golgotha.

The cross in Chicago is directly related in format, style, and iconography to two other crosses (figs. 3–4): one in the Museo del Bigallo in Florence, the other in the Palazzo Barberini in Rome.[2] All three have an identical decorative border surrounding the principal figure, consisting of a double blue and red line enclosing diamond shapes executed in gold paint; a single red line prescribes the terminals. In 1936, on viewing the present cross in the Silberman Galleries, Wilhelm Suida, Hans Tietze, and Raimond van Marle all recognized its relationship to the cross in Florence,[3] a connection Sandberg-Vavalà discussed in some detail in her article of 1939. Garrison (1949) later added to these two crosses the one in Rome. He dated the cross in Florence to 1225/35, the cross in Rome to 1235/45, and suggested a date of 1255/65 for the cross in Chicago. Ragghianti (1955), on the other hand, regarded the cross in Rome as the earliest in date and suggested, without producing any positive evidence, that the cross in Florence might have been painted at the time of the foundation of the Oratorio della Compagnia Maggiore del Bigallo in 1244. Like Garrison, Ragghianti regarded the cross in Chicago as the last in the sequence. Tartuferi (1990) placed the Chicago cross around 1230/40, slightly later than the Bigallo cross, which he dated c. 1230, denying any connection with the foundation of the Oratorio. He placed the cross in the Palazzo Barberini at the end of the artist's development, toward the middle of the century.

Offner was the first to discuss the painter of the cross in the Museo del Bigallo as a separate, definable personality,[4] whom most authorities now recognize as a Florentine painter trained under strong Lucchese influence. Indeed, the figure types on the crosses attributed to the Bigallo Master, especially the ovoid shape of the faces with the distinctive rounded chins and the handling of the hair, are to some extent derived from Berlinghiero, whose important signed cross dating from 1210/20 is still in Lucca.[5] Sandberg-Vavalà had previously posited connections with the Pisan school for the cross in the Museo del Bigallo,[6] but later (1939) revised her opinion in favor of a

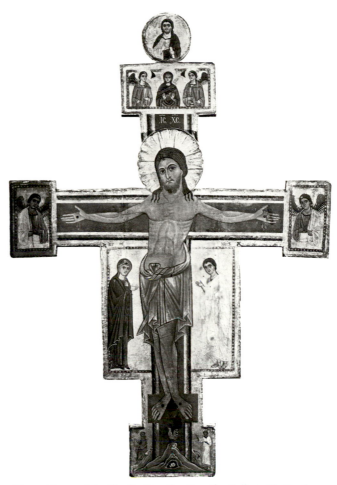

Fig. 4 Master of the Bigallo Crucifix, *Crucifix*, Galleria Nazionale d'Arte Antica, Palazzo Barberini, Rome

Lucchese influence. Ragghianti and Tartuferi are the only scholars since Garrison (1949) to make a sustained effort to define the stylistic characteristics of the Bigallo Master. Ragghianti (1955) returned to the position first favored by Sandberg-Vavalà by arguing that the painter was influenced by the Calci Master, a follower of Berlinghiero active at Pisa and susceptible to the influence of Giunta Pisano.[7] There is, however, little or no Pisan influence in any of the three crosses painted by the Bigallo Master, who was clearly more conversant with Lucchese painting. In addition to the three crosses already mentioned, the Bigallo Master was probably also responsible for the large retable of *Saint Zenobius Enthroned*, once in the cathedral in Florence,[8] and several panels of the Virgin and Child.[9] Garrison (1949) characterized the Bigallo Master as "the most important Florentine painter of the first half of the thirteenth century."

The principal stylistic features of the cross in Chicago are the system of highlighting, the bronze-colored flesh tone, the sharp zigzag pattern found in the draperies, and the color used for the draperies. The highlighting, while probably always more pronounced, is better preserved on the cross in Chicago than on the two related crosses and is characterized by a high degree of stylization, particularly on the face, stomach, and knees. The painter has woven a web of pattern over the surface of the body, rather than attempting to define the forms by the play of light on them. As Garrison argued, this stylized modeling is indicative of a date during the middle decades of the thirteenth century, since it is found on other works of a similar date in Florence, especially on cross no. 434 in the Uffizi.[10] The zigzag pattern in the draperies is best exemplified by Christ's *perizoma*. The palette, which anticipates that of the Magdalen Master active in Florence toward the end of the thirteenth century, is best characterized by the light colors (rose pink and ice blue) of Saint John the Evangelist's drapery. These stylistic features are common to many other Florentine painters of the mid-thirteenth century. Comparisons can be made not only with the painter of cross no. 434, but also with the work of the Bardi Master, the Vico l'Abate Master, or with the painter of the earlier of the two crosses in the Museo Bandini in Fiesole.[11] The figures in the *cimasa* of the cross in Chicago are somewhat more mannered in style than those of the Virgin and Saint John the Evangelist. They may possibly be by an assistant, although Garrison (1949) regarded the panel as autograph throughout.

The figure of Christ is shown with eyes open (*Christus triumphans*) on the crosses in Florence and Rome, and with eyes closed (*Christus patiens*) on the cross in Chicago. Although this important iconographic transition cannot be dated with precision, it accords well with the date of 1255/65 derived from the stylistic analysis of the Chicago cross. In other respects, however, the style of this work is retardataire in that the body of Christ is depicted rather rigidly with feet splayed. No doubt the vigorous system of highlighting, which is a new stylistic development, was intended to compensate for such a traditional treatment of Christ's body. For purposes of comparison, the works of Giunta Pisano may be re-

garded as representative of the more advanced type of cross in the middle of the thirteenth century in Italy.[12] In these the arms are bent, the head of Christ sags downward, a single nail pierces the feet placed one over the other, and the body describes a curve, thereby more closely assuming an attitude of death.

The gestures of the Virgin and of Saint John the Evangelist, who holds a scroll in his left hand, are also comparatively restrained on the cross in Chicago. The Virgin indicates the figure of Christ with her right hand and looks directly at the body. Saint John the Evangelist holds up his right hand with the palm turned outward and gazes at the spectator. Usually, Saint John the Evangelist is shown either pointing to the figure of Christ, as on the crosses in Florence and Rome, or else supporting his head with his right hand in the traditional gesture of grief.[13] The gesture given to Saint John the Evangelist on the present cross is occasionally found in Byzantine art and probably originated in pagan art, where it was associated with adoration or greeting.[14] By the fifteenth century, when gestures had begun to be codified, the raised hand with open palm signified a moment of particular religious import.[15] This last interpretation most likely applies to the gesture of Saint John on the cross in Chicago.

The cross symbolically incorporates incidents that took place both before and after the Crucifixion. Above, in the *cimasa*, the grouping of the Virgin with two attendant angels, surmounted by a roundel of Christ the Redeemer, is an abbreviated representation of the synoptic Ascension.[16] Thus, from top to bottom, along the vertical axis, are the Ascension, Christ on the Cross, and the Denial of Saint Peter. On the horizontal axis, the angels in the terminals may refer to the Resurrection, since angels holding scepters are usually shown guarding Christ's empty tomb.[17]

The early provenance of the crosses in Florence, Rome, and Chicago is unknown. This type, although often larger in size, was sometimes displayed on the rood screen in a church. Alternatively, it was attached to the back of an altar or suspended from above. Several frescoes and paintings dating from the beginning of the fourteenth century show painted crosses in situ, as, for example, in Scenes 4, 13, and 22 of the *Legend of Saint Francis* in the Upper Church of San Francesco at Assisi.[18] In Scene 13 a cross of the

present type is seen from the back, thus revealing elements of its construction.[19] There are no signs now of any elements of construction on the back of the cross in Chicago, but there does seem to be an indication of a stem extending below its base, which suggests that the cross might have been attached to the back of an altar.

NOTES

1 According to a letter from the E. and A. Silberman Galleries to Robert B. Harshe of May 13, 1936, in curatorial files.

2 Garrison 1949, p. 186, no. 470 (ill.), p. 189, no. 486 (ill.), respectively. For the cross in Florence, see also H. Kiel, *Il Museo del Bigallo a Firenze*, Milan, 1977, p. 117, no. 1, pls. 2–7, color pls. 1, 8.

3 According to statements submitted in 1936 to the Silberman Galleries (in curatorial files).

4 R. Offner, "The Mostra del Tesoro di Firenze Sacra," *Burl. Mag.* 63 (1933), pp. 75–76.

5 Garrison 1949, p. 187, no. 476 (ill.); *Museo Nazionale Villa Guinigi*, Lucca, 1968, pp. 137–38, color pl. IV.

6 E. Sandberg-Vavalà, *La croce dipinta italiana e l'iconografia della passione*, Verona, 1929, pp. 599–601.

7 For the Calci Master, see Garrison 1949, p. 219, no. 598 (ill.). Tartuferi (1990) also emphasized the importance of Pisan painting for the formation of the Bigallo Master.

8 Garrison 1949, p. 141, no. 363 (ill.); L. Becherucci and G. Brunetti, *Il Museo dell'Opera del Duomo a Firenze*, vol. 2, Venice, 1971, pp. 276–78, no. 35 (ill.).

9 Garrison 1949, p. 91, no. 220 (ill.), p. 93, no. 231 (ill.).

10 Ibid., p. 200, no. 516; L. Marcucci, *Gallerie Nazionali di Firenze: I dipinti toscani del secolo XIII, scuole bizantine e russe dal secolo XII al secolo XVIII*, Rome, 1958, p. 28, no. 6, figs. 6, 6a–b.

11 See U. Procacci and L. Tintori, "Distacco di tempere ducentesche sovrapposte," *Bollettino d'arte* 38 (1953), p. 35, fig. 5; Garrison 1956, pp. 210–11; and M. C. B. Viani, *Fiesole Museo Bandini*, Bologna, 1981, p. 3.

12 Garrison 1949, p. 208, nos. 543 (ill.), 546 (ill.), p. 215, no. 578 (ill.).

13 H. Maguire, "The Depiction of Sorrow in Middle Byzantine Art," *Dumbarton Oaks Papers* 31 (1977), pp. 140–51.

14 P. Thoby, *Le Crucifix des origines au Concile de Trente*, Nantes, 1959, figs. 112, 116; R. Brilliant, *Gesture and Rank in Roman Art*, New Haven, 1963, pp. 23–25.

15 M. Baxandall, *Painting and Experience in Fifteenth-Century Italy*, Oxford, 1972, pp. 65–66. Garrison (1962) described the gesture as simply one of "horrified condolence," and listed the other crucifixion scenes and crosses where it occurs.

16 Sandberg-Vavalà (note 6), pp. 190–94.

17 Compare, for example, a scene on Duccio's *Maestà*, illustrated in J. Stubblebine, *Duccio di Buoninsegna and His School*, Princeton, 1979, vol. 2, pl. 112.

18 A. Smart, *The Assisi Problem and the Art of Giotto*, Oxford, 1971, pls. 3, 4, 6, respectively.

19 For observations on the mathematical basis of the construction of a thirteenth-century cross of similar dimensions, see J. Brink, "Carpentry and Symmetry in Cimabue's Santa Croce Crucifix," *Burl. Mag.* 120 (1978), pp. 645–53.

Matteo di Giovanni

Active Siena 1452–1495

The Dream of Saint Jerome, 1476
Mr. and Mrs. Martin A. Ryerson Collection, 1933.1018

Tempera on panel, 37.4 x 65.7 cm (14¾ x 25⅞ in.); painted surface: 35.8 x 64.4 cm (14⅛ x 25⅜ in.)

CONDITION: The painting is in fair to good condition. It was treated in 1957 by Louis Pomerantz and was surface cleaned in 1965 by Alfred Jakstas, who undertook a more extensive cleaning in 1966. The panel is composed of a single board with a horizontal grain. At present, it has a slightly convex warp, and has been thinned and strengthened with two vertical battens dovetailed into the panel. Apparently, the picture originally had an engaged frame, as there were unpainted edges on all sides, which have now been filled. Those at the top and bottom are now gilded and those at the sides have been painted. Wear extends into the painted image on all sides and these areas have been inpainted or regilded. The faces of the judge, of the two flagellants, and of the pointing man at right were vandalized and their bodies scratched. These areas have been inpainted. Saint Jerome's torso and face are abraded. Nevertheless, the ground and paint layers are generally well preserved. Incisions mark the contours of the architecture. The gold ornament at left and right is punched and its outer edges are marked with double incised lines. Infrared photography shows considerable underdrawing in the figures and architecture (infrared, ultraviolet).

PROVENANCE: See below.

REFERENCES: See below.

EXHIBITIONS: See below.

Saint Augustine's Vision of Saints Jerome and John the Baptist, 1476

Mr. and Mrs. Martin A. Ryerson Collection, 1933.1019

Tempera on panel, 37.6 x 66.1 cm (14¾ x 26 in.); painted surface: 36 x 64.4 cm (14⅛ x 25⅜ in.)

CONDITION: The painting is in good condition. It was surface cleaned in 1965 by Alfred Jakstas, who undertook a more extensive cleaning in 1966. Like 1933.1018, the panel is composed of a single board with horizontal grain, and has been thinned and strengthened in the same manner.[1] A horizontal split beginning 27 cm from the top edge on the left and extending into the body of the monk has been filled and inpainted. The edges of the panel have been treated in the same way as in 1933.1018, suggesting an original engaged frame. The ground and paint surface are generally well preserved, apart from some scratches and dents, mainly in the upper left quadrant of the picture. These have been filled and inpainted. Incisions mark the contours of the architecture and the black draperies. The gold ornament is punched and incised in the same way as in 1933.1018. Infrared photography shows some underdrawing, including contour lines and widely spaced hatching. Some details, such as the width of Saint Augustine's desk and the perspective of the niches behind him, have been changed in relation to the underdrawn design (infrared, ultraviolet).

PROVENANCE: Placidi altarpiece, Chapel of Saint Jerome, Church of San Domenico, Siena, from 1476 until the dismemberment of the altarpiece sometime between 1784 and 1803.[2] Possibly removed to Palazzo Pubblico, Siena, by 1803.[3] Adelbert Wellington, third Earl Brownlow (d. 1921), Ashridge Park, Berkhamsted, by 1904,[4] sold as a pair, Christie's, London, May 4, 1923, no. 26 (ill.), as Benvenuto di Giovanni, to Colnaghi for £850.[5] Sold by Colnaghi to Martin A. Ryerson (d. 1932), Chicago, 1925;[6] on loan to the Art Institute from 1925; bequeathed to the Art Institute, 1933.

REFERENCES: Berenson 1909a, p. 194; 1932, p. 350; 1936, p. 301; 1968, vol. 1, p. 258, vol. 2, pl. 813 (1933.1018). G. F. Hartlaub, *Matteo da Siena und seine Zeit*, Strasbourg, 1910, pp. 117–18, 139. J. A. Crowe and G. B. Cavalcaselle, *A History of Painting in Italy*, 2d ed., vol. 5, ed. by T. Borenius, New York, 1914, p. 184 n. 3. Fogg Art Museum, *Harvard University: Collection of Mediaeval and Renaissance Paintings*, Cambridge, Mass., 1919, p. 128. R. M. Fischkin, "Two Paintings by Matteo di Giovanni," *AIC Bulletin* 20 (1926), pp. 30–32 (ill.). *Ryerson Collection* 1926, pp. 41–43. L. Venturi 1931, pl. CCXXVII. AIC 1932, p. 181, nos. 1686.25, 1687.25. Valentiner [1932], n. pag. M. Gengaro, "Matteo di Giovanni," *La Diana* 9 (1934), pp. 166–68. Van Marle, vol. 16, 1937, pp. 342–43 (1933.1018 ill.). G. Kaftal, *Saints in Italian Art: Iconography of the Saints in Tuscan Painting*,

Florence, 1952, no. 158, cols. 529, 532 (ill.). B. Wilczynski, "Matteo di Giovanni: Two Episodes from the Life of Saint Jerome," *AIC Quarterly* 50 (1956), pp. 74–76 (ill.). H. I. Roberts, "Saint Augustine in *Saint Jerome's Study*: Carpaccio's Painting and Its Legendary Source," *Art Bull.* 41 (1959), p. 289 (1933.1019 ill.). J. Pope-Hennessy, "A Crucifixion by Matteo di Giovanni," *Burl. Mag.* 52 (1960), pp. 63–67 (ill.). AIC 1961, p. 306. Huth 1961, p. 517. F. Russoli, *La Raccolta Berenson*, Milan, 1962, p. XLIX. S. Ekwall, "Ett ikonografiskt Birgittaproblem," *Konsthistorisk Tidskrift* 37 (1968), pp. 15–18 (1933.1019 ill.). G. Scaglia, "Fantasy Architecture of *Roma antica*," *Arte lombarda* 15, 2 (1970), pp. 17–18 (1933.1019 ill.). Fredericksen/Zeri 1972, pp. 139, 376, 408. D. Sutton, "Robert Langton Douglas: An *Annus Mirabilis*," *Apollo* 59 (1979), p. 304 (ill.). F. M. Jacobs, "Carpaccio's *Vision of S. Augustine* and S. Augustine's Theories of Music," *Studies in Iconography* 6 (1980), p. 83 n. 4. E. Trimpi, "*Iohannem Baptistam Hieronymo aequalem et non maiorem*: A Predella for Matteo di Giovanni's Placidi Altarpiece," *Burl. Mag.* 125 (1983), pp. 457–66 (ill.). E. Hall and H. Uhr, "*Aureola super Auream*: Crowns and Related Symbols of Special Distinction for Saints in Late Gothic and Renaissance Iconography," *Art Bull.* 67 (1985), p. 575 (ill. detail of 1933.1019). E. Trimpi, "A Re-attribution and Another Possible Addition to Matteo di Giovanni's Placidi Altarpiece," *Burl. Mag.* 127 (1985), pp. 363–67 (ill.). John Pope-Hennessy, "Whose Flagellation?" *Apollo* 124 (1986), pp. 163–65 (1933.1018 ill.). M. Mallory and G. Moran, review of *Painting in Renaissance Siena, 1420–1500* by K. Christiansen, L. B. Kanter, and C. B. Strehlke, in *Art Journal* 48 (Winter 1989), p. 354. J. Pope-Hennessy, *Learning to Look*, New York, 1991, p. 293.

EXHIBITIONS: London, Burlington Fine Arts Club, *Pictures of the School of Siena and Examples of the Minor Arts of That City*, 1904, nos. 38, 43, respectively, as School of Matteo di Giovanni. The Art Institute of Chicago, *A Century of Progress*, 1934, no. 32 (1933.1018 only). New York, The Metropolitan Museum of Art, *Painting in Renaissance Siena, 1420–1500*, 1988–89, nos. 49a, c.

When exhibited at the Burlington Fine Arts Club in 1904, these two panels, which once formed part of the predella of an altarpiece, were ascribed to the School of Matteo di Giovanni. In 1909 Berenson published them as works unequivocally by that master, although on the occasion of the Brownlow sale in 1923 an erroneous attribution to Benvenuto di Giovanni was preferred.

Matteo di Giovanni's paintings combine in a remarkable way intense realism with formal restraint.

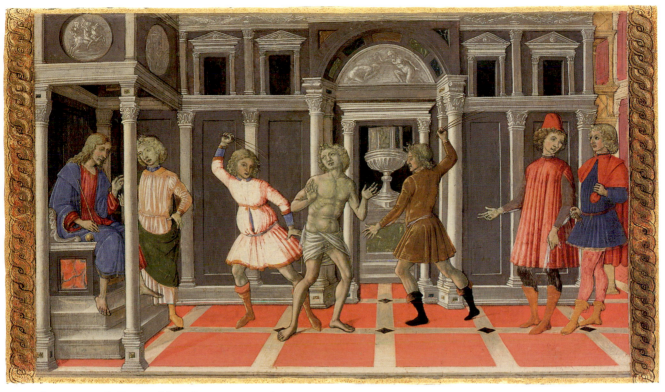

Matteo di Giovanni, *The Dream of Saint Jerome*, 1933.1018

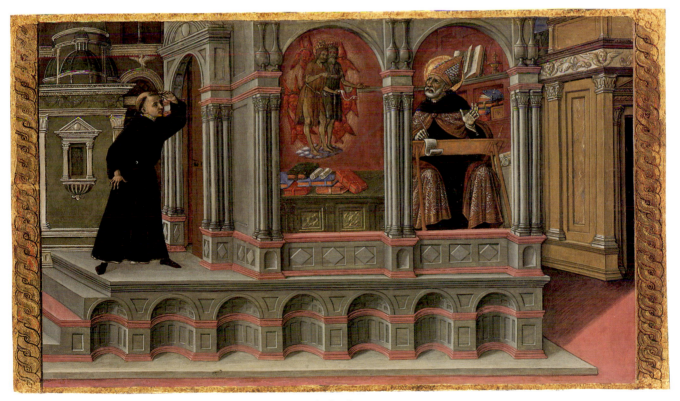

Matteo di Giovanni, *Saint Augustine's Vision of Saints Jerome and John the Baptist*, 1933.1019

This unusual fusion, which is derived as much from Florentine and Sienese sources as from north Italian illuminators active in Siena, underlies the strong narrative element in his work, most apparent in his numerous renderings of the Massacre of the Innocents. Matteo di Giovanni is possibly the most significant figure in Sienese painting during the second half of the fifteenth century and was commissioned to undertake a number of major altarpieces in Siena and Pienza.

Hartlaub suggested in 1910 that the panels were originally placed in a predella below *Saint Jerome in His Cell*, now in the Fogg Art Museum in Cambridge, Massachusetts, which has a damaged signature and date usually stated to be 1492.[7] Only Lionello Venturi (1931) and, more tentatively, Borenius (1914), as editor of Crowe and Cavalcaselle, openly accepted Hartlaub's suggestion, which was otherwise not widely discussed in the literature and can now be rejected.

Since then the panels have been incorporated into two further reconstructions, the first by Pope-Hennessy (1960) and the second, more recently, by Trimpi (1983). Pope-Hennessy proposed that the panels formed part of the predella below the *Massacre of the Innocents* of 1482 in the Piccolomini Chapel of the church of Sant'Agostino in Siena,[8] above which was a lunette comprising the *Virgin and Child with Two Angels and Saints Augustine and Francis*.[9] Other panels associated by Pope-Hennessy with the predella of this altarpiece, in addition to the two in Chicago, included *Saint Monica Praying for the Conversion of Saint Augustine* (41 x 38 cm) in The Harvard University Center for Italian Renaissance Studies, Villa I Tatti, Florence, and *The Crucifixion* (36.5 x 69.6 cm) in a private collection (fig. 1).[10] Unlike the others, the panel at Villa I Tatti has a vertical format, which implies that it must have been matched on the other side by another of similar shape as yet unidentified. The contiguity of the panels in Chicago and *The Crucifixion* is confirmed by the fact that each has the same elaborately tooled strips of twisted gilt ornament. Pope-Hennessy calculated that the width of the main part of the altarpiece, namely the panel of the *Massacre of the Innocents*, measured 232 cm, and that the total width of the predella panels, after due allowance is made for the missing panel, was 274 cm.

This discrepancy in size, he argued, could be accounted for by the framework of the altarpiece.

The iconography of the altarpiece, according to Pope-Hennessy, combined two separate themes. The central vertical axis referred directly to the life of Christ: the Virgin and Child in the lunette, the Massacre of the Innocents in the main section, and the Crucifixion in the predella below. The thematic link between these scenes could, therefore, be termed Christ's sacrificial role. The predella panels on either side of *The Crucifixion* were interpreted as depicting scenes from the life of Saint Augustine, the titular saint of the church, arranged according to a narrative sequence beginning on the left with the panel from the Villa I Tatti, which in fact shows two scenes: Saint Monica praying for the conversion of Saint Augustine on the left, and Saint Augustine reading the epistles of Saint Paul on the right. There followed, to the right of *The Crucifixion*, the scene Pope-Hennessy referred to as *The Flagellation of a Saint*, which until then had always quite reasonably been identified as *The Dream of Saint Jerome*. Pope-Hennessy contended, however, that as part of an altarpiece from a church dedicated to Saint Augustine the panel could not represent Saint Jerome, but must instead illustrate the subject of conversion in general or that of Saint Augustine in particular, even though there appears to be no specific Augustinian source for such an incident.[11]

Despite its physical and iconographical inconsistencies, Pope-Hennessy's reconstruction achieved some currency until Trimpi (1983) discovered documentary evidence that prompted a second, more convincing reconstruction, which is now widely accepted.[12] She argued that the two panels in Chicago and *The Crucifixion*, but not the differently proportioned panel at the Villa I Tatti, formed the predella of an altarpiece once in the church of San Domenico in Siena. This altarpiece was commissioned by the Placidi family, most probably on the occasion of the death of Giovanni di Angelo Placidi in 1473, his sons having obtained the right to a chapel in 1471. The Placidi Chapel is the third chapel to the left of the high altar and is, most significantly, dedicated to Saint Jerome. The main part of the altarpiece, which is still in the church, although it has been cut vertically into three sections, shows the *Virgin and Child Enthroned with*

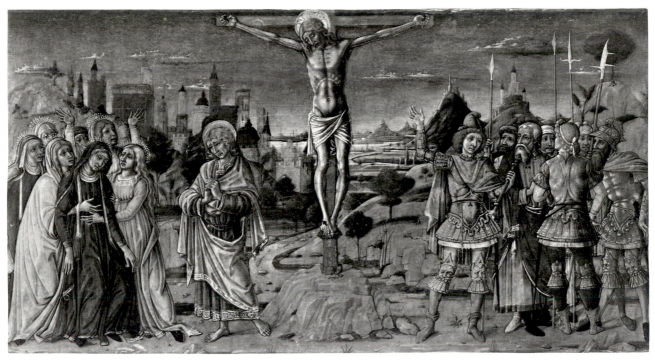

Fig. 1 Matteo di Giovanni, *The Crucifixion*, private collection [photo: Royal Academy of Arts, London]

Angels and Saints Jerome and John the Baptist.[13] This central part was surmounted by a lunette of *The Adoration of the Shepherds* now in the Pinacoteca Nazionale in Siena.[14] Trimpi (1985) later tentatively added two further items to the predella, namely, two standing saints (*Saint Augustine* and *Saint Vincent Ferrer*) in the Staatliches Lindenau-Museum in Altenburg (figs. 2–3). As she pointed out, it was not unusual for fifteenth-century painters to intersperse the narrative panels in a predella with standing figures or simply decorative features; Matteo di Giovanni did this himself in the predella of his altarpiece of 1477 in the church of Santa Maria delle Nevi in Siena.[15] Indeed, as Laurence Kanter (1988–89 exh. cat.) pointed out, the twisted gold ornament still intact on the sides of all three narrative predella panels implies some painted element between the scenes.[16]

The altarpiece in the Placidi chapel of San Domenico is mentioned by Mons. Francesco Bossio in his *Visita apostolica* of 1575 and again by Mons. Fabio Chigi in a listing of works of art in Siena made in 1625–26, when an attribution to Matteo di Giovanni and the date 1476 are recorded for the first time. It

appears from this that the Placidi altarpiece was once signed and dated. Presumably, the signature and date were on the frame or were cut from the lower edge of the main panel toward the end of the eighteenth century, when the altarpiece was dismantled and moved from the church.[17]

The later history of the altarpiece is confusing and Trimpi demonstrated, for example, how the partially inaccurate information contained in Ettore Romagnoli's manuscript text of 1835, *Biografia cronologica de' bellartisti senesi, 1200–1800*, misled Pope-Hennessy, for one, who seems not to have taken into account the larger part of the revisions made in the margin by another hand. The annotator observed that when the altarpiece was returned to the church the predella was no longer attached to the main panel of the altarpiece, although *The Crucifixion* could still be found in a private collection in Siena. There is no indication of where the two panels now in Chicago were located at that time.[18]

Stylistically, as Trimpi (1983) noted, the predella panels are all compatible with the main section of the altarpiece. She also argued that the scenes are invested iconographically with an Hieronymite,

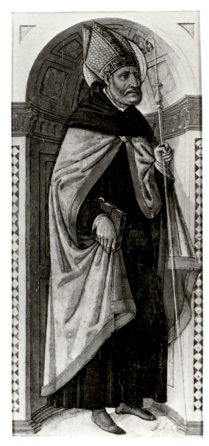

Fig. 2 Matteo di Giovanni, *Saint Augustine*, Staatliches Lindenau-Museum, Altenburg

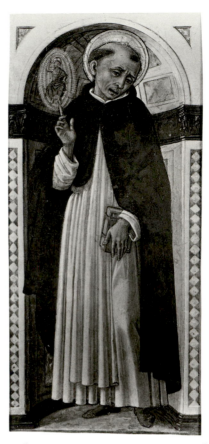

Fig. 3 Matteo di Giovanni, *Saint Vincent Ferrer*, Staatliches Lindenau-Museum, Altenburg

rather than Augustinian, significance. In support of this, Trimpi not only cited the dedication of the chapel to Saint Jerome, but also produced evidence to show that Giovanni di Angelo Placidi had a particular interest in Saint Jerome. It is in this context that the subject of 1933.1018 has considerable bearing. On comparison with the scene of *The Dream of Saint Jerome* in Sano di Pietro's predella in Paris,[19] there can be little doubt that the panel in Chicago also represents *The Dream of Saint Jerome*, an incident derived from *The Golden Legend* of Jacobus de Voragine.[20] According to this account, the saint dreams that he is being punished for his passionate devotion to classical literature, which leads him to read Cicero by day and Plato by night instead of the holy scriptures.[21]

It has been widely observed that there are overt references to baptism in the composition of *The Dream of Saint Jerome*, namely in the lunette showing the Baptism of a Neophyte over the doorway and in the font seen through the door, which is not unlike that in the Baptistery in Siena. No doubt the two

roundels above the entablature of the enthroned figure on the left are also symbolically related. One shows a figure on a leaping horse, which Wilczynski (1956) correctly interpreted as representing unbridled passion.[22] Trimpi argued that in this panel Matteo di Giovanni was equating Saint Jerome's eventual renunciation of the world, symbolized by retiring into the wilderness after his dream, with a type of second baptism.

Saint Augustine's Vision of Saints Jerome and John the Baptist can also be interpreted as a scene honoring Saint Jerome instead of Saint Augustine, who is, nonetheless, prominent in the composition. This subject is based on an apocryphal letter supposedly written by Saint Augustine to Saint Cyril of Jerusalem, but which, in fact, dates from the end of the thirteenth century. The letter, which was widely disseminated in manuscript and printed forms, records two visitations by Saint Jerome to Saint Augustine. Trimpi argued that here Matteo di Giovanni has depicted the second visitation, where Saint Augustine,

having attempted to write an encomium in honor of Saint Jerome, following the saint's death, falls asleep over its composition and has a vision of two figures in the midst of angels. The figure wearing three crowns (or *aureolae*) declares himself to be Saint John the Baptist and asserts that his companion, Saint Jerome, only has two crowns because he did not suffer death by martyrdom. Their purpose is to assist Saint Augustine in his literary task. The figure of the attendant monk, who is situated outside the saint's study and who also clearly sees the vision, is an addition to the narrative by Matteo di Giovanni.[23] Trimpi (1983) maintained that the point of this composition is the pairing of Saint Jerome with Saint John the Baptist, which not only echoes their depiction on either side of the Virgin and Child in the main part of the altarpiece, but also elevates the status of one of the early Fathers of the Church to that of one of the main saints. The fact that both figures here are dressed as penitents further argues in favor of this interpretation.[24] Saint Augustine thus serves only as the agent of the action and is not intended as the principal subject of the predella. In conclusion, it can be seen that Trimpi's reconstruction has both a visual and narrative consistency that Pope-Hennessy's ultimately lacked. Indeed, in Trimpi's own words, "The underlying meaning of Matteo di Giovanni's Placidi altarpiece is man's desire for repentance, conversion and baptism in order to be reborn into a more perfect life after death."[25]

As Fischkin remarked, the composition of *The Dream of Saint Jerome* undeniably recalls that of Piero della Francesca's *Flagellation of Christ* (Urbino, Palazzo Ducale), dating from the mid 1450s.[26] The subject of this famous painting has traditionally been identified as *The Flagellation of Christ*, but recently it has been argued that Piero della Francesca has in fact depicted *The Dream of Saint Jerome*.[27] It is possible that the painting now in Urbino may have served as a prototype for Matteo di Giovanni, since, like Piero della Francesca, he had close associations with Borgo Sansepolcro. In fact, one of his first commissions was to provide the surrounding panels for a polyptych in the town's Duomo, of which *The Baptism of Christ* by Piero della Francesca (London, The National Gallery) formed the central part.[28]

The emphasis on the architectural setting in both the present predella panels is typical of Matteo di Giovanni's treatment of narrative scenes. The style of the architecture, especially the triangular pediments above the windows in *The Dream of Saint Jerome*, somewhat resembles that of the painter's Sienese contemporary Francesco di Giorgio. The blind niches and paired columns in *Saint Augustine's Vision of Saints Jerome and John the Baptist* are less characteristic of Francesco di Giorgio, and indeed have been related by Scaglia to a series of fantasy drawings based on the buildings of ancient Rome executed during the second half of the fifteenth century. Two important sets of these are in the Uffizi, one by Ghiberti's nephew Buonaccorso Ghiberti.[29]

NOTES

1 The back is inscribed *Pietro [de?]lla / F [...]* in indistinct ink in an old hand.

2 See discussion below and Trimpi 1983, p. 463 n. 32.

3 See Trimpi (1983, p. 463 n. 32), who cited an inventory of pictures from San Domenico in the Palazzo Pubblico, Siena, including a predella with Passion scenes and the Placidi arms. She argued plausibly that the panels with *The Crucifixion* in the center could have been misunderstood as a Passion predella.

4 According to the 1904 Burlington Fine Arts Club exhibition catalogue.

5 According to an annotated copy of the sale catalogue at Christie's, London.

6 According to Colnaghi's invoice, Ryerson papers, Archives, The Art Institute of Chicago.

7 Fogg Art Museum 1919, no. 25, pp. 127–31 (ill.).

8 E. Carli, *Capolavori dell'arte senese*, Florence, 1946, pl. CLVII.

9 The lunette is dismembered with the parts distributed as follows: the center is in the Christian Museum in Esztergom, the figure of Saint Augustine (location unknown) was formerly in the collection of Lord Allendale, and that of Saint Francis is now in the Saibene collection in Milan. For the central part, see A. Mucsi, *Catalogue of the Old Masters Gallery at the Christian Museum in Esztergom*, Budapest, 1975, no. 204, p. 46 (ill.); and M. Boskovits, *Tuscan Paintings of the Early Renaissance*, Budapest, 1969, no. 23. The Saint Augustine was exhibited London, Burlington Fine Arts Club, *Catalogue of a Collection of Pictures, Furniture, and Other Objects of Art*, 1930–31, no. 66. A photomontage of the lunette is reproduced in Berenson 1968, vol. 2, pls. 815–17.

10 *Saint Monica Praying for the Conversion of Saint Augustine* is illustrated in Russoli 1962, p. XLIX, as Cozzarelli.

11 See Kaftal 1952, cols. 99–112, no. 32.

12 See Pope-Hennessy 1986, pp. 163–65; L. B. Kanter in 1988–89 exhibition catalogue; and Mallory and Moran 1989, p. 354.

13 Kanter (see note 12), p. 274, presumed that the main panels

were not cut, but were intended to be separated by framing elements.

14 Trimpi (1983, figs. 2–6, and text fig. A) provided a photomontage of this reconstruction of the Placidi altarpiece and a diagram of its basic elements. For *The Adoration of the Shepherds*, see also P. Torriti, *La Pinacoteca Nazionale di Siena: I dipinti dal XII al XV secolo*, Genoa, 1977, vol. 1, no. 414b, pp. 368–69 (ill.).

15 Trimpi 1983, fig. 7, and 1985, fig. 30.

16 L. B. Kanter (in 1988–89 exhibition catalogue), pp. 274–75.

17 These manuscript sources with detailed references are quoted and discussed in full by Trimpi 1983, pp. 459–60.

18 Trimpi (1983, pp. 460–63) recorded the annotations and provided the full reference for this important manuscript source. See also note 3 above.

19 Paris, Musée du Louvre, *Catalogue sommaire illustré des peintures du Musée du Louvre*, vol. 2, *Italie, Espagne, Allemagne, Grande-Bretagne, et divers*, 1981, p. 235, formerly in the Convento dei Gesuati di San Gerolamo in Siena; see also Trimpi 1983, fig. 8.

20 *The Golden Legend*, vol. 2, pp. 587–89.

21 The account in *The Golden Legend* is based upon a passage in the famous letter of Saint Jerome to Eustochium (*The Letters of Saint Jerome*, tr. by C. Mierow, ed. by T. C. Lawler, London, 1963, vol. 1, pp. 165–66, letter 22, sec. 30). For this subject as a whole, see M. Meiss, "Scholarship and Penitence in the Early Renaissance: The Image of St. Jerome," *Pantheon* 32 (1974), pp. 138–39, reprinted in his *The Painter's Choice: Problems in the Interpretation of Renaissance Art*, New York, 1976, pp. 195–97.

22 See also J. Fletcher and M. Cholmondeley Tapper, "Hans Holbein the Younger at Antwerp and in England, 1526–28," *Apollo* 117 (1982), p. 90, pl. IV, figs. 4–5.

23 For an extended discussion of this iconography, see Roberts 1959, especially pp. 285–87 with earlier bibliography. The relevant section of the apocryphal letter is given in English translation by J. P. Richter, *The Mond Collection*, London, 1919, vol. 2, pp. 503–06, from *Hieronymus: vita e transito*, Florence, 1490–91.

24 In contrast, Sano di Pietro, in the above-mentioned predella (see note 19 above), distinguished rather carefully between the garb of the two saints.

25 Trimpi 1985, p. 367.

26 *AIC Bulletin* 1926.

27 Pope-Hennessy 1986, pp. 162–65.

28 Regarding visual prototypes, Ekwall also drew attention to the fact that the setting and the saint's pose in the right-hand section of *Saint Augustine's Vision of Saints Jerome and John the Baptist* are similar to those of Saint Bridget writing in a drawing in a Florentine manuscript of the *Revelation of Saint Bridget* dating to c. 1400 (Florence, Biblioteca Nazionale, inv. MS II.II.393; Ekwall, fig. 7), but offered no explanation for this interesting occurrence.

29 Scaglia (1970) compared the building in the center of the composition with f. 163v, in reverse, of the Codex Santarelli (Scaglia 1970, fig. 16), and those to the right and left with f. 159r(a) and f. 164v(b), respectively, of the same codex, this second being identified as the *tenplum* [*sic*] *Vespasiani* (Scaglia 1970, figs. 13, 17).

Attributed to Michelangelo di Pietro Membrini, also called Mencherini (The Master of the Lathrop Tondo)

Documented Lucca 1484–1525

Virgin and Child Enthroned with Two Angels Holding a Crown, 1505/15

Mr. and Mrs. Martin A. Ryerson Collection, 1933.1016

Tempera on panel, 107.8 x 46.5 cm (42⅜ x 18⁵⁄₁₆ in.)

CONDITION: The painting is in fair condition. It was cleaned at the Art Institute in 1929 and again in 1962.[1] The panel has been thinned to a thickness of approximately 5 mm, cradled, and the spaces between the cradle members have been lined with fabric. The wood is severely worm-tunneled. The panel appears to be composed of a single board with vertical grain. A split runs the entire height of the panel, approximately 3 cm from the left edge, and another extends up into the Virgin's lap, beginning 29 cm from the left edge. Areas of damage at the edges of the panel, particularly on the sides, have been filled and inpainted. Apart from these losses, there are only minor areas of local loss to the paint layer. Nevertheless, the paint surface is abraded in the flesh tones, especially in the head of the Virgin and the body of the Christ Child, as well as in the dark blue-green cloak covering the Virgin's legs and in the background between the two angels. The surface is further disturbed by a pronounced age craquelure with slight cupping. The moldings of the throne are incised (mid-treatment, x-radiograph).

PROVENANCE: Elia Volpi, Florence, to 1910; sold Jandolo and Tavazzi, Florence, April 28, 1910, no. 376, as Tuscan School, fifteenth century. Martin A. Ryerson (d. 1932),

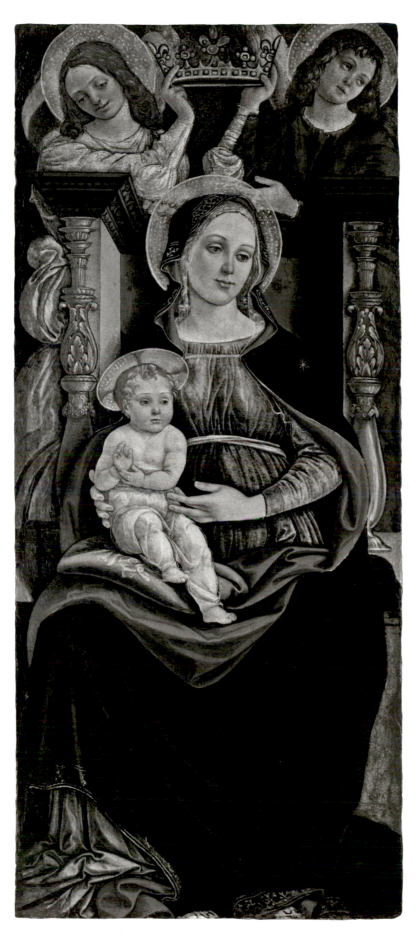

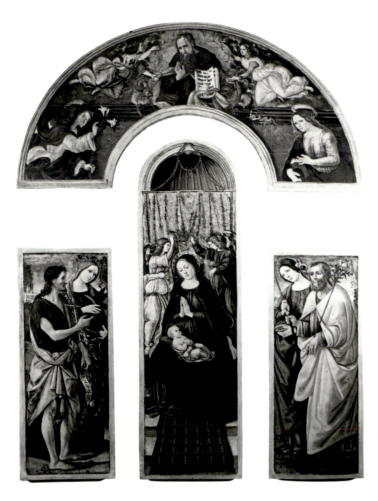

Fig. 1 Attributed to Michelangelo di Pietro Membrini, also called Mencherini (The Master of the Lathrop Tondo), *Altarpiece of the Virgin and Child Enthroned with Saints and Angels*, Museo di Villa Guinigi, Lucca

Chicago, by 1914; on loan to the Art Institute from 1914; bequeathed to the Art Institute, 1933.

REFERENCES: AIC 1920, p. 64; 1922, p. 74; 1923, p. 74; 1932, p. 181. Berenson 1932, p. 320; 1936, p. 275. AIC 1961, p. 264. Fredericksen/Zeri 1972, pp. 232, 334, 571. E. Fahy, *Some Followers of Domenico Ghirlandajo*, New York and London, 1976, p. 174.

EXHIBITIONS: Chicago, Service Men's Center (176 W. Washington), 1942–43 (no cat.).

This panel can be associated with a Lucchese painter whose oeuvre was first assembled around a tondo formerly in the Lathrop Collection and now in the J. Paul Getty Museum in Malibu.[2] Tazartes recently proposed that this group of paintings may be the work of Michelangelo di Pietro Membrini, also called Mencherini, traceable between 1484 and 1525 in Lucca.[3] She linked an altarpiece of Saint Anthony Abbot flanked by Saints Andrew, Dominic, Francis, and Bartholomew, attributed to the Master of the

Lathrop Tondo and still in the church of San Pietro Somaldi, Lucca, with the Michelangelo named as the painter of an altarpiece in the Chapel of Saint Anthony in that church.[4] While these recently published documents reveal few details of the life of this painter, they do not contradict the career deduced for the Master of the Lathrop Tondo. A Lucchese follower of Domenico Ghirlandaio and Filippino Lippi, this artist was influenced by Flemish painting, and later, by Amico Aspertini, who was active in Lucca from 1506 to 1509.[5]

Fahy was the first to attribute the Art Institute's panel to the Master of the Lathrop Tondo and observed that it was closely related to the central panel of an altarpiece (fig. 1) in the Museo di Villa Guinigi, Lucca.[6] This observation enabled him to identify a panel of Saints John the Baptist and Catherine of Alexandria (fig. 2), which was sold in London in 1953, as the left wing of an altarpiece that may have included the present picture as its central panel.[7] The Chicago picture may have been cut down

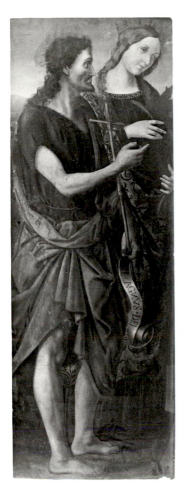

Fig. 2 Attributed to Michelangelo di Pietro Membrini, also called Mencherini (The Master of the Lathrop Tondo), *Saints John the Baptist and Catherine of Alexandria*, location unknown [file photo; Cooper neg. no. 189863]

piece, and of a related fresco of the Visitation in San Frediano, Lucca,[8] suggest that these are all relatively late works influenced by Aspertini's activity. As Tazartes rightly pointed out, now that the altarpiece in San Pietro Somaldi has emerged as the key work for the reconstruction of this painter's career, the attribution of paintings to him and their relative chronology will have to be reexamined.[9]

NOTES

1 The 1929 cleaning is reported in registrar's records.

2 For the Lathrop Tondo, see B. Fredericksen, *Catalogue of the Paintings in the J. Paul Getty Museum*, Malibu, 1972, pp. 21–22, no. 25, pl. 25.

3 M. Tazartes, "Anagrafe lucchese — III. Michele Angel (del fu Pietro 'Mencherini'): Il Maestro del Tondo Lathrop?" *Richerche di storia dell'arte* 26 (1985), pp. 28–39; and idem, "Nouvelles perspectives sur la peinture lucquoise du quattrocento," *Revue de l'art* 75 (1987), pp. 31–32. See also A. Ugolino, "Due singolari pale ed altri appunti lucchesi," *Ricerche di storia dell'arte* 36 (1988), pp. 81–92; and G. Concioni, C. Ferri, and G. Ghirarducci, *I pittori rinascimentali a Lucca: Vita, opere, committenza*, Lucca, 1988, pp. 136–61.

4 See Tazartes 1985 (note 3), pp. 28–29, fig. 1, doc. no. 10.

5 See E. Fahy, "A Lucchese Follower of Filippino Lippi," *Paragone* 16, 185 (1965), pp. 9–20; and M. Natale, "Note sulla pittura lucchese alla fine del quattrocento," *The J. Paul Getty Museum Journal* 8 (1980), pp. 37–49.

6 Fahy 1976 and letters from Fahy to John Maxon of March 29, 1966, and June 25, 1968, in curatorial files. For information on the altarpiece, see *Museo di Villa Guinigi, Lucca: La Villa e le collezioni*, Lucca, 1968, pp. 162–63, no. 138. As early as 1917, Berenson noted, "The enthroned Madonna with two angels crowning her is of a singularly mixed character. It looks as if it ought to be by R. di Carole, but may be a late Macrino d'Alba" (letter to Ryerson of August 31, 1917, Ryerson papers, Archives, The Art Institute of Chicago). Berenson (1932, 1936) later attributed the panel to the Piedmontese painter Macrino d'Alba, but there is no reference to the picture in subsequent editions of his "lists." More recently, Fredericksen and Zeri (1972) ascribed the panel to an artist of the Lucchese school.

7 Christie's, London, July 10, 1953, no. 147, 39 x 14½ in., as Sodoma. See letters from Fahy to Maxon cited above (note 6).

8 Fahy 1965 (note 5), p. 18, fig. 11.

9 In this context it is relevant to point out that Concioni, Ferri, and Ghirarducci (see note 3 above; pp. 175–83, figs. 30–32) have attributed the *Visitation* in San Frediano to the Lucchese painter Ansano di Michele Ciampanti (active 1498–1532), presumably because of its similarity to two documented altarpieces (datable to 1512 and 1517) by that artist in the churches of San Michele Arcangelo in Meati (Lucca) and Santi Filippo e Giacomo in San Filippo (Lucca). This attribution raises the question of Ciampanti's involvement with the Villa Guinigi altarpiece and the Chicago painting. One cannot rule out the possibility that some of these paintings were created through collaborative effort.

at top and bottom. The crown held by the two angels indicates that the Virgin is depicted as Queen of Heaven, and it is appropriate that the enthroned Madonna be flanked by attendant saints. The right wing and the lunette above have yet to be found.

The relationship between the Villa Guinigi altarpiece and the partially reconstructed complex to which the panel in Chicago probably belonged has still to be established. While the side panel of Saints John the Baptist and Catherine of Alexandria is virtually identical in both altarpieces, the direction of the Virgin's gaze, the pose of the Child, the design of the throne, and the positions of the angels on the main panel are different.

The influence of Domenico Ghirlandaio is evident in the Chicago panel in the careful execution of the decorative elements, notably those at the sides of the throne that have been picked out with such lavish highlights, and in the facial type of the Virgin. At the same time, the voluminous draperies and softer facial types of the Chicago panel, of the Villa Guinigi altar-

Alessandro Bonvicino, called Moretto da Brescia

c. 1498 Brescia 1554

Mary Magdalen, 1540/50

Gift of Mr. and Mrs. William Goodman, 1935.161

Oil on canvas, 166 x 47 cm (65⅜ x 18½ in.)

CONDITION: The painting is in good condition. In 1967 Alfred Jakstas cleaned the painting, removing an old glue lining and relining it using a wax resin adhesive. The canvas, which has a twill weave, has holes at regular intervals at the sides and bottom, possibly evidence of an old tacking margin. The bottom edge was extended 2 cm during an earlier relining and the original cusped edge of the canvas is visible in the x-radiograph. There is scattered flake loss in the sky and some abrasion and flake loss in the face and hair. The drapery is particularly well preserved. The x-radiograph and the mid-treatment photograph show that the artist adjusted the contours of the figure. Thus the saint's left shoulder was first painted higher and further to the left, and the lower left hem of her robe was also further to the left, probably accentuating the torsion of the figure (infrared, mid-treatment, ultraviolet, x-radiograph).

PROVENANCE: Avogadro, Brescia, by 1760, inventory after 1760, no. 82.[1] Fenaroli, Brescia, by 1820 to at least 1875.[2] P. Scalvini, Brescia, by 1898.[3] Thomas Humphry Ward, London;[4] sold Christie's, London, May 14, 1904, no. 54, to Farrer for 100 gns.[5] Sir William James Farrer (d. 1911), Sandhurst Lodge, Wokingham, from 1904; sold Christie's, London, March 23, 1912, no. 33, to Agnew for 200 gns.[6] Sold by Agnew, London, to Charles Fairfax Murray, 1912.[7] F. Mason Perkins, Florence, by 1912.[8] Sold by Perkins to T. J. Blakeslee, New York, 1913?–1915.[9] R. C. and N. M. Vose, Boston. Sold by Vose to William Owen Goodman, Chicago, 1917;[10] on loan to the Art Institute from 1928; given to the Art Institute, 1935.

REFERENCES: [L. Chizzola and G. B. Carboni], *Le pitture e sculture di Brescia che sono esposte al pubblico con un'appendice di alcune private gallerie*, Brescia, 1760, p. 179. F. Baldinucci, *Notizie de' professori del disegno*, vol. 6, Turin, 1820, p. 135. *Galleria di quadri esistenti in casa Fenaroli in Brescia*, Brescia, 1820, p. 13, no. 162. F. Odorici, *Guida di Brescia*, Brescia, 1853, p. 192. J. A. Crowe and G. B. Cavalcaselle, *A History of Painting in North Italy*, London, 1871, p. 401; 2d ed., ed. by T. Borenius, vol. 3, London, 1912, p. 291. S. Fenaroli, *Alessandro Bonvicino soprannominato il Moretto, pittore bresciano*, Brescia, 1875, p. 48. P. da Ponte, *L'opera del Moretto*, Brescia, 1898, p. 50. F. Mason Perkins, "Miscellanea," *Rassegna d'arte* 15 (1915), p. 123 (ill.). G. Nicodemi, *Gerolamo Romanino*, Brescia, 1925,

pp. 130 (ill.), 132. R. Longhi, "Recensione: Di un libro sul Romanino," *L'arte* 29 (1926), p. 146, reprinted in *Opere complete di Roberto Longhi*, vol. 2, Florence, 1967, p. 104. A. Venturi, vol. 9, pt. 4, 1929, p. 203 n. G. Gronau in Thieme/Becker, vol. 25, 1931, p. 141. G. Gombosi, *Moretto da Brescia*, Basel, 1943, p. 111, no. 161. AIC 1961, pp. 339–40. Maxon 1970, p. 254 (ill.). Fredericksen/Zeri 1972, pp. 144, 430, 571. *Alessandro Bonvicino, il Moretto*, exh. cat., Brescia, Monastero di S. Giulia, 1988, pp. 47 (ill.), 166, under no. 84. P. V. Begni Redona, *Alessandro Bonvicino, il Moretto da Brescia*, Brescia, 1988, pp. 446 (ill.), 447, no. 115.

EXHIBITIONS: The Art Institute of Chicago, *A Century of Progress*, 1933, no. 130.

The attribution to Moretto is traditional and has been accepted by all writers with one exception.[11] Moretto's style is basically an amalgam of Venetian and Lombard features. From Venice he derived a preference for rich colors and elegant materials, while from his Lombard predecessor Vincenzo Foppa he inherited an application of chiaroscuro that imbues his paintings with a silvery tonality. There are numerous portraits in his oeuvre, but his religious compositions, many of them incorporating unusual iconography, have a gravity and quiet sense of purpose that reflect ideas associated with the Council of Trent. Moretto's style also displays knowledge of works by Brescian contemporaries such as Girolamo Romanino and Girolamo Savoldo, as well as of developments in Rome transmitted to the north of Italy in the form of prints.

It is likely, as Gombosi (1943) first postulated, that *Mary Magdalen* was one of a number of saints forming a series.[12] Several possible candidates are mentioned in the early descriptions of the Avogadro and Fenaroli collections. Begni Redona (1988) argued that three paintings of similar format and dimensions are

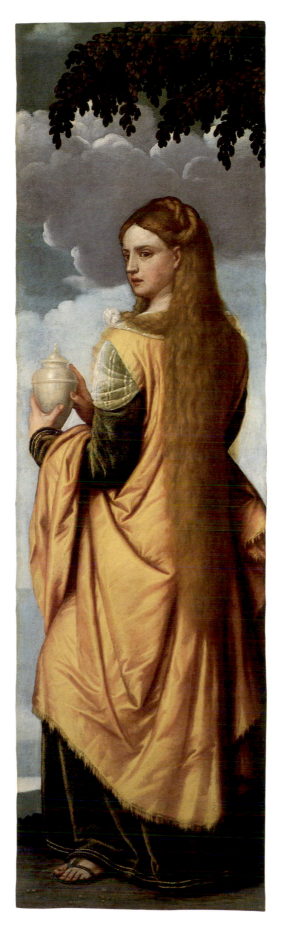

directly related to the present picture: *Saint John the Evangelist*, the *Samian Sibyl*, and *Solomon*. These three works, like *Mary Magdalen*, were once in the Avogadro and Fenaroli collections. Later they eventually came into the possession of Attilio Brivio, who in 1961 bequeathed them to the Pinacoteca Ambrosiana in Milan.[13] The same writer suggested that *Mary Magdalen* was paired with *Saint John the Evangelist*, and the *Samian Sibyl* with *Solomon*. The argument, however, rests there, as no documentation or later description of a complex including these figures has yet been found. The paintings were not necessarily incorporated into an altarpiece; they could just as easily have been part of a different decorative scheme in an ecclesiastical setting and perhaps one that comprised more than four paintings.

Gombosi (1943) omitted any mention of a date for the painting, but Begni Redona (1988) reasonably suggested a late date of 1545–46, shortly after *The Feast in the House of Simon the Pharisee* (originally for the refectory of the monastery of San Giorgio in Alga and now in the Museo Diocesano, Venice) dated 1544.[14]

The "elegant and elevated gentleness" that, according to Crowe and Cavalcaselle, characterizes this figure of *Mary Magdalen* is typical of nearly all of Moretto's religious paintings. The care lavished on such details as the flowing hair, and the varied texture of the paint that effortlessly captures the sheen of the drapery are highly characteristic. The monumentality of the figure, depicted looking back over her left shoulder towards the spectator, is emphasized by the low viewpoint and by the silhouetting of the upper part of the body against the sky.

The tree above the saint's head is identifiable as a member of the beech family.[15] In another painting, *Christ in the Wilderness* (New York, The Metropolitan Museum of Art), Moretto used the beech tree as a symbol of abstinence, which would also be relevant to Mary Magdalen.[16]

NOTES

1 Chizzola and Carboni 1760, p. 179; and MS inventory, L.II.6 m.3, in the Biblioteca Queriniana, Brescia.
2 The painting is listed in the 1820 catalogue of the Fenaroli Collection. Sir Charles Eastlake, Director of The National Gallery, London, saw the painting in the Palazzo Fenaroli in 1862 (*Diary*, MS, 1862, pt. 2, October 10, 1862, p. 5,

London, National Gallery Library) together with what he referred to as a companion panel of the Sibyl Samia. In 1875 it was still listed as part of this collection (see Fenaroli 1875, p. 48).
3 The dispersal of the Fenaroli Collection apparently began in 1876 (G. Frizzoni, *Arte italiana del Rinascimento*, Milan, 1891, p. 342). The bulk of the collection appears to have been sold to the local dealer Giuseppe Baslini. The present picture, however, was sold to another local dealer, P. Scalvini, according to Da Ponte (1898). It is probable that the painting was in the Fenaroli sale of 1882 (*Catalogo degli oggetti d'arte di...Girolamo Fenaroli [da vendersi all'asta nel 20 aprile 1882]*, Brescia, 1882), when it may have been acquired by Scalvini, but it has not been possible to find a copy of this catalogue. Begni Redona (1988, p. 447, no. 115) stated that the picture was in the 1882 sale but does not give an exact reference. The painting is not listed by Odorici in the second edition of his guide to Brescia (*Guida di Brescia*, Brescia, 1882) as being in the Fenaroli Collection. Bruno Passamani (letter to the author of October 10, 1988, in curatorial files) kindly assisted in the research into the early provenance of the painting.
4 T. H. Ward is the seller's name given in an annotated copy of Christie's 1904 sale catalogue (May 14, 1904, no. 54) at Christie's, London. For Ward, see *Who Was Who*, vol. 2, *1916–1928*, London, 1947, p. 1093.
5 According to annotated copies of the sale catalogue at Christie's, London.
6 According to annotated copies of the sale catalogue at Christie's, London.
7 Information recorded in the ledger of Thomas Agnew and Sons, Ltd., kindly checked by Evelyn Joll.
8 See letter from F. Mason Perkins to T. J. Blakeslee of December 5, 1912, kindly submitted by Robert C. Vose, Jr.
9 See letter cited above (note 8) and Gombosi 1943, p. 111.
10 See letter from Robert C. Vose, Jr., to Margherita Andreotti of May 12, 1988, in curatorial files.
11 Nicodemi (1925) unwisely suggested a painter he termed the Anonimo Morettiano, to whom he attributed, besides the painting in Chicago, *The Drunkenness of Noah* (Biella, Fenaroli collection), *The Brazen Serpent* (Brescia, private collection), and *The Death of Adonis* (Florence, Uffizi). Such a grouping cannot be substantiated and was ridiculed by Longhi (1926): *The Drunkenness of Noah* and *The Brazen Serpent* are assuredly by Moretto and *The Death of Adonis* is by Sebastiano del Piombo.
12 Both the 1904 and 1912 Christie's sale catalogues describe the painting as "One of the series of five pictures from the Fenaroli Palace, Brescia."
13 W. Pinardi, *La collezione Attilio Brivio alla Pinacoteca Ambrosiana*, Milan, 1961, p. 42, figs. 28–30. Also see Begni Redona 1988, pp. 444–46, no. 114. *Saint John the Evangelist* was included in the 1988 Moretto exhibition (no. 84).
14 Gombosi 1943, fig. 91. The altarpiece was included in the 1988 Moretto exhibition (no. 75).
15 Technically identifiable as an *ostrya carbonifolia*, known today as the hop hornbeam (information kindly supplied by the Department of Botany, University of Oxford).
16 See M. Levi d'Ancona, *The Garden of the Renaissance: Botanical Symbolism in Italian Painting*, Florence, 1977, pp. 62–63, fig. 15.

Giovanni Battista Moroni

1520/24 Albino (?), near Bergamo 1578

Gian Lodovico Madruzzo, 1551/52

Charles H. and Mary F. S. Worcester Collection, 1929.912

Oil on canvas, 199.8 x 116 cm (78⅝ x 45⅝ in.)

CONDITION: The painting is in very good condition. Leo Marzolo surface cleaned it in 1938 and then again in 1954, when he corrected lifting paint. Alfred Jakstas surface cleaned it in 1962 and then, with Timothy Lennon, cleaned it further in 1975–76. At that time an old glue lining was removed and the picture was relined with wax. The canvas has a twill weave. There is an arc-shaped tear 11.5 cm long at the sitter's right elbow, as well as several small paint losses in the left background on the lower part of the wall. There is slight abrasion in areas of the robe, particularly on the right shoulder. The edges of the canvas show tacking holes and pronounced cusping, but because no creases or fold lines are visible, it appears that Moroni tacked the canvas onto the stretcher from the front instead of turning it over the edge. The x-radiograph of the head suggests that Moroni may have altered the head's original contour (infrared, ultraviolet, x-radiograph of head).

PROVENANCE: Probably Madruzzo family, Castello del Buon Consiglio, Trent; by descent to Carlo Emanuele Madruzzo (d. 1658; inv. 1658/59).[1] Possibly his cousin Charlotte de Lénoncourt.[2] Barons Roccabruna, Trent, by 1682; by descent to Giacomo Roccabruna (d. 1735).[3] By descent to his sister Anna Caterina, wife of Baron Antonio Gaudenti della Torre, Trent.[4] Gaudenti family, Trent, until at least 1782.[5] Baron Isidoro Salvadori, Trent, by 1833.[6] Baron Valentino Salvadori, Trent, by 1835.[7] Sold by Salvadori to Trotti and Co., Paris, and Knoedler, Paris, 1906.[8] Sold by Trotti and Knoedler to James Stillman (d. 1918), Paris and New York, by 1907.[9] By descent to Charles Chauncey Stillman (d. 1927), New York; on loan to The Metropolitan Museum of Art, New York, 1921–26;[10] sold American Art Association, New York, February 3, 1927, no. 27 (ill.). Charles H. Worcester, Chicago, 1927;[11] on loan to the Art Institute from 1927; given to the Art Institute, 1929.

REFERENCES: A. Chiusole, *Itinerario delle pitture, sculture, ed architetture più rare di molte città d'Italia*, Vicenza, 1782, p. 21; reprinted in G. B. Emert, *Fonti manoscritte inedite per la storia dell'arte nel Trentino*, Florence, 1939, p. 125. C. Perini, *Trento e i suoi contorni, guida del viaggiatore*, Trent, 1859, p. 131; 1868 ed., pp. 130–31. O. Mündler, "Beiträge zu Jacob Burckhardt's Cicerone: Abtheilung Malerei," *Jahrbücher für Kunstwissenschaft* 11 (1869), p. 313. O. Brentari, *Guida del Trentino*, Bassano, 1890, p. 166. I. Lermolieff [G. Morelli], *Kunstkritische Studien über italienische Malerei*, Leipzig, 1891, vol. 2, p. 86 n. 1; Eng. ed., *Italian Painters, Critical Studies of Their Works: The Galleries of Munich and Dresden*, London, 1893, p. 65 n. 2. C. von Lützow, "Giovanni Battista Moroni," *Die Graphischen Künste* 14 (1891), p. 24. J. Burckhardt, *Der Cicerone*, 7th ed., 1898, p. 856. L. Oberziner, "Il ritratto di Cristoforo Madruzzo di Tiziano," in *Strenna del giornale dell'Alto Adige*, Trent, 1900, reprint, pp. 16–18. L. Oberziner, "Ritratti classici a Trento," *Rassegna d'arte* 11 (1902), pp. 88–89 (ill.). J. Burckhardt, *Der Cicerone*, 9th ed., Leipzig, 1904, p. 888. F. Menestrina, "Dipinti notevoli a Trento nel 1833," *Strenna del giornale dell'Alto Adige* (1904), p. 20. Berenson 1907, p. 272; 1932, p. 381; 1936, p. 327; 1968, p. 285. G. Lafenestre, "Les portraits des Madruzzi par Titien et G.-B. Moroni," *Revue de l'art ancien et moderne* 21 (1907), pp. 352, 357–60 (ill.). "Cronaca," *L'arte* 12 (1909), p. 76. G. Lafenestre, "Une Exposition de tableaux italiens," *Revue de l'art ancien et moderne* 25 (1909), pp. 18, 20. G. F[ogolari], "Madruzzo di Tiziano e del Moroni," *Il popolo — giornale socialista*, October 14, 1910, p. 1. G. Frizzoni, "Moretto und Moroni: Eine Charakterisierung auf Grund zweier massgebender Studienblätter," *Münchner Jahrbuch der bildenden Kunst* 7 (1912), p. 37. A. Michel, *Histoire de l'art depuis les premiers temps chrétiens jusqu'à nos jours*, vol. 5, pt. 2, Paris, 1913, p. 528. G. Fogolari, *Trento*, Bergamo, [1916], pp. 145 (ill.), 164. A. Locatelli Milesi, "Un grande ritrattista," *Emporium* 44 (1916), pp. 376, 380, 381, 385. A. L[ocatelli] M[ilesi] "Opere di G.-B. Moroni a Trento," *Bollettino della civica biblioteca di Bergamo* 10 (1916), pp. 104–05. H. B. W[ehle?], "A Notable Loan of Paintings," *Bulletin of The Metropolitan Museum of Art* 16, 9 (1921), p. 184. B. Burroughs, *The Metropolitan Museum of Art: Catalogue of Paintings*, 6th ed., New York, 1922, p. 213. G. Fogolari, *Trento*, Bergamo, [1924], pp. 142 (ill.), 158, 161. "Chicago," *Art News* 25, 27 (1927), p. 15. R. M. F[ischkin], "A Portrait by Moroni," *AIC Bulletin* 21 (1927), pp. 45–49, cover ill. "Portrait by Giambattista Moroni Loaned to Art Institute," *Chicago Evening Post*, April 5, 1927, pp. 1 (ill.), 12. Trotti and Co., letter to the editor, *Art News* 25, 32 (1927), pp. 8–9. "Chicago Opens Venetian Gallery," *Art News* 26, 32 (1928), p. 1. H. Merten, *Giovanni Battista Moroni: Des*

Meisters Gemälde und Zeichnungen, Marburg, 1928, p. 46, no. 82. A. Venturi, vol. 9, pt. 4, Milan, 1929, p. 277 n. 1. C. J. Bulliet, "Gallery to House Gifts to Museum," *Chicago Daily News*, February 18, 1930. D. C. Rich, "Chicago Given Worcester Art," *Art News* 28, 22 (1930), pp. 2, 9, 14 (ill.). D. C. Rich, "The Mr. and Mrs. Charles H. Worcester Gift," *AIC Bulletin* 24 (1930), pp. 30–31 (ill.). P. Arrigoni in Thieme/Becker, vol. 25, Leipzig, 1931, p. 165. L. Venturi 1931, pl. CCCXCVIII. S. Weber, "Notizie di pittori del secolo XVI nel Trentino," *Atti della società italiana per il progresso delle scienze* 11 (1931), p. 586. AIC 1932, pp. 5 (ill.), 165. G. Lendorff, *Giovanni Battista Moroni: Der Porträtmaler von Bergamo*, Winterthur, 1933, pp. 1, 10, 23–24, 27, 30, 33, 39, 57, no. 16; Italian rev. ed. published with monograph by D. Cugini, *Moroni pittore* (see below), Bergamo, 1939, reprinted 1978, pp. 18, 62–64, 68, 71, 75, 126, no. 16, p. 163. V. Nirdlinger, "The Art of History: Four Paintings in the Exhibition at Chicago," *Parnassus* 5, 4 (1933), pp. 8 (ill.), 11. S. Weber, *Artisti trentini ed artisti che operarono nel Trentino*, Trent, 1933, p. 206. AIC 1935, p. 20. H. Tietze, *Meisterwerke europäischer Malerei in Amerika*, Vienna, 1935, p. 330, no. 92, p. 92 (ill.). E. Mazza, "Gianbattista Moroni," *Rivista di Bergamo* 12 (1938), p. 484. *Worcester Collection* 1938, pp. 12–13, no. 8, pl. 7. D. Cugini, *Moroni pittore*, Bergamo, 1939, reprinted 1978, pp. 40–42, fig. 19. G. B. Emert, *Fonti manoscritte inedite per la storia dell'arte nel Trentino*, Florence, 1939, pp. 125, 138, 173. E. Mazza, "Giambattista Moroni," in *G. B. Moroni pittore*, Albino, 1939, pp. 19, 28. "Un monumento a G. B. Moroni in Albino," *Bergomum* 33 (1939), p. 120. W. Pach, *Masterpieces of Art: Catalogue of European and American Paintings, 1500–1900*, exh. cat., New York, New World's Fair, 1940, p. 9. F. Holland, "Superb Painting Chosen as Masterpiece of Month," *Chicago Sun*, September 10, 1944. D. Cugini, "Nota su G. B. Moroni a Trento," *Bergomum* 39 (1945), p. 45. AIC 1948, p. 26. P. Sannazzaro, "Lodovico Madruzzo," in *Enciclopedia Cattolica*, Rome, 1951, col. 1802 (detail ill.). F. A. Sweet, "La pittura italiana all'*Art Institute* di Chicago," *Le vie del mondo: Rivista mensile del Touring Club Italiano* 15 (1953), pp. 699–701 (ill.). *Italienische Malerei der Renaissance im Briefwechsel von Giovanni Morelli und Jean Paul Richter, 1876–1891*, ed. by I. and G. Richter, Baden-Baden, 1960, p. 350. AIC 1961, pp. 46 (ill.), 340–41. Huth 1961, p. 518. F. A. Sweet, "Great Chicago Collectors," *Apollo* 84 (1966), p. 203. Maxon 1970, p. 255 (ill.). Fredericksen/Zeri 1972, pp. 145, 512, 570. M. Gregori, "Il ritratto di Alessandro Vittoria del Moroni a Vienna," *Paragone* 27, 317–19 (1976), pp. 95, 99 n. 22. F. Rossi, "Giovan Battista Moroni nel IV centenario della morte," *Notizie da Palazzo Albani* 6, 2 (1977), p. 51. A. Braham, *Giovanni Battista Moroni: 400th Anniversary Exhibition*, exh. cat., London, The National Gallery, 1978, p. 7. D. Spinelli, "Trento lo scoprì prima di Bergamo," *L'eco di Bergamo*, February 15, 1978, pp. 3, 7. M. Gregori, "Gio-vanni Battista Moroni," in *I pittori bergamaschi dal XIII al XIX secolo*, vol. 3, *Il cinquecento*, Bergamo, 1979, pp. 98–99, 251–53, no. 92, p. 293, under no. 142, p. 295, under no. 173, p. 306, under no. 196, p. 307, under nos. 198–99, p. 311, under no. 208, p. 326 (ill.). S. Grossman, letter to the editor, "Titian and Moroni in Trent," *Apollo* 109 (1979), p. 246. Shapley 1979, vol. 1, pp. 340–41. M. Gregori in *The Genius of Venice, 1500–1600*, exh. cat., London, Royal Academy of Arts, 1983–84, no. 61, and under no. 62. A. Rosenauer, "Exhibition Reviews, London: Venice at The Royal Academy," *Burl. Mag.* 126 (1984), p. 305. E. Camesasca, ed., *Da Raffaello a Goya...da Van Gogh a Picasso: 50 dipinti dal Museu de Arte di San Paolo del Brasile*, exh. cat., Milan, Palazzo Reale, 1987, p. 84. *Master Paintings in The Art Institute of Chicago*, Chicago, 1988, p. 22.

EXHIBITIONS: Paris, Galerie Trotti, *Tableaux anciens de l'école italienne*, 1909, no. 20. The Art Institute of Chicago, *A Century of Progress*, 1933, no. 129. The Art Institute of Chicago, *A Century of Progress*, 1934, no. 50. The Art Institute of Chicago, *Masterpiece of the Month*, September 1944 (no cat.). The Dayton Art Institute, *Old Masters from Midwestern Museums*, 1948, no. 12. The Minneapolis Institute of Arts, *Great Portraits by Famous Painters*, 1952, no. 3. Bergamo, Palazzo della Regina, *Giovan Battista Moroni (1520–1578)*, 1979, no. 8. London, Royal Academy of Arts, *The Genius of Venice, 1500–1600*, 1983–84, no. 61.

A pupil of the Brescian Moretto, from whom he inherited Venetian painting techniques as well as an interest in highly refined optical effects, Moroni became one of the most accomplished portraitists of the sixteenth century. The years he spent in Trent, where he was exposed to Northern European painting and Counter-Reformation attitudes, reinforced his inclinations toward descriptive literalness and compositional austerity. These characteristics can be found also in his religious paintings, including his post-Tridentine altarpieces for the church of the Carmine, Bergamo (after 1575; now Milan, Pinacoteca di Brera), and in the Cathedral in Bergamo (dated 1576).[12]

A major early work in the genre for which Moroni is most famed, the Chicago portrait has been associated with two others of similar format and of approximately the same dimensions: a portrait of Cardinal Cristoforo Madruzzo by Titian, now in the Museu de Arte de São Paulo, dated 1552 (fig. 1),[13] and the presumed portrait of Gian Federico Madruzzo by Moroni

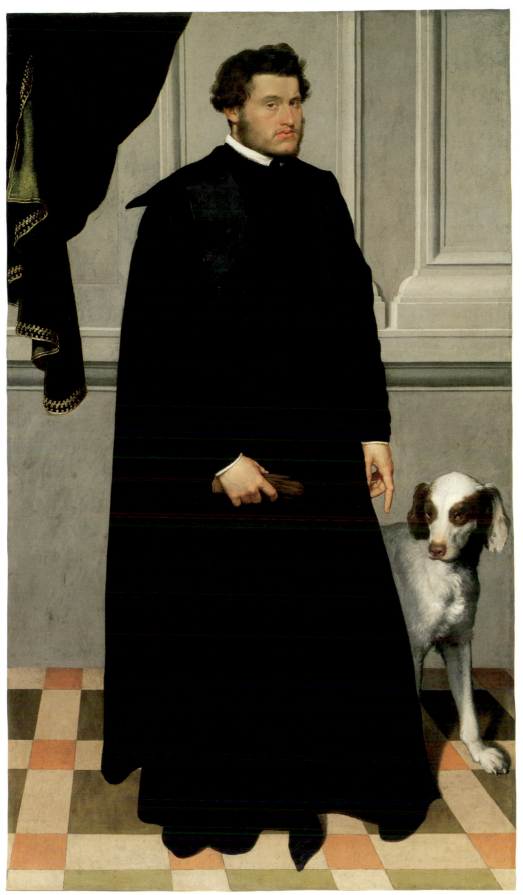

Giovanni Battista Moroni, *Gian Lodovico Madruzzo*, 1929.912

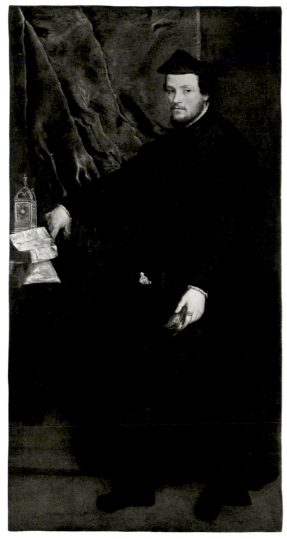

Fig. 1 Titian, *Cristoforo Madruzzo*, Collection of the
Museu de Arte de São Paulo, Brazil [photo: Luiz Hossaka]

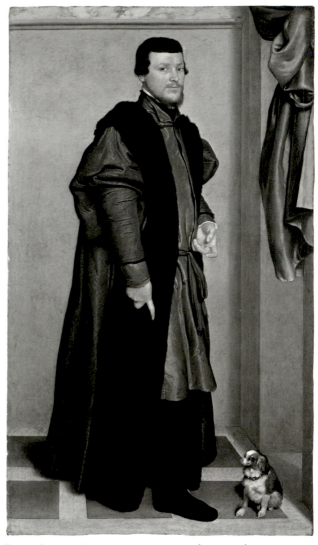

Fig. 2 Giovanni Battista Moroni, *Gian Federico Madruzzo*,
National Gallery of Art, Washington, D.C., Timken Collection

(fig. 2), now in the National Gallery of Art in
Washington, D.C.[14] Although the evidence for the
provenance of these pictures is complicated by the
lack of specific descriptions in local guides and
inventories, the three portraits appear to have
remained together for much of their history from the
sixteenth century until the dispersal of the Stillman
Collection in New York during the 1920s (see Prove-
nance). Their early provenance was established by
Oberziner (1900, 1902), with much of the evidence as
recorded in local guides first published by Emert in
1939. The tradition that all three portraits are
likenesses of members of the Madruzzo family, who
held the position of Prince-Bishops of Trent and

played a leading role in the organization and running
of the Council of Trent (1545–63), has been sup-
ported in the recent literature through comparison to
portrait medals (see below). Titian's portrait of Car-
dinal Cristoforo Madruzzo (1512–1578) was painted
in 1552 when, according to the inscription on the
papers in the painting, he was age thirty-nine. The
portraits in Chicago and Washington appear to repre-
sent Gian Lodovico (1532–1600) and Gian Federico
Madruzzo (c. 1530–1586), respectively, both sons of
Niccolò Madruzzo (d. 1576), the elder brother of
Cardinal Cristoforo.[15]

Perini (1859) was the first writer to identify the
subject of the present portrait as Gian Lodovico, an

ecclesiastic whose rise within the hierarchy of the church was rapid. He first became coadjutor in the see of Trent in 1550 before being created cardinal in 1561 and succeeding his uncle as Prince-Bishop of Trent in 1567.[16] This identification was supported by Oberziner (1900, 1902), who seems to have been the first to identify the subject of the portrait now in Washington as Gian Federico, soldier and diplomat. Only Grossman (1979) has challenged these identifications, suggesting instead that the portrait in Chicago is another portrait of Cardinal Cristoforo and that the portrait in Washington is of the cardinal's elder brother Niccolò. As Gregori (1979) has pointed out, this would seem to contradict both the stylistic evidence and the evidence provided by the comparative material in the form of medals (see below).

Gregori maintained with good reason that the portraits of all three members of the Madruzzo family were likely painted at the same time in connection with the activities of the Council of Trent and that Moroni's portraits therefore belong to the same year as Titian's portrait of Cardinal Cristoforo. Earlier writers had suggested a broader time span extending from 1552 to 1560, but Gregori's argument is convincing insofar as the portraits are in Moroni's early mature style. The artist is recorded in Trent in 1548 when he painted the *Annunciation* (now Trent, Ospedali Riuniti) and *Santa Chiara* (now Trent, Museo Diocesano) for the church of San Michele Arcangelo.[17] Although he is not documented in the city at the beginning of the 1550s, the altarpiece of the *Virgin and Child in Glory with the Four Doctors of the Church and Saint John the Evangelist* in the church of Santa Maria Maggiore, Trent, accords well with Moroni's stylistic development at that period and is indeed compatible with the portraits of the Madruzzo family for which Gregori postulated a date of 1551/52.[18] Gregori (1979, pp. 41–44) also pointed out that Moroni's activities in Trent seem to have coincided with the interrupted sittings of the Council, which would almost certainly have provided him with the opportunity of securing several important portrait commissions. Furthermore, the suggested dating of 1551/52 fits well with Moroni's development as a portrait painter. The portraits of unknown sitters in the Honolulu Academy of Arts and the Pinacoteca Ambrosiana, Milan, dated 1553 and 1554,

respectively, are in a more advanced personal style and less obviously influenced by the work of other painters.[19]

The dating is clearly significant for the identification of the members of the Madruzzo family shown in the portraits in Chicago and Washington, for if, as Grossmann (1979) argued, the figures are Niccolò and Cardinal Cristoforo they would have been in their early forties in 1551/52. The sitters in these two portraits, however, appear to be younger, although it is difficult to say exactly how much. If, as seems likely, Moroni painted his two portraits in 1551/52, then Gian Federico would have been in his early twenties and Gian Lodovico would have been about twenty.

Medals of the Madruzzo family seem to confirm these identifications. These include two medals of Cardinal Cristoforo dating from 1540 and 1547, reproduced by Habich.[20] Another medal depicting Cristoforo by Pier Paolo Galeotti (fig. 3), who signed with the initials P.P.R., is also dated, although the date itself is not absolutely distinct.[21] What is clear, however, is that Cristoforo is shown as an older man with a different coiffure and a longer beard than either of the two men portrayed by Moroni. The same aging process is also apparent in the medal of Niccolò by Antonio Abondio,[22] whereas a medal of Gian Lodovico inscribed ELECTUS TRIDENTINUS (fig. 4) indisputably records the features of a younger face that accords well with that of the portrait in Chicago.[23]

The portraits in Chicago and Washington were in all probability painted as a pair. Although the figures

Fig. 3 Pier Paolo Galeotti, medallion of Cristoforo Madruzzo, Kunsthistorisches Museum, Vienna

Fig. 4 Anonymous, medallion of Gian Lodovico Madruzzo, Kunsthistorisches Museum, Vienna

both look toward the right, the looped curtains provide a balance. The style of the portraits is still indebted to Moretto, notably in the way the figures are offset against a monochrome gray background. Moroni probably realized that his portraits would be compared with Titian's portrait of Cardinal Cristoforo Madruzzo, who stands facing left against a rose-colored curtain.[24] It is therefore hardly surprising that the younger painter has adopted a similar format, one which had first come to be used for official portraits in northern Europe.[25] Indeed, it is perfectly possible that Moroni was fully aware of developments in Germany. As Joanna Woodall of the Courtauld Institute of Art, London, first observed,[26] and as Rosenauer (1984) subsequently argued independently, the positioning of the full-length figure on a patterned floor and against a wall with a looped curtain in the background was perhaps derived from Jakob Seisenegger's portraits of the 1530s and 1540s.[27]

There are some interesting contrasts between the portraits in Chicago and Washington: Gian Lodovico is dressed as an ecclesiastic, while Gian Federico is portrayed as an aristocrat, their different modes of dress reflecting the course of their careers. Gian Lodovico is accompanied by a large standing dog, whose presence he acknowledges with his left hand, while Gian Federico seems in danger of treading on the diminutive animal in the lower right corner. It is unlikely that these animals are intended to be symbolic; they are probably an indication that, although formal in pose, the portraits were intended to be hung in a domestic setting.

In the Chicago portrait, Moroni displays great skill in modulating the austere color scheme imposed by the sitter's black robe. The figure's dark form is relieved by the floor pattern of contrasting salmon pink, green, and ochre squares, as well as by the gray background. The bottle green of the looped curtain serves a similar purpose in the upper half of the portrait, forming a transition between the light and dark tones in the picture. Compositionally, the curtain begins a broad diagonal extending downward through the sitter's hands and the dog. Moroni's use of light further heightens these features and the feeling of recession. Entering the picture from the left, it strikes the first fold of the curtain, then the face and hands of Gian Lodovico Madruzzo, and finally the muzzle and

chest of the dog, as well as the edges of the architectural elements of the wall in the background. Unlike the portrait in Washington, the painter has here lavished a great deal of attention on the dog, resulting in a passage of outstanding naturalistic painting.

NOTES

1 The Castello del Buon Consiglio was the official residence of the Prince-Bishops of Trent, an office held by the Madruzzo family until the male line became extinct in 1658 with the death of Carlo Emanuele. The Chicago portrait and its pendant in The National Gallery of Art, Washington, D.C., have been identified with "due quadri de ritratti de Madruzzi" (two paintings of portraits of the Madruzzos) recorded in the inventory of the Castello del Buon Consiglio after Carlo Emanuele's death (see Oberziner 1900, pp. 15–16, and Gregori 1979, p. 251). Camesasca (1987, p. 84) stated that this inventory, made between December 19, 1658, and January 13, 1659, is preserved in the Biblioteca Civica, Trent. According to Camesasca, Titian's portrait of Cristoforo Madruzzo was not recorded in this inventory.

2 Oberziner (1900, pp. 16–17) speculated that Charlotte de Lénoncourt might have sold the two Moroni portraits to Roccabruna to pay the debts of the last member of the Madruzzo family.

3 The two Moroni portraits, together with the one by Titian of *Cardinal Cristoforo Madruzzo*, are presumably identical with "i tre quadri grandi di Madruzzi" (the three large portraits of the Madruzzos) mentioned in a 1682 Roccabruna inventory cited by Oberziner (1900, p. 17). According to Gregori (1979, pp. 251–52), this document is now in the Archivio Municipale, Trent, no. 5271. Oberziner (1900, p. 17) stated that the Roccabruna family, of which Giacomo was the last male member, became extinct in 1735.

4 Oberziner 1900, pp. 17–18 n. 2.

5 Chiusole (1782, p. 21) noted that "il Signor Gaudenti, fra altre cose degne, conserva tre ritratti di Tiziano" (Signor Gaudenti, among other noteworthy things, owns three portraits by Titian).

6 According to an 1833 manuscript by Benedetto Giovanelli published by Emert (1939, p. 138), describing them only as "Tre ritratti de' Madruzzi" (Three portraits of the Madruzzos), and citing the succession from the Roccabruna and Gaudenti families.

7 According to the 1835 manuscript guide by Simone Consolati published by Emert (1939, p. 173), mentioning "i bellissimi ritratti d'intiera figura ed in grandezza notevole dipinti da Tiziano" (the extremely beautiful full-length, large-scale portraits painted by Titian).

8 Trotti 1927 and Gregori 1979, p. 252. The unsuccessful attempt made by the Louvre at the beginning of this century to buy this and the two related portraits of members of the same family from Baron Valentino Salvadori is described by Lafenestre 1907, pp. 351–52.

9 Trotti 1927 and Berenson 1907.

10 According to registrar's records.

11 According to registrar's records.

12 Gregori 1979, p. 374, fig. 2, p. 375, fig. 1, respectively.

13 H. E. Wethey, *The Paintings of Titian*, vol. 2, *The Portraits*, London, 1971, pp. 116–17, no. 62, pl. 166; shown in the 1983–84 London exhibition as no. 125 (color ill.).

14 Shapley 1979, vol. 1, pp. 340–41, no. 1579, vol. 2, pl. 248; and Gregori 1979, p. 311, no. 208.

15 Gregori (1979, p. 295, no. 173, p. 322, fig. 2) suggested that a *Portrait of a Soldier* by Moroni (location unknown) might also be a member of the Madruzzo family, Aliprando, who died in 1547 at the age of twenty-five, after fighting, like his nephew Gian Federico, in the war against the Turks. For the genealogy and for biographical details of the Madruzzo family, see P. Litta, *Celebri famiglie italiane*, Milan, 1819–1912, vol. 8.

16 Gian Lodovico Madruzzo was educated at the universities of Louvain and Paris. Apart from playing an important role in the third session of the Council of Trent (1562–63), he was also deeply involved in mediating between the Hapsburg Empire and the Papal Curia. He held a number of influential diplomatic posts, including papal legate to the Diet of Augsburg (1559), to the imperial court (1581), again to the Diet of Augsburg (1582), and to the Diet of Regensburg (1582). Gian Lodovico was present at no less than seven conclaves, at all of which he showed his pro-Spanish sympathies. He is buried in the family chapel in the church of San Onofrio in Rome, where a monument adorned with a bust was erected in his memory. There is no detailed modern account of his life beyond the entries in the *Enciclopedia Cattolica*, vol. 7, Vatican City, 1951, col. 1801, and *The New Catholic Encyclopedia*, vol. 9, Washington, D.C., 1967, pp. 54–55.

17 Gregori 1979, pp. 306–07, nos. 197–98, p. 319, figs. 4–5.

18 Ibid., pp. 305–06, no. 196, p. 325, fig. 2.

19 Ibid., pp. 268–69, no. 118, p. 327, fig. 6, p. 283, no. 142, p. 328, fig. 2, respectively.

20 G. Habich, *Die deutschen Schaumünzen des XVI. Jahrhunderts*, pt. 1, vol. 2, Munich, 1931, p. 190, no. 1366, pl. CLII (5), p. 194, no. 1392, pl. CLIV (1), respectively.

21 See G. F. Hill and G. Pollard, *Renaissance Medals from the Samuel H. Kress Collection at The National Gallery of Art*, London, 1967, p. 66, no. 352, where a date of 1552 is favored.

22 G. F. Hill, *Medals of the Renaissance*, Oxford, 1920, pl. VIII.10; and Habich (note 20), p. 489, no. 3341, pl. CCCXIV (5).

23 K. Domanig, *Die deutsche Medaille in Kunst- und Kulturhistorisches Hinsicht*, Vienna, 1907, p. 42, no. 258.

24 Perini (1859) recorded an unfounded tradition that the head of the portrait in Chicago was painted by Titian and the rest of the figure by Moroni.

25 J. Pope-Hennessy, *The Portrait in the Renaissance*, London and New York, 1966, pp. 171–72.

26 Verbal communication to the author.

27 See K. Löcher, *Jakob Seisenegger: Hofmaler Kaiser Ferdinands I*, Munich and Berlin, 1962, figs. 8, 27, 35, 42.

Attributed to the Workshop of Neroccio de' Landi

1447 Siena 1500

Two Putti, 1490/1510

Mr. and Mrs. Martin A. Ryerson Collection, 1937.1001

Tempera or oil on panel, 46.3 x 37.5 cm (18¼ x 14¾ in.); painted surface: 45.6 x 36.3 cm (18 x 14¼ in.)

INSCRIBED: TVT[. . .]DIRI F (on quiver)

CONDITION: The painting is in poor condition. In 1962 Alfred Jakstas cleaned and inpainted the picture, but left residues of old varnish. The panel has added strips on all four sides and has been mounted on a secondary support and cradled. The four corners are modern, and clearly the panel was not originally rectangular in shape. The sides have, in all probability, been trimmed, but the pattern of losses along the top and bottom suggests that these are the original edges of the paint surface. There are several horizontal splits in the panel. The paint surface is in poor condition. There appear to be two distinct layers of restoration, the earlier one being under a relatively heavy layer of varnish. There are numerous areas of retouching in the figures, covering small local losses. Losses in the armorial bearings have been inpainted but not filled. The green pigment of the background has darkened, but this whole area has been unevenly thinned and repainted.

PROVENANCE: Major-General John Barton Sterling, London, by 1886;[1] sold Sotheby's, London, April 29, 1914, no. 106, as School of Botticelli. Sold by Steinmeyer & Fils, Paris, to Martin A. Ryerson (d. 1932), Chicago, 1914;[2] at his death to his widow, Mrs. Martin A. Ryerson (d. 1937); bequeathed to the Art Institute, 1937.

REFERENCES: Berenson 1932, p. 70; 1936, p. 60; 1957, vol. 1, p. 30. Valentiner [1932], n. pag. K. L. Brewster, "The

Ryerson Gift to The Art Institute of Chicago," *Magazine of Art* 31 (1938), p. 97. R. Brimo, *Art et goût: L'Evolution du goût aux Etats-Unis d'après l'histoire des collections*, Paris, 1938, p. 92. C. L. Ragghianti, "Studi sulla pittura lombarda del quattrocento," *Critica d'arte* 3d ser., 8 (1949), p. 298 n. 29. AIC 1961, p. 226. Fredericksen/Zeri 1972, pp. 139, 503, 571.

EXHIBITIONS: London, Royal Academy of Arts, *Works by the Old Masters, and by Deceased Masters of the British School*, 1886, no. 173, as Italian School.

As noted above (see Condition), the corners of the panel are modern, suggesting that its original shape may well have been octagonal and that the painting, therefore, may once have served as a *desco da parto*, traditionally a round or polygonal panel. The *desco da parto* was a tray or salver customarily given to a mother after childbirth. It celebrated the birth of a child and honored the mother, often being displayed for that purpose in the home.[3] If not a *desco da parto*, then the present panel could have served either as a lid for a wooden box, as suggested in the 1961 catalogue of the Art Institute's paintings, or fulfilled some other decorative function. Most *deschi da parto* were painted on both sides.[4] The panel in Chicago is mounted on a secondary support and cradled and so this cannot now be established. The coats of arms on either side of the two figures tend to confirm that the painting was made in connection with a specific event, such as the birth of a child, to commemorate the family's lineage and to emphasize the importance of its perpetuation through childbirth. The coats of arms regrettably are much damaged, particularly that on the right, and are illegible. The one on the left is upside down.

A wide range of attributions has been suggested. Berenson (1932, 1936, 1957) mystifyingly identified the picture as a studio work in Giovanni Bellini's early style;[5] Valentiner (1932) suggested a follower of Neroccio; Brewster (1938) proposed Francesco di Giorgio; and Ragghianti (1949) advanced the name of Benedetto Bembo. The Art Institute's 1961 catalogue

of paintings described the picture as Italian School, sixteenth century, stating that the artist "followed the tradition of Francesco di Giorgio and Neroccio." Fredericksen and Zeri (1972) listed it as a work by Matteo di Giovanni. The association of the panel with Siena appears correct. Of the attributions suggested, that to Neroccio de' Landi is perhaps the most likely, although, in its present condition, the panel can at best only be deemed a product of the workshop. The heads of these putti are close to Neroccio's treatment of the Christ Child in his paintings of the Virgin and Child, although he generally preferred less portly figures.[6] Also comparable are two fragments of a painting of putti in a landscape dating from the final decade of Neroccio's life, which are evidently autograph and clearly influenced by the sculpture of Donatello.[7] A work of this conservative nature could also have been produced in the early sixteenth century.

NOTES

1 Colonel Sterling is listed as the lender to the 1886 exhibition.
2 According to an entry dated June 27, 1914, in Ryerson's notebook and a bill of sale from Steinmeyer to Ryerson dated July 3, 1914 (Archives, The Art Institute of Chicago).
3 For further bibliography, see E. Callmann, "The Growing Threat to Marital Bliss as Seen in Fifteenth-Century Florentine Paintings," *Studies in Iconography* 5 (1979), pp. 80–81; and D. Cole Ahl, "Renaissance Birth Salvers and the Richmond *Judgement of Solomon*," *Studies in Iconography* 7–8 (1981–82), pp. 157–74.
4 P. F. Watson, "A *desco da parto* by Bartolomeo di Fruosino," *Art Bull.* 56 (1974), pp. 4–9.
5 In an expertise of July 2, 1914, on the back of an old photograph in curatorial files, Berenson wrote, "The original of this photograph was doubtless due to a follower of the Bellini toward 1470"; in a letter to Ryerson of January 24, 1920, F. J. Mather, Jr., suggested an attribution to Matteo Balducci and a date of 1510 (Archives, The Art Institute of Chicago); and on studying the collection in January 1930, R. van Marle described the picture as "close to Francesco di Giorgio," according to a letter from D. C. Rich to Ryerson of January 13, 1930 (Archives, The Art Institute of Chicago).
6 See, for example, G. Coor, *Neroccio de' Landi, 1447–1500*, Princeton, 1961, figs. 61, 64. For Neroccio's workshop, see *Painting in Renaissance Siena, 1420–1500*, exh. cat., New York, The Metropolitan Museum of Art, 1988–89, p. 328.
7 Coor (note 6), pp. 91–92, 165, no. 12, figs. 70–71.

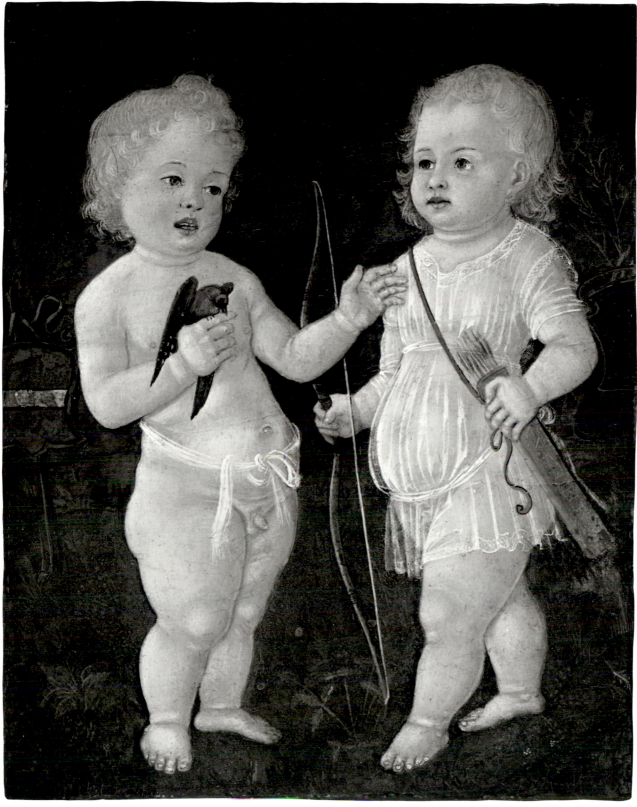

Attributed to the Workshop of Neroccio de' Landi, *Two Putti*, 1937.1001

Northern Italian

Sinan the Jew and Haireddin Barbarossa, c. 1535
Charles H. and Mary F. S. Worcester Collection, 1947.53

Tempera on canvas, 66.5 x 63.7 cm (26³/₁₆ x 25¹/₁₆ in.)

CONDITION: The painting is in fair condition considering its medium and support. It was lightly cleaned by Alfred Jakstas in 1965. Although the canvas may be a fragment of a larger composition (see discussion below), it must once have been placed on a slightly smaller stretcher since regularly spaced nail holes are visible at the top and sides. Some slight weave distortion corresponding to these holes is visible at the left and top edges. There are remnants of filling material along the top and bottom edges between the canvas and the lining fabric.[1] The paint surface is much abraded, notably in the turban and profile of the figure on the right and in the face of the figure on the left. The canvas itself is now visible in some areas here and in the background (x-radiograph).

PROVENANCE: Possibly Paolo Giovio (d. 1552), Como.[2] Private collection, Treviso.[3] Carlo Foresti, Milan.[4] Sold by Foresti to Charles H. Worcester, Chicago, 1930;[5] given to the Art Institute, 1947.

REFERENCES: C. J. Bulliet, "Masterpieces in Official Fine Arts Show," *Chicago Daily News*, October 28, 1933, p. 10 (ill.). A. M. Frankfurter, "Art in the Century of Progress," *Fine Arts* 20 (June 1933), p. 14 (ill.). Van Marle, vol. 17, 1935, pp. 154–55 (ill.). F. J. Mather, Jr., *Venetian Painters*, New York, 1936, p. 47 (ill.). *Worcester Collection* 1938, pp. 7–8, no. 4, pl. III. "Chicago Gets Handsome Gift," *Pictures on Exhibit* 9, 7 (1947), p. 14. K. Kuh, "The Worcester Gift," *AIC Bulletin* 41 (1947), pp. 59, 61, cover ill. "To Dedicate Art at New Building: Old Master Collection Honors Art Patrons," *Lawrentian*, May 26, 1950, p. 4. F. A. Sweet, "La pittura italiana all'*Art Institute* di Chicago," *Le vie del mondo: Rivista mensile del Touring Club Italiano* 15 (1953), pp. 696–98 (ill.). Berenson 1957, vol. 1, p. 29. AIC 1961, p. 21. Huth 1961, p. 517. Fredericksen/Zeri 1972, pp. 22, 522, 571. Y. Miller, "Medal by L. Neufahrer with a Portrait of Hayr-ed-din Barbarossa," *Bulletin of The Hermitage Museum, Leningrad* 38 (1974), pp. 63–64, with English summary on pp. 76–77. J. Meyer zur Capellen, *Gentile Bellini*, Stuttgart, 1985, pp. 151–52, no. C6, fig. 96. L. Klinger and J. Raby, "Barbarossa and Sinan: A Portrait of Two Ottoman Corsairs from the Collection of Paolo Giovio," *Arte veneziana e arte islamica: Atti del primo simposio internazionale sull'arte veneziana e l'arte islamica*, Venice, 1989, pp. 47–60, fig. 1. J. M. Rogers, review of *Arte vene-*

ziana e arte islamica: Atti del primo simposio internazionale sull'arte veneziana e l'arte islamica, in *Burl. Mag.* 132 (1990), p. 576.

EXHIBITIONS: The Art Institute of Chicago, *A Century of Progress*, 1933, no. 103, as Gentile Bellini, *Two Orientals*. The Art Institute of Chicago, *A Century of Progress*, 1934, no. 43, as Gentile Bellini, *Two Orientals*. The Toledo Museum of Art, *Four Centuries of Venetian Painting*, 1940, no. 5, as Gentile Bellini, *Two Orientals*. Appleton, Wisconsin, The Worcester Fine Arts Center, Lawrence College, *Exhibition*, 1950 (no cat.). San Francisco, The California Palace of the Legion of Honor and The M. H. de Young Memorial Museum, *Man — Glory, Jest, and Riddle: A Survey of the Human Form through the Ages*, 1964–65, no. 95, as School of Gentile Bellini, *Two Orientals*.

The painting has given rise to considerable discussion, much of it somewhat fanciful on account of the picture's subject matter, and the attribution of the work has yet to be satisfactorily resolved. A general consensus of opinion settled early upon the name of Gentile Bellini, which was obviously first proposed because of the artist's famous visit to the court of the Sultan Mehmet II at Constantinople between 1479 and 1481.[6] Van Marle (1935), Mather (1936), and Rich (*Worcester Collection* 1938), with the agreement of authorities like Fiocco, Morassi, and Suida,[7] regarded the painting as autograph, but most other authorities have favored a more tentative attribution such as "close follower of" (Berenson 1957), "immediate circle of" (AIC 1961), or "manner of" (Fredericksen/ Zeri 1972). More recently, Meyer zur Capellen (1985) rejected the attribution to Gentile, asserting that the picture dates at the earliest to the end of the second decade of the sixteenth century.[8] Klinger and Raby (1989) have subsequently described the work as by an anonymous artist, perhaps Venetian.[9] As shown

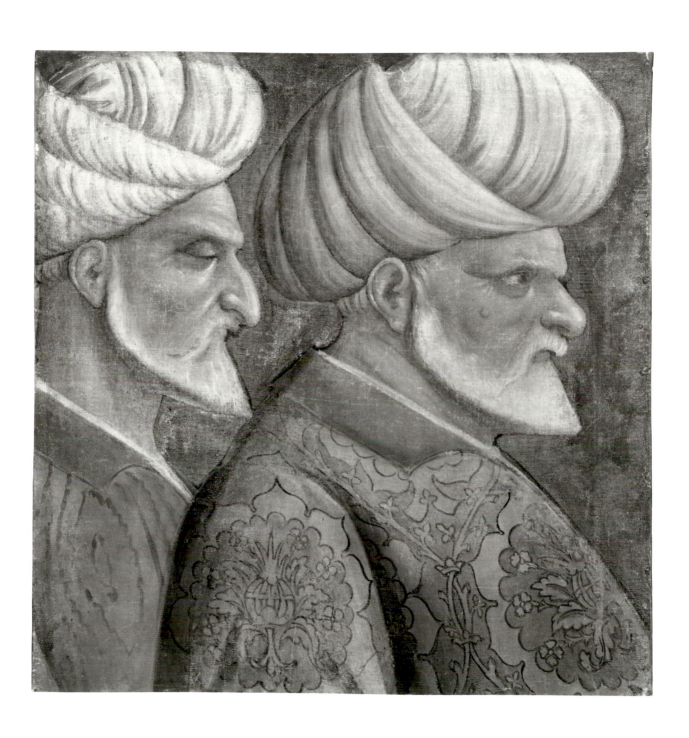

below, the attribution of the painting depends very largely upon its provenance and the identification of the figures. Van Marle, in correspondence with Charles Worcester, first suggested the possibility that the picture had formed part of the collection of the Giovio family,[10] a name that has subsequently been frequently cited in the provenance of the painting, but whose association with the painting has not until very recently been carefully explored.

Klinger and Raby (1989) have offered evidence that the Chicago canvas is a fragment of a large painting that was once in the famous collection of Paolo Giovio (1483–1552), the bishop of Nocera, who was an accomplished diplomat, historian, and biographer.[11] They have argued that the work in question can be identified with a picture mentioned in a letter from Giovio to Rodolfo Pio of August 20, 1535, where in exchange for a portrait of Pio's uncle, Alberto, Giovio offered to send a portrait of Haireddin Barbarossa (1466?–1546), Grand Admiral of the fleet of Sultan Süleyman the Magnificent.[12] The passage reads "e io vi mandarò il bravo ritratto di Barbarossa, il quale ho qui, con un concorso mirabile."[13] Apparently, Giovio offered a copy of this painting to the Cardinal of Lorraine in the following year, so that it must have achieved considerable fame as a work of art.[14] While it is difficult to imagine that the Chicago painting, even when in good condition, would have been regarded as "bravo," it does seem possible that the work is a copy after Giovio's picture, perhaps one of those made at the owner's request.

The reference in Giovio's letter of 1535 to a "concorso mirabile" suggests that his painting was a large composition with several figures, possibly moving in procession. The picture may have resembled one of Gentile Bellini's paintings celebrating particular events in Venetian life.[15] A document of 1588 refers to a room called the "sala de' Turchi" in Giovio's villa on Lake Como; conceivably, it was there that Giovio, an authority on Turkish history, kept his collection of artifacts that had once belonged to the corsair Barbarossa.[16] Klinger and Raby have conjectured that if the picture in Chicago is correctly identified as a fragment from a large painting, then this might have formed part, if not the centerpiece, of the decorative scheme for this particular room.[17] Although attractive, this hypothesis is problematic, since exami-

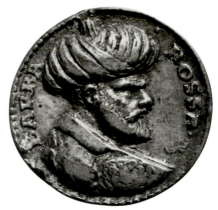

Fig. 1 Ludwig Neufahrer, silver medal of Haireddin Barbarossa, Ashmolean Museum, Oxford

nation of the weave of the painting's canvas does not indicate that it has been substantially cut down, and one would expect the background to be specified if the Chicago picture was at one time a part of a larger, historical scene.

More convincing is Klinger and Raby's identification of the two figures. Miller (1974) identified the figure on the right as Barbarossa on the basis of a silver medal (fig. 1) by the Austrian medalist Ludwig Neufahrer (d. 1563),[18] who also made a likeness of Giovio himself.[19] Klinger and Raby added to this evidence several portraits of Barbarossa from Ottoman and European sources, including two copies dating from the sixteenth century which were probably made from the portrait type in the painting belonging to Giovio. The first dates from before 1568 and was made by Cristofano (di Papi) dell'Altissimo for Duke Cosimo I. It is still in the Uffizi.[20] The second copy is in the collection at Schloss Ambras.[21]

Paolo Giovio's painting may also have formed the basis of two of the numerous woodcuts (figs. 2–3) prepared by the Swiss artist Tobias Stimmer as illustrations for Giovio's *Elogia virorum bellica virtute illustrium* (Basel, 1575).[22] Curiously, and confusingly, the features of the figure on the right of the Chicago painting are identified in one of the woodcuts (fig. 2) as those of Oruç (Book VI, p. 340), the brother of Haireddin, who had died in 1518, while those of Haireddin himself (Book VI, p. 342) are based on the famous engraving by Agostino Veneziano dating from 1535.[23] In the absence of a likeness of Oruç, it seems that one of his brother Haireddin was substituted. It is also possible, as Klinger and Raby tenta-

tively argued from circumstantial evidence, that the painting had already been cut down by the time Tobias Stimmer arrived in Como in 1569–70 to gather the necessary material for the woodcuts to be included in the *Elogia* and that in its fragmentary state individuals were misidentified.[24] If this is not the case, then the portraits, as happened with the headpieces for Vasari's *Lives*, must have been extrapolated with minor compositional adjustments from the original full-scale picture, so that they would appear *en suite* in the book with the other illustrations, which were for the most part based upon single images.

Another portrait in this publication (Book VI, p. 343) has enabled Klinger and Raby to identify convincingly the figure with eye closed on the left of the painting as Sinan the Jew, a corsair who served as one of Barbarossa's naval captains (fig. 3).[25] Van

Marle (1935), in discussing the Chicago picture, had described this figure as "haggard with eyes closed in meditation," whereas, in fact, as mentioned in Giovio's biography of Sinan, he was blind in one eye ("qui altero captus oculo").[26]

In addition to identifying the two figures, Klinger and Raby examined the issues surrounding the attribution of the Chicago picture, which, as mentioned earlier, they considered to be a fragment of the original composition of Haireddin Barbarossa shown in "un concorso mirabile." They rejected the traditional attribution to Gentile Bellini or his circle and concluded that the painting was probably executed in Italy but based on model drawings made in Istanbul, where, in fact, several Italian and North European artists are recorded during the 1530s.[27] The difficulty of associating specific styles with these itinerant art-

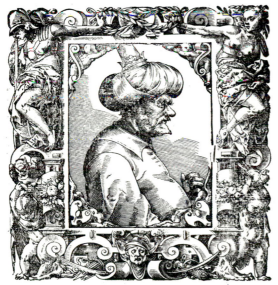

Fig. 2 Tobias Stimmer, "Horuccius," woodcut illustration from Paolo Giovio, *Elogia virorum bellica virtute illustrium*, Basel, 1575 [photo: courtesy of The Newberry Library, Chicago]

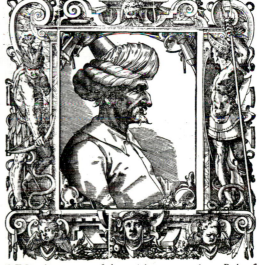

Fig. 3 Tobias Stimmer, "Sinas Iudaeus," woodcut illustration from Paolo Giovio, *Elogia virorum bellica virtute illustrium*, Basel, 1575 [photo: courtesy of The Newberry Library, Chicago]

ists documented in Istanbul remains, even though their influence can be seen in the new realism evident in Turkish painting at the close of the sixteenth century. The possibility must also be considered that the present picture is a copy, presumably by a Venetian or Lombard artist, of a section of the painting in Giovio's collection.

NOTES

1 Klinger and Raby 1989, p. 52 n. 4, referred to one-inch wooden strips added to the picture at top and bottom. These have since been removed.

2 See discussion section.

3 According to registrar's records.

4 According to undated document in curatorial files.

5 See note 4.

6 For a general discussion of this, with further bibliography, see J. Byam Shaw, "Gentile Bellini and Constantinople," *Apollo* 120 (1984), pp. 56–58.

7 See expertises in curatorial files.

8 Meyer zur Capellen 1985, pp. 151–52, no. C6.

9 Klinger and Raby 1989, p. 57.

10 Letter from Van Marle to Charles H. Worcester of October 21, 1930, quoted in letter from Worcester to Daniel Catton Rich of November 6, 1930, in curatorial files.

11 A scholar in the humanist tradition, Giovio's interests ranged from Turkish history (*Commentario de le cose de' Turchi*, published in 1531) to *imprese* (personal emblems or coats of arms with mottos; *Dialogo delle imprese . . .* , published in 1555). For much of his life he worked in the service of the Papacy and witnessed many important events during the first half of the sixteenth century, which culminated in his written historical and biographical works. His most famous work was the *Historiarum sui temporis*, published in 1550–52, which covered the history of Italy during the period 1494–1547. Related to his writings is the collection of portraits that he formed and used to illustrate his volumes of *Elogia*, for knowledge of which the study by E. Müntz, "Le Musée des Portraits de Paul Jove," *Mémoires de l'Institut National de France. Académie des Inscriptions et Belles Lettres* 37 (1901), pp. 249–343, is still useful. Giorgio Vasari's *Lives* was written at the instigation of, and was almost certainly inspired by, Paolo Giovio.

12 Klinger and Raby 1989, p. 48. Khidr (or Haireddin) Barbarossa (an adopted name) was, together with his older brother Oruç (or Aruj), one of the most famous corsairs in the history of the Mediterranean. Of Greek descent, Oruç and Haireddin fought the Spanish in North Africa. After the death of Oruç in 1518, Haireddin entered the service of Süleyman the Magnificent, establishing strongholds first in Algiers and then in Tunisia, which last was captured in 1534, although it was eventually retaken by Charles V. Haireddin was made admiral of Süleyman's fleet in 1533, taking up his duties in 1536 and operating successfully in the Mediterranean until his death ten years later. See P. Achard, *La vie extraordinaire des frères Barberousse, corsaires et rois d'Alger*, Paris, 1939.

13 Klinger and Raby 1989, p. 48. This passage may be translated as "and I will send you the fine portrait of Barbarossa, which I have here, with a marvelous meeting [of figures]."

14 Ibid.

15 T. Pignatti, *Le scuole di Venezia*, Milan, 1981, pls. 47, 49, 168.

16 Klinger and Raby 1989, p. 49.

17 Ibid.

18 G. Habich, *Die deutschen Schaumünzen des XVI. Jahrhunderts*, pt. 2, vol. 1, Munich, 1931, pp. 195–96, no. 1403, pl. CLV(3); and G. Probszt, *Ludwig Neufahrer: Ein Linzer Medailleur des 16. Jahrhunderts*, Vienna, 1960, p. 68, no. 17, p. 87, fig. 16.

19 Habich (note 18), pt. 2, vol. 2, pp. 549–50, no. 1309a, fig. 623; and Probszt (note 18), p. 89, no. 32.

20 *Gli Uffizi: Catalogo generale*, Florence, 1979, p. 637, no. Ic.268 (ill.).

21 See Klinger and Raby 1989, fig. 3, and F. Kenner, "Die Porträtsammlung des Erzherzogs Ferdinand von Tirol," *Jahrbuch der Kunsthistorischen Sammlungen des Allerhöchsten Kaiserhauses* 19 (1898), pp. 139–40, no. 27.

22 Klinger and Raby 1989, pp. 48–49.

23 For the portrait of Haireddin from Giovio's *Elogia*, see Klinger and Raby 1989, fig. 5. For the engraving by Agostino Veneziano, see K. Oberhuber, ed., *The Illustrated Bartsch*, vol. 27, *The Works of Marcantonio Raimondi and His School*, New York, 1978, p. 191, no. 518–I; and Klinger and Raby 1989, fig. 6.

24 Klinger and Raby 1989, p. 49.

25 Ibid., p. 48.

26 *Elogia virorum illustrium*, ed. by R. Meregazzi, in Paolo Giovio, *Opera*, vol. 8, Rome, 1972, p. 466.

27 Klinger and Raby 1989, pp. 49–50. On Süleyman the Magnificent's patronage, see E. Atil, *The Age of Sultan Süleyman the Magnificent*, exh. cat., Washington, D.C., National Gallery of Art, 1987; and J. M. Rogers and R. M. Ward, *Süleyman the Magnificent*, exh. cat., London, British Museum, 1988.

Allegretto Nuzi

Documented Florence and Fabriano 1346–1373

Bishop Saint Enthroned, 1360/70

Mr. and Mrs. Martin A. Ryerson Collection, 1933.1022

Tempera on panel, 118.8 x 65.7 cm (46¾ x 25⅞ in.)

CONDITION: The painting is in very poor condition. It was cleaned by Barry Bauman in 1977–78. The panel, which has a vertical grain, has been thinned and cradled. It was prepared with a fabric interleaf which is visible at the left edge and in the x-radiograph. There are several vertical splits in the panel, with the most prominent of these running the full height of the panel through the face of the saint. This split probably corresponds to a join in the panel and was apparently reinforced with an additional fabric strip. The paint surface has suffered extensive losses and is also disturbed by a pronounced horizontal craquelure. The saint's vestments, with the exception of the right side of the dalmatic, are severely abraded. Particularly damaged is the red chasuble, especially its embroidered decorative band, for which a layering of silver, gold, and pigments was used, possibly in a sgraffito design. No attempt was made to repair this band in the 1977–78 treatment. The saint's head is well preserved, however. The throne and gilded areas of the design are incised (infrared, mid-treatment, ultraviolet, x-radiograph).

PROVENANCE: Unknown dealer, Rome, by 1905.[1] Horace Morison, Boston, by 1913.[2] Sold by Morison to Martin A. Ryerson (d. 1932), Chicago, 1916; intermittently on loan to the Art Institute from 1916;[3] bequeathed to the Art Institute, 1933.

REFERENCES: J. A. Crowe and G. B. Cavalcaselle, *A History of Painting in Italy*, 2d ed., vol. 3, ed. by R. Langton Douglas, London, 1908, p. 181 n. 1. "Early Italian Paintings," *American Art News* 13, 22 (1915), p. 3. G. H. Edgell, "The Loan Exhibition of Italian Paintings in The Fogg Museum, Cambridge," *Art and Archaeology* 2 (1915), pp. 17 (ill.), 19–20. C. R. Post, "A Triptych by Allegretto Nuzi at Detroit," *Art in America* 3 (1915), pp. 214, 222, fig. 2; reprinted in *Bulletin of the Detroit Museum of Art* 10, 2 (1915), pp. 2, 5, 8, fig. 2. AIC 1917, p. 164; 1920, p. 63; 1922, p. 72; 1923, p. 72. Van Marle, vol. 5, 1925, pp. 160, 163, fig. 101. *Ryerson Collection* 1926, pp. 44–45. AIC 1932, p. 182. Valentiner [1932], n. pag. A. M. Frankfurter, "Art in the Century of Progress," *Fine Arts* 20, 2 (1933), p. 9 (ill.). D. C. Rich, "The Paintings of Martin A. Ryerson," *AIC Bulletin* 27 (1933), p. 8. F. A. Sweet, "La pittura italiana all'*Art Institute* di Chicago," *Le vie del mondo: Rivista men-*

sile del Touring Club Italiano 15 (1953), p. 692 (ill.). "A New Setting for the Medieval Collection," *AIC Quarterly* 53, 1 (1958), p. 8. AIC 1961, pp. 344–45. Huth 1961, p. 516. Berenson 1968, vol. 1, p. 302. Fredericksen/Zeri 1972, pp. 4, 455, 571.

EXHIBITIONS: Cambridge, Massachusetts, Fogg Art Museum, *Loan Exhibition of Italian Paintings*, 1915 (no cat.). The Art Institute of Chicago, *A Century of Progress*, 1933, no. 91.

Discussion of the attribution and date of this panel is restricted by its poor condition. However, the figure's face is well preserved, and this alone justifies the attribution to Nuzi first put forward by Langton Douglas and accepted by later scholars.[4] Although Nuzi was very probably a native of Fabriano, he was first documented in Florence in 1346, when he was inscribed in the guild of Saint Luke as coming from Siena. This designation may refer to an earlier Sienese sojourn. In any case, his early work reflects the influence of Florentine and Sienese painting, and his first dated work, a triptych of 1354 in the National Gallery of Art in Washington, D.C.,[5] was painted in collaboration with the Florentine Puccio di Simone, formerly identified as the Master of the Fabriano Altarpiece. Nuzi's later work, presumably executed in Fabriano and dated to the 1460s, shows a reassertion of a more local, decorative style.[6] It is to these later works that the Art Institute's panel may be compared, in particular to the figures of Saint Francis on the altarpiece of 1366 at Apiro (the Marches) and Saint Anthony Abbot on the altarpiece of 1369 at Macerata (the Marches), or with the bishop saint on the much-damaged altarpiece now in the Pinacoteca at Fabriano.[7] These figures are stylistically related to the Chicago painting in the brown flesh tones, the prominent highlighting of the nose and cheeks, the drawing of the thick, fleshy lips, and the stylized curls of the

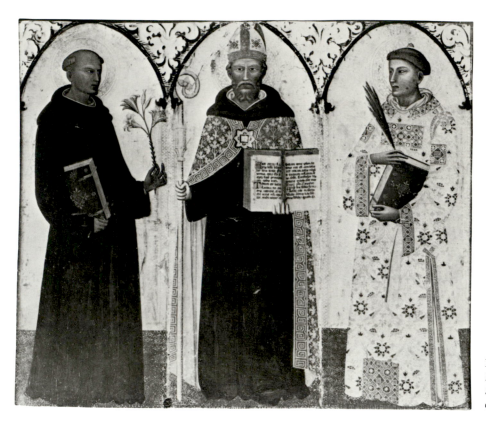

Fig. 1 Allegretto Nuzi, *Saints Nicholas of Tolentino, Augustine, and Stephen*, Pinacoteca Civica e Museo degli Arazzi, Fabriano

beard. Similar stylistic features also appear in the figure of Saint Augustine on a panel in the Pinacoteca at Fabriano (fig. 1) showing the saint between Saints Nicholas of Tolentino and Stephen. Indeed, the draperies of the figures of Saints Augustine and Stephen on this last panel give some impression of how the Chicago painting probably looked before it was damaged.

The identity of the bishop saint is still unknown. A crozier or any other specific attribute seems to have been deliberately omitted by the painter, rather than lost through damage or early restoration. Saint Nicholas of Bari, who is sometimes shown enthroned, is the most likely candidate.

Panels of this gabled, rectangular shape, without lateral scenes, were usually hung on the pillars of churches, though visual evidence shows that they could also be placed on altars.[8] A panel of similar format by a Florentine painter is the *Saint Blaise* by Bicci di Lorenzo in the Indianapolis Museum of Art.[9] Since the female donor kneeling in the lower left corner of the Art Institute's painting is dressed in a Dominican habit, the panel was probably painted for a church associated with that order.

NOTES

1 According to Langton Douglas in the second edition of Crowe and Cavalcaselle 1908, p. 181 n. 1; Langton Douglas stated that the painting was "in a fair state of preservation."
2 Letter of July 22, 1913, from Philip Gentner to Morison (Archives, The Art Institute of Chicago).
3 Letter of February 16, 1916, from Morison to Ryerson (Archives, The Art Institute of Chicago), and registrar's records.
4 As in note 1.
5 Shapley 1979, pp. 383–86, pl. 276.
6 For Nuzi, see most recently M. Boskovits, *Gemäldegalerie Berlin: Frühe italienische Malerei*, ed. by E. Schleier, Berlin, 1988, pp. 1–4. Compare also 1937.1006 catalogued above, a picture attributed to Nuzi's follower Francescuccio Ghissi.
7 For illustrations of the Saints Francis and Anthony Abbot panels, see Van Marle, vol. 5, 1925, figs. 95, 92, respectively. For an illustration of the bishop saint from the Fabriano altarpiece, see A. Colasanti, *Gentile da Fabriano*, Bergamo, 1909, p. 13.
8 R. Offner, *A Critical and Historical Corpus of Florentine Painting*, sec. 3, vol. 5, New York, 1947, p. 94 n. 1. See also the representation of a chapel in Agnolo Gaddi's fresco of *The Story of the Bad Debtor* in the Castellani Chapel, Santa Croce, Florence (B. Cole, *Agnolo Gaddi*, Oxford, 1977, pl. 12).
9 D. Miller, *Indianapolis Museum of Art: Catalogue of European Paintings*, Indianapolis, 1970, p. 10; "Catalogue of Ten Primitives from the James E. Roberts Collection," *Bulletin of the Art Association of Indianapolis, Indiana, The John Herron Art Institute* 11, 5–6 (1924), p. 32 (ill.).

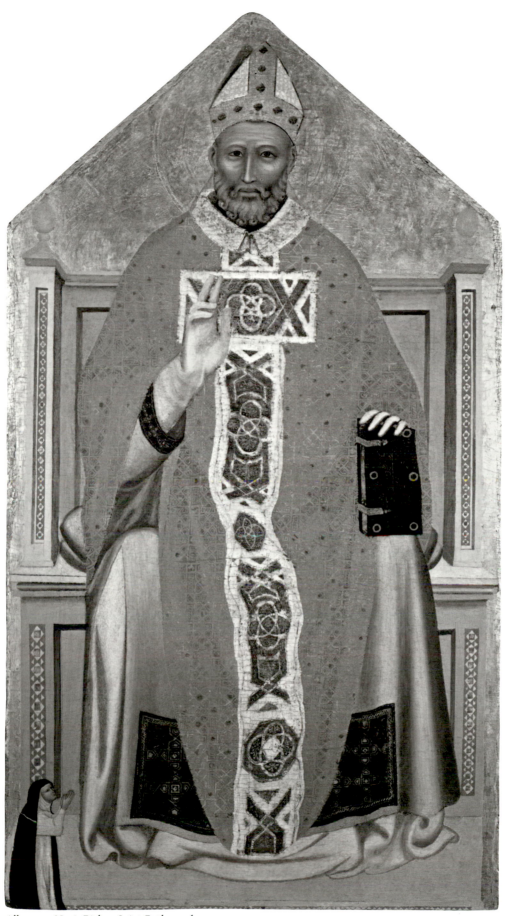

Allegretto Nuzi, *Bishop Saint Enthroned*, 1933.1022

Jacopo Palma, called Palma il Giovane

c. 1548 Venice 1628

Portrait of a Gentleman, c. 1590

Charles H. and Mary F. S. Worcester Collection, 1937.449

Oil on canvas, 108 x 81.3 cm (42½ x 32 in.)

CONDITION: The painting is in good condition. It has not
undergone a full treatment since its acquisition by the Art
Institute, although problems with bloom have necessitated
light surface cleaning and revarnishings. The canvas has an
old glue lining and has been extended on the left, bottom,
and top edges, as is evident from the x-radiograph (fig. 1).
It is unclear what the painting's original dimensions were,
since the edges have been altered several times. Thus, the
x-radiograph shows a set of tacking holes on the right side
indicating the flattening of the tacking margin to enlarge
that side. The other three sides have been enlarged by the
addition of a C-shaped piece of canvas extending approxi-
mately 5 cm at the bottom, 6–7 cm at the top, and 7 cm at
the left side. The reason for these extensions and when they
were made are not known. It is, therefore, by no means
certain whether these additions, and particularly the hand
holding the piece of paper, are an accurate reconstruction or
a fanciful recreation. The other hand was broadly under-
painted and changed, making it all the more difficult to judge
the artist's original intention. There has been some abrasion
in the beard and on the figure's left side. The face and
flesh tones are well preserved (infrared, ultraviolet,
x-radiograph).

PROVENANCE: Asscher and Welker, London, to 1937.[1]
E. and A. Silberman Galleries, New York, 1937. Sold by
Silberman to Charles H. Worcester, Chicago, 1937;[2] given to
the Art Institute, 1937.

REFERENCES: Worcester Collection 1938, p. 11, no. 6A. R.
P[allucchini], "Dipinti veneziani a Chicago, Detroit, Toledo e
Hartford," Arte veneta 1 (1947), p. 148. R. Pallucchini,
"Commento alla mostra di Jacopo Bassano," Arte veneta 11
(1957), p. 116. Berenson 1957, vol. 1, p. 17. E. Arslan, I
Bassano, Milan, 1960, vol. 1, p. 336. AIC 1961, pp. 18, 40
(ill.). Huth 1961, p. 518. E. E. Lowinsky, "Problems in
Adrian Willaert's Iconography," in Aspects of Medieval and
Renaissance Music: A Birthday Offering to Gustave Reese,
ed. by J. La Rue, New York, 1966, pp. 576, 588–94, pl. 22a.
Fredericksen/Zeri 1972, pp. 18, 526, 571. W. R. Rearick,
"The Portraits of Jacopo Bassano," Artibus et historiae 1
(1980), p. 99 n. 3. S. Mason Rinaldi, "Novità, ritrovamenti e
restituzioni a Jacopo Palma il Giovane," Arte veneta 35 (1982),
pp. 147–48, fig. 6. S. Mason Rinaldi, Palma il Giovane:
L'opera completa, Milan, 1984, p. 80, no. 59, fig. 112.

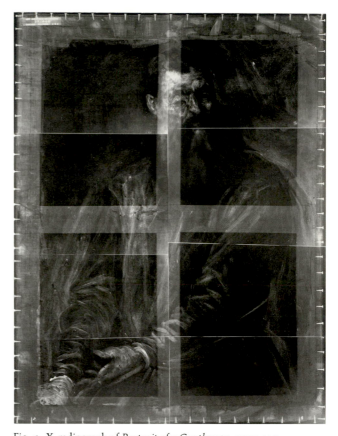

Fig. 1 X-radiograph of Portrait of a Gentleman, 1937.449

EXHIBITIONS: The Toledo Museum of Art, Four Cen-
turies of Venetian Painting, 1940, no. 3. Venice, Palazzo
Ducale, Jacopo Bassano, 1957, portrait no. 8. Venice, Museo
Correr, Palma il Giovane, 1548–1628, 1990, no. 81.

The attribution of this lively and skillfully executed
portrait has proved difficult in the past, but has
recently been settled in favor of Palma il Giovane,
who, after the death of Jacopo Tintoretto in 1594,
became the dominant personality in Venetian paint-
ing. Palma directly inherited the tradition of Titian,
Tintoretto, and Veronese, as exemplified by his role in
the decoration of the Palazzo Ducale in Venice. He

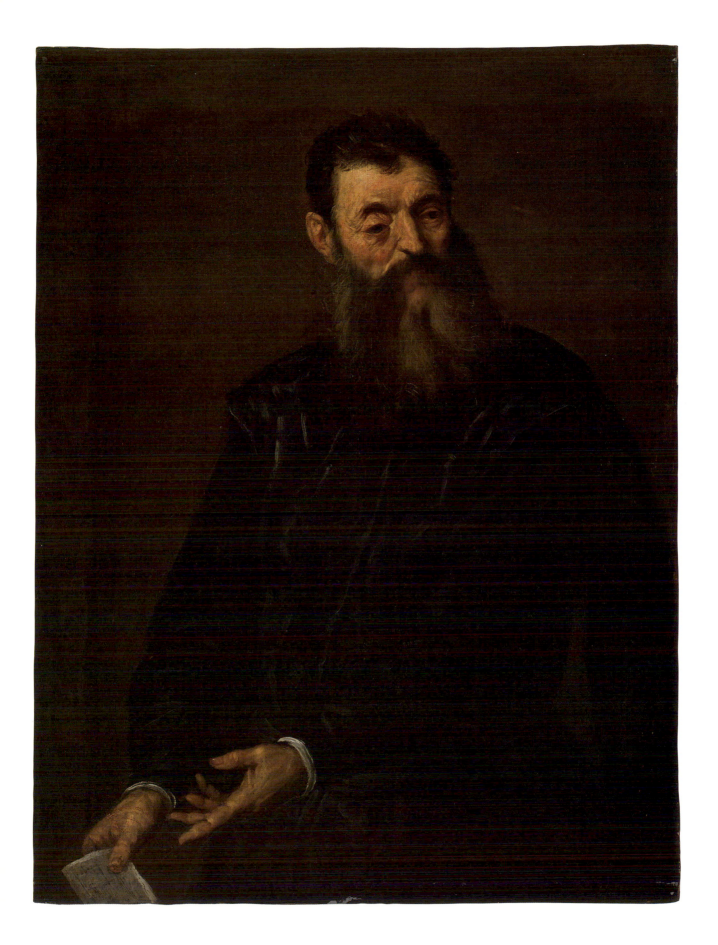

was an immensely prolific painter and a compulsive draughtsman, carrying out numerous official commissions and creating a body of work that forms an important stylistic link between Mannerism and the Baroque.

Rich (*Worcester Collection* 1938), Tietze (in the catalogue of the 1940 exhibition held at Toledo), Berenson (1957), and Fredericksen and Zeri (1972) maintained or upheld an attribution to Jacopo Bassano for this portrait.[3] Indeed, the picture was included in the group of thirteen portraits at the major exhibition devoted to Bassano in Venice in 1957, even though in the catalogue Zampetti expressed doubts about its association with the artist.

Dissent grew after the exhibition of 1957. Pallucchini (1957) tentatively suggested an attribution to an artist of the Brescian or Bergamasque school, and Arslan (1960) placed the portrait in his general category of Bassanesque works, but at the same time advanced the name of a Veronese painter, Marcantonio Bassetti.[4] Rearick (1980) was the first to argue in favor of an attribution to Palma il Giovane on comparison with the portraits in the paintings executed between 1584 and 1592 for the Oratorio of the Ospedaletto dei Crociferi in Venice.[5] Mason Rinaldi (1982, 1984) upheld Rearick's suggestion by comparing the Chicago picture to particular paintings in this series: the portraits in the scenes devoted to incidents from the life of Doge Pasquale Cicogna, dating from 1586–87, and the painting of *Christ Carried to the Tomb* of 1590.[6] The handling of the facial features, particularly the wrinkling of the skin around the eyes, the demonstrative gesture, the lighting of the face, and the loose, dexterous highlights on the drapery are directly comparable with the portraits in the cited works. As Mason Rinaldi observed, the influence of Jacopo Tintoretto is apparent in the pose and in the preference for offsetting the figure against a monochrome background. In the chronology of Palma il Giovane's early portraits established by Mason

Rinaldi, the present picture is situated between the *Portrait of Niccolò Cappello* (c. 1582) in the collection of the Duke of Devonshire at Chatsworth and the *Portrait of an Old Man* (c. 1600) in the National Gallery of Victoria in Melbourne.[7]

Lowinsky (1966) attempted to identify the sitter with Adrian Willaert (1480/90–1562), the Flemish-born composer and *maestro di cappella* of the Basilica di San Marco in Venice. However, the visual evidence for this identification was at the outset conflicting and is completely invalidated if the revised attribution and dating of the portrait are correct.[8]

NOTES

1 Letter from Kenneth Clark to Asscher and Welker of February 1, 1937, in curatorial files.
2 Bill from E. and A. Silberman Galleries to Charles H. Worcester of November 4, 1937, in curatorial files.
3 Kenneth Clark, Hans Tietze, and Hermann Voss had likewise attributed the painting to Jacopo Bassano in unpublished statements made in 1937 when the picture came on the market. See Clark's letter mentioned in note 1 above, a letter from Tietze to Silberman of June 27, 1937, and one from Voss to Silberman of July 8, 1937, in curatorial files.
4 For whom, see R. Pallucchini, *La pittura veneziana del seicento*, vol. 1, Milan, 1981, pp. 123–26, figs. 336–54.
5 Mason Rinaldi 1984, pp. 138–39, nos. 519–27, figs. 87–132. In fact, an attribution to Palma il Giovane had already been mentioned in passing in the catalogue of the 1957 exhibition.
6 Mason Rinaldi 1984, figs. 89–93, 100.
7 Ibid., p. 80, no. 57, fig. 68; p. 91, no. 144, fig. 309. Oddly, Berenson (1957) gave the painting a date of 1590, incorrectly implying that the portrait is dated; such a date would, in any case, be impossible for Jacopo Bassano, to whom Berenson attributed the portrait.
8 Lowinsky's case rests essentially on a comparison with the woodcut (Lowinsky 1966, pl. 20b) published in Willaert's *Musica nova* (1559) from which so many of the portraits of the composer derive. Lowinsky also described the sitter as dressed in a choir gown, but this is not entirely correct. According to Aileen Ribeiro of the Courtauld Institute of Art in London (letter to the author of June 6, 1984, in curatorial files), it can more properly be defined as an informal type of gown with hanging sleeves, tied at the waist with a sash, often worn by artists, writers, and musicians. The vogue for such gowns can be dated to the end of the sixteenth century and the beginning of the seventeenth, notably in the Netherlands, but also in Italy.

Workshop of Paolo Veneziano

Active Venice by 1333, d. 1358/62

Saints John the Baptist and Catherine of Alexandria, c. 1350

Charles H. and Mary F. S. Worcester Collection, 1947.116

Tempera on panel, 77 x 49.7 cm (30¼ x 19⅝ in.)

INSCRIBED: s̄ / JHS / BAPT / IST [. . .]· (to the right of Saint John the Baptist, in red pigment), SCA / KA / TS / RIN (to the right of Saint Catherine, in red pigment), ECCE / AGN / VS / DEI (on the scroll of Saint John the Baptist, in blue pigment)[1]

CONDITION: The painting is in very good condition. It was cleaned by Leo Marzolo in 1949 and was surface cleaned by Alfred Jakstas in 1975. The panel, which has a vertical grain, has not been thinned or cradled. Added pieces of wood, approximately 4 cm high, have been attached at the top of each arch, and the gilding has been extended onto these segments. The panel is approximately 2.5 cm thick, and the reverse is beveled at the right and bottom edges and at the top where the added segments have been attached. The panel is slightly bowed. All the edges appear to have been cut fairly recently, and the profiles of the present arched tops do not respect the original shape of the design, which was outlined by incised contours. These incised contours frame the saints' heads more narrowly and have an undulating form. There are only minor paint losses on the figures, notably on Saint John the Baptist's right shoulder and on Saint Catherine's cloak below her right wrist. There is a paint and ground loss on the medallion held by Saint John, and the rear portion of the lamb has been repainted. The gold decoration on Saint Catherine's robe and cloak is somewhat rubbed, as are the halos. However, the gold background is basically intact (x-radiograph).

PROVENANCE: Grimaldi, Venice.[2] The Roerich Museum, New York; sold American Art Association, New York, March 28, 1930, no. 150 (ill.), as Lorenzo Veneziano, to Robert B. Harshe acting on behalf of Charles H. Worcester.[3] Charles H. Worcester, Chicago, 1930–47; on loan to the Art Institute from 1933;[4] given to the Art Institute, 1947.

REFERENCES: See below.

EXHIBITIONS: See below.

Saints Augustine and Peter, c. 1350

Gift of Mrs. Charles V. Hickox, 1958.304

Tempera on panel, 77.4 x 49.5 cm (30½ x 19½ in.)

INSCRIBED: s̄ / AGV / STI / NV / S (to the left of Saint Augustine, in red pigment), s̄ / PET / RVS (to the left of Saint Peter, in red pigment)

CONDITION: The painting is in good condition. Its treatment history between the time of the Roerich sale, when it was separated from 1947.116, and its accession by the Art Institute is unknown, but it appears to have been somewhat more harshly cleaned than its companion piece. It was surface cleaned by Alfred Jakstas in 1975. The panel, which has a vertical grain, has not been thinned or cradled. It is approximately 3 cm thick and the reverse is beveled at the sides and bottom. The panel is slightly bowed. All the edges appear to have been trimmed more recently than is the case for 1947.116, though the contours of the two panels correspond. There is no major damage to the figures, though the faces are abraded. The mordant gilding is abraded, particularly in Saint Augustine's chasuble, and the large floral motifs have been repaired with yellow paint. The halos are also abraded. The gold background has suffered damage, notably in the area between the two figures (x-radiograph).

PROVENANCE: Grimaldi, Venice.[5] The Roerich Museum, New York; sold American Art Association, New York, March 28, 1930, no. 151 (ill.), as Lorenzo Veneziano, to Robert B. Harshe acting on behalf of Catherine Barker Spaulding Hickox.[6] Catherine Barker Spaulding Hickox, Michigan City, Indiana, and New York, 1930–58; on loan to the Art Institute from 1932; given to the Art Institute, 1958.

REFERENCES: F. J. Mather, Jr., "Roerich Museum to Sell Many Old Masters," *Art News* 28, 20 (1930), p. 3. "Roerich Museum Is to Sell Its Old Masters," *Art Digest* 4, 11 (1930), p. 15 (1947.116 ill.). D. C. Rich, "Two Trecento Venetian Panels," *AIC Bulletin* 24 (1930), pp. 86–89 (ill.). E. Sandberg-Vavalà, "Maestro Paolo Veneziano," *Burl. Mag.* 57 (1930), pp. 171, 177. Berenson 1932, p. 418 (1947.116); 1936, p. 359 (1947.116); 1957, vol. 1, p. 127. *Worcester Collection* 1938, p. 5, no. 1 (1947.116 ill.). E. Sandberg-Vavalà, "Maestro Paolo Veneziano: His Paintings in America and Elsewhere," (1939), in M. Muraro, *Paolo da Venezia*, University Park, Pennsylvania, and London, 1970, pp. 97, 98 n. 7. S. Bettini, *Pitture cretesi-veneziane, slave e italiane del Museo Nazionale di Ravenna*, Ravenna, 1940, p. 100 n. 1 (1958.304). "Chicago Gets Handsome Gift," *Pictures on Exhibit* 9 (April

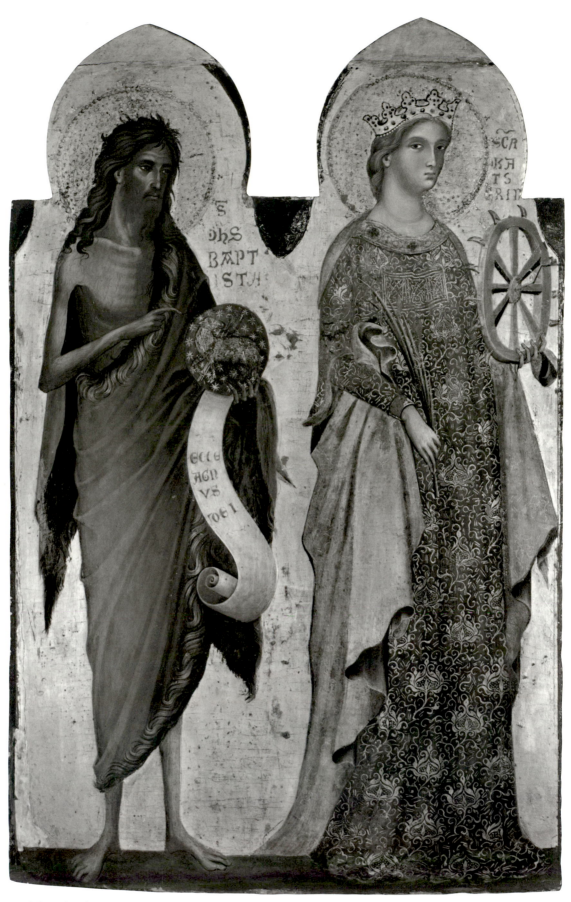

Workshop of Paolo Veneziano, *Saints John the Baptist and Catherine of Alexandria*, 1947.116

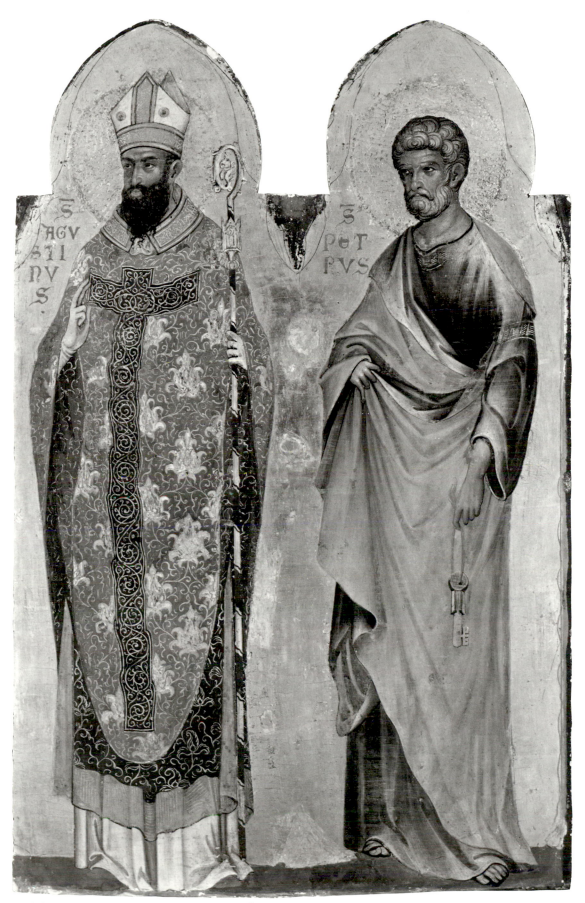

Workshop of Paolo Veneziano, *Saints Augustine and Peter*, 1958.304

1947), p. 14. R. Pallucchini, *La pittura veneziana del trecento*, Lezioni tenute alla Facoltà di Lettere dell'Università di Bologna, Bologna, 1955, p. 131. AIC 1961, pp. 349–50. Huth 1961, p. 516. R. Pallucchini, *La pittura veneziana del trecento*, Venice and Rome, 1964, p. 51, figs. 171–72. B. Klesse, *Seidenstoffe in der italienischen Malerei des 14. Jahrhunderts*, Bern, 1967, p. 269, no. 162d, p. 446, no. 460c. Maxon 1970, p. 23 (1958.304 ill.). M. Muraro, *Paolo da Venezia*, University Park, Pennsylvania, and London, 1970, pp. 55, 73 n. 47, 106, figs. 18–19. Fredericksen/Zeri 1972, pp. 158, 375, 382, 412, 441, 571. G. Kaftal with F. Bisogni, *Saints in Italian Art: Iconography of the Saints in the Painting of North East Italy*, Florence, 1978, col. 509, no. 150g.

EXHIBITIONS: The Art Institute of Chicago, *A Century of Progress*, 1933, nos. 87–88, as School of Lorenzo Veneziano. The Art Institute of Chicago, *A Century of Progress*, 1934, nos. 35–36, as School of Lorenzo Veneziano.

These two paintings clearly formed part of the main section of a polyptych, the original location and exact format of which are unknown. The panels appear to have been together until the time of the Roerich sale in 1930. Although bought by two different collectors on that occasion, they were reunited in The Art Institute of Chicago. Aside from the dimensions and the punching, the only positive clue for the identification of other parts from the same altarpiece is the shape of the arched tops as indicated by the incised contours still visible on the panels out of their frames. The relevant areas are now concealed by modern frames, and the arched tops have been recut (see Condition).

Paolo Veneziano or Paolo da Venezia was the leading painter in Venice in the first half of the fourteenth century. His style combines strong Byzantine influence with sinuous gothic elegance. Paolo's earliest secure work is the polyptych with the *Dormition of the Virgin* in Vicenza, signed and dated 1333,[7] although earlier dated works have also been attributed to him. His individual style has proved difficult to isolate and order chronologically, and the degree to which his works are collaborative efforts is suggested by the signatures of both Paolo and his son Giovanni on two important works, the cover of the Pala d'Oro of 1345 in the basilica of San Marco and the *Coronation of the Virgin* of 1358 in The Frick Collection, New York.[8]

In the catalogue of the Roerich sale, the panels were attributed to Lorenzo Veneziano. Van Marle advanced an attribution to the Master of the Pirano Altarpiece, whom he defined as "a figure somewhere between Maestro Paolo and Lorenzo Veneziano."[9] Sandberg-Vavalà, in her pioneering article of 1930, concluded that the Master of Pirano (also known as the Master of Chioggia) was really Paolo Veneziano himself and on that basis attributed the panels in Chicago to Paolo Veneziano and his family workshop. Berenson (1932, 1936, 1957) and Rich (*Worcester Collection* 1938) concurred with this suggestion. Muraro (1970) correctly denied the participation of Paolo Veneziano himself and assigned the panels entirely to the master's workshop. Fredericksen and Zeri (1972), however, used the designation "Paolo Veneziano (and Giovanni Veneziano)," emphasizing the collaborative nature of the workshop.

As regards chronology, Pallucchini (1964), followed by Klesse (1967), suggested that the Chicago panels belonged to the period of the dated polyptych of 1354 in the Louvre and the polyptych of 1355, formerly in the sacristy of the cathedral at Pirano, near Trieste.[10] Muraro (1970) favored a slightly earlier date around 1349–54, supporting Sandberg-Vavalà's (1930) comparison of the Chicago panels with the polyptych in San Giacomo Maggiore in Bologna and the panels of a dismembered polyptych now at the Worcester Art Museum in Massachusetts.[11]

Although Sandberg-Vavalà (1939) described the panels in Chicago as being "of Paolo's very best quality," this is slightly overstating the case. The modeling and the drawing in these panels do not, in fact, match Paolo Veneziano's own high standards of execution and finish in the Vicenza polyptych for example, although the figures of Saints John the Baptist and Catherine of Alexandria more nearly approach the master's style than do the figures of Saints Augustine and Peter. The latter figures reveal a less refined handling of the flesh tones and a crisper drawing of the facial features. These last two saints could almost be by a different hand, possibly reflecting a division of labor that is not unusual in a large altarpiece, and one that is perhaps implied in the form of attribution favored by Fredericksen and Zeri (1972). These differences are admittedly accentuated by the slightly more damaged state of the panel with

Saints Augustine and Peter. Nevertheless, it must be acknowledged that even after the publication of Pallucchini's general study of Venetian trecento painting (1964) and Muraro's important monograph on Paolo Veneziano (1970), there is still a great deal of uncertainty regarding the attribution and dating of paintings from this master's workshop.

The poses of three of the saints on the Chicago panels are comparable to others in the oeuvre of Paolo Veneziano and his workshop. The Saint John the Baptist resembles the same figure from a dismembered polyptych now in the Pinacoteca Tosio-Martinengo in Brescia, and Pallucchini (1955, 1964) compared this figure with the image of the saint on the polyptych of 1349 in the church of San Martino at Chioggia.[12] Saint Catherine of Alexandria recalls her counterpart on the polyptych in the Pinacoteca Comunale at San Severino, and the Saint Augustine, as Pallucchini observed, is akin to the figure of Saint Blaise on a polyptych once in the sacristy of the cathedral at Pirano.[13] The similarities among these paintings are of a general nature only, and they do not elucidate the problems of attribution or dating. Since the workshop made use of stock figures in different contexts, slight variations in dress, pose, and even a saint's attributes (as in the case of Saint Augustine) were inevitable.

Klesse (1967), in her important study of the silk textile patterns depicted in fourteenth-century Italian painting, confirmed the close connection of the present panels with Paolo Veneziano and his workshop. The motif appearing on the drapery of Saint Catherine of Alexandria is classified as rows of palmettes protruding from thin stems decorated with filigree work, while that on Saint Augustine's cope comprises palmettes placed between the four adjoining points of oval-shaped patterns. Both of these palmette motifs, ultimately derived from Chinese sources, were employed on numerous occasions by Paolo Veneziano and his assistants.[14]

Notes

1 John 1.29.
2 According to the Roerich Museum sale catalogue.
3 Harshe was listed as the buyer in the published results of the Roerich sale (*Art News* 28, 27 [1930], p. 31), but a letter from Harshe to Martin A. Ryerson of April 1, 1930 (Ryerson papers, Archives, The Art Institute of Chicago), and a receipt in curatorial files indicate that Harshe purchased the panel on behalf of Charles H. Worcester. The letter also implies that Ryerson too was interested in acquiring the panels.
4 A document in curatorial files dated October 11, 1945, indicates that this panel was owned by his wife, Mary F. S. Worcester.
5 See note 2.
6 According to Harshe's letter to Ryerson (see note 3).
7 Muraro 1970, pp. 131–34, pls. 21–22.
8 For the cover of the Pala d'Oro, see Muraro 1970, pls. 41–42; for the *Coronation of the Virgin*, see *The Frick Collection*, vol. 2, *Paintings: French, Italian, and Spanish*, New York, 1968, pp. 266–71 (ill.).
9 Letter to Robert B. Harshe of April 26, 1930, in curatorial files. Rich (1930) supported this attribution.
10 Muraro 1970, figs. 30–32, 163, 36–39, respectively. The present location of the Pirano polyptych is unknown.
11 For the polyptych in Bologna, see Muraro 1970, pls. 96–97; for the panels in Worcester, see *European Paintings in the Collection of the Worcester Art Museum*, Worcester, Mass., 1974, vol. 1, pp. 412–17, vol. 2, p. 634 (ill.), and Muraro 1970, pl. 105.
12 Muraro 1970, fig. 20, pl. 80, respectively.
13 Ibid., pl. 118, fig. 37, respectively.
14 Klesse 1967, pp. 65–66.

Pietro di Cristoforo Vannucci, called Perugino

1445/46 Città della Pieve–Fontignano 1523

FOUR PREDELLA PANELS WITH SCENES FROM THE LIFE OF CHRIST

The Adoration of the Christ Child, 1500/05
Mr. and Mrs. Martin A. Ryerson Collection, 1933.1025

Tempera on panel, transferred to canvas, 26.2 x 46.3 cm
(10⅝16 x 18¼ in.)

CONDITION: The painting is in good condition. It was
transferred from panel to canvas by Chapuy in 1893 and was
cleaned by Hughes at the same time.[1] Alfred Jakstas cleaned
it again in 1961. In general, the paint surface is in very good
condition, though in this picture and in the other three
scenes from the series in the Art Institute, the texture of the
present canvas support somewhat disrupts the delicacy of
the paint surface. Furthermore, the paint surfaces of all four
scenes are characterized by pronounced craquelure. In *The
Adoration of the Christ Child* there are minute paint losses
along the crackle pattern in the landscape beyond the shed
and in the sky just above the horizon; these losses have been
filled and the inpainting is now discolored. There are also
minute repairs in the Virgin's neck and Joseph's left sleeve.
Joseph's orange robe is somewhat abraded. The Virgin's
drapery is in excellent condition. Gold paint was used to pick
out the edges of the robes of the Virgin and Joseph and the
strands of the Virgin's hair (infrared, mid-treatment,
x-radiograph).

PROVENANCE: See below.

REFERENCES: See below.

EXHIBITIONS: See below.

The Baptism of Christ, 1500/05
Mr. and Mrs. Martin A. Ryerson Collection, 1933.1023

Tempera on panel, transferred to canvas, 27.3 x 46.4 cm
(10¾ x 18¼ in.)

CONDITION: The painting is in very good condition. Its
treatment history is the same as that of *The Adoration of the
Christ Child* (1933.1025). As in that picture, the transfer to
canvas somewhat disrupts the delicacy of the paint surface,
which is nevertheless in very good condition. There are
minute paint losses along the crackle pattern throughout the
picture and some larger areas of paint loss in the sky just
above the horizon. Inpainting in the lower portion of the sky
extends over original paint and is now discolored. The rest of
the landscape and the draperies are in fine condition. The

flesh tones are somewhat abraded, as is the top of Christ's
head. Gold paint was used to pick out the draperies of all the
figures except the angel immediately to the right of the
Baptist (infrared, x-radiograph).

PROVENANCE: See below.

REFERENCES: See below.

EXHIBITIONS: See below.

Christ and the Woman of Samaria, 1500/05
Mr. and Mrs. Martin A. Ryerson Collection, 1933.1024

Tempera on panel, transferred to canvas, 27.3 x 46.3 cm
(10¾ x 18¼ in.)

CONDITION: The painting is in very good condition.
Its treatment history is the same as that of *The Adoration of
the Christ Child* (1933.1025) and of *The Baptism of Christ*
(1933.1023). As in those pictures, the transfer to canvas
somewhat disrupts the delicacy of the paint surface, which
is in other respects well preserved. There is some abrasion
and discolored inpainting in the sky. The wheel of the well
pulley is also abraded, and there is a small area of paint loss
in the crook of Christ's right elbow. The draperies, particu-
larly those of the Samaritan woman, are in excellent condi-
tion. Gold paint was used in the robes of Christ and the
Samaritan woman and to pick out the strands of the woman's
hair (infrared, x-radiograph).

PROVENANCE: See below.

REFERENCES: See below.

EXHIBITIONS: See below.

Noli Me Tangere, 1500/05
Mr. and Mrs. Martin A. Ryerson Collection, 1933.1026

Tempera on panel, transferred to canvas, 27.3 x 46.3 cm
(10¾ x 18¼ in.)

CONDITION: The painting is in good condition. Its treat-
ment history is the same as that of the previous three panels.
As in those pictures, the transfer to canvas somewhat dis-

rupts the delicacy of the paint surface. There appears to have been slightly more movement in the original support of this painting than in the other three scenes; this is most evident in the foreground, where there are minor repairs. A crack extends horizontally just below Christ's knees. There is some abrasion and discolored inpainting in the sky just above the horizon. The angels in the tomb are quite abraded, as is the orange robe of the background figure second from the left. Otherwise the draperies are in good condition. The edges of the robes of Christ and the Magdalen were picked out in gold paint, as was the hair of the Magdalen (infrared, x-radiograph).

PROVENANCE: Alexander Barker, London, by 1852 to at least 1857.[2] Sold by Barker to William Ward (d. 1885), first Earl of Dudley, London, by 1868;[3] sold Christie's, London, June 25, 1892, nos. 76 (1933.1024), 77 (1933.1025), 79 (1933.1026), 80 (1933.1023), to Durand-Ruel, Paris and New York, acting on behalf of Martin A. Ryerson.[4] Sold by Durand-Ruel to Martin A. Ryerson (d. 1932), Chicago, 1893;[5] intermittently on loan to the Art Institute from 1893; bequeathed to the Art Institute, 1933.

REFERENCES: G. Waagen, *Treasures of Art in Great Britain*, vol. 2, London, 1854, p. 127. W. Bürger [T. Thoré], *Trésors d'art exposés à Manchester en 1857*, Paris, 1857, pp. 34–35. W. Bürger [T. Thoré], *Trésors d'art en Angleterre*, 3d ed., Paris, 1865, pp. 34–35. J. A. Crowe and G. B. Cavalcaselle, *A History of Painting in Italy from the Second to the Fourteenth Century*, vol. 3, London, 1866, pp. 250–51. J. C. Robinson, *A Critical Account of the Drawings by Michel Angelo and Raffaello in the University Galleries, Oxford*, Oxford, 1870, pp. 135–36, under no. 20. AIC 1898, p. 124, nos. 193–96. G. C. Williamson, *Pietro Vannucci, called Perugino*, London, 1903, p. 126. Berenson 1909, p. 218; 1932, p. 436; 1936, p. 374; 1968, vol. 1, p. 326. J. A. Crowe and G. B. Cavalcaselle, *A New History of Painting in Italy from the Second to the Sixteenth Century*, ed. by E. Hutton, vol. 3, London and New York, 1909, pp. 258, 259 n. 1. B. B[urroughs], "A Painting by Perugino," *Bulletin of The Metropolitan Museum of Art* 6, 6 (1911), p. 130. A. Venturi, vol. 7, pt. 2, 1913, p. 566 n. 1. AIC 1914, p. 208, nos. 2093–96. W. Bombe, *Perugino: Des Meisters Gemälde*, Klassiker der Kunst 25, Stuttgart and Berlin, 1914, p. 256. B. Burroughs, *The Metropolitan Museum of Art: Catalogue of Paintings*, New York, 1914, p. 205. J. A. Crowe and G. B. Cavalcaselle, *A History of Painting in Italy*, 2d ed., vol. 5, ed. by T. Borenius, New York, 1914, p. 365. AIC 1917, p. 165; 1920, p. 63; 1922, p. 72; 1923, p. 72. U. Gnoli, *Pietro Perugino*, Spoleto, 1923, p. 58. U. Gnoli, *Pittori e miniatori nell'Umbria*, Spoleto, 1923; reprinted 1980, p. 274. AIC 1925, p. 160, nos. 2065–68. A. McComb, "Francesco Ubertini (Bacchiacca)," *Art Bull.* 8 (1926), p. 150. *Ryerson Collection* 1926, pp. 48–52. F. Canuti, *Il Perugino*, Siena, 1931, vol. 2, p. 366. AIC 1932, p. 182. Valentiner [1932], n.

pag. Van Marle, vol. 14, 1933, pp. 396, 403, 406. D. C. Rich, "The Paintings of Martin A. Ryerson," *AIC Bulletin* 27 (1933), p. 12. R. Brimo, *Art et goût: L'Evolution du goût aux Etats-Unis d'après l'histoire des collections*, Paris, 1938, pp. 92, 180. K. T. Parker, *Catalogue of the Collection of Drawings in the Ashmolean Museum*, vol. 2, *Italian Schools*, Oxford, 1956, p. 21, under no. 31. E. Camesasca, *Tutta la pittura del Perugino*, Milan, 1959, pp. 112–13 (ill.). Bénézit, 2d ed., 1960, vol. 8, p. 473; 3d ed., 1976, vol. 8, p. 244. AIC 1961, p. 353. Huth 1961, p. 517. F. Zeri, "Appunti sul Lindenau-Museum di Altenburg," *Bollettino d'arte* 49 (1964), p. 52. M. Laclotte, *Le XVIe Siècle européen: Peintures et dessins dans les collections publiques françaises*, exh. cat., Paris, Musée du Petit-Palais, 1965–66, p. 14, under no. 18. C. Castellaneta and E. Camesasca, *L'opera completa del Perugino*, Classici dell'arte 30, Milan, 1969, p. 112, nos. 114 A–D. Maxon 1970, p. 251 (1933.1025 ill.). Fredericksen/Zeri 1972, pp. 161, 269, 277–78, 299, 571. D. Sutton, "Robert Langton Douglas, Part II," *Apollo* 109 (1979), p. 390. Zeri/Gardner 1980, pp. 59–61. Waterhouse 1983, p. 84. F. Gualdi Sabatini, *Giovanni di Pietro detto Lo Spagna*, Spoleto, 1984, pp. 297, 363. P. Scarpellini, *Perugino*, Milan, 1984, pp. 52, 113, no. 142, figs. 234–37. S. Ferino Pagden in *Die Kirchen von Siena*, ed. by P. A. Riedl and M. Seidel, vol. 1, pt. 1, Munich, 1985, p. 66 n. 87, under no. 8. F. Santi, *Galleria Nazionale dell'Umbria: Dipinti, sculture e oggetti dei secoli XV–XVI*, Rome, 1985, p. 111, under no. 93. F. Todini, *La pittura umbra dal duecento al primo cinquecento*, Milan, 1989, p. 264.

EXHIBITIONS: London, British Institution, 1852, nos. 31, 34–35, 45. Manchester, *Art Treasures of the United Kingdom*, 1857, nos. 83–85, 87. Leeds, *National Exhibition of Works of Art*, 1868, nos. 2905–07, 2909. London, Royal Academy of Arts, *Works of the Old Masters*, 1871, nos. 304, 308, 312, 327. London, Royal Academy of Arts, *Works by the Old Masters*, 1892, nos. 146–48, 155. The Art Institute of Chicago, *Selected Works of Old and Modern Masters*, 1898, nos. 9–12. The Art Institute of Chicago, *A Century of Progress*, 1933, nos. 123a–d. Chicago, South Side Community Art Center, *Exhibition of Religious Art*, 1942, no. 6 (1933.1023). Highland Park Library, Illinois, 1952 (1933.1023; no cat.). Canton, Ohio, The Art Institute, 1955 (1933.1025; no cat.).

Together with a painting of *The Resurrection* (fig. 1) in The Metropolitan Museum of Art in New York,[6] these four panels were originally placed in the predella of an altarpiece. All five pictures include identical borders painted in ochre, with the upper and left edges lined in black and the lower and right edges lined in white, simulating molded frames. The

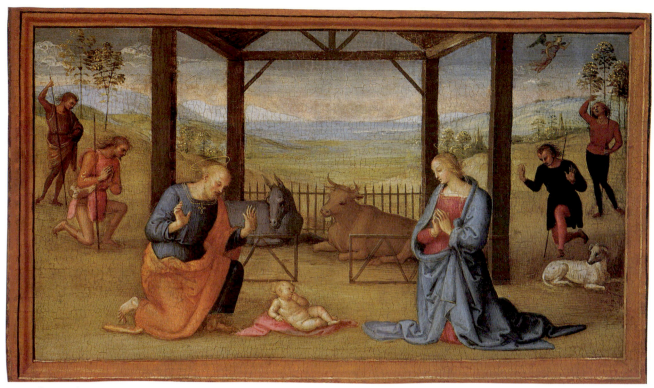

Pietro di Cristoforo Vannucci, called Perugino, *The Adoration of the Christ Child*, 1933.1025

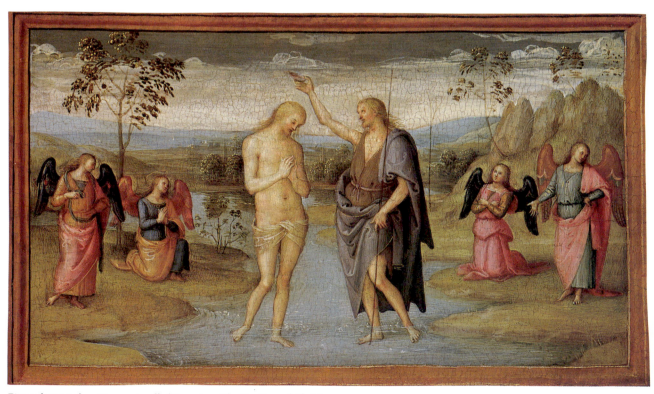

Pietro di Cristoforo Vannucci, called Perugino, *The Baptism of Christ*, 1933.1023

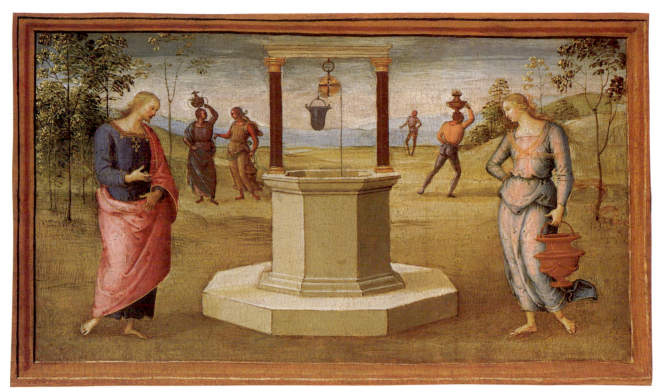

Pietro di Cristoforo Vannucci, called Perugino, *Christ and the Woman of Samaria*, 1933.1024

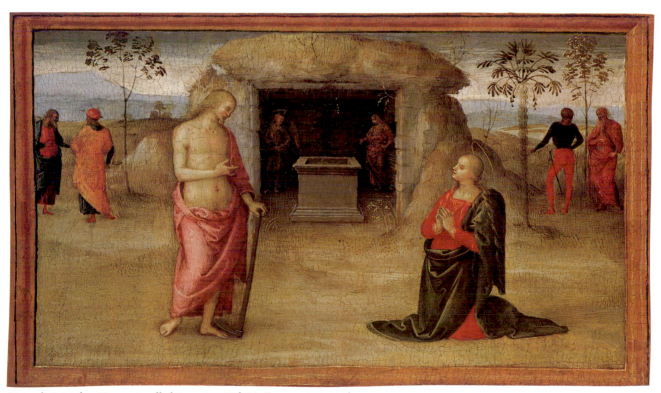

Pietro di Cristoforo Vannucci, called Perugino, *Noli Me Tangere*, 1933.1026

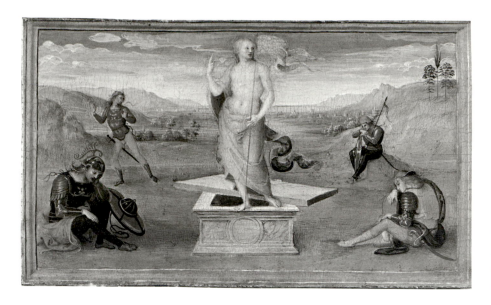

Fig. 1 Pietro di Cristoforo Vannucci, called Perugino, *The Resurrection*, The Metropolitan Museum of Art, New York, Frederick C. Hewitt Fund, 1911 (11.65)

argument advanced by Camesasca (1959, 1969), that *The Resurrection* dates from slightly earlier (1500/04) than the other panels (1510/15) and therefore comes from a different complex, has not been accepted.

While most writers have regarded the Chicago panels as autograph, some have expressed reservations. Both Bombe (1914) and Canuti (1931) questioned the attribution to Perugino; Gnoli (1923) thought the compositions had been designed by Perugino, but executed by assistants; Van Marle (1933) assigned them to the workshop; and Camesasca (1959) suggested the involvement of assistants in this project, especially for the *Noli Me Tangere*. With the exception of those in *The Baptism of Christ*, the subsidiary figures on the Chicago panels were probably executed by assistants; but the main figures, particularly in the handling of the draperies, are of high quality.

Perugino was the *caposcuola*, or leading master, of Perugia, but also practiced in Rome, Siena, and Florence, where, according to Vasari, he studied under Andrea del Verrocchio.[7] By the last two decades of the fifteenth century, his reputation was such that he received the important commissions to paint several frescoes in the Sistine Chapel (1481–82) and to decorate the Collegio del Cambio in Perugia (1496–1500).[8] His serene, polished style was very influential in both Tuscany and Umbria, and became a point of departure for his most famous student, Raphael.

The commission to which these predella panels belonged has been much debated. McComb (1926)

first noted the compositional relationship between *The Resurrection* in The Metropolitan Museum of Art and a panel of the same subject by Francesco Ubertini, known as Bacchiacca, in the Musée des Beaux-Arts in Dijon.[9] In 1980, Zeri and Gardner noted that another panel by Bacchiacca, in a private collection in Milan, is compositionally related to the *Noli Me Tangere* in Chicago. From these connections with the work of a Florentine artist, both Zeri (1964) and Laclotte (1965) deduced that the five predella panels in Chicago and New York must once have been part of an altarpiece in a Florentine church, possibly the one on which Perugino collaborated in the church of the Santissima Annunziata.

The history of the large, two-sided altarpiece in Santissima Annunziata is protracted. As recorded in the documents collected by Canuti (1931), the altarpiece was designed in 1500 by Baccio d'Agnolo, and Filippino Lippi was contracted to undertake the painting. Lippi began the work in 1503, but died in 1504, whereupon the commission passed to Perugino, who finished the task in 1507.[10] According to Vasari, who gave a good account of the history of the altarpiece based upon the reactions of older contemporaries such as Antonio Billi, there were complaints about the quality of Perugino's workmanship. The Servites clearly had high expectations for this project, as they had originally intended to give the commission to Leonardo da Vinci.[11] Of the main panels, *The Deposition of Christ* (Florence, Accademia, no. 8370), which was begun by Filippino Lippi and finished by

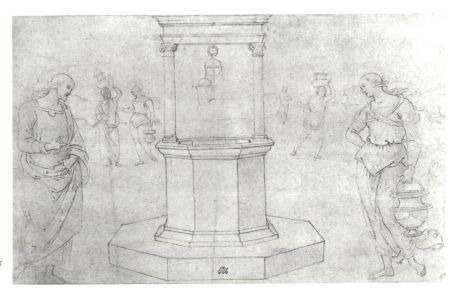

Fig. 2 Pietro di Cristoforo Vannucci, called Perugino, *Christ and the Woman of Samaria*, Ashmolean Museum, Oxford

Perugino, faced the nave, and *The Assumption of the Virgin*, which is still in the church, faced the choir.[12] Six pilaster panels have also been associated with the complex (Zeri/Gardner 1980), but no specific mention of a painted predella is made either in the documents, which include the original contract with Filippino Lippi,[13] or in the early sources. Insofar as Canuti's reconstruction is based upon the partial appearance of the altarpiece in a painting by Cristofano Allori dating from c. 1602,[14] the association of these five predella panels with the church of the Santissima Annunziata is unlikely.

Christiansen alternatively suggested that *The Resurrection* in New York, and by implication, the related panels as well, may have formed part of the altarpiece in the Chigi Chapel in the church of Sant'Agostino in Siena, which was commissioned from Perugino in 1502 and completed in 1506.[15] The main panel of *Christ on the Cross and Saints Augustine, Monica, the Virgin, John the Evangelist, John the Baptist, Jerome, and Two Kneeling Female Saints*, which is still in the church of Sant'Agostino, measures 400 x 289 cm.[16] There was certainly a predella, but the subjects of the scenes are not recorded, and it had apparently been removed from the church by 1755. The combined width of the five known predella panels in Chicago and New York, not allowing for framing elements, is 229.7 cm. However, Silvia Ferino Pagden (1985) expressed doubts about the association of these five panels with the Sant'Agostino altarpiece, since that complex was

originally surmounted by a terracotta statue of the resurrected Christ, and it is unlikely that the altar ensemble would have included two depictions of the same subject.[17] Moreover, it seems that the measurements of the panels in Chicago and New York are different from those of the Sant'Agostino predella panels, or at least from those of copies of the panels which are documented in the archives of the Chigi family, the patrons of the altarpiece.[18] The copies were apparently taller but not as long as the Chicago panels. Based on the dimensions recorded in the Chigi archives, Ferino Pagden concluded that the Sant'Agostino predella originally contained seven scenes.[19]

In all of the Art Institute panels except *The Adoration of the Christ Child*, the pose of the figure of Christ is repeated with only slight changes in the positioning of the hands and the angle of the head. There is a preparatory drawing by Perugino for *Christ and the Woman of Samaria* in the Ashmolean Museum, Oxford (fig. 2).[20] The technique of the drawing is described by Parker (1956) as black chalk with incised outlines and auxiliary perspective lines plotted by pinpointing. Its verso has been blackened, indicating that the drawing was used for transferring the design, probably onto the cartoon. This is confirmed by the fact that the figures in the drawing have exactly the same dimensions as those in the Art Institute's picture.

Although the destination of the predella scenes remains uncertain, all authorities have agreed in

dating them shortly after 1500, except Gnoli (1923) and Camesasca (1969), who suggested a date as late as 1515. The composition of *The Adoration of the Christ Child* was used again with some changes in 1513 for the predella of the altarpiece in the church of Santa Maria at Corciano near Perugia.[21] *The Baptism of Christ* in Chicago and *The Resurrection* in New York are compositionally related to the relevant panels in the predella (Rouen, Musée des Beaux-Arts) of an altarpiece of 1495–98 once in the church of San Pietro in Perugia.[22] Perugino may have regarded the compositions used in these predellas as smaller versions of large-scale works. Thus, *The Adoration of the Christ Child* is comparable with the frescoes in the Collegio del Cambio in Perugia, those for the church of San Francesco a Monteripido in Perugia (now in the Galleria Nazionale dell'Umbria, Perugia), and those in San Francesco at Montefalco (near Perugia).[23] *The Baptism of Christ* can be compared not only with the large compositions in the Sistine chapel, but also with the fresco of c. 1507 in the Chiesa della Nunziatella, Foligno.[24]

NOTES

1 According to a letter from Georges Durand-Ruel to Martin A. Ryerson of September 22, 1893 (Archives, The Art Institute of Chicago). *The Resurrection* (fig. 1; New York, The Metropolitan Museum of Art) is the only painting from this series of predella panels to retain its original support.

2 Barker loaned the panels for exhibitions in 1852 and 1857. See A. Graves, *A Century of Loan Exhibitions, 1813–1912*, vol. 2, London, 1913; reprinted New York [1968], p. 917.

3 According to the catalogue of the 1892 Dudley sale and W. Roberts, *Memorials of Christie's: A Record of Art Sales from 1766 to 1896*, London, 1897, vol. 2, p. 197, the Earl of Dudley had purchased these paintings, as well as *The Resurrection* (see note 1), from Alexander Barker. Both Barker and Dudley were among the foremost collectors of Italian art in nineteenth-century England. The Earl of Dudley is documented as the owner of the panels in the catalogue for the 1868 exhibition at Leeds.

4 Letters from Durand-Ruel to Ryerson dated June 25 and 29, 1892, indicate that Durand-Ruel purchased the paintings specifically for Ryerson (Archives, The Art Institute of Chicago). *The Resurrection* was separated from the other four panels at this sale, but there has never been any reasonable doubt that all five panels came from the same predella. *The Resurrection*, no. 78 at the Dudley sale, was purchased by Agnew (according to a letter from Durand-Ruel to Ryerson of June 25, 1892, cited above; see also A. Graves, *Art Sales from Early in the Eighteenth Century to Early in the Twentieth Century*, vol. 2, London, 1921, p. 318, and H. Mireur, *Dictionnaire des ventes d'art faites en France et à l'étranger pendant les XVIIIe et XIXe siècles*,

Paris, 1912, vol. 7, p. 283). Gnoli (1923) and Canuti (1931), perhaps misled by Borenius's note in the second edition of Crowe and Cavalcaselle (1914), persistently declared in error that the four pictures in the Art Institute were in The Metropolitan Museum of Art.

5 Although correspondence from Durand-Ruel to Ryerson from the day of the sale indicates that the dealer had bought the paintings for Ryerson (note 4), the bill of sale was not issued until April 8, 1893 (Archives, The Art Institute of Chicago).

6 Zeri/Gardner 1980, pp. 59–61 (ill.), measuring 27 x 45.7 cm.

7 Vasari, *Vite*, Milanesi ed., vol. 3, p. 568.

8 Scarpellini 1984, p. 153, fig. 44, p. 219, fig. 162.

9 M. Guillaume, *Catalogue raisonné du Musée des Beaux-Arts de Dijon: Peintures italiennes*, Dijon, 1980, p. 5, no. 8 (ill.).

10 Canuti 1931, vol. 2, pp. 241–48.

11 Vasari, *Vite*, Milanesi ed., vol. 3, pp. 585–87; see also C. von Fabriczy, ed., *Il libro di Antonio Billi*, Florence, 1891; reprinted 1969, pp. 329, 352 n. 144.

12 Scarpellini 1984, p. 266, figs. 239–40. The altarpiece was already being modified as early as 1546 (Canuti 1931, vol. 2, p. 251, no. 410), and was further tampered with in 1566 (ibid., p. 252, no. 412). The remaining elements were dispersed during the second half of the seventeenth century (ibid., p. 252, no. 413).

13 Canuti 1931, vol. 2, pp. 243–44, no. 393.

14 For the reconstruction, see Canuti 1931, vol. 1, p. 187. For an illustration of Allori's painting *The Blessed Manetto Healing a Cripple* (Florence, Santissima Annunziata), see G. Cantelli, *Repertorio della pittura fiorentina del seicento*, Fiesole, 1983, figs. 1–2.

15 K. Christiansen, "Early Narrative Painting in Italy," *The Metropolitan Museum of Art Bulletin* 41, 2 (1983), pp. 31–32, and letter to the author of February 6, 1984, in curatorial files. For the documents regarding Perugino's work on this project, see Canuti 1931, vol. 1, pp. 182–84; vol. 2, pp. 239–41, nos. 384–87, pp. 346–47. Scarpellini (1984), who apparently did not know of Christiansen's publication, kept an open mind regarding the panels' original location, remarking that the altarpiece to which they belonged could not be identified with any certainty, but that they may have been associated with either Santissima Annunziata or the Chigi Chapel in Sant'Agostino.

16 Canuti 1931, vol. 1, pl. CXXXV; Scarpellini 1984, p. 263, fig. 233.

17 Ferino Pagden 1985, vol. 1, pt. 1, pp. 66, 67 n. 93; vol. 1, pt. 2, figs. 139–40.

18 Ibid., vol. 1, pt. 1, pp. 65–66. Ferino Pagden noted that the inventories of c. 1650 and 1744 of the Chigi Villa alle Volte mention copies (now lost) after three predella panels from Sant'Agostino, giving the measurements of each as one-half *braccio* high and two-thirds *braccio* in length, which translates to approximately 29 x 38 cm.

19 Ibid.

20 Parker 1956, pp. 20–21, no. 31. The drawing measures 231 x 374 mm.

21 Scarpellini 1984, fig. 271.

22 Ibid., figs. 131, 133.

23 Ibid., figs. 162, 212, 216.

24 Ibid., figs. 44, 256.

Jacopo Carrucci, called Pontormo

1494 Pontormo, near Empoli–Florence 1557

Alessandro de' Medici, 1534/35

Mr. and Mrs. Martin A. Ryerson Collection, 1933.1002

Oil on panel, 35.3 x 25.8 cm (13⅞ x 10⅛ in.); painted surface: 31.4 x 25.8 cm (12⅜ x 10⅛ in.)

CONDITION: The painting is in fair condition. It was cleaned in 1961 by Louis Pomerantz, who removed overpaint in the background, and in 1987 by Frank Zuccari. The panel, which is composed of a single board with vertical grain, has been thinned and cradled. The original support was extended at the top and bottom by added strips of 1 cm and 1.5 cm, respectively. At the top, the original paint surface stops approximately 2.5 cm from the present edge of the support. The sides have been trimmed. The condition of the paint surface is compromised by past cleaning processes, which have broken through the upper paint layers. Both the face and background have been abraded by overcleaning, which has disturbed the complex, multilayered painting technique. In the background, a fine network craquelure exposes the light ground through the paint layer. The armor is very well preserved, however. A small black cap with a streamer hanging down to the left of the face is visible as a *pentimento*. Under the microscope it is evident that the cap lies under the gray background layer. It was apparently painted out by the artist and the brown curly hair was extended over the cap. Similarly, the red ruffle of the sitter's doublet was painted over the white shirt. A lattice of horizontal and diagonal incisions extending across the entire panel is visible in raking light and in the x-radiograph (fig. 1). Infrared reflectography shows that the face is underdrawn in what appears to be charcoal or chalk. Repeated lines at the lips and eyes suggest the artist's effort to establish and simplify the contours of these features (fig. 2). In addition, what appear to be fine stylus marks are visible in raking light along the contours of the eyes, on the proper right side of the face and nose, and at the bottom of the lower lip (infrared, infrared reflectography, mid-treatment, ultraviolet, x-radiograph).

PROVENANCE: Probably Cosimo I de' Medici (1519–1574), Florence.[1] William Ward (d. 1885), first Earl of Dudley, London; sold Christie's, London, June 25, 1892, no. 46, as Giovanni Bellini, for £180, to Durand-Ruel, Paris and New York, acting on behalf of Martin A. Ryerson.[2] Martin A. Ryerson (d. 1932), Chicago, from 1892; on loan to the Art Institute from 1930; bequeathed to the Art Institute, 1933.

REFERENCES: G. Frizzoni, *La Galleria Morelli in Bergamo*, Bergamo, 1892, p. 19. A. McComb, *Agnolo Bronzino: His Life and Works*, Cambridge, Mass., 1928, pp. 44, 137. Berenson 1932, p. 114; 1936, p. 98; 1963, vol. 1, p. 41. Valentiner [1932], n. pag. AIC 1961, p. 226. Fredericksen/Zeri 1972, pp. 168, 515, 571. E. Baccheschi, *L'opera completa del Bronzino*, Milan, 1973, p. 108, no. 145a (ill.). K. Langedijk, *The Portraits of the Medici, 15th to 18th Centuries*, vol. 1, Florence, 1981, p. 223, no. 10d. Waterhouse 1983, pp. 84, 86.

EXHIBITIONS: Art Gallery of Toronto, *Italian Old Masters and German Primitives*, 1931, no. 26, as Bronzino. Muskegon, Michigan, Hackley Art Gallery, *Italian Paintings in the Loan Collection from Mr. Martin A. Ryerson*, M. Knoedler and Company, E. and A. Silberman, 1932, no. 6, as Bronzino. Milwaukee Art Museum, *The Detective's Eye: Investigating the Old Masters*, 1989, no. 33.

Pontormo was the principal innovator of Mannerism in Florence. Trained by Andrea del Sarto and strongly influenced by Michelangelo, he developed a style that, in its drawing, color, and perspective, transcended the framework of the High Renaissance. Northern prints were also important to him. Pontormo's output included altarpieces, fresco cycles, and secular decorative works, as well as portraits notable for their psychological insight into the character of the sitter. His melancholic temperament, revealed in the diary he kept during the last two years of his life, almost certainly nurtured the more expressive and experimental aspects of his style. Pontormo was employed by the Medici from c. 1518.

The subject of this portrait is Alessandro de' Medici (1511/12–1537), son of Pope Clement VII and first duke of Florence. In 1536 Alessandro married Margaret of Austria, the daughter of Charles V; a year later he was murdered by Lorenzino de' Medici. At the time of the Earl of Dudley's sale in 1892, the portrait was loosely ascribed to Giovanni Bellini.[3] On

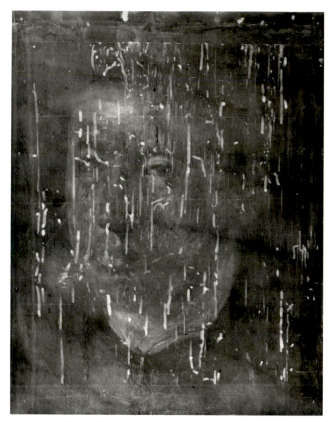

Fig. 1 X-radiograph of *Alessandro de' Medici*, 1933.1002

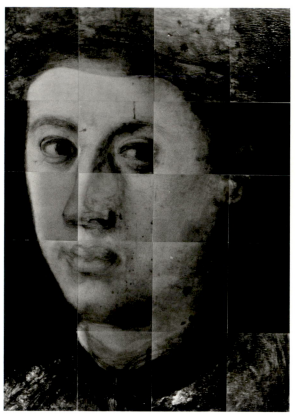

Fig. 2 Infrared reflectogram assembly of detail of *Alessandro de' Medici*, 1933.1002 [infrared reflectography: Carl A. Basner and Martina A. Lopez]

viewing the picture in 1930, Van Marle suggested the name of Andrea del Sarto.[4] More usually in the literature, however, the portrait has been associated with the name of Bronzino. Frizzoni (1892) was the first to connect the painting with this artist, regarding it as a copy after the portrait once in Giovanni Morelli's collection in Bergamo and now in the Accademia Carrara.[5] McComb (1928), Berenson (1932), and Valentiner (1932) then proposed an attribution to Bronzino himself.[6] Baccheschi (1973) placed the portrait only in the circle of Bronzino. The Art Institute's 1961 catalogue of paintings resigned itself simply to the general attribution, Italian school, sixteenth century.

Karla Langedijk's research (1981) on the portraits of the Medici allows more specific conclusions. The most relevant of several portraits of Alessandro de' Medici is the three-quarter-length portrait by Pontormo (fig. 3) in the John G. Johnson Collection of the Philadelphia Museum of Art.[7] This picture in all

probability dates to 1534/35 on account of the mourning worn by the sitter for the death of his natural father, Pope Clement VII (Giulio de' Medici). According to Vasari, Pontormo made a smaller portrait in preparation for the more formal portrait now in Philadelphia. The relevant passage in Vasari reads in full as follows:

> Avendo Iacopo, dopo le già dette opere, ritratto di naturale in un quadro Amerigo Antinori, giovane allora molto favorito in Fiorenza, ed essendo quel ritratto molto lodato da ognuno, il duca Alessandro avendo fatto intendere a Iacopo che voleva da lui essere ritratto in un quadro grande; Iacopo, per più commodità, lo ritrasse per allora in un quadretto grande quanto un foglio di carta mezzana, con tanta diligenza e studio, che l'opere de' miniatori non hanno che fare alcuna cosa con questa; perciocché, oltre al somigliare benissimo, è in quella testa tutto quello che si può disiderare in una rarissima pittura: dal quale quadretto, che è oggi in guardaroba del duca Cosimo, ritrasse poi Iacopo il medesimo duca in un

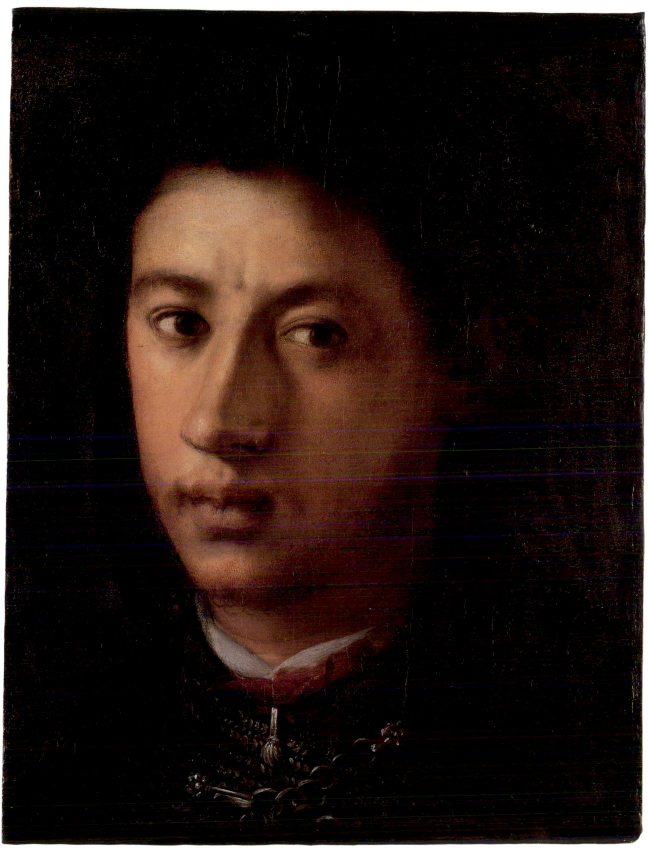

Jacopo Carrucci, called Pontormo, *Alessandro de' Medici*, 1933.1002

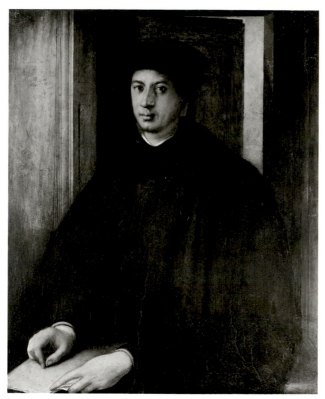

Fig. 3 Jacopo Carrucci, called Pontormo, *Alessandro de' Medici*, Philadelphia Museum of Art, John G. Johnson Collection of Philadelphia

quadro grande, con uno stile in mano disegnando la testa d'una femina: il quale ritratto maggiore donò poi esso duca Alessandro alla Signora Taddea Malespina, sorella della marchesa di Massa.[8]

The identification of the portrait in Philadelphia (now somewhat worn) is confirmed by Vasari's description of the sitter as in the act of drawing the head of a woman.

Langedijk pointed out that it was the smaller portrait that was most widely copied, principally, it would seem, in Bronzino's workshop, in the manner of the series of portrait miniatures of members of the Medici family, portraits that often show Alessandro dressed in a coat of mail and a doublet. A portrait of this type is included in a series of small (approx. 15 x 12 cm) portraits on tin of Duke Cosimo's ancestors and family that were commissioned from Bronzino after 1551 and are preserved in the Uffizi.[9] Langedijk concluded that the smaller portrait was lost and provided a long, though not exhaustive, list of the copies and derivations from it.[10]

The portrait in Chicago depicts the sitter wearing a coat of mail with a doublet and, more significantly, presents ample visual evidence that the figure once wore a *cappuccio*. Thus, the mode of dress relates the panel to the main portrait in Philadelphia, to the study for it presumed lost but recorded in numerous copies, and to the miniature dynastic portrait painted in Bronzino's workshop. This ambiguity prompted the recent technical examination of the portrait, which even in its uncleaned state could be seen to resemble more closely Pontormo's style of building up the surface of the face with several thinly applied layers of paint than Bronzino's hard and highly polished finish. The examination and subsequent treatment of the portrait (see Condition for a full account) confirmed the quality of the technique, which is demonstrated not only in the face but also in the treatment of the soft pliant curls of hair that frame the forehead and the wisps of an incipient beard. The contrast between the loose, evocative handling of the face and the crisp, highly articulate rendering of the coat of mail (particularly the clasp) is marked. By making such a contrast the artist heightened the portrait's psychological import, which is again characteristic of Pontormo. Also corroborating the attribution to Pontormo are the diagonal stylus incisions on the panel (see Condition). When transferring designs from sheet to sheet or from cartoon to support, Pontormo frequently drew diagonals, in lieu of or in addition to the more common procedure of squaring.[11]

Both the quality of the brushwork and the compositional changes, effected, it is now apparent, by the artist himself, suggest that the portrait in Chicago is the smaller of the two Pontormo painted of Alessandro de' Medici.[12] Vasari's description implies that the smaller portrait was made in preparation for the larger one now in Philadelphia. The changes evident in the Chicago portrait comply with the nature of a preparatory work, while the style is directly comparable with what is known of Pontormo's portraiture in his search for a deeper insight into character. It has to be admitted that the painting has suffered from abrasion, but enough of the original surface has been preserved for the high quality of the portrait to be discernible. Sydney Freedberg and Janet Cox-Rearick have agreed with this conclusion, the

latter noting that if the Chicago picture is the *quadretto* mentioned by Vasari, then it has been cut down, since Vasari described that painting as having the same dimensions as *un foglio di carta mezzana*, a standard size of paper, which measured 51.5 x 37.5 cm.[13] This, she added, would account for the cramped space around the bust in the panel. She went on to point out that there are a number of copies of the portrait that approximate the dimensions given by Vasari, also indicating that the Chicago panel was cut down.[14]

Cox-Rearick plausibly suggested that the alterations in the costume of Alessandro in the Chicago panel can be explained by the special circumstances of its commission when Alessandro was in mourning for Clement VII (who died in 1534). Cox-Rearick hypothesized that, after many years had passed, "when the event to which this costume alludes would not have any meaning for Duke Cosimo, he may have asked Pontormo (or, if after Pontormo's death in 1557, an artist of his circle, perhaps even Bronzino) to change the costume to something less funereal and more appropriate."[15] She believed that this altered picture would then have been used as a model by Bronzino's workshop between 1553 and 1568.

Notes

1 See Vasari, *Vite*, Milanesi ed., vol. 6, p. 278. As Langedijk (1981) noted, no sixteenth-century inventory of the Guardaroba seems to mention this portrait, despite Vasari's assertion that it was in Cosimo's Guardaroba. Langedijk suggested that "it may possibly have been installed in a Medici residence not covered by the Guardaroba inventories" (Langedijk 1981, p. 223).

2 According to annotated copies of Christie's sale catalogue (Ryerson Library, The Art Institute of Chicago, and Christie's, London) and a letter from Durand-Ruel to Ryerson of June 25, 1892 (Ryerson papers, Archives, The Art Institute of Chicago). Durand-Ruel noted that he bid £30 more than the price stipulated by Ryerson "on the advice of Mr. Warneck, who was sitting next to us."

3 Durand-Ruel, however, referred to the portrait as a Bronzino in his letter to Ryerson written on the day of the Dudley sale (see note 2). Interestingly, the copy of the sale catalogue at Christie's, London, is annotated by a contemporary hand crossing through the attribution to Giovanni Bellini and writing Bronzino instead (as is true for the Ryerson Library copy; see note 2). The same hand has also crossed through the printed title *Head of a Man* and added Alessandro de' Medici.

4 According to a letter from Daniel Catton Rich to Ryerson of January 13, 1930, in the Ryerson papers, Archives, The Art Institute of Chicago.

5 F. Rossi, *Accademia Carrara, Bergamo: Catalogo dei dipinti*, Bergamo, 1979, pp. 113–14, 120 (ill.).

6 Yet, according to Sydney Freedberg (letter to Martha Wolff of May 29, 1989, in curatorial files), the photograph in the Berenson Fototeca at Villa I Tatti is listed under "Bronzino (?)" but filed with Pontormo. On the back, in Berenson's hand, is the note, "This looks like the original from which the miniature in the Uffizi was taken." The assistance and interest of Sydney J. Freedberg and Janet Cox-Rearick are gratefully acknowledged.

7 Langedijk 1981, fig. 1.11, with earlier bibliography, and, more recently, C. B. Strehlke, "Pontormo, Alessandro de' Medici and the Palazzo Pazzi," *Philadelphia Museum of Art Bulletin* 81, 348 (1985), pp. 3–15, where new technical information on the portrait in Philadelphia is published. Two other portraits of Alessandro by Pontormo survive: a painting of c. 1525 in the Pinacoteca, Lucca, which scholars have connected with a work commissioned by Ottaviano de' Medici (see J. Cox-Rearick, *The Drawings of Pontormo: A Catalogue Raisonné with Notes on the Paintings*, rev. ed., New York, 1981, vol. 1, pp. 232–34, vol. 2, fig. 218, although Langedijk did not accept this as a portrait of Alessandro); and a black chalk drawing of the bust of Alessandro in profile in the Biblioteca Marucelliana, Florence (Langedijk 1981, p. 229, no. 1.19 [ill.]). A red chalk copy of a lost Pontormo drawing of Alessandro is in the Rijksmuseum, Amsterdam (see Cox-Rearick 1981 [cited above], vol. 1, p. 359, no. AI, and Langedijk 1981, p. 228, no. 1.18 [ill.], as Pontormo).

8 Vasari (note 1). "Jacopo having executed after the works described above a picture with the portrait from life of Amerigo Antinori, a young man much beloved in Florence at that time, and that portrait being much extolled by everyone, Duke Alessandro had him informed that he wished to have his portrait taken by him in a large picture. And Jacopo, for the sake of convenience, executed his portrait for the time being in a little picture of the size of a sheet of half-folio, and with such diligence and care, that the works of the miniaturists do not in any way come up to it; for the reason that, besides its being a very good likeness, there is in that head all that could be desired in the rarest of paintings. From that little picture, which is now in the guardaroba of Duke Cosimo, Jacopo afterwards made a portrait of the same Duke in a large picture, with a style in the hand, drawing the head of a woman; which larger portrait Duke Alessandro afterwards presented to Signora Taddea Malespina, the sister of the Marchesa di Massa" (G. Vasari, *Lives of the Most Eminent Painters, Sculptors and Architects*, tr. by G. Du C. de Vere, New York, 1979, vol. 2, p. 1534).

9 Langedijk 1981, pp. 75, 222–23, fig. 1.6. The Uffizi painting is not one of the nine listed in a Medici inventory of 1553 (Langedijk 1981, p. 385, no. 6), but would have been among the complete set mentioned by Vasari in 1568 (Vasari, *Vite*, Milanesi ed., vol. 7, p. 603).

10 J. Cox-Rearick, *Dynasty and Destiny in Medici Art: Pontormo, Leo X, and the Two Cosimos*, Princeton, 1984, p. 245 n. 41, suggested that the likeness of Alessandro de' Medici in the lost triple portrait of Clement VII, Ippolito, and Alessandro de' Medici by Battista Franco, dating from shortly after 1537, may have been based on the smaller of

the two portraits mentioned by Vasari.

11 Diagonal guidelines appear in drawings by Pontormo, such as the *Study of a Bending Figure* (Cox-Rearick 1981 [note 7], vol. 2, fig. 258, Uffizi no. 6536F) for the Santa Felicita *Deposition*, and, incised with stylus, in his portrait of Monsignor della Casa in the National Gallery of Art, Washington, D.C. (illustrated in Luciano Berti, *L'opera completa del Pontormo*, Milan, 1973, pl. LXIV).

12 As noted by Janet Cox-Rearick, who also considered the Chicago portrait to be Pontormo's lost portrait of the duke, it must have been altered before 1568, since it also served as the basis for the Bronzino workshop miniature (letter to Martha Wolff of December 15, 1991, in curatorial files).

13 Freedberg's comments (letter cited above, note 6) are based on his study of mid-treatment and post-treatment photographs of the picture. Cox-Rearick's opinion (letter cited above, note 12) is based on examination of the actual painting on November 8, 1991, in the paintings conservation laboratory of the Art Institute.

14 See letter from Cox-Rearick cited above, note 12, and Langedijk 1981, pp. 223–24, no. 10. Physical examination indicates that the panel has been trimmed, though it is not possible to determine how much (see Condition).

15 See letter cited above, note 12.

Workshop of Jacopo Carrucci, called Pontormo

1494 Pontormo, near Empoli–Florence 1557

Virgin and Child with the Young Saint John the Baptist, 1527/30

Charles H. and Mary F. S. Worcester Collection, 1963.206

Oil on panel (poplar), 81.6 x 57.4 cm (32⅛ x 22⅝ in.)

CONDITION: The painting is in fair condition. It was cleaned by Alfred Jakstas in 1963. The panel is composed of two boards joined vertically approximately 27 cm to the left of center. It is 3.2 cm thick and is supported by two wooden crossbars dovetailed into the wood near the top and bottom. A vertical split runs through the Virgin's left cheek and extends into her neck. In considering the condition of the painting, it should be borne in mind that the surface was apparently left unfinished. The best-preserved parts are the right side of the Virgin's face and her right shoulder and arm, which are also the most fully worked-up parts. The paint surface is nevertheless somewhat abraded throughout, especially on the left side of the Virgin's face, her left hand, and in the shadowed areas of the face and body of the Christ Child. All the figures have suffered in a minor way from scattered damage and small paint losses, but only the proper left cheek and temple of the Christ Child have been severely damaged. There is some inpainting in the background, particularly in the upper right corner where the support is very uneven. Infrared reflectography reveals that the composition is underdrawn with a fine contour line in what appears to be chalk or charcoal (fig. 1). In some areas, such as the legs and stomach of the Christ Child and the left hand of the Virgin, the line is repeated with slight adjustments (infrared, infrared reflectogram, mid-treatment, ultraviolet, x-radiograph).

PROVENANCE: Sestieri, Rome; sold to Colnaghi, London, 1962.[1] Purchased from Colnaghi by the Art Institute through the Charles H. and Mary F. S. Worcester Endowment, 1963.

REFERENCES: Maxon 1970, p. 254 (ill.). K. W. Forster, "A Madonna by Maso da San Friano," *AIC Museum Studies* 7 (1972), pp. 34–51, figs. 1, 4, 6, 13. Fredericksen/Zeri 1972, pp. 168, 336, 571. C. Gould, *National Gallery Catalogues: The Sixteenth-Century Italian Schools*, London, 1975, p. 87. V. Pace, "Maso da San Friano," *Bollettino d'arte* 61 (1976), p. 91. A. Matteoli, "Una S. Famiglia di Maso da S. Friano," *Mitteilungen des Kunsthistorischen Institutes in Florenz* 29 (1985), p. 394.

EXHIBITIONS: The Art Institute of Chicago, *The Art of the Edge: European Frames, 1300–1900*, 1986, no. 6.

A version of this composition, also on panel and virtually identical in size, is in The National Gallery in London (fig. 2).[2] Forster (1972) rightly concluded from the technical evidence afforded by x-radiography and infrared photography that both paintings were made in the same workshop from the same cartoon. Changes in the position of the Virgin's thumb in relation to the Christ Child's lower lip, for example, are common to both pictures, while the papillary

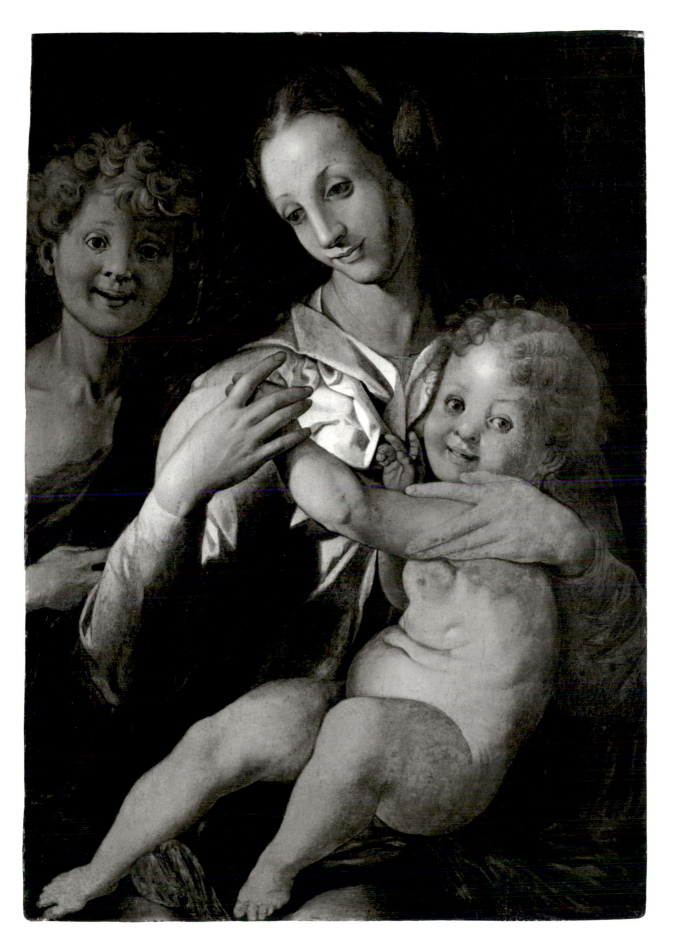

traces of the artist's fingers on both panels suggest that the same artist carried out the work.[3] There can be little doubt, however, that the painting in London has been brought to a higher degree of finish and is better preserved. This is particularly apparent in the handling of the folds of the drapery. As a result, that particular version appears to be of higher quality. The panel in Chicago has suffered from abrasion, but it also seems to have been left unfinished, since it is deficient in modeling and lacks the final glazes. The chiaroscuro is, therefore, less evenly distributed in the present painting and the outlines remain more prominent. Even so, this essential difference in finish does not necessarily mean that the panels are by separate hands.

The attribution and dating of the paintings in Chicago and London are unsettled. Forster (1972) argued in favor of an attribution to Maso da San Friano for the panel in Chicago with a tentative date in the 1560s, but Fredericksen and Zeri (1972) suggested an earlier artist, namely Pontormo. Gould initially ascribed the panel in London to Pontormo,[4] but later (1975) felt that such an attribution was not totally convincing and so modified it to "Florentine school" with a tentative date in the early 1520s, raising the possibility of Bronzino's involvement. Pace (1976) rejected Forster's suggestion of Maso da San Friano and extended Gould's hypothesis of Bronzino's involvement to include the panel in Chicago. It is surely true that Forster's attribution to Maso da San Friano cannot be upheld, although Matteoli (1985) has recently concurred. Comparisons with the equally unfinished, but larger, panel of a similar subject by Maso in Oxford (Ashmolean Museum) or with the more closely related in size, but more suavely painted, *Virgin and Child with the Young Saint John the Baptist and Two Angels* in Birmingham (City Museum and Art Gallery) reveal several differences in facture, drawing, and physiognomy.[5]

The composition is indeed, as Forster (1972) expressed it, "uncommonly rich in resonances of the historical development of Italian Renaissance painting." The same writer demonstrated the compositional links with Andrea del Sarto and Pontormo, as well as with certain quattrocento artists. Thus, the figure of Saint John the Baptist was related to his counterpart in Andrea del Sarto's tabernacle fresco

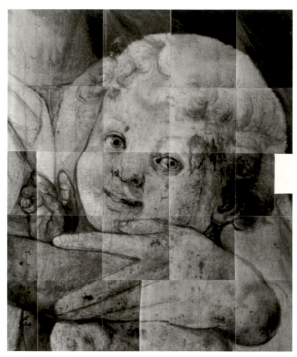

Fig. 1 Infrared reflectogram assembly of detail of *Virgin and Child with the Young Saint John the Baptist*, 1963.206 [infrared reflectography: Carl A. Basner and Martina A. Lopez]

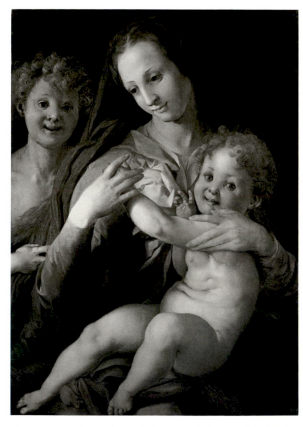

Fig. 2 Jacopo Carrucci, called Pontormo, *Virgin and Child with the Young Saint John the Baptist*, The National Gallery, London [photo: courtesy of the Trustees, The National Gallery, London]

of the *Madonna of Porta Pinti*, now only known through numerous copies, and the poses of the Virgin and Christ Child were compared with Pontormo's *Capponi Tondo* (c. 1527/28; Florence, Count Ferrante Capponi).[6] These are not direct quotations, since in the present composition the figure of Saint John the Baptist is placed to the left rather than to the right of the Virgin, and the pose of the Christ Child is reversed. Forster (1972) also drew attention to the foreshortening of the group which is seen slightly from below and is dependent upon paintings such as Pontormo's *Virgin and Child with the Young Saint John* in the Uffizi (1527/28).[7] The affinities with works dating from the quattrocento are limited to the pose of the Christ Child and involve the half-hidden gesture of blessing, which Forster compared with compositions by Luca della Robbia, Filippo Lippi, and Desiderio da Settignano.[8] The redeployment of these particular motifs, however, was associated by Forster with Florentine art of the second half of the sixteenth century, at that moment when Mannerist painters were once more reassessing the significance of artists of the High Renaissance such as Andrea del Sarto and Fra Bartolommeo.

Yet, the prototypes that Forster proposed, including those in Pontormo's work, were all directly available to a young artist coming to maturity during the later 1520s when the composition of the panels in London and Chicago should be more properly dated. Gould (1975) rightly emphasized the similarities with the types found in Pontormo's paintings, namely the possibility that the same youthful model was used both for the crouching bearer in the foreground of Pontormo's altarpiece of *The Deposition* (c. 1526–28) in the church of Santa Felicita in Florence and for the Virgin in the composition under discussion.[9] Similarly, the other bearer on the left of *The Deposition* has a facial likeness to Saint John the Baptist. Insofar as the kinship with Pontormo is so striking, it is more than probable that the present composition was evolved in his workshop.

Although it is possible, as Gould (1975) suggested, that Bronzino could have been involved in the execution of the Chicago picture, this seems, on the basis of the visual evidence, unlikely. Bronzino very noticeably asserted his own artistic personality in other paintings he produced in the mid- to late 1520s following Pontormo's drawings or cartoons, such as the *Madonna Enthroned* (c. 1525) in the Uffizi and the ceiling tondi of *Saint Luke* and *Saint Mark* (1525/28) in the Capponi Chapel of Santa Felicita.[10] Those pictures show a subtle reworking of Pontormo's physiognomies which is not found in the present work. Despite the fact that Vasari specifically mentioned only Bronzino as working in Pontormo's shop during the later 1520s, Vasari's passing remark about the master not letting "young assistants touch his own works" indicates that there were other artists in his employ in that period,[11] one of whom may have been responsible for the Chicago painting.

NOTES

1 Letter from Jeremy Howard of Colnaghi to Martha Wolff of January 29, 1991, in curatorial files.

2 Gould 1975, pp. 86–87, no. 6375.

3 One very small difference is the highlight on the folds of the drapery partly covered by the Virgin's right hand, which extends for a short distance along the tip of the third finger on the painting in London, but not on the picture in Chicago. Yet, this can hardly be described as a difference in design.

4 Letter from Cecil Gould to John Maxon of April 15, 1966, in curatorial files.

5 For the Oxford picture, see Forster 1972, fig. 20, and C. Lloyd, *A Catalogue of the Earlier Italian Paintings in the Ashmolean Museum*, Oxford, 1977, pp. 105–07, pl. 76; for the Birmingham picture, see *Old Masters from the City of Birmingham*, exh. cat., London, Wildenstein, 1970, no. 9 (ill.).

6 For the *Madonna of Porta Pinti*, see Forster 1972, fig. 10, and J. Shearman, *Andrea del Sarto*, Oxford, 1965, vol. 1, pl. 90b, vol. 2, pp. 247–49, no. 59; for the *Capponi Tondo*, see Forster 1972, fig. 11, and idem, *Pontormo*, Munich, 1966, p. 141, no. 32, fig. 57.

7 Forster 1972, fig. 15, and Forster 1966 (note 6), p. 144, no. 39, fig. 71.

8 Forster 1972, figs. 16–18, respectively.

9 Forster 1966 (note 6), pp. 141–42, no. 34, pl. V.

10 See the discussions of these works in C. Hugh Smyth, "The Earliest Works of Bronzino," *Art Bull.* 31 (1949), pp. 184–210, figs. 8–9, and J. Cox-Rearick, "Some Early Drawings by Bronzino," *Master Drawings* 2 (1964), pp. 363–82, figs. 2–4.

11 Vasari, *Vite*, Milanesi ed., vol. 6, p. 271; and see Hugh Smyth (note 10), p. 208.

Antonio Rimpatta

Documented Naples 1509, d. 1531/32

The Holy Family with Four Saints and a Female Donor, c. 1510

Clyde M. Carr Fund, 1963.209

Oil on panel, 125.3 x 120 cm (49⅜ x 47¼ in.)

INSCRIBED: [SVM VE]R[A] LVX [MVNDI] EGO (on the Christ Child's halo, in gold pigment)[1]

CONDITION: The painting is in fair condition. It is made up of three vertically joined boards, apparently of different wood types, and was evidently unstable over a period of years. The joins are 29 cm from the left edge and 29.5 cm from the right edge. When the picture came to the Art Institute, the support had recently been thinned and given a balsa-wood backing.[2] In 1963–64 Alfred Jakstas cleaned and inpainted the picture. In 1982 the continued instability and splitting of the support, accentuated by the cross grain of the balsa-wood backing, necessitated the removal of this backing, which was carried out by Mary Lou White and Faye Wrubel. The original support was found to be thinned, irregularly deteriorated, and impregnated with wax, and hence required reinforcement with an end-grain balsa-wood backing. At this time, the fills along the joins were repaired and the discolored inpainting corrected, but the picture was not recleaned. The paint and ground layers have suffered from flake loss, particularly in the red robe of the Madonna, in Saint John's red cloak, and in the figure of the donor. The Madonna's blue cloak is so severely damaged that the modeling is unclear. The flesh tones, however, are well preserved, with the exception of the shadows in Joseph's face. Changes in the contours of the Christ Child and in the hairline of the Madonna are visible in raking light and in the x-radiograph (infrared, ultraviolet, x-radiograph).

PROVENANCE: Acquired either by James Hugh Smith-Barry (1746?–1801) or by his eldest son John Smith-Barry (b. 1793), both of Marbury Hall, near Northwich, Cheshire, and Fota Island, County Cork, Ireland.[3] By descent to Arthur Hugh Smith-Barry (d. 1925), first and last Lord Barrymore. By descent to his daughter the Hon. Mrs. Dorothy Elizabeth Bell of Fota Island, County Cork, Ireland; sold Sotheby's, London, March 23, 1960, no. 116 (ill.), as Giovanni Antonio Boltraffio, to H. M. Calmann.[4] H. M. Calmann, London, 1960–63. Sold by Calmann to the Art Institute, 1963.

REFERENCES: *A Catalogue of Paintings, Statues, Busts, etc. at Marbury Hall, the Seat of John Smith Barry, Esq., in the County of Chester,* London, 1814, p. 9, no. 225; 2d ed.,

Warrington, 1819, p. 9, no. 225. G. F. Waagen, *Galleries and Cabinets of Art in Great Britain,* London, 1857, p. 409. C. L. Ragghianti, "I falsi artistici," *Critica d'arte* 8 (1961), pp. 16–17, fig. 16. Maxon 1970, p. 251 (ill.). Fredericksen/Zeri 1972, pp. 136, 571. A. Tempestini, "Antonio da Bologna: Uno o due?" *Mitteilungen des Kunsthistorischen Institutes in Florenz* 25 (1981), pp. 344–52, fig. 6.

EXHIBITIONS: Manchester, *Art Treasures of the United Kingdom,* 1857, no. 92, as Beltraffio [sic]. London, Royal Academy of Arts, *Works by the Old Masters,* 1879, no. 175, as Boltraffio.

The artist has depicted the Virgin and Child with Saint Joseph and Saint John the Evangelist holding a chalice on the right, and the half-length figure of a kneeling female donor in the lower part of the composition. A bishop saint positioned behind the Virgin and two other figures in the background to left and right are unidentified. This type of composition, with several figures grouped around the Holy Family in the presence of a donor, is known as a *sacra conversazione* and was evolved during the second half of the fifteenth century, becoming more popular with painters at the beginning of the sixteenth century, particularly in northern Italy. It is likely that such a panel served as an altarpiece in one of the smaller chapels of a church or in a private chapel in a domestic context.

When the picture was first recorded in the Smith-Barry collection, it was ascribed to Perugino, an attribution that Waagen (1857) easily dismissed on visiting Marbury Hall in the 1850s: "A title which a very superficial knowledge of the Italian schools of the 15th century suffices to set aside.... Those better instructed will at once perceive this to be one of the rare works of Beltraffio [sic] the admirable scholar of Leonardo da Vinci."[5] Waagen continued enthusiastically, "After the above-mentioned picture in the Louvre [the Casio altarpiece], this is the most

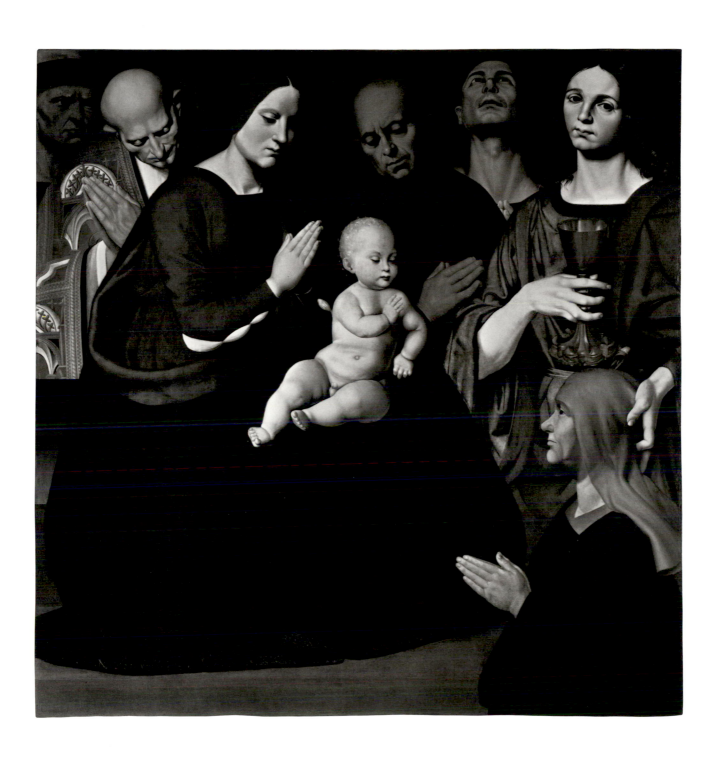

important work by Beltraffio [*sic*] I know, and also the most remarkable in this collection."

A century later, Ragghianti (1961) shed new light on the painting's attribution by grouping it with a *Sacra Conversazione* then in the Setmani collection in Milan, two panels of the *Virgin and Child with the Young Saint John the Baptist* in the Musée Granet in Aix-en-Provence and The Detroit Institute of Arts, respectively, and two panels of the *Virgin and Child* in the Museo Civico in Vicenza and the Galleria Sabauda in Turin, respectively.[6] Ragghianti recognized that these pictures could well be by a single hand and proposed a date of 1490–95, but he was puzzled by the mixture of styles evident within the group.[7] Fredericksen and Zeri (1972) dubbed this painter the Master of the Setmani *Sacra Conversazione*, whom, as Tempestini (1981) reported, Zeri tentatively identified as the Antonio da Bologna responsible for a fresco of the *Assumption of the Virgin* in the Cappella di Santa Scolastica at Monte Oliveto Maggiore, mentioned by Vasari (vol. 6, p. 473).[8] In 1963, however, Ellis Waterhouse had suggested an attribution to Antonio Rimpatta,[9] a painter whose known activity until recently was limited to the documented altarpiece of 1509–11 undertaken for the church of San Pietro ad Aram in Naples (now Naples, Museo e Gallerie Nazionali di Capodimonte).[10] Tempestini (1981) examined this somewhat confusing situation and discovered, on the basis of documents cited in secondary sources, that Antonio da Bologna and Antonio Rimpatta are in fact the same person. Little is known about this artist, except that he appears to have been born in Emilia and became a monk in the Olivetan monastery at Naples in 1511.

Although Rimpatta's work is eclectic and includes divergent stylistic references, there can be no reasonable doubt that the altarpiece in Naples and the Setmani *Sacra Conversazione* are by the same painter, the differences between them resulting from scale rather than from drawing or technique. The panel in Chicago can be stylistically related to both these key works. The morphology of the Christ Child and the inscription in the halo are directly comparable with those in the Naples altarpiece, just as the drapery of Saint John the Evangelist is rendered in a similar way to that of Saints Peter and Paul on the altarpiece.

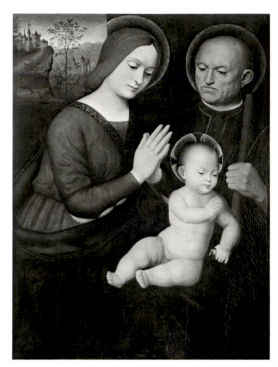

Fig. 1 Antonio Rimpatta, *Holy Family*, The Currier Gallery of Art, Manchester, New Hampshire

Likewise, the cope of the episcopal saint bending over the shoulder of the Virgin matches that of the altarpiece's Saint Augustine. On the other hand, the figure of Saint John the Evangelist in the Chicago panel can be more closely related to his counterpart on the Setmani *Sacra Conversazione*, while the three figures seen in half-light in the background of that composition are the same types as the Saint Joseph. The Christ Child, particularly in the shape of the cranium, the highlights in the hair, and the ring of flesh about the neck, is comparable with the dancing and music-making putti in the fresco of the *Assumption of the Virgin* at Monte Oliveto Maggiore, where, once again, the damp-fold drapery patterns of the angels resemble those of the garment worn by Saint John the Evangelist. Since the publication of Tempestini's important article of 1981, Everett Fahy has pointed out that the figures of the Virgin and Child on a panel in The Currier Gallery of Art, Manchester (New Hampshire), depicting the *Holy Family* (fig. 1), also appear in the more extended composition in the Art Institute.[11] In the present state of knowledge it is not possible to establish a detailed chronology for the oeuvre of Rimpatta and so the date (c. 1510) proposed above for this picture may need to be revised after further research.

The present painting, as implied by the variety of old attributions and the itinerant nature of the painter's working life, unites several styles. The facial features of the Virgin are distinctly Bolognese, close to Francesco Francia and to Lorenzo Costa, while the even more refined appearance of Saint John the Evangelist recalls the style of the Lombard painter Boltraffio. The rugged physiognomy of the older male figures is more akin to the types occurring in the work of other artists associated with the Lombard school, inspired by Leonardo da Vinci. The figure in the upper left corner, peering over the shoulder of the bald ecclesiastic, is a compositional motif found, for example, in such paintings as the *Ecce Homo* by Andrea Solario in the Ashmolean Museum in Oxford, which may have been derived from Andrea Mantegna.[12] Two additional stylistic aspects should be mentioned: first, the emphasis on steep foreshortening, as in the bishop on the left looking down and the figure on the right looking upward; and secondly, the meticulously realistic portrayal of the facial features, notably those of the bishop, Saint Joseph, and the figure on the right looking upward. Similar exaggerations are found in the work of central Italian painters such as Luca Signorelli and Bartolomeo della Gatta.

NOTES

1 The full inscription, EGO SVM VERA LVX MVNDI (based on John 8.12), is visible in the infrared photograph.

2 The backing was presumably applied after its sale at Sotheby's in 1960. The photograph of the picture in the sale catalogue shows an extra strip of some 10 cm along the upper edge which did not form part of the original support and has since been removed.

3 Lent to the *Art Treasures* exhibition of 1857 by "the late J. Smith-Barry." On the collection of James Hugh Smith-Barry, see Gerard Vaughan, "James Hugh Smith-Barry as a Collector of Antiquities," *Apollo* 126 (1987), pp. 4–11, which includes further references. Gerard Vaughan kindly supplied information on the Smith-Barry family and the collection at Marbury Hall. For the line of descent in the Smith-Barry family, see *Burke's Irish Family Records*, London, 1976, pp. 76–77.

4 According to an annotated sale catalogue in the Ryerson Library, The Art Institute of Chicago.

5 Waagen's attribution, based on the Casio altarpiece of 1500 by Boltraffio in the Louvre (Berenson 1968, pl. 1429), was apparently retained until the painting came up for auction in 1960.

6 For illustrations, see Tempestini 1981, figs. 3, 1–2, 5, and Ragghianti 1961, pl. 12, respectively.

7 Ragghianti first recognized the connection between a meticulously executed and carefully observed drawing of a male figure in Frankfurt-am-Main and the Saint Joseph in the Setmani *Sacra Conversazione* (Frankfurt am Main, Städelsches Kunstinstitut und Städtische Galerie, *Italienische Zeichnungen des 15. und 16. Jahrhunderts*, exh. cat. by L. S. Malke, 1980, no. 69, ill.). It is highly likely that similar drawings were made in preparation for the present picture.

8 Tempestini 1981, figs. 9–11.

9 June 7, 1963, according to a note in curatorial files.

10 Tempestini 1981, fig. 7.

11 Letter of August 30, 1987, to Martha Wolff, in curatorial files. The painting in The Currier Gallery of Art (no. 1987.7) measures 22 x 29⅝ in.

12 C. Lloyd, *A Catalogue of the Earlier Italian Paintings in the Ashmolean Museum*, Oxford, 1972, pp. 163–66, pl. 119. See also S. Ringbom, *Icon to Narrative: The Rise of the Dramatic Close-up in Fifteenth-Century Devotional Painting*, Åbo, 1965, pp. 142–47, fig. 114.

Attributed to Ercole de' Roberti

Documented Ferrara by 1479, d. Ferrara 1496

Virgin and Child, 1490/96

Charles H. and Mary F. S. Worcester Collection, 1947.90

Tempera or oil on panel, 52 x 35 cm (20½ x 13¾ in.)

CONDITION: The painting is in fair to good condition. It was cleaned in 1963 by Alfred Jakstas, who removed extensive overpainting, and in 1987 by Frank Zuccari, who removed varnish and discolored inpainting. The panel, which is made up of two boards with horizontal grain, has been thinned to approximately 7 mm and mounted on a laminated wood panel. The x-radiograph shows scattered, filled worm tunneling. It is clear from the raised edges of the paint surface and the unpainted wood on all sides of the panel that the painting originally had an engaged frame. There are two vertical splits in the center of the panel, one beginning about 20 cm from the left edge and extending down through the Virgin's nose to the Child's shoulder, the other beginning 19.7 cm from the left edge and extending

up through the Virgin's left hand to her bodice. There are other, shorter vertical splits at top and bottom. There are numerous small losses throughout, and the flesh tones of the Child, particularly the legs, are damaged by cleaning abrasion. The Virgin's face, neck, and hands are well preserved, as is her jeweled fillet. The x-radiograph shows that the artist adjusted the contours of the Virgin's head and hands, making her head larger and her hands smaller in relation to his first positioning of the contours of the drapery around them (infrared, ultraviolet, x-radiograph).

PROVENANCE: Adolf von Beckerath, Berlin, by 1909.[1] Benedict and Co., Berlin.[2] Sold by Benedict and Co. to Charles H. Worcester, Chicago, 1929;[3] intermittently on loan to the Art Institute from 1930; given to the Art Institute, 1947.

REFERENCES: T. Borenius, *The Painters of Vicenza*, London, 1909, p. 158 (ill. opp. p. 158). S. Rumor and M. H. Bernath in Thieme/Becker, vol. 5, 1911, p. 229. J. A. Crowe and G. B. Cavalcaselle, *A History of Painting in North Italy*, 2d ed., vol. 2, ed. by T. Borenius, London, 1912, p. 140 n. 1. A. Venturi, vol. 7, pt. 4, 1915, p. 636, fig. 408. R. Longhi, *Officina ferrarese*, 1934, reprinted with later additions in *Opere complete di Roberto Longhi*, vol. 5, Florence, 1956, pp. 42, 103 n. 83, 131, 181, fig. 141. *Worcester Collection* 1938, p. 10, no. 6, pl. v. S. Ortolani, *Cosimo Tura, Francesco del Cossa, Ercole de' Roberti*, Milan, 1941, p. 170. K. Kuh, "The Worcester Gift," *AIC Bulletin* 41 (1947), pp. 58–59. B. Nicolson, *The Painters of Ferrara: Cosme Tura, Francesco del Cossa, Ercole de' Roberti, and Others*, London, 1950, p. 19. M. Salmi, *Ercole de' Roberti*, Milan, 1960, pp. 31, 55 (ill.). AIC 1961, pp. 202–03. E. Ruhmer, "Ergänzendes zur Zeichenkunst des Ercole de' Roberti," *Pantheon* 20, 4 (1962), p. 244, fig. 8. L. Puppi, *Ercole de' Roberti*, Milan, 1966, pl. IX. E. Ruhmer, "Ercole de' Roberti," *Encyclopedia of World Art*, New York, 1966, col. 230, pl. 158, lower left. Berenson 1968, vol. 1, p. 121. Fredericksen/Zeri 1972, pp. 175, 323, 571. R. Molajoli, *L'opera completa di Cosmè Tura e i grandi pittori ferraresi del suo tempo, Francesco Cossa e Ercole de' Roberti*, Milan, 1974, pp. 98–99, no. 122 (ill.). J. P. Manca, *The Life and Art of Ercole de' Roberti*, Ph. D. diss., Columbia University, 1986, Ann Arbor, Mich., pp. 21, 171–74, 235, 305–07, no. 21, fig. 21. K. Lippincott, "A Masterpiece of Renaissance Drawing: A *Sacrificial Scene* by Gian Francesco de' Maineri," *AIC Museum Studies* 17, 1 (1991), pp. 13, 89 n. 11, fig. 5. J. P. Manca, *The Art of Ercole de' Roberti*, Cambridge, 1992, pp. 142–43, no. 21, fig. 21.

EXHIBITIONS: The University of Chicago, The Renaissance Society, *Religious Art from the Fourth Century to the Present Time*, 1930, no. 31, as Buonconsiglio. The Detroit Institute of Arts, *Italian Paintings of the XIV to XVI Century*, 1933, no. 100, as Buonconsiglio. The Art Institute of Chicago, *The Christmas Story in Art*, 1938–39 (no cat.).

Borenius (1909) attributed the painting to Giovanni Buonconsiglio (called il Marescalco), a follower of the Vicentine artist Bartolommeo Montagna, suggesting an early date before the remarkable *Pietà* in the Museo Civico in Vicenza.[4] This attribution was repeated by Borenius in the second edition of Crowe and Cavalcaselle (1912) and accepted by Rumor and Bernath (1911) in the entry for Thieme/Becker, as well as by Adolfo (1915) and Lionello (1929) Venturi,[5] and by Rich (1938). The latter reported that Berenson, on the basis of a photograph, initially assigned the work to Lorenzo Costa. Longhi, in his important reassessment of Ferrarese painting first published in 1934, suggested that "the elegant geometry of the forms, . . . the nervous yet abstract hands," and the color were closer to the style of Ercole de' Roberti at the time of the altarpiece commissioned in 1480 for the church of Santa Maria in Porto, Ravenna, and now in the Pinacoteca di Brera in Milan.[6] On viewing the picture in 1936, Kenneth Clark similarly proposed that the picture might be by Ercole de' Roberti, who was, with his teacher, Francesco del Cossa, and Cosimo Tura, one of the three major painters of fifteenth-century Ferrara and an important presence in Bologna.[7] This attribution has gained general acceptance, having been supported by Nicolson (1950), Salmi (1960), Ruhmer (1966), Berenson (1968), Fredericksen and Zeri (1972), Molajoli (1974), and Manca (1986, 1992), although it was rejected by Ortolani (1941). This last writer drew attention to the close similarities with a *Madonna and Child* in the Kress Collection (Lewisburg, Pennsylvania, Bucknell University, Study Collection), which Longhi had declared to be a late work by Francesco del Cossa.[8] Since cleaning in 1960, however, the appearance of the panel in the Kress Collection has changed so dramatically that both Longhi's original claim and Ortolani's modification of it can now be discounted.[9]

Some hesitancy should be expressed, however, regarding Longhi's association of the Chicago painting with the oeuvre of Ercole de' Roberti. Absent is the delicate balance between frenzy and calm one finds in other paintings by Roberti.[10] Moreover, the contours of the Virgin's face and the coiffure evoke comparison with Ferrarese painters of the generation following Roberti, such as Domenico Panetti, who

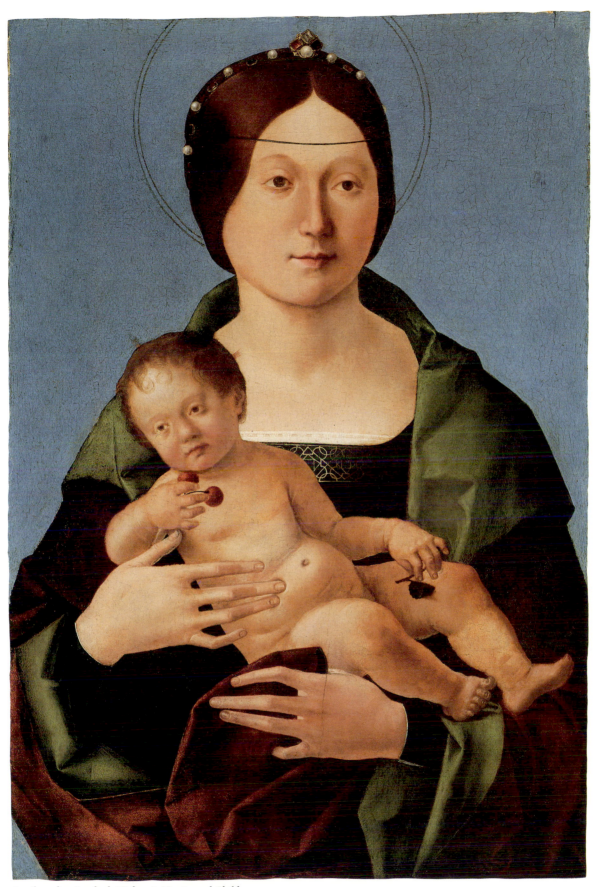

Attributed to Ercole de' Roberti, *Virgin and Child*, 1947.90

were influenced by Lorenzo Costa and Francesco Francia. The purity of the forms, particularly the oval of the Virgin's face, also echoes the style of Boccaccio Boccaccino, who worked in Ferrara during the late 1490s, while the gentle characterization of the figures and the careful technique anticipate Garofalo and L'Ortolano.

The headband studded with jewels interspersed with pearls is an unusual ornament for the Virgin to wear, but Ferrarese artists did often clothe their figures in garments festooned with precious or semi-precious stones, or ornamented frames with them, as exemplified by several works of Cosimo Tura.[11] The Child is shown holding cherries, a symbol of the Passion.[12]

NOTES

1 According to Borenius 1909.
2 See letter from Benedict and Co. to Worcester of June 7, 1929 (Archives, The Art Institute of Chicago).
3 Ibid.

4 F. Barbieri, *Il Museo Civico di Vicenza*, vol. 1, *Dipinti e sculture dal XIV al XV secolo*, Venice, 1962, pp. 93–100 (ills.).
5 See expertise submitted by Lionello Venturi to Worcester of June 22, 1929, in curatorial files.
6 Longhi, however, in discussing the Chicago picture, incorrectly described the figure's mantle as blue and the picture's background as "pale gold." The figure is actually wearing a wine-red mantle with green lining against a pale blue background. For an illustration of the Ravenna altarpiece, see Longhi 1934 (1956), fig. 140, color pl. XI.
7 See letter from Worcester to Daniel Catton Rich of November 19, 1936, and expertise by Kenneth Clark of November 18, 1936, in curatorial files.
8 Longhi 1934 (1956), pls. 103–04.
9 Shapley 1966, p. 86, no. K387, fig. 236, as Ferrarese School, late fifteenth century.
10 Believing the Chicago picture to be by Roberti, Manca (in a letter of March 20, 1992, to Martha Wolff, in curatorial files) explained the serene style of the painting as the result of a significant change in Roberti's artistic manner in the last decade of his life.
11 See E. Ruhmer, *Cosimo Tura*, London, 1958, pls. 14, 50.
12 M. Levi d'Ancona, *The Garden of the Renaissance: Botanical Symbolism in Italian Painting*, Florence, 1977, pp. 89–93, no. 33.

Sano di Pietro

1405 Siena 1481

Virgin and Child with Saints Jerome, Bernardino of Siena, and Angels, 1450/60

Mr. and Mrs. Martin A. Ryerson Collection, 1933.1027

Tempera on panel, 79 x 57 cm (31⅛ x 22½ in.); painted surface: 66.2 x 48.2 cm (26⅛ x 19¼ in.)

INSCRIBED: AVE GRATIA PLENA dOM (on Virgin's halo),[1] O SVM L (on Child's halo)[2]

CONDITION: The painting is in very good condition. It seems not to have been treated since coming to the Art Institute, apart from the consolidation of some flaking paint in 1958. The panel has been thinned to a thickness of approximately 2 cm and then cradled. Evidence of a barbe, wide edges of unpainted wood, and the thickness of the ground layer all indicate that the picture originally had an engaged frame (see discussion below). The panel is composed of three boards with vertical grain, joined approximately 9 and 47 cm from the left edge. The x-radiograph shows that these joins were covered with strips of fabric interleaf. In addition, two vertical splits extend the full height of the panel, one through its center and the other just to the right of the Virgin's face. Some old retouching is evident along these joins and splits, but otherwise the paint surface is in very good condition, apart from some minor blemishes in the gold background and a small repair to the Virgin's left temple. The color and the flesh tone are particularly well preserved, although the blue of the Virgin's drapery has darkened (infrared, ultraviolet, x-radiograph).

PROVENANCE: Probably private collection, London; sold Hôtel Drouot, Paris, February 27, 1882, *La Collection de M. M. de Londres*, no. 71, *Vierge avec gloire d'anges*, for Fr 675, or no. 74, *La Vierge et l'enfant*, for Fr 410.[3] Jean Dollfus, Paris; sold Galerie Georges Petit, Paris, pt. 3, April 1–2,

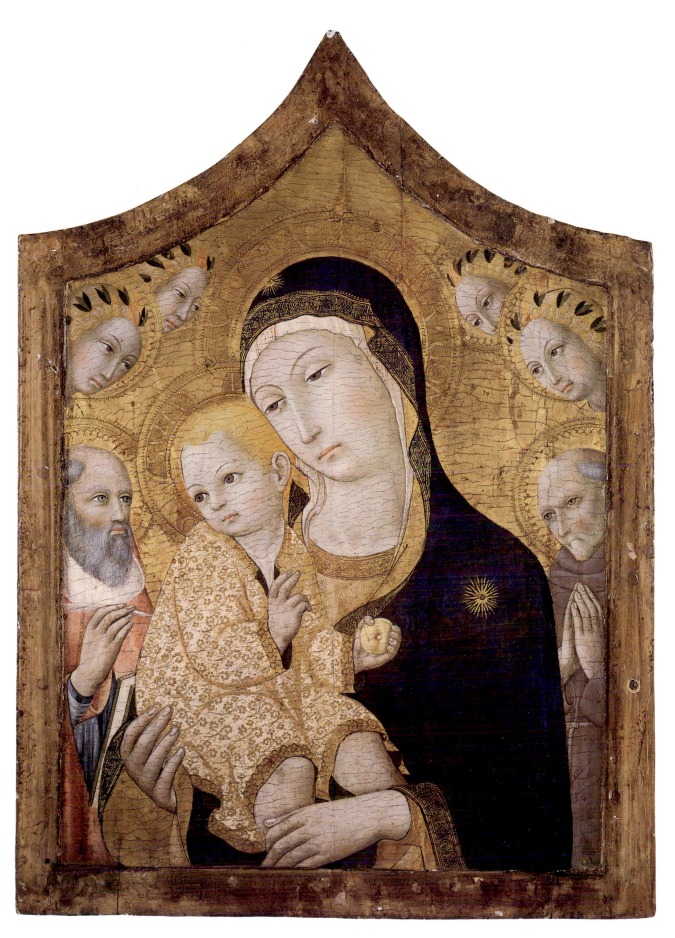

1912, no. 76 (ill.), to Kleinberger for Fr 15,600.[4] Sold by Kleinberger to Ferdinand Hermann, New York;[5] sold American Art Association, New York, January 15, 1918, no. 46 (ill.), to R. Ederheimer for $2100.[6] Private collection, New York;[7] sold Anderson Galleries, New York, February 18, 1921, no. 107, to Kleinberger, New York.[8] Sold by Kleinberger to Martin A. Ryerson (d. 1932), Chicago, 1922;[9] on loan to the Art Institute from 1922; bequeathed to the Art Institute, 1933.

REFERENCES: Berenson 1909, p. 239; 1932, p. 498; 1936, p. 429; 1968, vol. 1, p. 174. "Hermann Picture Sale," *American Art News* 16, 15 (1918), p. 7. "Next Weeks [*sic*] Picture Sales: The Ferdinand Hermann Pictures," *American Art News* 16, 14 (1918), p. 1. S. Reinach, *Répertoire de peintures du moyen-age et de la renaissance (1280–1580)*, vol. 5, Paris, 1922, p. 383 (ill.). AIC 1923, p. 73. E. Gaillard, *Un Peintre siennois au XVe siècle: Sano di Pietro*, Chambéry, 1923, p. 204, color frontispiece. "Sano di Pietro," *AIC Bulletin* 17 (1923), p. 5, cover ill. *Ryerson Collection* 1926, pp. 35–36. Van Marle, vol. 9, 1927, p. 494. AIC 1932, p. 182. Valentiner [1932], n. pag. D. C. Rich, "The Paintings of Martin A. Ryerson," *AIC Bulletin* 27 (1933), p. 8. M. Salmi, "Dipinti senesi nella Raccolta Chigi-Saracini," *La Diana* 8, 2 (1933), p. 82. AIC 1935, p. 20. F. Mason Perkins in Thieme/Becker, vol. 29, 1935, p. 415. R. Shoolman and C. Slatkin, *The Enjoyment of Art in America*, Philadelphia and New York, 1942, p. 284. AIC 1948, p. 25. H. Parker, *The Christmas Story Illustrated from the Collection of The Art Institute of Chicago*, Chicago, 1949, ill., n. pag. AIC 1961, p. 410. E. T. DeWald, *Italian Painting, 1200–1600*, New York, 1961, p. 340. Fredericksen/Zeri 1972, pp. 181, 320, 571. J. Pope-Hennessy with L. Kanter, *The Robert Lehman Collection*, vol. 1, *Italian Paintings*, New York, 1987, p. 146, under no. 61.

EXHIBITIONS: New York, F. Kleinberger Galleries, *Italian Primitives*, 1917, no. 62. Northampton, Massachusetts, Smith College, Hillyer Art Gallery, 1922 (no cat.).[10] The Art Institute of Chicago, *A Century of Progress*, 1933, no. 93. The Art Institute of Chicago, *A Century of Progress*, 1934, no. 34.

This panel is a fine and unusually well-preserved example of a type of private devotional picture that was an important part of Sano di Pietro's production. Sano, whose full name was Ansano di Pietro di Mencio, was a follower and possibly a pupil of Sassetta. He seems also to have worked in close association with the Master of the Osservanza. Following his emergence as an independent master in Siena in the 1440s, he was extremely productive, fulfilling

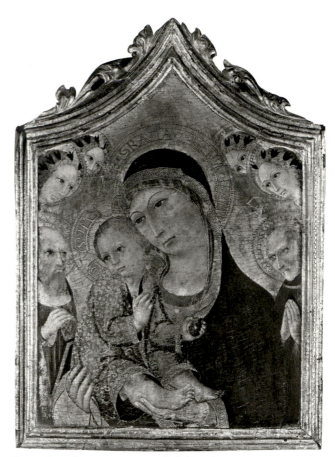

Fig. 1 Sano di Pietro, *Virgin and Child with Saints Jerome and Bernardino of Siena*, Musées Royaux des Beaux-Arts de Belgique, Brussels

numerous public commissions and also supplying altarpieces, particularly for the orders of the Gesuati and the Franciscan Observants.[11] As Van Os has pointed out, small devotional works, like this panel with its suppliant figure of Saint Bernardino of Siena, were probably intended for the cells of members of Sienese religious orders.[12]

Sano di Pietro repeated this composition of a half-length Virgin with Saints Jerome and Bernardino of Siena numerous times with minor changes in the number of attendant angels and the position of the Christ Child. Examples include panels in the National Gallery of Art, Washington, D.C., in the Lehman Collection, The Metropolitan Museum of Art, New York (with the addition of Saints John the Baptist and Anthony of Padua), and in the Harvard University Center for Italian Renaissance Studies, Villa I Tatti, Florence.[13] As Salmi (1933) observed, the pentagonal shape of the panel in Chicago is unusual. However, three variants of this devotional type by Sano di

Pietro with the same pentagonal shape and virtually the same dimensions are known: one in Brussels, Musées Royaux des Beaux-Arts de Belgique (fig. 1), one in New York, The Metropolitan Museum of Art, with Saints Catherine and Dorothy, and a third in Siena, Chigi-Saracini Collection.[14] Of these the panels in Brussels and Siena are still in their original engaged frames, while those in New York and Chicago are in modern frames of varying degrees of suitability. The Virgin and Child in all of these works also resemble Sano di Pietro's grouping of the same figures on the monumental Santa Bonda polyptych in the Pinacoteca Nazionale, Siena, and on the polyptych in the church of San Giorgio at Montemerano, which is dated 1458.[15]

Saint Bernardino of Siena, a renowned preacher and vicar general of the Franciscan Observants, died in 1444 and was canonized in 1450. This latter date can be taken as a *terminus post quem* for this group of small devotional pictures. Trübner dated the group after 1450 on stylistic grounds.[16] A date in the 1450s seems appropriate for the Art Institute's painting.

NOTES

1 Luke 1.28.
2 *Ego sum lux mundi* (John 8.12).
3 The Dollfus sale catalogue (see next item of provenance) incorrectly referred to this painting as no. 72 in the 1882 sale catalogue. No. 72 was a *Visitation* and therefore not the picture under discussion. An identification with either no. 71 or no. 74 is possible, but not definite.
4 Annotated sale catalogue in the Resource Collection of the Getty Center for the History of Art and the Humanities, Santa Monica.
5 The 1918 sale catalogue states that Hermann purchased the work from Kleinberger.
6 Annotated sale catalogue in the Ryerson Library, The Art Institute of Chicago, and *American Art News* 16, 15 (1918), p. 7.
7 The 1921 sale catalogue reads "The Art Collection of a New York Gentleman." The latter may be R. Ederheimer, the buyer of the picture at the 1918 sale, but it has not been possible to verify this.
8 Kleinberger records, Department of European Paintings, The Metropolitan Museum of Art, New York.
9 Kleinberger records (note 8) and invoice of May 24, 1922, in curatorial files.
10 See note 9.
11 For Sano di Pietro's career and his relationship to the Master of the Osservanza, see K. Christiansen in *Painting in Renaissance Siena, 1420–1500*, exh. cat., New York, The Metropolitan Museum of Art, 1988–89, pp. 99–100, 135–36, under no. 13, and pp. 138–39.
12 H. W. van Os, *Sienese Altarpieces, 1215–1460*, vol. 2, *Form, Content, Function, 1344–1460*, Groningen, 1990, p. 54, and fig. 31. See also K. Christiansen, "Notes on *Painting in Renaissance Siena*," *Burl. Mag.* 132 (1990), p. 209.
13 Shapley 1979, pp. 413–14, pl. 294; Pope-Hennessy 1987, p. 146, no. 61, ill. p. 147; and F. Russoli, *La Raccolta Berenson*, Milan, 1962, pl. XLIII.
14 Van Marle, vol. 9, 1927, fig. 314; *Musées Royaux des Beaux-Arts: Catalogue de la peinture ancienne*, Brussels, 1949, p. 106; Zeri/Gardner 1980, p. 81 (ill.); and Salmi 1933, pl. 7. Another devotional composition of similar shape and scale by Sano di Pietro is the *Madonna of Mercy* showing the Virgin as protectress of a group of Poor Clares; see Christiansen (note 11), pp. 144 (ill.), 145, no. 17.
15 Van Os (note 12), fig. 35, and Berenson 1968, vol. 2, pl. 584.
16 J. Trübner, *Die stilistische Entwicklung der Tafelbilder des Sano di Pietro*, Strasbourg, 1925, pp. 57–58.

Andrea del Sarto

1486 Florence? 1530

Domenico da Gambassi, 1525/28

Gift of Mrs. Murray S. Danforth, 1964.1097a

Oil on panel (poplar), painted surface: 22.5 x 15.9 cm (8⅞ x 6¼ in.); diameter of roundel containing portrait: 11 cm (4⁵⁄₁₆ in.)

INSCRIBED: XX (in cartouche below roundel)

The Wife of Domenico da Gambassi, 1525/28

Gift of Mrs. Murray S. Danforth, 1964.1097b

Oil on panel (poplar), painted surface: 22.5 x 15.9 cm (8⅞ x 6¼ in.); diameter of roundel containing portrait: 11.2 cm (4⁷⁄₁₆ in.)

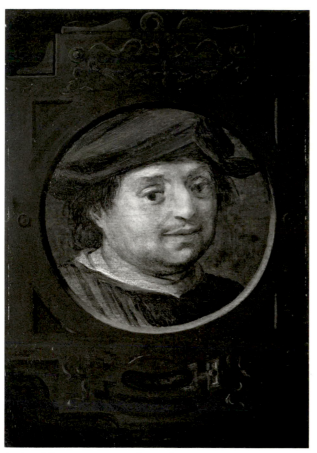

Andrea del Sarto, *Domenico da Gambassi*, 1964.1097a

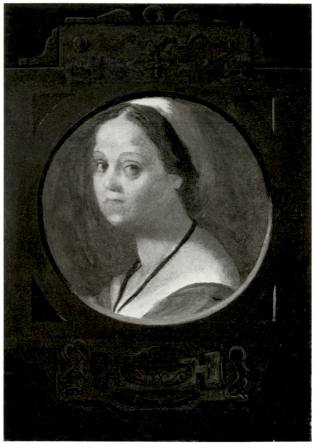

Andrea del Sarto, *The Wife of Domenico da Gambassi*, 1964.1097b

INSCRIBED: XX (in cartouche below roundel)

CONDITION: Both paintings are in poor condition. They were treated in 1963 and 1964.[1] The panels are composed of single boards with horizontal grain. They have been thinned and cradled and their edges trimmed. X-radiography shows a demarcation between the segments with strapwork decoration at the top and bottom and the center sections. Incised lines prepare the round openings and also run along the sides of the panels in the center sections, but do not continue into the sections with strapwork decoration. The upper and lower segments of both panels are also badly damaged. The lower segment of the male portrait is the best preserved. The strapwork and matching monogram in the female portrait are largely a reconstruction based on its companion piece. Microscopic examination indicates that the brown color of the fictive frame in both central sections has been repainted to match the strapwork decoration. A bolder terracotta red is visible at the edges of the roundels and through tiny flake losses. All of these circumstances suggest that the decorations at the top and bottom, while possibly very old, were not painted at the same time as the center sections with their illusionistic round openings.

The flesh tones in the male portrait are quite rubbed, but the high quality of the brushwork is by no means totally lost. There are scattered paint losses in the face and neck. The female portrait has suffered much more severely from rubbing and abrasion, particularly on the face and in the hair to the right. Paint losses are apparent on the forehead, around the left eye, and on the left cheek and chin, resulting in a loss of form in the shadow areas. Traces of underdrawing are visible around the eyes and nose of both figures (x-radiograph).

PROVENANCE: Probably Church of Santi Lorenzo e Onofrio, Benedictine Convent of the Romite, Gambassi (near Volterra), by 1525/28 to no later than 1637.[2] Probably Medici Collection, Palazzo Pitti, Florence, by 1637.[3] Possibly Leopoldo de' Medici (d. 1675), Villa del Poggio Imperiale, Florence, by 1655.[4] New York art market, 1963. Mrs. Murray S. Danforth, Providence, Rhode Island, 1963–64;[5] given to the Art Institute, 1964.

REFERENCES: S. J. Freedberg, "Andrea and Lucrezia: Two New Documents in Paint for Their Biography," *AIC Museum Studies* 1 (1966), pp. 15–27 (ills.). Fredericksen/ Zeri 1972, pp. 8, 510, 515, 571. S. M. Trkulja, *Omaggio a Leopoldo de' Medici*, pt. 2, *Ritrattini*, exh. cat., Florence, Uffizi, 1976, p. 12. H. Brigstocke, *Italian and Spanish Paintings in the National Gallery of Scotland*, Edinburgh, 1978, p. 128, under no. 75, fig. 26. E. Fahy, *The Legacy of Leonardo: Italian Renaissance Paintings from Leningrad*, exh. cat., Washington, D.C., National Gallery of Art, 1979, p. 57, figs. 37–38. *Giorgio Vasari*, exh. cat., Arezzo, Casa Vasari, 1981, sec. VIII, p. 270, under no. 27. R. Monti, *Andrea del Sarto*, 2d ed., Milan, 1981, p. 8. A. Conti,

"Andrea del Sarto e Becuccio bicchieraio," *Prospettiva* 33–36 (1983–84), pp. 161–65 (ill.). *Andrea del Sarto, 1486–1530: Dipinti e disegni a Firenze*, exh. cat., Florence, Palazzo Pitti, 1986, pp. 18, 134, 149. S. Padovani, *Andrea del Sarto*, Florence, 1986, p. 59. A. Natale and A. Cecchi, *Andrea del Sarto: Catalogo completo dei dipinti*, Florence, 1989, pp. 112–13, no. 52, p. 123.

EXHIBITIONS: Florence, Palazzo Vecchio, *Palazzo Vecchio: Committenza e collezionismo medicei*, 1980, nos. 360–61.

Upon their reappearance on the New York art market in the early 1960s, the two panels were attributed by Freedberg to Andrea del Sarto, an attribution that has remained uncontested.[6] A pupil of Piero di Cosimo and Raffaellino del Garbo, Sarto gradually relinquished the quattrocento style he learned from them as he absorbed the lessons of Leonardo da Vinci and Raphael. Following those masters and Fra Bartolommeo, he became one of the principal exponents of a High Renaissance manner in Florence. Sarto's art never advanced, however, to the highly

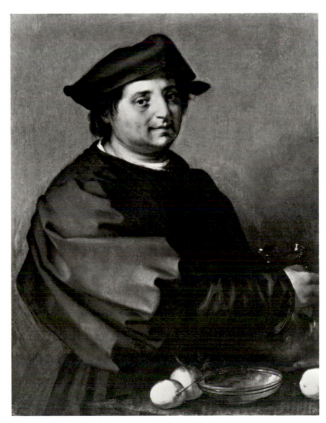

Fig. 1 Andrea del Sarto, *Portrait of Domenico da Gambassi*, National Gallery of Scotland, Edinburgh

idealized level of Leonardo's, as it remained partly tied to the prosaic naturalism of works of the previous century, even in late paintings such as the Gambassi *Madonna with Six Saints* (c. 1525–28; Florence, Palazzo Pitti).[7] Characteristic of Sarto is the direct and seemingly casual presentation of his subjects, as seen in these two loosely rendered portraits, apparently once part of the Gambassi altarpiece.

Thinly and freely painted despite their small scale, the portraits both appear to have once been surrounded by an identical fictive framework comprising strapwork motifs with foliate ornamentation. The framework of the portrait of *Domenico da Gambassi* is for the most part intact and includes Sarto's monogram in the cartouche below the roundel. As discussed in the condition report, the framework around the female portrait is largely a reconstruction based on that of the male portrait.[8] Clearly the portraits were conceived as a pair, but they were in all probability not intended to be displayed as a diptych.

Although Freedberg (1966) identified the male portrait as a self-portrait by Andrea del Sarto and the female portrait as a portrait of the artist's wife, Lucrezia del Fede, the two works probably represent the glassmaker (*bicchieraio*) Domenico da Gambassi and his wife. Conti (1983–84) was the first to propose this identification, referring to a relevant passage in Vasari's life of Andrea del Sarto:

Tornato Andrea a Firenze, lavorò a Becuccio Bicchieraio da Gambassi, amicissimo suo, in una tavola una Nostra Donna in aria col Figliuolo in collo, ed abbasso quattro figure, San Giovanni Battista, Santa Maria Maddalena, San Bastiano e San Rocco; e nella predella ritrasse di naturale esso Becuccio e la moglie, che sono vivissimi: la quale tavola è oggi a Gambassi, castello fra Volterra e Fiorenza nella Valdelsa.[9]

Shearman dated the Gambassi altarpiece to c. 1525–26 and Freedberg dated it to 1527–28.[10] The saints are more properly described as John the Baptist, Mary Magdalen, Onophrius, Sebastian, Lawrence, and Roch. The predella is missing.

Vasari's Becuccio Bicchieraio da Gambassi is, in fact, Domenico di Jacopo di Mattio (or Maffio), who is recorded in guild documents between 1503 and 1524.[11] As Conti established, Domenico da Gambassi was a successful glass manufacturer and an important

patron on friendly terms not only with Andrea del Sarto but also with Pontormo.[12] Conti's identification is corroborated by the attributes in a portrait of the same person in Edinburgh (fig. 1).[13] Conti noted the physiognomic differences, especially in the treatment of the nose, between the male sitter in the Chicago and Edinburgh portraits and the authenticated self-portrait of Sarto in the Uffizi.[14] He did not discuss the question of the female likeness. Because Vasari does not mention any narrative scenes in the predella, it must be assumed that the present portraits were placed discreetly at the sides below the columns of the frame. Such an arrangement would be unusual, but by no means unique.[15] Conti has suggested that the relatively loose handling of the portraits may be due to the fact that, as part of an altarpiece, they were meant to be viewed from a distance.

NOTES

1 The treatment report and related photographs cannot be located.

2 Vasari, *Vite*, Milanesi ed., vol. 5, p. 40; and Conti 1983–84, pp. 162–63. As Conti reported, the Gambassi altarpiece, to which the Art Institute's panels presumably belonged, is listed in the inventory of Palazzo Pitti of 1637.

3 See Palazzo Pitti inventory of 1637 (note 2).

4 It is possible, as Trkulja (1976, p. 12) first pointed out, that the portraits in Chicago once formed part of the collection of Leopoldo de' Medici (1617–1675), if they are correctly identified with entries in the inventories of 1655 and 1692: "Due quadretti in tavola, alti s. 7 lar¹ ¼ dipintovj in tondo di mano d'Andrea del Sarto, in uno il Suo rit., e nell'altro il ritr. della Sua Moglie" (Two small pictures on panel, 7 *soldi* high by ¼ [*braccio*] wide painted in roundels by Andrea del Sarto, in one His portrait, and in the other the portrait of His Wife). The measurements given in the inventory — 7 *soldi* by ¼ *braccio* (approx. 8 x 6 in.) — correspond closely to those of the Chicago works. The fact that the portraits were, by the seventeenth century, thought to be of Andrea del Sarto and his wife does not necessarily invalidate Conti's argument (see discussion).

5 According to Freedberg 1966, p. 35 n. 1, the Chicago pictures were purchased by Mrs. Danforth in New York in 1963 as "Portraits of an Italian Nobleman and his Wife," tentatively attributed to Franciabigio.

6 See Freedberg 1966.

7 J. Shearman, *Andrea del Sarto*, Oxford, 1965, vol. 1, pl. 137; and S. J. Freedberg, *Andrea del Sarto*, Cambridge, Mass., 1963, vol. 1, fig. 195.

8 For an illustration of the female portrait before cleaning and restoration, see Freedberg 1966, fig. 5.

9 Vasari, *Vite*, Milanesi ed., vol. 5, p. 40. "On his return to Florence, Andrea executed for Beccuccio da Gambassi, the glass-blower, who was very much his friend, a panel-picture of our Lady in the sky with the Child in her arms, and four figures below, S. John the Baptist, S. Mary Magdalene, S.

Sebastian, and S. Rocco; and in the predella he made portraits from nature, which are most lifelike, of Beccuccio and his wife. This panel is now at Gambassi, a township in Valdelsa, between Volterra and Florence" (G. Vasari, *Lives of the Most Eminent Painters, Sculptors and Architects*, tr. by G. Du C. de Vere, New York, 1979, vol. 2, p. 1031).

10 Shearman (note 7 above), vol. 2, p. 267, no. 76; and Freedberg 1963 (note 7 above), vol. 2, pp. 160–61.

11 Conti 1983–84, pp. 163, 165 n. 8.

12 Vasari, *Vite*, Milanesi ed., vol. 6, p. 260.

13 The painting in Edinburgh has long been considered a self-portrait by Sarto (see Brigstocke 1978, pp. 127–29).

14 Freedberg 1966, p. 19, fig. 4.

15 See A. Chastel, "Le Donateur *in abisso* dans les *pale*," in *Festschrift für Otto von Simson zum 65. Geburtstag,* Berlin, 1977, pp. 273–83.

Giovanni di Pietro, called Lo Spagna

Active Perugia by 1504, d. Spoleto 1528

Saint Catherine of Siena, 1510/15

Mr. and Mrs. Martin A. Ryerson Collection, 1937.1008

Tempera and oil on panel, 107.8 x 50.3 cm (42½ x 19¾ in.); painted surface: 103.8 x 49 cm (40⅞ x 19¼ in.)

CONDITION: The painting is in very good condition. It was cleaned by Leo Marzolo in 1938;[1] it was cleaned again in 1962 by Alfred Jakstas, who thinned the varnish and corrected inpainting, and in 1987 by Faye Wrubel, who again thinned but did not entirely remove the old varnish layer. The panel is composed of two boards with vertical grain joined approximately 27.5 cm from the left edge. The panel, which appears not to have been thinned, is approximately 3 cm thick. It is slightly bowed, and two horizontal battens were formerly inserted at the back, 23 and 86 cm respectively from the upper edge. Worm tunneling can also be detected at the sides and back of the panel. There were originally unpainted edges on all four sides; those at the sides have been painted black, while at the top the edge has been filled and the design extended. Damage to the paint surface is limited to scattered losses in the black robe, an irregularity caused by a disturbance in the wood below the saint's nose and through the side of her neck, some abrasion in the flesh tones, and more pronounced abrasion in the lower portions of the white robe. The landscape, apart from the sky, is extremely well preserved. An insoluble layer, applied overall and now brownish in tone, may be glare and was at some point mechanically removed from parts of the sky. These areas were toned in the most recent treatment. Examination with infrared reflectography revealed underdrawing in the face and hands (mid-treatment, x-radiograph).

PROVENANCE: Possibly William Blundell Spence, Florence, to 1857. Possibly sold by Spence to Lady Marion Alford (d. 1888), 1857.[2] Possibly by descent to her son Adelbert Wellington Brownlow, third Earl Brownlow (d. 1921), Ashridge Park, Berkhamsted;[3] sold Christie's, London, May 4, 1923, no. 50 (ill.), to Agnew for £924.[4] Sold by Agnew, London, to Martin A. Ryerson (d. 1932), Chicago, 1923;[5] intermittently on loan to the Art Institute from 1924; at Ryerson's death to his widow, Mrs. Martin A. Ryerson (d. 1937); bequeathed to the Art Institute, 1937.

REFERENCES: E. W. Gregory, "Earl Brownlow's Collection of Pictures at Ashridge Park," *Connoisseur* 13, 53 (1906), pp. 4–7 (ill.). Berenson 1909, p. 253; 1932, p. 544; 1936, p. 467; 1968, vol. 1, p. 412. Phillips, *Daily Telegraph*, December 7, 1909. U. Gnoli, "La pittura umbra alla Mostra di Burlington Club," *Rassegna d'arte umbra* 1 (1910), pp. 52–53. E. Harter, "Sei quadri dello Spagna," *Rassegna d'arte* 14 (1914), pp. 59 (ill.), 60. U. Gnoli, *Pittori e miniatori nell'Umbria*, Spoleto, 1923, pp. 165–66. AIC 1925, p. 160, no. 2077. Valentiner [1932], n. pag. Van Marle, vol. 14, 1933, pp. 458–60, fig. 297, p. 463. F. Mason Perkins in Thieme/Becker, vol. 31, 1937, p. 323. K. L. Brewster, "The Ryerson Gift to The Art Institute of Chicago," *Magazine of Art* 31, 2 (1938), p. 97. "Exhibition of the Ryerson Gift," *AIC Bulletin* 32 (1938), p. 3 (ill.). Bénézit, 2d ed., 1960, vol. 8, p. 41; 3d ed., 1976, vol. 9, p. 732. AIC 1961, p. 422. Huth 1961, p. 517. Maxon 1970, p. 253 (ill.). Fredericksen/Zeri 1972, pp. 191, 386, 571. *Dizionario*, vol. 10, 1975, p. 386. M. Levi d'Ancona, *The Garden of the Renaissance: Botanical Symbolism in Italian Painting*, Florence, 1977, p. 219, under no. 90. J. Fleming, "Art Dealing in the Risorgimento, III," *Burl. Mag.* 121 (1979), p. 500 n. 57. F. Gualdi Sabatini, *Giovanni di Pietro detto Lo Spagna*, Spoleto, 1984, vol. 1, pp. 57, 168, 193–94, no. 39, p. 195, under no. 41, vol. 2,

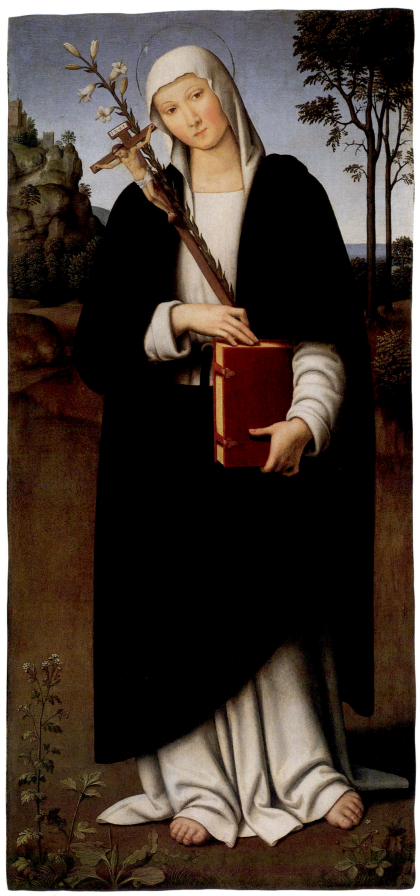

Giovanni di Pietro, called Lo Spagna, *Saint Catherine of Siena*, 1937.1008

pl. 73. F. Todini, *La pittura umbra dal duecento al primo cinquecento*, Milan, 1989, vol. 1, p. 313.

EXHIBITIONS: London, Burlington Fine Arts Club, *A Collection of Pictures of the Umbrian School*, 1910, no. 38. The Art Institute of Chicago, *A Century of Progress*, 1933, no. 119.

The painting has been unanimously attributed to Lo Spagna since its first publication in 1906.[6] The muted style and gentle characterization are wholly typical of this able follower of Perugino, who slightly modernized his master's style by drawing upon the example of Raphael. Although Van Marle (1933) and, more recently, Gualdi Sabatini (1984) have argued that the panel is close in date to the altarpiece executed in 1516 for the Basilica di San Francesco at Assisi, the style is almost certainly slightly earlier.[7] Comparison may be made with both the *Coronation of the Virgin* at Todi, which was begun in 1508 but not finished until 1511, and the fresco of the *Virgin Appearing to Saints Jerome, John the Baptist, Francis, and Anthony of Padua* at Trevi (Convent of San Martino), which is dated 1512.[8] As Gnoli (1923) pointed out, the pose of the saint in Chicago is very similar to that of the Virgin at Trevi, apart from the position of the arms.[9]

Harter (1914) was the first to compare the present panel with Lo Spagna's *Blessed Colomba of Rieti* (Perugia, Galleria Nazionale), formerly attributed to Perugino. Clearly, these two panels are close in date and similar in conception. It is, nevertheless, highly unlikely that they belonged to the same complex.[10] Indeed, in view of their substantial size, it is most improbable that either of these panels was ever inserted into a larger complex. More likely, they were meant to be seen as independent images in different locations.

Most authorities agree that the saint represented on the panel in Chicago is Saint Catherine of Siena, although Berenson (1909) began by referring to her as Santa Chiara and Van Marle (1933) tentatively identified her as the Blessed Colomba of Rieti, whose attribute is the lily, on comparison with the figure in Perugia. Proof that the painter has here represented Saint Catherine of Siena is found in the stigmata that are faintly but clearly indicated on the backs of the saint's hands.

The lily held by the saint in the same hand as the cross is a symbol of chastity. As Levi d'Ancona (1977) has stated, the lily is usually the attribute of the confessor saints as opposed to those who suffered martyrdom. According to Levi d'Ancona, the flowers in the left foreground are chamomile symbolizing Salvation or Resurrection.[11]

NOTES

1 The cleaning undertaken by Marzolo must have been superficial, judging from the fact that he was paid $10 to clean the present picture, the Ugolino di Nerio (1937.1007), and another picture attributed to a follower of Botticelli (memo dated May 11, 1938, in conservation files). Letters from Gerald Agnew to Martin Ryerson indicate that the frame was adjusted and the panel possibly treated for worm infestation when Ryerson acquired it, but give no indication of cleaning at that time (letters in Archives, The Art Institute of Chicago).

2 According to Fleming (1979), Ellis Waterhouse suggested that the present painting might have been acquired in 1857 from William Blundell Spence in Florence by Lady Marion Alford, mother of the second and third Earls Brownlow, if it can be identified with "a very fine St. Catherine by Pinturicchio" mentioned in a letter of April 14, 1857, from Spence to Lady Waldegrave.

3 Whether or not the present picture once belonged to Lady Marion Alford, it was in Earl Brownlow's possession by no later than 1906 (see Gregory 1906).

4 Price and buyer from *Art Prices Current, 1922–1923*, p. 205.

5 Invoice, Archives, The Art Institute of Chicago.

6 The back of the panel bears the old inscription in brush and brown ink: *originale di [...] Perugino*.

7 Gualdi Sabatini 1984, vol. 1, pp. 56–57; vol. 2, pl. 60.

8 Ibid., vol. 2, pls. 22, 45.

9 Gualdi Sabatini has related the Chicago picture stylistically not only to the works in Trevi and Todi but to the later *Mystic Marriage of Saint Catherine* (c. 1520) in the Palazzo Pitti in Florence (ibid., vol. 1, p. 194; vol. 2, pl. 110).

10 Ibid., vol. 2, pl. 285. Gualdi Sabatini has rejected the attribution of the *Blessed Colomba* to Lo Spagna and has assigned it instead to an artist in the circle of Perugino, possibly Ludovico d'Angelo Mattioli (ibid., vol. 1, pp. 348–50).

11 Levi d'Ancona 1977, pp. 78–79, no. 27.

Spinello Aretino

Active Arezzo 1373–1410/11

Pope Innocent III Sanctioning the Rule of Saint Francis, 1390/1400

Mr. and Mrs. Martin A. Ryerson Collection, 1933.1031

Tempera on panel (poplar), 88.7 x 62.9 cm (34⅞ x 24¾ in.)

CONDITION: The painting is in good condition. In 1945–46 the painting was cleaned by David Rosen at the Walters Art Gallery, Baltimore.[1] It was cleaned by Barry Bauman in 1978–79. The panel, which has a vertical grain, is composed of two boards joined approximately 15 cm from the left edge. It has been thinned, as is evident from exposed worm tunneling, and then cradled. There is an added strip approximately 1.8 cm wide at the upper edge of the panel, and the convex rim of the trilobed arch and the foliate decoration filling the spandrels extend over this added strip. These gilded decorations are early-twentieth-century additions.[2] A fabric interleaf is visible in the x-radiograph and at the edges of the panel. There is a vertical split extending upward from the lower edge on a line with, and reaching as far as the foot of, the papal throne. There is some further paint and ground loss in the lower right corner and at the edges of the panel. Other minor paint losses are mainly confined to the draperies, particularly in the area of the right arm of Saint Francis. The highlights on the draperies, however, are comparatively well preserved, apart from those of the Dominican cardinal, whose robe has darkened. The faces are especially well preserved. The papal throne was originally silvered, but this has now undergone chemical change and has darkened (infrared, ultraviolet, x-radiograph).

PROVENANCE: Private collection, Città di Castello, Umbria.[3] Sold by a dealer in Città di Castello to Horace Morison, Boston, by 1915.[4] Sold by Morison to Martin A. Ryerson (d. 1932), Chicago, 1916;[5] intermittently on loan to the Art Institute from 1916; bequeathed to the Art Institute, 1933.

REFERENCES: AIC 1917, p. 166. F. M. Perkins, "Una tavola d'altare di Spinello Aretino," *Rassegna d'arte* 18 (1918), pp. 5–6 (ill.). Fogg Art Museum, Harvard University, *Collection of Medieval and Renaissance Paintings*, Cambridge, Mass., 1919, p. 41. AIC 1920, p. 64. R. Wyer, "Two Panels by Spinello Aretino," *Art in America* 8, 4 (1920), p. 211 n. 1. AIC 1922, p. 74; 1923, p. 74. Van Marle, vol. 3, 1924, p. 606 n. 1. AIC 1925, p. 160, no. 2078. G. Gombosi, *Spinello Aretino: Eine stilgeschichtliche Studie über die florentinische Malerei der ausgehenden XIV. Jahrhunderts*, Budapest, 1926, pp. 39–40, 135. *Ryerson Collection 1926*, pp. 11–12. U. Procacci, review of *Spinello Aretino* by G. Gombosi, in *Rivista d'arte* 11 (1929), p. 276. Berenson 1932, p. 348; 1936, p. 471; 1963, vol. 1, p. 203. D. C. Rich, "The Paintings of Martin A. Ryerson," *AIC Bulletin* 27 (1933), p. 12. AIC 1935, p. 20. F. Mason Perkins in Thieme/Becker, vol. 31, 1937, p. 386. A. O. Quintavalle, "Precisazioni e restauri nella riordinata Galleria di Parma," *Bollettino d'arte* 31 (1937), p. 230. R. Brimo, *Art et goût: L'Evolution du goût aux Etats-Unis d'après l'histoire des collections*, Paris, 1938, p. 92. A. O. Quintavalle, *La Regia Galleria di Parma*, Rome, 1939, p. 180, under no. 452. AIC 1961, pp. 439–40. Huth 1961, p. 516. Fredericksen/Zeri 1972, pp. 192, 398, 571. H. W. van Os, "St. Francis of Assisi as a Second Christ in Early Italian Painting," *Simiolus* 7 (1974), pp. 125 n. 25, 127, fig. 14. M. Boskovits, *Pittura fiorentina alla vigilia del Rinascimento, 1370–1400*, Florence, 1975, pp. 146–47, 249 n. 244, 434, fig. 513.

EXHIBITIONS: The Art Institute of Chicago, *A Century of Progress*, 1933, no. 96. The Art Institute of Chicago, *A Century of Progress*, 1934, no. 38.

The attribution to Spinello Aretino has remained undisputed since the panel was first published by Perkins (1918). Perkins correctly dated the painting to Spinello Aretino's later years. Gombosi (1926), on the other hand, judged it to be an early work (c. 1370–79), but this was refuted by Procacci (1929). Boskovits (1975) suggested a date of 1390/95. Boskovits referred to the panel as a work of "exquisite elegance," a phrase that must be understood within the context of Spinello's career as a prolific artist much practiced in the looser technique of narrative fresco painting.[6] On the present panel, the painter's forceful late-gothic style is seen at its best in the treatment of the faces. The features look as though they have been chiseled out of wood, but this broad handling results in lively characterization. The architectural elements and the decorative features are more clumsily painted, and were perhaps left to an assistant.

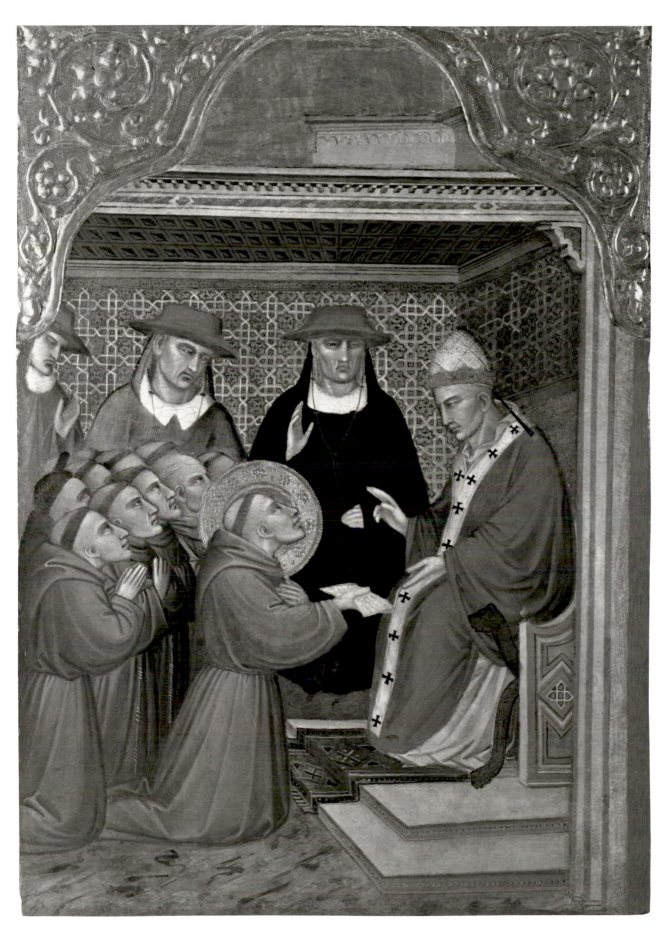

Perkins (1918) claimed to have seen the painting at the beginning of the century in a private *palazzo* in Città di Castello, Umbria; it is not known if it had always been in Città di Castello. Presumably, this panel originally formed part of a larger complex to which others illustrating scenes from the life of Saint Francis also belonged, although none of these has so far been rediscovered. These narrative scenes would probably have flanked a central cult image of the saint. A notable example of this type of complex honoring Saint Francis is the altarpiece painted in 1437–44 by Sassetta for the church of San Francesco, Borgo Sansepolcro. Sassetta's altarpiece is two-sided, the back comprising a series of eight scenes of the life of Saint Francis flanking a central image of the saint in ecstasy.[7] This particular format, with scenes from the life of the saint surrounding a full-length depiction, in turn recalls thirteenth-century altarpieces of Saint Francis.[8]

The cult of Saint Francis enjoyed great popularity in the fourteenth century, and the story of his life was illustrated in extensive narrative cycles. There has been some confusion about the identification of the subject of the Art Institute's painting. Saint Francis, accompanied by several brown-robed friars, is shown presenting a document to a Pope, who gestures in blessing. Three cardinals attend the enthroned Pope, the arm of whose chair is decorated with the head of a lion, while its leg terminates in a clawed foot. This motif is usually interpreted as a reference to the Throne of Solomon, or Throne of Wisdom (1 Kings 10.18–20), implying the origin of the Pope's authority. The subjects of *Pope Innocent III Sanctioning the Rule of Saint Francis* and *Pope Honorius III Confirming the Rule of Saint Francis* are not always easy to tell apart, particularly since compositionally they are often treated in a similar way. Van Os (1974) proposed *Pope Innocent III Sanctioning the Rule of Saint Francis*, whereas Boskovits (1975) continued to refer to this scene as *Pope Honorius III Confirming the Rule of Saint Francis*. On balance, it seems that here Spinello has probably depicted *Pope Innocent III Sanctioning the Rule of Saint Francis*, the literary source for which is Bonaventure's *Legenda maior*.[9] The one piece of internal evidence that might help to confirm this identification is the Dominican cardinal seated next to the Pope. This figure may be the

Bishop of Sabina, who, according to the *Legenda maior*, intervened at the Papal Curia on behalf of Saint Francis:

> Now when he had come unto the Roman Curia, and had been introduced into the presence of the Supreme Pontiff, he expounded unto him his intent, humbly and earnestly beseeching him to sanction the Rule aforesaid for their life. And the Vicar of Christ, the lord Innocent the Third, a man exceeding renowned for wisdom, beholding in the man of God the wondrous purity of a simple soul, constancy unto his purpose, and the enkindled fervour of a holy will, was disposed to give unto the suppliant his fatherly sanction. Howbeit, he delayed to perform that which the little poor one of Christ asked, by reason that unto some of the Cardinals this seemed a thing untried, and too hard for human strength. But there was present among the Cardinals an honour-worthy man, the lord John of Saint Paul, Bishop of Sabina, a lover of all holiness, and an helper of the poor men of Christ. He, inflamed by the Divine Spirit, said unto the Supreme Pontiff, and unto his colleagues; "If we refuse the request of this poor man as a thing too hard, and untried, when his petition is that the pattern of Gospel life may be sanctioned for him, let us beware lest we stumble at the Gospel of Christ. For if any man saith that in the observance of Gospel perfection, and the vowing thereof, there is contained aught that is untried, or contrary unto reason, or impossible to observe, he is clearly seen to blaspheme against Christ, the author of the Gospel."[10]

The composition of this panel is clearly inspired by the fresco of the same subject in the cycle of the *Legend of Saint Francis* in the Upper Church of San Francesco at Assisi,[11] the cycle that quickly came to be regarded as the official version of the saint's life after its completion at the very beginning of the fourteenth century. The direction of the action from left to right, the walls hung with damask, and the exclusion of the spectator from the room so that the figures are viewed through the architectural framework, as if in a tableau, are all features that the panel shares with the scene from the *Legend of Saint Francis*. The composition at Assisi is repeated on an altarpiece sometimes attributed to Giotto that was once in the church of San Francesco in Pisa (now in the Louvre),[12] where Spinello Aretino is recorded as having painted some frescoes, probably during his visit of 1391–92. Giotto developed the composition in the fresco painted in

one of the lunettes of the Bardi Chapel in Santa Croce, Florence,[13] after which it was widely disseminated in Italian painting, from Taddeo Gaddi to Domenico Ghirlandaio.[14] The composition had earlier been used in other contexts, as, for example, in reverse, by Ambrogio Lorenzetti for the fresco of *Saint Louis of Toulouse before Pope Boniface VIII* (Siena, San Francesco) and by Pietro Lorenzetti in two scenes from the predella of the Carmelite altarpiece of 1329 (Siena, Pinacoteca).[15] It seems, in fact, to have been Sienese artists who introduced the device of including a row of seated onlookers, seen from the back, positioned between the chief protagonists and the spectator, a composition specifically applied in a Franciscan context by Sassetta in his Borgo Sansepolcro altarpiece.[16]

Within Spinello's own oeuvre, variations of the composition occur on several other occasions: *The Dispute of Saint Catherine*, a fresco in the Oratorio di Santa Caterina all'Antella, Florence,[17] several times in the cycle of frescoes of scenes from the life of Pope Alexander III in the Sala di Balia in the Palazzo Pubblico, Siena,[18] in reverse in a drawing of *Pope Alexander III in Council* in The Pierpont Morgan Library, New York,[19] and on a predella panel, *Saint Benedict Giving the Rule to His Monks*, in the Galleria Nazionale, Parma.[20] Of these four, the last resembles the panel in Chicago most closely. It should also be observed that Vasari, in his life of Spinello Aretino,[21] described a fresco of *Pope Honorius III Confirming the Rule of Saint Francis* in the Cappella Marsuppini in the church of San Francesco, Arezzo, that seems to have had a similar composition, although it is now much damaged.[22]

NOTES

1 According to correspondence between David Rosen and Daniel Catton Rich (copies in curatorial files).

2 An earlier state of the picture without the foliate decoration is illustrated in Perkins 1918, p. 5. *Ryerson Collection 1926*, p. 11, states that the decoration is modern.

3 According to Perkins 1918, p. 6 n. 4.

4 Ibid. A letter from Morison to Ryerson of December 17, 1915, indicates that Morison owned the painting by that time (Archives, The Art Institute of Chicago).

5 Letter from Morison to Ryerson of February 16, 1916 (Archives, The Art Institute of Chicago).

6 Boskovits 1974, p. 147.

7 For a reconstruction, see A. Braham, "Reconstructing Sassetta's Sansepolcro Altarpiece," *Burl. Mag.* 120 (1978), pp. 386–90, esp. fig. 53. Van Os (1974) tentatively suggested, on the basis of the shape, scale, and narrative subject of the Art Institute's panel, that the complex to which it belonged might have provided a model for Sassetta. However, Christa Gardner-von Teuffel, "Masaccio and the Pisa Altarpiece: A New Approach," *Jahrbuch der Berliner Museen* 19 (1977), pp. 34–36 n. 40, showed that the model mentioned in the contract for the altarpiece in San Francesco, Borgo Sansepolcro, still survives in the Pinacoteca Nazionale of Sansepolcro.

8 Garrison 1949, p. 141, no. 361, p. 143, no. 371, p. 154, no. 402, p. 155, nos. 405, 408, p. 156, nos. 409–11.

9 *The Life of Saint Francis by Saint Bonaventura*, tr. by E. G. Salter, The Temple Classics, London, 1904, pp. 29–30, ch. 3, sec. 9.

10 Ibid.

11 Scene 7, illustrated in A. Smart, *The Assisi Problem and the Art of Giotto*, Oxford, 1971, pl. 53.

12 G. Previtali, *Giotto e la sua bottega*, Milan, 1967, fig. 494.

13 Ibid., fig. 371.

14 Gaddi used the composition in a scene on the doors of the reliquary cupboard in the Sacristy of Santa Croce, Florence (L. Marcucci, *Gallerie Nazionali di Firenze: I dipinti toscani del secolo XIV*, Rome, 1965, pl. 31r); Ghirlandaio used it in the frescoes decorating the Sassetti chapel in Santa Trinita, Florence (E. Borsook, *The Mural Painters of Tuscany*, 2d ed., Oxford, 1980, pl. 144).

15 G. Rowley, *Ambrogio Lorenzetti*, Princeton, 1958, vol. 2, figs. 104 and 102–03, respectively.

16 The relevant panel is in The National Gallery, London; see Braham (note 7), fig. 51, lower left.

17 Van Marle, vol. 3, 1924, fig. 329.

18 A. Cairola and E. Carli, *Il Palazzo Pubblico di Siena*, Rome, 1963, pl. XLI.

19 M. J. Zucker, "A New Drawing by Parri Spinelli and an Old One by Spinello," *Master Drawings* 7, 4 (1969), pp. 400–04, fig. 1.

20 Quintavalle 1937, p. 229.

21 Vasari, *Vite*, Milanesi ed., vol. 1, p. 681.

22 A detail of this fresco is reproduced in P. P. Donati, "Sull'attività giovanile dei due Spinello," *Commentari* 17 (1966), p. 59, fig. 3, as by Parri Spinelli.

Gherardo di Jacopo, called Starnina

Active Florence by 1387, d. Florence by 1413

The Dormition of the Virgin, 1401/05

Mr. and Mrs. Martin A. Ryerson Collection, 1933.1017

Tempera on panel (poplar), 43.6 x 67.6 cm (17⅛ x 26⅝ in.); painted surface: 40.4 x 64 cm (15¹⁵⁄₁₆ x 25¼ in.)

CONDITION: The painting is in excellent condition. Leo Marzolo secured the lower paint edge and revarnished the picture sometime after 1933. It was cleaned by Lawrence Majewski in 1963. The panel is composed of a single board approximately 3 cm thick with horizontal grain. A vertical batten formerly attached to the back of the panel at the center was secured by four nails driven into the wood from the front. Their backs were cut off following the removal of the batten, but are still visible. The panel was prepared with a fabric interleaf visible in the x-radiograph. There are added strips at the sides and top of the panel. An added strip at the bottom was removed during the 1963 cleaning. All the edges were apparently trimmed slightly in preparation for the addition of these strips, which have been gilded and re-painted. At the bottom, what must have been an unpainted edge approximately 1.5 mm wide has been filled and repainted. Similarly, an unpainted strip approximately 8 mm wide, measuring from the edge of the original panel, has been filled and repainted on either side. These edges suggest that the picture was painted in an engaged frame, as do the gaps left at the top between the pinnacles of a former cusped frame. These gaps have now been filled and gilded so that their contours are more clearly visible in the x-radiograph (fig. 1).

The paint surface is in excellent condition. It is basically intact, except for some inpainting in the draperies of the figures at the extreme left and right, in the ground plane, and in the cherubim above Christ, which are painted over fills. The gold ground is also in good condition, though a small section of the halo of the apostle standing fourth from the right has been filled (infrared, ultraviolet, x-radiograph).

PROVENANCE: D. P. Sellar, London; sold Galerie Georges Petit, Paris, June 6, 1889, no. 18, for Fr 300.[1] Jean Dollfus, Paris; sold Galerie Georges Petit, Paris, pt. 3, April 1–2, 1912, no. 51, p. 19 (ill.), as Florentine School, to Sambon for Fr 20,000.[2] Arthur Sambon, Paris, 1912–14; sold Galerie Georges Petit, Paris, May 25–28, 1914, no. 213 (ill.), as Florentine School, to Trotti for Fr 9,000.[3] Marcel Nicolle, Paris. Sold by Nicolle to Hermann Heilbuth, Copenhagen, by 1920.[4] Ehrich Galleries, New York. Sold by the Ehrich Galleries to Martin A. Ryerson (d. 1932), Chicago, 1923;[5] on loan to the Art Institute from 1923; bequeathed to the Art Institute, 1933.

Fig. 1 X-radiograph of *The Dormition of the Virgin*, 1933.1017

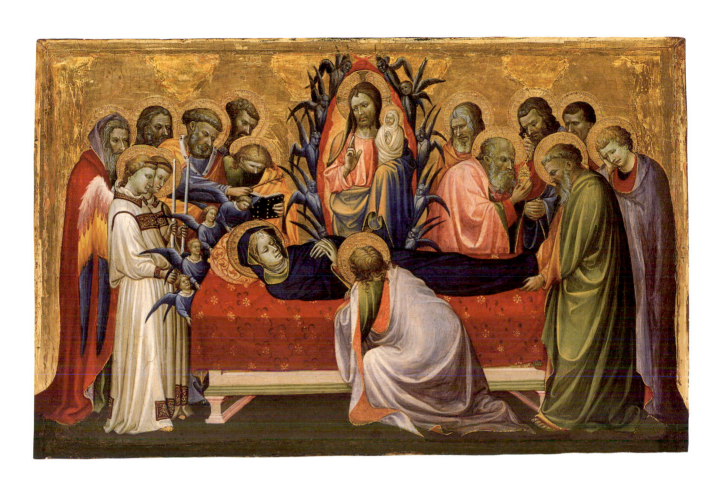

REFERENCES: "The Dollfus Sale," *American Art News* 10, 26 (1912), p. 10. B. Berenson, *Catalogue of a Collection of Paintings and Some Art Objects: Italian Paintings*, Philadelphia, 1913, vol. 1, p. 10, no. 13. S. Reinach, *Répertoire de peintures du moyen age et de la renaissance (1280–1580)*, vol. 5, Paris, 1922, p. 442 (ill.). AIC 1925, p. 160, no. 2052. *Ryerson Collection* 1926, pp. 13–15. Van Marle, vol. 9, 1927, pp. 199–200 n. 1. AIC 1932, p. 181, no. 168.23. Berenson 1932, p. 339; 1936, p. 277; 1963, p. 139. Valentiner [1932], n. pag. AIC 1935, p. 20. G. Pudelko, "The Maestro del Bambino Vispo," *Art in America* 26 (1938), p. 54, fig. 4. AIC 1948, p. 25. Davies 1951, p. 281, under no. 3926; 1961, pp. 362–63, under no. 3926. AIC 1961, p. 298. Huth 1961, p. 516. L. Bellosi, *La pittura tardogotica in Toscana*, I Maestri del Colore 239, Milan, 1966, [p. 5] n. pag. B. Degenhart and A. Schmitt, *Corpus der italienischen Zeichnungen, 1300–1450*, pt. 1, vol. 2, Berlin, 1968, pp. 296–97, no. 195, fig. 400. Fredericksen/Zeri 1972, pp. 125, 307, 571. C. Volpe, "Per il completamento dell'altare di San Lorenzo del Maestro del Bambino Vispo," *Mitteilungen des Kunsthistorischen Institutes in Florenz* 17 (1973), p. 351. J. van Waadenoijen, "A Proposal for Starnina: Exit the Maestro del Bambino Vispo?" *Burl. Mag.* 116 (1974), p. 90. R. Fremantle, *Florentine Gothic Painters from Giotto to Masaccio*, London, 1975, p. 445 (ill.). F. Sricchia Santoro, "Sul soggiorno spagnolo di Gherardo Starnina e sull'identità del 'Maestro del Bambino Vispo,'" *Prospettiva* 6 (1976), pp. 14, 19, fig. 10. C. Syre, *Studien zum "Maestro del Bambino Vispo" und Starnina*, Ph. D. diss., Bonn, 1979, pp. 113–14, fig. 124. J. van Waadenoijen, *Starnina e il gotico internazionale a Firenze*, Florence, 1983, pp. 45, 60, 67–68, pl. 54.

EXHIBITIONS: Copenhagen, Statens Museum for Kunst, *A Collection of Paintings…Exhibited in the Danish Museum of Fine Art*, 1920, no. 4. The Art Institute of Chicago, *A Century of Progress*, 1933, no. 90.

The events surrounding the Dormition, Burial, and Assumption of the Virgin are recounted in detail by Jacobus de Voragine in *The Golden Legend*.[6] Through divine intervention, the apostles were transported to the Virgin's deathbed and were all present when her soul left her body without pain to be reunited with Christ, who was accompanied by a heavenly host. In the present painting, Christ is centrally placed in a mandorla surrounded by cherubim and receives the soul of the Virgin in the form of a child in swaddling clothes. There is no indication of the martyr's palm that the angel carries in scenes of the Annunciation of the Virgin's Death and that is often included in the Dormition as a symbol of Paradise. The apostle on the left, using an aspergillum, is probably Saint Peter, while the bald apostle on the right holding a censer may be Saint Paul. Saint John the Evangelist is either the beardless apostle reading the order of service or the figure seen from the back kneeling on one knee in front of the bier. The iconographic tradition is essentially derived from Byzantine art, although somewhat abbreviated as regards the number and identity of the figures.

Berenson (1913) was the first to classify *The Dormition of the Virgin* as a work by the Master of the Bambino Vispo, so-called because of the lively pose of the Christ Child in his Madonna images. This anonymous master, presumed to have been active in Florence and Valencia, has recently been convincingly identified with the documented career of Gherardo Starnina.[7] A pupil of Antonio Veneziano according to Vasari, in 1387 Starnina registered with the guild of Saint Luke in Florence.[8] He traveled to Spain and possibly also to France, apparently settling in Valencia where he is mentioned in documents between 1395 and 1401. He must have returned to Florence shortly thereafter, becoming, with Lorenzo Monaco, one of the most important painters working in the International Gothic style in that city. Fragments of documented fresco decorations painted in 1409 for Santo Stefano at Empoli are the basis for assigning to him the body of work given to the Master of the Bambino Vispo (Van Waadenoijen 1974).

In *The Dormition of the Virgin*, the steeply foreshortened head of the apostle reading the order of service on the left is highly characteristic of Starnina, as is the use of a crouching figure seen from behind to define space. The calligraphic treatment of individual strands of hair and the sharply pointed noses are closely related to Valencian painting (Marzal de Sas and Pedro Nicolau). There is a striking similarity between the figure of Christ in this panel and that in *The Ascension* by the so-called Gil Master (New York, Hispanic Society).[9] These expressive qualities suggest a date close to Starnina's Spanish sojourn, possibly 1401/05, the date proposed by Van Waadenoijen.[10] As is so often the case with Starnina, the panel in Chicago is well-nigh perfectly preserved and the colors have not deteriorated. The artist worked with the delicacy, precision, and technical finesse of a miniature painter. The subject is repeated

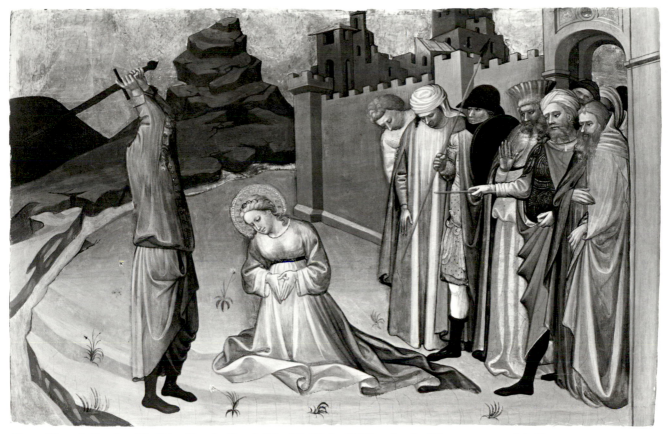

Fig. 2 Gherardo Starnina, *The Beheading of a Female Saint,* The National Gallery, London [photo: courtesy of the Trustees, The National Gallery, London]

elsewhere in Starnina's oeuvre, on a panel in the John G. Johnson Collection in Philadelphia,[11] and apparently on a panel in a private collection in Cologne.[12]

Davies (1951, 1961) first observed that a panel in The National Gallery, London (fig. 2; 40.6 x 62.9 cm), possibly formed part of the same predella as *The Dormition of the Virgin*. The measurements are sufficiently close, and there are traces of the same type of cusped framing along the upper edges of both panels to make this suggestion a distinct possibility. The panel in London shows the beheading of an unidentified female saint. Davies also asserted, probably correctly, that the panel in Chicago would have been placed in the center of the predella, owing to the importance of its subject. Volpe (1973) has since identified a third panel, depicting *The Last Communion of Mary Magdalen*, as belonging to the same predella, although the cusped framing along the upper edge is less pronounced in this case, judging from the photograph.[13] Volpe tentatively advanced

the idea that these three panels might have been placed in the predella of the triptych of the *Virgin and Child with Saints Margaret, Andrew, Peter, and Mary Magdalen* in the Martin-von-Wagner-Museum in Würzburg.[14] Yet, both iconographically and from the point of view of size, such a reconstruction does not appear to be feasible. It should be noted that similar marks made by a cusped frame are also visible along the upper edges of two more predella panels by this hand both in the Museum of Fine Arts in Boston,[15] although they are of slightly different dimensions (32 x 73.5 cm) from the panels in London and Chicago.

NOTES

1 For price, see annotated copy of 1889 sale catalogue (Fine Arts Division, Topeka Public Library, Topeka, Kansas), and annotated copy of 1914 Sambon Collection sale catalogue (The Thomas J. Watson Library, The Metropolitan Museum of Art, New York).

2 For buyer, see annotated copy of 1912 Dollfus Collection sale catalogue (Ryerson Library, The Art Institute of Chicago); for price, see annotated copy of 1914 Sambon Collection sale catalogue (note 1).

3 For price and buyer, see annotated copy of 1914 Sambon Collection sale catalogue (note 1).

4 See 1920 exhibition catalogue.

5 According to invoice dated February 1, 1923, in curatorial files.

6 *The Golden Legend*, vol. 2, pp. 450–51.

7 See Van Waadenoijen 1974 and 1983, and Syre 1979. The identification with Starnina is now also accepted by Boskovits (M. Boskovits, "Il percorso di Masolino: precisazioni sulla cronologia e sul catalogo," *Arte cristiana* 75 [1987], p. 61 n. 6.)

8 Vasari, *Vite*, Milanesi ed., vol. 2, p. 5.

9 C. R. Post, *A History of Spanish Painting*, vol. 3, Cambridge, Mass., 1930, p. 87, fig. 281.

10 Van Waadenoijen 1983, pp. 67–68. Syre (1979, p. 114) suggested that the execution of the Chicago panel was due in part to an assistant. But after seeing the picture, she correctly concluded that it was autograph throughout and proposed a date of c. 1404–07 (letter from Cornelia Syre to Susanna Meade of April 7, 1986, in curatorial files).

11 B. Sweeny, *John G. Johnson Collection: Catalogue of Italian Paintings*, Philadelphia, 1966, p. 51, no. 13, fig. 13.

The Johnson panel is a fragment of the central section of an altarpiece, the upper part of which is *The Assumption of the Virgin* in the Fogg Art Museum in Cambridge. For a photomontage, see Berenson 1963, vol. 1, fig. 470.

12 Bellosi 1966.

13 See Volpe 1973, fig. 6. According to Volpe (p. 351), *The Last Communion of Mary Magdalen* (42 x 65 cm) appeared at auction at the Palais Galliera on March 15, 1973, with an attribution to Sienese School, fourteenth century; the picture does not appear to be listed, however, in the sale catalogues of the two sales occurring at the Palais Galliera on that date, according to the staff of the Resource Collection of the Getty Center for the History of Art and the Humanities, Santa Monica.

14 See H. Ragaller, *Martin-von-Wagner-Museum der Universität Würzburg: Verzeichnis der Gemälde und Skulpturen*, Würzburg, 1969, p. 33; and, for a reproduction of the whole triptych, Berenson 1963, vol. 1, pl. 475.

15 *Isaiah with Two Angels* and *Jeremiah with Two Angels*, nos. 20.1856–57, the former illustrated by Van Marle, vol. 9, 1927, fig. 133, and both illustrated by Syre 1979, figs. 136–37.

Taddeo di Bartolo

1362/1363 Siena 1422

The Crucifixion, 1401/04

Mr. and Mrs. Martin A. Ryerson Collection, 1933.1033

Tempera on panel, 37.6 x 72.4 cm (14¾ x 28½ in.); painted surface: 33 x 68 cm (13 x 26¾ in.)

INSCRIBED: ·S·P· (on shield of soldier at right)

CONDITION: The painting is in fairly good condition. In 1961 Alfred Jakstas removed varnish and inpainted the picture, but left much old repaint which obscured original paint layers. This old repaint was removed in 1987–88 by Karin Knight, who cleaned and restored the painting. The panel has been thinned and cradled, and strips of approximately 2–2.5 cm have been added on all sides. These have been painted black. The paint surface at the top and bottom edges of the original support is quite broken up and has been filled and inpainted, although a line of punching at the top indicates that this is indeed the original margin of the image. The loss at the bottom edge is particularly extensive around the foot of the cross and into Christ's feet. The left edge is also damaged and the head of the figure at the extreme left largely reconstructed. The heads, draperies, and punched halos are comparatively well preserved, except for those of Longinus and the centurion. The gold background, halo of Longinus, and figures of Longinus and the centurion are rather abraded. The robes of Longinus and the centurion are painted over gold, with the decorative details executed in sgraffito technique. The outlines of forms that overlap the gold ground are incised, though the gold was very liberally applied in these areas and continues under the helmets of the soldiers on the right, under the rock forms around them, and under Christ's body. *Pentimenti* are visible at the thumb of the Magdalen's right hand and in the centurion's feet (infrared, mid-treatment, ultraviolet).

PROVENANCE: John Rushout, second Baron Northwick, Thirlestane House, Cheltenham, by 1857;[1] sold Phillips at Thirlestane House, August 18, 1859, no. 1467, as Giotto, to Cox, Berners Street, for 13 gns.[2] Canon A. F. Sutton, Brant Broughton, by 1909;[3] sold Sotheby's, London, June 25, 1924, no. 33 (ill.), as Giotto, to Oliver for £460.[4] Robert Langton Douglas, London, 1924. Sold by Langton Douglas to Martin A. Ryerson (d. 1932), Chicago, 1924;[5] on loan to the Art Institute from 1924; bequeathed to the Art Institute, 1933.

REFERENCES: *A Handbook to the Paintings by Ancient Masters in the Art Treasures Exhibition, being a reprint of critical notices originally published in "The Manchester*

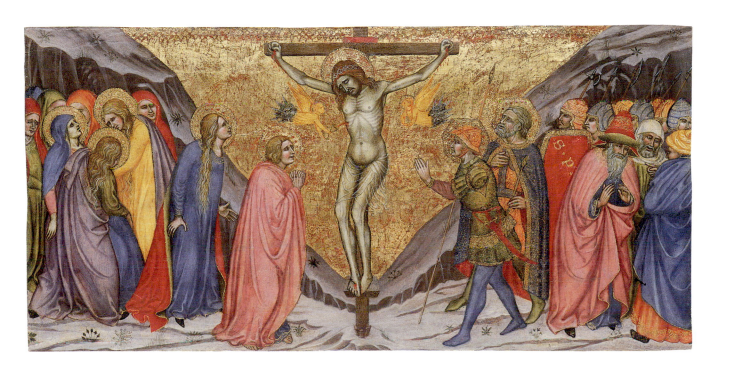

Guardian," London, 1857, p. 12. *Catalogue of the Extensive and Magnificent Collection of Paintings...at Thirlestane House, Cheltenham; The Property of John Rushout, Baron Northwick, Deceased; with the Purchasers' Names and Prices*, London, 1859, p. 20. W. Bürger [T. Thoré], *Trésors d'art en Angleterre*, 3d ed., Paris, 1865, pp. 22–23. J. A. Crowe and G. B. Cavalcaselle, *A History of Painting in Italy*, 2d ed., vol. 2, ed. by R. Langton Douglas, London, 1903, p. 112 (Lord Northwick collection misprinted as "Laci Nouhurik"). Berenson 1909a, p. 256; 1932, p. 551; 1936, p. 474; 1968, vol. 1, p. 418. AIC 1925, p. 160, no. 2080. [R. M.] F[ischkin], "A Crucifixion by Taddeo di Bartolo," *AIC Bulletin* 20 (1926), pp. 17–19 (ill.). *Ryerson Collection 1926*, pp. 27–29. AIC 1932, p. 183, no. 2923.24. "Ryerson Makes Princely Bequest to The Art Institute of Chicago," *Art Digest* 6 (1932), no. 20, p. 4 (ill.). Valentiner [1932], n. pag. AIC 1935, p. 20. F. Mason Perkins in Thieme/Becker, vol. 32, 1938, p. 396. AIC 1961, pp. 443–44. Huth 1961, p. 517. S. Symeonides, *Taddeo di Bartolo*, Siena, 1965, pp. 106–07, 222–23, 254 (ill.). H. W. van Os, *Marias Demut und Verherrlichung in der sienesischen Malerei, 1300–1450*, Kunsthistorische Studiën van het Nederlands Historisch Instituut te Rome 1, The Hague, 1969, p. 174 n. 78. Fredericksen/Zeri 1972, pp. 194, 291, 571. B. Klesse, *Katalog der italienischen, französischen, und spanischen Gemälde bis 1800 im Wallraf-Richartz Museum*, Cologne, 1973, pp. 122–23. M. Zucker, "The Polygonal Halo in Italian and Spanish Art," *Studies in Iconography* 4 (1978), p. 73, app. 1C, pt. 3(d). D. Sutton, "Robert Langton Douglas: Dramatic Days," *Apollo* 109 (1979), p. 469, fig. 38. G. C. Dini in *Il gotico a Siena: Miniature, pitture, oreficerie, oggetti d'arte*, exh. cat., Siena, Palazzo Pubblico, 1982, under no. 121.

EXHIBITIONS: Manchester, *Art Treasures of the United Kingdom*, 1857, no. 26, as Giotto. The Art Institute of Chicago, *A Century of Progress*, 1933, no. 98.

Berenson (1909) was the first to attribute this panel to Taddeo di Bartolo, and this suggestion has been universally accepted, with the exception of the Ryerson Collection catalogue of 1926 and, more recently, Fredericksen and Zeri (1972), who regarded it as a product of the workshop. The composition is certainly less elaborate than a similar scene painted for the predella of the magnificent altarpiece at Montepulciano, or in the predella panels now in the Louvre and in the Campana Collection in the Musée du Petit Palais at Avignon, but this does not necessarily denote a lowering of quality.[6] While the distribution of the figures is less complicated than in the other panels, the symmetrical arrangement of the groups is not without iconographical significance, in that the Holy Women and Saint John the Evangelist, to the left of Christ, are balanced, on the right, by those of varying or of different allegiance. The dramatic swaying motion of the figures and the broad characterization of their features are typical of Taddeo di Bartolo at his best. The female figure seen from the back supporting the fainting Virgin in the group at the left is admirably realized. A similar figure occurs in the fresco of *The Funeral of the Virgin* in the chapel of the Palazzo Pubblico in Siena.[7]

Taddeo di Bartolo's style is best described as transitional. His treatment of figures is archaizing, but the vigorous narrative, which is to a limited extent exemplified in the present painting, was of some significance for Sienese artists like Sassetta and Giovanni di Paolo (1933.1010–15) working during the middle decades of the fifteenth century. Active at the end of the fourteenth century in Genoa and Pisa, Taddeo di Bartolo also carried out commissions for altarpieces in Siena, Montepulciano, and Perugia at the beginning of the fifteenth century. He was a prolific artist with a large workshop based in Siena and, insofar as his work reflected developments in Emilian painting, it is clear that he helped to open up Sienese art to outside influences.

The present panel, as its shape and dimensions suggest, once formed the center of a predella, other parts of which probably showed scenes from the Passion. Several attempts have been made to reconstruct this predella. Zeri suggested that *The Resurrection* (Cologne, Wallraf-Richartz Museum), *The Arrest of Christ* and *Christ in Limbo* (both formerly in the Kisters collection in Kreuzlingen and now in the Kahl collection in Cologne), and *The Way to Calvary* (location unknown), formed part of the same complex.[8] Klesse (1973), however, rightly pointed out that *The Crucifixion* in Avignon is more likely to have formed the center of the predella to which *The Resurrection* and the two panels now in the Kahl collection once belonged, since all four panels are of the same height (28–29.5 cm).[9] *The Way to Calvary*, which measures 32.5 x 33 cm, probably belonged, instead, to a different predella, together with *The Crucifixion* in Chicago, as both are the same height and *The Way to Calvary* is approximately half the length of *The Crucifixion*. In addition, both panels were once owned

Fig. 1 Taddeo di Bartolo, *The Resurrection*, location unknown

by Langton Douglas, who, in 1927, according to Symeonides, stated on the back of a photograph that they came from the same predella.[10] The movement of the figures from left to right in *The Way to Calvary* implies that it would have been in the left half of the predella. It has also been suggested that *The Resurrection* (fig. 1) sold at the Spiridon sale in Amsterdam might have once formed part of it, since its size, style, and halo patterns are compatible with those of the other two panels.[11]

The Ryerson Collection catalogue of 1926 and Symeonides both related *The Crucifixion* to the predella commissioned in 1401 from Taddeo di Bartolo for the altarpiece, now lost, in the chapel of the Palazzo Pubblico in Siena. The lavish use of gold revealed in the recent technical examination of the panel might, indeed, suggest an association with such an important altarpiece. Yet, in view of the large number of unattached predella panels in the artist's oeuvre, this connection can be no more than supposition without proper documentation. Furthermore, the prestigious commission of 1401 may in itself have resulted in an increased demand for predella panels with scenes of the Passion; the date of 1401/04 suggested by Symeonides may thus have some credence

beyond purely stylistic considerations. The disposition of the predella panels on the completed altarpiece to which *The Crucifixion* belonged might have resembled that in the altarpiece painted by Taddeo di Bartolo in 1411 for the Palazzo dei Priori in Volterra.[12]

There are two points of iconographical interest in the present panel. First, the two figures standing beneath the cross to the right are, respectively, Saint Longinus, who holds a spear, and the centurion, who holds a military baton. Figures with either of these attributes are both sometimes referred to as Saint Longinus, although there are separate scriptural sources for the independent roles of Saint Longinus and the centurion at the Crucifixion.[13] The distinction is clearly made, for instance, by Simone Martini in *The Crucifixion* in Antwerp (Musée Royal des Beaux-Arts) from the so-called Passion Polyptych.[14] Saint Longinus and the centurion are, as here, frequently shown in Sienese painting of the late trecento or early quattrocento with hexagonally shaped halos signifying an implied form of sanctity and denoting a lower rank in the religious hierarchy reserved for the predecessors of Christ.[15] Secondly, two of the three Pharisees in the right foreground have exotic headgear: the one nearest the edge of the panel is an Oriental type and wears a turban; the other, facing outward, wears a tall conical hat with a turned-up brim and a flap at the back, which may have been inspired by a type of Hungarian dress sometimes found in Sienese paintings.[16] Such costumes are properly correlated with their wearers in the fresco by Ambrogio Lorenzetti of a *Franciscan Martyrdom* (c. 1326) in the church of San Francesco in Siena.[17]

The panel was engraved by Giuseppe Craffonara (1792–1837) with an attribution to Giotto.[18]

NOTES
1 According to the 1857 Manchester exhibition catalogue.
2 See 1859 Northwick collection catalogue.
3 According to Berenson 1909a.
4 According to annotated sales catalogue in the Thomas J. Watson Library, The Metropolitan Museum of Art, New York.
5 According to a letter from Robert Langton Douglas to Martin A. Ryerson of November 11, 1924, and a receipt dated November 18, 1924, in the Ryerson papers, Archives, The Art Institute of Chicago.
6 Symeonides 1965, pls. XXXc, LIIIa, LXXXVIc.
7 A. Cairola and E. Carli, *Il Palazzo Pubblico di Siena*, Rome, 1963, pl. XXXVIII.

8 Reported in Klesse 1973, pp. 122–23, which includes an illustration of *The Resurrection*. *The Way to Calvary* is illustrated in Symeonides 1965, pl. LIV.

9 For an illustration of *The Crucifixion* in the Campana Collection in the Musée du Petit Palais in Avignon, see M. Laclotte and E. Mognetti, *Avignon, Musée du Petit Palais: Peinture italienne*, Inventaire des collections publiques françaises 21, Paris, 1976, no. 227.

10 Symeonides 1965, p. 223, under note to pl. LIV.

11 This connection was suggested in notes compiled by Valerie Tvrdik in curatorial files. For *The Resurrection* (location unknown), see Frederik Muller, Amsterdam, June 19, 1928, no. 11 (ill.), 34 x 34 cm, from the collection of the Conti Galotti di Alessio, Pavia.

12 Symeonides 1965, pl. LXIV.

13 L. Réau, *Iconographie de l'art chrétien*, Paris, 1958, vol. 3, pt. 2, pp. 812–15.

14 G. Paccagnini, *Simone Martini*, Milan, 1955, pl. 13.

15 See the list published by Zucker 1978, pp. 72–73, app. 1C, pt. 3(d).

16 Observations concerning the origin of these figure types and their costumes may be found, respectively, in N. von Holst, "Ikonographie des Pfingstbildes in der Spanischen Kapelle," *Mitteilungen des Kunsthistorischen Institutes in Florenz* 16 (1972), pp. 261–68; and in S. M. Newton, "Tomaso da Modena, Simone Martini, Hungarians and St. Martin in Fourteenth-Century Italy," *Journal of the Warburg and Courtauld Institutes* 43 (1980), pp. 234–38.

17 G. Rowley, *Ambrogio Lorenzetti*, Princeton, 1958, vol. 1, pp. 80–85; vol. 2, figs. 111–20.

18 An impression of the engraving was offered for sale with the panel at Sotheby's, London, June 25, 1924, no. 33. The author has failed to find an impression. It is possible that the print might provide evidence of the early provenance of the panel.

Domenico Tintoretto

1560 Venice 1635

Venus and Mars with Cupid and the Three Graces in a Landscape, 1590/95

Charles H. and Mary F. S. Worcester Collection, 1929.914

Oil on canvas, 106.5 x 142.8 cm (41⅞ x 56¼ in.)

CONDITION: The painting is in poor condition. In 1966–67 Alfred Jakstas cleaned it, removing an old glue lining and attaching new lining fabric with wax.[1] The original canvas has a twill weave. The paint surface now has a very disturbed appearance due to a combination of abrasion, blanching, and discolored inpainting, accentuated by the fact that the image was painted over another composition. As the x-radiograph (fig. 2) indicates, a half-length figure of a penitent female saint was first painted perpendicular to the present design. In the mid-treatment photograph, her eye is faintly visible beneath Venus's left thigh. This area was further confused by the removal in the 1966–67 cleaning of a diaphanous veil that had been painted across Venus's abdomen. This area is now substantially inpainted. The armor in the lower left corner is painted over the crimson drapery that once filled most of this corner of the picture and may have belonged to the penitent saint. Whether the artist utilized part of this drapery for the new composition or whether it was uncovered by subsequent cleaning remains unclear. In addition, there are paint and ground losses in the thighs of the Graces at left and right, in the trees surrounding Venus's head, in her neck, and along the edges of the canvas (infrared, mid-treatment, ultraviolet, x-radiograph).

PROVENANCE: Don Gaspar Méndez de Haro y Guzmán, Marqués del Carpio y Helice and viceroy of Naples (d. 1687), Madrid and Naples.[2] Probably by descent to the Alba collection through Don Gaspar's daughter, Doña Catalina, who in 1688 married the tenth Duke of Alba.[3] Price collection, London, nineteenth or early twentieth century.[4] Dowdeswell and Dowdeswell, London.[5] H. M. Clark, London.[6] D. Heinemann, Munich. Sold by Heinemann to Charles H. Worcester, 1928.[7] Charles H. Worcester, Chicago, 1928–29; on loan to the Art Institute from 1928; given to the Art Institute, 1929.

REFERENCES: *Art News* 27, 13 (1928), p. 24 (ill.). D. C. R[ich], "Mars and Venus by Tintoretto," *AIC Bulletin* 22 (1928), pp. 102–03 (cover ill., detail ill.). D. C. Rich, "Chicago Given Worcester Art," *Art News* 28, 22 (1930), p. 9. D. C. Rich, "The Mr. and Mrs. Charles H. Worcester Gift," *AIC Bulletin* 24 (1930), p. 30. L. Venturi 1931, pl. CCCCIX. AIC 1932, p. 4 (ill.). Berenson 1932, p. 558; 1936, p. 480; 1957, vol. 1, p. 171, vol. 2, pl. 1285. A. L. M[ayer], "Italienische Bilder in Amerika," *Pantheon* 10 (1932), p. 218. D. C. Rich, "Die Ausstellung 'Fünf Jahrhunderte der Frühmalerei' in Chicago," *Pantheon* 12 (1933), p. 381. AIC 1935, p. 21 (detail ill.). *Worcester Collection* 1938, p. 15, no. 11, pl. X. Thieme/Becker, vol. 33, 1939, p. 193. L. Coletti, *Il*

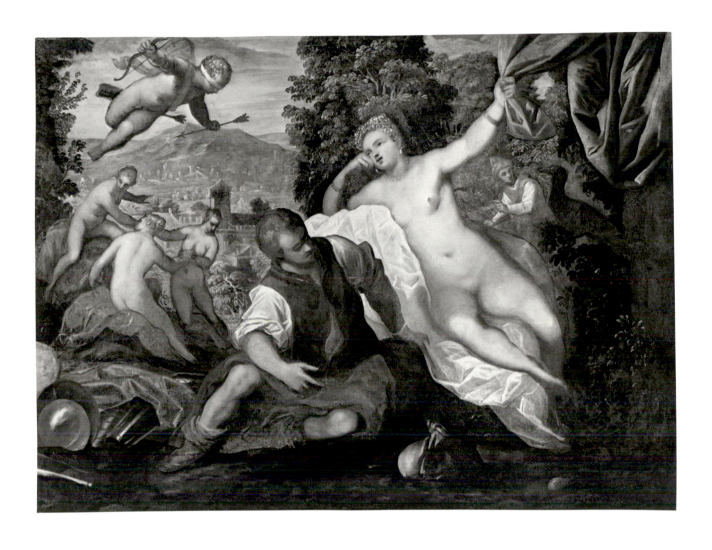

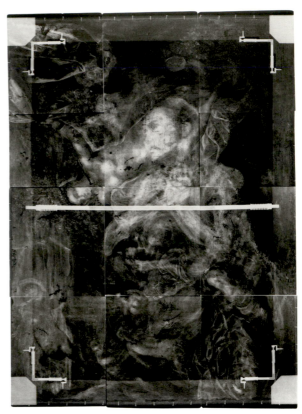

Fig. 1 Monogram on old lining canvas of *Venus and Mars with Cupid and the Three Graces in a Landscape*, 1929.914

Fig. 2 X-radiograph of *Venus and Mars with Cupid and the Three Graces in a Landscape*, 1929.914 (rotated 90°)

Tintoretto, Bergamo, 1940, p. 31. E. von der Bercken, *Die Gemälde des Jacopo Tintoretto*, Munich, 1942, pp. 70, 107, no. 62, fig. 193. R. Shoolman and C. E. Slatkin, *The Enjoyment of Art in America*, Philadelphia and New York, 1942, pl. 322. AIC 1946, pp. 25–27 (ill.); 1948, p. 26. F. A. Sweet, "La pittura italiana all'*Art Institute* di Chicago," *Le vie del mondo: Rivista mensile del Touring Club Italiano* 15 (1953), p. 689. W. Suida, *The Samuel H. Kress Collection at the University of Arizona*, Tucson, 1957, n. pag., under no. 16. AIC 1961, p. 450. F. A. Sweet, "Great Chicago Collectors," *Apollo* 84 (1966), p. 203. C. Bernari and P. De Vecchi, *L'opera completa del Tintoretto*, Classici dell'arte 36, Milan, 1970, p. 134, no. E13, p. 136 (ill.). Fredericksen/Zeri 1972, pp. 199, 473, 570. F. R. Shapley, *Paintings from the Samuel H. Kress Collection: Italian Schools, XVI–XVIII Century*, London, 1973, p. 62, under no. K2135. Bénézit, 3d ed., 1976, vol. 10, p. 192. J. D. Morse, *Old Master Paintings in North America*, New York, 1979, p. 262. R. Pallucchini, *La pittura veneziana del seicento*, Milan, 1981, vol. 1, p. 25. R. Pallucchini and P. Rossi, *Tintoretto: Le opere sacre e profane*, Milan, 1982, vol. 1, p. 242, no. A22, p. 252, under no. A98, vol. 2, fig. 649. P. Bermingham, ed., *University of Arizona Museum of Art: Paintings and Sculpture in the Permanent Collection*, Tucson, 1983, p. 29.

EXHIBITIONS: The Art Institute of Chicago, *A Century of Progress*, 1933, no. 137, as Jacopo Tintoretto. The Art Institute of Chicago, *A Century of Progress*, 1934, no. 55, as Jacopo Tintoretto. New York, Durlacher Bros., *A Loan Exhibition of Paintings by Jacopo Robusti, il Tintoretto, 1519–1594*, 1939, no. 9, as Jacopo Tintoretto. New York, M. Knoedler and Co., *Classics of the Nude*, 1939, no. 9, as Jacopo Tintoretto. The Art Institute of Chicago, *Masterpiece of the Month*, May 1941, as Jacopo Tintoretto (no cat.). Birmingham Museum of Art, Alabama, *Opening Exhibition*, 1951, pp. 17–18, as Jacopo Tintoretto. Chatanooga Art Association, Inc., Tennessee, *Opening Exhibition of Hunter Gallery of Art*, 1952 (no cat.). Urbana, University of Illinois, *Midwest Museum Loan Exhibition*, 1955 (no cat.). Richmond, Virginia Museum of Fine Arts, *England's World of 1607*, 1957 (no cat.).

This picture formerly had as its pendant a depiction of *Venus Lamenting the Death of Adonis* (fig. 3), now in the Kress Collection at the University of Arizona Museum of Art in Tucson.[8] The two paintings are virtually identical in size and complement one

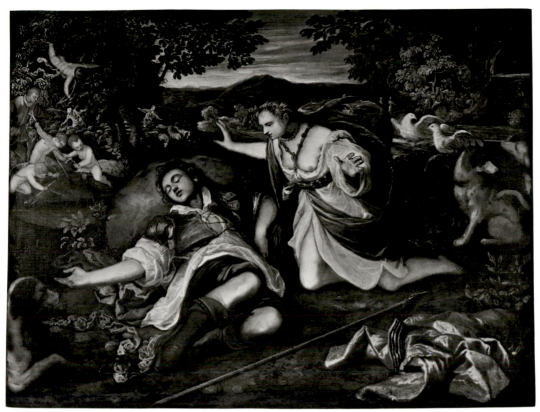

Fig. 3 Domenico Tintoretto, *Venus Lamenting the Death of Adonis*, Collection of The University of Arizona Museum of Art, Tucson, Gift of the Samuel H. Kress Foundation

another in subject matter.[9] Presumably they once formed part of a decorative scheme in a private *palazzo*, but no such scheme is mentioned in Carlo Ridolfi's *Le maraviglie dell'arte* (1648).

It might be argued that this picture and its pendant represent different stages or manifestations of love, with a deliberate contrast intended between the plight of the two pairs of figures, just as Veronese had paired his *Venus and Adonis* (Madrid, Museo del Prado) and *Cephalus and Procris* (Strasbourg, Musée des Beaux-Arts) painted around 1580.[10] While a specific textual source can be cited for *Venus Lamenting the Death of Adonis*, namely the poem by Theocritus,[11] no comparable reference can be supplied for the painting in Chicago. The blindfolded Cupid and the Three Graces certainly had been associated with Venus in the fifteenth century, notably in Neoplatonic circles in Tuscany, as, for example, in Botticelli's *Primavera*.[12] Such a prototype is harder to find in Venice unless it is *The Death of Adonis* by Sebastiano del Piombo.[13]

Nancy Webbe argued that the subject of the paint-

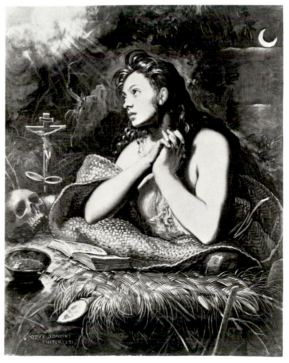

Fig. 4 Domenico Tintoretto, *Penitent Magdalen*, Pinacoteca Capitolina, Rome

ing in Chicago is really the story of Vulcan discovering the love of Venus and Mars as recounted by Ovid in the *Metamorphoses* (4.171–89).[14] The figure in the right background is identified by Webbe as Vulcan and the large bird (which was revealed when the painting was cleaned in 1966–67 and is in a poorly preserved state) is probably intended for the raven of Apollo that discovered the illicit liaison between Venus and Mars. Alternatively it might represent a woodpecker, which Ovid associated with Mars (*Fasti*, 3.37). Webbe emphasized that Mars is depicted here not solely as the god of war, but also in his other guise as a god of agriculture. As Webbe noted, this alternative characterization provides a link with the Three Graces: "Tintoretto transforms the conventional iconography into an allegory of spring disguised as a mythological marriage." If this interpretation is correct, then the picture can be understood as an example of a *poesia* rather than a straightforward illustration of a text.

Rich was the first to publish the painting as an autograph work by Jacopo Tintoretto in 1928, an attribution endorsed by Mayer, Von Hadeln, Lionello Venturi (1931), and Berenson (1932, 1936, 1957).[15] After 1938, support for the attribution to Jacopo Tintoretto continued for a time in the publications of Coletti (1940) and Von der Bercken (1942), but more recently opinion has shifted away from this early enthusiasm. Already in 1950 Tietze had suggested an attribution to Jacopo Tintoretto's son Domenico, or to someone else in Jacopo's workshop.[16] The compiler of the 1961 catalogue of the Art Institute's paintings concluded that it was a shop picture, suggesting that it was "perhaps by a northern follower whose style is close to Domenico Robusti's yet different from it." While Bernari and De Vecchi (1970) merely rejected the attribution to Jacopo Tintoretto without advancing an alternative, Fredericksen and Zeri (1972), and later Pallucchini (1981, Pallucchini/Rossi 1982) renewed the attribution to Domenico Tintoretto. A pupil and, for many years, an assistant of Jacopo, Domenico also had a successful independent career, developing a reputation primarily as a fine portraitist.

Virtually all the older authorities who favored an attribution to Jacopo Tintoretto dated the work fairly late in the artist's life.[17] The mythological paintings executed by the master during the late 1570s and early 1580s were of course the touchstone for the older attribution to Jacopo Tintoretto. Pictures such as *Mercury and the Three Graces* and *Bacchus and Ariadne*, painted for the Salotto Quadrato or the Atrio Dorato (now in the Anticollegio) in the Palazzo Ducale in Venice, *The Muses* at Hampton Court, and *The Origin of the Milky Way* in The National Gallery in London offer points of comparison in the circular type of composition and in the distinctive treatment of female physiognomy, but not as regards quality of drawing, brushwork, or color.[18] Nevertheless, the close dependence on Jacopo Tintoretto for general aspects of composition and style indicates an artist trained within his workshop. The pert faces, the stiffer treatment of the drapery, and the fashionable coiffure of the figure of Venus are highly characteristic of Domenico Tintoretto. The more fulsome handling of the landscape certainly reveals, as Pallucchini (1981) emphasized, the influence of northern painters such as Paolo Fiammingo,[19] but such influences did abound in Tintoretto's studio and were a feature of Domenico's early style. Further supporting the attribution to Domenico is the female figure visible in the x-radiograph (fig. 2), which seems very similar in pose, hairstyle, and placement on the canvas to the artist's paintings of the *Penitent Magdalen* in the Pinacoteca Capitolina in Rome (fig. 4) and in the church of Saint Bartholomew in Pilsen (Plzeň), Czechoslovakia.[20] This strongly suggests that the mythological composition was painted over a version of Domenico's repentent Magdalen. The Pilsen picture, which appears to be a later version of the painting in Rome, is signed and dated to 1586.

A date in the early 1590s would seem to be appropriate for the Chicago picture, insofar as a chronology for the artist's oeuvre can be established. The painting is not without certain qualities, evident despite its damaged state and reworked composition. Pallucchini remarked, for example, on "the landscape flickering with bursts of phosphorescent light." Another fine passage is the area of Mars's left arm, which is shown in shadow, silhouetted against the incandescent robe on which Venus lies.

NOTES

1 The mark *DGH / 4,67 / 1406* was painted on the back of the old lining canvas. The monogram is that of Don Gaspar Méndez de Haro y Guzmán, Marqués del Carpio y Helice.

A photographic record of the monogram and inventory number was made before the canvas was relined (fig. 1).

2 According to the monogram described above (note 1). For this important collection, see the entry for the *Portrait of a Lady* attributed to Fasolo (1946.382).

3 The Art Institute's painting is not included in the inventories of the Alba collection, which are apparently incomplete. For these inventories, which include information pertaining to the pictures owned by Don Luis and Don Gaspar Méndez de Haro, see A. M. de Barcia, *Catálogo de la colección...del...Duque de Berwick y de Alba*, Madrid, 1911. For paintings from this collection that remained in Italy following Don Gaspar Méndez de Haro's death during his tenure as viceroy in Naples, see the entry for Fasolo (1946.382).

4 The references to the Price collection and to Dowdeswell and Dowdeswell (see next provenance item) appear on the mount of a photograph of the painting in the Witt Library in London. This information does not necessarily precede the presence of the picture in the H. M. Clark collection.

5 See note 4.

6 According to registrar's records.

7 According to registrar's records.

8 The existence of the pendant was first noted by Heinemann (letter from D. Heinemann to G. E. Kaltenbach of November 27, 1928, in curatorial files) and was subsequently published by Mayer (1932). For the pendant, see Shapley 1973, p. 62, no. K2135, fig. 116. The pendant and the Chicago painting are illustrated as a pair by Von der Bercken 1942, pls. 193–94.

9 The Kress picture measures 108.6 x 142.6 cm.

10 For illustrations of these works, see *The Genius of Venice, 1500–1600*, exh. cat., London, Royal Academy of Arts, 1983–84, nos. 145–46.

11 *The Greek Bucolic Poets*, tr. by J. M. Edmonds, Loeb Classical Library, London and New York, 1919, pp. 191–95, Theocritus 15.99–145.

12 For a discussion of the iconography of a blindfolded Cupid with the Three Graces, and a representation of the theme by Francesco Vanni, see E. Panofsky, *Studies in Iconology: Humanist Themes in the Art of the Renaissance*, New York, 1937, pp. 95–169, fig. 123.

13 M. Hirst, *Sebastiano del Piombo*, Oxford, 1981, pp. 37–39, pl. 45.

14 Nancy L. Webbe, *The Three Graces in Renaissance Art: Origins and Transformations of a Theme*, Ph. D. diss., Boston University, 1986, pp. 229–35, copy in curatorial files.

15 Expertises by Mayer and Von Hadeln, dated 1927, are preserved in curatorial files.

16 According to a letter from Hans Tietze to Hans Huth of September 12, 1950, in curatorial files.

17 Mayer suggested a date of 1570/80; Von Hadeln, c. 1580; Lionello Venturi, 1583–87; and Von der Bercken, 1576/82. Only Berenson (1957) argued in favor of an early date.

18 For the paintings at the Palazzo Ducale in Venice, see Pallucchini and Rossi 1982, pls. 482–83; for the Hampton Court painting, see J. Shearman, *The Early Italian Pictures in the Collection of Her Majesty the Queen*, Cambridge, 1983, pp. 242–44, no. 257, pl. 218; for The National Gallery painting, see C. Gould, *National Gallery Catalogues: The Sixteenth-Century Italian Schools*, London, 1975, pp. 259–61, no. 1313, illustrated in The National Gallery, *Illustrated General Catalogue*, London, 1973, p. 721, no. 1313.

19 For this artist, see S. M. Rinaldi, "Paolo Fiammingo," *Saggi e memorie di storia dell'arte* 11 (1978), pp. 163–88.

20 For information and illustrations, see A. Venturi, vol. 9, pp. 656–58, fig. 460; and Pallucchini 1981, vol. 1, p. 25, vol. 2, fig. 10. Pallucchini noted the existence of other, later replicas of the Pilsen work.

Jacopo Robusti, called Tintoretto

1518 Venice 1594

Saint Helena Testing the True Cross, c. 1545
Gift of Böhler and Steinmeyer, 1932.44

Oil on canvas, 21.5 x 48.9 cm (8½ x 19⅜ in.)

CONDITION: The painting is in fair condition. It was treated by Leo Marzolo in 1955 and cleaned by Alfred Jakstas in 1965. The canvas has been relined, and the lining canvas extends approximately 1 cm beyond the original support on all sides. This area has been filled and the design extended. In addition, the edges of the original canvas appear to have been trimmed on all four sides. The x-radiograph shows tacking holes at the extreme edges of the original canvas at the top, bottom, and lower left side. The paint surface is abraded throughout, with severe abrasions exposing the bare canvas and the light ground in several areas: beneath the arm of the figure holding the cross to the right of Saint Helena, to the right of this figure, and around the corpse. The x-radiograph reveals a number of small alterations: the

head of Saint Helena was first positioned in three-quarter view, the head of the figure at the extreme left was repositioned, and his right leg was originally not hidden by the cross. It shows too that the figures were at first quickly set down in bold, summarizing strokes that efficiently conveyed their movements and distribution of weight (infrared, ultraviolet, x-radiograph).

PROVENANCE: Sir Thomas Andros de la Rue, Bt. (d. 1911), London; sold Christie's, London, June 16, 1911, no. 67,[1] to Robert Langton Douglas, London, for £273.[2] Sold by Langton Douglas to Captain and Mrs. Philip M. Lydig, New York;[3] to his wife Rita (de Acosta) Lydig, New York; sold American Art Association, New York, April 4, 1913, no. 130 (ill.) to W. W. Seaman for $2000.[4] Robert Langton Douglas, London, by 1924.[5] F. Hess, Berlin, by 1925;[6] sold Paul Cassirer and Théodore Fischer, Lucerne, September 1, 1931, no. 4, for Fr 9000.[7] Böhler and Steinmeyer, New York, by 1932; given to the Art Institute, 1932.

REFERENCES: "Rita Lydig Sale," *American Art News* 11 (April 12, 1913), p. 6. J. B. T., "The Lydig Collections," *American Art News* 11 (March 29, 1913), p. 6. W. R. Valentiner, *Illustrated Catalogue of the Rita Lydig Collection*, New York, 1913, no. 130 (ill.), n. pag. W. R. Valentiner, "Mrs. Lydig's Library," *Art in America* 1, 2 (1913), p. 69. *AIC Bulletin* 26 (1932), p. 80 (ill.). H. Tietze, "Bozzetti di Jacopo Tintoretto," *Arte veneta* 5 (1951), pp. 57–58 (ill.). W. R. Rearick, "Battista Franco and the Grimani Chapel," *Saggi e memorie di storia dell'arte* 2 (1958–59), p. 119 n. 67. AIC 1961, p. 450. Huth 1961, p. 518. C. Bernari and P. De Vecchi, *L'opera completa del Tintoretto*, Classici dell'arte 36, Milan, 1970, p. 134, no. A34. A. Bertini, "Un'ignorata opera giovanile del Tintoretto: L'erezione del vitello d'oro," *Arte veneta* 25 (1971), p. 261. Fredericksen/Zeri 1972, pp. 199, 402, 570. J. K. Kettlewell, *The Hyde Collection Catalogue*, Glens Falls, N.Y., 1981, p. 81. R. Pallucchini and P. Rossi, *Tintoretto: Le opere sacre e profane*, Milan, 1982, vol. 1, p. 21, no. 96; vol. 2, fig. 123.

EXHIBITIONS: Berlin, Kaiser-Friedrich-Museums-Verein, *Gemälde alter Meister aus Berliner Besitz*, 1925, no. 399b. Benent, Illinois, National Arts Foundation Museum, 1955 (no cat.).

The picture has traditionally been attributed to Jacopo Tintoretto. Together with Titian and Paolo Veronese, Tintoretto formed the triumvirate of great painters in Venice during the later sixteenth century. A prolific artist, he devised dramatic compositions which he executed with powerful brush strokes and a vibrant treatment of light. Tintoretto won important commissions from both the secular and the ecclesiastical authorities, the most famous of which is the series of paintings decorating the Scuola di San Rocco in Venice. He ran an active workshop in which his son Domenico played a prominent part. Seventeenth-century sources, such as Carlo Ridolfi and Marco Boschini, provide accounts of Tintoretto's unusual working methods, which included the use of mannequin figures and artificial lighting.

This picture, together with two others of the same scale, recounts the Legend of the True Cross, which is found in *The Golden Legend* of Jacobus de Voragine.[8] According to the story, Saint Helena, mother of the Emperor Constantine, traveled to the Holy Land in search of the cross on which Christ had been crucified. The Chicago picture shows the moment after her discovery of three crosses, when Saint Helena had to establish which was the True Cross. Each cross was tested by being brought close to a corpse; the third one (presumably that on the left of this picture) brought the corpse back to life, thereby winning acceptance as the True Cross.

In the De la Rue, Lydig, and Hess sales, the work was paired with a related painting of similar dimensions representing *The Discovery of the True Cross*.[9] This related painting is now in the Hyde Collection in Glens Falls, New York.[10] A third painting from the series, showing *The Embarkation of Saint Helena for the Holy Land*, is in the Victoria and Albert Museum in London, where it is attributed to Schiavone.[11] Clearly, the painting in Chicago must have once formed part of a series illustrating the whole legend.

The attribution to Jacopo Tintoretto was long-standing by the time Tietze published the painting in 1951.[12] In his 1913 catalogue of the Lydig collection, Valentiner described the picture as a sketch for a predella panel by Jacopo Tintoretto, with a passing reference to the fact that the artist executed a painting of the same subject in the church of Santa Maria Mater Domini, Venice, on behalf of the Scuola della Santa Croce. Tietze (1951) went so far as to suggest that the picture in Chicago was a *bozzetto* for the painting in the church of Santa Maria Mater Domini and consequently assigned it a date of 1561/62.[13] Rearick (1958–59) followed Tietze's dating and posited a compositional connection with Battista Franco's fresco of the same subject forming part of the

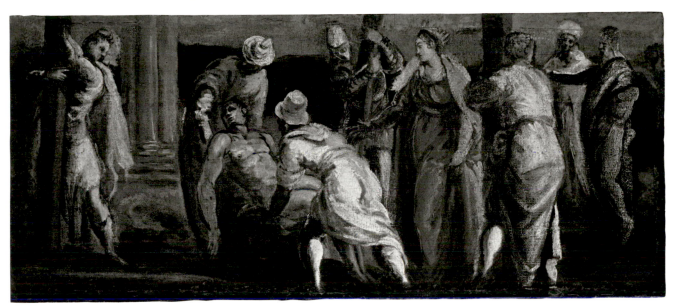

Jacopo Robusti, called Tintoretto, *Saint Helena Testing the True Cross*, 1932.44

ceiling of the Scala d'Oro in the Palazzo Ducale in Venice (still unfinished in 1561). Kettlewell (1981) believed the Chicago picture, together with the Hyde and Victoria and Albert paintings, was executed in the 1560s.[14] As Pallucchini and Rossi (1982) observed, Tietze's association of the present picture with the painting in Santa Maria Mater Domini is problematic. The compositions of the two paintings are very different, and, as Pallucchini and Rossi observed, there is also a considerable discrepancy between the styles and dates of the two works. Those scholars favored a date of c. 1545 for the Chicago painting.

Others have questioned the attribution to Tintoretto. The 1961 catalogue of the Art Institute's paintings listed the picture as by "an imitator (perhaps by an immediate follower) not before the end of the 16th century."[15] Bernari and De Vecchi (1970) denied the attribution to Tintoretto, while Fredericksen and Zeri (1972) regarded the painting as a product of the studio. On the basis of a photograph, Cecil Gould also rejected the attribution to Tintoretto, suggesting that the picture might be by Andrea Schiavone.[16]

In the opinion of the present writer, the influence but not the hand of Schiavone is apparent in the Chicago work. The closest stylistic analogies in Tintoretto's oeuvre for this painting are with a group of loosely depicted, richly colored, and vigorously brushed canvases typified by the six biblical scenes in the Kunsthistorisches Museum in Vienna.[17] These date from the mid-1540s, when the artist was most influenced by Schiavone.

NOTES

1 No. 67 in the De la Rue sale included two paintings: the Art Institute painting and a related painting, *The Discovery of the True Cross*, now in the Hyde Collection in Glens Falls, New York; the paintings were listed as *Finding of the True Cross* and *The Companion*. They seem to have remained together until 1932, when *Saint Helena Testing the True Cross* entered the Art Institute's collection.

2 *Art Prices Current*, vol. 4, London, 1910–1911, p. 556; and annotated copy of De la Rue sale catalogue in the Thomas J. Watson Library, The Metropolitan Museum of Art, New York.

3 According to Valentiner's 1913 *Illustrated Catalogue of the Rita Lydig Collection*.

4 "Rita Lydig Sale," 1913, p. 6. For price and buyer, see anno-

tated copy of 1913 Lydig sale catalogue in the Thomas J. Watson Library, The Metropolitan Museum of Art, New York.

5 According to the mount of a photo of this painting in the Witt Library, London.

6 According to the catalogue of the 1925 Berlin exhibition.

7 See annotated copy of the catalogue in the Ryerson Library, The Art Institute of Chicago.

8 *The Golden Legend*, vol. 1, pp. 269–76.

9 In the De la Rue sale, the two paintings were sold together, as no. 67 (see note 1). *The Discovery of the True Cross* was no. 129 in the Lydig sale and no. 3 in the Hess sale. *The Discovery of the True Cross* was offered for sale to The Art Institute of Chicago by Böhler and Steinmeyer when they gave the present picture (see registrar's records).

10 Kettlewell 1981, pp. 80 (ill.), 81. The Hyde painting measures 21.3 x 48.55 cm (8⅜ x 19⅛ in.).

11 Ibid., p. 81; and C. M. Kauffmann, *Victoria and Albert Museum: Catalogue of Foreign Paintings*, vol. 1, *Before 1800*, London, 1973, p. 260, no. 323 (ill.), as A. Schiavone, *Embarkation of a Queen*. The Victoria and Albert painting measures 22.8 x 59.7 cm (9 x 23⅛ in.), including a 2 cm (¾ in.) strip added at the top and a 1.3 cm (½ in.) strip added at the bottom.

12 The painting was attributed to Jacopo Tintoretto as early as 1911 (see De la Rue sale catalogue).

13 The painting in Santa Maria Mater Domini can be linked to a document of 1561 (Pallucchini and Rossi 1982, vol. 1, p. 181, no. 231; vol. 2, figs. 301–02). The relationship between the painting of *The Carrying of Saint Mark's Body* in the Musées Royaux des Beaux-Arts, Brussels (Pallucchini and Rossi 1982, vol. 1, pp. 154–55, no. 126; vol. 2, fig. 161), and the famous picture once in the Scuola Grande di San Marco (now Venice, Gallerie dell'Accademia; Pallucchini and Rossi 1982, vol. 1, pp. 183–84, no. 243; vol. 2, figs. 322–24), also discussed by Tietze in his article of 1951, is admittedly a parallel case, but one open to the same objections as in the present instance. It is doubtful if either of the pictures in Chicago or Brussels were part of the preparatory process for the larger paintings, to which they are surely both connected in subject only.

14 Kettlewell 1981, p. 81, hypothesized that the three paintings once formed the predella of an altarpiece which featured Saint Helena (Milan, Pinacoteca di Brera; formerly San Marcuola, Venice). For an illustration of this altarpiece, see Pallucchini and Rossi 1982, vol. 2, fig. 571.

15 Interestingly, for several years in the Art Institute the painting was attributed to the Master of the Corsini *Adulteress*, a painter so named by John Maxon ("The Master of the Corsini *Adulteress*," *Connoisseur* 148 [1961], pp. 254–61) after the picture now in the Galleria Nazionale, Palazzo Barberini, Rome (Pallucchini and Rossi 1982, vol. 1, pp. 149–50, no. 109; vol. 2, figs. 137–38), and tentatively identified by him as Aliense, a painter who emerged as an independent personality after working for several years in Tintoretto's workshop. Both the isolation of this small group of pictures and the identification with Aliense have failed to win acceptance (see Pallucchini and Rossi 1982, vol. 1, pp. 149–50, no. 109).

16 Letter to Martha Wolff of March 26, 1987, in curatorial files.

17 Pallucchini and Rossi 1982, vol. 1, p. 138, nos. 48–53; vol. 2, figs. 57–61.

Tarquin and Lucretia, 1580/90
Art Institute Purchase Fund, 1949.203

Oil on canvas, 175 x 151.5 cm (68⅞ x 59⅝ in.)

CONDITION: The painting is in fair condition. It was cleaned in 1969–70 by Alfred Jakstas when an old glue lining was removed and the picture relined with wax.[1] It was cleaned again by Frank Zuccari in 1992. The relatively fine canvas has a plain weave. There is a horizontal seam approximately 99 cm from the lower margin. A stretcher-bar crease across the upper left corner indicates an old stretcher with diagonal reinforcements. There is a tear above Lucretia's right breast and another vertical tear in her right thigh, about 59 cm from the lower margin. The paint surface is abraded, particularly in the green and blue drapery and in the figure of Lucretia, probably resulting in part from wear to the edges of cupping paint. The rather broken-up paint surface and the pronounced crackle pattern give the picture a clouded effect in the dark areas. There are small local losses throughout, as well as a larger loss in the knee of the statue to the right of Lucretia and another to the left of the falling pillow. The blue of the bed cover has lightened. *Pentimenti* are visible in the contours of Tarquin's back and left calf. The paint of the fallen statue has become especially transparent, revealing that the statue was painted over the drapery. Infrared photography shows that the drapery was in turn painted over the structure of the bed (infrared, mid-treatment, x-radiograph, ultraviolet).

PROVENANCE: Private collection, France.[2] R. Lebel, Paris, by 1937.[3] Richard Goetz, Paris and New York, by 1939.[4] Sold by E. and A. Silberman Galleries, New York, to the Art Institute, 1949.

REFERENCES: "Found in France: The New Veronese, Vivarini, and Tintoretto," *Illustrated London News* (December 4, 1937), p. 1015. A. M. Frankfurter, "The Classic Nude: 1460–1905," *Art News* 37, 29 (1939), cover ill. *Pictures on Exhibit* 4, 2 (1940), pp. 37–38. E. von der Bercken, *Die Gemälde des Jacopo Tintoretto*, Munich, 1942, p. 119, no. 265, figs. 12–14. H. Tietze, *Tintoretto: The Paintings and Drawings*, London, 1948, p. 357, fig. 285. R. Pallucchini, *La giovinezza del Tintoretto*, Milan, 1950, p. 151. F. A. Sweet, "Tintoretto and El Greco," *AIC Bulletin* 44 (1950), pp. 22–23 (detail ill., cover ill.). D. C. Rich, "The Windy City, Storm Center of Many Contemporary Art Movements," *Art Digest* 26, 3 (1951), p. 29 (ill.). F. A. Sweet, "La pittura italiana all'*Art Institute* di Chicago," *Le vie del mondo: Rivista mensile del Touring Club Italiano* 15 (1953), pp. 698–99 (ill.). Berenson 1957, vol. 1, p. 171, vol. 2, pl. 1291. R. Pedrazzi Tozzi, "La maturità di Domenico Tintoretto in alcune tele ritenute di Jacopo," *Arte antica e moderna* 12 (1960), p. 388. AIC 1961, pp. 449–50. Huth 1961, p. 518. C. Bernari and P. De Vecchi, *L'opera completa del Tintoretto*, Classici dell'arte 36, Milan, 1970, pp. 100–01, no. 131a (ill.).

Fredericksen/Zeri 1972, pp. 199, 482, 571. E. de Jongh, "Pearls of Virtue and Pearls of Vice," *Simiolus* 2 (1975–76), p. 88, fig. 18. J. D. Morse, *Old Master Paintings in North America*, New York, 1976, pp. 261–62. R. Pallucchini and P. Rossi, *Tintoretto: Le opere sacre e profane*, vol. 1, Milan, 1982, pp. 105, 229, no. 450 (ill.). S. Mason Rinaldi, *Palma il Giovane: L'opera completa*, Milan, 1984, pp. 46, 87, under no. 117. E. Weddigen, "Jacopo Tintoretto und die Musik," *Artibus et Historiae* 10 (1984), pp. 99, 102–03, 188 n. 180, p. 119 nn. 185, 187.

EXHIBITIONS: New York, M. Knoedler and Co., *Classics of the Nude*, 1939, no. 10. New York, World's Fair, *Masterpieces of Art: European Paintings and Sculpture, 1300–1800*, 1939, no. 378. San Francisco, The California Palace of the Legion of Honor and The M. H. de Young Memorial Museum, *Seven Centuries of Painting*, 1939–40, no. Y-19. The Cleveland Museum of Art, *Masterpieces of Art from the New York and San Francisco World's Fairs*, 1940, no. 63, traveled to The Minneapolis Institute of Arts (no. 37), and to the Los Angeles County Museum (no. 4). Philadelphia Museum of Art, *Masterpieces of Painting*, 1950–51, no. 24. New York, E. and A. Silberman Galleries, *An Exhibition of Paintings...For the Benefit of The Research Fund of Art and Archaeology, The Spanish Institute, Inc.*, 1955, no. 16. The Cleveland Museum of Art, *Venetian Tradition*, 1956, no. 49.

The main textual source for the legend of Tarquin and Lucretia is Livy (1.57–60), but the story is also recounted by Ovid (*Fasti* 2.685–852) and by Boccaccio in *De Claris Mulieribus* (ch. 46). According to these accounts, Sextus Tarquin, son of Tarquinius Superbus (534–510 B.C.), last king of the Romans, made advances to Lucretia, wife of Collatinus, in whose house he had been made welcome. When Lucretia resisted, Tarquin threatened to kill both her and a male slave, and then claim that he had discovered them in adultery. Lucretia was thus forced to submit, but later, after telling her husband, she stabbed herself to death. Tarquin was subsequently banished from Rome and Lucretia became famous as a Roman heroine respected for the defense of her chastity.

Of the accounts cited above, Ovid's is the most arresting. Describing Tarquin approaching Lucretia, he wrote (2.792–806): " 'Twas night, and not a taper

shone in the whole house. He rose, and from the gilded scabbard he drew his sword. . . . His hands pressed heavy on her breast, the breast that till then had never known the touch of stranger hand. Her lover foe is urgent with prayers, with bribes, with threats; but still he cannot move her by prayers, by bribes, by threats."[5] Tintoretto's depiction captures the heightened tension in Ovid's poetry and even embellishes it in the fallen statue and the displaced bed coverings, aspects of the scene that are not specifically referred to in Ovid's text or in Livy's more sober prose. De Jongh (1975–76) has pointed out the iconographic significance of the broken string of pearls in the Chicago picture, describing it as "a clear allusion to her [Lucretia's] chastity which is to be defiled in the next few moments." Likewise, the dagger in the right foreground clearly refers to Lucretia's suicide.

All authorities on Tintoretto have confidently maintained an attribution to Jacopo for this imposing painting, although in the Art Institute's 1961 catalogue of paintings it was suggested that the design should be credited to Jacopo and the execution to the artist's son Domenico. The dramatic force of the composition, characterized by the twisting poses of the bodies and the cascading folds of drapery placed on two opposed steep diagonals, has often been remarked upon in the literature, particularly by Tietze (1948) and Pallucchini (1982). The former described the present painting as "one of Jacopo Tintoretto's most powerful compositions of profane subjects." The outflung arms of Lucretia recall, but do not imitate, the pose of the same figure in Titian's famous composition of the subject dating from the late 1560s.[6] There can be little doubt that the design is by Jacopo; the execution is also not without quality, particularly in the drawing of the figures and the texture of the draperies. The evenness of the flesh tones is perhaps not wholly characteristic of Tintoretto, but this effect may be due to abrasion and relining. On the other hand, there are important *pentimenti* in the figure of Tarquin and in the bed which can be seen beneath the drapery, this in turn being visible beneath the displaced statue. Such features are indicative of Tintoretto's own working methods. Interestingly, the statues acting as bedposts, presumably to support a canopy (two can be discerned in the background

in the upper half of the painting while the third in the foreground has been broken in the struggle), resemble the type that Tintoretto is known to have drawn frequently and is reported to have kept in his studio.[7]

There has been some disagreement about the date of the painting. Von der Bercken (1942) proposed the years 1544–47 and Tietze (1948), followed by Bernari and De Vecchi (1970), suggested the late 1550s. This dating, however, was refuted twice by Pallucchini (1950, 1982), who regarded the work as having been carried out between 1585 and 1590, toward the very end of the artist's life, on comparison with such pictures as *Hercules Driving the Faun from the Bed of Omphale* (Budapest, Szépmüvészeti Múzeum) and the *Flagellation* (Vienna, Kunsthistorisches Museum).[8] Pallucchini admitted that the complicated poses and the dynamism of the composition of *Tarquin and Lucretia* do have affinities with earlier works, such as *Venus, Vulcan, and Mars* (Munich, Alte Pinakothek),[9] dating from c. 1550, when Tintoretto was still influenced by Mannerist principles. Yet he argued that the stylistic distinction most evident in the present painting is its luminism, an aspect of the artist's style closely associated with the cycle of paintings, documented between 1582 and 1587, in the lower hall of the Scuola Grande di San Rocco. As Pallucchini rightly asserted, *Tarquin and Lucretia* could be termed a remaking of *Venus, Vulcan, and Mars*, particularly as regards the corresponding poses of Tarquin and Vulcan.

The composition of *Tarquin and Lucretia* exists in two other versions: one last recorded in the Kunsthaus Lempertz in Cologne, the other in the Prado.[10] The version in Madrid, which is horizontal in format and shows an extension of the composition to the right incorporating still-life elements illustrative of the struggle, is widely regarded as a work by Domenico Tintoretto. Some of these still-life elements, notably a tapestry and musical instruments, are just discernible in the upper right corner of the Chicago painting as well. The version sold in Cologne is slightly smaller than the present picture, measuring 158 x 135 cm, but presents basically the same composition, and was accepted by Pallucchini and Rossi (1982) as an autograph work also dating from the 1580s. It does differ, however, in some details: it lacks

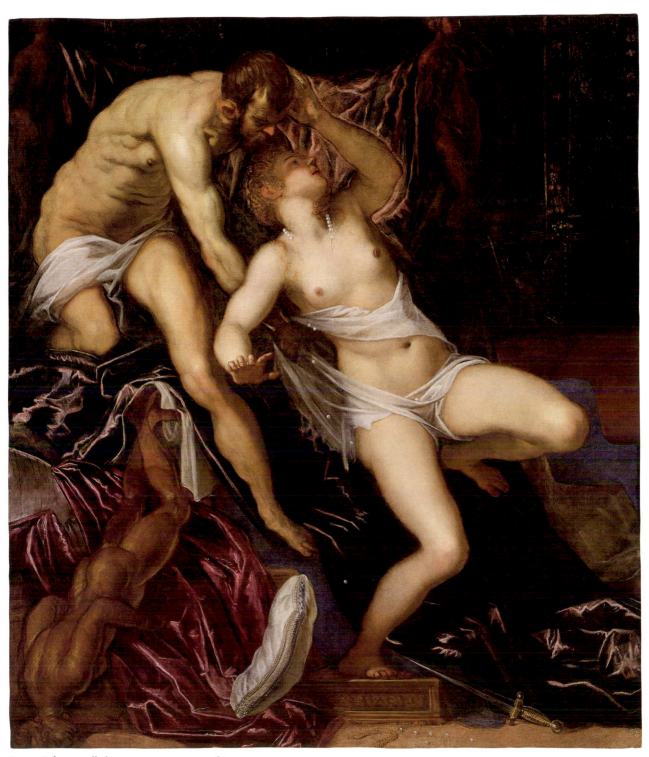

Jacopo Robusti, called Tintoretto, *Tarquin and Lucretia*, 1949.203

the fallen statue and cushion in the left foreground and the dagger in the right foreground. In addition, Lucretia is not shown wearing a string of pearls and the drapery of both figures is arranged differently. Rinaldi (1984) has compared Tintoretto's treatment of the subject with Palma il Giovane's painting of *Tarquin and Lucretia* (c. 1595–1600) in Kassel.[11]

NOTES

1 An indecipherable gray wax seal was removed from the lower left corner at that time and is now in the curatorial file.

2 Although the picture was certainly once in a French collection, there is no evidence that it belonged to Cardinal de Bernis (1715–1794), French ambassador to Venice and the Holy See, as has often been stated. Such an assumption seems to have originated in an ambiguously phrased announcement of the picture's rediscovery (*Illustrated London News* 1937).

3 *Illustrated London News* 1937.

4 According to the 1939 Knoedler exhibition catalogue.

5 Ovid, *Fasti*, Loeb Classical Library, tr. by J. G. Frazer, Cambridge, Mass., and London, 1989, pp. 115–17.

6 H. E. Wethey, *The Paintings of Titian: Complete Edition*, vol. 3, *The Mythological and Historical Paintings*, London, 1975, p. 180, no. 34, pl. 164.

7 For Tintoretto's working methods, see C. Ridolfi, *Le maraviglie dell'arte*, ed. by D. Freiherr von Hadeln, Berlin, 1914–24, pt. 2, p. 14 (first published in Venice in 1648); and for examples of his drawings after sculpture, see J. Byam Shaw, *Drawings by Old Masters at Christ Church, Oxford*, Oxford, 1976, vol. 1, pp. 204–07, nos. 758–67, vol. 2, pls. 427–45.

8 Pallucchini and Rossi 1982, figs. 572, 581, respectively.

9 Ibid., fig. 204.

10 Ibid., p. 229, no. 451, fig. 576, and p. 247, no. A59, fig. 683.

11 Mason Rinaldi 1984, fig. 269.

After Titian (?)

1480/85 Pieve di Cadore–Venice 1576

Portrait of a Lady, 1530/60

Max and Leola Epstein Collection, 1954.301

Oil on canvas, 63.5 x 51.8 cm (25 x 20⁵⁄₁₆ in.)

CONDITION: The painting is in poor condition. It was cleaned by Louis Pomerantz in 1961. Alfred Jakstas adjusted the inpainting in 1967. The canvas, which has a twill weave, has been glue lined. There are paint and ground losses in the background to the left of the sitter's head and in her hair. The paint surface is severely abraded, particularly in the background, on the left side of the sitter's face, and on her breast (mid-treatment, x-radiograph).

PROVENANCE: Private collection, Italy.[1] Sold by Böhler and Steinmeyer, New York, to Max Epstein (d. 1954), Chicago, between 1928 and 1930;[2] bequeathed to the Art Institute, 1954.

REFERENCES: *Art News* 28, 18 (1930), p. 3 (ill.). W. Suida, *Le Titien*, Paris, 1935, p. 112. Berenson 1957, vol. 1, p. 184. AIC 1961, p. 451. R. Pallucchini, *Tiziano*, Florence, 1969, vol. 1, pp. 223, 348, vol. 2, pl. 675. H. E. Wethey, *The Paintings of Titian: Complete Edition*, vol. 2, *The Portraits*, London, 1971, p. 169, no. X-60. Fredericksen/Zeri 1972, pp. 202, 531, 571. F. Heinemann, "La bottega di Tiziano," in *Tiziano e Venezia: Convegno Internazionale di Studi Venezia, 1976*, Vicenza, 1980, p. 438.

The picture has long been associated with Titian. As one of the great Venetian Renaissance painters, Titian received commissions from virtually all the major courts of Italy and Europe. The international demand for his richly textured paintings necessitated a large workshop of assistants to replicate or collaborate on the master's works.

The sitter in the Chicago picture has traditionally been identified as Giulia Gonzaga Colonna (c. 1513–1566), the wife of Vespasiano Colonna, Count of Fondi; but, according to Wethey (1971), there is no justification for such an identification. All writers have acknowledged the stylistic association of this work with Titian's famous female portraits of the mid- and late 1530s: *Eleonora Gonzaga della Rovere* (Florence, Uffizi), *La Bella* (Florence, Palazzo Pitti), *Isabella d'Este in Black* (Vienna, Kunsthistorisches Museum), and *Girl in a Fur Coat* (Vienna, Kunsthistorisches Museum).[3] The physiognomy of the woman in the present work also compares closely to Titian's

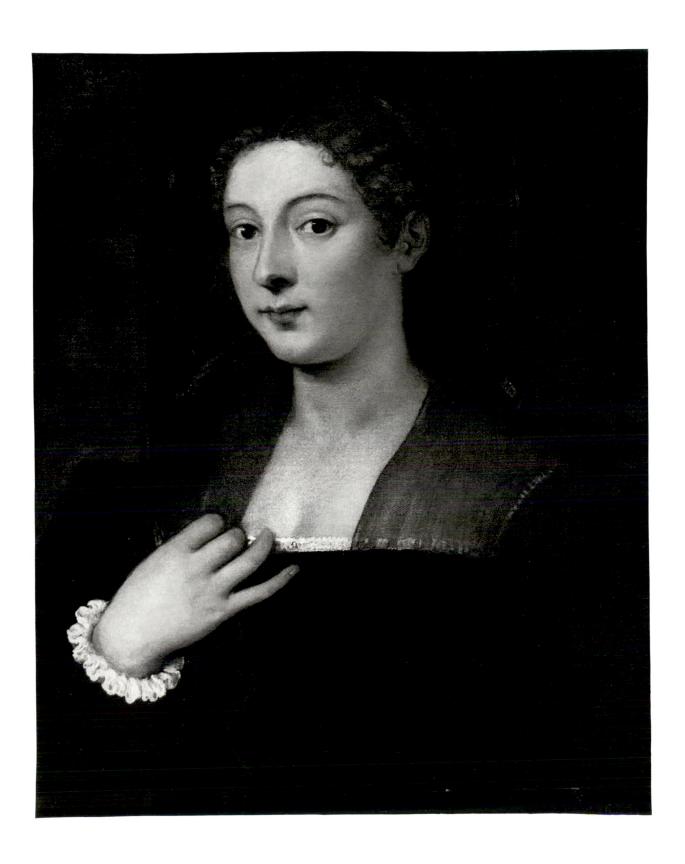

Venetian Girl of c. 1545–46 (Naples, Museo e Gallerie Nazionali di Capodimonte), his *Lavinia as Bride* of c. 1555 (Dresden, Staatliche Gemäldegalerie), and to a few portraits — or female types — usually assigned to Titian's workshop or followers.[4] According to Wethey, however, Maxon apparently preferred an attribution to Jacopo Tintoretto around 1550, an ascription with which Wethey seems tentatively to have complied. Pallucchini (1969) described the painting as a portrait of a woman in mourning, and believed it to be the work of a collaborator of Titian. He referred to, but did not reproduce, another portrait of the same sitter shown in half-length that he had seen in a Bolognese private collection.

Heinemann (1980) is the only writer to have given the portrait detailed consideration, but his conclusions are doubtful. He ascribed the portrait to the poetess and painter Irene di Spilimbergo (1540–1559), to whom he also attributed several other pictures, among them a portrait of the artist's sister and its pendant, a portrait of the artist herself that Titian might have helped to paint.[5] That Irene di Spilimbergo was a painter influenced by Titian is certainly a recorded fact,[6] but there is no surviving documentary evidence of her abilities as an artist, and thus no reason to attribute any of these particular paintings to her — quite apart from the fact that the group as a whole seems to lack any stylistic coherence.

The exact relationship of the present painting to Titian is difficult to determine, but the existence of one other version and a copy of the Chicago portrait in the Museo Cerralbo, Madrid (no. VH 473),[7] does suggest that there might have been a lost prototype by the master.

NOTES
1 There are several stamps on the back of the painting, including three customs stamps from Florence dated *16 Mar [?] 9*.
2 According to *Art News* (1930). The picture was not included in the 1928 summary catalogue of the Epstein collection, and therefore must have entered the collection after that date.
3 Wethey, vol. 2, 1971, pls. 70–73.
4 Ibid., figs. 194, 187, 265, 267, 269.
5 Both portraits, once in the Spilimbergo family collection, are now in the National Gallery of Art in Washington, D.C. See Shapley 1979, vol. 1, pp. 500–03, vol. 2, pl. 352. The other paintings, mainly portraits, thought by Heinemann to be by Irene di Spilimbergo are as follows: Madrid, Museo del Prado, no. 501 (formerly no. 540), on loan to the Casa El Greco, Toledo (T. Pignatti, *Veronese*, vol. 2, Venice, 1976, fig. 694); Toulouse, Musée, no. D.1958.5, on deposit from the Louvre, no. 158; Worcester Art Museum, Massachusetts, no. 1953.45 (*European Paintings in the Collection of the Worcester Art Museum*, vol. 2, Worcester, Mass., 1974, p. 624 [ill.]); Padua, Museo Civico, no. 2223 (L. Grossato, *Il Museo Civico di Padova: Dipinti e sculture dal XIV al XIX secolo*, Venice, 1957, p. 113, no. 79 [ill.]); London art market, sold Christie's, June 6, 1975, no. 83; and Castle Howard, Yorkshire, fragment of a putto holding a crown. Heinemann recorded the inventory number for the Padua picture as 169, but he seems to have mistaken the illustration number of another painting for the catalogue number of this painting — both appear on the same page of the museum's 1957 catalogue.
6 C. Ridolfi, *Le maraviglie dell'arte*, ed. by D. Freiherr von Hadeln, vol. 1, Berlin, 1914, p. 194.
7 Heinemann 1980, p. 438.

Imitator of Titian

1480/85 Pieve di Cadore–Venice 1576

Allegory of Venus and Cupid, c. 1600(?)
Charles H. and Mary F. S. Worcester Collection, 1943.90

Oil on canvas, 129.9 x 155.3 cm (51⅛ x 61⅛ in.)

CONDITION: The painting is in fair condition. It was cleaned in 1959. The canvas, which has a twill weave, has been glue lined. It has a slightly curving seam 14.5 cm from the top. A canvas patch, 11.5 cm high and 64 cm long, has been inserted along the bottom edge beginning approximately 12 cm from the left edge and ending below the outstretched hand of Cupid. The design has been extended onto this patch. The area immediately above it, which is severely abraded, has been extensively retouched. The picture is unfinished and the canvas and ground tone are prominent. The figures are defined more by outline than by modeling, but some areas of impasto remain, notably on the highlights

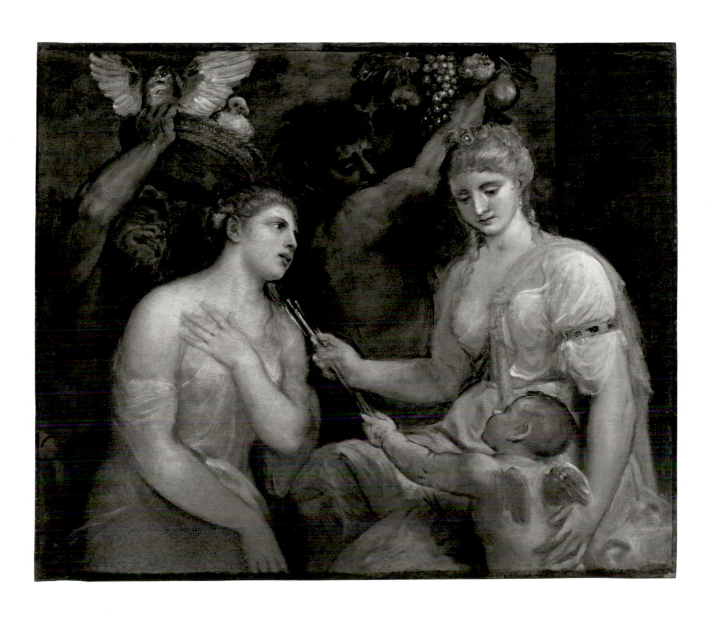

in the draperies of the protagonists and on the doves and fruit held aloft by the figures in the background. The two figures at the back of the composition appear to have been brought more nearly to completion, but, nonetheless, are thinly painted. The main figures, particularly that of Venus, were clearly meant to be worked on further, but for some reason this task was abandoned. The picture's unfinished appearance has probably been accentuated by earlier cleanings (infrared, ultraviolet, x-radiograph).

PROVENANCE: Francis, eighth Earl of Wemyss (d. 1853), Gosford House, Longniddry, East Lothian, Scotland, by 1835;[1] by descent to Hugo Richard, eleventh Earl of Wemyss. Sold by Hugo Richard, eleventh Earl of Wemyss, to Wildenstein, Paris, 1927.[2] Baron Heinrich Thyssen-Bornemisza, by 1930.[3] Wildenstein, Paris and New York, by 1935.[4] Sold by Wildenstein to Charles H. Worcester, Chicago, 1936;[5] on loan to the Art Institute from 1936; given to the Art Institute, 1943.

REFERENCES: J. A. Crowe and G. B. Cavalcaselle, *Titian: His Life and Times*, London, 1877, vol. 2, p. 468; 2d ed., London, 1881, vol. 2, p. 468. W. R. Valentiner, *Das unbekannte Meisterwerk in öffentlichen und privaten Sammlungen*, vol. 1, Berlin, 1930, no. 25 (ill.). L. Venturi, "Contributi a Tiziano," *L'arte* 35 (1932), pp. 489–91, fig. 5. "Buyers in Chicago Get Titian Canvas," *New York Times*, October 30, 1936, p. 25. "Famed Titian Work Acquired by Chicagoans," *Chicago Tribune*, October 30, 1936, p. 28. "A Great Titian Goes to Chicago," *Art News* 35, 5 (1936), p. 15 (ill.). W. M. Milliken, "The Twentieth Anniversary Exhibition of the Cleveland Museum of Art," *Art News* 34, 37 (1936), pp. 8–9 (ill.). "Rare Titian Composition Now Part of Chicago Collection," *New York American*, October 30, 1936, p. 23. H. Tietze, *Tizian: Leben und Werk*, Vienna, 1936, vol. 1, p. 242, vol. 2, p. 304. "Titian, Long Hidden in Britain, Is Sold Here to Chicago Couple," *New York Herald Tribune*, October 30, 1936, p. 25. "Worcesters Lend Great Titian to Chicago," *Art Digest* 11, 3 (1936), p. 15 (ill.). "A Great Titian," *AIC Bulletin* 31 (1937), p. 8. *Worcester Collection* 1938, pp. 16–17, no. 12, frontispiece ill. E. Panofsky, *Studies in Iconology: Humanistic Themes in the Art of the Renaissance*, New York, 1939, p. 165 n. 127. F. A. Sweet, "The Education of Cupid by Titian," *AIC Bulletin* 37 (1943), pp. 66–68 (ill., cover detail ill.). E. Tietze-Conrat, "The Wemyss *Allegory* in The Art Institute of Chicago," *Art Bull.* 27 (1945), pp. 269–71, fig. 1. "Art Institute Monument to City's Culture," *Chicago Sunday Tribune*, February 3, 1946, pp. 1, 16. R. P[allucchini], "Dipinti veneziani a Chicago, Detroit, Toledo e Hartford," *Arte veneta* 1 (1947), pp. 147–48. AIC 1948, p. 26. P. Della Pergola, *Galleria Borghese: I dipinti*, Rome, 1955, vol. 1, pp. 131–32, under no. 235. Berenson 1957, vol. 1, p. 184. F. Valcanover, *Tutta la pittura di Tiziano*, vol. 2, 1546–1576, Milan, 1960, p. 70. AIC 1961, p. 307. Huth 1961, p. 517. A. Ballarin, "Profilo di Lamberto

d'Amsterdam (Lamberto Sustris)," *Arte veneta* 16 (1962), pp. 76–77, 81 n. 38, fig. 90. A. Ballarin, "Lamberto d'Amsterdam (Lamberto Sustris): Le fonti e la critica," *Atti dell'Istituto Veneto di Scienze, Lettere ed Arti: Classe di scienze morali, lettere ed arti* 121 (1962–1963), p. 364. A. Ballarin, "Osservazioni sui dipinti veneziani del cinquecento nella Galleria del Castello di Praga," *Arte veneta* 19 (1965), p. 71 (detail ill.). R. Pallucchini, *Tiziano*, vol. 1, Florence, 1969, pp. 217, 265. P. Kultzen and P. Eikemeier, *Venezianische Gemälde des 15. und 16. Jahrhunderts*, Munich, 1971, vol. 1, p. 190, under no. 484. Fredericksen/Zeri 1972, pp. 140, 201, 476, 571. H. E. Wethey, *The Paintings of Titian: Complete Edition*, vol. 3, *The Mythological and Historical Paintings*, London, 1975, p. 207, no. X-3. H. Potterton, *Venetian Seventeenth-Century Painting*, exh. cat., London, The National Gallery, 1979, p. 32. V. Sgarbi, "Giovanni de Mio, Bonifacio de' Pitati, Lamberto Sustris: Indicazioni sul primo tempo del manierismo nel Veneto," *Arte veneta* 35 (1981), p. 60.

EXHIBITIONS: London, British Institution, 1835, no. 116, as Titian, "An Allegory (unfinished)." London, British Institution, 1858, no. 40, as Titian, *Venus, Cupid, and Psyche*. Edinburgh, Royal Scottish Academy, *Works of Old Masters and Scottish National Portraits*, 1883, no. 336, as Titian, *Venus, Cupid, etc.* The Cleveland Museum of Art, *Twentieth Anniversary Exhibition*, 1936, no. 181, as Titian, *Education of Cupid*. The Art Institute of Chicago, *Masterpiece of the Month*, May 1943 (no cat.), as Titian, *The Education of Cupid*.

The traditional attribution of this painting to Titian was resolutely maintained during the 1930s and 1940s by Valentiner (1930), Lionello Venturi (1932), Rich (*Worcester Collection* 1938) and Sweet (1943). Indeed, the Worcesters' donation of the picture to the Art Institute in 1943 generated a considerable amount of excitement. Gronau and Berenson also considered the painting to be a work by Titian.[6] The date of 1550/60 suggested by Valentiner (1930) was generally accepted by all of these writers. Other scholars expressed varying degrees of uncertainty about the attribution, namely Tietze (1936), Panofsky (1939), Valcanover (1960), Wethey (1975), and Gould.[7] As an alternative attribution, Tietze-Conrat (1945) proposed Damiano Mazza, a Paduan follower of Titian; Ballarin (1962, 1962–63, 1965) included the picture among the works of the Flemish artist Lambert Sustris, a suggestion that won partial approval from Pallucchini (1969). Neither of these attributions to

followers of Titian has been widely accepted, but this move away from an attribution to Titian himself and toward his followers was not a new development. Already by the late nineteenth century, Crowe and Cavalcaselle, in their pioneering monograph on Titian (1877, 1881), had included the painting on their list of "uncertified Titians," describing the execution of the painting as "very modern." Ever since, there has been a groundswell of discontent arising from the picture's stylistic weaknesses and iconographic oddities. Panofsky (1939) made perhaps the sternest pronouncement when he wrote that the picture was by a mediocre imitator and its iconography a pastiche of motifs taken from Titian. The pose of the female figure on the left (particularly of the arms) is derived from Titian's painting *Venus at Her Toilet with Two Cupids* in the National Gallery of Art in Washington, D.C.[8] There can be little doubt that the critical acclaim for the painting by certain writers in the past was overly enthusiastic, and that Panofsky's judgment was far more accurate.

Of the alternative attributions, that to Damiano Mazza has not been granted a great deal of credence, although it was accepted by the author of the 1961 catalogue of the Art Institute's paintings and by Fredericksen and Zeri (1972). Tietze-Conrat's attribution was inspired by Carlo Ridolfi's description of a painting apparently by Mazza: "Nelle case de' Signori Donati a Santa Maria Formosa sono due quadri contenenti Deità, Amori e Satiri con panieri di frutti, colombe e fiori."[9] There can be no certainty that the present picture is the one Ridolfi described, and there is no overwhelming stylistic connection between the present painting and those works assigned to Mazza, who seems to have been influenced by Titian's early style, whereas the artist of the Chicago painting appears to have had some knowledge of Titian's later works.[10]

The picture is, in fact, unfinished, especially in the figures of Venus and Cupid, and the resulting stylistic effect led Tietze-Conrat to advance the far-fetched theory that the picture had been reworked by Sir Joshua Reynolds in England during the late eighteenth century. Her argument was prompted by the need to resolve what she saw as a dichotomy between the description of the picture as "unfinished" in the catalogue of the 1835 exhibition at the British Institution and Crowe and Cavalcaselle's comment (1877, 1881) that the execution seemed "very modern." There is no need for such an elaborate explanation, however. In the first place, on cleaning, the painting was found to be genuinely unfinished, without having been extensively retouched. Secondly, the comment by Crowe and Cavalcaselle was clearly intended to suggest that the painting was by an imitator of Titian perhaps working more recently than had previously been supposed.

Ballarin's proposal that the present painting might be by Lambert Sustris needs closer examination. He argued that the picture had been painted in Venice around 1565 and that it is stylistically compatible with two works by Sustris, the *Rape of Proserpine* in the Fitzwilliam Museum in Cambridge, and *Saint Jerome in the Wilderness* in the Ashmolean Museum at Oxford.[11] There is, however, such a variety of handling and styles in the paintings attributed to Sustris, particularly in the supposedly late works dating from the 1560s, that it is difficult to have any confidence in Ballarin's suggestion.[12]

It thus seems best to categorize the present painting as by an imitator of Titian. It may date from the early seventeenth century and be by a Venetian painter distantly conversant with Titian's working methods, as demonstrated by the use of outline drawing with the brush. The painter was by no means unskilled, and the female figure on the left has a certain quality, even if the pose is derivative.

The iconography of this painting has given rise to a more wide-ranging discussion than the attribution, but there is general agreement about its derivation from Titian. Wethey summarized this issue by terming the painting a "rather facile combination of elements from Titian's *Cupid Blindfolded* and the so-called *Allegory of the Marchese del Vasto*."[13] Numerous copies and variants of both these compositions are known. Of these, a *Venus, Bacchus, and Ceres* in the Alte Pinakothek in Munich has certain features in common with the Chicago painting, such as the poses of the unidentified figure approaching Venus and the satyr in the background; but the composition as a whole is reversed and the position of Cupid is radically changed.[14] The positioning of Cupid in relation to Venus in the Chicago painting is closer to the arrangement in the *Cupid Blindfolded* in Rome,

although in the present painting Venus offers Cupid an arrow rather than blindfolding him. Because of these discrepancies, Pallucchini (1969) believed the Chicago painting to be after a lost work by Titian.

Tietze-Conrat (1945) suggested that the present painting reflected a lost composition by Titian listed in the inventory of Queen Mary of Hungary.[15] Wethey (1975) rejected this argument since the author of the inventory described the figures as being in different positions from those in the Chicago picture. Tietze-Conrat did, however, effectively dispose of another proposed connection (Tietze 1936) between the Chicago painting and a drawing in Van Dyck's Italian sketchbook at Chatsworth; as Adriani had already demonstrated, Van Dyck's sketch is after the painting of *Venus and Cupid with a Satyr* in the Galleria Borghese in Rome.[16]

The confusion caused by the iconography of this painting is evident from the various titles that have been given to the picture over the years. When it was exhibited at the British Institution in 1858, the title supplied was *Venus, Cupid, and Psyche*; but in 1877, Crowe and Cavalcaselle preferred *A Girl Initiated into the Mysteries of Venus*. Gronau suggested that the subject was *The Reconciliation between Venus and Psyche* as described by Apuleius in *The Golden Ass* (5.28–31),[17] an interpretation that would correspond with Lionello Venturi's (1932) identification of the female figure on the left as Ceres. Venturi based his identification on the attributes of the doves and fruit held aloft by the satyr. In fact, the doves are an attribute of Venus and, as Sweet (1943) observed, the pomegranate and grapes are attributes of Juno, who also played an important role in the story of the reconciliation of Venus and Psyche. Valentiner (1930) called the picture *The Education of Cupid*, which may be appropriate, although Wethey preferred the safer title *Allegory of Venus and Cupid*. The identity of the female figure on the left remains uncertain.[18]

Notes

1 Lent to the exhibition of 1835 by the Earl of Wemyss. See A. Graves, *A Century of Loan Exhibitions, 1813–1912*, New York [1968], vol. 3, pp. 1318–19.

2 According to Ay-Whang Hsia of Wildenstein, New York, in conversation with Lisa Dunn, October 11, 1991.

3 According to Felix Wildenstein, in a letter to Daniel Catton Rich of February 5, 1937, in curatorial files.

4 According to Ay-Whang Hsia of Wildenstein, New York (see note 2).

5 According to correspondence from Felix Wildenstein to Robert B. Harshe of June 8, 1936, and from Charles H. Worcester to Felix Wildenstein of November 21, 1936, in curatorial files.

6 Gronau's statement, dated June 18, 1935, is preserved in the Archives of The Art Institute of Chicago. Berenson gave his opinion in a letter to Daniel Catton Rich of February 16, 1937, in curatorial files. In the 1957 edition of his "lists," Berenson still described the painting as partly autograph.

7 According to a note in curatorial files, Cecil Gould viewed the painting in the fall of 1959 and stated that he believed it to be not by Titian but by someone working shortly after his lifetime.

8 Wethey 1975, vol. 3, pp. 200–01, no. 51, pl. 127.

9 See C. Ridolfi, *Le maraviglie dell'arte*, ed. by D. Freiherr von Hadeln, Berlin, 1914–24, pt. 1, pp. 223–24 (first published in Venice in 1648).

10 See D. Freiherr von Hadeln, "Damiano Mazza," *Zeitschrift für bildende Kunst* 24 (1913), pp. 249–54.

11 For these paintings, see J. W. Goodison and G. H. Robertson, *Fitzwilliam Museum, Cambridge: Catalogue of Paintings*, vol. 2, *Italian Schools*, Cambridge, 1967, pp. 187–90, pl. 42, as Christoph Schwarz; and C. Lloyd, *A Catalogue of the Earlier Italian Paintings in the Ashmolean Museum*, Oxford, 1977, pp. 164–66, no. A717, pl. 120.

12 Sustris, who was born in Amsterdam and came to the Veneto sometime during the late 1530s, was influenced at different times by Titian, Tintoretto, and Bordone, as well as by artists of the Mantuan and Emilian schools. Ballarin detected in the present picture the specific influences of Schiavone and Niccolò dell'Abbate. Although the loose brushwork, the strong dependence on white highlighting, and the use of acid blues, yellows, and violets might reflect knowledge of Schiavone, it is difficult to detect any influence of Niccolò dell'Abbate. Those works by Sustris that do reveal the pronounced influence of Niccolò dell'Abbate in the figures and landscape, such as his *Venus, Mars, and Cupid* in the Louvre and the *Jupiter and Io* in the Hermitage, St. Petersburg, are completely different in handling from the painting in Chicago. For illustrations of these works, see Ballarin 1962, figs. 72–73. Comparison of the present painting with Sustris's *Venus* (Amsterdam, Rijksmuseum) and *Susanna and the Elders* (Ponce, Museo de Arte) also make the suggested attribution unlikely (for illustrations of these two works, see Ballarin 1962, figs. 70, 69, respectively).

13 For the *Cupid Blindfolded*, which is in the Villa Borghese in Rome, see Wethey 1975, vol. 3, pp. 131–32, no. 4, pl. 159; for the *Allegory of the Marchese del Vasto*, which is in the Louvre, see ibid., pp. 127–29, no. 1, pl. 68.

14 Kultzen and Eikemeier 1971, vol. 1, pp. 189–91, no. 484, vol. 2, pl. 26. An engraving by Jacob Matham, after the Munich picture or a lost painting by Titian that it replicates, may have served as a model for the Chicago picture. The Matham print, like the Chicago painting, reverses the composition of the Munich work. For the Matham engraving, see W. L. Strauss, ed., *The Illustrated Bartsch*, vol. 4, *Netherlandish Artists: Matham, Saenredam, Muller*, New York, 1980, p. 195, no. 210 (ill.).

15 For the text, see Tietze-Conrat 1945, p. 270.

16 G. Adriani, *Anton van Dyck: Italienisches Skizzenbuch*, Vienna, 1940, p. 76, no. 114.

17 According to Gronau's expertise (note 6). For the textual source, see *The Golden Ass, Being the Metamorphoses of Lucius Apuleius*, tr. by W. Adlington (1566), rev. by W. Gaselee, London and New York [1915], pp. 240–49.

18 A possible reference made to Giulio Romano's fresco of *Venus Reproved by Juno and Ceres* in the Palazzo del Tè in Mantua (F. Hartt, *Giulio Romano*, New Haven, 1958, vol. 2, fig. 242), cited by Venturi and Sweet, does not clarify the iconographic problem.

Michele Tosini, called Michele di Ridolfo

1503 Florence 1577

Portrait of a Lady, 1550/60

Charles H. and Mary F. S. Worcester Collection, 1937.459

Oil on panel, 55.8 x 42.7 cm (22 x 16¾ in.)

CONDITION: The painting is in fair condition. It was cleaned by Alfred Jakstas in 1968. The panel is composed of a single board with vertical grain. The back has been thinned, as indicated by exposed and filled worm tunneling, and then coated with a dense layer of opaque paint. Edging strips have been attached to the panel on all sides. There are minor paint losses and abrasions throughout, particularly in the girl's hair. In addition, it is probable that glazes have been lost in both the figure and the background through past cleaning action. This is most evident in the background where tiny remnants of a deep green glaze are still visible, particularly on the left side of the figure. This glaze is over-lapped by the curls of the girl's hair and hence must be orig-inal. As a result of these losses the picture now has a raw and chalky appearance. Changes in the outline of the right shoulder are evident to the naked eye and in reproduction (infrared, ultraviolet, x-radiograph).

PROVENANCE: Elia Volpi, Florence, to 1910; sold Jandolo and Tavazzi, Florence, April 25, 1910, no. 64, pl. X, as Ridolfo Ghirlandajo. Sedelmeyer Gallery, Paris, by 1913.[1] Eugène Fischhof, Paris; sold Galerie Georges Petit, Paris, June 14, 1913, no. 69 (ill.), as Bronzino, for Fr 11,000.[2] Van Diemen Galleries, New York. Sold by Van Diemen to Cha-rles H. Worcester, Chicago, 1926;[3] intermittently on loan to the Art Institute from 1926; given to the Art Institute, 1937.

REFERENCES: F. M. Clapp, *Jacopo Carucci da Pontormo: His Life and Work*, New Haven, 1916, p. 101. A. McComb, *Agnolo Bronzino: His Life and Works*, Cambridge, 1928, pp. 142–43. *Worcester Collection* 1938, pp. 11–12, no. 7, pl. VI. C. Fabens Kelley, "Chicago: Record Years," *Art News* 51, 4 (1952), p. 59 (ill.). AIC 1961, pp. 226, 246. Fredericksen/ Zeri 1972, pp. 204, 530, 571. Shapley 1979, vol. 1, p. 334.

EXHIBITIONS: The Art Institute of Chicago, *Summer Exhibition*, 1930 (no cat.). The Art Institute of Chicago, *A Century of Progress*, 1933, no. 127.

At the time of the Volpi sale in Florence (1910), the portrait was very reasonably attributed to Ridolfo Ghirlandaio, but subsequently there was a tendency to associate it with Bronzino which is unacceptable.[4] In fact, McComb (1928) had rejected the attribution to Bronzino early on, tentatively suggesting instead the name of Francesco Salviati. The present attribu-tion was made by Everett Fahy in 1967 and is surely correct.[5] It was accepted by Fredericksen and Zeri (1972). The fluid handling of paint and the use of glazes,[6] quite apart from the characteristically sensu-ous mouth and the wide eyes, are typical of Michele di Ridolfo, who was an assistant and follower of Ridolfo Ghirlandaio, whose own style of portraiture is represented in the collection of the Art Institute (see 1933.1009). Comparable female portraits now associ-ated with Michele di Ridolfo are in the Palazzo Pitti in Florence and in the National Gallery of Art in Washington, D.C.[7] A portrait in The Metropolitan Museum of Art in New York, to which the Art Insti-tute painting has been compared (McComb 1928), was at first attributed to an unknown Florentine painter of the mid-sixteenth century, but was later listed by Fredericksen and Zeri (1972) as by Michele

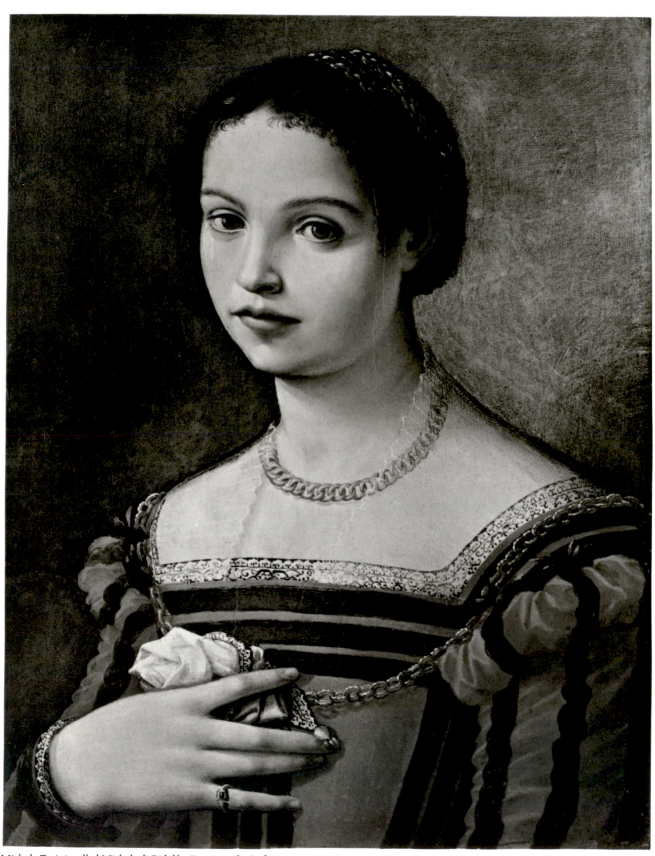

Michele Tosini, called Michele di Ridolfo, *Portrait of a Lady*, 1937.459

di Ridolfo, an attribution that is not wholly convinc-ing.[8] Although these portraits would both appear to date from the late 1550s on the basis of costume, it is not certain that they are by the same hand.

The prominence accorded the ring worn on the fifth finger of the sitter's right hand may signify that the portrait was painted on the occasion of a betrothal.

Notes

1 *Catalogue of the Twelfth Series of 100 Paintings by Old Masters...being a portion of the Sedelmeyer Gallery*, Paris, 1913, p. 34, no. 32, pl. 32, as Bronzino.
2 According to an annotated sale catalogue in the Ryerson Library, The Art Institute of Chicago.
3 According to a letter from Van Diemen to Worcester of November 8, 1926, in curatorial files.
4 Clapp 1916, Hermann Voss (opinion of March 17, 1926, in curatorial files), William R. Valentiner (opinion of November 3, 1926, in curatorial files), and Wilhelm von Bode (undated opinion in curatorial files) all attributed the work to Bronzino, an attribution accepted by Berenson on the basis of a photograph (*Worcester Collection* 1938). Dissenting opinions include Lionello Venturi, who apparently rejected the Florentine origin of the work (*Worcester Collection* 1938) and tentatively suggested Niccoló dell'Abbate (1933 *Century of Progress* exh. cat.), and Antonio Morassi, who suggested School of Parmigianino (opinion of October 10, 1952, in curatorial files).
5 Everett Fahy's attribution is reported in registrar's records.
6 As noted in the condition report above, only the smallest traces of these glazes remain today.
7 N. Cipriani, *La Galleria Palatina nel Palazzo Pitti a Firenze*, Florence, 1966, p. 210, no. 28 (ill.); and Shapley 1979, vol. 1, pp. 333–34, vol. 2, pl. 242.
8 Zeri/Gardner 1971, pp. 209–10 (ill.).

After Cosimo Tura

1430 Ferrara 1495

Pietà, 1475/1500

Mr. and Mrs. Martin A. Ryerson Collection, 1933.1037

Tempera on panel, 71.7 x 55.2 cm (28¼ x 21¾ in.)

CONDITION: The painting is in fair condition. It was cleaned in 1969 by Alfred Jakstas. The panel, which has been thinned and cradled, is composed of two boards aligned vertically with a join approximately 28 cm from the left edge. It has suffered from worm tunneling and there are several vertical splits at the upper edge. A strip of wood approximately 6 cm wide has been added at the bottom edge and the design repainted in this area. Since the cradle extends over this added strip and one of the cradle members bears a red wax seal marked *Collection Paul Delaroff / 1914*, this strip must have been added before the dispersal of the Delaroff Collection. The paint surface is abraded throughout and has, in addition, suffered numerous minute losses following the crackle pattern. There is a large area of paint and ground loss in the upper left corner, and the branches of the tree have been repainted. The paint in the upper right corner is original, though wear in both corners suggests that they may once have been covered by an arched frame. The design is incised throughout, including the main figures, the folds of the Virgin's drapery, and the hill of Calvary, suggesting the use of a cartoon (x-radiograph).

PROVENANCE: Paul Delaroff (d. 1914), St. Petersburg, to 1914;[1] sold Galerie Georges Petit, Paris, April 23–24, 1914, no. 233 (ill.), as Cosimo Tura. Kleinberger, New York. Sold by Kleinberger to Martin A. Ryerson (d. 1932), Chicago, 1923;[2] on loan to the Art Institute from 1923; bequeathed to the Art Institute, 1933.

REFERENCES: AIC 1925, p. 161, no. 2085. F. [R. M. Fischkin], "A *Pietà* by Marco Zoppo," *AIC Bulletin* 20 (1926), pp. 55–56 (ill.). *Ryerson Collection* 1926, pp. 46–47. D. C. Rich, "A Crucifixion by Carlo Crivelli," *AIC Bulletin* 23 (1929), p. 147 (ill.). AIC 1932, p. 183, no. 2585. Valentiner [1932], n. pag. *Exposition de l'art italien de Cimabue à Tiepolo*, exh. cat., Paris, Petit Palais, 1935, under no. 468. R. van Marle, "Two Ferrarese Wood-Carvings of the XVth Century," *Apollo* 21 (1935), p. 12, fig. IX. E. Ruhmer, *Cosimo Tura: Paintings and Drawings*, London, 1958, pp. 48, 58 n. 95, 175–76, under nos. 47–48 (ill.). AIC 1961, pp. 487–88. *Art Institute of Chicago*, Grands Musées 2, Paris, [1968], pp. 24, 67 (ill.). Fredericksen/Zeri 1972, pp. 205, 296, 571.

EXHIBITIONS: The Art Institute of Chicago, *A Century of Progress*, 1933, no. 101, as Marco Zoppo. The Art Institute of Chicago, *A Century of Progress*, 1934, no. 40, as Marco Zoppo.

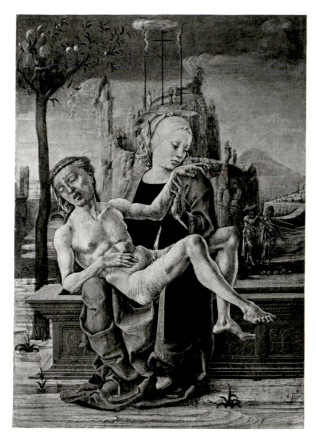
Fig. 1 Cosimo Tura, *Pietà*, Museo Correr, Venice

the folds of the Virgin's drapery gathered at her feet, result from the extension of the design onto an added strip (see Condition). Comparison of the two paintings, particularly of the main figures, reveals the general lowering of quality in the Chicago picture. This is especially evident in the rendering of the anatomy of the dead Christ. The hardening and exaggeration of Tura's style in the Chicago painting suggests the work of a Ferrarese artist, in all probability carried out within Tura's lifetime.

Closely related to Tura's composition in Venice are a terracotta sculpture (formerly Florence, Ventura Collection), first published by Van Marle,[5] and a finished drawing (London, M. H. Drey Collection).[6] Both have been attributed to Tura. Ortolani suggested that the hieroglyphs decorating the sarcophagus in the Venice *Pietà* might be the artist's signature.[7] Similar, though not identical, hieroglyphs appear in the Chicago picture.[8] Ruhmer (1958) rightly treated this suggestion with skepticism.

This panel has long been recognized as a copy after Cosimo Tura's *Pietà* dating to the early 1470s in the Museo Correr in Venice (fig. 1).[3] Tura was painter to the court at Ferrara for most of his career, though little of his work for his Este patrons survives. His style, combining intense emotion and classical vocabulary, is known largely through altarpiece fragments and small devotional works like the Museo Correr *Pietà*.

The principal difference between the autograph painting in Venice and the larger copy in Chicago is the omission of the symbolic ape in the branches of the tree on the left. This may be accounted for by the paint and ground loss and by the compensating repaint in this part of the Chicago picture (see Condition). In this context, the ape, a symbol of Eve, enhances by contrast the virtue of the Virgin, the new Eve redressing the sins of man's forebears.[4] Other minor differences between the Venice and Chicago paintings, in the vegetation in the foreground and in

NOTES
1 See also the red wax seal on the back of the panel described above in the condition report.
2 Invoice from Kleinberger to Ryerson of June 22, 1923 (Ryerson papers, Archives, The Art Institute of Chicago).
3 Ryerson purchased the panel in 1923 as a work "attributed to Cosimo Tura" (see note 2), and the painting was listed as Cosimo Tura in the 1925 guide to the Art Institute's paintings. By 1926 (Fischkin 1926), however, the picture had been reattributed to the Bolognese painter Marco Zoppo, an attribution that was retained as late as 1961 (AIC 1961). On seeing the painting in 1930, Van Marle had stated that it was by "Zoppo or some other Paduan [*sic*]" after Tura's original (letter from Daniel Catton Rich to Ryerson of January 13, 1930, in curatorial files), but by the time of his 1935 *Apollo* article, Van Marle ascribed the picture to Tura himself. Valentiner (1932) attributed it to a follower of Tura, describing it as "a contemporary replica by a Ferrarese master, possibly done in Tura's workshop c. 1500" (*Century of Progress* 1933 and 1934), and Ruhmer (1958) simply dismissed the painting as "the work of a feeble imitator."
4 For more on the symbolism of the ape, see H. W. Janson, *Apes and Ape Lore in the Middle Ages and the Renaissance*, London, 1952, pp. 109, 119–36, 151, esp. pp. 122–23, on Tura's Venice *Pietà*.
5 Van Marle 1935, fig. VI.
6 Both the sculpture and the drawing are reproduced in Ruhmer 1958, pls. 46, IX, respectively.
7 S. Ortolani, *Cosmè Tura, Francesco del Cossa, Ercole de' Roberti*, Milan, 1941, p. 42.
8 Related hieroglyphs also appear on the sarcophagus in a *Pietà* by Tura in the Kunsthistorisches Museum in Vienna (Ruhmer 1958, pl. 81).

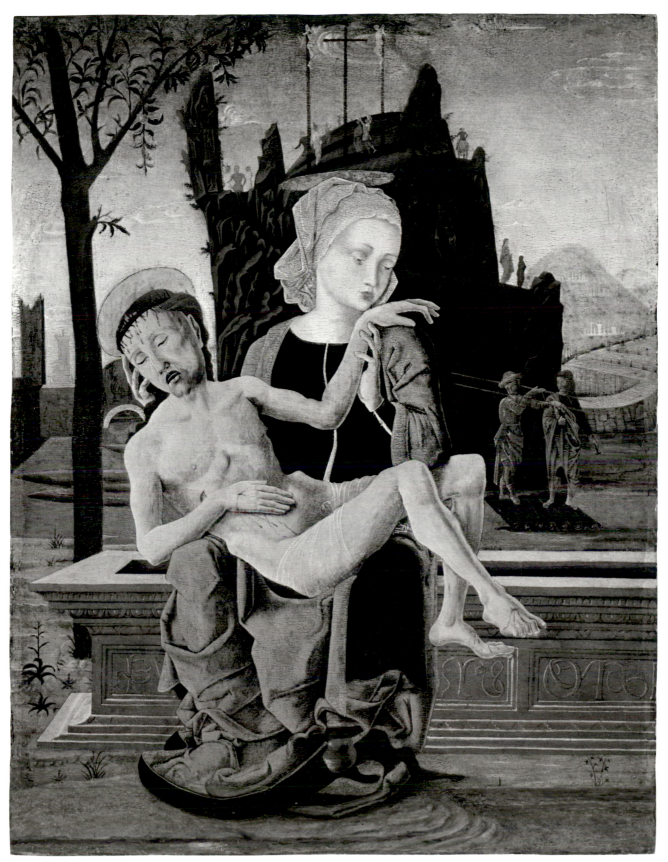

After Cosimo Tura, *Pietà*, 1933.1037

Attributed to Ugolino di Nerio

Documented in Siena, 1317–1327

Virgin and Child Enthroned with Saints Peter, Paul, John the Baptist, Dominic, and a Donor, 1325/35

Mr. and Mrs. Martin A. Ryerson Collection, 1937.1007

Tempera on panel, including frame: 43.4 x 29.1 cm (17⅛ x 11⁷⁄₁₆ in.); painted surface: 37.2 x 23.2 cm (14⅝ x 9⅛ in.)

CONDITION: The painting is in fair condition. It was cleaned in 1938 by Leo Marzolo and again in 1966 by Alfred Jakstas. The panel retains its applied engaged frame, and its back has been painted to simulate marble (fig. 1). There is evidence that hinges formerly secured this panel to another to form a diptych: there are gouged marks across the width of the left edge approximately 6 cm from the top and bottom, while the right edge has smaller puncture marks approximately 4 cm from the top and bottom and in the middle of the edge. These punctures extend approximately 6.5 cm onto the back of the panel, but appear in areas of undisturbed original paint. Hence it seems most probable that the panel was originally hinged on the left side. The paint outlining the lozenge pattern on the frame has been renewed, but this design appears to be original. There is considerable abrasion and scattered paint and ground loss on the Virgin's blue robe, with a resultant loss of modeling. The 1966 cleaning included the removal of modeling that was apparently repaint in this area. The sgraffito decorations on the cloth of honor and cushion of the throne are somewhat damaged, and some areas of pigment covering the gold underlayer have been retouched. An area of damage extends down the right edge of the panel from the ear of Saint Paul to Saint Dominic's left arm. Scratches in the patterned floor on the left by Saint John the Baptist's right foot have been inpainted, and the entire ground plane on which the monk kneels appears to have been strengthened. Paint and ground losses in Saint Peter's drapery below his right forearm, on the side of the Child's head, and where he clasps the Virgin's veil have been filled and inpainted. The Virgin's face is very well preserved, as are the faces and most of the draperies of the saints. The figure of the Christ Child and the hands of the Virgin appear markedly less refined than the other flesh areas; this may be due to a combination of overcleaning, workshop intervention, and later retouching (infrared, mid-treatment, ultraviolet, x-radiograph).

PROVENANCE: Johann Anton Ramboux (d. 1866), Cologne, by 1862.[1] Léopold Goldschmidt, Paris; sold Galerie Georges Petit, Paris, May 14, 16–17, 1898, no. 68, as School of Giotto, for Fr 650.[2] Martin A. Ryerson (d. 1932), Chicago, probably by 1904;[3] at his death to his widow, Mrs. Martin A. Ryerson (d. 1937); bequeathed to the Art Institute, 1937.

REFERENCES: J. A. Ramboux, *Katalog der Gemälde alter italienischer Meister (1221–1640) in der Sammlung der Conservators Johann Anton Ramboux*, Cologne, 1862, p. 50. J. Breck, "A Trecento Painting in Chicago," *Art in America* 1 (1913), pp. 112–15, fig. 26. Van Marle, vol. 5, 1925, p. 448. *Ryerson Collection* 1926, pp. 25–26. R. Offner, *Italian Primitives at Yale University*, New Haven, 1927, p. 4. L. Venturi 1931, pl. XXII. Berenson 1932, p. 582; 1936, p. 501; 1968, vol. 1, p. 437. Valentiner [1932], n. pag.

Fig. 1 Attributed to Ugolino di Nerio, *Virgin and Child Enthroned with Saints Peter, Paul, John the Baptist, Dominic, and a Donor*, 1937.1007 (reverse)

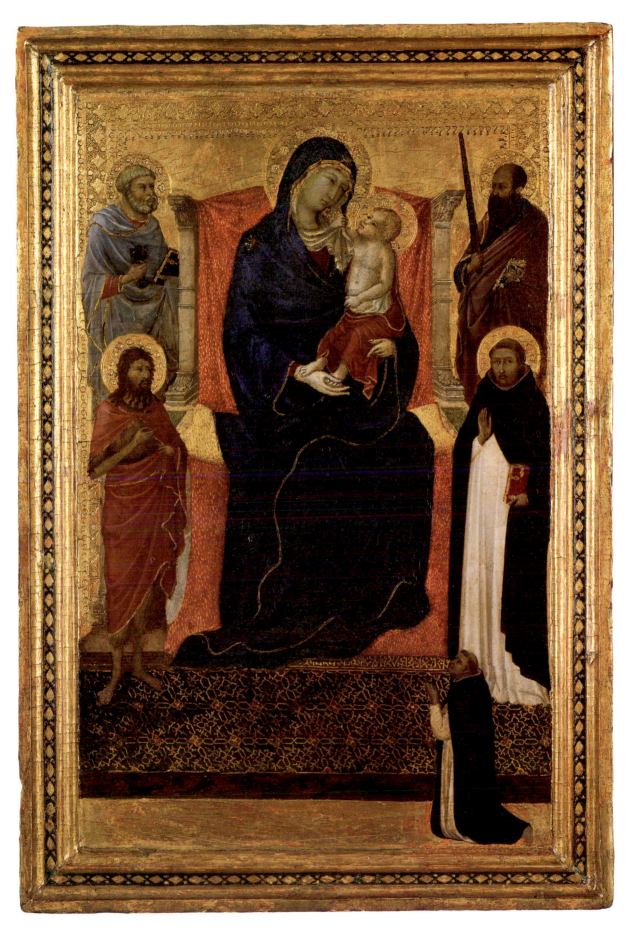

ATTRIBUTED TO UGOLINO DI NERIO 259

"The Century of Progress Exhibition of the Fine Arts," *AIC Bulletin* 27 (1933), p. 60. J. L. Allen, "The Entire Ryerson Collection Goes to the Chicago Art Institute," *Art News* 36, 21 (1938), p. 10 (ill.). K. L. Brewster, "The Ryerson Gift to The Art Institute of Chicago," *Magazine of Art* 31 (1938), pp. 95 (ill.), 97. "Exhibition of the Ryerson Gift," *AIC Bulletin* 32 (1938), pp. 2–3 (ill.). "Recent Important Acquisitions of American Museums," *Art Quarterly* 1 (1938), pp. 228 (ill.). C. Brandi, *Duccio*, Florence, 1951, pp. 142, 153, 155, pl. 119. F. A. Sweet, "La pittura italiana all'*Art Institute* di Chicago," *Le vie del mondo: Rivista mensile del Touring Club Italiano* 15 (1953), pp. 693 (ill.), 696. G. Coor-Achenbach, "Contributions to the Study of Ugolino di Nerio's Art," *Art Bull.* 37 (1955), pp. 162 n. 39, 163 n. 52. G. Coor, "Trecento-Gemälde aus der Sammlung Rambroux," *Wallraf-Richartz-Jahrbuch* 18 (1956), pp. 114, 116, fig. 93. AIC 1961, p. 413. Huth 1961, p. 516. J. H. Stubblebine, *Guido da Siena*, Princeton, 1964, p. 86. M. Frinta, "An Investigation of the Punched Decoration of Mediaeval Italian and Non-Italian Panel Paintings," *Art Bull.* 47 (1965), p. 264. L. Vertova, "Un frammento duccesco," *Arte illustrata* 2, 22–24 (1969), pp. 41–43, fig. 4. Fredericksen/Zeri 1972, pp. 207, 317, 571. J. H. Stubblebine, "Duccio's *Maestà* of 1302 for the Chapel of the Nove," *Art Quarterly* 35 (1972), p. 264 n. 16. L. Amico, "Reconstructing an Early Fourteenth-Century Pentaptych by Ugolino di Nerio: St. Catherine Finds Her Niche," *Bulletin of the Krannert Art Museum, University of Illinois, Urbana-Champaign* 5, 1 (1979), pp. 25–26, 30 n. 24. J. H. Stubblebine, *Duccio di Buoninsegna and His School*, Princeton, 1979, vol. 1, pp. 176, 179–80, 189, vol. 2, fig. 444. M. Davies, rev. by D. Gordon, *National Gallery Catalogues: The Early Italian Schools before 1400*, London, 1988, pp. 23–24, under no. 6386.

EXHIBITIONS: The University of Chicago, The Renaissance Society, *Commemorative Exhibition from the Martin A. Ryerson Collection*, 1932, no. 2, as Segna [di] Bonaventura. The Art Institute of Chicago, *A Century of Progress*, 1933, no. 95, pl. XII, as Segna di Bonaventura. Dallas, Museum of Fine Arts, *The Centennial Exposition*, 1936, no. 20, as Segna di Bonaventura. The Art Institute of Chicago, *The Art of the Edge: European Frames, 1300–1900*, 1986, no. 3 (ill.).

This panel must once have been the right wing of a diptych, as indicated by what appear to be hinge marks on the left edge (see Condition). The left wing probably portrayed the Crucifixion. The prominence granted to Saint Dominic demonstrates that the diptych was commissioned by a member of that order. The panel's small scale and the fact that its back is painted to simulate marble (fig. 1) suggest that the diptych functioned as a portable altarpiece for private devotion.

The panel had already been separated from its companion piece by the mid-nineteenth century, when it belonged to Johann Anton Rambroux (1790–1866), one of the foremost nineteenth-century collectors and connoisseurs of early Italian and northern European painting.[4] The type of punching and the molding of the engaged frame are typical of Sienese paintings dating from the second quarter of the fourteenth century. In style the panel is clearly the work of a painter in the Ducciesque tradition. While in Rambroux's collection, it was attributed to Segna di Bonaventura,[5] which was the attribution favored by the Art Institute through the mid-1970s. Berenson (1932, 1936, 1968), Sandberg-Vavalà,[6] and Fredericksen and Zeri (1972) ascribed the panel to Ugolino di Nerio or his workshop. Coor-Achenbach (1955) tentatively identified the artist as one of Ugolino di Nerio's brothers; however, no surviving work can be firmly attributed to either brother. Brandi (1951) and Stubblebine (1979) included the panel in specific, although different, groups of pictures that they ascribed to anonymous hands. Brandi formed a group around the *Virgin and Child* once in the Tadini-Boninsegni Collection (now Florence, Palazzo Pitti, Contini-Bonacossi Collection),[7] which he defined as being in a style halfway between Ugolino di Nerio and the Master of Città di Castello. Stubblebine (1979), on the other hand, in the most extensive study of Duccio and his followers so far published, attributed the panel to an Ugolino follower he called the Polyptych 39 Master, based on an altarpiece in the Pinacoteca in Siena.[8] He described this painter as "Ugolino's closest assistant," and placed his period of activity between c. 1320 and c. 1335. Stubblebine regarded the panel in Chicago as dating from as late as c. 1335, which would account for the apparent influence of Simone Martini.

Little is known about Ugolino di Nerio, who is mentioned in Sienese documents of 1317, 1325, and 1327, and presumably was a follower and collaborator of Duccio. In the first edition of his *Lives*, Vasari reported Ugolino's death date as 1339, but gave it as 1349 in his second edition. Although Ugolino's art is

firmly rooted in the tradition of Siena, being a subtle revision of Duccio's forms in the light of the work of Pietro Lorenzetti and Simone Martini, he received important Florentine commissions, for the high altars of Santa Croce and Santa Maria Novella. Surviving fragments of the high altar from Santa Croce, formerly signed by Ugolino and also ascribed to him by Vasari, are the basis for attributions to the painter. These are now divided among The National Gallery in London, the Gemäldegalerie in Berlin, and other collections.[9]

Of the other works attributed by Stubblebine to the Polyptych 39 Master, the *Virgin and Child* in the Princeton University Art Museum (no. 37.357) and the *Crucifixion* in The Metropolitan Museum of Art in New York are the most accessible for comparison.[10] The refined facial features and long elegant fingers are characteristic of this group, as is the highlighting of the nose. Even though Stubblebine believed the panel in Chicago to have been executed after the painter had left Ugolino di Nerio's workshop, the figure of Saint Dominic still strongly resembles the Saint Francis on the polyptych in Siena.[11] However, the distinction between Stubblebine's Polyptych 39 Master and the oeuvre of Ugolino di Nerio is a narrow one and has not been generally accepted. Boskovits, Kanter, and Fahy, for example, considered that the works attributed to the Polyptych 39 Master are really by Ugolino himself.[12] In view of these opinions and the very high quality and delicate colors of those portions of the Chicago panel that are well preserved, a cautious attribution to Ugolino himself seems appropriate.[13]

Regarding the composition, Stubblebine (1979) demonstrated that the hierarchical distribution of the saints and the elevated position of the Virgin are dependent upon Duccio's lost *Maestà* of 1302, a point first made by Brandi (1951).[14] In composition, scale, and function, the Chicago panel is also closely related to the Ducciesque *Virgin and Child with Four Angels* in The National Gallery in London.[15] This type of composition was also popular in Florence by the 1330s with such artists as Bernardo Daddi and Jacopo del Casentino, and continued to be used by retardataire painters in Siena during the second half of the fourteenth century.

NOTES

1 According to an inventory of Rambouxs collection drawn up in 1862 (see References). The relevant passage from this inventory is quoted by Coor (1956).

2 According to an annotated copy of the sale catalogue in the Resource Collection of the Getty Center for the History of Art and the Humanities, Santa Monica.

3 In a letter of January 18, 1904, Robert Herrick reported on a visit by Berenson, who was interested in "the little Sienese Madonna... which first he thought was a Duccio worked over. But decided was a 'School of Lippo Memmi'" (Ryerson papers, Archives, The Art Institute of Chicago). This was in all probability no. 1937.1007.

4 For Ramboux, see *Johann Anton Ramboux: Maler und Konservator, 1790–1866*, exh. cat., Cologne, Wallraf-Richartz Museum, 1966–67; and H.-J. Ziemke, "Rambouxs und die sienesische Kunst," *Städel-Jahrbuch*, n.s., 2 (1969), pp. 255–300.

5 Rambouxs 1862; see also Coor 1956.

6 According to an undated expertise in curatorial files.

7 Stubblebine 1979, vol. 2, fig. 373.

8 Ibid., figs. 438–40.

9 Ibid., figs. 396–414.

10 For illustrations, see ibid., fig. 441; and Zeri/Gardner 1980, pp. 46–47, pl. 11, respectively.

11 Stubblebine 1979, fig. 438.

12 M. Boskovits, review of *Duccio di Buoninsegna and His School* by J. H. Stubblebine, in *Art Bull.* 64 (1982), p. 497; L. B. Kanter, "Ugolino di Nerio: *Saint Anne and the Virgin*," *National Gallery of Canada Annual Bulletin* 5 (1981–82), esp. pp. 13–14, 26 n. 15; and letter from Everett Fahy to Martha Wolff of March 31, 1987, in curatorial files. See also E. Fahy, review of *Duccio di Buoninsegna and His School* by J. H. Stubblebine, in *Apollo* 114 (1981), pp. 130–31.

13 John Pope-Hennessy (visit of April 7, 1987), Everett Fahy (letter cited in note 12 and visit of April 23, 1991), and Laurence Kanter (visit of May 2, 1988) have all attributed the picture to Ugolino, according to notes in curatorial files. Interestingly, Stubblebine remarked earlier (1964) that the figure of Saint Dominic on the right, with raised hand, was ultimately derived from a cut-down panel of the saint dating from the thirteenth century (Cambridge, Massachusetts, Fogg Art Museum). For this panel, see C. Gomez-Moreno, A. Wheelock, Jr., E. H. Jones, and M. Meiss, "A Sienese *St. Dominic* Modernized Twice in the Thirteenth Century," *Art Bull.* 51 (1969), pp. 363–66. Frinta subsequently demonstrated that the Fogg panel had actually been decorated with punching in the workshop of Ugolino di Nerio during the early fourteenth century (M. Frinta, "Note on the Punched Decoration of Two Early Painted Panels at the Fogg Art Museum: *S. Dominic* and the *Crucifixion*," *Art Bull.* 53 [1971], pp. 306–07).

14 See J. Stubblebine 1979; and Brandi 1951, p. 141 n. 23. For further information about Duccio's lost *Maestà* of 1302, see Stubblebine 1972, pp. 239–55.

15 As follower of Duccio, in Davies/Gordon 1988, pp. 23–24, pl. 18. Julian Gardner's opinion, cited in this entry, that the London and Chicago pictures may be by the same hand, does not seem justified.

Giorgio Vasari

1511 Arezzo–Florence 1574

The Temptation of Saint Jerome, 1541/48

Charles H. and Mary F. S. Worcester Collection, 1964.64

Oil on panel, 166.5 x 121.9 cm (65½ x 48 in.)

CONDITION: The painting is in very good condition. It has not been treated since its acquisition by the Art Institute. The panel, which is approximately 3 cm thick, has not been thinned.[1] It is composed of three boards aligned vertically with joins approximately 41 and 76 cm from the left edge. Two horizontal battens have been set into the panel. There are several vertical splits along the upper edge of the panel, and one of these has been reinforced by a butterfly cleat inserted in its back. The paint surface is very well preserved, given its unfinished state. Examination in ultraviolet light reveals scattered minute retouches compensating for pinpoint losses of paint throughout. Other such scattered losses have not been retouched. Further retouching is concentrated in the shadowed areas of Saint Jerome's face. The only larger area of damage coincides with a knothole on the shoreline above the river god. There is a pronounced drying crackle in the dark areas. The underdrawn preparation for the figures and a grid, presumably used to guide the transfer of the design, are clearly visible to the naked eye. Infrared reflectography reveals that the distant landscape was underdrawn as well. Papillary marks are visible in Venus's skirt and elsewhere. A circle approximately 12 cm in diameter has been incised with a compass in the lower right corner.

PROVENANCE: Sold Sotheby's, London, July 3, 1963, no. 89 (ill.), to Patch for £3800.[2] Julius Weitzner, London. Purchased from Weitzner by the Art Institute through the Charles H. and Mary F. S. Worcester Collection Fund, 1964.

REFERENCES: Maxon 1970, p. 254 (ill.). C. Monbeig-Goguel, "Giorgio Vasari et son temps," *Revue de l'art* 14 (1971), p. 108. Fredericksen/Zeri 1972, pp. 209, 409, 571. Bénézit, 3d ed., vol. 10, 1976, p. 404. *Dizionario*, vol. 11, 1976, p. 258. A. M. Bracciante in *Giorgio Vasari*, exh. cat., Arezzo, Casa Vasari, 1981, sec. 4, p. 80, under no. 11. D. Clark, "Vasari's *Temptation of St. Jerome* Paintings: Artifacts of his Camaldoli Crisis," *Studies in Iconography* 10 (1984–86), pp. 102, 106, 108, 110, 112, 115 n. 25, 117 n. 48, fig. 2 (mislabeled). C. M. Brown, "'Verzeichnis etlicher Antiquitäten, so von Herrn Kardinal von Trient überschickt worden': Paintings and Antiquities from the Roman Collection of Bishop Gerolamo Garimberto Offered to Duke Albrecht Vth of Bavaria in 1576," *Xenia* 10 (1985), pp. 60, 64, 69–70 n. 18. L. Corti, *Vasari: Catalogo completo dei dipinti*, Florence, 1989, p. 38, under no. 21.

EXHIBITIONS: University of Notre Dame, Indiana, Art Gallery, *The Age of Vasari*, 1970, no. P18.

Best known as the author of the monumental *Le vite de' più eccellenti pittori, scultori ed architettori* (published first in 1550 and again, in expanded form, in 1565), Giorgio Vasari was also an architect and a prolific painter. He traveled widely and developed an eclectic style, indebted not only to Florentine Mannerist artists such as Rosso Fiorentino and Francesco Salviati, but also to Northern Italian painters, including Parmigianino. A favorite of the Medici as much for his administrative skills as for his artistic ability, he was asked by Cosimo I to supervise the refurbishing and fresco decoration of the Palazzo Vecchio (1556–72). He was also responsible for the renovation and decoration of the Florentine churches of Santa Croce and Santa Maria Novella (1566–72), as well as for numerous other projects commissioned by the Medici.

A painting of the same subject as the present work, ordered by Ottaviano de' Medici, is described in Vasari's autobiography:

> Nel medesimo tempo ch'io feci questa tavola, che fu posta, come ho detto, in Sant Apostolo, feci a messer Ottaviano de' Medici una Venere ed una Leda, con i cartoni di Michelagnolo; ed, in un gran quadro, un San Girolamo, quanto il vivo, in penitenza, il quale, contemplando la morte di Cristo, che ha dinanzi in sulla croce, si perquote il petto per scacciare della mente le cose di Venere e le tentazioni della carne, che alcuna volta il molestavano, ancorchè fusse nei boschi, e luoghi solinghi e salvatichi, secondo che egli stesso di sè largamente racconta. Per lo che dimostrare, feci una Venere che con Amore in braccio fugge da quella contemplazione, avendo per mano il Giuoco, ed essendogli cascate per terra le freccie ed il turcasso; senza che, le saette da Cupido tirate verso

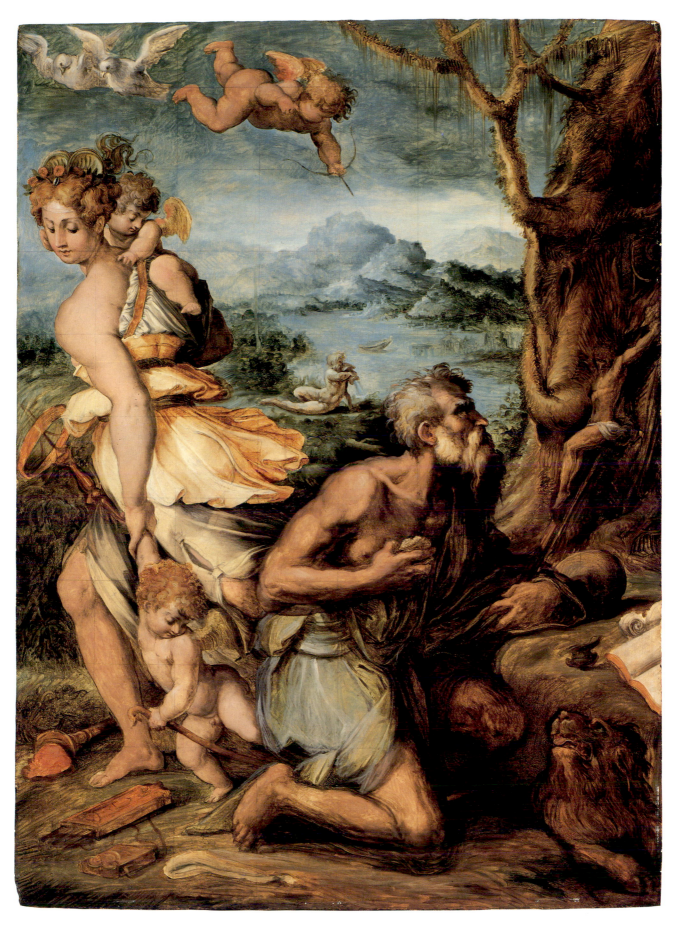

quel Santo, tornano rotte verso di lui, ed alcune che cascano gli sono riportate col becco dalle colombe di essa Venere.[3]

A further reference to the picture for Ottaviano, this time with an indication of the date, 1541, occurs in Vasari's studio book:

Ricordo come a di ultimo dagosto 1541 il Magnifico Messer Ottavjano de Medici mj fecje fare un quadro grande di braccia dua emezzo alto et braccia dua largo drentovj un San Jeronimo in penitentia che tenendo il Crocifisso in mano si percuote il petto: et ment(r)e Venere abracciando i suoi amorj si fuggie et il giu(o)co lo stragina per un braccio et cupito gli tira le freccie sendo cascati gli arnesi amorosi loratione romper ogni cosa venerea. quale si lavorò con diligentia.[4]

Two replicas of this composition are also recorded in the artist's studio book. The first was made in 1545 for Tommaso Cambi, and the second in 1547 for Monsignor de' Rossi, Bishop of Pavia.[5] It is apparent from the entry in the studio book that the replica for the Bishop of Pavia was of the same dimensions as the original painting for Ottaviano de' Medici, while it is possible that the replica for Tommaso Cambi was slightly smaller since its price was lower. There are three extant versions of this composition that are virtually identical to the present picture in size: Florence, Palazzo Pitti (169 x 123 cm; fig. 1); Leeds, Temple Newsam House (168.8 x 120 cm; fig. 2); and Vincigliata (near Florence), Graetz collection (165 x 117 cm).[6] It is difficult to establish with certainty which of these three versions is the primary one painted for Ottaviano de' Medici, but it would be reasonable to assume that it is the one now in the Palazzo Pitti.

Although the Chicago panel is similar in size to the other three versions, its composition is different; it is a variant, not a replica. Here Venus turns her back on Saint Jerome and flees out of the picture away from the spectator; Vasari has further opened up the composition by emphasizing the landscape background and by incorporating the figure of a river god and some boating activity on the lake in the middle distance. One result of this arrangement is that the size of the figures in relation to the background is reduced, so that the actions of the protagonists are less concentrated and, given the greater amount of space, invested with a more forceful dynamism. The type of vegetation has also been altered in the present painting, with the tree on the right more closely resembling the natural world as depicted by the Danube School. Other differences between the Chicago painting and the other three versions include the reversal in the positions of the doves and Cupid at the top, and the addition of a volume of scripture and an inkwell to the saint's attributes in the lower half of the panel. The Art Institute's painting is also the only unfinished version. The paint has been very thinly applied and the squaring in black chalk over the whole surface of the panel is easily visible to the naked eye. The figure of Venus and the head of Saint Jerome are more highly finished than other parts of the figures, just as the distant landscape has been worked over more than the foreground. Prominent *pentimenti* are visible around the right forearm and leg of Saint Jerome.

In the 1970 exhibition catalogue, Milkovitch suggested that the present composition had been executed before the version now in the Palazzo Pitti; this was also Clark's opinion (1984–86). However, stylistically the present picture appears to be closer to works dating to later in the 1540s, for example, the allegorical figures in the frescoes of 1542 and 1548 on the ceilings and walls of the Camera della Fama e delle Arti, the Camera di Abramo, or the Camera del Trionfo della Virtù in the Casa Vasari at Arezzo, and the frescoes of 1544 in the refectory of the monastery of Monte Oliveto in Naples.[7] The figure of *Abundance* at Monte Oliveto is especially close to the Venus in the Chicago painting. The landscape in the present picture is characteristic of Vasari and can be compared to those in several of his paintings, including the *Madonna and Saints* (1548) in the church of San Francesco at Castiglion Fiorentino (near Arezzo) and *The Calling of Saint Peter* (1551) in the Badia di Sante Flora e Lucilla in Arezzo.[8]

Monbeig-Goguel (1971) doubted the attribution of the Chicago panel to Vasari, and Iris Cheney suggested that the picture was by "an independent personality very much influenced by Salviati."[9] She believed a painting of *Justice* at the Bargello in Florence (there attributed to Salviati) to be by the same hand. However, a comparison between the Chicago and Bargello pictures is not persuasive. If Vasari's

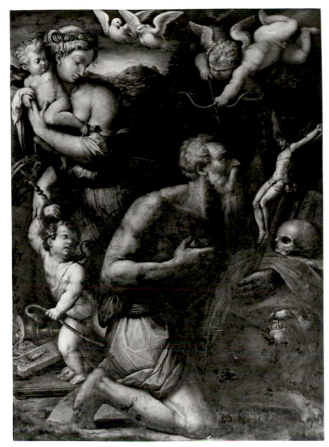

Fig. 1 Giorgio Vasari, *The Temptation of Saint Jerome*, Palazzo Pitti, Florence [photo: Gabinetto Fotografico della Soprintendenza ai Beni Artistici e Storici, Florence]

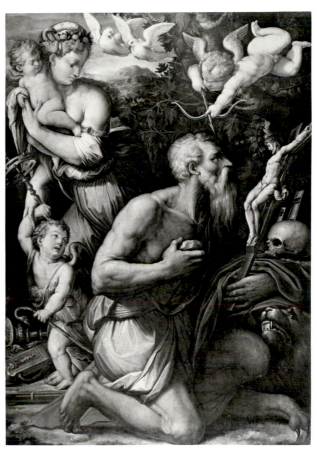

Fig. 2 Giorgio Vasari, *The Temptation of Saint Jerome*, Temple Newsam House (Leeds City Art Galleries)

own hand is not preferred, then it is necessary to look at other artists working in his immediate milieu, such as Cristofano Gherardi.

Both compositionally and thematically, the picture is essentially a composite. Like the *Allegory of the Immaculate Conception* painted by Vasari in 1540 for the church of Santi Apostoli in Florence,[10] *The Temptation of Saint Jerome* reveals the painter's numerous artistic allegiances. Barocchi, writing about the principal version in Florence, observed that the saint's pose is reminiscent of that of Cacus in Bandinelli's marble group of *Hercules and Cacus* dating from 1534 in the Piazza della Signoria in Florence.[11] The proportions of the figures can be somewhat loosely but legitimately described as Michelangelesque, perhaps inspired by the copies the artist made of Michelangelo's *Leda* and *Venus and Cupid* just before painting *The Temptation of Saint Jerome*.[12] The figure of Venus with Cupid and Play (*Giuoco*), however, is

surely an allusion to classical sculpture, as Bracciante (1981) indicated. These influences have been somewhat diluted in the present painting, and the work emerges as a fine example of Vasari's growing maturity.

The iconography is clearly inspired by a passage occurring in the famous letter of Saint Jerome to Eustochium:

How often, when I was established in the desert and in that vast solitude which is scorched by the sun's heat and affords a savage habitation for monks, did I think myself amid the delights of Rome! I would sit alone because I was filled with bitterness. My limbs were roughly clad in sackcloth — an unlovely sight. My neglected skin had taken on the appearance of an Ethiopian's body. Daily I wept, daily I groaned, and whenever insistent slumber overcame my resistance, I bruised my awkward bones upon the bare earth. Of food and drink I say nothing, since even the sick drink only cold water, and to get any cooked food is a

luxury. There was I, therefore, who from fear of hell had condemned myself to such a prison, with only scorpions and wild beasts as companions. Yet I was often surrounded by dancing girls. My face was pale from fasting, and my mind was hot with desire in a body cold as ice. Though my flesh, before its tenant, was already as good as dead, the fires of the passions kept boiling within me.[13]

In his autobiography, Vasari explained his elaboration on the conventional iconography of this subject. However, none of the known versions of the composition corresponds in every detail to his written account of the painting for Ottaviano de' Medici. For example, none of the paintings includes visual elements to match the account of Cupid's marksmanship or the description of the arrows being fetched by the doves. Vasari's description also underplays the originality of his treatment of the iconography, although the degree of its complexity is open to question. The general theme is indisputably the victory of the mind over the body, or the intellect over the senses, but it is harder to establish the exact terms of reference for the juxtaposition of Saint Jerome with Venus and her supporting cast and equipage.

Bracciante (1981) suggested that Vasari had adapted his written analysis of the iconography of Saint Jerome to suit the special conditions of the Counter-Reformation. She interpreted the doves and the torch as symbols of love in the context of the *Hieroglyphica* of Horapollo, which was well known in Medicean circles for some time before the publication of Pierio Valeriano's edition of the work in 1556.[14] Clark (1984–86) broadened the terms of reference to include Neoplatonic literature, in addition to other letters by Saint Jerome (particularly the *Letter to Heliodorus the Monk*),[15] and then attempted to unravel the meaning of the picture in light of Vasari's own stylistic development. It is highly doubtful that the imagery in the painting is open to Clark's convoluted interpretation, and indeed it is questionable whether any secondary meaning was intended at all. Recondite texts undoubtedly contributed to the cultural climate in which the painting was made, but it does not follow that the artist used them or even knew of them. It should be remembered that Vasari, who was never slow to advertise his own achievements, failed to mention any such sources for his paintings of Saint

Jerome. It is perhaps legitimate to look for hidden meanings in Vasari's secular paintings for the Medici. But it is unlikely, given his prodigious output, that on this occasion Vasari devised anything more elaborate than a novel, yet straightforward, rendering of a theme that focused on religious elements and also provided an opportunity to introduce mythological overtones.

NOTES

1 The number *166C* has been painted on the back of the panel.

2 According to an annotated copy of the sale catalogue in the Ryerson Library, The Art Institute of Chicago.

3 Vasari, *Vite*, Milanesi ed., vol. 7, pp. 669–70. "At the same time that I painted that picture, which was placed, as I have said, in S. Apostolo, I executed for M. Ottaviano de' Medici a Venus and a Leda from the cartoons of Michelagnolo, and in a large picture a S. Jerome in Penitence of the size of life, who, contemplating the death of Christ, whom he has before him on the Cross, is beating his breast in order to drive from his mind the thoughts of Venus and the temptations of the flesh, which at times tormented him, although he lived in woods and places wild and solitary, as he relates of himself at great length. To demonstrate which I made a Venus who with Love in her arms is flying from that contemplation, and holding Play by the hand, while the quiver and arrows have fallen to the ground; besides which, the shafts shot by Cupid against that Saint return to him all broken, and some that fall are brought back to him by the doves of Venus in their beaks" (G. Vasari, *The Lives of the Most Eminent Painters, Sculptors, and Architects*, tr. by G. Du C. de Vere, New York, 1979, p. 2235).

4 *Il libro delle ricordanze di Giorgio Vasari*, ed. by A. del Vita, Rome, 1938, p. 36. A translation of this passage might read as follows: "I record on the last day of August 1541 that I have made for the Magnificent Ottaviano de' Medici a large picture two and a half braces high and two braces wide [c. 57 x 46 in.]. In it a Saint Jerome in penitence holds a crucifix in his hand and strikes himself on the chest, while Venus carrying her cupids flees — she drags Play by an arm and Cupid shoots arrows at him [Jerome]; the tools of love have fallen and his prayer breaks everything of Venus. On the picture I have labored with diligence."

5 Ibid., pp. 50, 57. Brown (1985) demonstrated that the version made for the Bishop of Pavia was included on a list of items (mainly antiquities) owned by Gerolamo Garimberto, Bishop of Gallese, drawn up in 1569. In 1576, Garimberto's collection was offered for sale to Albrecht V of Bavaria. Cardinal Cristoforo Madruzzo of Trent (for whom see the entry above on Moroni's *Gian Ludovico Madruzzo* [1929.912]) drew up an inventory for Albrecht V in anticipation of this sale, but the transaction was never concluded and the collection was dispersed.

6 For the painting in the Graetz collection, see *Mostra dei tesori segreti delle case fiorentine*, exh. cat., Florence, Circolo Borghese e Della Stampa, 1960, p. 25, no. 47, pl. 38. As observed by Paul Joannides in a letter to the author of May 15, 1984 (in curatorial files), the composition of

Vasari's painting was also known in the Veneto, where Gaspar Rem, a Netherlandish painter who was born in Antwerp in 1542 and subsequently worked in Venice, used it toward the close of the sixteenth century. In Rem's painting *Saint Jerome at Prayer* (Padua, private collection), the figure of Venus has the air of a Venetian courtesan. For an illustration, see R. Pallucchini, *La pittura veneziana del seicento*, Milan, 1981, vol. 1, p. 65, vol. 2, fig. 161.

7 For illustrations, see *Vasari* 1981, figs. 5–10, 16–20, 22–66; and P. Barocchi, *Vasari pittore*, Milan, 1964, pls. 28a–b, 29b, respectively.

8 Barocchi (note 7), figs. 35, 39.

9 According to a letter from Cheney to Everett Fahy of February 1, 1987 (copy in curatorial files). Cheney had earlier suggested in a letter to John Maxon of August 12, 1964 (in curatorial files), that the Chicago picture was a variant

painted around 1543 by Francesco Salviati after Vasari's composition.

10 Barocchi (note 7), pp. 116–17, pl. XI.

11 Ibid., p. 22. For an illustration of this sculptural group, see A. Venturi, vol. 10, pt. 2, 1936, fig. 170.

12 For copies after these works, see C. de Tolnay, *Michelangelo*, vol. 3, *The Medici Chapel*, Princeton, 1948, pp. 106–09, 190–96.

13 *The Letters of St. Jerome*, tr. by C. Mierow, ed. by T. C. Lawler, vol. 1, London, 1963, pp. 139–40, letter 22, sec. 7. Numerous editions of Saint Jerome's collected letters were available in Italy during the sixteenth century.

14 See *Vasari* 1981, sec. 6, pp. 181–83, no. 5.

15 *The Letters of St. Jerome* (note 13), pp. 59–69, letter 14, esp. pp. 63–64.

Venetian

The Flight into Egypt, 1540/50

Charles H. and Mary F. S. Worcester Collection, 1947.111

Oil on canvas, 42 x 98 cm (16½ x 38½ in.)

CONDITION: The painting is in poor condition. In 1959 Anton Konrad surface cleaned it and attached metal edging strips. The relatively fine flat-weave canvas had earlier been glue lined to a coarser canvas. The x-radiograph shows weave distortion and old tacking holes at the bottom and right edges and some weave distortion at the top and left edges, suggesting that the canvas has been only minimally trimmed. The paint is applied over a dark ground. The paint surface is much disturbed by abrasion, by the imposition of the texture of the lining canvas, and by the dark ground now visible through minute flake losses along the crackle pattern. There are numerous small retouches throughout. A *pentimento* surrounds the form of the dog (x-radiograph).

PROVENANCE: Agnew, London and New York, by 1930.[1] Sold by Agnew to Charles H. Worcester, Chicago, 1930;[2] intermittently on loan to the Art Institute from 1930; given to the Art Institute, 1947.

REFERENCES: AIC 1932, p. 193. "A Painting by Schiavone," *AIC Bulletin* 27 (1933), pp. 39, 44 (ill.). *Worcester Collection*

1938, p. 14, no. 9, pl. VIII. Berenson 1957, vol. 1, p. 168. AIC 1961, p. 309. Fredericksen/Zeri 1972, pp. 185, 275, 571.

EXHIBITIONS: The University of Chicago, The Renaissance Society, *Religious Art from the Fourth Century to the Present Time*, 1930, no. 30, as Schiavone. Art Gallery of Toronto, *Italian Old Masters and German Primitives*, 1931, no. 31a, as Schiavone. The Art Institute of Chicago, *A Century of Progress*, 1933, no. 133, as Schiavone. Grand Rapids Art Gallery, Michigan, *Community Angels Build*, 1959–60 (no cat.).

The painting is of a type probably intended for the decoration of a private room in a secular context. Such pictures were produced in great quantities in the Veneto by artists like Bonifazio de' Pitati and were usually displayed as overdoors or else incorporated

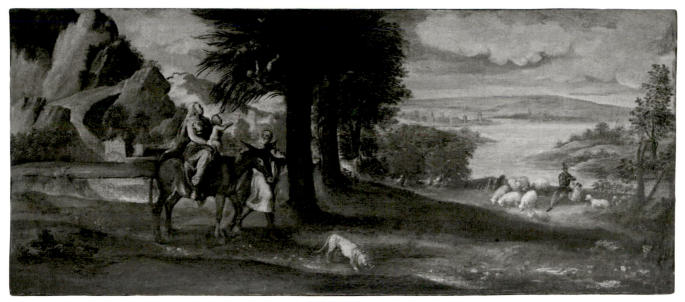

Venetian, *The Flight into Egypt*, 1947.111

into pieces of furniture. The attribution of the present painting to Schiavone has not been upheld with any confidence since the picture first became known in 1930. According to Rich (*Worcester Collection* 1938), Berenson once suggested that the artist was Friedrich Sustris. G. M. Richter was apparently the first to suggest the name of Schiavone, which was retained for many years.[3] There is no mention of the painting, however, in the 1980 monograph on Schiavone by Francis L. Richardson, not even in the section devoted to paintings mistakenly attributed to Schiavone. The attribution has yet to be satisfactorily resolved, and for the present purposes the painting is best categorized as Venetian.

The pastoral treatment of the Flight into Egypt was common among north Italian artists. The scriptural source for this is the apocryphal gospel of the Pseudo-Matthew (chs. 20–21), in which the young Christ bids the palm tree to give forth of the fruit of its branches and of the water from beneath its roots.[4]

A rather literal interpretation of this incident is provided by the acrobatic performance of the little angels in the palm tree, who seem to be dropping dates into the Christ Child's extended hands, and by the stream in the foreground from which the dog is drinking.

NOTES

1 According to registrar's records. The early provenance of the picture is unknown. A letter from Agnew's to Daniel Catton Rich of February 25, 1937, in curatorial files, states that the painting was bought from another London dealer, who had in turn acquired it at a sale where it was apparently sold anonymously.

2 According to registrar's records and 1930 exhibition catalogue. A document in curatorial files dated October 11, 1945, indicates that *The Flight into Egypt* was owned by Mary F. S. Worcester.

3 G. M. Richter's opinion is reported by Rich in *Worcester Collection* 1938. All published references to this work attribute it to Schiavone, except for Berenson, who in the 1957 edition of his "lists" gave the painting to Lambert Sustris.

4 M. R. James, tr., *The Apocryphal New Testament*, Oxford, 1955, p. 75.

Portrait Presumed to Be of Antonio Zantani, 1550/60

Charles H. and Mary F. S. Worcester Collection, 1947.115

Oil on panel, 31.8 x 24.3 cm (12½ x 9 9/16 in.)

INSCRIBED: ANTONIVS. / ZANTANI. / COMES.ET. / EQVES (upper left corner)

CONDITION: The painting is in poor condition. It was cleaned by Leo Marzolo in 1935. Alfred Jakstas surface cleaned it in 1962 and cleaned it more thoroughly in 1965. The panel is composed of a single board with vertical grain. Edging strips have been attached at the right, top, and bottom. On the left side, exposed worm tunneling indicates that this edge has been cut somewhat. A strip approximately 1 cm wide at the upper edge of the painting has been filled and repainted. A narrow strip along the bottom edge has also been repainted. The paint surface is severely abraded throughout and has been extensively retouched, particularly in the hair, beard, and background (infrared, x-radiograph, ultraviolet).

PROVENANCE: Possibly Henry Pfungst and J. J. van Alen, Rushton Hall, Kettering (Northamptonshire).[1] L. Breitmeyer, London.[2] Asscher and Welker, London. Sold by Asscher and Welker to Charles H. Worcester, Chicago, 1935; given to the Art Institute, 1947.

REFERENCES: *Worcester Collection* 1938, pp. 14–15, no. 10, pl. IX. K. Kuh, "The Worcester Gift," *AIC Bulletin* 41 (1947), p. 63. H. Comstock, "Tintoretto's Portrait of a Venetian Senator," *Connoisseur* 121 (1948), p. 46 (ill.). Berenson 1957, vol. 1, p. 171. P. Wescher, "I ritratti del Doge Girolamo Priuli del Tintoretto," *Arte veneta* 9 (1957), p. 207. AIC 1961, pp. 450–51. Huth 1961, p. 518. C. Bernari and P. De Vecchi, *L'opera completa del Tintoretto*, Milan, 1970, p. 134, fig. F14. Fredericksen/Zeri 1972, pp. 199, 518, 520, 571. P. Rossi, *Jacopo Tintoretto*, vol. 1, *I ritratti*, Venice, 1974, pp. 140–41.

Daniel Catton Rich (1938) catalogued the portrait when it formed part of the Worcester collection as an autograph work by Jacopo Tintoretto. The opinions of several other authorities are recorded in Rich's entry

for the Worcester catalogue: Raimond van Marle favored an attribution to Titian around 1555 or after,[3] while Lionello Venturi, G. M. Richter, and Berenson upheld the traditional ascription to Tintoretto.[4] Of these authorities, only Berenson published his attribution, by including the portrait as an early work by the artist in his "lists" of 1957. Comstock (1948) and Wescher (1957) also retained the attribution to Tintoretto. More recently, there has been far less confidence about such an attribution. The 1961 catalogue of the Art Institute's paintings included the following statement about the picture, "The execution is either by the workshop or else, more probably, is the work of an untalented imitator of the master," which is a fair assessment of the quality of the painting. Fredericksen and Zeri (1972) considered the portrait to be a product of Tintoretto's workshop. Bernari and De Vecchi (1970) rejected the attribution to Tintoretto without discussion, as did Rossi (1974), who preferred to classify the portrait as a work by an anonymous sixteenth-century painter of the Venetian school, but one with stylistic links closer to Titian than to Tintoretto.

Doubts have been raised about the authenticity of the inscription, which may have been added later. Based on it, the sitter is usually identified with Antonio Zantani (1514–1567), the son of Marco Zantani and Tommasina Tommasini, who achieved fame as a scholar and philanthropist, and was granted the title *comes et eques* (count and knight) by Pope Julius III in 1553. An early authority on medals, he is best known in this field as the author of *Le imagini con tutti i riversi trovati et le vite degli imperatori tratte dalle medaglie et dalle historie degli antichi* (Venice, 1548), which was illustrated with engravings by Enea Vico. Zantani also financed the building of and probably helped to design the Venetian church of the Ospedale degli Incurabili, now destroyed. He was buried in the Chiesa del Corpus Domini, Venice.[5]

Hans Tietze believed that the sitter is shown wearing the uniform of a Venetian admiral and on that basis suggested that this might be a portrait of Jacopo Soranzo the Younger (1518–1587).[6] However, a woodcut in Cesare Vecellio's *Degli habiti antichi et moderni di diverse parti del mondo* (Venice, 1590, bk. 1, p. 103) shows that the uniform is really that of a Venetian general, and is described as follows: "Generale di Venetia in tempo di guerra. . . . egli era vestito tutto di velluto cremesino, in testa haveva la beretta Ducale, & indosso il manto d'oro; che noi habbiamo altrove mostrato essere il vero Paludamento, allacciato sopra la spalla destra con alcuni bottoni d'oro massiccio" (A Venetian general at the time of war. . . . he was dressed all in crimson velvet, he wore a ducal cap on his head and on his back the gold cloak, which we have elsewhere shown to be the true Roman cloak, attached to his right shoulder with some solid gold buttons).

There should be four buttons on the right shoulder instead of the three visible here, which suggests that the panel may have been trimmed (see Condition). The uniform can be compared with that in Tintoretto's *Portrait of a Venetian General* in the Armand Hammer Museum, Los Angeles, which, similarly, has only three shoulder buttons visible.[7] Antonio Zantani did have a famous uncle of the same name who died in 1500 fighting the Turks, but this relation never held the rank of general and the portrait cannot be described as commemorative. The attribution and the identification of the portrait thus remain unsettled.

NOTES

1 The painting came from Rushton Hall, according to a letter from Asscher and Welker to Daniel Catton Rich of February 9, 1937, in curatorial files. Rushton Hall has had a complicated history, changing hands several times during the nineteenth century (see *Country Life*, vol. 26, 1909, pp. 454–61, 490–501, and vol. 115, 1954, pp. 599–600). The most likely owners of the present picture were Henry Pfungst and J. J. van Alen.

2 Letter from Asscher and Welker cited in note 1.

3 Van Marle's opinion is recorded in letters to Worcester of March 1, March 6, May 4, and May 27, 1935, and in an expertise dated June 4, 1935, on the reverse of a photograph of the painting; all these documents are preserved in curatorial files.

4 Letter from Venturi to Rich of February 11, 1938, and letter from Richter to Rich of March 29, 1937, in curatorial files.

5 For biographical details and an account of his activities, including plans of the church of the Ospedale degli Incurabili, see E. A. Cicogna, *Delle inscrizioni veneziane*, Venice, vol. 2, 1827, pp. 14–16, and vol. 5, 1842, pp. 337–38.

6 Letter from Hans Tietze to Hans Huth of September 12, 1950, in curatorial files. For portraits of Jacopo Soranzo the Younger, see F. Kenner, "Die Porträtsammlung des Erzherzogs Ferdinand von Tirol," *Jahrbuch der Kunsthistorischen Sammlungen des Allerhöchsten Kaiserhauses* 18 (1897), p. 254, pl. XXIX, fig. 132.

7 R. Pallucchini and P. Rossi, *Tintoretto*, vol. 2, *Le opere sacre e profane*, Milan, 1982, p. 618, fig. 613.

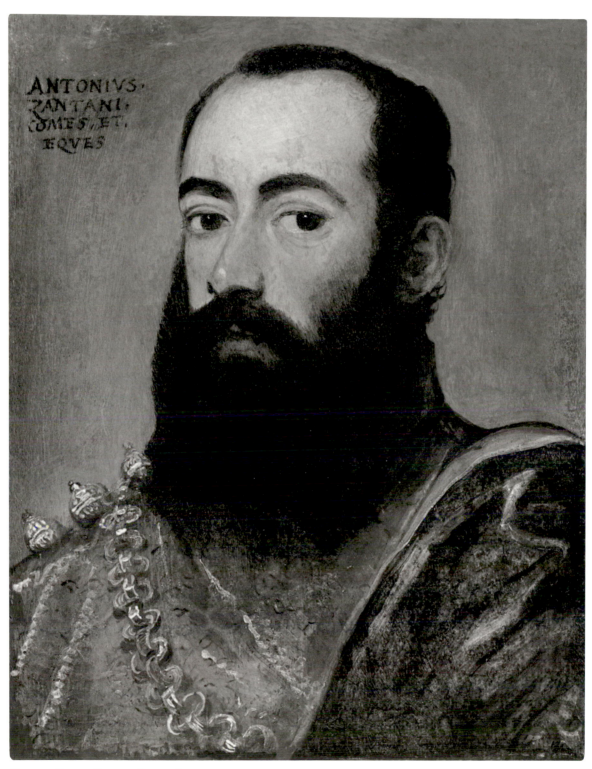

Venetian, *Portrait Presumed to Be of Antonio Zantani*, 1947.115

Portrait of a Gentleman, 1540/50
Gift of Chester D. Tripp, 1954.195

Oil on canvas, 89.8 x 71.6 cm (35⅜ x 28³⁄₁₆ in.)

CONDITION: The painting is in poor condition. In 1962 Alfred Jakstas surface cleaned it and corrected the inpainting. He then cleaned it more thoroughly in 1967; at that time a glue lining was removed and the picture was wax lined. The picture is severely abraded throughout. The modeling of the drapery has almost completely disappeared, leaving the pose of the figure and the position of his left hand barely legible. Prominent craquelure, particularly evident in the face, has been minimized by inpainting. *Pentimenti* are visible at either side of the head, suggesting that at one time the sitter may have been shown wearing a hat. *Pentimenti* and evidence provided by the x-radiograph indicate that the contour of the sitter's shoulder was adjusted (infrared, ultraviolet, x-radiograph).

PROVENANCE: E. and A. Silberman Galleries, New York. Sold by Silberman to Chester D. Tripp, Chicago, 1945;[1] given to the Art Institute, 1954.

REFERENCES: AIC 1961, p. 451. R. Pallucchini, *Tiziano*, Florence, 1969, vol. 1, pp. 223, 348; vol. 2, pl. 674.

The portrait has not been widely discussed, although it was listed in the 1961 catalogue of the Art Institute's paintings as a work by Titian dating from 1545–50. No mention was made of the painting in Harold Wethey's monograph on Titian.[2] When the portrait was sold to Chester D. Tripp in 1945, the attribution to Titian was supported by written opinions from Tietze-Conrat, Tietze, Suida, and Valentiner.[3] At the time, Tietze-Conrat suggested that the sitter might be Giovanni Francesco Leoni, a member of Titian's intellectual circle and tutor to Ranuccio Farnese, grandson of Pope Paul III, but this was no more than an inspired guess.[4] The attribution to Titian was advanced on the basis of a comparison with the artist's portraits of Daniele Barbaro (Ottawa, National Gallery of Canada) and Antonio Anselmi (Lugano, Thyssen-Bornemisza Collection).[5] Even allowing for its state of deterioration, the present painting surely never equaled these two autograph works in quality. Pallucchini (1969) referred to the portrait as the work of a Titianesque painter.

In the 1961 catalogue, the suggestion was made that the portrait "also relates to a certain period of Lotto"; more recently the attribution of the painting was changed to Lotto. Of the numerous portraits by this Venetian artist, those painted in his maturity, between 1535 and 1540, are the most relevant here. Lotto's later portraits were much influenced by Titian, possessing what Berenson termed a "wistful gravity."[6] The *Portrait of a Man Holding a Letter* (Venice, Galleria dell'Accademia) does seem fairly similar in handling, but that painting is itself neither in good condition nor fully accepted as a work by Lotto.[7] The late *Portrait of a Cross-Bowman* (c. 1550) in the Pinacoteca Capitolina in Rome also bears some resemblance to the Chicago picture.[8] The lighting of the face and the handling of the high forehead in the Chicago painting are somewhat characteristic of Lotto's portraits, but the close detailing of the features is missing and the eyes lack the penetration of even the artist's later, less idiosyncratic portraits. The poor condition of the present picture also precludes a satisfactory attribution.

NOTES
1 Letter from Silberman to Tripp of March 2, 1945 (Archives, The Art Institute of Chicago).
2 H. E. Wethey, *The Paintings of Titian: Complete Edition*, vol. 2, *The Portraits*, London, 1971.
3 Curatorial files, The Art Institute of Chicago.
4 Letter from Tietze-Conrat to Silberman of January 18, 1945, in curatorial files.
5 This comparison was made in AIC 1961. For the portraits in Ottawa and Lugano, see Wethey (note 2), pp. 80–81, no. 11, pl. 95, and p. 74, no. 2, pl. 158, respectively.
6 B. Berenson, *Lorenzo Lotto: Complete Edition*, London, 1956, p. 93.
7 S. Moschini Marconi, *Galleria dell'Accademia di Venezia: Opere d'arte del secolo XVI*, Rome, 1962, p. 132, no. 210 (ill.).
8 For an illustration, see P. dal Poggetto and P. Zampetti, *Lorenzo Lotto nelle Marche: Il suo tempo, il suo influsso*, exh. cat., Ancona, Chiesa del Gesù, Chiesa di San Francesco alle Scale, and Loggia dei Mercanti, 1981, p. 453, no. 133.

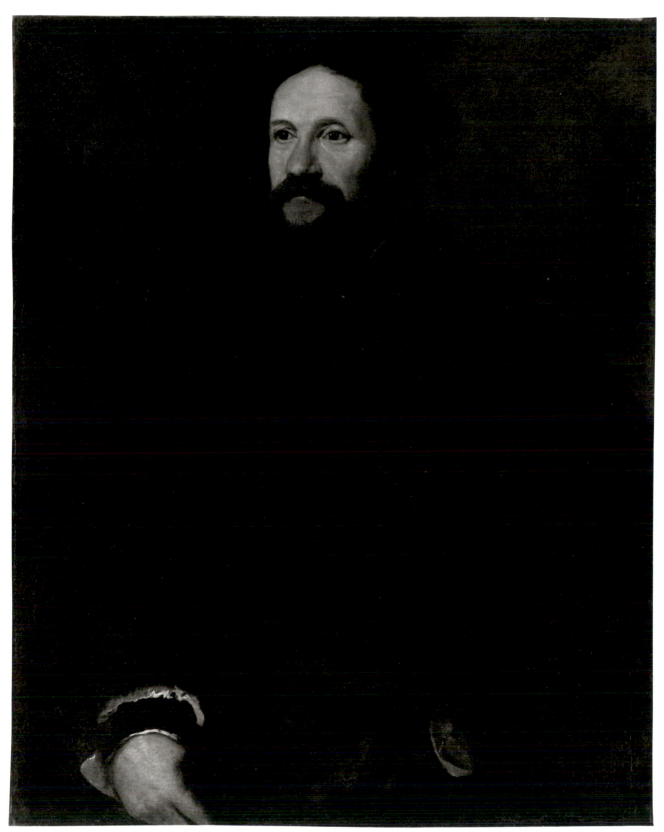

Venetian, *Portrait of a Gentleman*, 1954.195

Altarpiece: *The Assumption of the Virgin with Saints*, 1450/75

George F. Harding Collection, 1984.24a–g

Saint Monica
1984.24a

Tempera and oil on panel, 126.6 x 31.2 cm (49⅞ x 12¼ in.); painted surface: 119 x 24.9 cm (46⅞ x 9¹³⁄₁₆ in.)

CONDITION: The painting is in good condition. In 1992 Jill Whitten removed facing tissue applied after the 1976 Sotheby's sale and surface cleaned the painting. The panel is composed of a single board with vertical grain. The reverse shows irregularly raised wood fibers. The panel is 2 cm thick and has margins of unpainted wood on all sides varying in width from 3 to 4 cm, suggesting that the panel originally had an engaged frame. The left edge appears to have been relatively recently sawn and shows exposed worm tunneling, while the right edge is rough hewn. The ground layer is continuous for both the painted image and the spandrels on either side of the arch, the spandrels being painted blue-green. The fact that this blue-green paint overlaps the gold background suggests that it is modern (see also under 1984.24d).[1] There are five pairs of holes in the panel which correspond to those on other panels of the altarpiece and presumably relate to battens or supports for the work as a whole. They are approximately 4, 33, 62.5, 91, and 122 cm from the bottom edge. A split at the bottom left extends 5 cm into the painted image. The paint surface is well preserved, though covered by a thick layer of discolored varnish. There are scattered worm exit holes throughout. The gold is also fairly well preserved, though the punchings at the lower left and right side of the halo appear to have been redone.

Bishop Saint
1984.24b

Tempera and oil on panel, 126.7 x 26.5 cm (49⅞ x 10⁷⁄₁₆ in.); painted surface: 119 x 25.5 cm (46⅞ x 10 in.)

CONDITION: The painting is in fair condition. In 1992 Jill Whitten removed facing tissue applied after the 1976 Sotheby's sale and surface cleaned the painting. The panel is composed of a single board with vertical grain. It is approximately 2 cm thick. The reverse shows irregularly raised wood fibers. There are margins of unpainted wood on all sides; those at top and bottom are approximately 3.5 cm wide and those at the sides are approximately 3 to 7 mm wide. Both side edges are roughly hewn with worm

exit holes rather than exposed worm tunneling. The ground layer is prepared as in 1984.24a, and the spandrels on either side of the arch are painted blue-green. There are five pairs of holes visible on the back of the panel; their placement corresponds to those described under 1984.24a.[2] The paint surface is disturbed by lifting paint, particularly in the lining of the saint's chasuble. The original blue-green pigment here has also been largely overpainted. There are worm exit holes scattered throughout the image which is covered by a layer of discolored varnish (x-radiograph).

Saint Nicholas of Tolentino
1984.24c

Tempera and oil on panel, 126.7 x 30 cm (49⅞ x 11¹³⁄₁₆ in.); painted surface: 118.9 x 24.8 cm (46¾ x 9¾ in.)

CONDITION: The painting is in good condition. In 1992 Jill Whitten removed facing tissue applied after the 1976 Sotheby's sale and surface cleaned the painting. The panel is composed of a single board with vertical grain and is approximately 2 cm thick. The reverse shows irregularly raised wood fibers. The edges of unpainted wood on all sides varying in width from 3 to 4 cm, together with the barbe particularly evident on either side of the paint surface, suggest that the picture originally had an engaged frame. The right edge of the panel appears to have been relatively recently sawn, whereas the left is rough hewn. The ground layer is prepared as in 1984.24a, and the spandrels are painted blue-green. Holes in the panel, presumably to secure the structure of the altarpiece, correspond to those in the other panels (see 1984.24a). The paint layer is very well preserved, though obscured by dirt and discolored varnish. There are worm exit holes scattered throughout the image.

The Assumption of the Virgin and Saint Thomas Receiving the Virgin's Girdle
1984.24d

Tempera and oil on panel, without added strips: 125.8 x 40 cm (49½ x 15¾ in.); painted surface: 122.6 x 40 cm (48¼ x 15¾ in.)

CONDITION: The painting is somewhat more damaged than the others in the series. In 1992 Jill Whitten removed facing tissue applied after the 1976 Sotheby's sale and surface cleaned the painting. The panel is composed of a single board with vertical grain and is approximately 1.8 cm thick. It lacks the raised wood fibers of the other panels. Added strips approximately 1.5 cm wide have been attached on either side and no edges of unpainted wood are evident here. The ground layer stops approximately 3 cm from the top

edge, but the blue-green paint covering the spandrels extends over this margin and also over the added strips, indicating that it is relatively modern. The painted design may also have been extended over the unpainted edges of wood at the bottom and sides. The five rows of holes visible on the back of the panel correspond to those on the other panels of the series. The paint surface is unevenly preserved. There are substantial areas of discolored paint and repaint, particularly in the blues and greens. These include the landscape, the Virgin's blue-green cloak, and the robes of all the angels except those at the upper right and middle left. In addition the features and hands of Saint Thomas are damaged and repainted. However, other areas, notably the head of the Virgin, the most prominent donor heads, and the heads of the angels, are relatively well preserved.

Bishop Saint
1984.24e

Tempera and oil on panel, 126.2 x 30 cm (49⅝ x 11¹³⁄₁₆ in.); painted surface: 119 x 25.5 cm (46⅞ x 10 in.)

CONDITION: The painting is in fair condition. In 1992 Jill Whitten removed facing tissue applied after the 1976 Sotheby's sale and surface cleaned the picture. The panel is composed of a single board with vertical grain and is approximately 2 cm thick. The reverse shows irregularly raised wood fibers. The edges of unpainted wood on all sides vary in width from 4 cm at the top and bottom to 3 cm at the left edge and to 2 cm at the right edge. There are clear traces of a barbe at the sides, suggesting that the panel originally had an engaged frame. While the left edge appears to have been relatively recently sawn, the right edge is rough hewn. The ground layer and spandrels are prepared as in 1984.24a, and the holes in the panel, presumably made to secure the structure of the altarpiece, correspond to those in the other panels (see 1984.24a). There are areas of paint loss and repaint in the saint's green cloak, particularly at his left shoulder, below his left hand, and along the lower left edge of his cloak. The cloak is also disfigured by more general discoloration and repaint. There are worm exit holes scattered throughout the image, which is covered by a layer of dirt and discolored varnish.

Saint Anthony Abbot
1984.24f

Tempera and oil on panel, 126 x 27 cm (49⅝ x 10⅝ in.); painted surface: 119 x 25.5 cm (46⅞ x 10 in.)

CONDITION: The painting is in good condition. In 1992 Jill Whitten removed facing tissue applied after the 1976

Sotheby's sale and surface cleaned the painting. The panel is composed of a single board with vertical grain and is approximately 2 cm thick. The reverse shows irregularly raised wood fibers. There are margins of unpainted wood on all sides; those at the top and bottom are approximately 3.5 cm wide, on the left side, approximately 1.2 cm wide, and on the right side, approximately 0.3 cm wide. Whereas the left edge appears to have been relatively recently sawn, exposing worm tunneling, the right edge is rough hewn. The ground layer is prepared as in 1984.24a, and the spandrels on either side of the arch are painted blue-green. There are five pairs of holes visible on the back of the panel; their placement corresponds to those described under 1984.24a. There are some planar distortions in the paint surface, on the saint's cap, his right shoulder, and below his right hand and the bell. The gold around the saint's head has been renewed, and the crackle pattern here is incised. Worm exit holes are scattered throughout, but the paint surface is otherwise well preserved, though covered with a thick layer of discolored varnish.

Saint Giustina of Padua
1984.24g

Tempera and oil on panel, 126.2 x 31.9 cm (49⅝ x 12⁹⁄₁₆ in.); painted surface: 119.5 x 25.5 cm (47 x 10 in.)

CONDITION: The painting is in good condition. In 1992 Jill Whitten removed facing tissue applied after the 1976 Sotheby's sale and surface cleaned the painting. The panel is composed of a single board with vertical grain and is approximately 1.5–2 cm thick. The reverse shows irregularly raised wood fibers, but these have been planed away along the left edge, exposing worm tunneling. There are wide edges of unpainted wood on all sides, varying in width from 3 to 4 cm. The right edge appears to have been relatively recently sawn and shows exposed worm tunneling, while the left edge is roughly hewn. The ground layer is prepared as in 1984.24a, and the spandrels on either side of the arch are painted blue-green. Pairs of holes visible on the back of the panel correspond to those described under 1984.24a. A split at the lower right extends approximately 25 cm into the painted surface. Apart from some losses along this split and some lifting paint and losses in the lower portion of the saint's robe, the paint surface is in good condition. There are a few scattered worm exit holes throughout, and the paint surface is obscured by discolored varnish.

PROVENANCE: Achillito Chiesa, Milan; sold American Art Association, New York, pt. 1, November 27, 1925, no. 59 (ills.), as Workshop of the Vivarini. George F. Harding, Jr. (d. 1939), Chicago; The George F. Harding Museum,

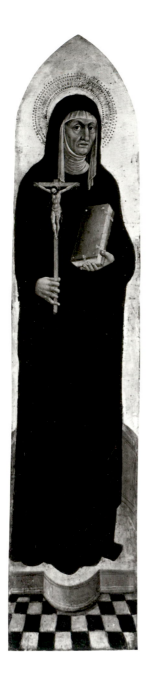
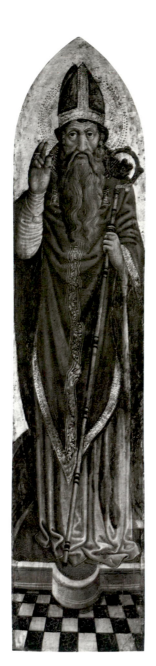
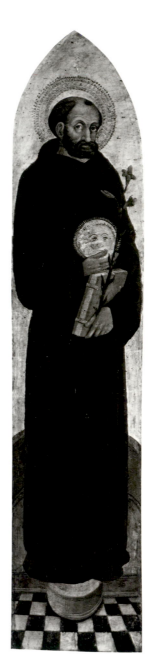
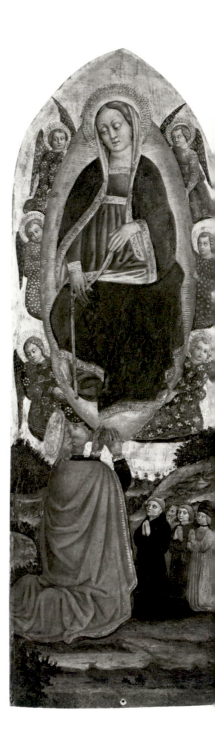

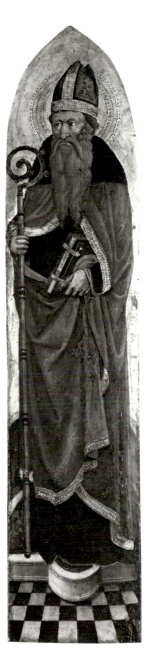
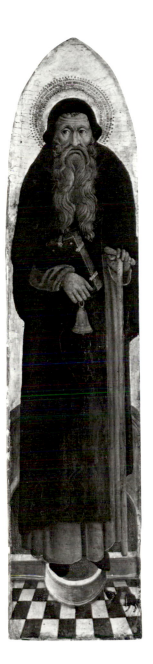
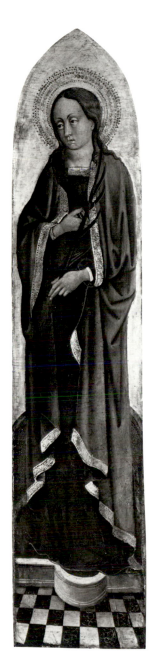

Venetian, altarpiece: *The Assumption of the Virgin with Saints*, 1984.24a–g

Chicago; Sotheby's, New York, December 2, 1976, nos. 180, 182 (ills.), withdrawn; transferred to the Art Institute, 1984.

REFERENCES: Fredericksen/Zeri 1972, pp. 246, 307, 372, 434, 436, 572.

The panels almost certainly came from the same polyptych. The ornate frame is not original, but does adhere to the type characteristic of fifteenth-century Venetian altarpieces. There are indications that the altarpiece originally had an engaged frame (see Condition). It is unclear whether the ensemble had an upper tier, pilasters, or a predella. Given that the individual panels have been reframed, the present order of the panels may not be correct.[3] It does make visual sense, however, until the floor patterns are taken into account. Those beneath Saint Monica, Saint Nicholas of Tolentino, and Saint Anthony Abbot are tinged with red, suggesting that the bishop on the left with hand raised in blessing may have been substituted for Saint Anthony Abbot, if consistent groupings of white or red tiles were intended.

The polyptych has gone almost unnoticed in the literature. When in the Harding Collection, it was attributed to the workshop of Alvise Vivarini (1442/ 53–c. 1505), a not unreasonable starting point, although too late in date. The facial and figure types strongly resemble those in paintings by other members of the Vivarini family and workshop, such as the polyptych (1443) by Antonio Vivarini, Alvise's father, and Giovanni d'Alemagna in the Cappella di San Tarasio in the church of San Zaccaria, Venice, and the *Virgin and Child* (1450/60) attributed to Bartolomeo Vivarini, Alvise's uncle, in the Saint Louis Art Museum.[4] The painter is undoubtedly provincial, as the figures are stiff and wooden, with rather crudely painted features and heavy, lifeless draperies. Fredericksen and Zeri (1972) listed the altarpiece as Venetian fifteenth century.

The incident of Saint Thomas witnessing the Assumption of the Virgin, who lowers her girdle to the saint as proof of her Assumption, is recorded in the apocryphal gospel devoted to the Assumption of the Virgin attributed to Joseph of Arimathea.[5] The subject offers an obvious parallel with the biblical episode of the incredulity of Saint Thomas (John 20.27). Artists often made the scene a subsidiary event in the narrative of the Assumption of the Virgin and it is rare for it to be given the emphasis found in this altarpiece. It is a scene often depicted by Tuscan artists because the holy relic of the girdle itself is housed at Prato, but its depiction is not limited to that part of Italy.

The female saint on the right balancing Saint Monica is only tentatively identified as Saint Giustina of Padua, who was stabbed with a sword in her breast; the figure points to such a wound with her right hand while holding a palm in her left. The altarpiece was presumably painted for an Augustinian institution, since both Saints Nicholas of Tolentino and Anthony Abbot belonged to that order, while Saint Monica was Saint Augustine's mother. One of the bishop saints was probably intended to represent Saint Augustine himself.

NOTES

1　There is a red wax seal with an indecipherable coat of arms on one spandrel.

2　Three shallow gouged lines at the center of the lower margin of unpainted wood may relate to the panel's position in the ensemble.

3　Old gummed labels attached to each of the panels with standing saints bear the handwritten numbers *1* and *2* for 1984.24a and b, *5* and *6* for 1984.24f and g, and, oddly enough, *43* and *44* for 1984c and e. The central panel has no label.

4　R. Pallucchini, *I Vivarini (Antonio, Bartolomeo, Alvise): Saggi e studi di storia dell'arte*, vol. 4, Venice [1962], figs. 32–34, 130.

5　M. R. James, tr., *The Apocryphal New Testament*, Oxford 1955, pp. 217–18.

Veneto-Lombard

Portrait of a Gentleman, 1530/50
Bequest of Chester D. Tripp, 1988.266

Oil on panel, 76 x 66 cm (29⅞ x 26 in.); painted surface: 73 x 64 cm (28¾ x 25¼ in.)

CONDITION: The painting is in poor condition. It was surface cleaned by Alfred Jakstas in 1972. Barbara Pellizzari cleaned it more thoroughly in 1991, removing overpaint that had entirely covered the background. The support is a single board, 1.5 cm thick. Broad wooden slats are attached to the back of the panel along the edges, with one cross member. Ten small wooden blocks abut these slats at the top and bottom. There is exposed worm tunneling on the sides of both the panel and the wooden slats. This may indicate that the edges have been trimmed slightly. The painted image does not extend to the edges of the panel, and the exposed wood has been painted red. A vertical crack in the panel, approximately 21 cm from the right edge, runs from the top of the panel to the middle of the figure's left shoulder, and has been filled and inpainted. The paint surface is very abraded, particularly in the areas of the face, beard, hands, and the front of the ledge. A *pentimento* is visible above the right hand, indicating that it once held a pen. The x-radiograph (fig. 1) reveals another head to the left, slightly below the visible one. This head, also of a bearded man, is turned more to the left than the head above it (infrared, mid-treatment, ultraviolet, x-radiograph).

PROVENANCE: Pallavicini-Andrassy collection, Styria, Hungary;[1] sold Knight, Frank, and Rutley, London, May 27, 1927, no. 28 (ill.), as Raphael, *Portrait of a Papal Secretary*, for £3,100.[2] Sold Hugo Helbing, Frankfurt, June 12, 1928, no. 65 (ill.), as Raphael, *Portrait of a Papal Secretary*, for 20,000 marks.[3] E. and A. Silberman Galleries, Vienna and New York, 1928.[4] Sold by Silberman to Chester D. Tripp, 1930.[5] Chester D. Tripp (d. 1974), Evanston, Illinois, and Chicago, 1930–74; at his death to his widow, Jane B. Tripp (d. 1988); intermittently on loan to the Art Institute from 1930; bequeathed to the Art Institute, 1988.

REFERENCES: "A. C. Carter on the Pallavicini Collection," *Art News* 25, 28 (1927), p. 3. A. C. R. Carter, "Forthcoming Auctions: Pallavicini Collection and Others," *Burl. Mag.* 50 (1927), advertising supplement, pp. li–lii. "Murillo Leads in Pallavicini Sale Prices," *Art News* 25, 35 (1927), p. 1. "Pallavicini Sale Catalogs Are Now Here," *Art News* 25, 33 (1927), p. 2. "Another Raphael Work Revealed in This Country," *New York Herald Tribune*, March 22, 1930, p. 17 (ill.). "Raphael Portrait Sold," *The World*, March 22, 1930, p.

6. "A Raphael," *Art Digest* 4, 14 (1930), p. 7, cover ill. "Chicago Collector Buys Raphael," *Art News* 28, 25 (1930), p. 3 (ill.). *Chicago Daily News*, March 29, 1930, photogravure section, n. pag. (ill.). *Chicago Daily Times*, April 15, 1930, pp. 16–17 (ill.). E. Jewett, "Painting by Raphael Here; Story Is Told," *Chicago Daily Tribune*, March 24, 1930, p. 33. *Parnassus* 2, 4 (1930), p. 13 (ill.). "Raphael Painting Going to Chicago," *New York Times*, March 22, 1930, p. 18. D. C. Rich, "A Newly Discovered Portrait by Raphael," *AIC Bulletin* 24 (1930), pp. 58–59, cover ill. "$200,000 Raphael Property of Chicago Society Woman," *Chicago Evening Post*, May 17, 1930, sec. 1, p. 1 (ill.). C. J. Bulliet, "Art in the 1934 Fair, no. 86," *Chicago Daily News*, September 4, 1934, p. 12 (ill.). Bénézit, vol. 7, 2d ed., 1960, p. 516.

EXHIBITIONS: The Art Institute of Chicago, *A Century of Progress*, 1933, no. 125, as Raphael. The Art Institute of Chicago, *A Century of Progress*, 1934, no. 54, as Raphael. New York, E. and A. Silberman Galleries, *Art Unites Nations*, 1957, no. 7, as Raphael, *The Parmesan*.

Once considered a work by Raphael, based on the opinions of such eminent authorities as Suida, Friedländer, Van Marle, Glück, and Adolfo Venturi,[6] the picture received considerable attention at the time of the Pallavicini sale in 1927 and again when it was purchased anonymously by Chester D. Tripp in 1930. Over the years, the attribution to Raphael has been doubted and ultimately rejected.[7] The flatness of the figure (due only in part to the painting's condition) and the awkwardly shaped left hand are not characteristic of that master. The softly textured treatment of the face and garments suggests instead a painter of a northern Italian school. An attribution to the Brescian painter Giovanni Battista Moroni on the mount of a photograph of the painting in the Witt Library in London is probably accurate in identifying the geographical origin of the work, but not its authorship. This association was perhaps made because of the artist's placement of the sitter against a subtly modulated gray wall, a favorite device of Moroni.[8] This same device was employed earlier, however, in the

Veneto-Lombard region by artists such as Moretto da Brescia and Paolo Cavazzola.[9] In fact, in its general stiffness and in the mannered treatment of the hands, the present painting would seem to predate Moroni's austere, yet natural portraits. The Chicago work corresponds in some respects to portraits of 1530/50 by the earlier, Bergamasque artists Bernardino Licinio (c. 1485–c. 1550) and Giovanni Cariani (c. 1480–c. 1548), although it cannot be ascribed to either of these masters.[10]

The present picture appears instead to be the product of a less accomplished painter, whose seemingly tentative approach to the subject has resulted in a work that has the inconsistencies of a pastiche. While the face has the insistent naturalism of a portrait by Lorenzo Lotto, the left hand has been subjected to a not wholly successful process of Mannerist refinement. Although the hat and overgarment with *sbuffo* (puffed) shoulders were popular men's fashions in northern Italy during the sixteenth century and are indicative of a strong Germanic influence there, the thin, crepe-like material used at the cuffs of the shirt is more closely related to German and Swiss women's dress.[11] Placed before the sitter is a curious combination of objects. The artist apparently painted the pen, inkwell, and paper first (*pentimenti* indicate that the sitter originally held the pen in his right hand), and later, somewhat incongruously, added a piece of fruit and gloves. This indecisiveness is further evidenced by the x-radiograph (fig. 1), which reveals beneath the present portrait another head of a man, in three-quarter view, placed below and to the left of the visible head. The odd, off-center position of the hidden head suggests either that the panel was cut down before the present portrait was painted or that the artist had an especially clumsy false start. The possibility that the picture is a later pastiche cannot be entirely excluded.

NOTES

1 Carter 1927; and *Art Digest* 1930.
2 According to an annotated copy of the sale catalogue in the Resource Collection of the Getty Center for the History of Art and the Humanities, Santa Monica.
3 According to an annotated copy of the catalogue in the Ryerson Library, The Art Institute of Chicago. The sale catalogue lists the owner of the painting as a "Herr M. L. in W." Presumably, this was Lindemann, who received opin-

ions about the picture from G. Fiocco and M. J. Friedländer in 1925; copies of their notes are in curatorial files.
4 According to registrar's records. In October 1928 Silberman sent the painting to the Art Institute for consideration for purchase.
5 See note 4.
6 The opinions of these scholars were recorded in the promotional booklet produced by E. and A. Silberman Galleries, *The Parmesan (Evangelista Tarascono Parmigianino) by Raphael*, Vienna and New York, 1930, pp. 7, 11–14 (in curatorial files). The picture was erroneously identified by some scholars as the lost portrait of Leo X's secretary Evangelista Tarascono of Parma mentioned by Marcantonio Michiel (Marcantonio Michiel, *The Anonimo, Notes on Pictures and Works of Art in Italy Made by an Anonymous Writer in the Sixteenth Century*, tr. by P. Mussi, ed. by G. C. Williamson, London, 1903, p. 107). Because of this identification, the painting was believed to have been in the collections of the Bishop of Lodi and Antonio Foscarini in Venice, as reported by Michiel.
7 The painting was not included in Oskar Fischel's 1948 catalogue of Raphael's oeuvre, nor has it been mentioned in any subsequent catalogues raisonnés or monographs on the artist.
8 See, for instance, Moroni's *Portrait of a Man* (c. 1555–60) in the Minneapolis Institute of Art and his *Portrait of a Young Man* (1567) in the Pinacoteca dell'Accademia Carrara in Bergamo; for illustrations of these paintings, see P. Zampetti, ed., *I pittori bergamaschi dal XIII al XIX secolo:*

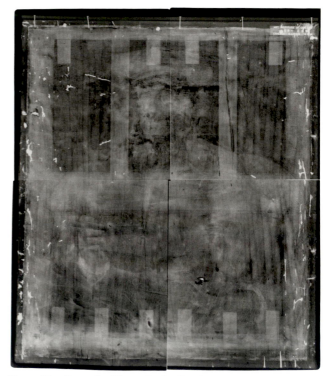

Fig. 1 X-radiograph of *Portrait of a Gentleman*, 1988.266

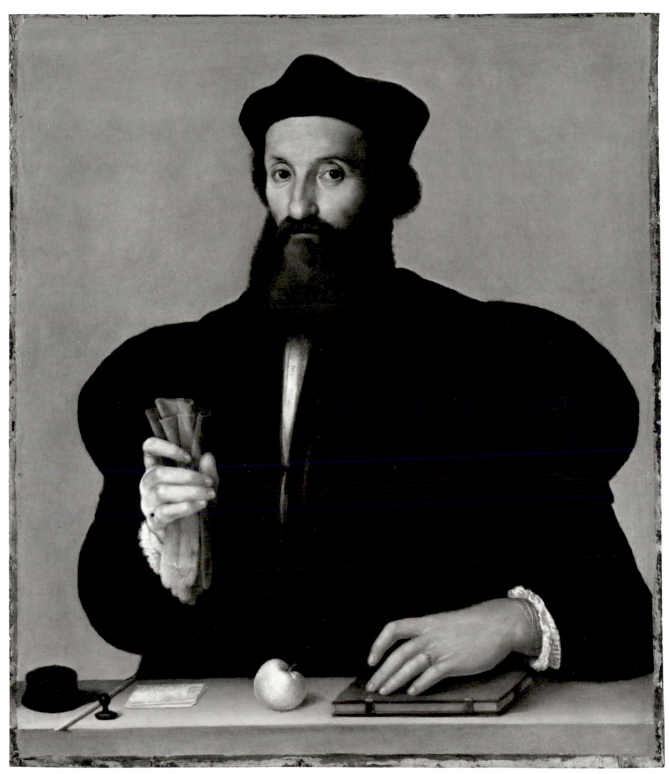

Veneto-Lombard, *Portrait of a Gentleman*, 1988.266

Il cinquecento, vol. 3, Bergamo, 1975, pp. 157, 192.

9 For example, Cavazzola's *Portrait of a Woman* (c. 1515) in the Pinacoteca dell'Accademia Carrara in Bergamo; see R. Levi Pisetzky, *Storia del costume in Italia*, vol. 3, Milan, 1966, pl. 48.

10 The handling and figure type of the Chicago work can be compared with those of portraits by Licinio in the Museo Civico in Vicenza, the Ashmolean Museum at Oxford, and the Kunsthistorisches Museum in Vienna, and portraits by

Cariani in Berlin (Staatliche Museen Preussischer Kulturbesitz, Gemäldegalerie) and formerly in the collection of A. Werner-Newlands in Edembridge. See *I pittori bergamaschi* (note 8), vol. 1, pp. 404–05, 456, fig. 1, p. 300, fig. 6, p. 301, fig. 3.

11 According to a letter from Edward Maeder, Curator of Costumes and Textiles at the Los Angeles County Museum of Art, to Pamela Glaser of November 7, 1991, in curatorial files.

Veneto-Riminese

Triptych: *Virgin and Child with Scenes from the Life of Christ*, 1320/40

Denison B. Hull Restricted Fund, 1968.321

Tempera on panel, center panel: 63.8 x 46.8 cm (25⅛ x 18⅜ in.); painted surface of center panel: 57.3 x 41.4 cm (22½ x 16¼ in.); left wing: 63.8 x 22.7 cm (25⅛ x 8¹⁵⁄₁₆ in.); right wing: 63.8 x 23 cm (25⅛ x 9¹⁄₁₆ in.).

INSCRIBED: H̄R̄ (in the tooling to the left of the Virgin's head), ŌV̄ (in the tooling to the right of the Virgin's head), ĪC̄ and X̄R̄ (to the left of the Child's halo)

CONDITION: The painting is in good condition considering its age. It appears not to have been treated since its acquisition by the Art Institute. All three panels are composed of wood with vertical grain. The central panel has been thinned, as is evident from exposed worm tunneling. Two horizontal battens have been set into the central panel. Three vertical battens have also been attached to the reverse of the central panel, with one covering a vertical split that extends the full height of the panel through the Virgin's left cheek. Similar vertical battens are attached to the center of each wing. The wings are each fastened to the central panel with three hinges. An applied engaged frame is attached to the front of the central panel. The backs of the wings were prepared with a layer of ground and paint, which appears blue-black and is now quite worn. A rim approximately 2.5 cm wide runs along the bottom edge of the left wing on the reverse; a similar rim along the outer vertical edge of this wing abuts it, but extends beyond the left edge of the panel. Whether these elements are part of the original framing system is difficult to determine, but they appear to be very old, and the dark paint and ground are lacking at the top of the left wing and at the top and bottom of the right wing,

indicating that similar rims have been removed from those edges. All three panels have concave warping: 0.5 cm for the left wing, 2.5 cm for the center panel, and 0.5 cm for the right wing. This warping has necessitated a brace at the back to support the open triptych. In general the paint surface is comparatively well preserved, especially in the case of the narrative scenes. The flesh tones are abraded, particularly in the central panel, as is the Virgin's blue cloak, which has also darkened. The gold background is not unduly damaged (x-radiograph).

PROVENANCE: Julius Böhler, Munich.[1] Sold by Böhler to Franz Haniel, Munich, by 1930.[2] Christie's, London, July 1, 1966, no. 49 (ill.); bought in and offered for sale again at Christie's, London, November 24, 1967, no. 72 (ill.), to Julius Weitzner, London.[3] Sold by Weitzner to the Art Institute, 1968.

REFERENCES: A. L. Mayer, "Die Sammlung F. H. in München," *Pantheon* 5 (1930), p. 263 (ill.). Garrison 1949, pp. 21, 118, no. 302 (ill.). D. C. Shorr, *The Christ Child in Devotional Images in Italy during the XIV Century*, New York, 1954, pp. 42, 48 (ill.). R. Pallucchini, *La pittura veneziana del trecento*, Venice and Rome, 1964, pp. 70–71, fig. 328. R. Heinemann, *The Thyssen-Bornemisza Collection*, Castagnola, 1969, p. 348, under no. 321. Maxon 1970, p. 250 (ill.). M. Boskovits with S. Padovani, *The Thyssen-Bornemisza Collection: Italian Painting, 1290–1470*, London, 1990, p. 196 n. 4.

EXHIBITIONS: The Art Institute of Chicago, *The Art of the Edge: European Frames, 1300–1900*, 1986, no. 1.

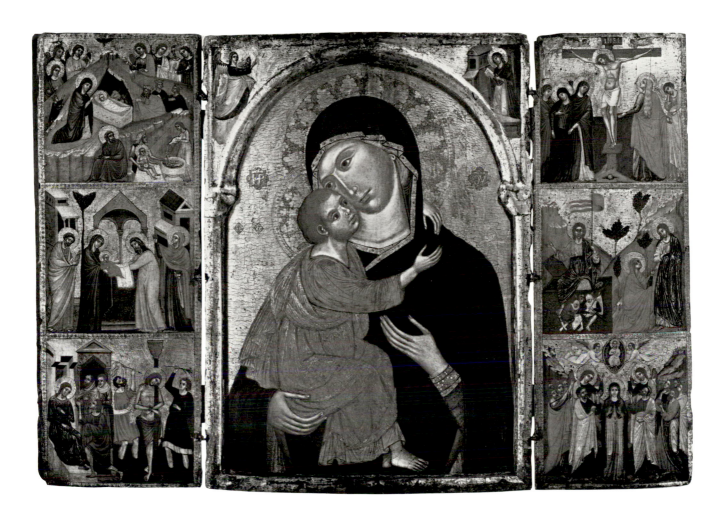

The Virgin and Child occupy the center panel, and the scene of the Annunciation is shown in the spandrels of the engaged frame. On the left wing, in descending order, are *The Nativity with the Adoration of the Magi, The Presentation of Christ in the Temple*, and *The Mocking and Flagellation of Christ*. The right wing depicts, from top to bottom, *The Crucifixion, The Resurrection with the Noli Me Tangere*, and *The Ascension*.

Garrison (1949) classified the triptych as a rectangular tabernacle with an inscribed arch. He divided the surviving examples of this form of triptych into two types based on the shape of the wings.[4] The present triptych belongs to the first type, with rectangular wings which cover the entire center panel when closed; in the second type, the inscribed arch at the top of the center panel is considerably raised in relief, necessitating arched wings to fit under this projection. Garrison listed only five intact examples of the first type, one being the triptych now in Chicago.[5] Both types seem to have had their origins in Byzantine applied art, particularly ivories. Garrison dated the earliest Italian examples of these triptychs to the third quarter of the thirteenth century and maintained that they originated in Siena before becoming popular in the Veneto and related areas on the Adriatic coast during the fourteenth century.

Garrison ascribed the Chicago triptych to the Venetian school with a date of 1320/40. Earlier, Mayer (1930) had suggested an attribution to a pupil of Duccio. Shorr (1954) accepted Garrison's proposal that the triptych was Venetian, but dated it to the late thirteenth century. Garrison, in fact, regarded this work as the name-piece of a very small group of panels, designating the painter as the Haniel Tabernacle Master, whom he characterized as showing "typical Venetian Byzantinism imposed upon Ducciesque features, the whole tempered by a soft chiaroscuro, possibly under Giottesque influence." The other works in the group suggested by Garrison are a *Madonna and Child* from the Bastianelli collection in Rome and a *Nativity* in The Detroit Institute of Arts.[6] However, in the light of recent research, neither of these paintings can be confidently upheld as being stylistically related to the present triptych. In fact, Fredericksen ascribed the Detroit panel to a Veneto-Byzantine artist of c. 1330.[7]

While Garrison's dating appears to be correct, the connection with Venice is open to question. Pallucchini (1964) is the only scholar apart from Victor Lasareff to have examined in detail Garrison's groupings of artistic personalities in the Veneto at this date. While accepting the specific individuality of the so-called Haniel Tabernacle Master, Pallucchini argued that two of the surviving triptychs of this type, one formerly in the Stoclet Collection in Brussels (location unknown) and the other still in the Thyssen-Bornemisza Collection in Lugano, are related not only in form but also in style.[8] However, the connection of either the Stoclet or the Thyssen work with the present triptych cannot be sustained: the drawing of the faces of the Virgin and Child in the center panel, as well as the modeling of the flesh tones, is totally different, and the treatment of the narrative scenes in the wings of the Chicago triptych is far more fluid.

Pallucchini was correct, however, in his observation that the Byzantine elements in the Chicago triptych are overlaid by Riminese stylistic features. The use of red, green, plum, and blue, for example, is distinctly Riminese, as is the rich brown used for the hair of most of the figures. It is unlikely that the artist was specifically Riminese, but it is not impossible that he had examined the work of a painter such as Giovanni da Rimini, particularly as regards the softness of forms and rhythmical movement.[9] Pallucchini's designation, "Venetian-Riminese master of the second quarter of the Trecento," which he proposed somewhat tentatively, still seems to be the most valid, although further research may indicate that a specific connection with the Veneto should be omitted. Technical evidence presented by the punching, as interpreted by Mojmír Frinta, is also slightly confusing, since the principal punch (a penta-star) can be found in the Romagnole-Riminese areas, as well as in Genoa and even possibly in Naples.[10] The first of these areas does not conflict with the stylistic evidence.

There are certain retardataire elements in the narrative scenes, such as the cave in *The Nativity and the Adoration of the Magi*, the positioning of Christ behind the column in *The Mocking and Flagellation of Christ*, and the figure of Christ stepping directly out of the tomb in *The Resurrection with the Noli Me Tangere*, but none of these features is difficult to find

in thirteenth-century Italian paintings. The compositions appear reminiscent of famous narrative sequences from the beginning of the fourteenth century, for example, Giotto's frescoes in the Arena Chapel in Padua or Duccio's *Maestà* in Siena, but there are no direct quotations from these works. It is perhaps an indication of the artist's ability that several of the narrative scenes on the triptych, notably *The Presentation of Christ in the Temple*, *The Crucifixion*, *The Resurrection with the Noli Me Tangere*, are so successfully and convincingly composed, even within rather retardataire terms of reference, that the search for prototypes at first appeared necessary and then proved fruitless. The groups of figures within each scene are achieved with considerable economy of space, the figures themselves are related convincingly to the architecture, and, although the perspective is idiosyncratic, there are

fine passages such as the pose of Mary Magdalen in *The Crucifixion* or the unfurled pennant held by Christ in *The Resurrection with the Noli Me Tangere*.

NOTES

1 Garrison 1949.
2 Ibid. and Mayer 1930.
3 According to a letter of May 13, 1968, from Weitzner to Charles Cunningham, in curatorial files.
4 Garrison 1949, p. 117.
5 Ibid., pp. 118–19, nos. 300–04 (ill.).
6 Ibid., p. 232, no. 649 (ill.), p. 108, no. 277 (ill.), respectively.
7 According to a letter from Burton B. Fredericksen to the author of April 13, 1981.
8 Garrison 1949, p. 118, nos. 300–01 (ill.). For the Thyssen painting, see Boskovits 1990, pp. 192–97, no. 30 (ill.).
9 See, for example, C. Volpe, *La pittura riminese del trecento*, Milan, 1965, pp. 12–18, pls. 26–57.
10 According to a letter from Frinta to the author of August 19, 1984, in curatorial files. Frinta remarked that the placing of the Greek abbreviations in cartouches derived from western, Gothic traditions is a rare feature.

Paolo Caliari, called Veronese

1528 Verona–Venice 1588

The Creation of Eve, 1570/80

Charles H. and Mary F. S. Worcester Collection, 1930.286

Oil on canvas, 81 x 103 cm (31⅞ x 40½ in.)

CONDITION: The painting is severely damaged. It was treated in 1959 by Louis Pomerantz, who consolidated flaking paint. In 1964–65 Alfred Jakstas undertook an extensive treatment, relining and cleaning the painting, and removing much old repaint. At this time, traces of four more animals were revealed, namely, the ass in the lower left corner, the bull emerging from behind God the Father, the goat by the head of Adam, and the sheep in the lower right corner. There are two tears in the canvas, one extending down from Eve's left hand into Adam's arm, the other in the foreground below Adam's left forearm. There is a hole with a diameter of about 4.5 cm in the tree above Adam's head. These and other local losses in the head and drapery of God the Father, below Eve's breasts, and between the two trees in the middle distance have been filled and inpainted. The

overall condition of the picture can best be judged from a mid-treatment photograph (fig. 1). The flesh tones are rubbed, and the sky and landscape, particularly to the left of God the Father, are severely abraded. There are further paint losses in the right foreground by the figure of Adam, as well as in the trunk of the tree above God the Father and in the tree at the far right. The two trees in the middle distance were abraded so severely as to require almost total reconstruction. Though the painting has suffered grievously in the past, its original quality has by no means been totally lost. The mid-treatment photograph shows a *pentimento* in the left contour of the drapery of God the Father, which was changed, bringing it closer to the body (infrared, mid-treatment, ultraviolet).

PROVENANCE: Sold by a London dealer to Böhler and Steinmeyer, New York, by 1929.[1] Sold by Böhler and Steinmeyer to Charles H. Worcester, Chicago, 1930; given to the Art Institute, 1930.

REFERENCES: D. C. Rich, "An Unpublished Veronese in Chicago," *Pantheon* 7 (1931), pp. 20–23 (ill.). AIC 1932, pp. 7 (ill.), 175. Berenson 1932, p. 420; 1936, p. 361; 1957, vol. 1, p. 130, vol. 2, pl. 1094. L. Venturi, *Italian Paintings in America*, New York, 1933, pl. 575. G. Fiocco, *Paolo Veronese*, Rome, 1934, p. 127. AIC 1935, p. 21. *AIC Bulletin* 32 (1938), p. 48 (ill.). A. M. Frankfurter, "Venetian Holiday: XV and XVI Centuries in Review," *Art News* 36, 29 (1938), pp. 10 (ill.), 21. W. Friedlaender, "Venetian Paintings of the XV and XVI Centuries," *Art in America* 26 (1938), p. 131. "The Splendor and Color That Was Old Venice," *Art Digest* 12, 14 (1938), pp. 5 (ill.), 28. *Worcester Collection* 1938, p. 18, no. 13, pl. XI. R. Shoolman and C. E. Slatkin, *The Enjoyment of Art in America*, Philadelphia and New York, 1942, pl. 321. R. Pallucchini, *Veronese*, 2d ed., Bergamo, 1943, p. 41, fig. 125. AIC 1948, p. 26 (ill.). L. Dame, "Progressive Worcester Museum Celebrates Its Golden Anniversary," *Art Digest* 22, 15 (1948), pp. 13 (ill.), 23. F. A. Sweet, "La pittura italiana all'*Art Institute* di Chicago," *Le vie del mondo: Rivista mensile del Touring Club Italiano* 15 (1953), p. 693. L. Réau, *Iconographie de l'art chrétien*, vol. 2, pt. 1, Paris, 1956, p. 75. L. Vertova, "Some Late Works by Veronese," *Burl. Mag.* 102 (1960), p. 68. AIC 1961, pp. 138 (ill.), 462. Huth 1961, p. 517. *Art Institute of Chicago*, Grands Musées 2, Paris, [1968], pp. 25, 67 (ill.). G. Piovene and R. Marini, *L'opera completa del Veronese*, Classici dell'arte 20, Milan, 1968, p. 113, no. 159 (ill.). Maxon 1970, p. 256 (ill.). Fredericksen/Zeri 1972, pp. 39, 253, 570. M. and N. Samuels, *Seeing with the Mind's Eye: The History, Techniques and Uses of Visualization*, New York, 1975, p. 87 (ill.). T. Pignatti, *Veronese*, Venice, 1976, vol. 1, pp. 90, 139, no. 190; vol. 2, figs. 486–87. *The Art Institute of Chicago: 100 Masterpieces*, Chicago, 1978, pp. 48–49, no. 12 (color ill.). D. von Hadeln, *Paolo Veronese*, ed. by G. Schweikhart, Florence, 1978, p. 122, no. 51. J. D. Morse, *Old Master Paintings in North America*, New York, 1979, p. 294.

EXHIBITIONS: The Art Institute of Chicago, *A Century of Progress*, 1933, no. 141. The Art Institute of Chicago, *A Century of Progress*, 1934, no. 59. New York, M. Knoedler and Co., *Venetian Paintings of the 15th and 16th Centuries*, 1938, no. 21. The Art Institute of Chicago, *Masterpiece of the Month*, August 1938 (no cat.). Worcester Art Museum, Massachusetts, *The Art of Europe during the XVI–XVII Centuries*, 1948, no. 4. Appleton, Wisconsin, Worcester Fine Arts Center, Lawrence College, 1950 (no cat.). Birmingham Museum of Art, Alabama, *Veronese and His Studio*, 1972, p. 22, traveled to Montgomery, Alabama.

Fig. 1 Mid-treatment photograph of *The Creation of Eve*, 1930.286

Veronese was born and received his earliest training in Verona, but his name is more closely associated with Venice where he spent most of his life. Like Jacopo Tintoretto, he won a considerable reputation for extensive decorative works in public buildings and churches, although neither painter gained the international success that came to Titian. Veronese absorbed some of the Mannerist tendencies imported into Venice from central Italy, but his mature style is notable for its warm color and relatively controlled brushwork, in contrast with the numerous highly charged drawings he made in preparation for his compositions. The emphasis placed on the architectural and pastoral elements in his work indicates the wide range of his abilities, which were, if anything, more apparent on a reduced scale, as in the present painting. There is a similar range in Veronese's treatment of subject matter, which incorporated mythological and religious themes. Indeed, his somewhat secular approach to religious texts drew the attention of the Inquisition, which in 1573 called him to account for the liberties he had taken with *The Last Supper* (painted for the church of Santi Giovanni e Paolo, Venice, and subsequently retitled *The Feast in the House of Levi*). Veronese was a major influence on eighteenth-century Venetian painters such as Sebastiano Ricci and Giovanni Battista Tiepolo.

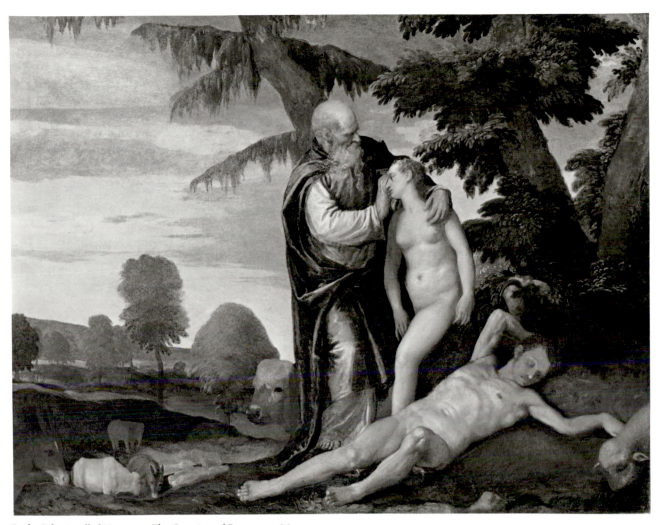

Paolo Caliari, called Veronese, *The Creation of Eve*, 1930.286

The attribution of this painting to Veronese, advanced by von Hadeln and Berenson and first published by Rich (1931),[2] has been accepted by all later writers. The modeling of the nude figures and the close-fitting drapery of God the Father are wholly characteristic of the master's personal style. Although considerably damaged, the arcadian spirit of the landscape is still apparent and has encouraged scholars to propose a late date for the picture, sometime during the eighth decade, when the artist executed several of his most important mythological paintings, such as *The Rape of Europa* (Venice, Palazzo Ducale, Sala dell'Anticollegio), *Venus and Adonis* (Madrid, Museo del Prado), and *Cephalus and Procris* (Strasbourg, Musée des Beaux-Arts).[3] The detailed treatment of the foliage (owing to the picture's condition, only the central tree in the right foreground should be considered) and the compositional device of using trees to frame the figures are common to all these paintings. Pignatti (1976) also compared the landscape with that of the altarpiece of Saint Jerome in the church of Sant'Andrea della Zirada in Venice, dating from the 1570s.[4] Based on the stylistic evidence, the decade 1570/80 seems an appropriate date for the picture.[5]

A series of four scenes from Genesis (*The Creation of Eve, Original Sin, Adam and Eve*, and *The Family of Adam*) in the Uffizi is now thought to have been painted by the artist's son Carletto Caliari.[6] Although only the sprawling figure of Adam is remotely comparable with that in the present composition, this series does suggest that the painting in Chicago might have once formed part of a similar narrative sequence.

The scriptural source for the painting is Genesis (2.21–23):

> And the Lord God caused a deep sleep to fall upon Adam, and he slept: and he took one of his ribs, and closed up the flesh instead thereof; and the rib, which the Lord God had taken from man, made he a woman, and brought her unto the man. And Adam said, "This is now bone of my bones, and flesh of my flesh; she shall be called Woman, because she was taken out of Man."

While the subject is relatively rare in Venetian art and is more closely associated with central Italy, both Tintoretto and Jacopo Bassano did depict themes from Genesis. By Tintoretto, for example, there is the cycle of paintings dating from 1550–53 executed for the Scuola della Trinità; four of these survive, including *The Creation of the Animals* and *The Temptation of Adam and Eve*.[7] *The Creation of Eve*, which formed the fifth and last painting of the series, is lost, but is recorded in a drawing by Paolo Farinati.[8] As might be expected, Tintoretto created a far more energetic scene than Veronese by showing God the Father swooping down on Adam and Eve. By Bassano, there are two paintings of Adam and Eve in Paradise (Rome, Galleria Doria, and Florence, Palazzo Pitti) both dating from 1565/70.[9] Although there are no compositional links between these paintings and the present picture, what they do all conspicuously share is a similar pastoral mood. Veronese's Garden of Eden is, in Rich's phrase, "built on an alternation of cold and warm greens, expressed in a series of clear planes, gradually leading back into the distance." The overall green tonality is offset by the vivid, cobalt blue of the sky and the crimson red and indigo blue of God the Father's drapery. The freshness of this lush, verdurous setting complements the subject of the picture perfectly and, regardless of its damaged state, brings to mind the poetry of John Milton as much as the paintings of Adam Elsheimer.

NOTES

1 According to registrar's records and letter from Julius Böhler to Daniel Catton Rich of February 17, 1937, in curatorial files.

2 Registrar's accession records refer to von Hadeln's expertise of February 2, 1929, and a note from Berenson of September 6, 1930, is preserved in curatorial files.

3 Pignatti 1976, vol. 2, figs. 522, 583, 585, respectively.

4 Ibid., fig. 483.

5 While all scholars have dated the picture to Veronese's late period, they vary somewhat in their emphasis. Von Hadeln (note 2) suggested a date of c. 1570, an opinion reiterated in the catalogue of the Worcester collection (1938) and in the Art Institute's 1961 catalogue of paintings, but not confirmed in von Hadeln's posthumous publication of 1978, which gave no date for this picture. Fiocco (1934) merely described the painting as a "late work." Piovene and Marini (1968) favored 1572, whereas Pallucchini (1943), like Pignatti (1976) more recently, suggested the second half of the eighth decade. Finally, Vertova (1960) preferred a still later date at the beginning of the 1580s.

6 Pignatti 1976, vol. 1, pp. 182–83, nos. A100–03; two of

these, including *The Creation of Eve*, are reproduced by L. Crosato Larcher, "Per Carletto Caliari," *Arte veneta* 21 (1967), pp. 109–10, figs. 120–21.

7 R. Pallucchini and P. Rossi, *Tintoretto: Le opere sacre e profane*, vol. 1, Venice, 1982, nos. 149–52, figs. 197–201.

8 Ibid., p. 266; and M. Muraro, *Venetian Drawings from the Collection of Janos Scholz*, exh. cat., Venice, Fondazione Giorgio Cini, 1957, no. 31 (ill.).

9 E. Arslan, *I Bassano*, Milan, 1960, vol. 1, p. 108; vol. 2, figs. 139, 141, respectively.

Follower of Paolo Caliari, called Veronese

1528 Verona–Venice 1588

Virgin and Child with Saints John the Baptist and Anthony Abbot, 1575/1625

Charles H. and Mary F. S. Worcester Collection, 1929.913

Oil on canvas, 167.7 x 207 cm (66 x 81½ in.)

CONDITION: The painting is in fair condition. It was cleaned by Leo Marzolo in 1949, revarnished by Anton Konrad in 1959, and surface cleaned by Alfred Jakstas in 1975. The canvas, which has a twill weave, is made up of two sections joined vertically about 89.5 cm from the left edge. It has been glue lined. The paint is thinly applied and is also somewhat abraded throughout, but particularly in the background and in the brown robes of the saints. As a result, the warm ground tone shows through in many areas. The picture appears to have suffered considerable scuffing along the edges, since relatively broad strips — approximately 6 cm on the left, 9 cm on the right, and 12 cm on the top — have been filled and repainted.

PROVENANCE: Possibly Hohenzollern Collection, Berlin; sold by the trustees of the ex-Emperor of Germany to the Van Diemen Galleries, Berlin.[1] Sold by Van Diemen to Agnew, London and New York.[2] Sold by Agnew to Charles H. Worcester, 1927.[3] Charles H. Worcester, Chicago, 1927–29; on loan to the Art Institute from 1927; given to the Art Institute, 1929.

REFERENCES: "Notable Works of Art Now on the Market," *Burl. Mag.* 50, 297 (1927), advertising supplement, pl. 4, n. pag. "Venetian Art Exhibition at Agnew Galleries," *Art News* 26, 7 (1927), pp. 1, 3. R. Cortissoz, "Some Old Masters Recently in New York," *Scribner's Magazine* 83 (1928), pp. 370 (ill.), 373. F. J. Mather, Jr., "Some Old Masters of Venice," *The Arts* 13, 1 (1928), pp. 22–24 (ill.). D. C. R[ich], "A Painting by Veronese," *AIC Bulletin* 22 (1928), pp. 30–31 (cover ill., detail ill.). D. C. Rich, "Chicago Given Worcester Art," *Art News* 28, 22 (1930), pp. 3, 9 (ill.). D. C.

Rich, "The Mr. and Mrs. Charles H. Worcester Gift," *AIC Bulletin* 24 (1930), p. 30. D. C. Rich, "An Unpublished Veronese in Chicago," *Pantheon* 7 (1931), p. 20. AIC 1932, p. 6 (ill.). Berenson 1932, p. 420; 1936, p. 361; 1957, vol. 1, p. 130. G. Fiocco, *Paolo Veronese*, Rome, 1934, p. 127. AIC 1935, p. 21. *Worcester Collection* 1938, pp. 18–19, no. 14, pl. XII. AIC 1961, p. 348. Huth 1961, p. 517. G. Piovene and R. Marini, *L'opera completa del Veronese*, Classici dell'arte 20, Milan, 1968, p. 132, no. 322. Fredericksen/Zeri 1972, pp. 39, 336, 570. T. Pignatti, *Veronese*, Venice, 1976, vol. 1, p. 175, no. A47, vol. 2, fig. 760. D. von Hadeln, *Paolo Veronese*, ed. by G. Schweikhart, Florence, 1978, p. 122, no. 52. J. D. Morse, *Old Master Paintings in North America*, New York, 1979, p. 294. R. Cocke, *Veronese's Drawings with a Catalogue Raisonné*, Ithaca and London, 1984, p. 342, under no. 165 n. 8.

EXHIBITIONS: New York, Thomas Agnew and Sons, *Paintings by Old Masters of the Venetian School*, 1927, no. 21, as Veronese.

Charles Worcester acquired the painting as a work by Paolo Veronese, an attribution that has not been maintained with the utmost confidence, although upheld principally by von Hadeln[4] and then by Rich (1928, 1930, 1931, *Worcester Collection* 1938), Fiocco (1934), Berenson (1932, 1936, 1957), and Fredericksen and Zeri (1972). Berenson classified the picture as a late work. The author of the Art Institute's 1961 cata-

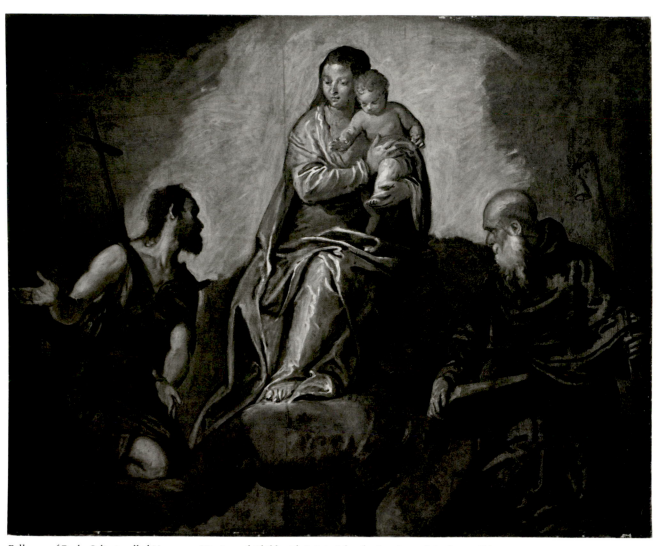

Follower of Paolo Caliari, called Veronese, *Virgin and Child with Saints John the Baptist and Anthony Abbot*, 1929.913

logue of paintings dissented from this opinion, attributing the painting to Palma Giovane and suggesting a date of 1575/85; but this idea has not won acceptance. Piovene and Marini (1968) listed the painting among the works attributed to Paolo Veronese, as did Pignatti (1976).

While rejecting the proposed attribution to Palma Giovane, Pignatti pointed out that the Virgin and Child in this picture can be compared to the corresponding figures on Veronese's main altarpiece of San Sebastiano in Venice and on his altarpiece in the church of San Giovanni in Xenodochio in Cividale del Friuli.[5] Similarly, he noted a resemblance between the head of Saint Anthony Abbot and that of the father in the scene of *Saints Mark and Marcellus Led to Martyrdom* in San Sebastiano in Venice.[6] Such connections led Pignatti to suggest that the work in Chicago might be a pastiche executed sometime after the death of Paolo Veronese. Cocke (1984), on the other hand, proposed that the painting formed part of a group which included the Bevilacqua-Lazise altarpiece, once in San Fermo in Verona (now Verona, Museo di Castelvecchio), and the *Saint Nicholas in Glory*, once in San Niccolò dei Mendicoli in Venice (now Venice, Gallerie dell'Accademia), as well as a number of less distinguished works.[7] The Bevilacqua-Lazise altarpiece has for many years been attributed to Veronese himself and the *Saint Nicholas in Glory* to his son Carletto Caliari,[8] but Cocke argued that these paintings and the works he grouped with them could be by Veronese's nephew Alvise dal Friso, who was born about 1554.[9] The homogeneity of this group is questionable. Although the handling of the highlights in the various paintings does seem to be fairly similar, the morphology and characterization of the figures differ. Furthermore, in the absence of a signed or documented work by Alvise dal Friso (as opposed to attributions in the early secondary sources), the connections between the artist and the cited paintings can only be tentative.

In addition to the stylistic confusion, it is not quite clear what function the painting served. Rich (1928) began by referring to the picture as unfinished, defining it as "a studio sketch." In 1938 (*Worcester Collection*), although continuing to call it unfinished, he described the painting as "evidently the top of a large altarpiece." Pignatti noted that the composition is virtually monochromatic.

Based on the available evidence, it seems reasonable to assert that the present painting dates from the very end of the sixteenth century or the beginning of the seventeenth century and that it is in the style of Paolo Veronese, although not necessarily from his studio. It most probably served as an altarpiece of some kind.

NOTES

1 According to a letter from Colin Agnew to Robert Harshe of January 9, 1928, in curatorial files. Agnew stated that Van Diemen had purchased the painting from the trustees of the ex-Emperor of Germany, and that it had been included in Friedländer's catalogue of the Hohenzollern Collection, *Gemälde alter Meister in Besitze seiner Majestät der deutschen Kaisers und Königs von Preussen*, ed. by P. Seidel, Berlin, Leipzig, Vienna, and Stuttgart, 1906. However, no reference to the painting appears in that volume.

2 See letter cited in preceding note.

3 Registrar's records indicate that it was lent to the Art Institute by Charles Worcester in 1927. The painting was presumably owned by Agnew at the time of their 1927 exhibition of Venetian paintings (see Exhibitions).

4 According to an expertise of May 4, 1927, in curatorial files.

5 For illustrations of these works, see Pignatti 1976, vol. 2, figs. 377, 380, 764.

6 Ibid., figs. 383–84.

7 Cocke 1984, pp. 341–42, under no. 165. For illustrations of these works, see Pignatti 1976, vol. 2, fig. 1; and Cocke 1984, p. 190, fig. 51.

8 Regarding the attribution history of the Bevilacqua-Lazise altarpiece, see Pignatti 1976, vol. 1, p. 103, no. 1; for the attribution of the *Saint Nicholas in Glory* to Carletto Caliari, see J. Schulz, *Venetian Painted Ceilings of the Renaissance*, Berkeley and Los Angeles, 1968, pp. 74–75, no. 17.

9 Cocke 1984, pp. 189–90, under no. 80, pp. 341–42, under no. 165.

Workshop of Paolo Caliari, called Veronese (possibly Benedetto and Carletto Caliari)

1528 Verona–Venice 1588

Saint Jerome in the Wilderness, c. 1585/90

Charles H. and Mary F. S. Worcester Collection, 1947.117

Oil on canvas, 134.8 x 176.6 cm (53⅛ x 69⅞ in.)

CONDITION: The painting is in very good condition. It was cleaned by Leo Marzolo in 1949 and given a light surface cleaning by Alfred Jakstas in 1962. The canvas has a herringbone weave and an old aqueous lining. A horizontal seam about 15 cm from the lower edge extends across the whole painting. The x-radiograph shows that this is a strip of the same canvas as the rest of the picture, but with the weave running in the opposite direction. The paint layers have been slightly flattened in lining. The darks of the foliage and rocks have sunken somewhat, reducing their legibility. The bottom edge is worn and inpainted (infrared, x-radiograph).

PROVENANCE: Rev. John Sanford, Florence and London, by 1837;[1] sold Christie's, London, March 9, 1839, no. 131, to G. Yates for £23 2s.[2] Possibly George Byng (1764–1847) or his nephew George Byng (1806–1886), second Earl of Strafford of the third creation, Wrotham Park, Barnet, Middlesex.[3] A. L. Nicholson, London, by 1930.[4] Knoedler, New York, 1944.[5] Sold by Knoedler to Charles H. Worcester, Chicago, 1945;[6] given to the Art Institute, 1947.

REFERENCES: *Catalogue of Paintings belonging to the Rev. J. Sanford; collected in Italy, from 1815 to 1837. Entrusted to G. Yates and Son, to be partially disposed of by private contract at 209 Regent Street*, London, 1838, p. 19, no. 102. "Chicago Gets Handsome Gift," *Pictures on Exhibit* 9, 7 (1947), p. 14. K. Kuh, "The Worcester Gift," *AIC Bulletin* 41 (1947), pp. 62–63 (ill.). AIC 1948, p. 26. F. A. Sweet, "La pittura italiana all'*Art Institute* di Chicago," *Le vie del mondo: Rivista mensile del Touring Club Italiano* 15 (1953), p. 698 (ill.). B. Nicolson, "The Sanford Collection," *Burl. Mag.* 97 (1955), pp. 208, 214, no. 56. Berenson 1957, vol. 1, p. 130. AIC 1961, p. 461. Huth 1961, p. 517. G. Piovene and R. Marini, *L'opera completa del Veronese*, Classici dell'arte 20, Milan, 1968, p. 104, no. 76 (ill.). Fredericksen/Zeri 1972, pp. 39, 409, 571. T. Pignatti, *Veronese*, Venice, 1976, vol. 1, p. 175, no. A49, vol. 2, fig. 763. R. Cocke, review of *Veronese* by T. Pignatti, in *Burl. Mag.* 119 (1977), p. 786. J. D. Morse, *Old Master Paintings in North America*, New York, 1979, p. 294. R. Cocke, *Veronese*, London, 1980, p. 110, pl. 72. H. Friedmann, *A Bestiary for Saint Jerome: Animal Symbolism in European Religious Art*, Washington,

D.C., 1980, p. 347. L. Larcher Crosato, "La Bottega di Paolo Veronese," *Nuovi studi su Paolo Veronese: Convegno internazionale di studi, Venezia, 1–4 giugno 1988*, ed. by M. Gemin, Venice, 1988, pp. 263, 265 n. 50.

EXHIBITIONS: The Art Institute of Chicago, *Masterpiece of the Month*, December 1949 (no cat.).

The picture has been traditionally ascribed to Paolo Veronese.[7] Kuh (1947) and Berenson (1957) upheld this attribution, but all other writers, including Pallucchini as cited by Piovene and Marini (1968), have admitted some degree of workshop participation.

There are considerable differences of opinion over the extent and character of collaboration in the painting. Pignatti (1976) stated that the figure of the saint reflects the style of Benedetto Caliari (1538–1598), Paolo's brother, and that the landscape has a strong Flemish accent. Cocke (1977), however, in his review of Pignatti's monograph, regarded the picture as "essentially autograph," although he credited Carletto Caliari (1570–1596), Paolo's son, with the landscape. This opinion was propounded in greater detail in Cocke's book of 1980, where what he described as the "fussy detail" of the landscape was compared with the background of a painting of the *Penitent Magdalen* by Carletto Caliari, formerly in the Duke of Northumberland's collection at Alnwick.[8] Cocke stated that x-radiographs of the picture in Chicago "confirm that the saint was painted first, by Veronese, and that the landscape was then added, by Carletto."

It is difficult to agree with Cocke's analysis entirely. Even though the painting is of a fairly high quality, the figure of Saint Jerome is not good enough to be by Veronese himself, as comparison with the two major altarpieces of this subject by the master

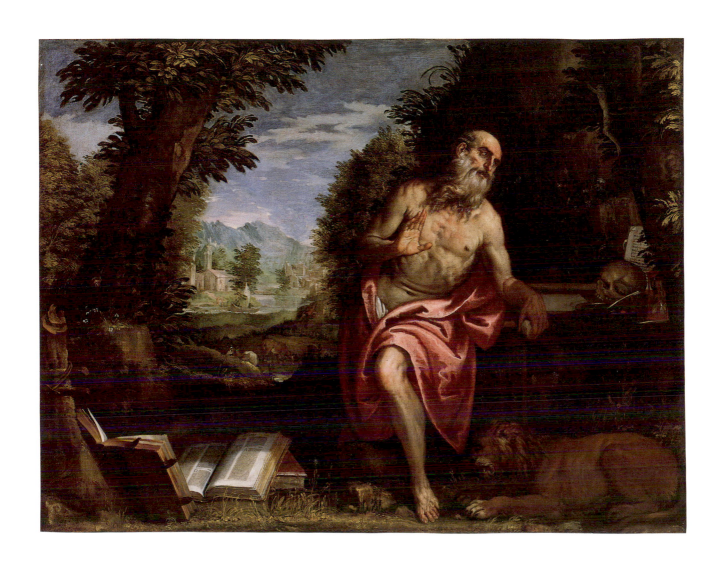

reveals (Murano, San Pietro Martire; and Venice, Sant'Andrea della Zirada).[9] The drawing of the torso in the present picture is admittedly somewhat similar to that in the two altarpieces, but the expression and attitude of religious zeal are much weaker. The facial features and poses of the figures in the two altarpieces are characterized by a total abandon to spiritual ecstasy, whereas the saint in the present painting seems only outwardly affected and devoid of inner conviction.

Even harder to reconcile with Veronese's style is the treatment of the drapery, particularly the highlights. The drapery swathing this Saint Jerome appears stiff, almost starched, and does not properly define the shape of the body beneath or respond to the saint's movements. The highlights tend more to describe form than to define texture. This handling of drapery is closer to that of Benedetto Caliari, as shown in his painting of *The Last Supper and Christ Washing the Disciples' Feet* of 1582, particularly in the drapery of the disciple seen from the front in the center.[10]

As Pignatti (1976) observed, however, the landscape is not characteristic of Benedetto. The teeming variety of vegetation, from the meticulous detail in the foreground and middle distance to the more luminous and atmospheric rendering of the background, seems more typical of Carletto. Cocke (1977) was the first to ascribe the landscape to Carletto, basing his attribution on a comparison with the painting of the *Institution of the "Soccorso"* (Venice, Gallerie dell'Accademia) dating from the 1590s.[11] Even more pertinent, as far as the landscape is concerned, are the two versions of *Angelica and Medoro* (Padua, Barbieri collection; and Prague, Národni Galeri).[12] If these stylistic observations are correct, then the picture in Chicago must be described as a work of collaboration executed jointly by Benedetto and Carletto Caliari, perhaps toward the end of the 1580s, in Paolo Caliari's workshop.

The iconography of Saint Jerome in the Wilderness has been studied by Friedmann (1980), who pointed out that the "wilderness meant not only a remote and wild region, but, in some instances, any area outside the protective walls of the cloisters or a town."[13] In his famous letter to Eustochium, the saint stated that he had daily encounters with "scorpions and wild beasts."[14] This expression was interpreted freely, particularly by North Italian and Venetian artists, who included numerous animals in their compositions, some of which are not strictly relevant to the subject. In the present painting, Saint Jerome is shown in the wilderness occupied principally with scholarly pursuits. The lion seated at his feet is the saint's main attribute, and the stone held in his left hand is a further attribute associated with the act of penitence. The animals grazing in the middle distance probably have no specific symbolic significance. In the left foreground, however, on the bark of the tree, is a snail, which, according to Friedmann, "seldom occurs in the iconography of S. Jerome" and has been interpreted as a symbol of the Resurrection.[15] Similarly, the lizard or salamander depicted on the tree stump in the lower left corner symbolizes Saint Jerome's search for salvation.[16]

NOTES

1 According to the 1838 catalogue of the Sanford collection, the picture was acquired in Venice. The Rev. John Sanford and his family went to Italy in 1815, but only in the early 1830s did they finally settle in Florence where they are first recorded in 1833. Sanford owned relatively few Venetian pictures. Before leaving Florence, watercolor copies were made by Italian artists of all the paintings in the collection. These copies were inherited, along with the remaining collection, by Sanford's daughter, Anna Horatia Caroline, who married Frederick Henry Paul Methuen, later second Lord Methuen, of Corsham Court. The copies are still preserved in four volumes at Corsham Court where the present picture is no. 182.

2 Annotated copy of the sale catalogue at Christie's, London.

3 The receipt dated May 10, 1945, sent by Knoedler to The Art Institute of Chicago, states that the picture was once in the collection of "Lord Enfield, Earl of Strafford, Wrotham Park, Barnet," near London, but this cannot be confirmed. According to Julian Byng, whose help is gratefully acknowledged, no painting of *Saint Jerome in the Wilderness* from the circle of Veronese is recorded in any of the relevant inventories of the paintings at Wrotham Park. Neither was such a picture noticed by G. F. Waagen, *Galleries and Cabinets in Great Britain*, vol. 4, London, 1857, pp. 318–25. For the formation of the collection at Wrotham Park, see Washington, D.C., National Gallery of Art, *The Treasure Houses of Britain: Five Hundred Years of Private Patronage and Art Collecting*, exh. cat., 1985–86, no. 308 (entry by F. Russell).

4 Letter from Bernard Berenson to Nicholson of February 20, 1930, in curatorial files.

5 According to a letter from Knoedler, New York, to Margherita Andreotti of August 15, 1988, in curatorial files.

6 According to registrar's records.

7 Berenson attributed the picture to Veronese as early as 1930 in the letter to Nicholson cited above (note 4). W. Suida likewise attributed the painting to Veronese in an expertise dated February 27, 1945, in curatorial files. For general comments on Veronese, see *The Creation of Eve* (1930.286) catalogued above.

8 Cocke 1980, pl. 72a.

9 Pignatti 1976, vol. 1, p. 131, no. 159, p. 138, no. 188; vol. 2, figs. 419–20, 483–84, respectively.

10 This painting was once in San Niccolò della Lattuga and is now in the Cappella del Rosario, Santi Giovanni e Paolo, on deposit from the Accademia. See S. M. Marconi, *Gallerie dell'Accademia di Venezia: Opere d'arte del secolo XVI*, Rome, 1962, p. 77, no. 128, fig. 128; and L. Larcher Crosato, "Note su Benedetto Caliari," *Arte veneta* 23 (1969), pp. 122–23, fig. 136.

11 Marconi (note 10), p. 80, no. 134, fig. 134.

12 Reproduced in L. Crosato Larcher, "Per Carletto Caliari," *Arte veneta* 21 (1967), fig. 119; and R. Pallucchini, *La pit-tura veneziana del seicento*, Milan, 1981, fig. 9. Larcher Crosato (1988, pp. 263, 265 n. 50) has recently attributed the Chicago picture to Carletto alone, comparing the figure of Saint Jerome to that of Saint Nicholas in Carletto's *Madonna in Glory with Saints* formerly in the church of San Niccolò del Lido and now in the Cini Foundation, Venice. For an illustration of the San Niccolò del Lido altar-piece, see Crosato Larcher 1967, p. 118, fig. 133.

13 Friedmann 1980, pp. 48–100.

14 See *The Letters of Saint Jerome*, tr. by C. Mierow, ed. by T. C. Lawler, vol. 1, London, 1963, pp. 139–40, letter 22, sec. 7. See also the entry for Vasari (1964.64).

15 Friedmann 1980, pp. 291–92.

16 Ibid., pp. 268–69. The salamander and lizard are inter-changeable in their symbolic meaning. However, Friedmann pointed out that salamanders are unharmed by fire, which, in the context of a representation of Saint Jerome, could refer to the saint's determination to ignore the erotic visions he experienced in the wilderness.

Antonio Vivarini

Active Venice and Padua by 1440, d. 1476/1484

Saint Peter Martyr Exorcizing a Woman Possessed by a Devil, 1440/50

George F. Harding Collection, 1983.384

Tempera on panel, 54.8 x 35.5 cm (21⁹⁄₁₆ x 14 in.); painted surface: 51.3 x 33.7 cm (20³⁄₁₆ x 13¼ in.)

CONDITION: The painting is generally in good condition. It was cleaned in 1984–85 by Karin Knight. The panel, which is bowed, is composed of a single piece of softwood with a vertical grain. Extensive exposed worm tunneling on the back indicates that the panel has been thinned. There is an irregular split running down through the center of the panel which had broken open and was rejoined in the 1984–85 treatment. The design was originally contained in a trilobed frame which was engaged, as is evident from the barbe and unpainted edges at the left, bottom, and top. The right side was probably trimmed, since it lacks a barbe and unpainted edge. These edges were gessoed and the design extended to a rectangle at an early date. Two triangular pieces were also added to square off the panel. There are scattered paint and ground losses in the bottom right corner and around a knothole in the foreground, between the steps and the figure of the woman. There is minimal paint and ground loss along the split and some wear along the arch of the frame, including the face of the man at the extreme left. In addition, there are some scratches in the sky, the buildings at the right, and the devil. These and scattered tiny losses have been filled and inpainted. Apart from such local losses, the paint surface and modeling are very well preserved (infrared, mid-treatment, ultraviolet, x-radiograph).

PROVENANCE: Paolo Paolini, Rome; sold American Art Association, New York, December 10–11, 1924, no. 90, as Quirizio da Murano, to George F. Harding, Jr.[1] George F. Harding, Jr. (d. 1939), Chicago, from 1924; The George F. Harding Museum, Chicago; Sotheby's, New York, December 2, 1976, no. 28 (ill.), withdrawn; transferred to the Art Institute, 1983.

REFERENCES: Van Marle, vol. 17, 1935, p. 49. G. Pudelko, "Ein Petrus-Martyr-Altar der Antonio Vivarini," *Pantheon* 20 (1937), p. 284 (ill.). M. M. Salinger, "A Gift of Two Ital-ian Paintings," *The Bulletin of The Metropolitan Museum of Art* 33 (1938), pp. 8–10. G. Fiocco, "Le pitture venete

del Castello di Konopiste," *Arte veneta* 11 (1948), p. 20 (ill.). Berenson 1957, vol. 1, p. 200, pl. 84. R. Pallucchini, *I Vivarini*, Venice, 1962, pp. 27, 98, no. 20, fig. 20. R. Pallucchini, "Giunte ai Vivarini," *Arte veneta* 21 (1967), p. 200. F. R. Shapley, *Paintings from the Samuel H. Kress Collection: Italian Schools, XV–XVI Century*, London, 1968, p. 31, under no. K1116. Fredericksen/Zeri 1972, pp. 211, 444, 572. Zeri/Gardner 1973, p. 89. G. Kaftal with F. Bisogni, *Saints in Italian Art: Iconography of the Saints in the Painting of North East Italy*, Florence, 1978, no. 236, col. 845. Staatliche Museen Preussischer Kulturbesitz, Gemäldegalerie, *Catalogue of Paintings, 13th–18th Century*, 2d ed., Berlin-Dahlem, 1978, p. 470, under nos. 66, 67.

Antonio Vivarini ran the most important family workshop in Venice before the emergence of the Bellinis. He is sometimes referred to in documents as "da Murano" and may, therefore, have originally come from the island of Murano in the Venetian lagoon. Antonio collaborated extensively with his brother-in-law Giovanni d'Alemagna during the first part of his career (c. 1440–50) and then with his older brother, Bartolomeo, specializing in elaborate altarpieces with numerous panels surrounded by architectural frames of Gothic design. Antonio Vivarini is essentially a transitional artist working in a part of Italy where Renaissance principles were not fully developed until late in the fifteenth century. However, he was susceptible to the influence of Tuscan artists working in the Veneto, and a short period of activity (1447/48–50) in Padua, where Donatello was working (1443–53), would have introduced him to the revival of antiquity.

The painting belongs to a series of seven known panels illustrating scenes from the life of Saint Peter Martyr. The other six panels are as follows: *Saint Peter Martyr Received into the Dominican Order* (fig. 1; Berlin, Gemäldegalerie, Staatliche Museen Preussischer Kulturbesitz), *Saint Peter Martyr Attempting to Burn His Cloak* (fig. 2; Berlin, Gemäldegalerie, Staatliche Museen Preussischer Kulturbesitz), *Saint Peter Martyr Exorcizing the Devil Disguised as a Statue of the Virgin and Child* (location unknown; formerly Claude Lafontaine collection, sold Paris, Palais Galliera, April 10, 1962, no. 7), *Saint Peter Martyr Healing the Leg of a Young Man* (fig. 3; New York, The Metropolitan Museum of Art), *Saint*

Peter Martyr in His Cell Visited by Saints Agnes, Catherine, and Cecilia (Rome, Count Leonardo Vitetti collection), *The Funeral of Saint Peter Martyr* (Milan, Mario Crespi collection).[2] The number of panels originally included in the series has not yet been established. Kaftal (1978), who provided the fullest account of the iconography of the saint, listed as many as thirty-two incidents from the life of Saint Peter Martyr known to have been illustrated during the fifteenth century; it is thus possible that other scenes, such as his dramatic death, were included in the series.

Saint Peter Martyr (1205–1252) was born in Verona and educated at Bologna University before taking the habit. He rose to high rank within the Dominican order and was appointed inquisitor for Milan in 1234, his area of jurisdiction being extended in 1251 to incorporate Venice, Genoa, Bologna, and the Marches. He traveled extensively in Italy, becoming well known as a preacher and for conducting disputations with heretics. He was assassinated while traveling from Como to Milan and was canonized by Pope Innocent IV in 1253. His tomb is in the Portinari Chapel of San Eustorgio in Milan. As the first Dominican martyr, he was widely venerated in Europe and often represented in art.

Pudelko (1937) was the first scholar to establish the connection between the panels in Berlin, New York, and Chicago. Berenson (1957) added the panel in the Crespi collection and Pallucchini (1967) published the scenes of *Saint Peter Martyr Exorcizing the Devil Disguised as a Statue of the Virgin and Child* and *Saint Peter Martyr Visited in His Cell by Saints Agnes, Catherine, and Cecilia*. There can be little doubt that the panels once formed part of a large altarpiece and most probably surrounded a full-length image of the saint. Such a format had its origins in the thirteenth century and was retardataire by the second half of the fifteenth century. Altarpieces of this type were, nevertheless, still being produced by Venetian artists at this date. Pudelko (1937), for instance, argued that the original altarpiece to which all these panels belonged probably resembled the roughly contemporary Saint Lucy altarpiece signed by Quirizio da Murano,[3] while Zeri and Gardner (1973) cited an earlier altarpiece by Simone da Cusighe, showing the Madonna della Misericordia

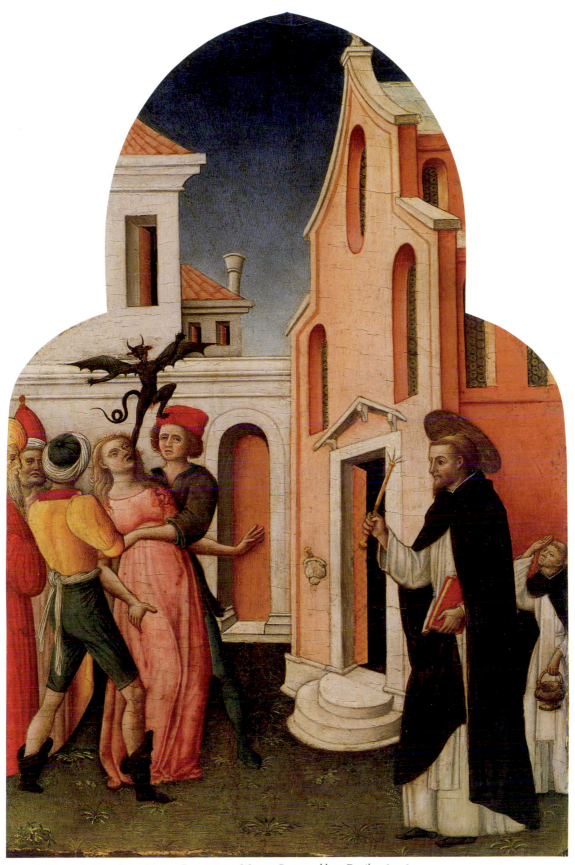

Antonio Vivarini, *Saint Peter Martyr Exorcizing a Woman Possessed by a Devil*, 1983.384

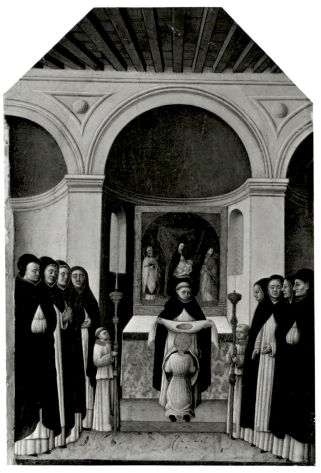

Fig. 1 Antonio Vivarini, *Saint Peter Martyr Received into the Dominican Order*, Staatliche Museen Preussischer Kulturbesitz, Gemäldegalerie, Berlin

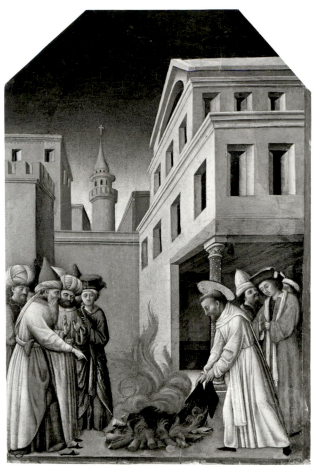

Fig. 2 Antonio Vivarini, *Saint Peter Martyr Attempting to Burn His Cloak*, Staatliche Museen Preussischer Kulturbesitz, Gemäldegalerie, Berlin

surrounded by scenes from the life of San Bartolomeo (Venice, Gallerie dell'Accademia).[4]

More to the point, however, is a comparison with the series of altarpieces dedicated to the leading Dominican saints, formerly in the old church of San Domenico in Modena.[5] Of these, only the altarpiece (dated 1450) dedicated to Saint Peter Martyr painted by Simone Lamberti (Parma, Galleria Nazionale) is intact.[6] The other altarpieces, dedicated to Saints Vincent Ferrer, Thomas Aquinas, and Dominic, respectively, are now dismembered and were painted by Bartolommeo degli Erri at a slightly later date, perhaps during the 1470s. These were very large altarpieces with as many as twelve or more scenes arranged chronologically in two rows on either side of the central image of the saint. Like these, the altarpiece to which the present panel once belonged pre-

sumably played an important role in establishing Dominican iconography.

Unfortunately, the early provenance of the seven related scenes is not known. The panel of *Saint Peter Martyr Healing the Leg of a Young Man* (New York, The Metropolitan Museum of Art) was in a private collection near Venice by the end of the eighteenth century, but its history before that has yet to be discovered. Pudelko (1937), followed by Fiocco (1948), suggested a possible connection with the church of Santi Giovanni e Paolo in Venice, although Vivarini worked fairly extensively throughout the Veneto. As in the case of Modena referred to above, such an altarpiece may have been one of several made for a major Dominican church. No attempt has yet been made to arrange the Saint Peter Martyr panels in their original sequence.[7] It should be noted that se-

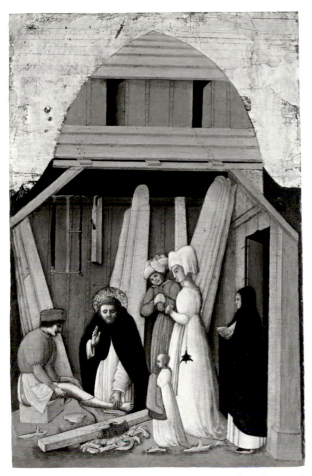

Fig. 3 Antonio Vivarini, *Saint Peter Martyr Healing the Leg of a Young Man*, The Metropolitan Museum of Art, New York, Gift of the Samuel H. Kress Foundation, 1937 (37.163.4)

determine the evolution of his style. This situation renders the dating of *membra disjecta*, such as those illustrating the life of Saint Peter Martyr, uncertain and a matter that remains essentially unresolved. Insofar as the neat figure style and the treatment of narrative seem to depend in part upon painters of Tuscan origin like Paolo Uccello and Filippo Lippi, a date during the 1440s when Tuscan influence was being felt in Lombardy and the Veneto seems likely.

NOTES

1 According to The George F. Harding Museum papers, Archives, The Art Institute of Chicago.

2 Four of these panels are conveniently illustrated by Berenson 1957, vol. 1, pls. 81–83, 85, while the other two, *Saint Peter Martyr Exorcizing the Devil Disguised as a Statue of the Virgin and Child* and *Saint Peter Martyr in his Cell Visited by Saints Agnes, Catherine, and Cecilia*, are illustrated by Pallucchini 1967, figs. 252–53.

3 Van Marle, vol. 17, 1935, fig. 22.

4 S. M. Marconi, *Gallerie dell'Accademia di Venezia: Opere d'arte dei secoli XIV e XV*, Rome, 1955, no. 20 (ill.).

5 This series of altarpieces is fully discussed by A. M. Chiodi, "Bartolomeo degli Erri e i polittici domenicani," *Commentari* 2 (1951), pp. 17–25.

6 A. O. Quintavalle, *La Regia Galleria di Parma*, Rome, 1939, pp. 15–19 (ill.). The scenes from this altarpiece are illustrated in full by Kaftal 1978.

7 One factor that will be important in such an exercise is the evidence of the old frame marks. The surface of the panel in Chicago bears indications of a trefoil-shaped frame with a cusped arch, which is incorrectly rendered in Berenson 1957, vol. 1, pl. 84, as are those of the two panels in Berlin (ibid., pls. 81–82). It seems that originally all the panels in the series had trefoil-shaped frames with cusped arches, but only the compositions of those in New York and in the Crespi and Vitetti collections have not been extended into the upper corners at a later date.

8 *Scenes from the Life of Saint Monica* (Pallucchini 1962, p. 97, nos. 13–17, figs. 13–17) and *Scenes from the Life of the Virgin* (ibid., p. 102, nos. 46–51, figs. 46–51), to which *Scenes from the Lives of Female Martyrs* (ibid., pp. 98–99, nos. 23–26, figs. 23–26) should be added.

9 Zeri and Gardner 1973, p. 89.

quences of narrative panels from at least two other dismantled altarpieces of elaborate design by Vivarini have survived.[8]

In the catalogue of the 1924 sale of the Paolini collection, Berenson was responsible for an initial attribution to Quirizio da Murano, later adopted by Van Marle (1935). Pudelko (1937), however, recognized that the present panel, together with those in New York and Berlin, was a work by Antonio Vivarini, an attribution that is now widely accepted. The panel in New York has been dated on the basis of style to the decade 1450/60,[9] although Pallucchini, in his monograph of 1962, placed the Saint Peter Martyr panels slightly earlier, during the mid-1440s.

Although there are several dated altarpieces in Vivarini's oeuvre, the division of hands between the master and his collaborators makes it difficult to

Uncertain Authorship

The Visitation, nineteenth to mid-twentieth
century
Bequest of Chester D. Tripp, 1987.252

Tempera, possibly with oil, on panel, 33 x 21.9 cm
(13 x 8⅝ in.)

CONDITION: The painting is in poor condition. Cynthia
Kuniej cleaned it and consolidated tenting paint in 1988–89.
The panel, composed of a single board with horizontal grain,
is approximately 8 mm thick. It has been thinned, as indi-
cated by exposed worm tunneling on the back of the panel
and on the edges, and then cradled.

There are numerous areas of paint loss and inpainting,
particularly in the lower draperies of all the figures,
throughout the drapery of the Virgin (identified as the
figure right of center), and on the right edge of the city wall
at the left of the picture. The pattern of the craquelure is
very irregular (mid-treatment, x-radiograph).

PROVENANCE: E. and A. Silberman Galleries, New York.[1]
Chester D. Tripp (d. 1974), Evanston, Illinois, and Chicago;
at his death to his widow, Jane B. Tripp; bequeathed to the
Art Institute, 1987.

When this painting was bequeathed to the Art
Institute in 1987, it was attributed to the fifteenth-
century Florentine painter Benozzo Gozzoli.
However, the use and misinterpretation of a variety
of motifs from works associated with Fra Angelico,
together with the presence of modern pigment, indi-
cates that the work is of recent origin. Everett Fahy
recently called attention to the "awkward scale of the
figures in relation to one another, the absurd archi-
tecture, and the pattern of the craquelure."[2] He noted
as well that the two figures on the right, seen from
behind and in profile, are direct quotations from the
scene of *Saint Peter Preaching* in the predella of Fra
Angelico's Linaiuoli Triptych (1433; Florence, Museo
di San Marco).[3] In recasting the man in profile, the

artist responsible for the Chicago painting apparently
misunderstood the gesture of the figure, who grasps
his belt in Fra Angelico's picture. On the basis
of a photograph, Fahy concluded that the work is
a forgery.

Other figures and architectural elements also seem
to be culled from paintings by Fra Angelico and his
assistants in the church and monastery of San Marco
in Florence. The inexplicable, leaning pose of the
figure, right of center, which is presumably intended
as the Virgin Mary, seems to be based on depictions
of the Virgin swooning and may derive specifically
from the Virgin in Fra Angelico's *Crucifixion* (1441–
46) in the Sala del Capitolo of San Marco.[4] The figure
of Elizabeth in the Chicago work may depend on the
woman at the left in the painting of *Christ Carrying
the Cross* attributed to the Master of Cell 2, in
monastic Cell 28 at San Marco.[5] It is also possible that
the structure at the left of the Chicago painting is
an awkward variation on the city wall and gate in
Fra Angelico's *Deposition* (c. 1443), painted for the
church of Santa Trinita, but now in the Museo di
San Marco.[6]

Analysis of several pigment samples taken from
The Visitation has confirmed Fahy's suspicions. Inge
Fiedler, Conservation Microscopist at the Art Insti-
tute, has determined, with the aid of a polarizing
light microscope and electron microprobe, that areas
of original paint contain pigments that were not
manufactured until the eighteenth and nineteenth
centuries.[7] Elizabeth's blue robe, the yellow tower
at upper left, and the white scarf of the woman at
right all contain a mixture of zinc white and barium
sulfate, pigments not produced until the early to mid-
nineteenth century. The tower also contains chrome

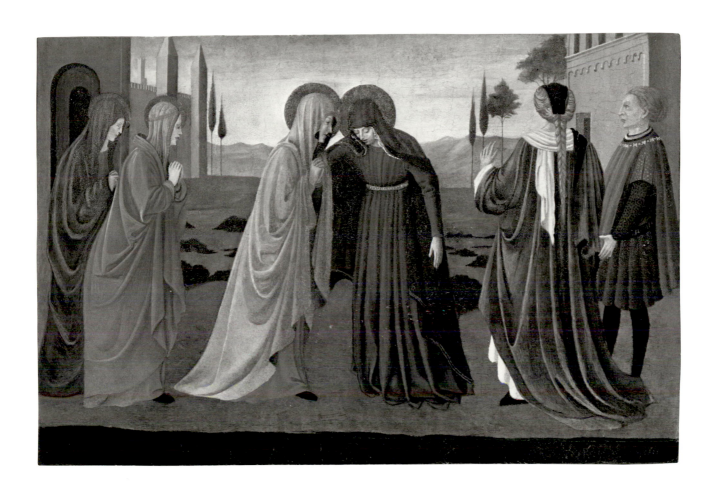

yellow, a pigment first used in the early nineteenth century, and Mary's drapery includes prussian blue, which only began to be manufactured in the early eighteenth century.

Based on a photograph, Gianni Mazzoni has suggested that the Italian restorer and forger Giuseppe Catani Chiti (1866–1945), friend and sometime collaborator of the better-known forger Icilio Federico Ioni, may be the author of the Chicago painting.[8] Mazzoni has pointed to similarities between the Chicago picture and other forgeries he believes to be the work of Catani, such as a *Crucifixion* in the Lehman Collection (New York, The Metropolitan Museum of Art).[9] While *The Visitation* does share some traits with the Lehman painting, including similarities in the treatment of hands and drapery folds, the Chicago picture cannot be assigned with certainty to Catani.

NOTES

1 According to a label removed from the back of the painting and preserved in curatorial files.
2 Letter of August 5, 1991, to Larry J. Feinberg, in curatorial files.
3 For an illustration, see J. Pope-Hennessy, *Fra Angelico*, New York, 1974, pl. 30.
4 Ibid., pls. 72–73. The Virgin Mary in the Chicago picture also approximates in pose the central figure in *The Maries at the Sepulchre* by Fra Angelico's assistant, the Master of Cell 2, in monastic Cell 2 of San Marco (ibid., fig. 30).
5 Ibid., fig. 32.
6 Ibid., pls. 104, 107.
7 Copies of Fiedler's report, dated July 1992, are preserved in curatorial and conservation files.
8 Letter of September 8, 1991, to Larry J. Feinberg, in curatorial files.
9 See J. Pope-Hennessy assisted by L. B. Kanter, *The Robert Lehman Collection*, vol. 1, *Italian Paintings*, New York, 1987, pp. 268–69, no. 112 (ill.). Mazzoni has published a brief biography of Catani and a list of some of his forgeries in *La pittura in Italia: L'ottocento*, vol. 2, Milan, 1991, p. 749.

List of Previous Owners

Agnew
 Jacopo Bassano, 1968.320
 Attributed to Francesco Botticini, 1937.1009
 Moretto da Brescia, 1935.161
 Lo Spagna, 1937.1008
 Venetian, 1947.111
 Follower of Veronese, 1929.913
Alba, Duke of
 Domenico Tintoretto, 1929.914
Alford
 Cambiaso, 1942.290
 Lo Spagna, 1937.1008
Altieri
 Attributed to Ghissi, 1937.1006
Ambroz-Migazzy, Count
 Bolognese, 1947.56
Asscher and Welker
 Palma il Giovane, 1937.449
 Venetian, 1947.115
Avogadro
 Moretto da Brescia, 1935.161
Aynard, Edouard
 Giovanni di Paolo, 1933.1010–15
Bacon
 Attributed to Allori, 1965.1179
Barker, Alexander
 Attributed to Francesco Botticini, 1937.1009
 Crivelli, 1929.862
 Perugino, 1933.1023–26
Barrymore, Lord
 Rimpatta, 1963.209
Bassano, Jacopo
 Jacopo Bassano, 1939.2239
Beattie, William
 Ridolfo Ghirlandaio, 1933.1009
Beckerath, Adolf von
 Attributed to Roberti, 1947.90
Bell, Hon. Mrs. Dorothy Elizabeth
 Rimpatta, 1963.209
Benedict and Co.
 Attributed to Roberti, 1947.90
Berendt
 Empoli, 1960.1
Beurnonville, Baron E. de
 Crivelli, 1929.862
Bexley, first Baron
 Empoli, 1960.1
Blakeslee, T. J.
 Moretto da Brescia, 1935.161
Böhler and Steinmeyer
 Jacopo Tintoretto, 1932.44
 After Titian (?), 1954.301
 Veronese, 1930.286
Böhler, Julius
 Apollonio di Giovanni, 1933.1006

Botticelli, 1954.282
 Veneto-Riminese, 1968.321
Bourgeois, S.
 Attributed to Ghissi, 1937.1006
Boyce, G. P.
 Attributed to Francesco Botticini, 1937.1009
Brancaccio, Prince
 Ridolfo Ghirlandaio, 1933.1009
Breitmeyer, L.
 Venetian, 1947.115
Brocklebank, Ralph
 Frediani, 1954.289
Bromhead
 Florentine, 1933.1034
Brownlow, fifth Baron
 Cambiaso, 1942.290
Brownlow, third Earl
 Matteo di Giovanni, 1933.1018–19
 Lo Spagna, 1937.1008
Byng, George
 Workshop of Veronese, 1947.117
Calmann, H. M.
 Rimpatta, 1963.209
Carlisle, ninth Earl of
 Jacopo Bassano, 1968.320
Chalandon
 Latin Kingdom of Jerusalem, 1933.1035
Chiesa, Achillito
 Central Italian, 1984.16
 Florentine, 1933.1032
 Venetian, 1984.24a–g
Chigi-Saracini
 Beccafumi, 1986.1366
Clark, H. M.
 Domenico Tintoretto, 1929.914
Clemente, Achille de
 Florentine, 1933.1034
Collings
 Cambiaso, 1942.290
Colnaghi
 Apollonio di Giovanni, 1933.1006
 Matteo di Giovanni, 1933.1018–19
 Workshop of Pontormo, 1963.206
Compagnia di San Michele Arcangelo, Siena
 Beccafumi, 1986.1366
Cox
 Taddeo di Bartolo, 1933.1033
Dale, Chester
 Attributed to Fasolo, 1946.382
Danforth, Mrs. Murray S.
 Sarto, 1964.1097a–b
De la Faille
 Botticelli, 1954.283
Delaroff, Paul
 After Tura, 1933.1037

303

Moroni, 1929.912
Northern Italian, 1947.53
Palma il Giovane, 1937.449
Workshop of Paolo Veneziano, 1947.116
Attributed to Roberti, 1947.90
Domenico Tintoretto, 1929.914
Imitator of Titian, 1943.90
Tosini, 1937.459

Venetian, 1947.111
Venetian, 1947.115
Veronese, 1930.286
Follower of Veronese, 1929.913
Workshop of Veronese, 1947.117
Yates, G.
Workshop of Veronese, 1947.117

List of Paintings by Accession Number

1929.862 Carlo Crivelli, *The Crucifixion*

1929.912 Giovanni Battista Moroni, *Gian Lodovico Madruzzo*

1929.913 Follower of Paolo Caliari, called Veronese, *Virgin and Child with Saints John the Baptist and Anthony Abbot*

1929.914 Domenico Tintoretto, *Venus and Mars with Cupid and the Three Graces in a Landscape*

1930.286 Paolo Caliari, called Veronese, *The Creation of Eve*

1932.44 Jacopo Robusti, called Tintoretto, *Saint Helena Testing the True Cross*

1933.550 After Giovanni Bellini, *Virgin and Child*

1933.1002 Jacopo Carrucci, called Pontormo, *Alessandro de' Medici*

1933.1003 Bernardino Butinone, *The Flight into Egypt*

1933.1004 Bernardino Butinone, *The Descent from the Cross*

1933.1006 Apollonio di Giovanni, *The Adventures of Ulysses*

1933.1008 Girolamo da Santacroce, *Virgin and Child Enthroned*

1933.1009 Ridolfo Ghirlandaio, *Portrait of a Gentleman*

1933.1010 Giovanni di Paolo, *Saint John the Baptist Entering the Wilderness*

1933.1011 Giovanni di Paolo, *Ecce Agnus Dei*

1933.1012 Giovanni di Paolo, *Saint John the Baptist in Prison Visited by Two Disciples*

1933.1013 Giovanni di Paolo, *Salome Asking Herod for the Head of Saint John the Baptist*

1933.1014 Giovanni di Paolo, *The Beheading of Saint John the Baptist*

1933.1015 Giovanni di Paolo, *The Head of Saint John the Baptist Brought before Herod*

1933.1016 Attributed to Michelangelo di Pietro Membrini, also called Mencherini (The Master of the Lathrop Tondo), *Virgin and Child Enthroned with Two Angels Holding a Crown*

1933.1017 Gherardo di Jacopo, called Starnina, *The Dormition of the Virgin*

1933.1018 Matteo di Giovanni, *The Dream of Saint Jerome*

1933.1019 Matteo di Giovanni, *Saint Augustine's Vision of Saints Jerome and John the Baptist*

1933.1022 Allegretto Nuzi, *Bishop Saint Enthroned*

1933.1023 Pietro di Cristoforo Vannucci, called Perugino, *The Baptism of Christ*

1933.1024 Pietro di Cristoforo Vannucci, called Perugino, *Christ and the Woman of Samaria*

1933.1025 Pietro di Cristoforo Vannucci, called Perugino, *The Adoration of the Christ Child*

1933.1026 Pietro di Cristoforo Vannucci, called Perugino, *Noli Me Tangere*

1933.1027 Sano di Pietro, *Virgin and Child with Saints Jerome, Bernardino of Siena, and Angels*

1933.1029 Master of Apollo and Daphne, *Susanna and the Elders in the Garden, and the Trial of Susanna before the Elders*

1933.1030 Master of Apollo and Daphne, *Daniel Saving Susanna, the Judgment of Daniel, and the Execution of the Elders*

1933.1031 Spinello Aretino, *Pope Innocent III Sanctioning the Rule of Saint Francis*

1933.1032 Florentine, *The Crucifixion*

1933.1033 Taddeo di Bartolo, *The Crucifixion*

1933.1034 Florentine, *Virgin and Child*

1933.1035 Latin Kingdom of Jerusalem, diptych: *Virgin and Child Enthroned with the Archangels Raphael and Gabriel* (left wing), *Christ on the Cross between the Virgin and Saint John the Evangelist* (right wing)

1933.1036 Workshop of Apollonio di Giovanni and Marco del Buono Giamberti, *The Continence of Scipio*

1933.1037 After Cosimo Tura, *Pietà*

1935.161 Alessandro Bonvicino, called Moretto da Brescia, *Mary Magdalen*

1936.120 Master of the Bigallo Crucifix, *Crucifix*

1937.449 Jacopo Palma, called Palma il Giovane, *Portrait of a Gentleman*

1937.459 Michele Tosini, called Michele di Ridolfo, *Portrait of a Lady*

1937.996 Bartolommeo di Giovanni, *Scenes from the Life of Saint John the Baptist*

1937.997 Attributed to Raffaello Botticini, *The Adoration of the Magi*

1937.1001 Attributed to the Workshop of Neroccio de' Landi, *Two Putti*

1937.1002 Workshop of Francesco Francia, *The Mystic Marriage of Saint Catherine of Alexandria*

1937.1003 Niccolò di Pietro Gerini, *Virgin and Child*

1937.1004 Lorenzo di Bicci, *Madonna of Humility with Two Angels*

1937.1005 Follower of Domenico Ghirlandaio, *The Virgin Adoring the Child with the Young Saint John*

1937.1006 Attributed to Francescuccio Ghissi, *The Crucifixion*

1937.1007 Attributed to Ugolino di Nerio, *Virgin and Child Enthroned with Saints Peter, Paul, John the Baptist, Dominic, and a Donor*

1937.1008 Giovanni di Pietro, called Lo Spagna, *Saint Catherine of Siena*

1937.1009 Attributed to Francesco Botticini, *Virgin and Child with Two Angels*

1939.2239 Jacopo da Ponte, called Bassano, *Diana and Actaeon*

1942.290 Luca Cambiaso, *Venus and Cupid*

1943.90 Imitator of Titian, *Allegory of Venus and Cupid*

1946.382 Attributed to Giovanni Antonio Fasolo, *Portrait of a Lady*

1947.53 Northern Italian, *Sinan the Jew and Haireddin Barbarossa*

1947.56 Bolognese, *Madonna of Humility*

1947.90 Attributed to Ercole de' Roberti, *Virgin and Child*

1947.111 Venetian, *The Flight into Egypt*

1947.115 Venetian, *Portrait Presumed to Be of Antonio Zantani*

1947.116 Workshop of Paolo Veneziano, *Saints John the Baptist and Catherine of Alexandria*

1947.117 Workshop of Paolo Caliari, called Veronese (possibly Benedetto and Carletto Caliari), *Saint Jerome in the Wilderness*

1949.203 Jacopo Robusti, called Tintoretto, *Tarquin and Lucretia*

1951.318 Attributed to Pietro de Mariscalchi, *Portrait of a Gentleman*

1954.195 Venetian, *Portrait of a Gentleman*

1954.282 Sandro Botticelli, *Virgin and Child with Two Angels*

1954.283 Sandro Botticelli, *Virgin and Child with Angel*

1954.289 Vincenzo Frediani, *The Adoration of the Christ Child*

1954.301 After Titian (?), *Portrait of a Lady*

1954.318 Lippi-Pesellino Imitator, *Virgin and Child*

1958.304 Workshop of Paolo Veneziano, *Saints Augustine and Peter*

1960.1 Jacopo Chimenti, called Jacopo da Empoli, *Portrait of a Noblewoman Dressed in Mourning*

1963.206 Workshop of Jacopo Carrucci, called Pontormo, *Virgin and Child with the Young Saint John the Baptist*

1963.209 Antonio Rimpatta, *The Holy Family with Four Saints and a Female Donor*

1964.64 Giorgio Vasari, *The Temptation of Saint Jerome*

1964.1097a–b Andrea del Sarto, *Domenico da Gambassi and The Wife of Domenico da Gambassi*

1964.1169 Vincenzo Catena, *Virgin and Child with a Female Saint in a Landscape*

1965.688 Antonio Allegri, called Correggio, *Virgin and Child with the Young Saint John the Baptist*

1965.1179 Attributed to Alessandro Allori, *Francesco de' Medici*

1968.320 Jacopo da Ponte, called Bassano, *Virgin and Child with the Young Saint John the Baptist*

1968.321 Veneto-Riminese, triptych: *Virgin and Child with the Annunciation* (center panel), *Scenes from the Life of Christ* (wings)

1974.393 Workshop of Apollonio di Giovanni and Marco del Buono Giamberti, *The Assassination and Funeral of Julius Caesar*

1974.394 Workshop of Apollonio di Giovanni and Marco del Buono Giamberti, *The Battle of Pharsalus and the Death of Pompey*

1983.384 Antonio Vivarini, *Saint Peter Martyr Exorcizing a Woman Possessed by a Devil*

1984.16 Central Italian, *Virgin and Child*

1984.24a–g Venetian, altarpiece: *The Assumption of the Virgin with Saints*

1984.27 Ferrarese or Northern Italian, *Phaeton Driving the Chariot of Phoebus*

1986.1366 Domenico Beccafumi, called Il Mecarino, *Saint Ignatius of Antioch Disemboweled by Trajan's Torturers*

1987.252 Uncertain Authorship, *The Visitation*

1988.266 Veneto-Lombard, *Portrait of a Gentleman*

List of Artists

Allori, Alessandro, attributed to
 Francesco de' Medici, 1965.1179
Apollonio di Giovanni
 The Adventures of Ulysses, 1933.1006
Apollonio di Giovanni and Marco del Buono Giamberti,
workshop of
 The Continence of Scipio, 1933.1036
 The Assassination and Funeral of Julius Caesar,
 1974.393
 The Battle of Pharsalus and the Death of Pompey,
 1974.394
Bartolommeo di Giovanni
 Scenes from the Life of Saint John the Baptist, 1937.996
Bassano (Jacopo da Ponte)
 Diana and Actaeon, 1939.2239
 Virgin and Child with the Young Saint John the Baptist,
 1968.320
Beccafumi, Domenico (called Il Mecarino)
 *Saint Ignatius of Antioch Disemboweled by Trajan's
 Torturers*, 1986.1366
Bellini, Giovanni, after
 Virgin and Child, 1933.550
Bolognese
 Madonna of Humility, 1947.56
Botticelli, Sandro
 Virgin and Child with Two Angels, 1954.282
 Virgin and Child with Angel, 1954.283
Botticini, Francesco, attributed to
 Virgin and Child with Two Angels, 1937.1009
Botticini, Raffaello, attributed to
 The Adoration of the Magi, 1937.997
Butinone, Bernardino
 The Flight into Egypt, 1933.1003
 The Descent from the Cross, 1933.1004
Cambiaso, Luca
 Venus and Cupid, 1942.290
Catena, Vincenzo
 Virgin and Child with a Female Saint in a Landscape,
 1964.1169
Central Italian
 Virgin and Child, 1984.16
Correggio (Antonio Allegri)
 Virgin and Child with the Young Saint John the Baptist,
 1965.688
Crivelli, Carlo
 The Crucifixion, 1929.862
Empoli, Jacopo da (Jacopo Chimenti)
 Portrait of a Noblewoman Dressed in Mourning, 1960.1
Fasolo, Giovanni Antonio, attributed to
 Portrait of a Lady, 1946.382
Ferrarese or Northern Italian
 Phaeton Driving the Chariot of Phoebus, 1984.27
Florentine
 The Crucifixion, 1933.1032
 Virgin and Child, 1933.1034

Francia, Francesco, workshop of
 The Mystic Marriage of Saint Catherine of Alexandria,
 1937.1002
Frediani, Vincenzo
 The Adoration of the Christ Child, 1954.289
Gerini, Niccolò di Pietro
 Virgin and Child, 1937.1003
Ghirlandaio, Domenico, follower of
 *The Virgin Adoring the Child with the Young Saint
 John*, 1937.1005
Ghirlandaio, Ridolfo
 Portrait of a Gentleman, 1933.1009
Ghissi, Francescuccio, attributed to
 The Crucifixion, 1937.1006
Giovanni di Paolo
 Saint John the Baptist Entering the Wilderness,
 1933.1010
 Ecce Agnus Dei, 1933.1011
 *Saint John the Baptist in Prison Visited by Two
 Disciples*, 1933.1012
 *Salome Asking Herod for the Head of Saint John the
 Baptist*, 1933.1013
 The Beheading of Saint John the Baptist, 1933.1014
 *The Head of Saint John the Baptist Brought before
 Herod*, 1933.1015
Girolamo da Santacroce
 Virgin and Child Enthroned, 1933.1008
Latin Kingdom of Jerusalem
 Diptych: *Virgin and Child Enthroned with the
 Archangels Raphael and Gabriel* (left wing), *Christ on
 the Cross between the Virgin and Saint John the Evan-
 gelist* (right wing), 1933.1035
Lippi-Pesellino Imitator
 Virgin and Child, 1954.318
Lorenzo di Bicci
 Madonna of Humility with Two Angels, 1937.1004
Mariscalchi, Pietro de, attributed to
 Portrait of a Gentleman, 1951.318
Master of Apollo and Daphne
 *Susanna and the Elders in the Garden, and the Trial of
 Susanna before the Elders*, 1933.1029
 *Daniel Saving Susanna, the Judgment of Daniel, and
 the Execution of the Elders*, 1933.1030
Master of the Bigallo Crucifix
 Crucifix, 1936.120
Matteo di Giovanni
 The Dream of Saint Jerome, 1933.1018
 *Saint Augustine's Vision of Saints Jerome and John the
 Baptist*, 1933.1019
Membrini, Michelangelo di Pietro, also called Mencherini
(The Master of the Lathrop Tondo), attributed to
 *Virgin and Child Enthroned with Two Angels Holding
 a Crown*, 1933.1016
Moretto da Brescia (Alessandro Bonvicino)
 Mary Magdalen, 1935.161

ITALIAN PAINTINGS BEFORE 1600
IN THE ART INSTITUTE OF CHICAGO
A CATALOGUE OF THE COLLECTION

Designed by Bruce Campbell

Typeset in Aldus by Paul Baker Typography, Inc., Evanston, Illinois,

with display type on cover and title page in Arrighi

Duotone negatives by Robert J. Hennessey, Middletown, Connecticut

Color separations by Elite Color Group, Providence, Rhode Island

Printed in an edition of 2500 copies by Meridian Printing,

East Greenwich, Rhode Island,

on 100 lb. Lustro Offset Enamel Dull Text